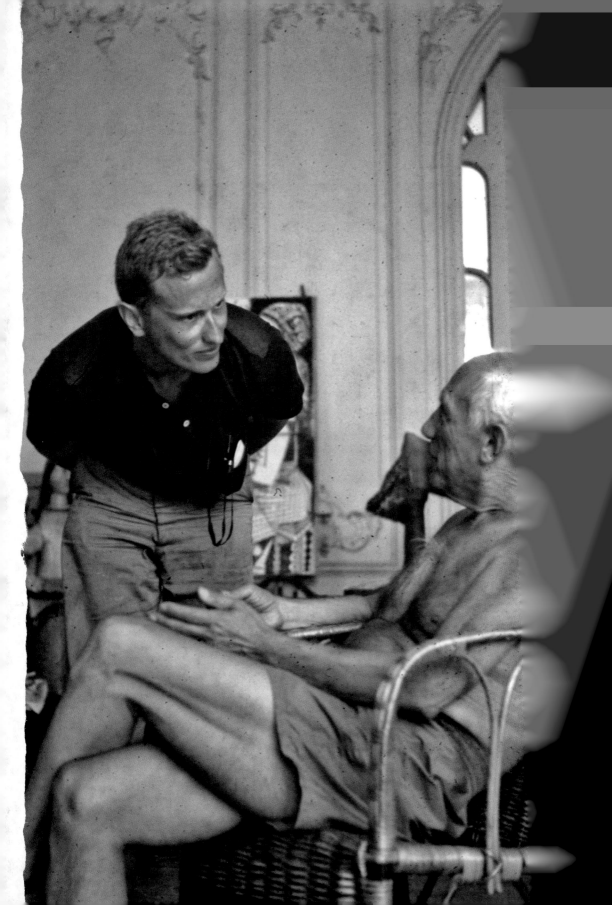

Dear

An illustrated

with freedom

Mr. Picasso

love affair

Fred Baldwin

Schilt Publishing

CONTENTS

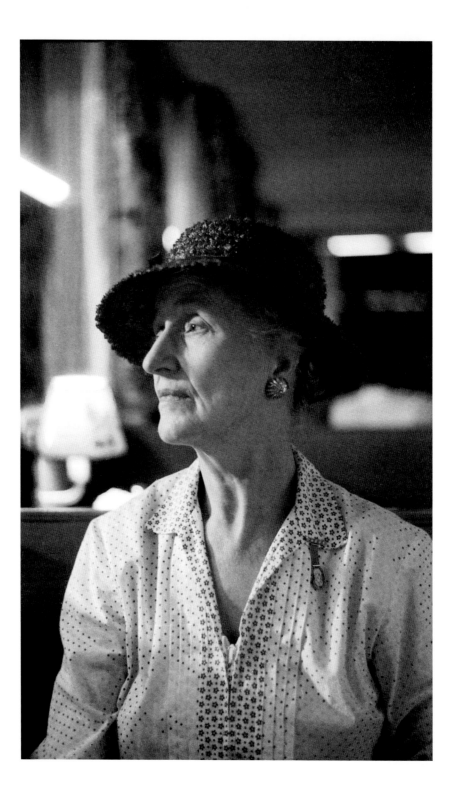

1 – **PROLOGUE**
REUNION IN FLORENCE

"You're blaming me for almost killing yourself."

Those were the words that poured out of my mother's mouth as we sat in the garden of a converted monastery, Villa San Michelle, in Fiesole, overlooking Florence five miles below. Mother briefly lost her composure, but not her dignified bearing. She sat ramrod straight, clad in cool silk. A tiny Tiffany watch hanging from her collar marked the moment.

She had arrived the previous day; I'm not even sure from where. Her last postcard to me had been from Cairo, and the one before that from Bali. Since girlhood my mother had been a traveler. The cards had finally caught up with me a month before in the Lofoten Islands of Norway, above the Arctic Circle. Now it was May and I had finished my job — diving into cod-fishing nets trying to photograph from the point of view of the fish. Since January I had been consumed in this freelance dare-devil stunt, an exercise that was probably as much about ego as journalistic investigation. It was early in my new career as a photographer, and I was anxious to tell my mother everything. I imagined us exchanging stories about her exotic tour of the Far East while I laced the conversation with anecdotes about my freezing exploits in the Arctic. My mind was still dressed in my rubber diving suit.

I was so wrong.

We had come from opposite ends of the world in more ways than one. Mother had made reservations for us both at this five-star hotel where we could meet after a year of separation. Our possessions also met and they also told different stories. My ragged backpack and banged-up camera bag joined her

lightweight brown suitcases, trimmed with leather, shaped to contain their contents — round for hats, smaller and rectangular for shoes, and a big one for everything else. Each was monogrammed with her initials: M.G.B. — Margaret Gamble Baldwin. It was 1958 — not an era when suitcases had wheels on the bottom. These were designed to be carried, not by my mother of course, but by porters with white gloves at hotels like Villa San Michelle.

After her surprising outburst, my mother glanced away, her dignified face and aquiline nose framed by a dark blue straw hat, designed for her by Mr. John, the famous milliner who had crowned Vivian Leigh in *Gone with the Wind*, as well as countless other actresses and socialites. He had done the same for my mother — marking her as a lady of presence — whether out for the evening in Savannah or meeting her son in Florence.

But a dark shadow had passed over our reunion.

This was not like my mother. She was comfortable almost anywhere; her character and charm enabled her to maneuver events in ways that suited her, and she projected social certainty. Perhaps Mr. John had framed Marlene Dietrich's and Greta Garbo's faces for similar roles, but this wasn't the movies. My mother's blue eyes hardened briefly, then softened as tears gathered.

For me, two worlds began to unexpectedly collide.

I had just made the long drive from Stockholm thinking about the best way to deliver my *new* self. Which tales could I tell that would counter the memory of my dismal past, my failed schoolboy years, my inability to find a happy, successful role in the family business in Georgia? What evidence could I produce to convince her that my new career as a photojournalist was not a patch-up, but that I was reconstructed — a robust free-spirited survivor of my own follies. It was time to tell her how much I understood about the sacrifices she had made, sending me to the best schools — I had been kicked out of two, suspended from a third, and flunked out of university. My life had been a mess. So when I spoke, it was with conviction and rare candor.

Recent triumphs had shifted boulders of insecurity out of my way and these painful, hard-won truths were the presents I had to offer. And it hadn't been a free ride. Should I tell her about the reindeer migrations with the Sami? What about the near miss with the avalanche?

But now I was dealing with another avalanche.

When I had begun to earn a living, only recently, I discovered that I had a taste for the elite, but had never mastered anything that could pay for it. All the usual agendas for young men to make their way in the world I found either too difficult or boring. So I had come to Florence to make peace with my mother and explain that I had a new way of living my life. My mother admired courage, and I imagined that she would probably be glad to hear that I had paid my dues and had faced enough danger to give an edge to my tales. On my three-day drive south from Stockholm I had conducted a non-stop review of my adventures. In a way, I had been waiting to make this delivery for a long time, and I wanted my story to join those from her past.

As a young woman, Mother — unmarried, attractive, rich, spoiled, pampered by a doting, handsome, successful, all-powerful aristocratic father, backed by an equally strong mother, and a family who adored her — must have been hell on wheels. I remember one story, for example, of a suitor who had chauffeured my mother from Jacksonville, Florida up to a summer house in Asheville, N.C. Unknown to him, the purpose of the trip was for my mother to rendezvous with the man she was in love with, the person who was to become my father, and to announce their engagement. Poor guy.

She didn't get married until she was twenty-nine, and she had the pick of the crop. She was brutal, in a charming and completely impossible way. It never occurred to my beautiful mother that the whole world wasn't built to amuse her, and she had the courage to take what came her way and do with it what she wanted. If she couldn't swing it, her PaPa (emphasis on the first Pa) could; he could buy it, shoot it, make it illegally, do what he damn well pleased if she wanted it. That's the kind of family she had.

The first Robert Gamble came from Londonderry, North Yorkshire, England to Augusta County, Virginia in 1735. He married Leticia Breckenridge, who chose him after rejecting Captain Merriweather Lewis, and was the father of Captain Robert Gamble, a Revolutionary War hero who fathered another Robert Gamble, a Captain in the Confederate Army.

My grandfather, Robert Gamble, PaPa, died before I was born, but he influenced much of the way I approached manhood. Though I never knew him, my mother passed on many tales about PaPa, and seemed to remember everything he had ever told her and believed every word he had said. He was a tall,

imposing, handsome, aristocratic-looking man who started without a penny and became a millionaire. He quit school at the age of 13 when he was punished for something he didn't do, sold orange trees in central Florida, and became a train conductor on the Florida East Coast Railway. When he realized that he would not likely become president of Henry Flagler's railroad, he quit to build his own empire, erecting brick factories and ice plants in Florida and Georgia.

The current Robert Gamble was my Uncle Bob, my mother's brother, who had a strong influence on my life both as the male relative that I saw more frequently than others during my late teens and early twenties, and a man who became my first employer. He lived near Charleston, and my mother, brother, and I spent many Christmas vacations with Uncle Bob and Aunt Mildred at New Cut Plantation on Wadmalaw Island, 420 acres of the past, dating back to 1842 and with a spectacular river view.

Uncle Bob was now nearly blind but he never complained. His behavior reflected his heritage. He volunteered as an ambulance driver during the early days of World War I, was wounded while serving, and later decorated by the French. When the United States declared war on Germany he returned to the U.S. to enlist as a Naval Air Cadet at the Massachusetts Institute of Technology (MIT) and became cadet commander. After graduation he formally achieved that rank as a naval aviator during his service. When World War II broke out, far beyond the age for active duty, Uncle Bob enlisted again and once again became the "Commander" — a title he retained for the rest of his life.

Souvenirs from my mother's family abounded in my youth. Silver pitchers, trays, and bowls were everywhere. Interestingly, the more meager supply of silver from my father's side is plain, but every piece of my mother's Tiffany sterling displayed a tiny standing knight, the Gamble family crest. Every fork seemed designed to remind me of who I was supposed to be.

Apart from infrequent contact with Uncle Bob, Gamble family traditions were kept alive through the women. My mother was trained from birth to be proud of the family heroes, whose legends were breast-fed to her from infancy. She loved her super parents and she learned to hate anyone or anything that reflected on their honor. As a young girl she once slugged a grown male cousin for saying something she didn't like about my grandfather, inaugurating a family feud that continued for fifty years. My mother's courage began early

and never flagged. When she was a girl of only eight or nine she beat the day-
lights out of a bully who was picking on her younger brother, and she never
lost her taste for a fight. When my father was stationed in Lausanne, Switzer-
land as American Consul, he got a bad performance review from a supervisor.
My mother thought this was ridiculous, so she got on a boat to the United
States and without my father's knowledge went to Washington, D.C. to see Un-
der Secretary of State Cordell Hull. She told Mr. Hull that the review was un-
fair, and I'm sure said in the most charming tones that she was going to see
Senator Somebody-or-Other, a friend of my grandfather's, and get a senate in-
vestigation going. Instead of my father getting fired for having a crazy wife as
well as a bad report, he got another review and Mr. Secretary became a buddy
of my mother's. The remarkable thing is that the whole thing was a bluff; my
grandfather had been dead for some years and Senator Somebody-or-Other
probably wouldn't have done a damn thing for her anyway.

On another occasion my mother acted with equal directness. My Uncle Bob
and wife were separated or divorced and it was felt that it was not appropriate
that this Jezebel should have custody of her two children, so the children were
abducted by my uncle and brought to Jacksonville, Florida, where grandfather
could keep things tightly secured. In due time, Aunt Jezebel (I think it was ac-
tually Virginia) decided to kidnap the children back and hired some profes-
sionals for the purpose. My grandfather got wind of this and took defensive
measures. (The official version is that an ex-New York detective, who my

grandfather had helped out for some reason, tipped him off out of gratitude.) As it happened, our house in Jacksonville ran through the lot from Riverside Drive to Oak Street in the rear. Private detectives were hired to be with my cousins around the clock and all members of the family were armed, including my grandmother, an invalid at the time, who was posted with a moose rifle in a rocking chair by the window in her room that had a commanding view of the back yard and garage. My mother carried a small automatic pistol in her purse (.25 caliber Colt) and of course my two uncles walked around at all times with large bulges under their coats.

One day, my mother saw two men sitting in a black car with the engine running. One door of the car was open, and the situation was obviously very suspicious: nobody just sits in a car with the engine running and a door ajar unless they are about to kidnap someone, so mother goes over to investigate; she sticks her foot in the door and asks the gentlemen to identify themselves. She had, of course, explained in a measured tone of voice that, "we are having a bit of trouble around here." If my mother had said, "Won't you gentlemen please introduce yourselves?" they would doubtless have complied, but my mother wanted positive identification: driver's license, birth certificate, passport, laundry tags, etc. Well, the two gentlemen felt put upon and attempted to close the door that was being obstructed by my mother's foot. At this juncture they also discovered that they were gazing down the barrel of an automatic pistol. They panicked and lit out across the street. My mother called for reinforcements and, shortly, my two uncles flushed the two men from under the dining room table of an absolutely astonished neighbor. As it turned out, the two were not kidnappers but tourists and when they tried to sue the family for scaring them to death, no lawyer in Jacksonville would take the case. Our family lawyer told them, "That was Margaret Gamble, you're lucky you didn't get shot!" And so it went.

As I was driving to Italy to meet my mother, these stories as well as my own ran through my imagination like old movie teasers — playing over and over until I reached the outskirts of Florence. The streets were familiar. I had been here in 1955 and it wasn't surprising to me that the Vespa-crowded center was a tangle of traffic confusion. Then it happened. Amazingly, I saw my mother walking on the street, but she didn't see me. Frantically blowing my horn and

yelling: "Mother!", I stopped in the middle of the traffic. But she kept going. I was blocking everybody. A policeman tried to wave me on. I refused to move, still screaming for my mother, and he came over to arrest me. He thought I had gone mad. I blurted out, waving and pointing in her direction, "Mama mia, mama mia."

Instead of giving me a ticket, he chased down my mother on foot, and we were reunited.

It was early evening and we went to the Villa San Michelle to check me in. The porter greeted Signora Baldwin with a deep welcoming bow. I was hoping for something in the same spirit from my mother later at dinner: my stories required a special setting. Cleaning up hurriedly after the long trip, I was eager to reconnect in a new way. This was to be my long-awaited graduation party, celebrating maternal acceptance. My appearance was carefully arranged. I put on a blue blazer that had been meticulously folded into my backpack. The two were not completely compatible, however. The blazer spoke of a lifestyle that had been suspended for a year, and now smelled faintly of the reindeer sleeping bag that had shared my backpack.

Dinner began well; my mother speaks Italian and she was at home in these surroundings. It was the perfect place to have our peace conference. I felt connected as well in familiar and friendly neutral territory. People knew my family's name. Immediate pleasures were at hand. The pasta I craved would replace the continuous diet of boiled Arctic cod. The linguini would be *al dente*, and a glass of Brunello di Montalcino would lubricate the occasion. The hills of Fiesole, just below, were enveloped in a cloud of Italian charm.

Florence was in my genetic code; it had been my father's home for his early years. He had been born in Ansonia, Connecticut, but was brought up in Europe, the eldest of six children. His father, William Wilberforce Baldwin, got his first medical education starting at Long Island College in Brooklyn in 1876, and finished at the University of Vienna. He opened a practice in Florence in his mid-thirties and managed to have an exceptional career for the next twenty years or so. His practice included members of the British royal family and a number of the writers and intellectuals who frequently passed through Florence in those days. They included William and Henry James, Mark Twain, Edith Wharton, and W. D. Howells. Sir Luke Strett, a character in Henry James's

The Wings of a Dove, was modeled on my grandfather. Historian Linda Simon writes that "his patients' letters, taken as a whole, give us a portrait of a warm, charming, even charismatic man: a man who possessed an artistic temperament and, as William James put it, 'genuinely social genius... and gallant personal pluck.'" More than a thousand of these letters are in the Pierpont Morgan Library in New York: Morgan was also a patient.

Grandfather Baldwin was born in Walton, New York in 1850, the son of a gloomily devout Calvinist minister, who provided him with his middle name in honor of William Wilberforce, the English politician whose fervent, almost singlehanded leadership of the abolition of slavery movement was drawn from a powerful religious zeal. His father's "hideous Calvinistic" religious beliefs, however, were reported to have haunted grandfather. Deep bouts of depression and heart disease also exacerbated his burdens. But his willingness to be completely open with his patients about his own problems created remarkable connections with those similarly afflicted. It was an age where physicians were both judgmental and unsympathetic. William Wilberforce Baldwin's situation may have persuaded his eldest son, Frederick William Baldwin, who shared his father's charm and intelligence but not his black moods, to take a path that was less augustly ambitious and exercise his considerable talent for enjoying life.

So Florence was part of my childhood; indeed, my brother, Gamble, was born there in 1923, a few miles below from where my mother and I were sitting and where my father had been American Consul in the early 1920's. My more recent memories of Florence were warm, and a few words of the language were still stuck in my brain, where a little band was playing a catchy tune I loved. I can't remember the name but there's lots of "Amore" and it took me to Italy when I heard it.

But it hadn't always been this way. Twenty-three years earlier, in 1935, the music had stopped when I was five-years-old — my father died — after which the music started with a different tune. From that point on, all the special things that I might have learned from my father were delivered by women — my mother and my grandmother, a grand dame who smelled of 4711 Cologne — both from the Southern side of my family. In addition to the stories, there were patterns of behavior and expectation that were biblical in intensity. They were not religious but might as well have been. They had to do with family

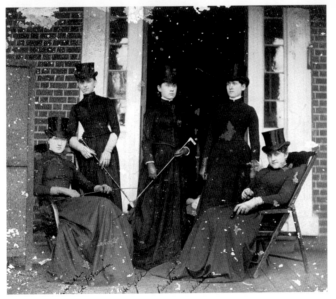

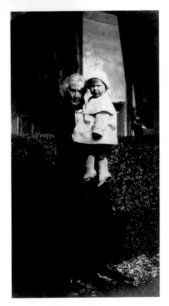

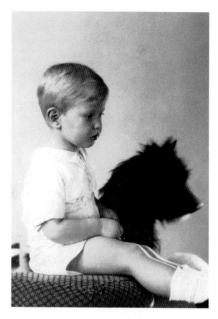

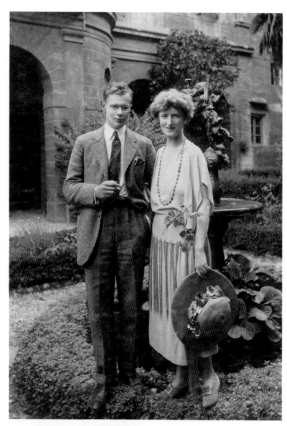

myths that were deeply based; even, it seemed, coded in the marrow of their bones. However, codes do best if they are unmolested by change, and geographic stability was not part of my history.

So here we were, high above a place that represented half of my heritage, with the other half now looking at me, sad and hurt. Maybe my father would have been proud of what I was about to say, and I was so hoping that my mother would be, too, if I explained everything carefully. I thought I had finally learned to climb out of a desperate, slippery, black hole and could begin to imagine that mountains existed on my horizon, and I wanted to tell my mother about even more formidable peaks I wanted to climb. This was a message that I was desperate to get to her. And then — at a moment I could never have anticipated — from deep inside me came words that I had never said to anyone.

"I'm doing it all for you."

It was an emotional hand grenade. Just when I was expecting one thing, and I was not even sure what that was — understanding, forgiveness, compassion, love? — I got another. My mother shed a few more tears then said it again, not quite looking at me: "You're blaming me for almost killing yourself."

Her heart must have pounded as mine stopped. Then, I realized that I was trying to talk to my father and he was dead. This sad situation revealed my deeply scrambled understanding of women. People who were not men had taught me about manhood and somehow this had led to confusion. Sure, I had King Arthur and Superman as early models, but of course they were wimps compared to my mother and grandmother. Why couldn't I get it straight in Florence? Where and why was I missing the boat?

There are so many possible ways that this could have happened that I am not going to try to discover them. So I am going to jump in and start here to reveal those things that I was unable to launch on that beautiful night in Florence.

2 – SCHOOLS AND GIRLS, AND ICE

When Dwight D. Eisenhower, then President of Columbia University, was handing out diplomas on a hot June day in 1956, I was not dressed in a black gown and mortar board; I was in my room a block away, wearing a bathing suit and typing furiously, sweating out the expansion of some of my adventures from the summer of 1955, trying to stretch them into a book.

Muriel Camp, my creative writing teacher at Columbia, had agreed to be my agent and had received a letter from a publisher that said in part, "I am not sure that this young man is going to have the patience to sit down and do the painstaking extraction and rebuilding work that will be necessary to make a whole of any single one of his interesting episodes. I hope he will, for he does have a freshness... if he will grow out of his sophomoric bodily functions and immature sexual absorptions... there is the possibility that he can finish it before he gets too discouraged." Signed, Beulah Phelps Harris, editor, E.P. Dutton.

Mrs. Harris was a wise lady, but in June 1956 there was another problem that she didn't know about. Apart from my impatience, which Mrs. Harris accurately identified, I hated to be cooped up with a typewriter that constantly reminded me that I didn't know how to spell. Spelling in school had always been a guaranteed F. My Olivetti had become as much a generator of embarrassment as an instrument of expression; if spell check had been invented in 1956, it might have nudged me in the direction of writing rather than toward photography. I suppose I was, and am, dyslexic, but sixty years ago there was neither a diagnosis nor a remedy for such ailments.

As a teenager I had learned to be a storyteller rather than a writer, spinning yarns about the boarding schools that had expelled me — one after another. These disasters were generated, at least in the beginning, by my inability, in addition to bad spelling, to cope with rote learning. Memorizing poetry, Latin declensions, all the things that students destined to take their place in the upper ranks of society were expected to master, eluded me.

The disability found its first major consequence at St. Mark's School, in Southborough, Massachusetts, one of New England's reincarnations of the English public schools. St. Mark's carried forward the moral certainty of the English upper classes, which had served them well during the final expansion of the British Empire in the 19th century. Recruits were cut, pounded, polished, and shaped like pieces of fine leather until they became malleable and comfortably fit the traditional ways of class.

St. Mark's and the other elite boarding schools in New England served to prepare young men to enter the country's best universities, then finally to colonize Wall Street and other centers of power. Similar schools for young women carefully prepared suitable partners to maintain, support, and become pedigree breeders for the American elite. My mother and her mother had gone through this training.

Boarding schools figured in my education and my brother's in part because our father was a career foreign service officer in the Consular Affairs unit of the U.S. Department of State. It may be hard to digest such acts today but in the 1930s, if you had the resources, it seemed that the protective power of maternal instinct could be transferred to a nurse or, in my brother Gamble's case, to a boarding school. At the incredibly young age of four, Gamble had entered the exclusive Marie José School located in the snow-clad ski resort of Gstaad. To be fair, this was necessitated according to family lore because Gamble had a respiratory problem; the clean mountain air would presumably do him some good, but my parents' social life in Lausanne may have also been a factor. At the time, my father was the American consul there. I was born in Lausanne.

My father's next post was Barbados, British West Indies, and again Gamble was shipped to boarding school, but he returned to the comforts of home on weekends. Upon his promotion to Consul General, my father was transferred to revolutionary Havana at a time when Fulgencio Batista had led the Revolt of

the Sergeants. This caused my family to move to Nassau in the nearby Bahamas to be safely as close as possible. I never saw him again.

My mother told me that when we lived in Barbados, my father used to swim a mile out to sea and back every day. He was a superb athlete. When he was in Havana, he must have done the same thing because as the family story goes, while swimming, he aspirated some seaweed into his lungs and developed a massive lung infection. Shortly after being shipped to Bethesda Naval Hospital near Washington, DC he died. He was forty-nine years old. My brother told me years later that he smoked a pack of Camels a day. I still have a picture of him on my bureau in his bathing suit on the beach in Barbados. His physical fitness has always been an inspiration to me.

After my father's death we continued to move around. When I was five my widowed mother, Gamble, my grandmother, and her nurse-companion "Cutie" rented a house near Peekskill, New York for the summer as it was too hot to live in Jacksonville, Florida in my grandmother's house. It was Southern practice to travel north to cool off from humid hot places in pre-air-conditioned times – if you could afford it.

Then it was down to Cloverfields, a large farm near Keswick, Virginia run by Miss Randolph, a great-granddaughter of Thomas Jefferson, where my family spent several winters. Miss Randolph kept the family place running by taking in "paying guests" and was a close friend of my grandmother. While there, I entered the first grade at St. Anne's School in Charlottesville, not as a boarder, but driven to and fro each day over the fifteen miles to school by Joe, my mother's chauffeur, in her Ford Station Wagon. This only begins to describe the academic bouncing around that resulted in living in twenty-two houses before I was eleven years old.

I next found myself in Switzerland after a summer with my paternal grandmother in Italy. I was shipped off to Institute Morgana, in Lausanne, where life was conducted in French. But war was clearly looming in 1938, so my mother and I returned to the U.S., where we moved in with my grandmother in Jacksonville. There I was enrolled at the Bolles School, then a military academy, where I learned close order drill instead of French. After three years at Bolles, I was off to St. Mark's at the age of twelve, following Gamble, who had just graduated.

The American private school system now had six more formative years to shape and educate me. I was an academic disaster, but through osmosis I came to have a deep visceral understanding of one basic, inviolate rule by which progress could be made. Whether it was Switzerland or Southborough, Massachusetts, to pass through the portals of privilege it was necessary to walk a straight line, suffer every test without complaining, follow the program no questions asked, and recognize authority from the top down. Grades, which were called "forms" in private schools, were like six steps to heaven, starting in hell in the First Form (7th grade).

This package, at least in New England, was largely sanctified by the Episcopal Church, which is why "Saint" forms part of a number of elite schools' names, such as Mark, George, Timothy, and Paul; others, called Groton, Middlesex, Deerfield, Choate, and Brooks weren't named after saints, but nevertheless maintained strong connections to the Church.

One of the many ways Saint Mark's shaped attitudes about class hierarchy was with regimented living accommodations. The youngest boys slept in alcoves that were strung together like stalls, with just enough room to fit in a bed and a chest of drawers. An eight-foot wall separated the alcoves, and a curtain served as a door. (Living quarters were improved as students approached the Fourth Form — 10th grade — when two students shared a private room.) Since we were not allowed to move from the alcoves at night to the communal bathrooms, a potty was provided for each boy. There was also a window that unofficially served the same purpose: on cold, wintery mornings you could see little yellow dots in the snow on the ground below.

My dormitory was a huge vaulted space shaped like an upside-down ship, perhaps modeled on the Mayflower. It was brown and forbidding. In winter, toothpaste sometimes froze overnight in our alcoves after the central heating was turned off. At 6 a.m. a cacophony of clanking, banging, and hissing announced the return of hot water to the refrigerated radiators and some warmth to the dormitories.

Social ranking in the school was maintained by discouraging integration between grades. Second Formers — 8th grade — did not usually associate with First Formers. This was not prohibited, but it didn't happen much because each grade slept in separate quarters. As a disciplinary measure, Sixth Formers — 12th graders — were allowed to conduct "dorm raids," occasional sweeps

through the dormitories, where the little boys, taken from their beds, were required to bend over to receive a whack or two, administered to their bottoms with a wooden paddle. This could occur at any time after "lights out" and was occasionally necessary to discipline the disrespectful. Perhaps one of the little boys had omitted calling a senior "sir" — required by tradition. A vivid memory from my first year at school was a paddle, ominously hanging on the wall of the Monitors' room — a symbol of the authority of the two sixteen-year-olds who kept order and were quartered in a room in the same dormitory.

A letter to my mother, found at the time, was a revealing voice from the past and hinted at my academic condition with respect to French and spelling in the English language, but more clearly, it marked the birth of anger and rebellion when I was fourteen years old at St. Mark's.

In it, I described what happened one day when the entire school was assembled and nobody knew what the Headmaster, Mr. Brewster, wanted. It was rumored to be everything from an outbreak of scarlet fever to his bringing back paddling. Finally he arrived. He sat down and asked why some boys were missing. Told that they were student waiters and would come in late, he decided to wait for them. When they arrived, he got up and said that five lamps in the library had been twisted out of their bases, and he wanted the boy who did it to get up and tell him. No one got up. He said that it was an act of vandalism, and confessing the crime would be for the good of the boy. Then he said he would give the boy five minutes to think it over. I felt very strange inside. I felt as if I should get up and confess, although I hadn't done it.

Mr. Brewster said that if we did not find the boy and bring him to him by six o'clock he would punish the whole school. Nothing happened all afternoon and we had another assembly at 6:00. Mr. Brewster said that nobody had been brought in, so we would be "restricted to campus" until Sunday and would not have an upper school dance. Boy was I relieved; I thought they would take our Thanksgiving vacation away. But he said he would do it if we remained silent.

What happened next never solved the mystery of the vandalism, but was somehow typical of conflict resolution at St. Mark's. I reported in my letter that the Head Monitor and some monitors took two First Formers, paddled them and then made them take cold showers in our dorm. The two boys had great red spots on their rears and huge blood blisters under their skin.

The letter revealed a headmaster who would punish the whole school for an incident of vandalism, while tolerating institutionally sanctioned bullying and violence. What I was communicating was not good news, and it upset me, but at the same time, in putting it down on paper, the little drawings and faces I added moderated my grim description of school life. The comically cheery faces and rough illustrations became a habit of mine that would gradually become a valuable tool — one that I had learned from my mother's own letters.

The boarding school system manipulated teenage insecurity, compressed it and molded class consciousness by allowing each student to gain in power as he progressed year by year through the system, eventually from paddled to senior paddler. This isolation compressed our lives so that every sadistic bullying tendency to which teenagers are prone was exaggerated. We formed cliques within our tiny forms. Luckily, every minute of the day was planned, reducing teen nastiness through busyness. An important outlet for me was sports — where frustration, confusion, and doubt could combine to fuel action and redeem some aspect of honor and respect. I wasn't a great athlete, but I could take hard physical contact and became tough. It was good preparation — mentally and physically — starting at age twelve, for my stint in the Marine Corps ten years later.

Ironically, apart from my dismal grades, I liked the school and adjusted well enough to the system. I enjoyed thinking that in spite of my failings, I was on the road to becoming one of the "elite," whatever I thought that was at the time. If I could survive each indignity, I would eventually emerge to take my rightful place among the other survivors. Then, a special door would open and let me in because I had learned to express, without saying a word, the special secret codes of upper class communication.

The school tie was an obvious emblem of school and class. To everybody else in the world, a tie was a tie. But the initiated could read ties, just as the British understood that ties with Regimental Stripes referred to actual military units. This was not a fashion statement but a matter of maintaining traditions. The St. Mark's tie — blue with white horizontal bands — was knitted of a finely meshed crochet material exclusively available at the school store and only allowed to be purchased after the student had attended for a year. The student then also had to learn to tie it to make the white stripe appear in the center of the knot, and making sure that the square ends of the tie came out even — perhaps an appropriate metaphor for the future.

Among other style matters was how you wore your hair and how you spoke. Hair was to be worn long but not too long — just enough to extend over the collar about half an inch. Being shaved up the back of the neck was to be avoided. It seemed that we were all being groomed to eventually look like William Buckley. There were also conversational styles that had to be mastered. What was not said (the ironic understatement) was very important; the accent and a thousand other hints signaled who you were. Only the initiated had the ear for recognizing the SaintGrotelsex crowd (code for all the Saint schools, plus Groton, Middlesex, and so on). The promise of this recognition was a powerful balm for my massive insecurity, something that I came to believe was vital to gaining the special status that I deserved by virtue of becoming strong and a believer in the system.

Loneliness goes way back, probably before I can remember. It must have come from bouncing around the world — the child of a diplomat. In the Caribbean in 1934, I wanted to have a flat nose like the black gardener's children who lived next door. In Mexico in 1937, I wanted to be brown. When I was five, I asked my mother whether I could marry my brother when I grew up because he knew everything and could do anything. He was eleven. These things my mother found amusing and charming and it all went into a beautifully illustrated book. It's lovely, this Baby Book. My mother could have been a first-rate illustrator. The book was done in gold and azure blue with the care of a medieval illuminator, but with a fairy tale spirit. The handwritten text often quoted me. I've looked at my Baby Book many times, but never had the heart to read much of it. Why? Maybe I felt I could never live up to such an optimistic appraisal. Or maybe I didn't want to be cute forever.

I gave myself to St. Mark's, but often tried to escape briefly, through various dodges; I grabbed any opportunity that came my way. When the school found out I couldn't see the blackboard clearly, I was measured for and got a pair of eyeglasses. This gave me a two-day reprieve. As it turned out I was just as much a disaster sighted as blind. I also needed braces to straighten my crooked teeth and I loved going to see Dr. Blumenthal, the orthodontist, because it took me to Boston once a month to get my braces adjusted; I also got to buy a copy of Spicy Detective Magazine at a newsstand near Copley Square before returning to Southborough on the train.

My invalid grandmother also served as a possible diversion from school as her periodic health failings signaled a family gathering. She had been in the process of dying ever since I could remember. Grandmother was not a little invalid, an insignificant invalid; she carried her invalid-hood like a queen. She was nearly six feet tall, feared or loved or both by one and all. She lived with us of course, or more accurately, we with her. Her nurse-companion "Cutie" had been with her forever, one of those unnatural family outgrowths who get their strength by usurping all lines of communication between the outside world and Mama (grandmother). "Cutie" had expanded her functions to monitor any disturbances caused by me that might create a dangerous domestic ripple that could carry off my dear grandmother. It seemed to me that the old lady had spent her whole life, at least the part I knew, getting ready to die if I sneezed.

My grandmother was a brilliant woman, or so I was told. Her grades had always been "A," I felt certain. She was formidable in every way, but very sweet when she wasn't sick, which was before I remember her very well. I'm sure she was warm and kind, but I remember not being particularly sad when she died. I got the word at St. Mark's and went to see Rev. Brewster, the Headmaster to get consoled. I thought that was what I was supposed to do. Mr. Brewster didn't say or do anything remarkable, but I thought at the time I would offer my dead grandmother as atonement for my numerous sins. If they thought, "The boy's grandmother just died," maybe they would let up for a while — three or four days.

During my second year of incarceration at St. Mark's, raging puberty introduced me to a new flood of distractions. In addition to being locked up with two hundred boys for nine months, I spent my vacations on an isolated family farm in Virginia, a social desert island. Sex hit me hard on the farm, but the only young females available had four legs or feathers. And at school, as my body grew and began to change, there were juicy thoughts but no girls. Then I discovered a toy available between my legs, which offered more fun than trying to live up to my fabled ancestors. Female fantasies became a temporary release from growing guilt about my grades.

St. Mark's itself did provide an occasional respite from failed tests. During my third year, students from a nearby girl's school were invited to a dance held in our school gym. GIRLS, girls — I couldn't believe it — were lined up in a row fac-

ing all of us St. Mark's boys. Each girl was given a chance to review the boys, come over, pick out her partner, and dance. This was to happen one by one. The head girl of the Senior Class, obviously the most brilliant, beautiful and accomplished one — the King Maker, so to speak — was allowed to choose first. It was a brutal moment. Every St. Marker was lined up for inspection. She chose, and to nobody's surprise it was Charlie Coulter, a Sixth Former, blond and rippling with what every sixteen-year-old girl dreams about. It was all so predictable. Charley always wound up with a bombshell. You could tell by the framed pictures on his bureau. In later years he took out Jacqueline Bouvier (later Kennedy).

Then it was time to make the next choice. The younger boys — the Second, Third and Fourth Formers — were secretly placing their bets on this boy or that — the established "make-out artists." My form was obviously out of the running, safe from the embarrassment of not being chosen. But those big, "smooth" Sixth Formers were sweating it, and then it happened.

The girl chose me.

Out of two hundred possibilities, I had been picked by the second-fairest of them all. I can't remember her name or what she looked like, but she must have been very beautiful, and of course she became more so every time I told the story. Actually, she was probably myopic. In those days before contact lenses, she was undoubtedly too vain to wear her glasses and chose me blind. At fourteen, I was nearly six feet tall and gawky looking. The blur filled me out. She was compassionate, and probably didn't even know it.

The dance experience put ideas in my head, and I began writing to the sisters of my classmates in desperate search for contact with girls. I developed fantasy relationships that were wonderful; we danced and dated through words. I drew little cartoons in my letters to illustrate the wild yarns I was spinning. The process provided an outlet for my imagination and connected me with a fantasy world that was full of hope and promise. We could all take off our inhibitions and romp in naked words with complete safety, sending kisses that were as light as the postage stamp that carried them. One note was even signed: "With puddles of purple passion." Oh! My God!

Actually, long before I got to St. Mark's, I had had a love life. It began early, with my rangy, good-looking young German nurse. My Baby Book indicates that I was a beautiful child and she loved me. She came with us by boat from Europe

to New York and then on to Barbados. Nurse's attentions to me in the bath and shower piqued my interest. Putting on her stockings also got my attention and evidently, I once told my mother, "Nurse has pretty legs." This cute expression from "little Freddy" went down in the Baby Book.

Later, it turned out that the girl was not only a German spy but a thief; she stole some of my mother's furs, though God knows why mother had furs in the British West Indies. Tucked into my Baby Book is a color postcard: "Dear little Snooky, I miss you, etc., etc. Love, Nurse." The other side of the card shows a battalion of Storm Troopers marching under the Brandenburg Gate. There are little swastikas in each corner, and the postage stamps postmarked January 1934 show Hindenburg and Adolph Hitler. Anyway, at age four I missed her too.

When I was five, there was a little girl in Nassau named Pamela Burnside. She came to wave goodbye when we left. There must have been something else going on because I remembered her name and I took a lot of trouble to draw a picture of a boat for her that mother intercepted for the Baby Book.

Also staying at Cloverfields, the Randolph farm near Keswick, Virginia, were the Caruthers sisters — one was shy and the other was not. The not-so-shy one took Brian Smith, the farmer's son, and me down into the cellar one day. I can still remember the smell of potatoes and apples in this cool, damp, and musky place as she pulled down her pants and let us have a look. Brian unbuttoned his pants and they made comparisons. Brian's looked very funny to me because he wasn't circumcised. I didn't lower my pants, but was admitted into the show on Brian's credit. We were all seven.

I actually liked the shy sister better and was very sorry when they left. Years later, I bumped into one of them at the end of my freshman year at the University of Virginia. Lolly Caruthers and I were very attracted to each other, but nothing came of it because I had to leave the day after our first date. I never did find out which sister she was, and never saw her again.

When I was eight, my mother and brother and I lived in Jacksonville, Florida in my grandmother's house at 1020 Riverside Drive. Patricia Milam lived across the street in a huge house with six brothers and sisters. Sometimes we played at her house, sometimes at mine, but the rules were different. At my house we lived with Mama, my formidable grandmother and the fearsome "Cutie." Tip-toeing was the normal pace at our house, but Patricia Milam lived

in a bold and different world, and was curious about all manner of things. One day, Patricia took me into our bathroom and pulled her pants down. I found her most interesting. When "Cutie" heard our voices behind the locked door she started pounding. "What's going on?" I was about to treat Patricia to a look at me, but changed my mind and jumped out the window instead.

At nine, I met Rosemary Murphy during a summer we spent at Quaker Hill near Pauling, New York. She lived in a large house on a beautiful lake. I went swimming there often. Her shiny wet body in her bathing suit is a memory that lingers. She was the prettiest girl around, and I was in love with her. She kissed me in the garden once. When I went back to Jacksonville, I was very sad.

Then there was Eloise Ashby when I was ten. She lived nearby in Jacksonville Beach, just down the road from our rented house. There was something about those first moments when I realized that she liked me that can never be forgotten. The gentle shower of glances — they were delicious. I was at the center of the universe. Everything was charged; gestures, touching, how we sat next to each other in the car — the two of us squeezed into the back seat, pressed together. Those dumb adults didn't know what was going on. We had secrets. We'd hide in her garage and do exotic things like rubbing noses.

My best friend, Gene Gill, was invited to come down to Jacksonville for two weeks. Gene Gill came from a simple background. His father was gone, his mother had to work. He went to public school and took trumpet lessons. Our common bond was model airplanes. Secretly, I felt that his were better than mine, but I liked him. Unfortunately, so did Eloise Ashby. He began to get kissing lessons. This made me very unhappy. Eloise went to North Carolina for two weeks in the middle of summer. I thought I would go out of my mind.

I knew another girl at Cloverfields, but I can't remember her name. She was from New York, and her parents were Communists. This realization came to me when I visited her in New York. Her family had a dark walk-up apartment way over on the east side of Manhattan on Third Avenue. The elevated subway ran by her apartment at the same level, shaking the windows every time it passed. I guessed this was the kind of place Communists lived. At Cloverfields her family lived directly above our apartment and our bathroom was under hers; water pipes connecting the two. We worked out a code and a schedule, and before going to bed each night, both of us, naked and in our bathtubs, would tap on

the pipes; tap, tap messages to each other, sending our sensual secrets on the water pipes.

There were older women in my life as well. When I was ten, I was in a boarding school in Switzerland. One of the teachers was French and I thought she was rather mean. She would come and help me with my bath — very embarrassing. One night she slipped into my room and asked me to kiss her. "Embrassez-moi," she murmured in a low voice. I can still remember it. I had never been kissed like that. It was warm and soft — oyster soft — on my mouth but I was smothered with embarrassment. I didn't like her very much, but after that I looked at her in a different way.

On weekends I would get away from that dismal school where we had to drink boiled milk. War was in the air. It was late 1938, and German Jewish children filled the classes. But a short train ride took me from Lausanne to Vevey — a different world. There, Mrs. Dorothy Thompson had a finishing school for young ladies. She was English and an old friend of my mother's from Barbados. She was sweet to me, and I would sometimes spend the weekend. There were wonderful teas with lots of cakes and cookies and there were long hikes into the high hills behind Vevey. Below the school, separating it from Lac Lemon (Lake Geneva) ran the trains. I loved trains. They were green and clean and very fast electric trains. I was a budding philatelist, and some of the girls at the school gave me the stamps that came on their letters from home. On two occasions, two different girls came into my room and slipped into bed with me, but not for long. They would hold me, and one kissed me on the forehead. I liked it, but more important for me was to encourage the girls to bring me stamps.

During the summer of 1941, my mother rented a house in Princeton, New Jersey to be near my brother, Gamble, who was an undergraduate at the university. I was twelve, and toward the middle of summer I met Adelaide de Long, who was also twelve. My acquaintance with Adelaide was filled with fun. Before long we were doing everything together. We pedaled on our bikes all over Princeton. In time it became more intimate. We shared secrets and wrote notes to each other that nobody else could understand. Finally, we began to sneak across the street from her house to a special hiding place in the bushes where we snuggled very close and watched the cars go by in the dark. This was physical, our arms touched and we talked about things that had flown away. It

was intense, personal, private, and secretive. Adelaide and I never kissed or even held hands, we just lay there consumed and wrapped in the special cocoon of a dark, leafy, hidden secret place that only belonged to us.

I loved those girls. I loved every one of them. Life was good to me — trains, cakes, stamps, and secrets. It was a good start.

But then came St. Mark's, and the hard reality that the road to life in the upper class was paved with passing grades, which I wasn't getting. I did have one mentor at St. Mark's — Mr. Potter — my English teacher, who encouraged me to write instead of memorizing Latin poetry. Bob Potter — Mr. Potter — Bob. He wanted his students to call him Bob. I took his advice, though not to write good essays or original stories, but to correspond with girls. My mailbox was always full. Seeing those dark diagonal shapes in the tiny numbered window was such a cheerful sight.

Mr. Potter also encouraged me to paint. My single triumph at the school was having my watercolors hung in the school lounge, and I received an invitation to show my work at the Children's Museum in Boston. But my secret feeling was that there might be something wrong with a teacher who recognized anything special in me, and that art was a path that was slightly disturbing. It was inching me toward "out" rather than "in," which was not where I wanted to be. Had the football coach encouraged me as well, perhaps painting would have felt more comfortable. They were even going to let Bob take me to Boston to visit museums on condition that my grades improved, but they didn't, and I never went.

Grades were getting me down. Posted weekly, on the main bulletin board, my brain was charted, week after week, and for three years I had come up as below average. But the letter writing, the stories I made up and their responses had been life preservers that kept me from sinking out of sight. My imagination soared with things that had nothing to do with school subjects. My epistle-prone girlfriends were excited too, but St. Mark's wasn't. I was low man in almost everything that counted. I could have endured being stupid if the school could, but at the end of my third year I was called in for another chat with the Headmaster.

Rev. Brewster told me that I might be happier elsewhere. It wasn't so important to continue at St. Mark's, he said, I could probably go on to be a successful salesman or something. Not everybody needed St. Mark's, something

less demanding than a college preparatory school, a fine technical school might be just the thing. The idea of going to a technical school was poisonous to me, but somehow I didn't get the full meaning of the Headmaster's chat. It was end of term, vacation time, and I was buoyed by the prospect that one of my correspondences, Peggy Chew, the sister of my best friend, Peter, had netted me an invitation to their family home in Glen Cove, Long Island. For once, I was not going right to Waterford, the 200-acre farm that my mother had bought in Virginia. So I left school at the end of my third year in high spirits.

It was not to be, however, for just as I was leaving school my mother received a letter from the Headmaster informing her that I was not being invited back to St. Mark's. Couched in soft phrases, the letter said that St. Mark's did not seem to be a suitable school for her son. Basically, of course, it said I had flunked out. It was the end of the world for me – the lowest point in my life.

It was devastating to think that I would be attending some other school. My belief in the St. Mark's system as an approach to privilege crashed, and as a believer, I crashed as well. The work of rebuilding my blitzed ego took many years, but it started at this precise point — when I thought that my pass to the top had been revoked.

However little I learned academically at St. Mark's, my experience there gave me a perspective on life, a set of permanent markers by which I am able to judge social conduct and aspects of class structure. Bob Potter's positive encouragements with writing and painting had got something going creatively although I can't remember anything I wrote except the letters to girls. But something was started, a seed was planted.

St. Mark's also planted an angry seed though. When I'm in a bad mood, depressed because I can't control some aspect of my life, my mind brings up the memory of my early days at St. Mark's, when sixteen-year-olds were sanctioned to paddle twelve-year-olds. The idea still lives in a very dark place in my soul. Under special conditions, a black cloud of rage is ready to emerge screaming, as I fantasize about violently defending myself from a Sixth Form paddler. Ironically, I may have tolerated paddling to show how tough I was. And to be fair, I can't remember whether I was really ever paddled or not – and I may have been proud of it if I was.

By 1942, the world had changed. We were at war, my brother had joined the Army Air Corps and my mother married Delavan Munson Baldwin (no rela-

tion), the son of William Delavan Baldwin, President and Chairman of the Otis Elevator Company. I referred to him as "Uncle Denny," from the earliest days when he began to pursue my mother shortly after my father's death during a summer we were spending in Peekskill, NY. They were married in her house on North Washington Street in downtown Alexandria, Virginia where we had moved after the death of my grandmother. I never referred to Uncle Denny as my stepfather, however. Men and women who became friends of my mother were often called "Uncle" or "Aunt." This was perhaps a Southern reflex, but in the case of Denny, the designation followed family tradition and never progressed to the use of the word "Father" because neither Uncle Denny nor time were able to erase the deep wound of my father's absence.

Denny was kind to me as a child, and allowed his black groom Willie Brevard to teach me to ride. I developed a deep affection and admiration for the man, but as time passed the same process didn't take place with Uncle Denny. When we had moved to Waterford, a remote 200-acre farm seven miles from Shadwell, VA (the local gas station and Post Office), I was trapped with Uncle Denny in a place that felt like solitary confinement and the only way I could see a boy my age who lived five miles away was get on one of Uncle Denny's polo ponies and ride there. His privileged background provided him with tailored English habits, and a roly-poly charm based on his ability to laugh at any joke. But he wasn't very smart or interesting. Before long, he became sadly detoured in the direction of alcoholism, womanizing, and the eventual abuse of my mother. By the time she divorced him in 1947, I despised the son of a bitch and speculated that the only reason my mother married him was that she was lonely and didn't want to change the name tags on her luggage.

My departure from St. Mark's was kind of a miscarriage of hope for my poor mother, aborting my passage to "the best." Freddy wasn't cut out for the East Coast version of elite education. She accepted this and gamely decided to enroll me in a backup Southern version, one that had the convenience of being nearby. My next school destination was Woodberry Forest in Woodberry Forest, Virginia, a Southern boarding school with academic standards that were applied more gently than at St. Mark's. Woodberry, however, required me to go to summer school to repair my broken schoolwork, and perhaps determine whether it was even repairable. At least I wouldn't have to endure the entire three months of "summer vacation" at Waterford Farm, where lonely became a

disease and fantasy sex was my obsessive escape. During that second summer in Virginia, I masturbated so much, and got so gaunt and thin, that my mother thought I had TB. I was taken to a sanatorium near Charlottesville and checked. The TB test was negative, but I almost wanted to stay because there were people there. I preferred to be sick than alone.

It was 1942, the first part of World War II, and because of gas rationing we rarely drove from the farm to Charlottesville, the nearest town twenty miles away, so I stayed at home and jerked off the whole time I was there. When I felt guilty and wanted to stop, I would visualize my grandmother. She worked like saltpeter, the sexual suppressant allegedly used by the ton in the dining room at St. Mark's.

In addition to pure fantasy, my inspiration for masturbation was my supply of "dirty magazines" but my mother somehow discovered them and one day they disappeared. There was no confrontation, but knowing I had been exposed exaggerated my shame, and I sought to kill each fantasy as I jerked them away. Girlie books became my sex education — reinforcing misconceptions, twisting innocence with guilt. I went to bed with only my imagination to join the lump in my pants.

Woodberry Forest, located in the beautiful rolling hills of Virginia about thirty miles from Charlottesville, has a campus that includes a private room for every student, a golf course, a wonderful river that flows through its hundreds of acres of woodlands, with high climbable cliffs that beckon to the foolhardy and robust — and a huge swimming pool. It also provides an excellent education and my mother used all her Southern charm and connections to persuade crusty old Carter Walker, the Headmaster, to let me in.

Miraculously, in the pool during the summer of 1943, when I went to Woodberry to do my academic catch-up work, there were teenage girls. They came to share with their parents the pleasures of the campus, which became something of a resort for "nice" families from Richmond and Washington who wanted to cool off during the hot un-air-conditioned Virginia summers. It was paradise for an academically and socially disconnected kid like me. And in that relaxed and pleasant atmosphere, I began to learn to study and my grades gradually rose from D's to B's. It seemed possible that they might continue to improve.

As regards the girls, however, I still had no idea how to deal with live, three-dimensional, warm-blooded, teenage females. Was there a chance that if I learned to say the right things and behaved in the right way, they might let me kiss them? Happily for me, a more experienced teenager named Caroline Scott, from Richmond, began my education, for which I was most grateful.

The rest of my education proceeded well at Woodberry Forest, a wonderful school, where I was given a lot of freedom. Students associated freely with one another; no rigid class or status rules were in place. It was easy to make friends with anybody. Every aspect of life there was more forgiving than at St. Mark's, where I had been trying to wear a three-button Brooks Brothers suit — two sizes too small for me.

At Woodberry Forest my strategy was to try to be funny. It had worked with my letter writing to the seven girls at St. Mark's. My first conscious memory of trying to be funny to an audience — funny for effect — was not a complete success. What I launched rushed out of me with wildness, straight from my imagination. It was brave — sheets of it came out. People looked at me and they sort of laughed. But it didn't make much sense. The pace was right, the certainty of delivery was there, and they laughed because they knew from my sureness, the speed and color of my words that it was a joke — so they laughed, and I laughed to mark the place where they were supposed to laugh; but it didn't make sense because what I said wasn't true. I got the pace right, I inserted outrageous fragments, but not quite enough ridiculous detail to reveal the whole picture. Humor can paint the canvas with one stroke. The relationship between how little one says and how much is described — that's wit. But my style and certainty were right so they laughed anyway, a little at me because I was all heated up and a little just in case they were stupid and didn't get the point.

That's how it started. I learned to pick more accurately — instinctively — and I became funny and popular at the same time. I wasn't conscious of this development, but looking back I can see how it happened. Fantasy, courage, and truth became occasional wit, and the reward to this program gave me the will to truly learn. And so I backed up or slid into things I could never have gotten in the usual way and that's the way with me — nothing to talk about except what I've experienced and felt. Stimulated by those I could draw from, I started as a sucker fish following a shark, hoping to live on the chewed-up scraps that came my way. Then I became the shark.

My happy life at Woodberry was not to continue without a major disaster, however, and was the product of my disturbing tendency to up the ante when it came to outrageous behavior.

It all began, of course, with girls. During my second summer school, which I had to attend thanks to a failing grade in French, I began to notice that the guests who vacationed at Woodberry often left the keys in their cars. Their owners had nowhere to go and the school was remote, so the cars sat parked at night feeling lonely and unused. I had previously learned to drive at the farm, so occasionally I borrowed one to visit a buxom young girl down the road who worked in the school Post Office. I didn't even have to buy gas; I took to siphoning gas from a pump at the school garage. The pump was locked, but I was able to drain enough gas out of the hose every night to accumulate several gallons a week, which I stored in glass jugs and hid. This cache I would donate to the borrowed car.

When summer school ended, and the fall semester rolled around, my borrowed visitor's car transportation came to an end, but my romance did not. I knew that the school had a broken-down truck that was used to tow the lawnmower over the golf course. This vehicle was missing lights, license plates, doors, and instruments of any sort, but it would run, and, best of all, the key was left in the ignition. One Saturday night, I struck out in the truck for a date at my girlfriend's house near Orange, Virginia. It was a moonlit night, and I only had to drive five or six miles, so I wasn't too worried about getting there. My friend lived in a small cottage with her parents. That night she let me sit extra close to her on the sofa and I seem to remember that I was able to put my arm around her. It was more cozy than hot because her parents were within earshot in the bedroom, so things were never too far out of control. Even so, when I left around midnight I was elated, certain that I was making progress. However, trouble was waiting for me.

It was beginning to rain, and just as I was entering the outskirts of Orange I ran out of gas. I had miscalculated. Abandoning the vehicle, I set out with my jug to find fuel. Absurdity was about to reach the next level. I had brought a .22 caliber Colt Woodsman pistol with me with the thought that should I spot a raccoon on the moonstruck road I might shoot it as a special trophy to commemorate my adventure. It was a hunting tryst — something Davy Crockett would have under-

stood. The bizarre truth is that hunting was something I did on our Virginia farm and to me it didn't seem unnatural to have a gun at school. Owning a personal firearm wasn't something I flashed around, and I may have been the only boy in the school with a pistol, but I had no trouble rationalizing having it there. Sometimes, I would get up very early in the morning and hike into the surrounding woods to shoot squirrels. I don't remember ever killing one, but raccoon and squirrel hunts were active fantasies in my imagination.

This night, as it was now pouring with rain, I didn't want to leave my pistol in the abandoned vehicle and I didn't want to get it wet, so I tucked it into my belt under my rain clothes. Somehow, walking toward town, I found a taxi, secured a gallon of gas, and arrived back at the school truck at about the same time as the Orange Police. In no time at all, I was booked and jailed, charged with driving without registration, lights, or a driver's license, and carrying a concealed loaded weapon. At 2:30 a.m. the Assistant Headmaster, John Walker, a kindly old gentleman and the brother of the Headmaster, bailed me out.

The next day, I had an interview with the Headmaster, Carter Walker, and as I recounted my tale, he kept shaking his head. He explained that it was not going to be possible to keep me in the school because the word had already leaked out about my criminal activities. Mr. Walker didn't put it this way, but the real problem was that I was now the school hero. Nothing at Woodberry Forest — within memory — could compare with the scale of my felonious evening.

So I was once more destined to go to another boarding school. This time, however, I went with the recommendation of Mr. Walker, who decided that although I had transgressed in many ways, I had not broken the Woodberry Forest Honor Code, the most sacred law of the school. I had told the truth at every point in our interview, when I might have tried to wriggle free with excuses or lies. This saved me from Mr. Walker's much-feared wrath; he may have even been a bit amused by the escapade. Whatever the case, he wrote a positive letter of recommendation to Lawrenceville School in New Jersey, citing my honorable character that had been unfortunately overcome by temporary insanity. Lawrenceville declined, but a nearby school took me in.

The Hun School in Princeton, New Jersey, founded in 1914 by Dr. John Gale Hun, a professor at Princeton University, was my next stop. It was the autumn of 1945 and I was a 10th grader. This was, at that time, mostly a school of last

resort, peopled with misfits like me, refugees from the SaintGrotelsex crowd. There were also tough Italian kids from Trenton and Brooklyn, some of whom were reputed to come from Mafia backgrounds, and as World War II had just ended there were a number of veterans who hadn't finished high school. One member of our schoolboy crew was an ex-Marine who had fought on Iwo Jima; another was a bomber pilot who had flown missions over Germany in the RCAF. For me, this was the closest I had ever come to being in school with truly mixed backgrounds. I loved the experience.

Being located in Princeton gave many of us a chance to pretend we were university undergraduates, leading hopefully to invitations to parties in New York. One of my chums was a St. Paul's School dropout who had stolen some War Bonds from his older brother and with the cash bought an elegant black 1936 Rolls Royce town car. He kept it hidden in some woods near the school. It was the kind of car in which the chauffer sat in an open front compartment and the passengers sat in the rear separated by a roll-up window. One of us would wear a chauffeur's cap and a black Chesterfield overcoat and we would cruise into New York for the weekend. It was all fake and fun and the girls loved it.

Hun School in those days was unimaginably loose on discipline. Weekends frequently found many of us in Princeton at the Nassau Tavern, pretending to be undergraduates and drinking beer. It was a twenty-minute walk into town, and we found that we could sneak out of our dorm rooms and back into school with impunity. One night the administration decided to crack down, and they did a head count in the middle of the night. A substantial number of students were missing. The next day we were all called into the Headmaster's office, one by one, to explain our absences. Dozens of students explained that an epidemic of loose bowels had sent them all to the bathrooms for long stays during the night. How they expected to get away with this lie I have no idea. I told the truth. This was not Woodberry Forest, however, and truth telling was not a premium virtue; I was suspended for two weeks.

That was my only brush with authority and I managed not only to graduate from the Hun School, but to be accepted as a freshman at the University of Virginia (UVA) for the fall of 1946. UVA at that time was considered by every girl I met in New York and elsewhere as the crème de la crème of party schools. The girls that I was meeting in Manhattan and was interested in, unfortunately,

turned out to be attending Vassar or some other lengthy commute from Charlottesville. This guaranteed my demise at UVA because I missed dozens of classes traveling up and down the East Coast.

While at UVA, however, I joined an infantry company of the U.S. Marine Corps Reserve. This probably had to do with my brother Gamble's family status as a war hero; he had been an Air Force officer and was shot down on a mission over Germany. He had also survived St. Mark's, Princeton, and prison camp, in that order. I must have thought that joining the USMC Reserve would earn me some family respect. In spite of my schoolboy negative reaction to authority, there was a strong tradition of military service on my mother's side of the family and I liked the Marines. It was an elite corps and maybe a big part of me wanted to sneak through that door again.

In 1947, at the end of my freshman year, my many missed classes led me to be suspended from the University of Virginia. God knows how my mother survived my immaturity — endlessly shaking her head — "If only Freddy would apply himself." Since my father's death, she had carried the burden of me alone. Although I could have gone to summer school at UVA to make up for my missed classes, I decided not to do it, and went off with a friend to spend the summer working on logging camps and a plywood mill in Oregon. It was my first summer of complete freedom and I loved it. Making my own money, having fun and a girlfriend was great, and I was able to build into my Western trip a couple of weeks of USMC training at Camp Pendleton, California. This time discipline came with an M-1 rifle.

When I returned east, my mother announced that she had finally had enough and I was invited to support myself. Conveniently, I didn't even have to look for a job; one was already waiting for me at the Georgia Ice Company in Savannah, the ice factory that had been started by Robert Gamble, my mother's father, and was run by her brother, my Uncle Robert. As for living accommodations, I began at the YMCA, which cost a dollar a day, and where breakfast was 35 cents at a nearby café. But I soon found a basement to rent in a formerly fine old structure next to the Georgia Historical Society for $15 a month. Never mind that it was so damp that my leather shoes turned green. I walked three miles to work six days a week to save more money. I was planning my escape.

The workers at the Georgia Ice Company were mainly poor whites and blacks, but in spite of being the nephew of the absentee owner, "the Commander," who lived on a plantation near Charleston, S.C., they were kind to me. If you don't have much money to go out on a lonely Saturday, or any friends, it doesn't take much to kill the rest of the week if people laugh at your mistakes or roll their eyes when you make them. This didn't happen, because my fellow workers showed me how to do the work in a way that I didn't feel the bite of my own ignorance. We had some fun together, too. On our Saturday half-days off, Buddy Waters, the mechanic who kept the ice trucks running, and I would go to the beach in his Buick Roadmaster. It featured decorative chrome-edged holes in the hood that hinted speed, and was the preferred vehicle in which to chase girls and drink beer.

There were bi-monthly upgrades to my diet when the Commander — Uncle Bob — arrived for his visit to check on the administration of the Georgia Ice Company in his capacity of president of the company. This was an important event in my life because it meant that I would be treated to a steak dinner at the Desoto Hotel or barbecue at Johnny Harris'. I admired Uncle Bob — his French "Croix de Guerre" during World War I and his role as a naval aviator. His physical courage was demonstrated to me one day when (as an old man) he faced down a burly truck driver at the "factory" who was resisting all instructions where to park his tractor trailer until a glaring, confident Uncle Bob exerted his "command presence" and got the driver and his truck to go where it was supposed to go. This was a memorable event in my young life but so was the delicious dinner that followed that night. Again, Uncle Bob took command as he instructed the white-jacketed African-American waiter:

"Charlie, make sure that the steak isn't overdone."

Again I was impressed. "Uncle Bob, how do you remember all these waiters' names?"

"Oh," Uncle Bob replied," I call all (black) waiters Charlie."

That was the other side of the influence of my closest male role model — a scramble — parts of which I admired and parts that I began to hate.

I was also taken under the wing of a Mr. Insley, from York Refrigeration, who was installing an ammonia compressor at the ice plant. He took me with him for lunch to the Canton Gardens every day, where we feasted on sub-gum

fried rice for $1.25 and he showed me how to tip a waitress. He would look into a Chinese waitress's eyes and say with a lecherous smile, "I'd like to give you more," as he inserted the coin balanced on his index finger as deeply as he could into the little pocket on the front of her dress. His outrageous behavior kept me laughing and sane.

Later, when I got promoted to the office and was making 50 cents an hour, I was befriended by one of the office workers, Ed Joyce, and his wife, Hendrie, who would take me in for a home-cooked meal. They shared books and music and made what was then a lonely life bearable. Gradually, I discovered people my own age and background.

On Saturday nights in Savannah in those days, young people gathered at the bar at the De Soto Hotel in the center of town. At the bar, I was just another guy in a seersucker suit and white buck shoes, my leftover uniform from the university. I had just enough money to buy three beers to last the evening. Since I was there every Saturday night, I began to hang out with the regulars. Like me, they had limited resources, and we were all looking for miracles — to snare some of the more attractive young women, who were usually there on the arms of our better-financed rivals. Savannah, then as now, had a substantial gay community and there were always a few older men at the De Soto, looking out for the same kind of miracles with us. They would buy a few drinks for the un-der-privileged, and were more amusing than aggressive in their flirting.

The De Soto was a friendly place, where you couldn't necessarily take out the prettiest girl, but where it was easy to make friends, and we got to know each other — men and women — as if we had all been to school together. We were there, after all, every Saturday night. But getting to know a special girl under these conditions had particular requirements. Good looks and glib con-versations were helpful, but a really successful Saturday-nighter became de-fined by details that circulated through casual gossip — and something new got the headlines.

This was a matter I had been working on. A graph on my desk at the office represented $10 bank deposits that inched up a red line like a thermometer. By late in 1947, it had reached $1,800 and the next day I went to a car dealership down in Jacksonville, Florida, where I made my escape from the ranks of the unnoticed. I bought the first foreign-made sports car — an English MG TC — to

be seen in Savannah, Georgia. It attracted enough notice that a picture of me with my little convertible made the local papers. This same car connected me with actor Steve McQueen many years later, but more importantly at that moment it ratcheted up my social life considerably. I began to have some special fun. Girls loved the car and driving it with them I could mentally and physically speed away from a life I hated.

In 1949, my mother moved to Savannah and I was able to live at home. This was a dramatic change from my dank basement dwelling and my shoes returned to their normal color. Every aspect of my life improved. Comfortable accommodations, social acceptance, and an improved regular diet meant that at the De Soto bar, I graduated from a "two-beer" bachelor of unknown prospects to a "two-beer" bachelor with roots in the upper echelon. In time, it could be imagined, I might even rise to become the head of a long-standing local business — the ice factory. Although everything was better, I still dreaded Sunday; sure, it was a full day off from work, but the dreariest day of the week, Monday, loomed ahead and then the cycle would begin all over again.

It must be said that I had pretty much screwed up my life thus far so there was justice in my having to serve time at the factory. But I began to feel that in spite of the upgrade, I was serving a sentence of "life without parole" in a place

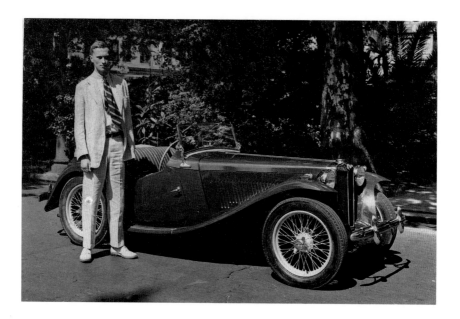

that hemorrhaged hope five-and-a-half-days out of every week. Yet, did I even know what more I wanted out of life? There were no clues here. Ironically, the letterhead of the Georgia Ice Company showed a mule pulling an ice wagon, an appropriate symbol of the profitable company that had been founded in 1918 by Grandfather Gamble. But the profit that lifted the family depressed my soul. It seemed that even acquiring more exotic sports cars was not going to speed me away from the factory.

On June 25th, 1950, North Korea, a place I could barely identify on a map, did me a big favor by invading South Korea. When I had moved to Savannah in 1947, I transferred my membership in the United States Marine Corps Reserve to the local unit, and I became a leatherneck in D, for "Dog," Company. On July 7th, United Nations Security Council Resolution 84 was adopted and President Harry S. Truman declared a "Police Action," committing American military forces to the conflict. At that moment, I was practicing amphibious landings at Little Creek, Virginia with my Marine unit and immediately went on active duty. This provided me with an instant "honorable discharge" from my increasingly depressing job. Only heaven knew what I would be getting into, but I was out of Savannah in a way that might even meet with family approval.

3 – THE MARINE CORPS

On August 28th, 1950, 181 members of "Dog" Company marched to the Savannah train station led by a Marine Corps band from Parris Island. My mother was in Italy, thank God, so my departure was non-traumatic. The night we left, I went to see my friend, Dr. Dick Schley; it was his Army Reserve drill night. When he dropped me off to join my unit, he kindly carried my sea bag. I thought that having an Army Major carry my gear was an excellent beginning.

Before we left, *The Savannah Morning News* had published a story proposing a big sendoff for us. The chairman of the draft board and chaplains of the principal faiths were to host the event at the Avon Movie Theater. "The men will sit with their families... get refreshments and say goodbye. The chaplains will each say a prayer... The Shrine Band will play. This solemn and moving ceremony will let the boys know that we appreciate their sacrifices... their loved ones will be left warm and in the company of others... spared the anguish so prevalent in drab train stations in the rain and snow during the last war."

I was appalled at this proposed sentimentality and made my first stab at journalism by writing a Letter to the Editor:

"I am horrified to think that we might be subjected to the ceremony described. Reservists will find this public display embarrassing. The weeping and wailing of distraught mothers will only depress the servicemen... if the ceremony comes to pass... the Red Cross should pass out smelling salts to the loved ones rather than chewing gum to the troops *Frederick C. Baldwin USMC Reservist*."

Fortunately, we were spared this mawkish event. I got kissed by some girls who I had been trying to kiss for years and we boarded the train. For the next three days, we rocked along comfortably on our way to California, berthed in Pullmans. The food was good. Two PFCs — Privates First Class — who were Baptist ministers thanked God at every meal, and provided daily services in the next car to prepare us for our Crusades.

On September 1st, we pulled into Camp Pendleton, California. Fifteen trainloads poured in and eighteen more were expected.

On September 10, 1950, I wrote my mother: "We were sent to Tent Camp 2, several hundred Quonset huts located eleven miles back in the hills. Camp Pendleton is 200,000 acres of desert dedicated to introducing former civilians to military inconvenience and sand. Showers are 200 yards north and the water is boiling hot or freezing cold. The toilets, in rows of twenty, are located 50 yards west. The place to shave and wash is 200 yards south. The mess hall is a mile and a quarter from our hut."

Job classifications were assigned at Camp Pendleton: artillery, tanks, machine guns, etc. Because of my civilian job as an indentured screw-up, exiled to the family ice business in Savannah, I became a Refrigeration Engineer, assigned to service the beer cooler at the Officers Club. The Marines had been my

escape from a life sentence at the ice factory, and I was not about to fall back into routine that reflected my civilian past. I had joined the Corps to make a military contribution. After all, my uncle, Robert Gamble, "the Commander," had been wounded in World War I, and later became a naval aviator. My mother had volunteered with the Red Cross in France. World War II had ended only five years earlier and my brother had been shot down over Germany. John Wayne had set the tone for Marines as the star of Sands of Iwo Jima; it was impossible to think of him as the hero of Cool the Beer in the Officers Club. So I asked an officer friend, Bob Glenn, to get my job changed to 0311 — advanced infantry. This was not difficult to arrange, as most such requests tended to be from combat duty to non-combat duty, so my transfer was quickly approved.

I eagerly departed Camp Pendleton with the 2nd Replacement Draft on October 15th, 1950, sailing for Japan on the USS General William Mitchell.

Monotony aboard the Mitchell was fought in a variety of ways. Only Las Vegas saw more crap games played. One gifted businessman realized that the ship, steaming at sixteen knots, could provide a perfect solution for our rancid fatigues after a week at sea. He experimented first by tying his fatigues into a tightly wrapped bundle attached to a long rope secured to the railing and dropped into the churning wake of the ship. After starting his first load he went to chow, dreaming of making his fortune by doing laundry for 5,000 smelly Marines. Forty-five minutes later, he retrieved a tangle of spotlessly clean threads — formerly dungarees. Perhaps the Captain could slow the ship down on Laundry Day — or maybe 10 seconds would do the job.

But there were other amusements aboard. The toilet facilities (called "heads" in Navy parlance) were a communal affair; a stainless steel trough thirty feet long with seats attached allowed a continual stream of seawater to enter one end and flow to the opposite end. This arrangement excited the imagination of the cleverest Marines. The game involved sitting close to the inflow of seawater and waiting until somebody arrived to do his business downstream. When the victims were deeply engaged in girlie book reading and relieving themselves, the jokester on the intake end would carefully squirt lighter fluid on a ball of toilet paper, ignite it, and float a miniature bonfire down to the concentrating readers downstream. This level of entertainment continued for two weeks across the Pacific Ocean.

Arriving in Kobe, Japan on October 30th, we picked up our cold weather gear, ammunition, and other supplies, and sailed to Korea. We made an unopposed amphibious landing at Wonsan in North Korea on November 11th, and then proceeded to Majon-ni, 28 miles west. There, for the first time, I met the undisguised consequences of war; a tent full of long, black zipped-up bags containing the bodies of dead Marines. We were their replacements.

It was about this time that General MacArthur announced that we would be home by Christmas. Rather than being delighted, I was deeply disappointed, deprived of a chance to find myself an honorable page in the family history book. It appeared that there would be no combat; we had missed the glory. Then, a new feeling came to the surface. Suddenly, Korea just became dreary and cold, just more and more sights of pitiful shivering half-naked children and wretched women attracted by the hot water available at Wonsan train station. The desperation I saw was plainly visible. I even made some photographs of the misery. I was warm enough, but the cold got to them and I somehow parked my reaction in a "that's so sad" part of my brain. Little did I understand that sympathy would be replaced by visceral agony later in the month.

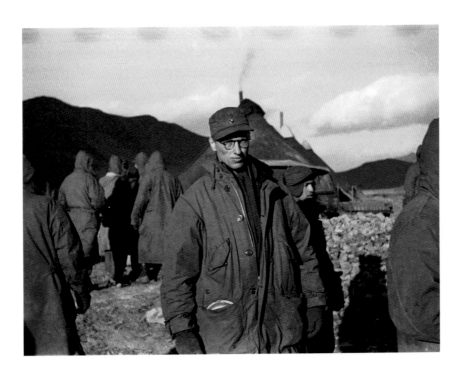

I was assigned to the security platoon of H&S (Headquarters and Service) Company, 3rd Battalion, 1st Marines, of the First Marine Division. Our job was to provide a defensive perimeter around battalion headquarters, a protective shield for the unit that provided military direction, care, and feeding of one thousand Marines.

By November 14th I found myself perched atop drums of high-octane aviation fuel "riding shotgun" in open rail cars, to repel possible attacks by North Korean guerillas. But instead of guerillas, we saw hordes of children emerging from the devastation as the train slowed down to pass through the wreckage. Our guys on the train conducted a lively exchange with the kids — apples for matches and candy. The cold eight-hour ride finally brought us to demolished Hungnam, the major port of formerly industrialized North Korea. We regrouped and settled into a tent camp at Chigyung near Hamghung.

Pining for adventure and a solid meal of real food, I went on patrol slogging across rice paddies where the water was just beginning to freeze over, looking for a farmer who would sell me a substitute for powdered eggs à la USMC. I bought six fresh eggs with military scrip, but was soon joined by seven scowling men during my negotiations. Guerillas had been seen. It now dawned on me that I might be gathering more than eggs. Armed only with my .38 revolver, the math wasn't in my favor; one Marine, seven strangers, and six bullets. I gave up shopping and got the hell out of there.

After Thanksgiving, on November 23d, 1950, we were loaded onto 2½-ton trucks and began moving north from the coastal plain, inching up an increasingly steep grade, up and up a twisting, narrow, icy, one-way, winding dirt road with a sheer wall on one side and a deadly drop on the other. Huddled on freezing benches in open trucks, we bounced up through snow-covered mountains for sixteen hours. Finally leveling off at 4,000 feet, we pulled onto a plateau and approached the tip of the Chosin Reservoir in North Korea. (We called it the Chosin Reservoir because the maps we used were of Japanese origin and labeled it thus. Koreans call the reservoir Changjin after the river that fills it.)

General MacArthur's intelligence officers in Tokyo had ignored information that was beginning to trickle in about Chinese troops crossing the Yalu River from Manchuria. And we were only 70 miles south of the Manchurian border. It was getting cold — very, very cold, and it was hard to remember the

steaming hot day four months earlier when this journey began. When we unloaded from the trucks after our long ride to Hagaru-ri, we erected comfortable squad tents, equipped with stoves and cots, before we dug defensive foxholes on the perimeter. We had no idea what was going on. When bits of hard news filtered down to the squad it didn't seem real. There was little sense about what was coming — a cyclone was due but the sky was clear.

Our Thanksgiving turkey feast barely digested, we discovered that twenty-two Chinese divisions — 120,000 men — had materialized and surrounded us, the First Marine Division, as well as Army units comprising some 15,000 Americans on November 26th. The Chinese now completely controlled the 75-mile single-lane mountain road we had just passed over. We had moved north just in time to be trapped by the soldiers of China's 9th CCF Army. Because Lt. General Oliver P. Smith, the commanding officer of the First Marine Division, had been suspicious of MacArthur's intelligence, he had not deployed Marines to the Manchurian border as ordered. But it turned out that we were behind enemy lines, 54 miles from the safety of the coast.

A few days before, at Chigyung, we had met our legendary regimental commander, Colonel Louis B. (Chesty) Puller, a short, barrel-chested officer who had earned five Navy Crosses and a Distinguished Service Cross and had begun his career as a private. "Chesty" was reported to have said: "Great! Now we can shoot at those bastards from every direction!"

Luckily, the Seventh Marines had passed through the area before us and had blasted out holes in the concrete hard ground. Those holes became home. Gone were the comfortable tents. For two days, we built fires to melt frozen dirt, and hacked and hacked, trying to go deeper with entrenching tools to meet the arrival of the Chinese. A letter to my Uncle Robert reported: "We are now up at the Chosin Reservoir... we have been here for four days. My canteen is frozen solid every morning. The temperature got down to -16° F last night, so you can imagine what it is like to sleep in a foxhole. The first night we slept in an open one but it has now been made very luxurious."

What I didn't describe was that first night on line, November 28th, the night of the first big attack. I was still in an open unimproved foxhole about a foot-and-a-half deep and it was snowing hard with very little visibility. Our section was dug in on the north side of the perimeter defense. That was one of

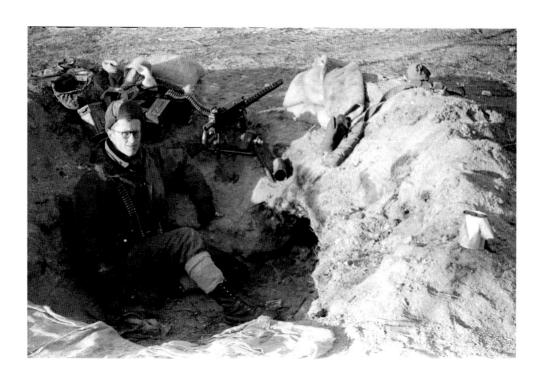

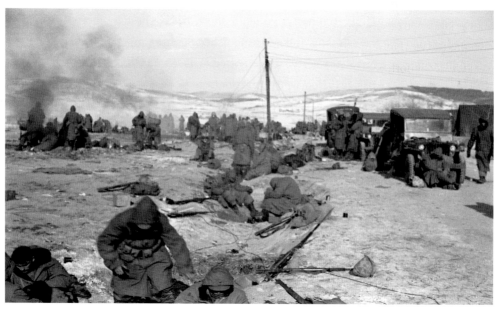

the bad nights although the line was quiet where we were. Then, about 6 p.m. we were joined by a number of Republic of Korea (ROK) soldiers who had straggled into Hagaru-ri along with Army units who had been badly mauled in an ambush to the north of us. Six men were crammed in our hole. Our part of the line was quiet until the Koreans joined us. The ROKs hadn't been there ten minutes before they began to fire their weapons like madmen, expending clip after clip of ammunition. Our Gunnery Sergeant, who shared our hole that night, became furious, and threatened to shoot the next man who opened up. They were reassigned the next day and I don't know where they went but thank God they weren't with us.

My letter continued the next day: "We now have straw and corrugated tin covering the sides and top and it is quite warm — at least up to -10° F. My platoon, the security platoon, is strung out in a perimeter, thirty-nine of us, to defend a bulldozed strip — still under construction — that will provide a way of getting supplies in and wounded out."

On the night of November 29th, Roy Courington, our company commander — a Savannah reservist — joined us, a frozen refugee returning from inspecting the line. It was crowded, but an extra body added warmth. We were all frozen buddies that night, Captain or Corporal, rank be damned. Adding a measure of comfort, we had found a parachute to cover the foxhole, a gift from the air support guys who dropped ammo and supplies to us, and sometimes *on* us, from the air. The chute cut the howling wind from Manchuria, and when we floored our ice hole with cardboard from ration boxes, the space became more bearable.

1950 turned out to be the coldest winter in a hundred years. My squad mate, Pete Kapesis, carried the squad's most powerful weapon, a Browning Automatic Rifle, a BAR. He was supposed to fire rounds every few minutes to keep it warmed up. But it was frozen tight. Tomorrow we would fix the useless weapon by washing all its moving parts with gasoline, but tonight, oil had become glue.

There had been a fierce assault by the Chinese a thousand yards to the south and a mile or so to our east, but we knew nothing about it. Not a shot was fired from our position and bulldozers continued a frenzied scraping of frozen earth with lights full on to complete the airstrip during the attack.

Around our position we strung rolls of barbed wire and hung them with empty C-ration cans to rattle should the enemy try to slip in. Early that morning, we heard a distinctive clatter in the wire, but it was just a hungry dog trying to get at the food. Each lick must have burned the animal's tongue as it touched freezing metal. But the dog kept working deeper into the wire to get what scraps it could. Down the line of foxholes somebody fired at the poor creature. Target practice, amusement, putting the animal out of its misery? Trapped in the coils, the animal ripped himself bloody trying to escape. An angry cry went up from adjacent foxholes. The false alarm disturbed what sleep we could get. And ammunition was wasted on a dog.

While this is going on, two companies on our flanks were suffering heavy losses. November 29th had been a busy night and I was to learn later that Hagaru-ri was nearly overrun that night. The Chinese chose to launch a mass attack on adjacent high ground held by How (H) and Item (I) Companies rather than our thinly held position. Our battalion executive officer, Major Reginald Myers, led a team of cooks and service personnel to retake a crucial East Hill held by 4,000 Chinese. He lost 170 men. The battle lasted 14 hours. Heroism and suffering were transformed into legend and Major Myers earned the Congressional Medal of Honor.

Then absurdity joined the mix. During this intense fighting, our battalion was running low on ammunition. A radio call went out for an air drop. The airmen did their best, but somehow, along with the ammunition, thousands of Tootsie Rolls were dumped from the sky. Nobody was killed by a flying Tootsie, and the energizing little candies, warmed up close to our bodies, were edible, unlike our frozen C-rations.

We had another surprise from the sky. A Marine Corsair fighter plane came in low over us with smoke pouring from it and crash-landed. It had been strafing the Chinese and was hit by small arms fire. It went down just beyond our sight in a dip that extended below my foxhole in uncertain territory. It was a swampy area as well, but we knew we had to get to the plane to see if the pilot had survived. Charlie Carmin joined Pete Kapesis and me, and we smashed, slipped, and splashed through the ice, arriving at the crash site in worse shape than the pilot. We found a Marine Master Sergeant calmly standing next to his plane, his parachute slung over his shoulder, smoking a cigarette. We hustled him back to our lines.

At this point, my war had to do with outwitting a single enemy — the killer cold. Defense required putting on layers of clothing. It was so cold that our canteens were kept under our heavy parkas, close to the body; otherwise they became containers of solid ice; the same was true of our canned C-rations. To defend myself from -35° F and worse, I wore a green T-shirt and shorts, then thermal underwear, and a wool shirt. Sent from home was a soft sand-colored cashmere sweater with a matching scarf, appropriate for a breezy evening on the veranda of my uncle's plantation near Charleston. That additional layer spelled style rather than warmth, but I put it on just the same. Neither the scarf nor the sweater did much more than bring back memories of warm, pleasanter times. The Brooks Brothers labels should have at least guaranteed me a smart preppy edge, but they were covered up by the next layers; a heavy wool sweater, over which I wore a dungaree jacket, a military field jacket, and finally — over everything — a thick, heavy, knee-length, hooded parka. Heavy woolen mittens on my hands were devoted to the support of a single trigger finger. These eleven layers were supposed to create air spaces that retained heat, but at the Chosin Reservoir they mostly retained misery.

On my feet were shoepacks: rubber boots with high leather sides and felt innersoles. Walking in them produced an unmilitary waddle, but much worse, the rubber made your feet sweat. The minute you stopped walking, the warmth produced by the exercise stopped and the moisture on your feet oozed through thick wool socks into the felt innersoles and froze. Shoepacks worked if soggy socks and innersoles were frequently replaced by extra pairs of dry ones that you kept next to your body. My partner, Pete, a conscientious innersole changer, forgot to warm the dry socks one night. In the morning he had ice between his toes. He was able to warm them. They didn't turn black. Gangrene hadn't set in. They didn't amputate them later.

There were different levels of misery. Apart from the Chinese and the cold, there were the shits. A friend of mine had somehow been able to buy a beautiful white rabbit skin hat from a Korean in Hamhung before we started north. He was very proud of it and went to the greatest lengths to keep it clean. One freezing day, he was squatting near the airfield at Hagaru-ri having a breezy bowel movement, when he looked up and saw a Marine firing at him — zing, zing! He jumped up and yelled: "Stop, you son of a bitch, I'm a Marine." Finally recognized and spared an undignified end, he then wiped himself with his

beautiful hat and with a disgusted gesture retired to his foxhole. War is hell —
but there are different kinds of hell.

There were twice as many serious casualties from frostbite at the Chosin
Reservoir as there were battle-wounded. The wind chill in some places plunged
the temperature to –70° F. Nobody wanted to open up clothing to pee, and for
anything more serious, God help you. Eric Hammel, in his book, *Chosin, Hero-
ic Ordeal of the Korean War*, describes this brilliantly: when Marguerite Hig-
gins, *New York Herald Tribune* correspondent, asked a Marine wounded at the
Chosin, what for him had been the hardest part of the action; he fired back: "[It
was] getting four inches of dick out of six inches of clothes to take a leak."

Should anyone ask me about Hagaru-ri, my tale has nothing to do with res-
cuing pilots, or fighting in heroic battles. I speak instead of a wounded Marine
knocked flat by drinking our coffee, a gastronomic hand grenade made with
boiling water, ground coffee beans, and the residual detergent left in our cook-
ing pots. It was the detergent that did it: cookware was impossible to clean in
such cold weather, and a lingering slimy layer of strong liquid soap was deliv-
ered with each steaming cup of Java. My worst fears materialized; detergent
was bulldozing my guts.

As close to hell as I have ever been was to crawl out of the security and rel-
ative warmth of our foxhole, to remove layer after layer of clothing to make it
possible to perform the sickly, miserable, stinking, naked act of defecation. I
was vulnerable three times over; to the stabbing wind, the deadly enemy, and
the slaughter of dignity. Shivering like a wet cat, in the snot-freezing cold, I
covered up and returned to my hole, only to emerge, I don't know how many
times, to do it all over again.

The huge battle, very close, was an indifferent, momentary blip in my con-
sciousness, unperceived as my body went to war with me and I couldn't tell
the difference between wanting to live or die at those special — oh so visceral
moments — when I gave up the proud bearing of a United States Marine to be-
come a naked whining misery puppy. To this day, when flying in the warm
cabin of a jet airliner and the monitor in the aircraft indicates that we are flying
at 35,000 feet and the outside temperature is -40° F, my mind for a moment is
sitting on the wing, remembering Hagaru-ri.

When morning finally came after that first night, I stumbled to Sick Bay for
help. The tent was packed. It had a warm humid smell. Stringent emergency

antiseptics cut the primal odor of bloody bandages. The doctors and medics were focused on doing what they could for the wounded. If you could walk, you stood in line. Outside the medical tent, I found Charlie Monroe, a Savannah reservist, lying on a stretcher, wounded; waiting to be evacuated. Charlie went blind because of his injuries, and eventually received the Navy Cross for his bravery the night before. And me with the shits! I - could - not - face - the - medicos. It was hard to imagine asking for a pharmaceutical stopper when the wounded were calmly lying there waiting for help, evacuation, or death.

Not getting help, however, was a huge mistake. My gut was furious and it continued to punish me for my stupidity.

To the northeast of us, the U.S. Army had collapsed, having followed MacArthur's disastrous plan. We, the Marines, were clearly outflanked, and a retreat was in order — something we preferred to think of as an advance to the rear. When my battalion began to pull out of Hagaru-ri late in the afternoon of December 6th, I joined the tail end of a long dreary march toward Koto-ri, eleven miles away. Among the military garbage strewn on the road, I found a looped cloth strip containing a dozen bullets that miraculously fit my .38 caliber pistol. They would come in handy.

The seriously wounded had been evacuated by C-47s from the "barely long enough" airstrip at Hagaru-ri. Those who remained were the living and the dead. Marines have a particularly strong tradition of recovering our dead, sometimes at considerable risk. Reality was often surreal. One body was taken out tied to the barrel of a 155 mm cannon with communications wire; others were secured to the hoods of jeeps like deer trophies during hunting season. Many were stacked on trucks along with equipment.

At one point on this march we stopped, pinned down by sniper fire. My gut temporarily under control and having done more shitting than shooting, I decided to join the war and volunteered to check out a bunker that might be the problem. It had begun snowing and visibility was poor; that was good for me, but my every footstep crunched and crackled, potentially sending signals to the sniper. I made a clumsy, noisy slog but got to the bunker safely and quickly dropped in a grenade. It went off with a powerful Whumph! Snow flew off the roof of the bunker and the whole thing shook like a wet dog. Were there guts and pieces of a Chinese soldier plastered all over the inside? Probably not. I think the bunker was empty. I didn't look.

I was beginning to fade, out of gas. This was my final contribution to the war effort that day. My poisoned guts, in reserve briefly, counterattacked again, causing frequent stops by the side of the road. Hard-shell biscuits and chocolate, the only unfrozen rations that I could eat, made things worse. I ate snow. I was dehydrated and thirsty, but food and liquid entered and departed my body almost without pause and I became so exhausted that at one point I was unable to remember how to put one foot in front of the other. I literally fell asleep while walking and collapsed.

A few miles out of Hagaru-ri, I was thrown onto the back of a 2½-ton semi-truck loaded with equipment and some dead bodies. Crawling into my feather-filled sleeping bag, I shrank North Korea to a size that could be kept warm. Things that used to be important got smaller and smaller. Even the dead Marines, zipped-up nearby, lost their meaning to me. I gave up wondering if I knew them. At what point does total misery diminish to the final flickering out of life? I was not there yet, but my world grew very small; I feared that any movement I made might set off another explosion. I tried to adjust to the lolling motion of the truck. My body was more frightening to me than the enemy. The struggling stopped and I passed out.

When I woke up it was dark and we were under fire. I had no idea where we were; sanity dictated leaving the truck but I didn't move. The friendly sleeping bag provided the last bit of warmth in my universe. My guts had signed a temporary truce. There were little flashes from the uphill side of the truck. My rifle was jammed next to me with my pack, supplies, and dead bodies. At the risk of dying, I refused to consider getting cold again. Instead, I returned to war on my own terms by getting out my revolver. I unzipped my sleeping bag just enough to poke out my arm and fire shots at what I thought I saw. That was my only contribution to the epic battle at what became known as the "Frozen Chosin." The ambush that I slept through was later named "Hell Fire Valley" by military historians.

The next thing I heard, half in my dreams, was the voice of our First Sergeant when the convoy lurched to a temporary stop at Koto-ri, calling for my platoon to fall in. I didn't move. I could have but I didn't. At that point I couldn't take more pain. I had given my last shit for the Marine Corps. All my life I have thought: "What would better men have done? What would it have taken to get me out of that bag?"

I didn't have the heart to get out of my sleeping bag. So when the truck started again I was still there with the dead bodies.

What did happen while all this was going on was that three of my most desperate-looking, war-weary, ravaged squad mates were photographed by famed war photographer David Douglas Duncan. And the pictures of them squatting around a fire heating up beans in a can appeared in the January 2nd, 1951 issue of *Time* magazine. The men were Sgt. Stickles, Pfc. Green, and Pfc. Carmin. I'm not in it, of course. Had the heroic shitter stirred himself back into action, I would have joined them on the pages of *Life* magazine as well, and on the walls of museums into the next century. Their images continue to illustrate books on the Korean War. This I regret. If there was any punishment for my giving in to the pain that was stronger than I was — this was it.

When daylight came, it revealed a few holes in the truck, but there were none in me. But shortly, a miracle occurred that truly saved my life, and those of thousands of others.

For the full background to this story, I am indebted to the insights and information I gained many years later from reading *Escaping the Trap* by Lt. Col. Roy E. Appleman, AUS, Ret. The book describes how a military invention, the Treadway Bridge, perhaps saved my life and certainly changed my perception of history, where good luck and immediate collaboration replaced inter-service rivalries and paralyzing bureaucracy.

The situation was this: the Chinese had blown up the concrete bridge that crossed a deep gorge cutting through the mountains three-and-a-half miles south of Koto-ri at the Changjin Power Plant. Now, our escape route south was cut by a gaping hole, 29 feet wide that dropped 1,000 feet into the valley below.

This meant that the majority of the First Marine Division, Army units, and a force of British Royal Marines, roughly 14,000 men, and over fifteen hundred vehicles were completely trapped. Bypassing this gorge by moving up or downstream in any direction was impossible. On December 6th, 1950, aerial reconnaissance made clear the full extent of the disaster.

On December 7th, the Air Force in Japan and Korea, Marine Corps Engineers, and Army troops desperately cobbled together a plan that depended on a series of untried experiments with Treadway Bridges normally used in water crossings. Prefabricated bridge sections, weighing more than a ton apiece, had to be delivered by parachute to Koto-ri. Such a delivery had never been at-

tempted. But the Air Force had just introduced a new cargo plane to Korea, the C-119 Flying Boxcar. Twin booms extending from the engine cowlings on the wings made it possible to load heavy equipment into the bulbous cargo compartment through doors in its rear. Nobody, however, had ever transported a Treadway Bridge this way. Every aspect of the mission was experimental. Among other things, Treadway Bridge sections were longer than the airplane fuselage, so the rear cargo doors were removed and the bridge pieces were inserted into a C-119 with some seven feet of their length sticking out. A delicate balancing act and skillful flying would be necessary even to get the C-119s airborne. Next was the problem of how to get the bridge sections on the ground where they were needed. Clearly the plane couldn't land with this cargo, so how many parachutes would be needed to float this bridge safely to earth at just the right spot? Time was desperately short. Troops had to move out of Koto-ri in three days if the breakout was going to succeed. The Army's Combat Cargo and Quartermasters at Yonpo airfield, Korea had to figure this out.

After some trials, the Air Force successfully got a 2,550-pound bridge airborne; a Treadway was dropped with four 24-foot parachutes attached: the bridge dug a 20-foot grave for itself. More parachutes were sent from Japan and in further tests two larger parachutes got a bridge safely to the ground. But C-119 pilots still had to drop the Treadway Bridges onto a 300-yard-target zone within the Koto-ri perimeter at an altitude of 800 feet. To make the drop more accurate, the bridges were extended even further out of the rear of each aircraft. This load had to be moved and re-lashed while in flight, giving the crew a few additional seconds to provide more accuracy for the release. The equipment was not designed for such work. The crews made it up as they went along.

On December 9th, six Flying Boxcars took off from Yonpo, each carrying an 18-foot Treadway Bridge. As they approached Koto-ri, one by one, the pilots gunned the throttles, pulling up the noses of each aircraft, as crews pushed the ponderous bridges on their wooden pallets out of the C-119s. As planned, static lines tripped the parachute ripcords and, amazingly, the Treadway Bridges floated to the ground. The score was one to the Chinese and one destroyed, but four were safely delivered to the Marines at Koto-ri.

In a stroke of luck, the Army's 58th Engineer Treadway Bridge Company was also trapped at Koto-ri with two operational six-ton Brockway trucks, able to move two Treadway Bridges each. Everything still depended on Marines be-

ing able to clear out the Chinese, who held the high ground at Funchilin Pass, which was under constant machine gun fire and nightly assault. Other vulnerable spots along the evacuation route were also under attack, something I had experienced on the way from Hagaru-ri.

As things emerged, when the Treadway Bridges reached the site of the crossing, it was found that the combined sections were still seven feet too short, but Marine Corps engineers had scrounged some "just in case" timber and the span was completed after only one collapse. By 2:45 a.m. on December 10th, the first vehicle crossed the Treadway Bridges. Although a brilliant combined effort had put the bridges in place, there still remained the ticklish job of driving fully loaded trucks, equipment, tanks, artillery, and jeeps, across this blessed span — in the dark — without headlights. There was not only the problem of the Treadways being flexible since they were designed to rest on airbags to float on water, but also that two of them, laid side by side, were only 11 feet, 4 inches wide, meaning that the tanks had only two extra inches to navigate the crossing.

The cat eyes, the tiny lights on the truck fenders, helped the engineers guide each vehicle. Working with flashlights, Marines made judgments that steered traffic over a bridge with a thousand-foot drop beside it. It was just as well that drivers couldn't see the gap they were crossing.

I was still perched on a truckload of frozen bodies and baggage as the convoy inched over the bridge. We were again on the road that had taken me to Hagaru-ri, but on this ride back I slept through it all, only waking up years later to understand what professionalism, imagination, daring, inter-service cooperation, and good luck had meant to my comrades and me.

There were frequent stops along the way, and then the line lurched forward toward the coast where the U.S. Navy, including the battleship USS Missouri, with the massive firepower of its 16-inch guns, provided protection. Hungnam was a temporary safe haven while the First Marine Division, other X Corps units, and hundreds of thousands of North Korean civilians prepared for evacuation. Dismounting from my truck, I found my battalion and chaos was replaced with stability by December 11th. The killer cold lifted to a more bearable level and I got the medical help that I had unwisely rejected at Hagaru-ri. I was officially diagnosed as being a severe incontinence case. There was a rumor that the severely frostbitten might receive Purple Hearts but inconti-

nence cases were insufficiently heroic to be on the list. My offended gut, however, began to recover, and my absence from Koto-ri was lost in the general confusion and went unrecorded except by me.

It took us about a week to put what was left of the units back together as trucks, tanks, jeeps, and artillery were loaded onto ships. All the supplies we couldn't carry off were left to be picked over by desperate civilians, but extra fuel and items useful to the enemy were collected for destruction. Then we boarded a troop ship, the USS Gen. G.M. Randall. She was equipped to accommodate 5,000 Marines but the Navy, short of transports, loaded a large part of the First Marine Division as well as North Korean refugees aboard. It was every man for himself. Men slept on deck, in lifeboats, everywhere. I camped on the open Captain's bridge the first night. Even the cold steel deck felt warm compared to my foxhole at Hagaru-ri.

In the morning, I joined thousands in an endless chow line. After a three-hour wait, we were each rewarded with a scoop of beans, a generous helping of creamed chipped beef, known as "shit on a shingle," and a canned half-peach accompanied by a steaming canteen cup of coffee — this time minus the detergent soap.

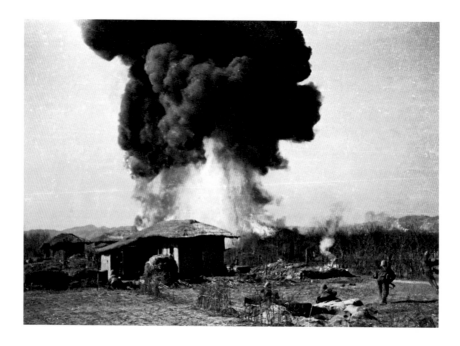

After chow I got lucky and met a woman kitchen supervisor whose quarters were right next to the Officers Mess. She agreed to stuff six others and me into her double bunk cabin. Sensing an opportunity for some better food, I immediately volunteered for duty in the Officers Mess. There, as I dished out fresh, not powdered, scrambled eggs, steak, and ice cream to the officers, I made sure to include myself. Our Lady of Mercy's stateroom also had a shower, and I luxuriated in it at every opportunity; water ran off me in small brown rivers. Clean water, fresh food, and good luck finally appeased my ravaged gut and restored my spirits. For three days I had a chance to catch up on sleep and chow and now that I was warm, some of the things I had seen and heard began to thaw out as well. But I couldn't forget the frozen bodies of the Chinese soldiers I saw, whose miserable cotton quilted uniforms became death suits as their sweaty forced marches turned them into icemen. Their canvas sneakers guaranteed frostbite, and the lack of gloves produced corpses whose fingers were frozen to the triggers of their weapons. Those poor bastards died in droves, and the history books I later read, amplified what I saw and felt about the demise of hundreds of thousands of these ill-equipped Chinese soldiers.

4 – TO THE 38TH PARALLEL

Three days later, we arrived in Pusan, and continued south to Mason by train. In Mason, we caught our breath. The First Marine Division was resupplied with better sleeping bags, new field jackets, and other equipment needed to bring us to combat-readiness. Some of it had been adapted and "modernized" based on our recent experience. The new sleeping bags had zippers that extended from top to bottom, enabling a fast breakout in case of a surprise attack.

Here, we slept normal hours, and receiving mail from home put us in the mood to celebrate. It was the holiday season and I wrote to my mother, "Today is Christmas; we have trees up around the tents and the atmosphere is festive. The trees are decorated with red, green, and blue parachute shrouds and bits of tinsel from cigarette packages. I have lots of mail..." I sent this drawing also:

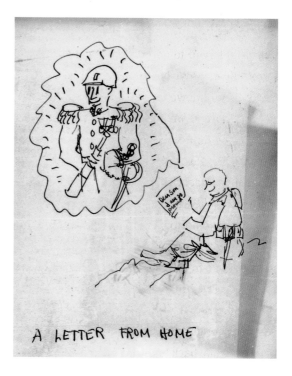

A LETTER FROM HOME

Food was mentioned in almost every letter home. Everybody I had ever called "Aunt" sent food. Culinary delights poured in from everywhere. Food emporiums delivered pâté de fois gras and tinned cheese from Aunt Helen. Dark chocolate, bizarre nuts, small cans of special fruit came from Aunt Peggy, and combined with what Aunts Cornelia, Mildred, and Vivian provided, the mailbag sometimes got to be the size of Santa himself.

January 5th, 1951, "Dear Mother, I had a very happy Christmas and New Year and we were all issued six cans of beer... I was saving the fruit cake for a later date, but I couldn't resist... cut the cake, heard a clank... delighted to discover a silver flask..." My name, serial number, and USMC had been engraved. It was filled with Courvoisier VSOP Cognac older than I was.

I also got a Christmas card from a car rental agency — Hava-Kar-U-Drive-It — from Beverly Hills; they appreciated my confidence in them and wished me a prosperous New Year — all in verse. I remembered that once, on a weekend liberty from Camp Pendleton, I had to show up to rent a car in civilian clothes because they wouldn't rent the nice blue convertible to a serviceman in a nice green uniform.

January 15th, 1951, "Dear Mother... we are moving north. The First Marine Division will spearhead the drive to the 38th parallel. There are all kinds of rumors; it's hard to describe the feeling of going back on line. Will there be something new? We have gotten used to lots of the same, but now we are waiting for the unknown to wiggle in... there is something about night that excites me, especially if we are in a warm tent. It's hard to get excited when you're cold. In the tent, voices are humming, the radio is squawking, one man is cleaning his rifle, another cooking... the usual conversation about a girl at a bar in Long Beach. The spirit is running high. It won't be as high tomorrow at 5:30 a.m... we're warm and feel OK. Tonight we're ready to go but we don't have to go. We go tomorrow."

January 20th, 1951 – Yonchon, "Dear Mother... our battalion is around the airfield set up in a perimeter defense here. The 'security platoon' (my platoon) is part of a line bristling with machine guns. We have machine gun watches, but I don't think the North Korean guerilas will attack, and there are no Chinese. They prefer to attack convoys and small groups. Last night three Army Captains came back to our line to make inquiries. The Army has some men in

front of our position and they explained that in the event of a heavy attack, the Army would move back to our lines. The Captains wanted to know where we would retreat if things really got rough. This gave my squad mate Cpl. Augustine the chance of a lifetime. 'Well Hell, Captain,' he explained, 'we'll just move to the back of our holes.'"

March 6th, 1951 – 10 to 15 miles north of Wonju, "Dear Mother… we have gone on to the offensive and now we are climbing up and down hills, or rather mountains, in pursuit of the Chinese. I just took off my shoes for the first time in a week. Amazingly, I haven't seen a live enemy since the offensive started. It's climbing, climbing, and more climbing these damn hills. Every night we dig in on the top of one as the high ground is most easily defended. The weather has warmed and we are traveling as light as possible. Our parkas have been abandoned along with our packs. My field jacket and sleeping bag are tied to my cartridge belt in the rear. Looks like a bustle. A hollowed-out niche in the side of the mountain, covered with pine boughs about six inches thick is where I roll out my sleeping bag, wrap it in my poncho and stay quite warm. Of course, at night, I accumulate a half an inch of ice around the opening where my nose sticks out. Too bad I inherited such a long nose."

Capt. Corrington, my former company commander from Savannah, got transferred to Weapons Company, so I took the opportunity to get out myself. Somehow, security platoons supplied all the "working parties" when we weren't fighting: digging tin can holes, putting up everybody's tents, and digging the latrines. So I got out, volunteering for a line company when the chance presented itself.

March 8th, 1951 – North of Wonju, "Dear Mother… I was a little startled by your suggestion of sending a dictionary. Perish the thought, dear Mother. I carry enough gear for two men and I can't eat a dictionary. It won't keep me warm. It doesn't shoot. It doesn't lift my morale and I don't want one. You will have to struggle along with my present state of illiteracy. Things have been very quiet around here. Artillery and our Air Force have been raising hell with the Chinks. Two boys in my company cracked last night. One shot himself in the foot and the other went berserk. FCB however is in fine shape. I was enough cracked up before I got here to be immune."

March 10th, 1951 – North of Wonju, "Dear Mother… I am fine and we are proceeding toward the 38th parallel with great haste… Much hill climbing but

don't know where I am... Could you send me all the pictures you have of the MG. Strange request, but I spend hours thinking about mechanical changes, adjustments, additions to my car. Pictures help. Anything to keep my mind off this place and photos are easy to carry. Send some snapshots of yourself. I can gaze at the pictures of Audrey's party and go off into another world."

March 19th, 1951, "Dear Uncle Bob... my glorious military career has mostly consisted of climbing up and down many hills. When it isn't the hills it's the rice paddies... this doesn't make for perfect fighting conditions either. The weather is warming up but unfortunately this means mud. There had been an unusual amount of rain, then the temperature went to freezing again. You can't win. It's too hot or too cold... Up at 5:30 a.m., eat chow, after building a fire and rolling up sleeping bag and poncho, which are then attached to my rear on my cartridge belt. We generally have two to six miles to cover for the day depending on the information sent from little Piper Cub spotting planes. Meanwhile, Marine and Navy Corsairs start working over the opposition. Artillery opens up on our objective and we shove off. Moving out in a file, we descend and as we get to the bottom we spread out and start up the next hill. If we are pinned down, we call for an air strike or mortars, which are attached to us. Generally we have heavy machine guns on the hill behind us, which give us covering fire.

Unfortunately, neither Air Force, tanks or artillery can root out the Chinese if they don't want to leave their well-camouflaged bunkers, which are built with logs 6-12 inches thick, and heavily piled with dirt. Many have long trenches leading to the rear. So when you approach these bunkers you don't know whether anybody's in or out. Everyone has to be carefully checked because they love to let us get half a company through, then open up. The holes are lined with straw matting and sometimes they get between the straw and the wall of the hole. Smart soldiers."

The "hole checking" that I described in my letter to Uncle Bob was a problem for me because I never have enough grenades to throw in every one. I found it much easier to stick in my pistol and fire a few rounds. It is very difficult to stick a rifle in as the openings to the holes were so small. It wasn't wise to expose yourself by looking in. Peek-a-boo, bang!

On one occasion when the "mountain climbing" actually became an assault, we went up with fixed bayonets, screaming what sounded like "CHAUNEE." Ac-

cording to a couple of old China hands, this is alleged to have a devastating effect as it's supposed to mean 'We are coming up to cut your throat with a sharp edge.' The Chinese recognize our linguistic efforts and roll down a lot of grenades in appreciation.

Living two by two in foxholes enhances the basic foundation of infantry: look out for your buddy. Life depends on it. And, please, take no unnecessary risks, and add no intellectual burdens. It's about the immediate; live in the present, and remember that you're married to the dirt you live in and the guy you live with.

As for things of the mind, for example, a close friend of mine, a squad leader, told me he was an atheist. He made no attempt to hide the fact that he didn't believe in God. Now a Marine rifle company is not a college campus where debates about a Divine presence are routine, and it was considered bad luck to associate with anybody who might piss off God, especially when there were so many opportunities for Him to let you get popped off. The pressure of conditions on the line, therefore, put such intellectual speculation in a straitjacket; everybody was looking for safe ground. I felt like everyone else did about my friend, because during wartime you're an innocent man on death row and sometimes you can't help saying: "God, get me out of this shit."

There were other aspects to the moral side of foxhole culture. In early 1951, my company was on reconnaissance patrol probing an area between our lines and the enemy. It was raining and cold and when we came to a cluster of houses, we stopped to take a break in a farmer's courtyard. A Marine decided that we needed a fire. He entered the house, grabbed a sewing machine, dragged it out into the courtyard, knocked off the wooden parts and built a fire to warm us. In half an hour we departed, leaving behind a devastated Korean farmer and a smoldering sewing machine. On the way out of the compound, another Marine set fire to the thatched roof of a building with his Zippo as we proceeded on our patrol. We returned to base and nobody reported the incidents — and that included me. We had made no contact with the enemy, except the ones we had perhaps recruited among those farmers.

By accepting this, I too, was part of the stupidity of war — the ultimate moral failure and calamity. Why? Unit solidarity is built on twos. It begins with one; individual survival is the primary concern of a foxhole-bound rifle-

man. The loyalty of the other person in the foxhole is the First Commandment. Thou shalt do everything for your buddy because he is then under obligation under the rule of survival to do the same for you. In a two-by-two person world, a rifle squad can be a most generous and caring place because it's all made up of the survival needs of twos — but not threes. The human arithmetic of threes can add up: two against one. This could be fatal in a foxhole. Marine Three can be a whistle blower or a guy left out. So goes the mentality of the rifle squad, and the platoon, and on to the company. In spite of the worst aspects of the "logic of twos," its best attributes can deliver extraordinary courage, generosity, and loyalty.

None of my letters home told the full story of the danger we faced every day. I was wounded on the drive north on March 12th, 1951, near Hoengsong. A Chinese 81mm mortar blast lifted me five feet off the ground and dropped me on my ass, fracturing my dignity, though thank God not much else. But I felt as though I had been fired from a circus cannon. By some miracle there was no shrapnel in me, but I could barely walk. Somebody dug up the tail fin of the mortar and it said it had been made in 1945 in the USA. How did the Chinese get hold of that munition?

My experience in the medical tent at Hagaru-ri taught me not to ignore help so I went to see a doctor, but he told me just to go back to my foxhole and soak my tail with hot towels three times a day. "Home" was up the mountain 800 meters skyward, and there was no water there other than what could be dragged up in five-gallon containers for drinking. This was going to be a problem. Doctors always know best, however, so I started the climb to build a fire, find water to heat in my helmet, and begin treatment. I didn't get very far. Each step upward fired up the nerves in my bottom until they all got together to retaliate with what felt like a bayonet attack on my bottom. Hobbling back to medical for a second opinion, I got it and was immediately evacuated.

I sent the following report from E Medical Company, located God knows where, to my mother: "This is my second day in the hospital... feel like I'm at a tented Waldorf. Had hot cakes, syrup, sunny-side-up eggs, dry cereal, doughnuts and coffee. My cot is so comfortable that I can't sleep. I keep waking up my buddy Bob Maxwell, who was also 'mortarfied' and sleeps next to me.

'Hey Max, wake up, time to go on watch.' He halfway wakes up, 'OK Professor, OK.' (I was nicknamed "Professor" when it became known that I had spent a year at UVA.) Then blissfully realizing he isn't in a foxhole, contentedly tells me to go to Hell."

My next move was from the Division Hospital because E Medical didn't have buckets big enough to soak my fractured ass and there were a lot of wounded coming in. I eventually arrived — via plane and a very luxurious hospital train and ambulance — at Hospital Ship, USS Repose. There, I shaved, bathed, and cleaned up to go to the Operating Theater. I met my surgeon, a full Captain in the Navy, and two junior doctors who were ready to go to work. The following information was directed to the junior doctors:

"Get some sleep. There's a flood of Marines coming aboard tomorrow. Big battle at the front."

Information came to me indirectly when the Captain tested the juniors.

"What are the four ways that you kill the patient while doing a spinal tap?"

"Inject the needle directly into the spinal cord," said one brightly.

"Correct," as I felt a foreign object entering my tailbone.

"Pushing the needle too far and contaminating it by entering the colon."

"Good answer," as I felt the needle go deeper.

About this time, things got blurry. I imagined they were calling for the chaplin. But then I started laughing.

"What are you laughing about?" asked the Captain, slightly irritated.

"Sir, my ass has never been to school before — all by itself."

In addition to my dignity, my Argus C-3 camera was also stolen on the hospital ship, but I ordered a Canon from the PX in Japan to preserve my status as a well-armed tourist. The pain in my ass gradually subsided. My fractured coccyx, or whatever it was, repaired itself. The doctors on the Repose didn't have much bedside manner; they were not too chatty and I got no medical report, but I was released in a couple of weeks and then spent another two weeks in Masan recovering. I returned to my company just as we moved up toward the Hwachon Reservoir in the spring of 1951.

We dug in on a long nameless numbered ridge that was connected by a saddle of land to a parallel ridge a couple of thousand yards directly in front of us. Were there Chinese holding the position? My squad was detailed to make

the reconnaissance. This was standard operating procedure — small probes, make contact, and pull back. It was as if we were the tiny feelers on a bug, sensing and gathering information on how to proceed.

We set out and I was in the lead on the left side of the saddle. It was an uneventful probe until we almost got to the hill. Suddenly a concussion grenade went off with a big bang, knocking down my buddy John Campbell, on the right. He wasn't badly hurt, but I charged over the crest meeting what seemed like a large number of enemy soldiers — four, five, eight — I have no idea.

Going into action in a ridiculous fashion — I didn't take cover — just started firing my rifle. Wiping the sweat out of my eyes and glasses, I re-loaded and started firing again. One man went down, and I may have shot others running away. Pumped with adrenalin, unconcerned about myself — this was probably the most exciting moment I have ever experienced — I shot as many as I could get in my sights.

Suddenly, I was alone, except for one frightened enemy soldier with his hands up; another lay wounded nearby. I had them both covered with my rifle. My prisoner had grenades strung around his neck on a cloth band. As I unsheathed my Ka-Bar knife, he started giggling, terrified. He thought I was going to kill him, but all I did was cut the grenades off his body.

My squad, pinned down below the crest of the hill, couldn't see what was happening. Somebody threw a smoke grenade. Hearing the firing, they had assumed I was dead and were coming for my body. Grabbing my prisoner, I motioned to the wounded man, "stay down." I didn't want him to get shot. It didn't make sense. I had just shot him. I grabbed my prisoner and we headed back through the smoke.

The enemy troops on our flank then woke up and we started taking fire. It was time to go home. Back among my squad, somebody wanted to shoot the prisoner. He was slowing us down. Rounds were beginning to whizz through the air. I told my buddies that I would shoot anybody who laid a finger on my prisoner.

We made it safely back to our lines. I remember breathlessly telling Lt. Birch Alt, a new officer who had just come to Item Company: "This was like a turkey shoot." It was a doubly significant moment; by the strangest coincidence, Alt and I had gone to rival preparatory schools and I was to some extent

telling a Grottie (for Groton) about a St. Marker's wildest adventure. For a fleeting moment we could have been at a Yacht Club on Long Island.

But something had happened between the time I was "turkey shooting" and when I cut the grenades off my prisoner. Militarily, of course, a dead prisoner was useless. Our company had set out to gather information, and here was a live soldier bearing knowledge of exactly what we had been sent to get. But my switch from killer to protector turned on a brief moment of physical contact with a terrified enemy when he switched from target to human. His life became my responsibility. We bonded during a wildly primitive, intense moment. I discovered the frightened soldier's humanity as well as my own. Civilized notions had managed, somehow, to take charge, and I hope he survived the war and is aging peacefully somewhere.

Recently, when I was looking back at events of the Korean War on the Internet, I found a story that illustrates how "war stories" can grow on their own. This unexpected fragment is from *Korean War Educator – Chosin Reservoir, The Memoirs of a Chosin Veteran* by Charlie Carmin — the same guy who had helped rescue the pilot at Hagaru-ri. A retired Marine with an outstanding military record, he converted complexity to simplicity in retelling something similar to my experience with the captured soldier.

"Funny things happen in combat situations — at least, to the men doing the fighting they seem funny. A story told in Item Company was about a tall scholarly Reserve Marine from Georgia. He was nicknamed Schoolteacher (my nickname, of course, was Professor) for his mild manner and thick glasses. Schoolteacher's glasses were always fogging up at critical times, but he persevered. A few Reserve Marines came to Korea with their personal weapons. Schoolteacher's personal weapon was a long barrel thirty-eight pistol.

It was snowing hard and visibility was poor when Schoolteacher's patrol flushed five or six Chinese; the Chinese ran up a narrow draw with Schoolteacher in hot pursuit. Schoolteacher and the Chinese disappeared in the blowing snow, with the remainder of the patrol following in trace. Occasionally a pistol shot rang out. The men following would then stumble across dead Chinese. After four or five shots and a like number of dead Chinese, Schoolteacher came trudging back down the ravine rejoining the patrol. One of the Marines asked him if he had killed all of them. Schoolteacher replied, 'Hell no, my damn glasses fogged up or I would have.'"

Charlie Carmin's description of glasses fogging and sweat in the eyes is correct — it was a constant curse. And, in the post-survival bravado of battlefield action, I probably made such a remark.

In 1954, I had an eerie encounter at a New York fundraiser organized by actress Betsy von Furstenberg for paraplegic veterans. There, I met a man in a wheelchair, an ex-Marine who had been in How (H) Company, in my battalion, and as we put dates and places together, it turned out he had been hit assaulting the same hill on which I took my prisoner in the spring of 1951.

Funny stories about men who live under extremes are part of the oral tradition of fishermen, oil field workers, cops, and cowboys. They crown the ordinary with significance. They're a lift during long, boring, sometimes miserable, pauses between actions. I admit I enjoy them and with the help of Charlie Carmin had made my own contribution.

In late April of 1951, the Glosters, a British regiment (whittled down to battalion strength) in a valley to the northwest of us, were getting badly mauled. This created a big hole in the defensive line. We were pulled out of reserve, loaded onto trucks and shoved off about three o'clock in the afternoon to plug the gap. On the way, our battalion passed truck after truck of South Korean soldiers heading in the wrong direction, reinforcing my strong negative feelings about ROK (Republic of Korea) troops. The "bug out" of the entire ROK 6th Division had left a fifteen-mile hole in the line.

The battalion was trucked over a pass and down into a riverbed at the base of a mountain. Extra grenades and bandoleers of ammo were issued. Battle was imminent. Our mission was to get to the top of Hill 902 (named after its elevation) before the Chinese did. The whole battalion was strung out single file. Our platoon brought up the rear.

It was hot, sweaty, and difficult to keep our footing on the path. The weight of the extra ammunition and everything else spoke to me during this marathon of military stumbling and cursing. My physical and psychic existence depended on what I could hang on my body: a nine-pound rifle, ammo, two water canteens, pack, sleeping bag, C-rations, grenades, bayonet, poncho, helmet, boots, Ka-Bar knife, an entrenching tool, pistol, more ammo, extra socks in the pack, four layers of clothes covered with a field jacket.

For four hours I lurched, slipped, cursed, stopped and started up again — strain became pain. When the first units lagged, everybody behind jammed up

and ground to a halt. As it grew dark, more gaps opened. I had turned in my six-pound parka — because of the warmer weather — thank God. I hated to see it go. It had saved my life, but I was so glad to lose the weight.

But I was carrying all kinds of other stuff, including the new camera, which had just arrived. Why couldn't it have come later? A couple of rolls of film, and the pen plus the notebook — how much did they weigh? There was the little prayer book from Dr. Tucker, the Episcopal minister in Savannah, whose church I belonged to but never attended. I wanted to toss it — I never read it but it stayed in my right front shirt pocket.

The silver flask filling my left front shirt pocket brimmed with cognac. If it were only water! Pain and thirst — strain becomes pain banging into my legs, yelling from one muscle to the next until it gets to my brain and screams: STOP!

We pushed on again to maintain contact with George Company in front of us. Shreds of military discipline kept us together until we reached the top at ten o'clock, when we began to dig in — or tried to. A foxhole was impossible to dig so we started scraping rocks just to get flat. A hot climb; then chilling sweat. (It was cold in the mountains. I longed for my retired parka.) Then the shooting started. The word was passed from George Company, a hundred yards to our left, "four men killed in their sleeping bags." From then on it was 100% watch... everybody awake... we could see tracers streaking from the hills in front of us. Graceful arcs of death.

About midnight, Army self-propelled 155mm howitzers (the "Red Devils") started blasting the opposite hill about eight hundred yards in front occupied by Chinese. The huge guns were delivering a beautiful concentration, the explosions lighting up the mountain very nicely. The explosions kept rolling in closer and closer but when they should have stopped — they didn't. I hugged the ground — helpless. My world became an earsplitting, erupting volcano. Concussion kicked us. Dirt and debris showered us, pelting us with tree limbs and rocks; the earth was literally opened up by the cannon fire. I felt more than I saw. My face was buried eating dirt. A few in our company were killed. The Army artillery forward observer got his hand blown off. Our Corpsman went off his head and there was a lot of praying. Finally it stopped.

The Chinese started dropping in mortars — anticlimactic after the 155s. Much worse, was the lack of water — none available except what was left in our canteens.

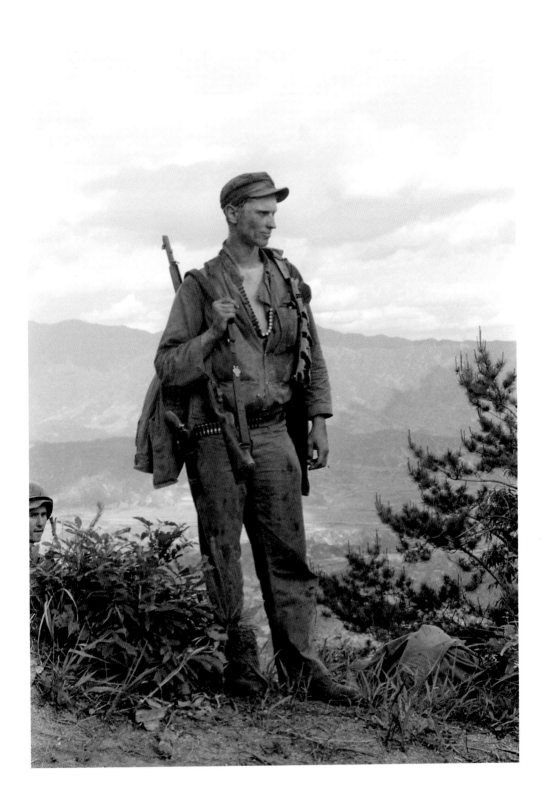

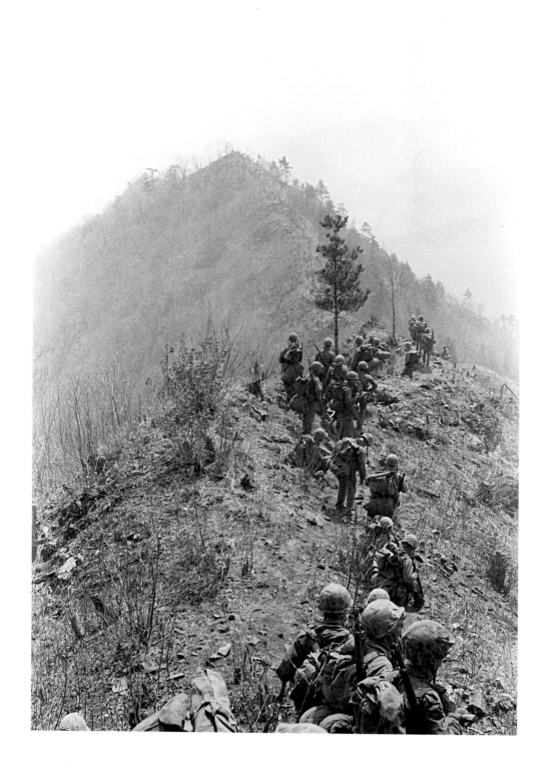

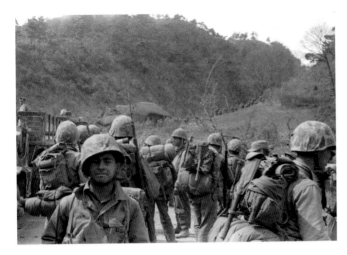

Not a shot was fired from my position, but 100 yards to our left George Company was blocking the attack on a saddle connecting the ridge held by Marines and the advancing Chinese. The enemy kept coming, lobbing grenades, crawling over their own dead in the dark in the furious firefight. More than a hundred Marines were killed or wounded; Gunnery Sergeant Wilson earned the Congressional Medal of Honor that night, stopping what was later estimated to be a regiment of Chinese.

Had Item Company preceded George Company, it would have been us. It was an awful night but nobody in my platoon was wounded or killed.

The next morning we had to carry the wounded out. The hill was so steep that four men carrying a stretcher couldn't get any footing and they were stumbling and dropping stretchers — an agony trip for the wounded. Many of the regular stretcher bearers had been hit so everybody had to help. I carried a couple of men. It was an exhausting job. Still no water and hot as hell.

That afternoon, about three o'clock, the battalion started moving off the mountain. More supplies and help for the wounded were impossible. Of course, we took off the dead. They were tied onto stretchers and improvised poles with communications wire.

We worked in shifts of four — one crew would carry the man a couple of hundred yards and then the other two would take over. It was a jerking, stumbling, grungy job; hot and dusty and my mouth felt like I could spit sand. My dead Marine kept rolling off the stretcher. At least the poor guy didn't complain.

It was impossible to take stretchers anywhere except along the ridgeline, which was under fire. The mountain was too steep to land helicopters. The trip down took about five hours and most of the badly wounded died before we could get them to the bottom.

Although the day was pure hell for me, it was worse in the valley for the trapped British Glosters on our left flank. The Chinese attack proved a four-day disaster, but they were ultimately blocked and didn't make a breakthrough to Seoul. As usual, we had no idea what was going on.

About four-thirty, Marine Corsair fighters began circling us — then they dove and fired rockets. They thought we were Chinese. There was a tremendous blast and I was bounced down the mountain. I wound up under a dead man and a bunch of dirt and rocks. One of our men was killed and three

wounded. Reflective plastic identification panels were quickly displayed and the planes left.

I don't know what happened to the dead Marine. I was momentarily "out of action" but found my rifle and helmet; crawled up to the troops filing along the crest and continued moving out. We were lucky. The Marine Corsair planes — thank God — didn't have napalm.

It was a horrible trip down — no drinking water for eight hours. The night had been cold but the day was hot. When we finally got to the bottom, we passed a stream that was gently cascading over the carcass of a dead horse. Plunging in, I drank and drank, filling myself and two canteens as the cool water soothed my sore feet. I didn't wait for my chlorine pill to kill whatever dead horse bugs flowed in my direction.

After our hike down Hill 902, we dug in for the night with two tanks on low ground. Finally, we were safe. But all night we heard strange whistling noises and the tank crews got nervous. Perpetually jumpy from getting their treads blown off from mines dug into the roads — they were itching to shoot something, but if those guys got trigger-happy and fired their 90 mm gun, concussion would scramble our brains, so we politely let them know that if the cannons opened up, we would switch sides and drop a grenade down each turret hatch.

More weird noises and we went on 100% alert. With few mobile radios available, the Chinese were fond of blowing whistles and bugles to control their movements. Imagining the enemy creeping closer kept droopy eyelids open. At dawn we went to investigate and flushed a pair of amorous pheas-ants. They escaped unharmed.

The next day we moved out again. Starting at five o'clock that afternoon we arrived at some town at 1:00 a.m. Another nightmare — only five breaks. At every stop we were instantly asleep. We dug in for two days and then we marched ten more miles to an assembly area where we boarded trucks and moved near the Inje River. We arrived that night — I don't know when. I wrote my mother: "Our battalion is now in Division reserve and we will now have a rest... please send some canned fruit and chocolate drink. No more thirsty-making fish balls or sardines. I never want to be thirsty again."

Finally we felt lucky. The weather blessed us and there were no Chinese. Birds were singing and we knew they were birds. We got sleep and water and

food. Life was good for the moment. I repaired my feet. Blisters had burst but now we had Band-Aids, a blessed layer to protect raw red welts of pain that could turn us into cripples.

From April 22nd until April 30th, 1951, we had just survived the start of the Chinese CCF Spring Offensive, what the history books described as "the biggest single battle of the War."

On May 4th, my letter home reported a return to the hospital, complications from my tumble down 902 and the march out. This time I was evacuated to the USS Haven; I definitely preferred this ship to the USS Repose. They were identical twins but had different personalities. Here, the chow was better and more plentiful. The personnel were nicer. The PX was open and unlike on Repose it was possible to get ice cream more frequently than just for an hour in the morning and another in the afternoon. Ice cream was important; it was the opposite of the reality that we faced out there. This may sound silly, even child-like, but our reactions, including our fears and cravings, were viscerally changed in combat.

What were we afraid of? In my case, white phosphorus short rounds: I saw deadly plumes rise majestically into the sky and then turn — returning to seek me out. It only happened once, and death fell short, but I can never forget the terror. At the front, misery and fear led me to insane laughter and stupid jokes. During the bombardment from our own artillery on 902, I asked Murphy whether he was awake and standing a good watch. "Did you hear what the Professor asked me last night?" Murphy tells everybody the next day.

After a week, I was allowed to go ashore in Pusan, and discovered a hospital run by the Swedish Red Cross. But their beautiful nurses only treated Army personnel — the only time I regretted being a Marine. I had a more serious complaint, however; the Pusan black market.

On the streets in Pusan, Korean hawkers were selling U.S. military clothing and equipment; jackets, blankets, boots, you name it. I was pissed off. As I wrote in a letter home: "One big problem is boots. Nobody in my battalion can get hold of a pair. Mine are worn out and half the sole is gone — here I will get a new pair but there are men in my squad whose feet are a wreck from worn-out boots. All that can be done is turn them into Sick Bay until boots are found... Fulkerson, my squad mate, had been trying to get shoes for a month. Also Mc-

Minimee, my platoon leader, couldn't walk after our hike. And army boots were on sale on the black market."

How was it that our guys, tramping through the mountains of Korea, couldn't get decent boots on their feet to fight for this fucking country?

Later, I found that my message home had been forwarded to *The New York Times* by my aunt, Helen Stam. And Aunt Peggy's copy was published in *The Tribune* and my letters were transformed into a radio report by George Grim on a news show out of Minneapolis on the eve of Memorial Day, May 29th, 1951.

Following a short convalescence in Mason, reality welcomed me back to Item Company with a long truck ride — 48 hours in the rain. We started up a hill and I slipped and fell flat on my face in the mud. I was still a little out of shape from my vacation. It wasn't turning out to be my day. After a climb to the top, John Crawford and I dug in at 9 p.m. It was still raining. Our sleeping bags were sopping wet. Digging a foxhole meant simply moving mud. Darkness didn't help. Rigging up a poncho over us with sticks and communications wire kept most of the rain out, but the soft ground offered no stability. Just as we dried out a bit, our shelter collapsed, showering us again with cold water.

Fortunately, I had been issued an air mattress after the hospital (in addition to new boots). It added more weight to my 60-pound load, but was now my most cherished possession. Poor John didn't have one and slept in three inches of water. After a certain point, being wet hour after hour, we just sat in our hole, screamed bloody murder, then laughed like maniacs.

At 8:00 a.m. the next morning we went on a reconnaissance patrol. Buckling on a clammy cartridge belt put me in a sour mood. We departed without breakfast because there had been a mix-up and rations hadn't been delivered either that morning or the previous day. But I had some fancy chocolate, so John and I were OK.

We found the ridgeline littered with U.S. and Chinese gear: one heavy machine gun, thirty or forty sleeping bags, cases of grenades and ammunition. There were a dozen dead Chinese and lots of C-rations. We grabbed rations and a waterproof cover for my sleeping bag, a new cartridge belt, a sharper bayonet and a rubber mattress for John. Now, we could float in style during the rainy season.

This supply bonanza resulted because Baker B Company, 7th Marines had taken the hill from the Chinese, but had been driven off the next day. Baker Company counterattacked and retook the hill, but with many casualties. They

used all their men to get the wounded off, leaving the gear behind. We replaced Baker Company.

There was plenty of water coming out of the sky, but the drinking water situation was acute. We were rationed a half canteen cup each. When it rained, we collected water in our rubberized ponchos and filled canteens. By adding instant coffee, sugar, and powdered milk plus a chlorine tablet, I could create a delicious drink, although the dirt washed off the ponchos provided a mouthful of grit to filter through my teeth. John, a country boy from North Carolina rejected my taste-enhancing additives and liked his water with a dash of mud to go with the pungent aroma of a rubberized poncho.

Later we sent out a fire team (four men) and a large Korean working party. (We had 270 Korean civilians who now worked for our battalion.) The Korean men were used to bring up food and water when we were in the high mountains. They carried everything on their backs with A frames, wooden yokes that were their traditional transportation tools. This was something completely new to us. By the time we got up the mountain we were pretty exhausted. This was the experience that taught me that a five-gallon container of gasoline was much lighter than water. But we now had Korean porters. They were a huge help.

Another group of load-bearing Koreans passed us carrying 60 rounds of mortar ammunition and two mortars model 1945. We used model 1942. We were now using captured Chinese mortar ammunition. The company commander allegedly didn't know about this, but the rounds were three years newer than ours. This generated a lot of talk about where the Chinese were getting these munitions: captured from whom?

Later that first day atop the ridge, when the sun came out, John and I luxuriated sitting in our shorts and drying out the sleeping bags, clothes, and boots. Perched on top of a commanding mountain, with the swamp in our foxhole drained, and with newly liberated rations, we looked across a wide scenic valley and saw Chinese troops getting pounded with heavy artillery and bombers; the war was almost enjoyable. As we sat there, a U.S. plane flew around overhead broadcasting in Chinese over an aerial loudspeaker. The weird sound faded in and out against the drone of the aircraft and the boom, boom, boom of artillery. Presumably the message was recommending that the Chinese surrender.

It was also time to relax and think about things — friends, comrades, and relationships. I felt good about the men I was with. We could count on each other. The men who made up my rifle squad were Southern farm boys and workers from big industrial cities in the North. Individuality was recognized by nicknames. I had, of course, been christened "Professor" because of my year at college. "Dumbo" Barber was always getting in trouble; if he hadn't, he would have been simply called Barber.

I thought a lot about water and weather. Those two elements had been such amazing teachers and were at the top of my list. Fighting in the mountains, a full canteen of drinking water was what was important in life. At the same time, too much water — sheets of freezing rain, sleeping in mud — wasn't fit for an animal. — The war for me was as much about dealing with terrain as the Chinese. We were advancing, and this meant taking the high ground, climbing, mountains; high ground that not only protected the enemy but *was* the enemy.

The endless lugging, step-by-step, for hours and hours, provided no adrenalin-filled moments, just a deepening anger that each painful step was leading to an unknown place. Sometimes it was a turnaround — the same slog — then a chance to do it all over again for a 'who the hell knows why' reason. Then back up the mountain, and the mountain switched sides and became a defense line, an ally but the rain still poured down your neck and every man fleetingly considered wounding themselves — and a few did — to get off this endless treadmill of pain.

With all the physical agony, the supply of food was adequate, and I had a good number of aunts who kept me and my fire team topped up. Mail from home was my major source of sanity, keeping hope alive and proving strong evidence that there really was something worth living for beyond the horizon. And way, way down on the list was sex. Even if it had been available, I would have traded it for more sleep.

Getting killed was not something I thought much about. That was something that happened to somebody else. I had only come face-to-face with enemy soldiers on three occasions. There was no shortage of death or dismemberment around me, of course, and it could happen in an almost casual, impersonal way. Apart from the medics, most of us never saw many of our friends and comrades killed or wounded in action. I carried out dead bodies on 902 and I saw

wounded at Hagaru-ri but I never had a dramatic firsthand experience. Was this due to luck? Perhaps, but in my experience when you are in the assault you move through the dead and wounded and leave it to the medics. In spite of being wounded three times in roughly nine months, I didn't see that much bloodshed. Ironically, had I not been wounded so many times, and had frequent vacations from the war, I might have seen more.

Hill 902 had demonstrated so many elements of luck — good for me, bad for others. No matter how skillful we became in the art of survival, luck was the joker that remained mysterious, generous, ironic, perverse, and dangerously fickle. On that hill, I sat sunning myself watching the Chinese being blasted to hell. That's good luck — the secret God that we all prayed to but nobody understood.

On June 12th, we were still dug in on the high ground in a position overlooking the Inje River. We were no longer leisurely admiring the Chinese being bombarded in the first balmy days of the month. We were attacking again and it was getting warm.

Because of my aggressive behavior capturing the prisoner, I had been rewarded by being made a BAR man. This meant I would carry a 20 lb. automatic rifle along with another heavy load of magazines. I took this to be a compliment and an opportunity to shoot even more enemies. Regimental commander "Chesty" Puller would have understood. But at the same time this might have been a reward for scaring the hell out of my squad when I disappeared over the hill at the big shoot-'em-up. In any case I was about to get another chance at immortality.

Again, I was in the lead on the left side of a ridge and we were climbing, advancing, taking new ground in the mountains. Enemy concussion grenades were rolling down and one went off near me. My right leg was smacked like a home-run-hit from a baseball bat and a small hole appeared in my dungaree pants; under that there was one in me. My ears still ringing, I realized that I had been wounded but not too seriously. Another Marine was waving frantically for me to join him on the crest of the hill. I collected myself, got my leg working, and crawled up to join him.

The lower ground ahead was swarming with Chinese and I started firing the BAR on full automatic. Then I stopped and thrust the weapon to my companion. We were the first to the top but I couldn't see a damn thing; sweat was

pouring into my eyes under my glasses. I became the loader, and tried to mop up my glasses while my buddy did the shooting.

When things calmed down, a corpsman caught up with me, I was relieved of duty, patched up, and told to get off the mountain to the medical tent. Hobbling down, I was stopped by a Marine colonel who had been observing the whole scene through his binoculars.

"Who was that guy doing the firing on the crest?"

I gave him my buddy's name and he later received the Silver Star – and another lesson was learned. It's important to have a Colonel watching if you start mimicking John Wayne. Also lie and give more credit to wounded Marines with sweaty glasses.

On June 12th, 1951, I was again ambulanced to the collection of tents that made up the medical facilities at Division HQ. This was the first stage of my progress to the hospital ship, USS Repose in Pusan Harbor. One day, as I lay there on a cot, I met Four Star General Matthew Ridgeway. Ridgeway had replaced General MacArthur, who had been fired by President Truman. He was inspecting those of us who were not seriously wounded, were on vacation, goofing off from the war. We had been bandaged, cleaned up, and combed — ready to act out our roles as heroes. However, we were languishing in a den of thieves: my revolver was lifted here, which explained why medics fifty miles behind the lines looked so "combat-ready," carrying side arms stolen from the wounded and dead.

Still, most of us here were lucky. A 2nd Lt. on the next cot had been shot in the throat. The bullet passed through one side of his neck and out the other not touching anything important. He had two Band-Aids, one where the bullet entered, the other where it exited. His slightly raspy voice sounded like he was getting over a cold.

General Ridgeway arrived with his trademark hand grenade attached to his overcoat. There was a lot of tape securing the firing pin. Grenades were supposed to be carried in a special pouch, but nobody used them because the pin tended to work loose in the pouch. I had a friend who was very "regulation" about using his pouch — and a grenade blew his ass off.

Frankly, I thought the General's grenade was a bit ridiculous. If he ever got close enough to the enemy to use it, he should have been court-martialed for losing his mind and endangering the command structure.

The General's job was to cheer up us heroes and inspire us to go back and do it all over again. When he got to my bunk, he asked me how I was doing. This must have been boring for him, asking the same question over and over again, so I decided to cheer him up. I considered it, in fact, my patriotic duty.

"General, I have so much shrapnel in me that I have trouble not pointing north."

It would be gratifying to report that General Ridgeway roared with laughter and invited me over for a drink at his HQ next time I was in town, but I can't remember any particular reaction. The General's sense of fun may have been somewhat retarded by his responsibilities, but the Marine colonel standing next to him looked at me with a "court martial glare."

Having collected enough Purple Hearts, I was sent home after my last wound in July 1951. I left at a time when I felt that my rifleman's role had some purpose. Ironically, I never knew what was happening. As a rifleman, I had no idea what was going on strategically — the big picture. My foxhole view of the war allowed me to understand what I could see in front of me, to the left or the right, depending on the light and what was visible — a tiny personal world of no value to generals.

Recent readings have flung these perspectives wide open and the discoveries have colored and illuminated the war in ways that were previously unmanageable from a foxhole. It began with a positive "big picture" perspective with the Treadway Bridge story. The administration of war could be nimble. Again, by good luck, I left Korea at the very beginning of the peace process at Kaesong and later at Panmunjom. The First Marine Division was perhaps fortunate to have served under the command of an excellent combat commander Lt. General Oliver P. Smith, but I was lucky to be gone when General Mathew Ridgeway became the inflexible, inexperienced, blundering negotiator for the United Nations with the North Koreans.

The slaughter after my departure continued at an accelerated rate, its purpose — to accommodate an end to hostilities, apply pressure for negotiating — seesawed the battle back and forth over a few miles of high ground. Heartbreak and Bloody Ridge resulted. It all finally ended on July 27th, 1953. During this period, political and military ineptness at the highest level chewed up more than 60,000 UN casualties and 234,000 of the enemy. This perspective,

unlike Treadway, provides a deeply gloomy "big" picture. How lucky I was not to understand any of this as our troop ship, USNS Gen. Nelson M. Walker, passed under the Golden Gate Bridge from the foggy Pacific. A gray curtain lifted and a brilliant California day, cool and crisp, made me feel that all doubts, all bumps in the road, imagined or real, had been erased by the clear shining light greeting us in San Francisco Bay.

Walking alone by the docks edging the bay, I could see pelicans and seagulls riding the air currents, flapping, flying, and gliding, occasionally diving for a fish. That's where I was, too — up there with them. Alcatraz was there, too, that escape-proof prison in the middle of the bay. And, it was there, symbolically, that I temporarily locked up in the deepest cell of the "Rock," bits and pieces of my Korean experience that might try to escape to bring me down to earth on my first liberty in the USA.

Then, I began climbing California Street to Nob Hill — to the Top of the Mark, the highest bar I could find. On the 19th floor of the Mark Hopkins Hotel, the view of the bay below turned golden with the celebratory lights of evening. Toasting the West, I officially said goodbye to everything on the other side of the Pacific Ocean. This would have been the perfect place to close such an important chapter in my life, but this didn't turn out to be possible. The past was not to be erased so easily.

In my uniform, I met a young woman at the bar who was a nurse. We had a wonderful evening and I felt welcome. She was attractive, married, her husband was overseas, and she gave me her telephone number. But I couldn't bring myself to call her. The grunge and grit that had accumulated in my soul needed to be washed away. A phone call the next day wasn't a good way to start the process.

Next day, at Treasure Island, where we were being processed for new assignments, I met my buddies straggling in on their first night of liberty. They were combat veterans, many coming home because of multiple wounds, but today they were the barely ambulatory survivors of their first night on the town. They had set off to pick bar fights, but it had been a rough patrol. Most had been wounded at the same ratio as at the Chosin Reservoir. Some lost teeth, another had a broken nose, and black eyes were common. Friends who had somehow escaped wounds in Korea were finally able to catch up with the rest of us in California.

The Korean War was an extraordinary learning experience and these stories about my first night of liberty deal with some of my conclusions about it. Balanced against the stupidity and crudeness of choosing a barroom brawl as a "first-night celebration" was a deep loyalty to my teacher — the Marine Corps — which had introduced me to an education that I could not have gotten in any other way. The Marine Corps taught me that the "letting off steam" that had been so crudely celebrated in San Francisco drew from the same conviction that saved us at the Frozen Chosin — we were the best. This was the low side of elitism as much as I hated to admit it.

I also learned never to take a mountain for granted, or fail to remember what water means in all its modes. Those realities were my esteemed professors. My fellow pupils also taught me. Some I admired and some I didn't. But I had graduated, and my diploma encouraged me to keep asking the same question for the rest of my life: "Now that I know these things, what am I going to do with it?"

5 – CHANGE OF SCENERY

There were a lot of things to think about after I was discharged from the Marine Corps on March 27th, 1952, and I didn't want to think about any of them. After a brief stay at home, I sailed for Europe with my mother and sister-in-law. My older brother had a top job with American Express in Paris and we all settled in together for the next nine months.

Walking Paris's beautiful streets, I avoided all possibilities of doing anything useful — including learning proper French. Within a month, I fell in love with Patricia O'Brian, an American girl who had just graduated from Vassar. She helped me discover a world that quickly suggested new priorities and had nothing to do with the wisdom I had acquired in Korea. Firsthand experience with the brotherhood of grungy comradery and the trick or treat aspects of combat were replaced by strolls along the Seine and weekend picnics on the beach at Étretat on the English Channel. The Korean commandments flip-flopped as these gentle moments opened a sensual gate and sex rose once again to the top of the list.

Pat also taught me that my war stories were not acceptable social currency among bright well-informed people such as George Plimpton, her friend at the *Paris Review* magazine. I was declared "cute" but woefully uneducated. I hadn't read the articles and books or seen the shows, and the one thing I was well informed about — being a professional killer — was definitely off the high-brow list. Accidental and unconscious military flashbacks were misunderstood. Once, walking with Pat on crowded Avenue de l'Opéra at noon, low-flying jets roared overhead and I hit the deck. When I told Pat my story to justify

and explain my embarrassment she looked puzzled; I had to explain that the jets had sounded like incoming artillery.

Returning to the U.S. after Korea, meant returning to a world that was not at all interested in the Korean War and this idea extended to my experience in Paris even more strongly. In America the war was thought to have been too expensive and inconclusive and it was an increasingly unpopular political issue, mostly aimed at President Truman, but also reflected by the public reaction to returning vets. I remember one night just after my return and in New York, when I was sitting at a hotel bar and overheard a conversation that was very critical of the war effort. I went back up to my room, changed back into my uniform and returned to the bar looking for a fight. Today this seems an unimaginably stupid thing to do but in 1951, it illustrated the divide between the prevailing attitude and my own disappointment and rage. It was not that I considered myself a hero, but I at least wanted some respect given to my two Purple Hearts and a couple of rows of ribbons. In Paris, it was better in some ways, although the young ladies I wanted to impress found zero interest in the Korean War and my sea stories. I do remember, going into a Paris bar, I was a civilian of course, and getting into a conversation with three French officers who had just returned from Indo-China. When they found out I was a Korean veteran, they were very friendly and bought me a drink. I hadn't yet found what else you could talk about to somebody who wasn't a comrade.

This was not my family's attitude, of course; they were respectful, but there may have also been a little wait and see attitude. This was not the prevailing attitude in France, however. Parisians were not particularly friendly to Americans in general. We were respected but that's all; they were tired of being grateful for World War II, and were often quite abrupt, even rude, if your French was not up to par, especially in Paris. There has been an amazing change of attitude in the last twenty years, especially among young people who in public places are happy to accommodate you in English, but in 1952, I felt a palpable pall that darkened the City of Light for me.

As I endlessly walked the streets and boulevards of Paris, I was on a quest that didn't seem to have any point beyond satisfying my restlessness. I explored the city widely, and sometimes, when my feet gave out, I would check into a movie. All of them were French, of course, but I quickly learned that,

unlike Hollywood productions, there were often nude scenes, and this, rather than my desire to learn the language, influenced my selections. The films also gave me a chance to remember what naked girls looked like because I wasn't getting any exposure to them in any other way. Once, on the bus, a French girl smiled at me. She was not only pretty but seemed nice. I have asked myself a thousand times why I didn't try and pick her up and begin my French lessons in the best possible way.

Because I had been to Paris as a child, the city wasn't completely unfamiliar, but I had never had a chance to explore it on such a grand scale. The broad boulevards I walked had a special damp, acrid perfume in late March; maybe it was a touch of coal smoke. Sometimes it was the smell of fresh bread as I passed a boulangerie or stepped inside a brasserie and took in a host of most attractive food smells that mingled with the distinctive reek of Gauloises dangling from lips of countless male French film stars and half the population of France.

These were among my first memories that overtook the grim odors of the recent past. There couldn't have been anything more different as I strolled along these broad avenues rather than the agony peaks of Korea. Even the simplest foods, an array of cheeses and hardcrusted baguettes, croissants, and *pain chocolate* became lodged in my long list of things French that I would always crave. Here I was free, skimming on the surface of the slightly grimy, unscrubbed but resoundingly majestic surface of Paris in 1952.

Paris is a triumph of the idiosyncratic, a city of surprises; little individualistic shops selling specialty foods, postcards, antiques; the flea market, where special investigation was needed to separate the fascinating from junk. There were endless bookstores and long wooden stalls along the Seine selling maps, paper and leather-bound books, old magazines, prints; a most diverse archive that seemed to house every possibility of junk treasure imaginable. But the bookstalls seemed to symbolize my restless condition; here, it seemed almost anything that was printed could be available, but gaining access to this enormous supply of diverse stimulation required endless patience. I had the few francs needed but didn't have the patience to uncover any satisfying treasures. So I kept up my restless pace, admiring and never stopping. The same was true of the Louvre, which I passed through quickly more than once, although I toured Les Invalides and paused to marvel at Napoleon's tomb, the grand or-

nate embellishment of gilded glory and disaster. That place, with rows of gigantic cannons out in front, remains a strong memory as a reminder of the glory and folly of French history — and gigantic those cannons should be.

My family was living in the 16th arrondissement, a very stylish district, near the Bois de Boulogne. The Duke and Duchess of Windsor were neighbors. The apartment was rented from a well-connected client of my brother, Gamble, who spoke French fluently. We had both been exposed to the language as children in Switzerland, but he remembered it and I didn't. My mother could hold her own in French as well as Italian, and my beautiful sister-in-law, Marisa, an Italian countess, was charmingly accented in several European languages.

At the Baldwin apartment, a stream of interesting people were cocktailed, dined, and entertained. There were lots of rich ones as well as people like Gino, an Italian adventurer who had been prospecting alone in the jungles of Venezuela and arrived for dinner one evening with a pocket full of uncut diamonds. There was an editor from the magazine *Paris Match*, and a former American Army officer, who had been part of the remarkable military unit responsible for tracking down and rescuing art looted by the Nazis in Europe during the war, a group known as the Monuments Men. He spent the evening telling me about Pablo Picasso, a conversation that I would remember especially well.

There were others, young couples, some French, some American, and a few who operated in the rarefied altitude of French society. Caroline Scott, an old family friend from Richmond, Virginia, was married to the heir of the Singer sewing machine fortune, a French count. Countess Caroline invited my mother, Marisa, and Gamble for dinner, but I was not included, probably because of my regrettable inability to speak proper French. The news of my disinvitation, delivered by my brother, was not received gracefully, especially since years before, when I was sixteen, seventeen-year-old Caroline had taught me how to kiss properly during Summer School at Woodberry Forest. I had been an ardent pupil, but since our voluptuous exchanges in Virginia she had evidently decided that I had become tongue-tied and couldn't perform in French.

Clearly, I needed to take control of my life. Nobody said anything. Were they waiting to see who had jumped out of the foxhole? Sgt. Baldwin, USMC

Retired? Nobody knew for sure — including me. But mother and brother were patient, even respectful. No "clean up the mess" nagging. But I knew that an unemployed, uneducated me who couldn't speak enough French to be invited out for dinner didn't fit in. About that time, Pat O'Brian dumped me for somebody who did fit in. That did it.

Anger began to reshape my thinking. My new tongue would be long enough to wrap around Caroline Scott's throat and strangle her. My boot was big enough kick out Pat O'Brian, but a new approach to my life was necessary; eliminate the pieces that didn't fit, and make the ones that I liked twice their size. The cartoonish drawings I had sprinkled into my letters from St. Mark's to Korea had been a success. They amused and spoke all languages. So I moved from the edge of one uncertainty to another by enrolling in a drawing class at Académie Julian on the Left Bank, where speaking proper French was not the point, where expression came from the business ends of brushes, pencils, and pens.

Reading about art and going to exhibitions replaced my aimless foot patrols around Paris. I discovered artists who with a single thin line of ink could take a trip and glide along with simple certainty until it had delivered a flower, or a voluptuous woman — anything. My favorite artist was Picasso. With him, a simple line led to so many possibilities. Not that my illustrations were in any way remarkable, but they made me think that being an artist, being *out* — what is unconventional, not standard issue — might fit me better than *in*. But there was a problem; I needed to discuss this with someone. How do you become an artist; how do you continue to create; how do you make a living?

Apart from intermittent contact with two uncles and the distant influence of my six years older brother — who I unsuccessfully tried to copy in so many ways — I had no male role models. The relationship with my stepfather had not been a success. My teenage years were a kaleidoscope of mixed messages with no sustained signals from any male relative I cared about. And I needed to talk about many things: loneliness, women, keeping chaos under control. Complex questions needed complex answers. Were there pockets of possibility lurking in my otherwise undeveloped character? How could I make this discovery? Perhaps only a father could show me, but mine had died when I was five.

It occurred to me that there was an artist, about whose work and life I was largely ignorant, but who approached art in a way that touched me. Pablo Picasso took art forward the way I would have approached a sniper's bunker in

Korea. He broke from one idea to another, jumping in this way and then running for that, taking a shot and then moving to another position. Maybe psychological survival meant being unpredictable and breaking the old "rules of engagement." So Picasso became a kind of imaginary father when I was twenty-three — an idol of inspiration and advice. When and how I would get to meet him remained to be discovered.

Departing Paris at the end of August 1952, I returned to Savannah, where I enrolled in Armstrong Junior College. Paris had got me concerned about my ignorance, and at Armstrong a variety of books and two first-rate teachers showed me how to begin filling gaping holes in my knowledge and comprehension. Reading and discussions blended in with what I had learned in Korea.

Paris had given me a new perspective, and my rejections there produced an anger that drove me. I discovered, among other things, that I loved the classics, was quite smart, and had something to say. Despite some bad poetry I wrote, a string of straight "A's" won me a scholarship to Harvard Summer School. Cambridge was wonderful, but New York City was closer to what I thought I needed, whatever that was. In any case, I applied to and was accepted at Columbia College, the undergraduate liberal arts school at Columbia University, in 1953. There, I was very happy; I began to become involved with ideas, and made friends with people who would change my life yet again.

The GI Bill provided my principal support, and despite its modest benefits my life was rich and busy in New York. There was still a certain rebellion lurking in me, however. I decided that working my way up through the ranks of Columbia College's student newspaper, *The Spectator*, and competing with all those smart Jewish kids from Brooklyn wasn't for me. So, in defiance of my total ignorance about journalism, I recruited a group of older students who were taking classes at Columbia's School of General Studies, and I co-founded a newspaper called *The Crown* that was aimed at older students. Some of our staff were veterans, such as Dick Mumma, who had been a photographer in the Army. Another was actually a reporter for the *Herald Tribune*. The stories we ran were fun. One was about a woman student who was perpetually late for class because of delayed flights from Rome; she was a TWA flight attendant. The paper lasted four issues, which proved to be a good thing, because I found being Managing Editor of *The Crown* more exciting than going to class.

Apart from classes and work at the newspaper, I met some interesting drinking friends at a bar called Pete's Tavern, a colorful Italian-American hangout for gamblers, actors, writers, and friendly ladies down near Irving Place. My favorite waiter at Pete's, known as Babe, doubled as a bookie. He wanted me to look up his buddy "Lucky" on my next trip to Italy. His pal turned out to be the recently deported Mafia boss "Lucky" Luciano.

Another of my colorful drinking buddies that first summer in New York had an English sports car identical to mine, except that his MG TC was yellow and mine was green. (In those days it was possible to find street parking and I had brought my car up from Savannah.) He was Steve McQueen, a budding actor trying to make his way to Broadway, and also an ex-Marine. He and I were operating at about the same economic level and we had a lot of fun together on a very restricted beer budget. Steve and I had different styles of expressing ourselves through our cars. More horsepower was my goal. Every penny I could save up went into the addition of a supercharger, a Scintilla Vertex magneto, relieving and porting the exhaust system, shaving the heads and increasing engine compression ratios. I had learned how to do all this in Savannah because no mechanic there knew how to fix a weird English sports car. So I taught myself. This meant that my MG's top highway speed was raised to 83 mph — with the windshield down. Steve, on the other hand, managed an even more breathtaking effect by driving 72 mph on the streets of New York.

Another game we played was switching girlfriends. I liked Steve's ladies because they were used to being driven at high speed. Mine, on the other hand, tended to have social ambitions and were more expensive to maintain. But Steve loved changing roles. In fact, he was so good at it that he moved to Hollywood, where his financial and social situation improved greatly as a movie star. Later I moved back to Europe and we sadly lost touch.

Although a little older than many of my college friends and a veteran, I was still completely in the dark about what I was going to do with my life. I had to learn the difference between discipline and the impulsive creative assaults that were driving me this way and that.

During my junior year at Columbia, my grandmother Baldwin, who lived in Florence, died. She left me a bequest in Italian lira that couldn't be convert-

ed to dollars and transferred to the U.S., so I decided to go off to collect it. It wasn't a huge amount but enough to put me on the road.

I got right to business and went to meet my friend Jim Buxbaum, one of the brightest people I knew, who I deeply respected because his favorite question also seemed to be: Why? Jim had graduated from Harvard and was finishing his Law degree at Columbia. What I didn't want to reveal to my friend was the absence of a clear goal, plan, map, intellectual backup, or strategy; that my direction had more to do with internal dysfunctions than a search for knowledge. Our conversation bounced around until, making one last hopeless stab at rationality, I blurted out that "I hope to photograph him."

"Photograph who?"

"Pablo Picasso," I replied. "I want to visit all the people I will never get a chance to meet after I have to get a job. Maybe interview Pablo Picasso and write about the experience." I explained that I had borrowed our mutual friend Dick Mumma's Rolleiflex camera.

Jim looked at me as if I was truly demented and asked how I planned to do this. And with his sharp logical mind he began to pick apart my plan.

"Do you know any of his friends, journalists who could advise you? Have you studied his work? Who gave you his address? Do you know that he is well known for his cantankerous, unpredictable behavior?"

Jim, who always came with more bright ideas than an average man can cope with, suggested that I see Bernard Berenson instead. Why he suggested Berenson I'm not sure, but he knew I was going to Florence, and he knew that the great Renaissance art scholar — also a Harvard alumnus — lived there. Jim was grounded in the past in a way that Picasso flew into the future.

"Yes?" said I, hesitatingly, "But I don't know a thing about Renaissance art."

"Why don't you read some of his books?"

What I was unwilling to tell Jim was my strong connection to Pablo Picasso, about how he had become my imaginary father. Had I done so I'm sure he would have felt that I was truly off my rocker. Could I possibly explain that it had to do with losing my father when I was a child? Not knowing the road I should take? How I should look at things from a male perspective? Of course, boarding school and the Marines taught me how to follow a system, obey orders, do what was expected, but at the same time I also learned to subvert the

system, to sneak myself into the driver's seat, making adjustments to the route I was told to follow — but this lonely process was embarrassing to talk about.

I couldn't explain to Jim that I was determined to chase my dreams during my last college summer holiday, my last free summer ever. But this Picasso dream — where did it come from? I felt that he was the greatest living artist in the world and I had to see him. But why?

Picasso was the largest figure I could think of who might be sympathetic to my attraction to creativity — a condition I couldn't even define. He swam in currents that would drown lesser men. He was strong enough to survive changing circumstances. How had he achieved that? Was it because he had been trained by his father — an artist — in the strict discipline of classical drawing and painting? But he broke with that tradition, and was fearless about smashing convention by plunging into something new. This was a man who drew energy from some special internal condition. What was it? Where did it come from? This was a secret that I needed to see close up.

"Don't waste your time chasing stars," Jim said.

I thought to myself, "I'm navigating by this star, not chasing it."

But the Picasso that I wanted to learn from was largely built out of my deepest needs and hopes and bundled with meager scraps of information, a bit from Paris, a bit from here. There were dangers even if I saw the great artist. I had a positive but wholly imaginary relationship with the man, and all that could crash if I failed to meet him.

"He might not see me," I admitted.

Jim agreed, "That could be embarrassing."

No, not embarrassing but another crushing disappointment, and an outcome that was more than likely. But on the other hand, if my fantasy came to life, it might serve me as an ongoing inspiration. It was an enormous gamble. It could go either way, but I had a lot of practice making disappointments into good stories.

"Jim, do you remember the young English mountain climber, George Mallory, who died in 1924 attempting to scale the world's highest mountain? He went down in history with the famous response to the question: 'Why are you climbing Mt. Everest?' Mallory's dramatic but enigmatic answer was: 'Because it's there.'"

Jim said: "You've already vanished into a cloud and are nowhere near the summit."

"What are the transformative possibilities in dealing with psychic risk?" I asked, trying to counter with something that sounded intellectual.

Jim demurred, "I'm not interested in operating at that altitude."

So, Picasso became my Everest in the summer of 1955, the highest point that I could imagine. I was not Mallory, but I wanted to see if a less gifted mortal could attempt a metaphorical Everest and a few other peaks as well.

Most important, Picasso personified a kind of freedom that rejected the practical office-bound issues that I would soon have to face. As a junior at Columbia College, I wasn't looking forward to graduation because nothing from the past provided me with anything that I could imagine being good at in the future.

My imaginary Picasso would understand such things. But would he be the same as the living Picasso? It didn't matter. Picasso was alive and lived in the South of France.

This last vacation was a summer's reprieve — one last summer that belonged to me — a time that didn't have to be adjusted to responsibility and family expectations. I was twenty-six and running out of time. Next year, I could only read about the people and parts of the world I was curious about. The borrowed Rolleiflex camera would record my last summer of freedom. I didn't really know how to use it, but such a fine camera would surely figure things out on its own.

6 – DEAR MONSIEUR PICASSO

The lines were slipped off and the tugs backed the SS Maasdam into the Hudson. After going down to my cabin, No. 520, I discovered three boozy cabin mates singing "Auld Lang Syne." This was not what I had in mind for my last voyage to freedom so I took one turn around the deck, found a comfortable deck chair, got out my notebook, and opened it to page one.

It was clean and white, symbolizing the whole trip that lay ahead. I could do with it what I wanted, leave it blank, or make a record. I was determined to use the eight-day trip across the Atlantic to prepare for my adventure, whatever that might be. Daily observations would be recorded in my journal, training me to keep alert and improve my powers of description. This process started with:

June 16th, 1955 SS MAASDAM

11:02 a.m. The people on this ship at first glance appear to be quite dull, at any rate they aren't too attractive. In other words, there aren't any particularly good-looking women aboard.

11:45 a.m. On further observation there aren't any good-looking women on board. The sober people are quite dull and the less dull are obnoxious. We are moving out of New York Harbor. There goes Cony Island. (My dyslexia persisted.)

Soon a steward came through ringing chimes for lunch. The chief steward had given me a slip of paper with my table number. I found my seat, which was identified by a large napkin envelope with my name written on it. Presently, everybody introduced themselves, my eating companions for the next eight days: Otto, a German exchange student, returning from an industrial school in

Detroit; Arlene Meyers, an Ethical Culture schoolteacher from Brooklyn; two Swiss secretaries who worked in Montreal, and Jean-Paul, a French graduate student at Princeton on his way home for the summer.

Nobody said much until the soup arrived. Otto dipped right in, "Dis is goot soop." Arlene Meyers identified it on the menu, "It's Consumé de Dieppe."

In the meantime the Swiss girls clasped their hands together and bowed their heads in prayer. Everyone else went on eating.

Jean-Paul checked the menu and said in disgust, "Every time they serve a plate of water, they call it French. This soup is a disaster."

The entrée was a watery broth with five little chunks of porous rubbery meat accompanied by a few loose shreds of celery floating around them. I made a wild guess, "Must be turtle soup."

"Ja, it is good," said Otto.

The Frenchman had nothing further to say and neither did the two Swiss girls. In fact, they never opened their mouths again, except to put in more food.

After lunch I went back up on deck to get some sun. By this time we were passing a Coast Guard picket boat and a garbage scow with a trail of screaming seagulls. We were well on our way out to sea. Land could hardly be seen. I got comfortable in my deck chair and began to think. Was I crazy to try and meet Picasso? The idea was too overwhelming to make a serious plan. I didn't know where to begin, but I felt somehow that the direction would come to me through magical sources that wouldn't scare me to death. I had eight days to avoid my obsession. The days flew by. My original evaluation of the shipboard population was overly pessimistic and there were shipboard flirtations, happy distractions before we arrived at Le Havre. After getting my passport stamped, I wrote in my journal:

June 24th. 5:55 p.m. Boat train – next stop PARIS. I am here and it feels wonderful.

Karen and Jerry O'Brien met me at Gare St. Lazare. They were old friends from New York now living in Paris. We drove down Avenue Kleber to their apartment. It was quite late, eleven o'clock, the streets had just been washed and the car tires sang as they picked up the dampness. The fountains and the monuments were lit and I gradually became aware of a familiar sharp, yet slightly humid odor.

Paris, I suddenly remembered, is a city of smells that constantly change. Here they are a combination of the aromas from a million dinners that gently mix with thinner air, to be sucked in and blown out of taxi engines and buses, absorbed and then blended with the special flavor of the river or the ancient vapors lurking in murky sewers; finally they are distilled and purified by the summer fragrance of the chestnut trees. The smells of Paris are something I got used to quickly and they brought back strong memories that for me were as Parisian as the Eiffel Tower.

My first day in Paris was fortuitous; there was a big exhibition on covering Picasso's *Human Comedy* series of 180 drawings. Going to Le Petit Palais, I had a chance to study his work up close, buy some posters and one of his books, and do some research to reconnect with my dream.

Then, a second piece of good luck; Jerry O'Brien knew an Air Force colonel who was returning to the United States and wanted to sell his car. I might get it for a reasonable price. I was soon the proud owner of a 1954 Hillman Minx convertible with a dead battery and one window that wouldn't roll up. Suddenly I was itching to get out of Paris. I bought a Michelin map of France and started my journey to find Picasso, knowing that he had once done pottery in Vallauris, a small town on the Riviera noted for its ceramics. That might be a good place to start. Mustering all of my courage, I headed south.

Perhaps my cruising of the Museum of Modern Art in New York to familiarize myself with Picasso's work and having hallucinations about the great man was not the best intellectual preparation for my visit. Rational voices began to scare me, but I forced myself to set a course toward the only star in my sky. Two days later, nearing Vallauris, I began to see billboards advertising ceramic shops and exhibitions. One pointed to the Picasso Museum.

Vallauris was bustling with tourism. It was hot, and there were glass-domed buses parked everywhere, the drivers fanning themselves in the little shade they could find. The tourists were being led through the narrow streets from one ceramic shop to another. The buses made it impossible to drive very far, so I parked next to one of the ceramic museums, bought a ticket, and went in.

The only difference between some so-called "museums" and the museum-like-shops was that there was a 100 francs charge to see what was in the "museums" whereas the shops were free; both, however, were prepared to sell

whatever was on display. In one "museum," pretty girls wearing shorts, low-necked blouses, and sandals served as sales clerks; the ceramic disks they wore around their necks were also for sale. Another beautiful girl sold perfume: she delivered a squirt, "You like that?" — a line she could deliver in four languages.

After nosing about Vallauris for a while, I realized that the place I wanted was the real Picasso Museum – a place filled with plates, pots, and vases decorated with animal and fish designs, ceramic birds and heads, all done by Picasso. The attendants in the real museum, however, didn't measure up to the other museums and nothing was for sale.

I approached a serious-looking middle-aged lady who I found was the museum director.

"Madam, would you possibly know where I could find Monsieur Picasso?"

"Non" she said in no uncertain terms. "People are always bothering *le maître*. I am not Monsieur Picasso's wife. He is a busy man and how am I supposed to know these things?"

After persisting in stumbling French I found that Picasso no longer lived in Vallauris, but in Cannes, further east along the coast. Ten more minutes of smiling and saying, "Merci, merci," no matter what she said, finally produced Picasso's home address; the name of the villa where he lived, *Villa La Californie*.

I was truly grateful and retired quickly under another broadside of "Je ne suis pas Madame Picasso," etc. I tucked Picasso's treasured address into my wallet in a place of honor, next to my last remaining ten-dollar bill and took off for Cannes.

In Cannes, I made many stops asking for directions to Picasso's villa. The magic paper with Monsieur Picasso scribbled in red letters above the address, gave me new status. Showing the address, I sometimes got a surprised look or a respectful look, but it was always a polite look. But too soon there were no more people to ask. I was there.

High in the hills on the outskirts of Cannes was *Villa La Californie*. Big trees surrounded the villa, a huge white limestone mansion with elaborate iron balconies and high windows. A gravel driveway led to a garage that was occupied by the hulking front fenders, distinctive headlights, hood ornament, and radiator of an enormous black Hispano-Suiza touring car. This grand, pre-

war, hand-made vehicle was the work of thousands of hours of intricate crafts-manship. Aesthetically, it was a Faberge egg scaled to Zeppelin-like propor-tions. It reeked of Old World status. This classic monster was immediately recognizable to me; I had seen photographs of Picasso in it.

To the right of the garage, by the front door, a small bell was hanging on a sprung piece of metal. Heart pounding, I gave the bell a pull. The metal bowed, recoiling back and forth, ringing. Shortly after an old woman came to the door.

"Is Monsieur Picasso in?"

"No, monsieur, he isn't expected until late tonight and won't see *anyone*."

"What about tomorrow, Madame?"

"I don't know," she said, and that was that.

"I will be back at nine in the morning," I told her.

"You can try."

Fretting around for the next twenty hours, I walked all over Cannes, driv-ing my car as little as possible to conserve gas. There was just enough to make it to Italy where my Italian lire lived.

On a deserted road near Palm Beach, I went for a swim. The sea had a won-derful effect after a confused and active day. It was hot and I was tired one minute, and then, cool and floating. The hot sweaty walk, *Villa La Californie*, the museum, the girls, Madame Directrice de la Musée Picasso, the road to Val-lauris — spiky tensions dissolved into softer moments as I relaxed into the cool water. Splashing and floating, the memory of the day's most savory moments rose to the surface. Last night seemed a week ago.

Finally, back on the beach, I dried off and went to buy food — a baguette, a chunk of mildly acidic Port Salut cheese, and dark chocolate, which was washed down with a few gulps of Beaujolais. After my feast, I relaxed happily in my car for a good night's sleep.

Sleeping in a Hillman Minx requires commitment. The right-hand front seat folded forward. Draped across the back seat, resting partially on my por-table typewriter and a five-gallon gas can, I created a reclining "L" shaped bridge to the front seat providing my 6 foot 3 inches with a degree of horizon-tality in the little English car.

The flies and the sun woke me up at 6 a.m. but the laundry bag over my head gave me a few more hours' sleep. A café on the harbor provided coffee

and rolls. I washed and brushed my teeth in the men's room but didn't shave. I was too sunburned to scrape my beard off with cold water. Fidgeting with little lumps of bread, dissolving them in coffee, I began a postcard.

"Dear Mother, today I am going to see Picasso..." but stopped.

My appetite vanished — terrified that another postcard tomorrow would report that I hadn't made it.

A big passenger liner cruised into sight. The huge ship maneuvered alone in the middle of the harbor. It was too far to hear them but I could see the sailors on deck and the noiseless churning foam under the stern as the great ship backed down. Then a big white splash followed a moment later by the hollow metallic roar of the anchor as it took tons of chain toward the bottom of the harbor.

More tourists landing in France; what were *they* going to do today?

Downing another cup of coffee for courage, I headed for *Villa la Californie*.

In a way I wanted to get it over with. Having committed myself, I had to go through with seeing Picasso, but my self-imposed task wasn't fun. It was uncomfortable and ridiculous. But I kept on driving to the villa, with part of me feeling a little sick.

I got to the villa at nine o'clock sharp and again I was told that Monsieur Picasso was not to be disturbed. Apparently, he had returned late, was tired, and would see no one.

"Would it be possible to come back later?" I pleaded.

"Perhaps you could try at eleven o'clock."

My last desperate postscript was, "I'm an American journalist and have come all the way from the United States to see Monsieur Picasso."

She promised to tell him.

The two hours between nine and eleven dragged painfully; neither scenery nor sightseeing held any interest for me. As eleven o'clock finally crawled around, I was back anxiously ringing Picasso's bell. The old woman said that Monsieur Picasso was exhausted and left orders not to admit anyone. She had told him that an American wanted to see him but his response wasn't cheerful — fatigue, too much work, too many people.

Feeling depressed, I reviewed the situation. My money was almost gone, and hope was fading — but if I conserved what funds remained, squeezed a

meal out of a couple of pieces of bread, a square of cheese, and the remaining five swallows of wine, I could last one more day in Cannes.

On my visit to the *Petit Palais* in Paris I had purchased *L' Œuvre Gravé de Picasso*, a book filled with engravings of bearded men and naked women, many echoing classical myths and legends. There were no defeated men in *this* book. Sometimes they were drunk, killing, ravishing; sometimes they became wild animals, particularly bulls. The women were seductive. The images were charged with aggressive sexual energy. Sometimes the bearded classical men were moving gently toward the naked beauties, but on the next page they were ripping into them. It was a book filled with action — the images exuded masculine certainty. They told me I had to do something, I couldn't just slip away.

So I decided to take the chance and try once more to see Picasso. Tomorrow morning would be the final push, and in the meantime I had to work on a new plan. The American journalist story was getting me nowhere. It was a ridiculous idea even to me.

Another long walk served to break the monotony of waiting. I was looking for inspiration everywhere — in the trees, in the streets, in people's faces. My brain was alive with fantasies. I would find Picasso's wallet — bump into him on the road — run over him in my car — pole-vault over his wall saying "Bonjour, I just had to drop in, Je suis un JOURNALISTE AMERICAIN!"

I absorbed the bearded men and beautiful women, beards and breasts; ugly shriveled-up men and beautiful classic women, monkeys and cupids and midgets holding masks over their faces, peering lewdly at naked ladies — articulated fantasies? To me they were profoundly ridiculous, comical, and compelling. Just like me sleeping in my Hillman Minx. But if it had been Picasso he wouldn't have been sleeping in it alone.

Again, I spent the night in my car parked on Picasso's doorstep. I didn't get much sleep — kept waking up hearing little noises, half expecting to see Picasso's face peering at me through the car window. The mosquitoes were also feeding, so I rolled up all the windows and blasted the inside of the car with a bug bomb. This had a worse effect on me than on the mosquitoes. The laundry bag over my head resulted in further breathing difficulties. Sleep and inspiration were not possible at *Villa la Californie* so I went for a drive before dawn. Departing Cannes on the dark road to Grasse, the air was cool. There were little

pockets of mist collected in the low spots along the road. My windshield wiper collected and pushed the moisture away, clearing a vision of the new day that was just beginning to cut deep valleys of light into the greenish black hills. Around each bend I caught tantalizing glimpses of shimmering light, silhouetting the cool dim shapes of the hills. The road finally climbed out of the valley to a point where I could see far ahead. To the northeast there were long feathery clouds, the highest in the sky, their colors constantly changing as they caught the first orange light of the coming day. Below them, cast over the horizon in somber piles, were layers of gray clouds. As the morning grew older these clouds took on a warm amber color. Then for a short minute they opened and the whole skyline was diffused in a soft golden hue as the rising sun briefly gilded the mighty snow-capped Alps far away.

By 5:15 a.m. the most beautiful part of the sunrise was over, but I still sat for almost an hour watching, fascinated by the approach of daylight. For the first time in three days I had completely forgotten about my struggle to see Picasso. I drove down to a café and ordered a huge cup of café-au-lait, half-thinking about the day ahead and reflecting on what I had just seen. The deliciously sharp, scalding French roasted coffee calmed and smoothed by frothy milk cooled toward a first perfect sip and set the scene: the first elements of a plan were born, an exciting, implausible, perfectly crazy plan. Remembering what I had seen in his book, I decided to write a letter to Picasso, telling him about my plight in pictures.

Picasso was full of humor. It was in his drawings. If I could make him laugh, appeal to his sense of the ridiculous, the effrontery of my approaching the great artist might work. I wrote the draft in English but my French wasn't up to translating it accurately. I needed help so I jumped into my car and tore down the mountain and back to Vallauris to the Ceramic Museum.

The museum was not open. It was too early. Impatient, almost jumping out of my skin, finally, they were open. I bolted in and explained to the sales girl that I needed to write my letter of introduction to Picasso in better French and I asked for her help. This was my trip to the moon — in the spirit of Picasso. The perfume girl's English didn't go much beyond "Do you like this perfume?" but between the two of us we translated my letter. People in the museum, curious, began to gather. Various other girls made suggestions and told me things that I

couldn't understand. The director came over and returned my 100 franc admission. Giving me *le maître's* address three days before had been her first reluctant blessing, now she added an additional miracle:

"We cannot charge *le journaliste*," she enthusiastically announced.

It was a party, and when I finally left, we all shook hands, the girls hugged, wished me luck, and kissed me goodbye.

Over coffee in a café and alone, I now hurriedly added my illustrations to the French version.

July 28th, 1955

Dear Monsieur Picasso:

I am a student at Columbia University and this summer I am a freelance jour-
nalist. I know that you are very busy but I am here in my car and each day that
you won't see me, my beard grows longer and longer. I will soon look like Moses.
If you would let me take some color photographs then I could go to Florence where
I have some money and cut off my beard.

With hope I am,

Fred Baldwin

Intense excitement and exhilaration gave me the will to climb through my
self-doubts, but dread still lurked in my stomach. I was feeling panic, insecu-
rity, inexperience, every exam I had ever flunked, every girl I had ever missed
kissing — all the things Picasso was and I wasn't — became tangled up with
the excitement of approaching Picasso's doorstep. Everything depended on the
only key I thought I could find to unlock his door — humor.

At ten o'clock I parked my car in front of the villa, took out my camera bag,
checked the equipment, the Rolleiflex, and rechecked everything again, con-
vinced that something had been forgotten. My pockets seemed full of things
that kept falling out. I kept stuffing them back, handkerchief, keys, coins,
pushing little balls of French money into the bottom of my pants pocket, and
finally slung the strap of the camera bag over my shoulder, got my loose-leaf
journal and the Picasso book and two posters that I had bought in Paris and
started up toward the house. This was my final assault. I gave the bell a good
hard pull and hoped, hoped for the best. In a moment, the old woman came
and I gave her the letter for Monsieur Picasso.

While I was waiting, the postman arrived, and then several other people.
This seemed a good sign? Maybe Picasso was receiving visitors. We all waited
for admittance. In a few minutes an attractive young woman opened the door,
looked around and everybody began to talk at once — except me. Her hair,
bleached by the sun, hung around her shoulders. Wondering who she was, I
thought perhaps she was Picasso's wife or mistress — or something.

The girl looked around again – then she asked:

"Who is the American?"

"Oui, oui, c'est moi."

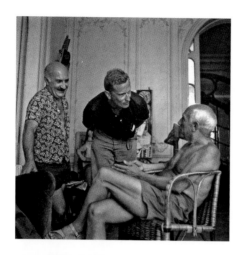

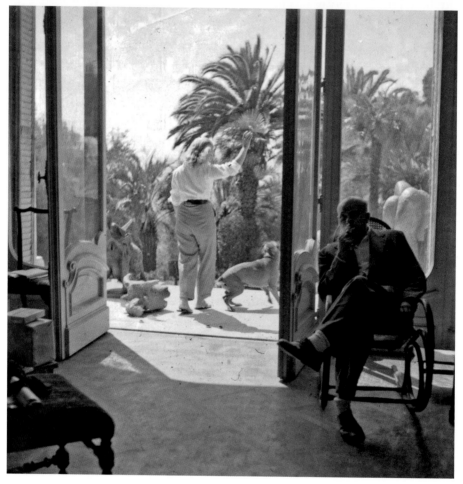

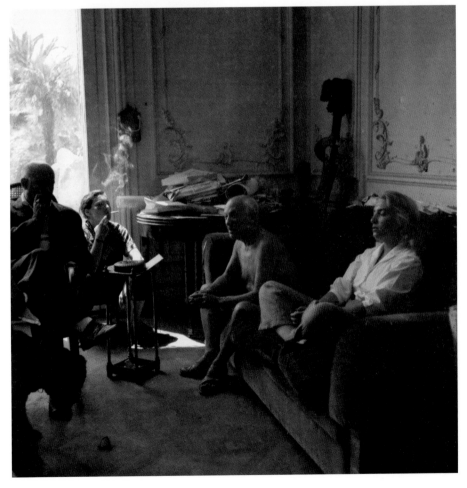

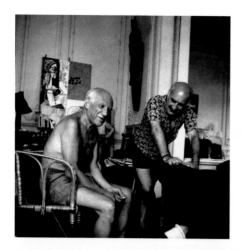

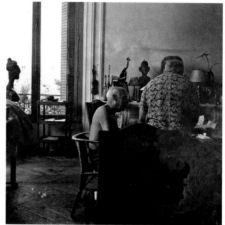

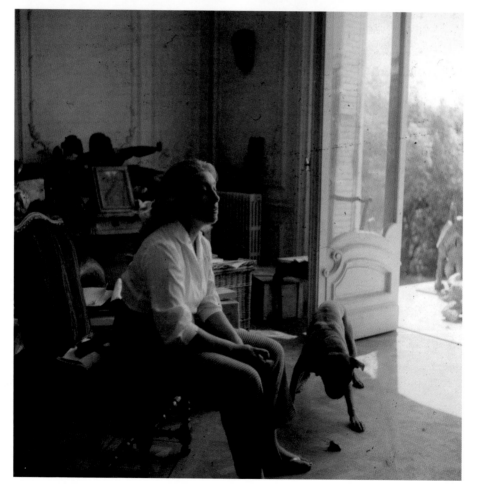

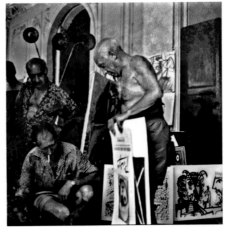

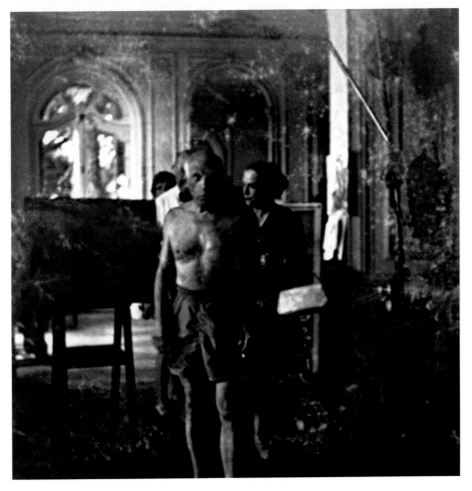

I was through the front door and on my way to the house before I realized that I had finally made it.

The girl and I went inside followed by the others. It was cool. The shutters were closed and there was no furniture, just large wooden crates piled one on top of another. The entrance hall was a storeroom, crates contained sculptures and some flat ones held paintings.

This hall led to a spacious light-filled room with high French doors opening onto a garden. The white walls of the room were decorated in elegant plaster cast designs with details of grapes, leaves, flowers, swirls and twirls, in the high style of the French Rococo. It was the sort of house that you might expect a French aristocrat to own. One elaborately carved marble fireplace stood under a ten feet tall mirror that reached to the ceiling. It was fitted into the wall, edged by long narrow fluted columns entwined with plaster leaves. The furnishings contrasted with the architecture. Cubism nestled comfortably in the lap of the antique past. In one corner dozens of things were stacked like cordwood on an unpainted wooden table. Underneath there were more — weird African figures, wooden dolls, some standing, others buried under piles of animal representations: primitive masks, brown wrapping paper, heads, jars and even an empty bottle of ink with no cap, the dry ink crusted on the inside. At first glance this part of the room gave the impression of a junk shop.

There was also an adjoining room to the right and there, sitting at a round table talking to a man, was Picasso. He was dressed in a pair of faded blue shorts and leather sandals. He wore nothing else. Picasso was tanned from the top of his bald head to his feet. Except for what was left of his hair, now white, and a few tufts of white on his chest, he was brown all over. The skin on his body was finely wrinkled at the joints, but it was taut. The seventy-four-year old Picasso had the physique of a man of fifty.

While he talked, he leaned forward, speaking clearly but softly, moving his hands and his face as well. Hundreds of tiny folds and wrinkles radiated from his eyes, giving his look intensity and at the same time mobility, which changed his expression with the course of the conversation. His eyes had a whimsical look, but his gaze was as uncompromising as the lens of a camera. When his companion, who I later learned was the publisher Guingot-Nolaire, talked, he sat back in his chair, relaxed, with his knees crossed. Among the motley group assembled there, Guingot-Nolaire was the most formally dressed,

wearing a baggy suit but no tie. When they pored over a book together, Picasso put on a pair of horn-rimmed glasses. In a few minutes their discussion ended, Picasso got up, took his glasses off and looked around.

He saw me and immediately asked me where my beard was. I explained in my fragmentary French, that it was an imaginary beard and that my real one was very light, and this was all I could muster in three days. He laughed and told me to take as many pictures as I wanted.

Then he sat down at the table with another man and began a discussion about the book he had been looking at before. This turned out to be a Monsieur Ilizzard, an old friend of Picasso's who was publishing a poem about a boy who had died several years previously. Picasso was illustrating the poem with line drawings of horses. Monsieur Ilizzard was dressed in a pair of blue bathing trunks and a flowered sports shirt.

In the meantime I worked making pictures, trying not to disturb Picasso while I photographed him. I was having flash problems and was relieved when he moved to the other room, where the light was much better.

Arriving there, he sat on a little wicker chair and everybody got up to offer him a more comfortable seat. I began to remove my camera equipment from the couch but was told to leave it there. Everyone was on his best behavior. The group revolved around Picasso but he was quite relaxed. He got up, looking for a light for his cigarette. Three people scrambled for matches but Monsieur Ilizzard lit it and Picasso sat back in his wicker chair smoking, using an ashtray made in the form of a Michelin tire and chatting amiably with everybody.

It turned out that the young woman who had opened the door for me was Maya, Picasso's daughter.

Maya played with a dog, a young female boxer, throwing a rubber bone onto the porch. Picasso was amused and watched the dog race outside to get the bone. Everybody looked, and the conversation temporarily stopped. Then it began again as Picasso read aloud a letter from an unknown female admirer. He seemed in high spirits but didn't make fun of the letter. There was laughter, for the letter was intimate in a highly complimentary way to Picasso. Maya told me that her father got regular fan mail from women who found him irresistible.

As he moved around the room, Picasso spotted the Swiss book of his graphic art that had revealed so much to me sitting among my photo equipment. He hadn't seen this edition, quickly took a look at it, and signed it for

me. Maya pointed out and marked all the drawings of her mother, Marie-Therese Walter. He also graciously signed the two posters that I had brought from Paris.

To record the historic moment of our meeting and get a photograph of myself with the great man, I balanced the Rolleiflex on the arm of a chair, because I had no tripod. Quickly, I set off the self-timer, hoping that the camera wouldn't fall off the chair before it snapped a picture of me trying to talk to Picasso in my primitive French. Our conversation didn't make sense but that didn't seem to bother him.

More people arrived and Picasso got up to greet them. One newcomer was Polly Weil, a young American from St. Louis. Polly was just as surprised to be seeing Picasso as I was. She had arrived in Paris with an address book full of friends to look up. One of these turned out to be a girl who worked in an art gallery and through her Polly met a young Spaniard, Javier Vilató Ruiz. Because Polly was interested in painting, the trio spent much time going through galleries. Vilató learned that Polly's tour went through Cannes and he asked whether she would like to look up his uncle who lived there. Polly said that she would probably be too busy. Later, at dinner at Vilató's house, Polly commented on the interesting design of the dinner plates. He revealed that his uncle had made them. "He likes to do that kind of thing."

Polly thought they were very pretty and asked whether his uncle sold any. Vilató said, "Yes, if people will buy them." After dinner, Vilató asked if she would have time to deliver an engraving to his uncle. Polly knew that her tour to Cannes was short but Vilató had been so kind that she finally gave in. Vilató wrapped the engraving and wrote Polly a letter of introduction. She was stunned to find the letter addressed to Pablo Picasso, whose sister, Lola, was Javier's mother. After meeting Picasso, Polly wandered around, a little dazed, still not quite believing that she was really in his studio.

By now Picasso was very busy and I began to take pictures freely, moving around the rooms. It was difficult to tell what was studio and what was not. In one corner, sitting on top of a pile of bent and crumpled papers, some of which had sketches on them, was an old bowler hat. In another corner were flood lamps, the type used by photographers.

Maya explained that her father was making a movie. "He paints on a silk screen which is illuminated by the lights, making it possible to catch each

brush stroke as it progresses without Picasso himself being visible. The effect is one of seeing a picture paint itself before your eyes."

"Living in *Villa La Californie* is like living in a railway station," she said and continued in a slightly irritated mood, "People are constantly pouring in — those that have business and those who do not."

It turned out, according to Maya, "Father is not always in such an expansive mood." She was obviously a little impatient with him, but probably with the rest of us as well. "It's way past lunch time and the guests still haven't left."

I got the message. It was time to go.

"Monsieur Ilizzard can I give you a ride home?"

We were the last to leave and Picasso waved us off with a friendly goodbye.

On the way down the hill, Monsieur Ilizzard said, "You were very fortunate to see Picasso."

I didn't disagree.

"This was apparently one of his good days," he added.

We stopped for cigarettes for Monsieur Ilizzard and I bought a postcard. This one was easy to write:

Dear Mother,

Am in Cannes and having a wonderful time. Just spent the morning with Picasso. You'll love my new beard.

Love,

F.

7 – HOW DO YOU DO, MR. BERENSON

The Picasso meeting had been a long time in coming but the final resolution was dramatic — four days that changed my life. The background that formed the underpinnings of this event describes a long process. The allies and enemies that helped and hindered me in taking control of my life came from many unexpected and even contradictory sources. They included my family: a dead father, mother, brother, grandmother, and a legacy of elitism that was delivered in a hundred different ways. This was the chorus that gives my breakout its special flavor, but the miracle that occurred was not when I met my imaginary father, but when I met myself.

The Picasso experience showed me that I could dramatically sway doubt in the direction of certainty. It cost nothing that was unaffordable and set the stage for the future. This gave me a rudder that worked. I was no longer dead in the water because of the engine that propelled me, the Picasso mantra, drew on four points: I had a dream, used my imagination, overcame my fear, and ACTED. This proved to me that if I could do this, I could do anything.

Meeting Picasso didn't replace my longing for a real father, but it did generate the self-confidence that a close and prolonged relationship with my dad might have achieved. I passed the greatest test of my life and had pictures to prove it; this moment probably launched my interest in a serious photography career as well.

When I left New York in quest of Picasso, I had no way of knowing that I would actually meet the great man, so my friend Jim Buxbaum encouraged me to have a backup plan. Realizing that I would travel to Florence, where I could

collect my inherited Italian money and where I also had some old family connections, Jim suggested a visit to Bernard Berenson, the foremost authority on Renaissance art, who lived nearby. And to prepare myself, I bought a book by Berenson, a just in case tome that I hoped would launch a second front in case my invasion of Picasso's privacy failed. If it was Jim Buxbaum's idea, there must be merit in it somewhere.

At the ship's bar on the Atlantic crossing aboard SS Maasdam, I had met one woman who was both attractive and helpful, Gwen Hodges, former editor of *House and Home* magazine, who was now starting her own art gallery in New York. When she learned that I was a freelance journalist, she perked up immediately and wanted to know what I was freelancing.

"Among other things, I'm about to do a story on Bernard Berenson."

"Oh," she said, "have you seen the article on him in the last *Art News*?"

"No, somehow I missed it."

She produced the June issue commemorating Berenson's ninetieth birthday. I read it three times, hoping to ground myself a little more than "not at all" in Renaissance art and the life of Berenson. And, unlike my totally blind approach to Picasso, not even knowing where the illustrious Spaniard lived, I had access to influential people in Florence, a city that I also knew fairly well from previous visits. In fact, I was headed there to convene with many members of my family, including all my aunts and uncles, the brothers and sisters of my father, who were preparing for the wedding of my cousin, Nicholas Baldwin.

The Baldwin family connection with Florence went back more than half a century. My grandfather, William Wilberforce Baldwin, an American originally from Connecticut, had, since the end of the 19th century, been practicing medicine in Europe, where, like many American physicians, he had received some of his training. Settling in Florence, Grandfather Baldwin became a favorite of the expatriate community, getting to know many of them extremely well, including, in particular, the writers and artists who loved the city. Although I was only dimly aware of it at the time, his friends included half of the names of the novelists studied in my literature class at Columbia. The compassionate doctor of the heroine of Henry James' *The Wings of the Dove*, Sir Luke Strett, is modeled on Grandfather Baldwin. Dr. Baldwin was close friends with and treated Henry James, his brother William, Edith Wharton, William Dean

Howells, Booth Tarkington, and Mark Twain. His patients included many other names still familiar a century later — William Waldorf Astor, Sen. Henry Cabot Lodge, and Mary Duchess of York (later Queen Mary). Our family treasures include a silver bookmark with a diamond in the center presented to my grandfather, according to a handwritten note, by Queen Victoria. It's hard to believe but the message, lovingly folded around this exotic memento, goes on to say that he rode with the Queen in her coach on the occasion of her Diamond Jubilee, June 26th, 1897. Perhaps he was serving as a high-level just in case medic — nonetheless it was a nice souvenir to take home from the party.

His obituary in *The New York Times*, on October 19th, 1910, indicated that "he was a friend of J. Pierpont Morgan, and Mr. Morgan often consulted him professionally" and also noted that "there are nearly a thousand letters in the Pierpont Morgan Library in New York from William Wilberforce Baldwin's patients."

The secret of Grandfather's success apparently stemmed from a physician-patient relationship that was unique for his day. Unlike the typically remote and uninvolved physicians of the period, he adopted an attitude of intimacy and candor, becoming deeply involved with the suffering of his patients. In an era where moral rectitude compounded stress, where mental illness was attributed to lack of will power, my grandfather openly drew on his own problems of deep depression and other ailments for insights and empathy, which he shared with his patients. Dr. Baldwin cared about his charges and his approach was therapeutic. William James was quoted as saying that my grandfather had "no more exact science in him than a fox-terrier," but he and his wife found his medical approach "deeply intuitive, morally certain, and congruent with their own sense of self."

When Grandfather visited London, he often stayed with William's brother, Henry, sometimes for several weeks at a time. Grandfather Baldwin's good looks, urbanity, cultural interests, charm, and good manners helped him fit into the lives of those he served, first as a doctor, then as a friend.

In addition to the many writers and editors he knew, Grandfather Baldwin was also friendly with a number of painters. When he decided to have his portrait done, he had to choose between two friends; the American John Singer Sargent or the Bavarian-born British painter Hubert von Herkomer.

Unfortunately, Herkomer's towering seven-foot portrait hung in the dining room of the palazzo, rather than Sargent's and remained there until my grandmother's death, when the villa was sold.

But that's not the end of the story. My aunts gave Grandfather's portrait to the venerable Uffizi Gallery in Florence, home of so many works by Botticelli, da Vinci, Michelangelo — and now Hubert von Herkomer. For years, Grandfather lived in the museum's deepest and darkest corner, and when Aunts Cornelia and Peggy came to Florence twice a year to visit Uncle Jack, they also visited the director of the Uffizi and asked to see *Dr. Baldwin*. The portrait would then be hauled out of solitary for yet another viewing. Finally, the director gave up and had the portrait permanently installed in his office in anticipation of a visit from the Baldwin girls, who my Uncle Stanley called the GaGa sisters. Uncle Stanley was a bit of a character himself, and in his old age, back in Minneapolis, drove a Ferrari and wore white spats. I called him Uncle Fangio, in honor of Juan Manuel Fangio, the famous Argentine racing driver of the period.

Since my family was quite well known in Florence, I asked my Uncle Arthur, who was married to one of the sisters and was in town for the wedding, what he would advise about seeing Mr. Berenson.

Uncle Arthur knew the old gentleman and Berenson possibly knew my family. He was told, however, that Mr. Berenson only saw "intimate groups" of people at teatime — museum directors, intelligentsia of one sort or another, where brilliant, witty conversation was the norm and the most interesting and well-connected people gathered, should they be passing through Florence.

A family acquaintance who had just returned from a tea party at the Berenson villa said the group on that occasion had included a curator from the National Gallery in Washington and a gentleman from the Victoria and Albert Museum in London. "The conversation was 'on an Olympian level,'" she reported, referring to Mr. Berenson as "B.B." and his long-standing housekeeper and companion, Miss Mariano as Nicky. They must have had a grand time. "B.B. was charming, invited me back, expressed regret that I hadn't come sooner, and insisted that I stay longer."

The conversation had centered on Plato and the woman reported that she had engaged the three experts in a lively discussion, contending that Plato had said that Art was a copy of Nature. She had read somewhere that art was im-

mortal, passed on as a memory from Paradise. There was a lot of back and forth about this statement that resulted in no substantial agreement, but this evidently didn't make any difference and they all promised to think about one another when they next read about Plato. Another matter they had discussed, however, related to my possible visit to Berenson, and it gave me pause. Some-body mentioned that the best thing that Charles I of England had ever done was to have his portrait painted by Van Dyck. It was decided that it was a pity that choosing so fine an artist could not be said about the present English monarch. That comment referred to the Italian painter Pietro Annigoni, who had recently completed a portrait of Queen Elizabeth, an image so popular with the monarch and others that it became a postage stamp.

As it happened, Pietro Annigoni was my next target to visit after Berenson. Knowing of my Italian trip, a classmate had told me about him because his brother was currently studying with the artist, and I was given the address of a Canadian woman, a Mrs. Lucas, who was a friend of Annigoni. They both lived close to Viareggio, not far from Florence, on Torre del Lago. Since Florence was steaming hot at the time, I was happy to have an excuse to go anywhere with lake as part of its name. I also needed time to figure out how to deal with Mr. Berenson on a non-family level.

I found Mrs. Lucas' house and rapped on the door. She suddenly appeared on a balcony above me in a dressing gown. To my amazement, she was young, beau-tiful, and Italian. Her first words were: "Do you want to go for a swim, darling?" Minutes later, Donella Lucas arrived in the front hall with a bunch of grapes, and we set out in a rowboat for a swim. The water was very warm. Between splashes, I explained to Donella about Annigoni and my hopes as a freelance writer.

When we got back to her house, people began to drop in and dinner was somehow arranged for everybody; prosciutto, salami, melon, crayfish, salad, and gallons of red and white wine. As new people arrived, more chairs and plates were produced, and somehow more and more food arrived at the table.

Among the group there was a large good-natured man who everybody called Buddha. He spoke no English but a little French and I was able to find out he was a master restorer of Renaissance paintings. His name was Mario Gensini and it turned out, coincidentally, that he was restoring one of Berenson's paint-ings and visited the old gentleman frequently. Maybe he was my entry point.

Donella Lucas's warmth extended to a neighbor. Among Donella's circle of friends was a man called Albrighi who lived next door to her and was also a great friend of Gensini's, and I was invited to spend the night, something I looked forward to as I had again taken to sleeping in the Hillman Minx when on the road. Next day, she introduced me to Annigoni and although we got along quite well, I reckoned that my chances of meeting Berenson were more likely to happen through Gensini.

A few days later, Gensini took me to his studio in Florence and I had a chance to watch him restoring Berenson's painting, a panel by one of the Bellini brothers. This work required nerves of steel, the accuracy of a brain surgeon, and extraordinary judgment and knowledge about the techniques of Renaissance painting. It involved cutting away the gesso, the plaster base, from the wood on which the picture was painted. Gensini let me watch, explaining the steps as he worked.

This, I thought would make an interesting article, providing me something I could talk to Berenson about. Gensini said that he would go with me when I asked permission to write about the Bellini.

Signor Albrighi, my host, was also a great friend of Gensini's. By dumb good luck, he had known Berenson for twenty years and he offered to write me a letter of introduction. He also complimented me on my good judgment in not going to one of the tea parties, where he agreed I would get lost in the crowd of highbrows. "The old man is ninety," he added, "and sometimes by teatime he is just nodding his head, half gone."

Albrighi's letter of introduction was addressed to Nicky Mariano and described me as "a former student of Harvard (Berenson's beloved alma mater) who is now a journalist and a lover of the Renaissance." This was a bit optimistic and considerably exaggerated, but you come to expect an extra bouquet in Italy.

A delightful bonus in meeting Albrighi was that the house he lived in was the one in which Puccini had written Madame Butterfly, and on one memorable evening we sat playing records of the opera looking out over the lake. No wonder everybody loves Italians.

A few days after the letter of introduction went off, Albrighi phoned Gensini, said that Berenson had agreed to meet with me, and arranged for me to pick up the restorer at 9:00 a.m. in Florence.

That night I crammed on Berenson's book, *Italian Painters of the Renaissance*, and carefully composed a list of fourteen questions to ask him about the Bellini, which was one of the 400 works illustrated in his book.

The next morning at 7:30, I grabbed the book from under my bed and went to pick up Gensini. We were headed not for Berenson's Villa I Tatti in Fiesole just outside Florence but for his summer cottage at Vallombrosia. The drive was beautiful, about twenty kilometers along the Arno and then up into the mountains. The early September air was cool and refreshing. Gensini was in a great mood. He sang songs of Emilia-Romagna, his native region north of Tuscany. One of them was about priests "who told the right time to girls by making dingdong under their cassocks." He looked like one of those jolly priests himself.

After an hour or so, we found Berenson's summer cottage, Casa al Dono, which was definitely off the usual track. The villa was simple and attractive. We were ushered into a hall upstairs. While we waited for Nicky Mariano, I wandered around trying to identify the many black-and-white engravings of Renaissance artists framed on the wall. They were frontispieces taken from ancient art books. The house was filled with them, all the same size 8" x 12", with the artist's name printed on the bottom. Some were in bad condition, with holes torn in them and flaps of paper hanging loose. Under a dirty-looking trophy-like ox head was an etching of a battle across the Arno. The ox head was decorated with some tattered bits of faded colored cloth — a formerly festive ox from some part of Italy.

After about fifteen minutes, Nicky Mariano appeared. She greeted Gensini warmly and was most cordial to me. We followed her into a sitting room, which was adjacent to Berenson's bedroom. She produced a bottle of Campari, glasses with ice, and a small pitcher of lemon juice.

Miss Mariano was a handsome woman with a sympathetic face. She wore a white sweater over a white wool dress with a pleated skirt. The house was a little chilly, and she frequently adjusted a large flowered silk shawl. She told us in hushed tones that Mr. Berenson did not feel very well. He had had a bad night. Several times during the conversation she got up and went to his room.

It was finally arranged that we were to see the old gentleman. There had been considerable doubt about this when we first arrived, but Miss Mariano said that Mr. Berenson had taken his injection and thought he would feel better soon.

"Injection," I thought to myself. "Good God, maybe I should have gone the cocktail route."

"It may be very difficult," she warned me, "because Mr. Berenson is extremely negative when he doesn't feel well." Then she asked me what I wanted to talk to Mr. Berenson about and I explained my mission.

"I hope that you do not want to take any photographs. Mr. Berenson has had so many taken for his ninetieth birthday and he is sick of the idea of photos." She gently explained that she was also camera shy. "I come out so badly in photographs."

Sitting on the sofa in her white dress, her lovely gray hair, she would have made a beautiful picture, a big handsome woman in her sixties with that wonderful soft expression that people have who spend their lives doing things for others. Her eyes were alert but I noticed that they were a little teary. She was very concerned about the old gentleman.

A bell tinkled and Miss Mariano went into Mr. Berenson's room. While she was gone I photographed the room, Berenson's hat, coat, and a few other things. After another Campari I felt better about the interview. Miss Mariano came back and said, "Mr. Berenson will see you now."

I grabbed my camera, just in case, my Berenson art book, and my list of fourteen questions.

When I walked in, I saw a frail old man propped up in bed, resurrected from a condition I could only guess about. I had never seen anybody this old. He looked as if he were supported by the starch in the sheets. But he had been lovingly covered with soft, warm-looking shawls and blankets by Miss Mariano. His hands were white, his skin was transparent and blue-veined. For a moment nobody said anything.

I introduced myself.

"How do you do, Mr. Berenson. I am Frederick Baldwin."

"Yes, what is it that you want?" he said, speaking in a high-pitched voice, uttering each syllable carefully, measuring every breath.

"Did you know my grandfather, William Baldwin?"

"Where is he from?"

"Florence."

"That was your father?"

"No" I said, "that was my grandfather."

"Was any member of your family in the Diplomatic Service?" he asked.

"Yes" I said, "my father."

"Was he in Warsaw?"

"No, that was my uncle."

"What was his name?"

"Arthur Bliss Lane."

"Is he dead?" asked Mr. Berenson.

"No, my father is dead."

This conversation was going nowhere, but we finally got it untangled. He knew Uncle Arthur and Aunt Cornelia and was interested in their whereabouts.

"I am glad they are well," he said. "Please be good enough to give them my regards."

"I understand that you want to write something about me," Mr. Berenson said.

"I hope to get your permission, sir, to write about your Bellini and its restoration."

"Are you an art historian?"

"No" I answered.

"Are you an art critic?"

"No sir."

He was impatient by this time.

"My child, give up this foolish idea of yours. This is not interesting. I strongly advise you to choose something else."

Then he told me to make up my mind to be either an art critic or an art historian.

"Do you know anything?" he asked.

I almost choked on that. "I have read your book."

"I have written twenty books," he said coldly.

I laughed for both of us and showed him the book I had brought.

"Oh, that book is for beginners," he said scowling at me. "You will learn nothing there. I am afraid that this won't do at all."

By that time I saw that there was no point in bringing up my list of fourteen questions. There wasn't going to be an interview; his patience with me was clearly exhausted.

"Where were you educated?" Mr. Berenson asked.

"Harvard." I replied on the strength of Harvard Summer School. Mr. Albrighi, in his letter to Miss Mariano described me as a Harvard man.

"How old are you?" was the next question.

"Twenty-six"

"What have you been doing all these years?"

"I was in the Marines, and then after Harvard, I went to Columbia."

There was a pause, and then he said, "That is like going from Paradise to Purgatory."

I gave him my toothiest smile.

"I've studied Journalism."

"Journalism, what a terrible thing."

More smiles from me. Each scowl was met with a cheery grin. I was grinning my damn-fool head off.

"Who are you writing for?"

"*Art News*," I lied through my teeth.

He nodded. At least that registered.

"Do you know Dr. Frankfurter, my editor?" I hopefully inquired.

"Yes."

"Do you know Tom Hess?" I asked, citing Alfred Frankfurter's executive editor at *ArtNews* and exhausting all the names I could drop. "Who?"

"Tom Hess."

"What?"

"TOM HESS."

"I cannot hear what he is saying." said Mr. Berenson, looking again at Miss Mariano.

"Tom Hess," she said.

"Never heard of him," was the reply.

"What have you written for *Art News*?"

"I'm working on an article about Tomassi, the sculptor." Leon Tomassi, an Italian artist living in Argentina, was working on a huge monument with a statue of Evita Peron, to be taller than the Statue of Liberty, according to Donella Lucas.

"Who?" Again the same routine. He couldn't understand and Miss Mariano had to translate.

"Modern?" asked the great critic.

"Yes, modern Italian," I replied.

He looked at me as though someone had given him something very unpleasant.

"Never heard of him. Not interested in moderns."

I thought I would take a couple of shots in the dark to see what would happen.

"I'm doing an article on Picasso." I said brightly, but I caught the ricochet right between the eyes.

This news brought a lot of pain to the old gentleman. It was a look filled with pity, not for me, who had uttered the blasphemy, but for himself who had to hear it.

"Oh, this is too much. Do you know what I call Picasso?"

"No, what?"

"I call him Picassette."

This was the closest he ever came to smiling, but he reconsidered.

"I'm afraid that you and I have nothing more to talk about."

My last hope went down with all hands, but I laughed merrily.

"I suppose that you want me to autograph the book," he said. "I am afraid that is all I can do for you." He unscrewed a long pen and with a shaky hand started to write. I decided to fire my last conversational volley of the day.

"What do you think of the Neo-Futurists, that group of young painters who emulate the style of the Renaissance?" referring mistakenly to Annigoni. I was clearly way out of my depth here, but fortunately I didn't have to explain myself.

"I am not interested in anything that has been done in the last thirty years. I have nothing more to say to you. Give my regards to your uncle and aunt and please pay close attention to this inscription that I have put in the book. Goodbye."

"Oh yes, thank you. I shall always treasure it."

I didn't have the nerve to ask if I could photograph him. Mr. Berenson would have sailed right off to Paradise or Harvard or wherever he is going and I would have been charged with murder.

Gensini then had a short talk with Mr. Berenson about the restoration work. Before we left, Miss Mariano asked Mr. Berenson point blank if he wanted me to write about the Bellini.

"No, by no means." was the reply.

"Thanks for the interview," I said with my same paralyzed smile.

"Read what I have written in your book." was his final word.

After we left Mr. Berenson's bedroom, Miss Mariano immediately said to me, "I was afraid this would happen. It was a bad day. When Mr. Berenson doesn't feel well he says no to everything."

I thanked her for her kind concern and assured her that it had been most interesting.

"It's too bad that you arrived on such short notice. Mr. Berenson says no automatically unless he has time to get used to an idea. The lack of preparation was unfortunate."

Gensini and I finally left. On the road above Casa al Done we stopped the car and got out to pee. I took the chance to read the inscription Berenson had written. Then I read it again.

To Frederick Baldwin with hope that he will see the light.

B. Berenson

As ridiculous as this interview was, Berenson had been right; I didn't know anything — certainly not anything he cared about — and he had figured me out in thirty seconds. But "seeing the light," yes, that was something I would have to consider. That's what my quest was all about, and I turned in my mind to my imaginary father, Picasso, and began to tell him things, a one-way conversation that was now only beginning.

I had loved meeting Picasso because I had been able to walk through his door by using humor and my imagination to gain my end. But the Berenson visit was derailed because I was clearly talking nonsense and he held me accountable — told me the truth.

Looking back at the men I had just met, I realized that I wanted to be like Picasso, with an open, accepting spirit, as big as the sky, as unpredictable as the weather. I couldn't be like Gensini, meticulously slicing into ancient gesso, dissecting the priceless past, or the short-tempered rationalist Berenson, who wouldn't take the time to suffer a fool. My youthful arrogance had got exactly what it deserved, and one really can't ask for more than that.

That's where I was at twenty-six, ready to see the light.

And maybe my perseverance and daring in seeking a father in Picasso — and finding that I could succeed even in as unlikely a quest as that was — was enough to give me the confidence to father myself.

8 – FINDING PHOTOGRAPHY

After my summer adventures meeting two giants of the world of art, I returned to New York to finish up at Columbia. I didn't have a girlfriend at the time, but I was on the lookout. I already had a thing about Swedish girls, having once watched a troop of schoolgirls in Stockholm going through a museum and finding that half of them were very pretty and ten percent were absolutely stunning, with elegant bones and fine, erect posture; the whole throw of their bodies got to me. Coincidentally, sexy Swedish movies I had seen in Paris and a famous *Time* magazine story of the day about free love in Scandinavia supported my fantasies.

My first direct experience of Swedish girls was Anna, who had a bold manner and was clear about what she liked and didn't like. She was a friend of a Columbia classmate, who was also Swedish. They both lived in Princeton. She was a heartbreaker, with all the self-confidence of the daughter of an aristocrat; her father was a baron. She toyed with people, did what she liked, and didn't give a damn. "Screw you, Sonny Boy" was her favorite expression. She had a reputation, but I was ready for her. The affair was robust. It began in the back seat of a station wagon as we drove around fashionable parts of New Jersey, visiting her friends in nearby Bernardsville. Somehow, what was going on in the back was unknown to the other passengers, who were too busy with their own variations of what we were up to.

I really liked Anna, that little Swedish beauty. Despite her apparent sophistication, this was only her second time at lovemaking. The affair went on all summer, until her parents found out that we were sleeping together. My

"friend" had tipped them off. He was probably jealous, and before we knew it Anna was being shipped off to an all-girls church school in Italy.

Before she left, we made plans for her escape and to meet in France. She wanted to get married, but I said we would have to wait and see. In fact, I had no intention of getting married, but our correspondence was passionate. Unfortunately, she confided all this to a romantic old aunt in Sweden, who blew the whistle. Instead of a liaison in Paris, Anna was flown to Sweden and placed under lock and key by her parents.

Then I met Monica.

There was a dance at Columbia and a friend asked me to look out for a Swedish girl named Monica Lagerstedt who would be there and didn't know anyone. As it happened, about five hundred people were there, and unless this girl wore a Swedish flag, I didn't know how I was supposed to identify her. But I did find Monica that night — just as the dance was ending. There she was, standing in the coat line with a man dressed in a naval uniform. He wasn't her date, just someone trying to be helpful in finding her coat. She must have been trolling, too.

Monica was unmistakably Swedish. She was lovely, with dark hair, a small beautiful head, alert, but with a somewhat unsure look about her. She was so different from everyone else I met at the time. Even the way she stood was distinctive, back very straight like a dancer's, her arms down by her sides; so shy, but innocently provocative.

The girl had to be Monica. To break the ice and satisfy my curiosity I said something that sounded like, "Du snaka Svensk?" and was supposed to inquire if she spoke Swedish. It sounded Swedish enough to get her attention. It worked. She quickly replied in Swedish something I couldn't understand, and I had to explain that my only connection with Sweden was that I knew the daughter of the Swedish Consul General in New York, someone I had met through Anna. She told me that her name was Monica Lagerstedt — dumb luck — and that she worked at the Swedish Consulate as a secretary. We began to chat, and after that it wasn't hard to get her telephone number. Thus began a crazy courtship. We met in the fall of 1955 and I took her out twice, but she wouldn't say a word — not one word. Of course, she responded politely to direct questions but that was it. I couldn't figure out whether she was abnormal-

ly shy or didn't like me. Although enchanted by her innocent good looks, I began to run out of things to ask her. I had stories to tell, but they didn't seem to be registering, so I gave up and stopped pursuing her. Then on a whim, I called her up in the spring of 1956 and invited her to go to the beach. "Yes," she said. That was a lot of words for Monica in those days, but on the way out of Manhattan she finally said something:

"Do you know how to swim?"

"Yes," I said, "I'm a good swimmer."

She said, "I like that."

That's all there was, but for me it was everything I needed to hear: she did like me. I could also tell by her tone that she sounded excited. Picking her up in my car at the Park Avenue Consulate residence, we headed for Long Beach on Long Island, near an area called East Atlantic Beach, to a two-story bungalow that she shared with several colleagues from the Consulate General. This became our weekend trek.

There I met a Monica I hadn't known. Among other things, she looked totally different in a bathing suit. She appeared to be quite thin in clothes, but she really wasn't, although part of her was. To me, she was the most delicious woman-child I had ever seen. Her bathing suit was a little too small; it was one piece and quite modest, but she seemed to be about to burst out of it. Her legs were nice and her skin was quite brown; she had been sunning herself at every available opportunity in the Swedish tradition, and her skin was incredibly smooth. Her hips and thighs were delicately shaped, but much broader than I had supposed. She was a tawny healthy woman. Her waist was narrow, and her dancer's back — the traditional stance of the Swedish girl — was elegantly straight. Her arms — beautiful arms, round, not big, perfectly proportioned to her shoulders — were held somewhat stiffly, at attention, pressing together two small breasts that were almost childlike. They were revealed, however, because Monica's one-piece bathing suit was loose at the top, built for a bigger woman. Her breasts were quite free to see, unless she stood straight, which she did most but not all of the time.

Monica's head was covered in fine chestnut brown hair, and her dark eyebrows framed gray, gentle eyes. Experience had not put things there that indicated a difficult life in her twenty-one years. She retained the sweet softness of

a child who remains beautiful until age and rough treatment eventually coarsens them. Her mouth was well formed, quite delicate like her arms and neither thin nor thick, but full, just slightly, a tiny bit full — with a hint of sensuality. Her chin was round and a bit soft — her nose slightly turned up. Her ears were small and perfectly proportioned. Contrasted with the delicacy of her features and the elegance of her upper body, her feet were terrible, broad like a duck's. They struck me as sad feet, destined to be shod forever in sensible shoes and never tormented by stylish narrow high-heeled footwear. But she didn't care much about such things anyway.

Lying next to this silent beauty on the beach — just looking at her breasts and her mouth I was spellbound. Then, near her mouth I saw a small something, a tiny mole, or a crumb, on her face. With my handkerchief, I flicked it away. It came away easily. My God, it was a blackhead, almost ready to depart on its own. But it must have been there for months, perhaps years. Doesn't this girl look in the mirror, I thought? And I found out, of course, that she didn't, and that was Monica.

Although she was always scrupulously neat, Monica was not particularly concerned about chic. She was totally unfamiliar with the usual feminine embellishments such as nail polish or makeup, and I don't remember her even bothering with lipstick. So perhaps this facial blemish was just a cosmetic detail left ignored, unnoticed. Or was it a symptom of an unreality in her psychology that would prove problematic in our relationship?

Our lovemaking began very soon after our beach date, and I learned that not only was she completely inexperienced but also that the usual, gradual process from first-date, first-kiss to more serious petting did not exist. For Monica, it was all or nothing from the start. Once our sleeping together became regular, however, her reactions were unpredictable; when she was excited, one touch where she liked it and she was responsive. At other times, if she was feeling shy, nothing happened at all. And she didn't know how to kiss, so as a joke I bought her a book — Sixty-Seven Ways How to Kiss. She read on page three about French kissing and her mouth opened.

One weekend early in our relationship I took her to Connecticut to see my friends Henry and Elaine White. We were staying with Henry's parents at their country house on Long Island Sound. I wanted to sleep with Monica and I

thought this would be a relaxed and friendly place to do it. But in typical, proper New England fashion we were put in separate rooms and it somehow didn't seem appropriate.

The weekend was a catastrophe. She wouldn't talk to me or any of the other guests when we got there. Disappointment became anger. I sent her back to New York with the Whites and followed separately. Two difficult weeks followed, but I wouldn't call her. Finally something inside me turned off and I began to recover from my hurt feelings. I missed her, especially because she fit my sexual fantasies, although she didn't seem like a suitable partner in my social life. Could I get beyond this? And then, she called me and said that she wanted to see me, and that she wanted me to be her lover. We talked about the weekend at the White's, and she said that she had wanted me so badly that she was afraid that everybody would see it.

When Monica and I became lovers, our relationship was wonderful from a physical standpoint, but our troubles began almost immediately. Being alone was fine, but when we went out with or met other people, there was a lurking anxiety. Nobody minded her quietness except me. She knew how to speak to others; she just didn't do much of it. Everybody thought she was charming, and her innocence had a certain appeal, but it became extremely limiting. So, as our lovemaking continued, I kept wondering if sex was enough. I had plenty of one thing I badly needed, but there were other satisfactions that were missing. We came from such different worlds. How and where could we connect better? Then it emerged that Monica's shyness and reticence were deep seated; she was emotionally troubled enough to be undergoing psychoanalysis, and gradually she began to share with me bits of information about her past, revelations that were entirely new to me.

Monica had never gone beyond high school in Sweden, and although as a young girl she had shown a talent for drawing and storytelling, she had never studied art. Several of her early illustrated books had even been considered for publication in Sweden, but when puberty appeared the creative process stopped, for reasons that she couldn't understand. This troubled her. Perhaps it had something to do with being the oldest of five brothers and sisters. Perhaps her emerging family responsibilities — imposed by an authoritarian father — blocked her. Or was it a difficulty in dealing with the changes in her

body? Or something else? She desperately turned to her father, which seemed a logical thing to do as he was in charge of the largest psychiatric hospital in Sweden. His response, however, put her into a state of shock, from which she was still trying to recover. Psychiatrist Dr. Lagerstedt had informed her, "No daughter of mine could possibly have psychological problems." And that was that.

Our relationship was based from the beginning on two things: my strong physical attraction to her, and her remarkable innocence. That quality seemed to indicate to me that she could be gently molded into whatever I needed. She was the dream come true for someone who knew what he wanted, but I still had so many questions about what I wanted and where I could get it, that she was turning out to be more of a burden than an asset. One incident was very revealing. We took a trip together to Sebring, Florida to attend the annual sports car race. I had wangled a press pass through a drinking buddy from *Esquire* magazine to cover the event. Photojournalism was already lurking in my dreams. We planned to drive down from New York in my MG sports car. Monica was in charge of organizing picnic supplies for the trip. The weather was hot in New York and was sure to be even hotter along the way. Monica chose to bring milk to drink and avocado sandwiches. I was furious with her and exploded in anger; how could she be so stupid, not knowing that we were traveling where milk sours quickly and avocado gets slimy.

The incident became a metaphor for our relationship. Monica endured every bad-tempered, insensitive, male egoistic indignity, and yet continued to believe that I was right, that I knew what I was doing. Her irritating blindness to my failings was the source of my irritation. It was also part of what kept me from letting her go. She was so vulnerable. I couldn't bear to see her abandoned, turned out like a stray. So we continued going back and forth emotionally; I would throw her out and then call her back. Clearly, this had to do with my own fears of abandonment, but it wasn't something I could understand or cope with at the time. The break did come, however, and after six months, the emotional rollercoaster ride ended. She wanted to get married, I wouldn't do it, and she left me.

As it happened, her tour of duty in New York at the consulate was up and she applied for a transfer to Buenos Aires, but was turned down because of her

psychoanalysis. She returned to a Swedish Foreign Office job in Stockholm. The bureaucrats, like her father, were not sympathetic to her psychological complexity. When we parted, I had no idea that we would meet again.

In the spring of 1957, I graduated from Columbia, and did what I was expected to do, look for a job. My GI Bill support was over and I needed to go to work. Taking advantage of Columbia's Career Services office, I went for an interview, one that turned out to be weird but interesting. The job councilor at Columbia had numerous lists, contacts, and telephone numbers of possible employment openings, but the most curious part of our interview was a test that he administered, having discovered that I had not been educated to do anything useful with respect to employment. He told me that he was going to read me a long list of words that I was to respond to. My reactions would reveal my talents, strengths, and weaknesses. It was a kind of verbal Rorschach test. He started with "s-c-r-u-p-u-l-o-u-s," mouthing the word precisely, and then went on to "finicky, punctilious, and precise." When the right word came up, I was supposed to cry out, "Yes that's me!" and then explain why. None of the first words elicited the revelatory response. Then he added "valuable, practical, useful, and beneficial," and they didn't make the grade either. Nothing he said worked.

Finally giving up, he made an appointment for me to see the gatekeeper at the McCann-Marschalk Advertising Agency, who interviewed me for a job as an assistant to the assistant copy editor. Presumably I would work for someone who I assumed was like a hairdresser, fixing fuzzy ideas into beautifully coiffed concepts to sell things that I didn't care about. Foamy shaving cream and Dutch Boy Paints were the big clients of the agency.

When I was told that the job paid $10,000 a year and would rise if I progressed, I explained: "I can't keep clean for $10,000 in New York, and I will need double that." Actually, the offer was quite reasonable for 1956, and, of course I wasn't hired, but now I could tell my mother and brother that I had tried to get a job but that, unfortunately, McCann-Marschalk had hired some other genius.

During my rollercoaster romance with Monica I had become serious about photography, although the Canon camera I had bought in Korea was the only relevant asset I had. Nothing in my life except the camera was photography-

related, but I had something else, my Picasso mantra, the conviction that if I wanted something badly enough, I could get it. Had this not been firmly embedded in my psyche, I might have a different story to tell.

Using my Picasso mantra, and the photographs I had made of the master in Cannes, I applied for a job. It was a little scary, but I went to see Clay Felker, who was then the Features Editor at *Esquire* magazine. I had bumped into him at some of my Greenwich Village haunts, but he was not a drinking buddy. When I showed him my Picasso photographs he was not as impressed with them as I was.

"There are Picasso pictures all over town," he told me. OK. I thanked him and was out the door, but I had overcome my fear and acted; the Picasso mantra was in place.

Actually, Felker didn't tell me anything that I didn't know already, because during my last year at Columbia I had spent a lot of time around New York seeing photography at various museums and galleries, especially the Light Gallery, almost the only one showing photographs exclusively at the time. The work that most impressed me was the photography done in Europe during the 1930s, 40s and 50s, the great early generation of photojournalists such as Henri Cartier-Bresson, Robert Capa, Alfred Eisenstaedt, and others. I also, of course, haunted *The Family of Man* exhibition at MoMA organized by Edward Steichen; a formative experience. A few professional photographer friends were willing to coach me as I made pictures around the city; one worked in the photo lab at *Life* magazine as an assistant.

Knowing that I needed more technique, I signed up for a workshop with Lisette Model, one of the most celebrated art photographers of the period. I only attended one session ($10) because I found that I had almost nothing in common with the other students (one of whom, I learned later was Diane Arbus), much less so with our powerful, confrontational teacher, who talked about things that were over my head. What I needed was grounding in the mechanics of photography and a few gentle pats of encouragement, not wrenching criticism delivered in a language about creative concepts that I had not yet learned to understand.

As I became serious about photography, I began to read as many books of and about photography as I could find, as well as a variety of magazines; tech-

nical articles by Bob Schwalberg, an intelligent columnist for Popular Photography magazine who became my professor at "teach-yourself-school of photography."

I realized that back home in Savannah was the place to start. The likelihood of finding a job in New York that had to do with photography was dim, and I couldn't afford to stay in the big city without work, so I headed south.

The one idea I had about how to earn a living with photography in Savannah was inspired by my memory of the photographs of children at *The Family of Man* exhibition at MoMA. Wouldn't it be fun, I thought, to make picture documents about aspects of a child's life rather than the usual sit-down portraits? And wouldn't my mother's friends among Savannah's "old" families pay for such pictures? The work of Wayne Miller, Elliot Erwitt, Russell Lee, and Bill Brandt, among many, took me in directions that were new and different for me and the idea caught on. My mother's patience and generosity allowed me to live at home and apply everything I earned toward launching my career.

An Omega enlarger was installed in my bathroom at my mother's house and experiments began. The local camera store provided Kodak darkroom supplies and numerous clearly written step-by-step "how to" manuals, and before long I had taught myself how to develop black-and-white film, and make acceptable enlargements.

For $40 I would spend the whole day with the kids. "What is fun" became my shooting script. If boys loved fishing, we went fishing. Climbing trees was popular. Everything we did was out of doors, so I didn't have to worry about fancy lighting, about which I knew nothing. So I would expose about ten rolls of hit and miss pictures, and my shower curtain was soon replaced with hanging rolls of 35mm film. I learned to make contact sheets, how to select the best frames to enlarge, and then make acceptable 8 x 10 inch prints for the family's inspection. My friends "dumb luck" and "persistence" helped to produce enough good images to satisfy my customers, and I learned as I went.

My photographs of the kids got better and better, and more families called me with assignments. My prices began to climb, and within six months I was charging a $400 a day as my basic rate, with extra fees for prints — still produced in my bathroom.

One of my assignments netted me a special bonus. Alice Jones's daughter, Bonnie, and I decided to build a house out of a large cardboard box. I snapped away while we glued everything together. When her parents came home and saw Bonnie's cardboard house, they were delighted, and even more so when they saw my prints. Don Jones, Bonnie's father, was the General Manager of WSGA, a local radio station, and he put me on air to talk about how I photographed kids. This encouraged me to send one of Bonnie's images to *Pageant* magazine, a digest-sized monthly similar to *Reader's Digest* but with more pictures. It was accepted, and when the publication appeared on the newsstands — my first magazine sale — business boomed.

Soon I was making enough money to buy a Leica M3 camera, a top of the line professional machine that was more professional and top of the line than I was. Owning the world's best 35mm camera made me feel like a rising star. This was Henri Cartier-Bresson's camera, and the one used by David Douglas Duncan to photograph my squad in North Korea for *Life* magazine.

This tiny machine had a special magic for me. I followed the camera into photography, rather than the other way around, hoping to grease the squeaky wheels of my inexperience with something that would move me forward at a more accelerated pace.

The Leica somehow provided me with a sense that I could always be moving up in the world. This also described the lifestyle that I sought, and it led me to extend this feeling by acquiring a used 135mm telephoto lens at the local camera store. It was inexpensive, with a Leica mount and I thought it might help me achieve a certain intimacy in situations where I was too shy or nervous to shoot with a normal lens. It effortlessly brought closer things that I was curious about, thus giving me a kind of magic pass beyond the No Trespassing signs. The lens was to have an effect on my life that I could never have anticipated, and it taught me lessons about what was important to me in photography that would have surprised even Lisette Model.

9 – REIDSVILLE KU KLUX KLAN

Shortly after buying the telephoto lens, I decided to try to do something new; a picture story rather than photographs of kids. I felt it was important for me to see if I could put together a coherent narrative in photographs, not just single shots designed to warm a mother's heart. Scanning the newspaper for ideas, I spotted an article about a tobacco auction in a rural town near Savannah that might provide me with my experimental assignment. So I rented a car, thinking that my flashy British sports car would send the wrong message to the farmers in a town whose name escapes me because I never got there.

Pablo Picasso and several imaginary friends were invited to come along to coach and encourage me. Henri Cartier-Bresson, Robert Capa, and Walker Evans had provided me with inspiration for several years and I sensed they were a little bored with children's photography and would enjoy the change.

From the elegant squares of downtown Savannah, I drove through the shabby industrialized outskirts of the city, and then down a highway that led toward my assignment deep in rural Georgia. Squat little general stores and lone gas stations began to be spaced further apart, replaced by small farms, corn fields, and long stretches of wounded pine trees, cut with angled slashes that dribbled into tin cans and the bleeding sap that would be used to make a few gallons of turpentine. In some places along the road, white sandy strips reflected the sun. Then a bit further, there were patches of darker soil with tangled underbrush where moss-draped scrub oaks reminded me that Walker Evans had been taken with such landscapes when he had documented poverty-stricken areas of the rural South in the 1930s. With each passing mile, the

dirt-poor reality of this world began to feel more charged in my mind, coming up clear like a developing photo print. Memories of Evans' photographs mixed in the chemistry of my imagination and they would become stronger.

Twenty-five miles west of Savannah, down Highway 280, I reached Pooler, Georgia, driving deep into a world that I had passed through on other occasions but knew little about.

To me this country was about what was not there. Missing were the meandering waterways, dense groves of oaks that marked little islands set out in the marshlands that were alive with flights of water birds and deer, quail, raccoons, possums, and graceful wild animals that you knew were there even if you couldn't see them. Absent were great estates down long sandy roads that led to a plantation house with wide verandas waiting to introduce you to a magnificent sunset if you were lucky enough to be invited over for a drink with the "amusing set." This was a different place. It was inland, not coastal. There were few views sufficient to stir the soul or inspire a cocktail. Even Sand Fly, a tiny hamlet near Savannah, didn't have the pejorative ring of Pooler, Georgia.

People in Savannah often said "Poolergeorgia" as if the words were joined, in a faintly mocking tone. Nobody knew anybody who lived there. Pooler's population lived on the small farms nearby, but it was impossible to tell much about the inhabitants or how many there were, as they were mostly invisible from the road in 1957.

A few utilitarian buildings marked its urbanity, and one of them, a little cinder block structure, was the headquarters for its notorious speed trap. Here the artificially low speed limit provided revenues for somebody in the middle of nowhere. Observation didn't indicate who or what that might be. This trap and the comic name Pooler gave nice people, driving from Savannah to Atlanta, a chance to say "watch out" and then not to say what they would normally think but never articulate: "this is the land of the poor white trash – and you have to be careful."

Slowing down in anticipation of the speed trap, I noticed a long line of parked cars on the other side of the road. The cars were being decorated with U.S. and Confederate battle flags. This didn't surprise me, but I was stunned to see large white letters painted on doors, hoods, and trunks of the cars with the bold letters – KKKK (Knights of the Ku Klux Klan). A black Chevrolet provided

precise identification with a placard reading: *U.S. Klan, Georgia 41* with bright red edging highlighting the white cross. I stopped.

Having been brought up in the South, the Klan's reputation was odious and familiar to me. But who were these people? I knew that poor white farmers had long been recruited into the Klan, and that radical white men, preaching racial hatred led the organization. Their violent reputation was the tipping point that separated them even from the many whites who supported segregation, a regional condition from which nobody seemed safely inoculated. Unfortunately, racism was alive and well. The Klan promoted this condition to undereducated rural whites as a God-given absolute, their right of divine superiority — whiteness — the only thing that separated them from rural blacks, who were also exploited and undereducated. To make their point, murder had often been the Klan's tool of choice. Although the lynching of black citizens was not a frequent occurrence in the South, it was always a threat, and was felt up to and beyond 1957.

What an opportunity to make some sensational photographs, I thought. But I was deeply uncomfortable. What was the next step? How do I proceed? I had my recently purchased 135mm lens and perhaps the sensible thing to do was just sit in my car and take pictures with the telephoto. A New York friend, Tony Triollo, who worked for *Life*, had photographed a Klan meeting in Tampa, Florida a few months earlier, and he said that this was the scariest thing that he had ever done. I now took what he said seriously. Every rational part of my being screamed, "I really do not want to do this." It would be like picking up a rattlesnake by the tail with my bare hands.

The men I saw decorating their cars were not wearing the outlandish hooded and white-robed Klan costumes. They were unmasked, wearing normal clothes in broad daylight, their identities only given away by what they were painting on their cars. Were these people less dangerous unmasked, identifiable? Not necessarily — but how would I know?

So I got out of my car and crossed the highway, walking slowly, dragging one foot behind the other, still dreading the moment when I would actually reach the most frightening looking man of the group, whom I assumed was in charge.

I was fearful. I fully appreciated that this was not a good idea. Dread, caution, common sense, gave way to the excitement of taking advantage of exploiting a possible photo op that became one of the wildest moments in my entire life. Walking up to a group that represented elements of Southern bigotry that I had been brought up to fear and hate — people I saw as despicable patrons of ignorance. To me they were *opposite-of-me* whites. But as it turned out, there was no need to weave and bob to take out this bunker as I had in Korea because deep down — without realizing it at the time and looking back on it today — I must have instinctively drawn on my special pass. I was not black. I was a blond, baptized, blue-eyed white man safe in my hoary skin.

My request to take photographs was delivered with what I hoped sounded like a deep Southern drawl. My speech normally tends to have a preppy New England inflection — the wrong tune for this man's ears. First, I had to convince him that I was not with *LIFE* or *Time* magazines, unpopular publications with the Klan. Then he noticed that there were Florida license plates on my rental car. "Yes," I lied, "I'm from St. Augustine," and he immediately wanted to know if I knew about the Klan group there. Yes, I had heard of them, but didn't actually know any members. This seemed to satisfy him and everybody around him, so they invited me to take pictures and then join the motorcade to nearby Reidsville for a rally.

Actually, close up, most of these people didn't look frightening at all. The women and children and the older men looked like normal Southerners from farms in the region, and the young girls were dressed up as if they were going to a party. A few young men had a hard look, but they didn't mind having their pictures taken. One of my favorite subjects, whom I christened Mean Face, drove a new big-finned Ford convertible. As I photographed him, glowering at me from the driver's seat, he posed and posed.

There had been many Mean Faces in the Marines so I illogically thought if I had been able to get along in that rough-and-tumble society, I could do it here. Nothing came to mind on how to achieve this, however, as the slogans of this day weren't good conversational entry points for me — White Supremacy, Yesterday Today Forever, God Give Us Men and Guard America, and KKKK painted on every side of every vehicle. In fact, I was truly amazed watching ordinary country men, accompanied by their wives, children, and grandchil-

dren, painting slogans that elicited fear and disgust in the minds of most Americans, particularly black Americans. And the decorating was a family process; the symbols of hate and racism were being cheerfully applied by all with the high spirits of preparing for a high school football rally.

Finally, all the cars were finished and ready to roll. Asked whether I would like to have my own car done, I declined on the basis that I didn't deserve such an honor.

As I pulled into the line of cars covered with hate slogans, the situation triggered my wildest fantasies. What would it be like to drive home, through the streets of genteel Savannah with KKKK and America Deserves White Supremacy painted on the car, pulling up to my mother's house on the handsome old square in front of the Cathedral on East Charlton Street in time for her weekly canasta party? What would be her reaction, and that of her friends?

Savannah in 1957 was very much a racially divided city. I didn't know a single black person to have a beer with, and the only black face in a "How about lunch?" dialogue would have been the cook. I lived in a well-mannered dream world that substituted civil behavior for civil rights. My properly brought up mother had always been kind to Negroes. I was taught to do the same. There were mild rumblings of change coming as the result of World War II — a rising professional class of black lawyers, doctors, and educators — but the first peeling away of total white dominance was invisible to me in 1957.

One dark night, a few months before, I had been driving from Wilmington Island back to Savannah when I passed a group of white-robed men burning a cross in an open field. There weren't many people and just a few cars were parked along the road but who were they? The dregs of "poor white trash" was my first reaction. I felt safely white and superior and as I passed them at 45 mph, I was immune. That's what I wanted to believe. It was hard to imagine anything else.

All my life I had heard about the Klan. They were violent whites, despised by "nice" people in genteel Savannah; but I had never knowingly met a Klansman. Were they ignorant country people, who scratched a living from land that was as worn out as they were, the lowest level of "Georgia Crackers?" Then I thought of my Marine buddies; so many were Southern farm boys. I hated the term "Crackers," the phrase stripped dignity from sweat and I never used it.

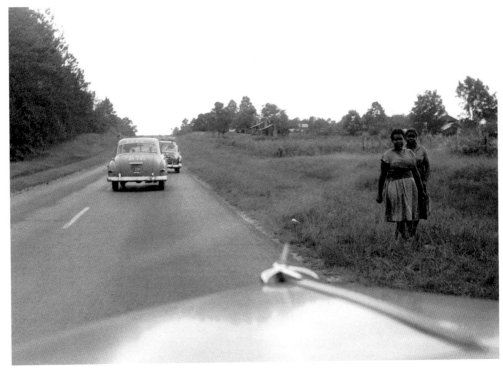

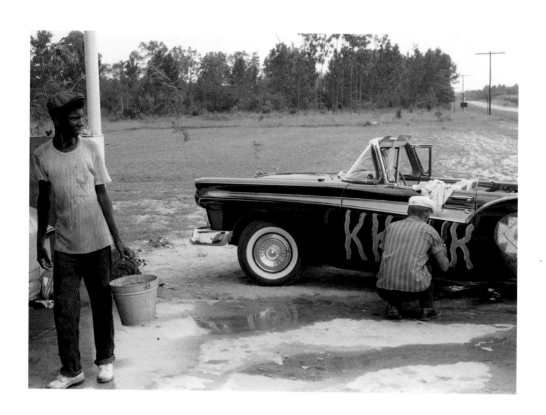

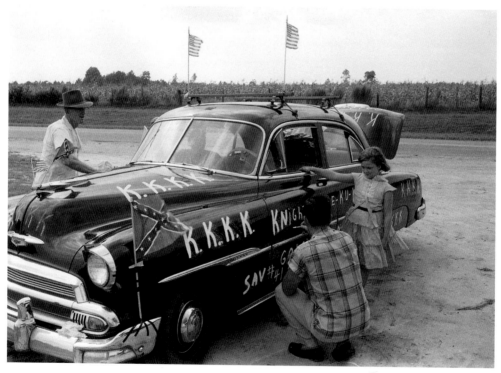

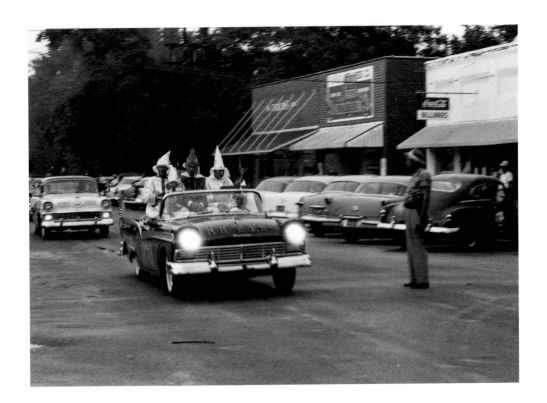

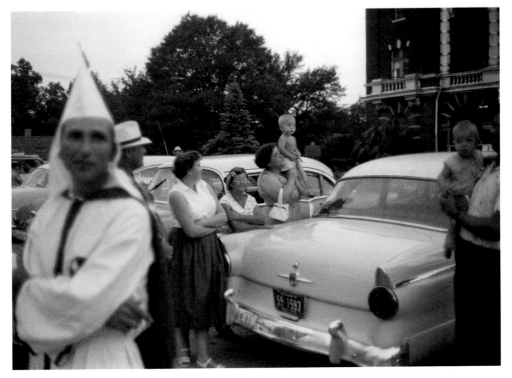

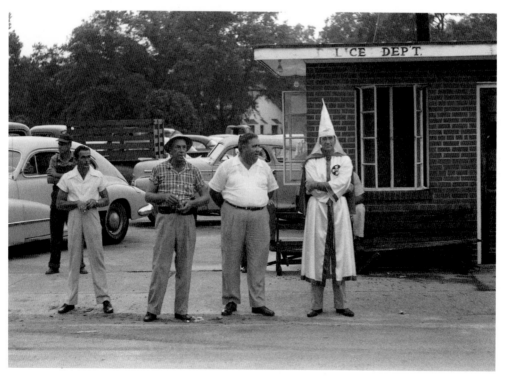

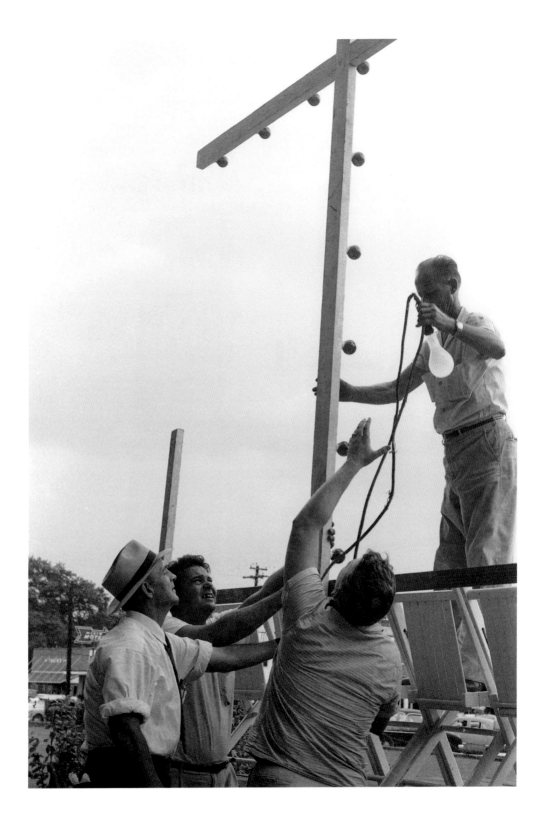

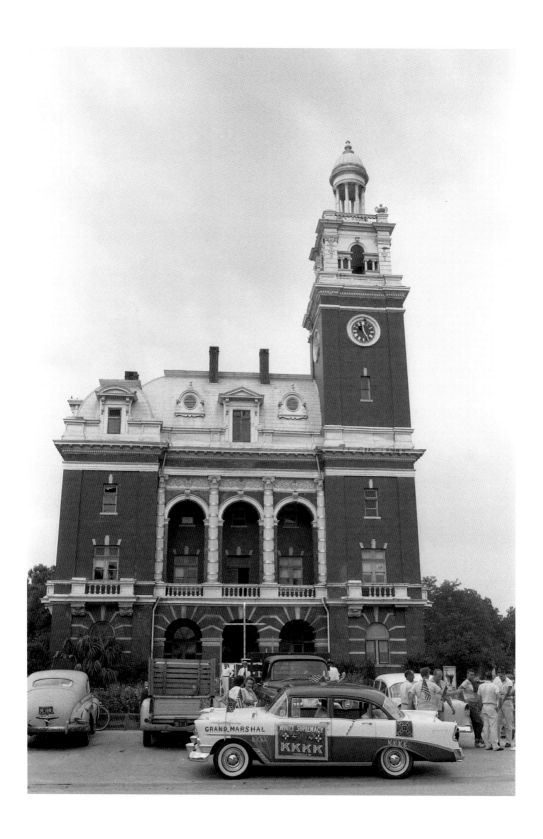

But I didn't slow down to find answers to my own questions that night — I accelerated. Now, up close, face-to-face, what kind of people was I among? Finally, I had stopped.

So many reflections were churning through my brain, over-stimulated by the extraordinary circumstance of traveling down a road following a line of cars advertising racial hatred, heading for a celebration of the rites of a world I knew nothing about.

As we moved toward Reidsville, we passed a few black people on the road — two women walking. What were they thinking? Was it like passing a poisonous snake that wasn't trying to bite at the moment but might later on? Or was this the kind of parade that one got used to on Saturday afternoons in rural Georgia?

Mean Face pulled off at a filling station to repair his paint job. A young black man gave him a wary look. I then saw another carload of Klansmen at a gas station. I was hoping to photograph some reaction to them from the black filling station attendants, but the driver filled up the car himself.

It began to rain about thirty miles down Highway 280. The KKKK decorations on the cars, applied with water-based paint, began to weep. After the storm passed, the group stopped for repairs, after which they continued to the outskirts of Reidsville, where they pulled over to wait until dusk. Darkness suited the Klan — they called themselves the "Invisible Empire."

To most South Georgians, the town of Reidsville had an ominous reputation — in part due to the familiar presence of chain gangs, men dressed in striped prison uniforms, working on roads near the state penitentiary on the outskirts of town. Otherwise, Reidsville was an ordinary market town, serving the surrounding population of tobacco, corn, and cotton farmers. As in many other areas of the Deep South in 1957, the farms around Reidsville were small and the farmers poor. Reidsville, the county seat of Tattnall County, had a population less than 3,000 — about half black. On Saturday afternoon this population doubled, when farm families came into town to shop for supplies and socialize on Main Street across from the courthouse. There was nothing else to do in Reidsville; there was no bar — it was a devoutly Christian dry town — and no movie theater. But on this day, they were about to have a special treat, a Klan rally.

In the courthouse square, there were men in shirtsleeves and white Panama hats talking, separated by an invisible barrier from the women socializing in front of Blounts Department Store. The young girls had a gawky look that went beyond what you would expect from teenagers: their arms and legs were stick-thin, and they stood in awkward stances that came from conditions that I knew nothing about. What kind of a diet produced this look, or was it something else?

They didn't look as ravished as the rural Southerners pictured by Dorothea Lange in the 1930s, but there was that look. Some of the middle-aged men squatted on their haunches with the ease of Asian farmers. These people didn't look desperate, but they seemed worn. It was easy to imagine them out in a field bent over behind mules, plowing. Some of the white children were barefoot.

In front of the courthouse itself, several men erected a platform. When it was assembled, a giant cross was raised on the courthouse steps, watched by the mixed race crowd with great interest.

Down the block on the corner of the courthouse square was a small brick building, which might have been mistaken for a public toilet except for the

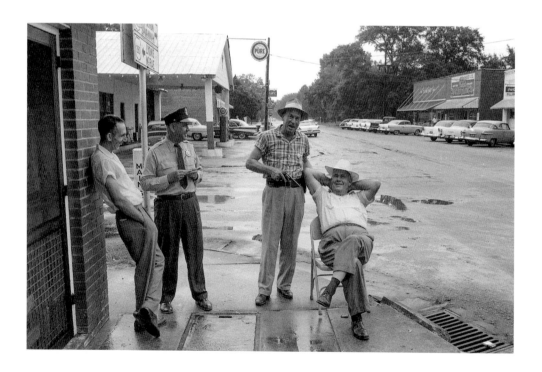

words POLICE DEP'T painted above a single window. When I started to take a picture of it, the good old boys began to cut up. The Tattnall County Deputy Sheriff drew his .38 caliber revolver and aimed it at the Tattnall County Sheriff. Everybody roared with laughter and yelled: "Take his picture!" I did.

Someone pointed out to me that the Mayor of Reidsville had arrived, and shortly after that came the Grand Kleagle of the Knights of the Ku Klux Klan, who just happened to be a Baptist minister from a nearby town. In broad daylight, he looked more ridiculous than fearsome in his Klan outfit. The police station was to serve as the official reviewing post. More people gathered, both black and white, to watch the show.

Shortly, down the street came the parade of cars that I had arrived with, led by a police car with a flashing red dome light, followed by Mean Face, in full Klan regalia. Five white-sheeted Klansmen were crammed into his convertible, including a small child in a miniature Klan outfit. Their tall dunce hats gave the scene a comic, lunatic look. The car parade drove slowly down Main Street, and then disappeared to make a tour of what I was told was the black neighborhood. They were back in ten minutes. Reidsville was not a big town.

As I wandered around the courthouse square, I met and chatted with several women standing among some Klansmen — all rather respectable looking. One middle-aged woman wanted me to take a picture of her with her adult son, dressed up in his bizarre Klan outfit. They were nice together, almost sweet. We talked, and I felt comfortable with the pair. We didn't exchange many words, but there was a relaxed intimacy. It was like an encounter at the grocery store where a few casual remarks about the vegetables would have been appropriate. There were so many things I wanted to know about them. Were they farmers, were they poor? None of them sounded particularly educated. The women, children, and perhaps even the men didn't seem larger-than-life monsters of bigotry and fearmongering. But clearly they clung to the only mark of difference between themselves and blacks — the color of their skin.

There were still a few drops of rain coming down, but the rally began. Everyone sang the National Anthem, followed by a public recitation of the Lord's Prayer. Invocations of Country and God placed the agenda on unassailable high ground, but it was downhill from there as the Baptist Minister-Grand

Kleagle railed forth on the evils of Communism, Jews, Niggers, Catholics, foreigners, and *Time* magazine from his elevated perch on the steps of the County Courthouse.

A large crowd of whites and blacks watched discreetly across the street from the courthouse. By 9:30 p.m., the rally was over. It had stopped raining. Everybody went home. I found my car and drove away.

A week after my long day with the Klan I got a call from a friend reporting that Klansmen were in downtown Savannah, on Broughton Street, all garbed up. "Mean Face" and his brothers were passing out leaflets in my own backyard — the place that I had incorrectly assumed was above and beyond the reach of the Klan. Their reach was wider than I thought.

Later the same year, I went to see the legendary Edward Steichen, then the Director of Photography at the Museum of Modern Art in New York. Mr. Steichen said that he wanted to encourage me and he bought one of my children's prints for MoMA, explaining that when he was a young photographer he had sold a print to Alfred Stieglitz for $5, the same amount he paid me.

It never occurred to me to show my Klan pictures, eight rolls of film that covered everything I saw. But I had made a lot of mistakes; many pictures were blurred because I was using slow film in low light, and my second-hand telephoto lens proved to be a disaster; it was clearly broken, a huge disappointment. Technical quality was still beyond me.

But what might have happened if I had shown him my first photojournalism experiment – a day with *U.S. Klan, Georgia 41*?

Later, I traveled back to Tattnall County, and visited County Judge H.O. Walker, who identified a number of people in my photographs. I gave prints to those I could find who had been photographed. One set of pictures was displayed in the local café and the Police Chief took my photo of the courthouse, which included Klansmen, to hang in his office.

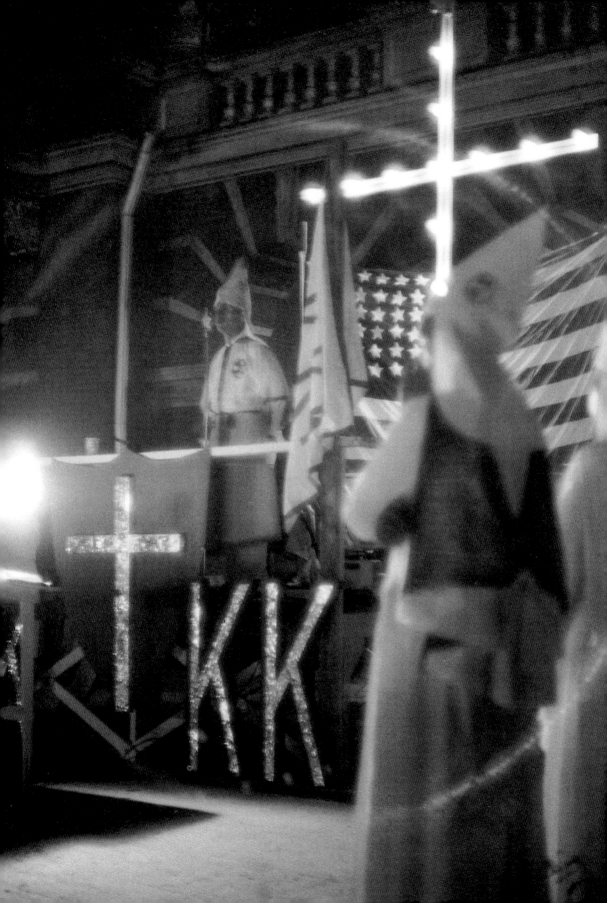

10 – EUROPE

My trip to New York to see Edward Steichen at the Museum of Modern Art boosted my confidence. And it led me to hope that if magazine editors detected a pinch of talent and a lot of enthusiasm in me, they might be persuaded to write a polite "To whom it may concern" letter designed to show editors or potential subjects that this unpublished, unknown photographer would risk anything to produce a good story. Luckily, my brother had a friend, Donna Desmarais, who was a magazine editor, and agreed to guide me. She provided two lists; an A list — the "impossible to see" editors — as well as a "they might respond" B list.

Defying logic, common sense or intelligent analysis, I started at the top of the A list with the world-famous Art Director of *Harper's Bazaar*, Alexey Brodovitch. To my surprise, this volatile, hawk-nosed, Russian émigré, turned out to be convivial, kindly, and optimistic. Luckily for me, he was far more interested in my adventures in the Marines and contact with Picasso than the technical matters that I was so worried about. I was further amazed when he provided an astonishing letter authorizing me to find stories for the magazine. This encouraging pat on the head was in lieu of even the smallest cash advance, but I deeply appreciated it. Years later I learned that Mr. Brodovitch had discovered a long and impressive list of artists whom he had nurtured because each of them had approached photography in ways that were unconventional at the time. They included Irving Penn, Richard Avedon, Robert Frank, and my recent nemesis Lisette Model.

By the summer of 1957, I had earned roughly $10,000, enough cash to try my luck in Europe — a place that seemed to breed photojournalists. Photo-

graphing children was fun, but when funding came out of Mom's cookie jars, it was always problematical. Mothers learned to love my work, but not all the bill payers, their husbands, understood my approach, which at that time was unconventional. How to proceed was unclear. There were other options, and my proposed leap across the Atlantic required answering serious journalistic questions — such as where to go, how to get there, and why? Competition from American photojournalists overseas ruled out London and Paris; that's where every other photographer I had ever heard of seemed to be based, along with all the photo agencies that were not interested in my work.

I could perhaps have gone to war again as a photographer — the Suez Canal crisis had erupted in 1957 — but I had lost interest in wars. Although I knew how to survive in combat, I had no clue how to make my way through the maze of press accreditation, or how to insert myself into an international crisis in competition with experienced photojournalists. That was a skill I had not yet acquired. Apart from that, war disgusted me. I had learned a great deal, but I also had come to the conclusion that war was man's stupidest way of solving problems. So I headed in a different direction, a destination that had a longstanding reputation for peace. I decided to look in the one place that was far away, yet provided possible contacts for economic survival and story ideas — Sweden.

Sweden was also, of course, where Monica was. Letters between us had begun to pass back and forth across the ocean and they seriously influenced the answers to the *Where* question and maybe even, the *Why*? Was this a proof of the forecast offered by the wise editor from E. P. Dutton that "adolescent fantasies" tended to sway my judgment? I didn't know the answer to that.

But in addition to Monica, I also had some interesting Swedish addresses from another source. My godfather, Samuel Shellabarger, was a Princeton history professor and the author of the best-selling novel *Captain From Castile*. His Swedish wife, who I called Aunt Vivian, came from a family sprinkled with barons and counts. The Shellabargers were close family friends and we visited back and forth. They provided me with a special feeling about Sweden. Aunt Vivian's friends and relatives had visited Savannah and were treated by my mother to her extensive hospitality. These were urbane, attractive people and fluent in English, a condition that would save me from the embarrassment of

being dropped from dinner parties because I didn't speak the local language well enough. I knew from them also that Swedish high society was a tight club in a small country, so where could there be a better place to re-start my children's work than with a few contacts from Aunt Vivian?

On July 11th, in 1957, I flew to Frankfurt and caught the train to Stuttgart to collect a new Mercedes 220S Cabriolet, a convertible, taking advantage of a huge savings if I picked up the car at the factory in Germany. The most impressive argument to choose this expensive car over the more practical, economical VW Beetle was the strength of the dollar in 1957, and the fact that German manufacturers provided extraordinary deals for Americans who were willing to travel to the factory to get their cars. It cost around $5,000 — a lot of money for a car at the time — but the Beetle never had a chance. My dear old Hillman had returned with me to the U.S. but succumbed to a fender bender in New York, and I sold it for $200.

The Mercedes salesman told me that there were only three cars like mine in Scandinavia, two belonged to shipping magnates in Denmark, and a member of the Norwegian royal family owned the other one. Mine would be the only one in Sweden: would it impress and entice society families there to hire me to photograph their children? And what a wonderful surprise for Monica.

From Stuttgart I motored in style to the Leica Factory at Wetzlar, where I took possession of two Leica MP cameras. Once again, the strong dollar justified my extravagance. My visit to Wetzlar also coincidentally gave me a chance to see the effect of my new car on others: the publicity director of Leica was sufficiently impressed to invite me to an expensive lunch at a restaurant housed in a former castle perched on a nearby hilltop. It was comforting to discover that photography was not the only way to gain respect in these circles. It was a lesson I wouldn't forget.

Choosing the slightly more upscale model MP Leica over the equally efficient M-3 model also had to do with my attraction to upgrades. The M-3 was about $325 and the MP slightly more. The P added to the M series Leicas stood for Professional, a classification that I hoped I would soon truly earn. (I didn't know it at the time, but in making this purchase, I really lucked out. As it happened, Leica only made 400 MPs. Fifty years later, the 2011 issue of *Leica World* magazine reported that one of them had been sold at auction for 94,000 euros,

about $120,000 at the time. My MP, which had cost me $375, and which I still had, was removed from my camera bag and transferred to a bank lock box the same day.)

My drive from Germany to Denmark on my way to Sweden in my convertible was a voyage of anticipation. Although I had only briefly visited Sweden in 1953, it seemed the spiritual opposite of home turf that contained too many ghosts from my past. Again I was ready to escape — this time to a place where the playing field was neutral, the air was cool, and the sky was clear. The lower part of Sweden connected to a Europe that I knew and which contained many hoped-for contacts, but there was another part that took my imagination a thousand miles north — all the way to the Arctic Circle, to the land of nomadic reindeer herders. That seed had been planted years before, when, as a seven-year-old boy, I pored over stacks of the *National Geographic* at Cloverfields in Virginia looking at pictures of exotic places and heroes of the north. These memories from the past would affect my future.

As I approached the Scandinavian coast, my mind was also flooded with nude beach scenes from a Swedish movie I had seen years before in Paris. Sex and romance were in the air. I kept my eyes peeled as I drove, but although it was midsummer, I was almost freezing to death with the top down, which may have explained the shortage of naked young women prancing around the beaches.

Monica had selected for our rendezvous a hotel in Helsingborg, a short ferry ride from Helsingør, Denmark. Although I had not explained in my telegram that my arrival would be in a beautiful green Mercedes convertible with red leather seats, I secretly hoped that our hotel would match the importance of the moment and be the appropriate first step for all the expectations that accompanied my elegant new vehicle.

I don't remember the name of our rendezvous; it may have been the Grand Hotel, but that's a guess because every other hotel in Europe is called the Grand Hotel. This Grand was not grand at all, however. It was an old structure with tall narrow windows and an ornate neo-Gothic-shaped tower at one end. The elderly woman at the registration desk demanded my passport and Monica's identification. There were a lot of questions in Swedish about why our names were not the same. We finally got our key, but the pomposity of this offi-

cious woman was both surprising and embarrassing. This was not the Sweden I had anticipated.

We rode up to our room in an elevator housed in a cage in the tower. The contraption was barely large enough to accommodate two people with no more baggage than a toothbrush, but it creaked and jerked us to the second floor. We found our room, and there, between peeling papered walls with a faded floral design was a double bed and basin. The bathroom was down the hall. For me this was not an appropriate introduction to the Land of Free Love.

Although the hotel was a setback, I was still looking forward to introducing Monica to my new car, which I had just washed in Denmark before taking the ferry to Sweden. I had been careful not to mention this wonderful addition to my life during our eight months of correspondence, but when we went out to the parking lot to retrieve my luggage from the trunk of the gleaming Mercedes-Benz Cabriolet, Monica took no particular notice — another setback. I had just introduced her to a car that described the new me.

Part of what attracted me about Monica was that she gave me the impression that I was on some altar in her mind where everything I did was OK, and I operated above the traffic of mere human behavior. Unpleasant creeping truths held no fears for her, nor did she have any defenses against them. She had no skills in either manipulating people or information. Mercedes vs. battered Hillman Minx didn't register with Monica. Perhaps her artlessness drew from some deeper truth that I couldn't understand but felt was there. That's what I loved about her *and* she was also the opposite of my mother.

The next day we made the long drive north to Stockholm — with the top up and the heater on — the cool wonder of the Swedish landscape in the midnight sun began to erase the gloom of hotel memories.

Monica took some time off from work and we drove to visit her parents in Uppsala in central Sweden. When I met Dr. and Mrs. Lagerstedt, I couldn't forget Monica's story of going to her father when she was a teen to confide about some confusion in her life and hearing that "no daughter of mine could possibly have a psychological problem." Meeting the doctor, I found him to be Gibraltar-like, guarding the entrance to a world that I had heard about but only vaguely understood. His formality was impenetrable, conversation was limited, and I got no sense that my presence with his daughter bound him either to

ask questions or reveal anything of himself. Communication was polite, and humor was nowhere to be found. This all gave me the feeling that he had finally discovered that his daughter did have psychological problems and that I might be a major symptom.

Mrs. Lagerstedt, on the other hand, was a warm and agreeable person. Although both of them were well educated and intelligent, there were no clues that, unlike Monica, they had ever been tempted to investigate the world beyond Sweden. That was the first and only time I ever saw Dr. and Mrs. Lagerstedt.

When we returned to Stockholm, I found that Monica, to my surprise, had recently acquired a roommate, a Bulgarian refugee named Senka, who was away on vacation but would soon be returning. Monica's one-room apartment at Grev Turegatan 34 would clearly not accommodate me. I had hoped to be staying with her, but had not said so in our correspondence. Although Monica was as sweet as ever, we had difficulty getting together. She now had a roommate and I had no place to live. She still mightily attracted me, but I was hopelessly unemployed. Something had to be done. A big chunk of my $10,000 had been spent on car, cameras, and my trip over, but perhaps with some introductions supplied by Aunt Vivian it might be possible to soon be rolling up to various castles — with the top down of course — in search of children to photograph. Alexey Brodovitch might also be interested to see such pictures if my good luck held. My campaign started with a phone call to Inger Nilsson, a very attractive friend of Aunt Vivian who I had met when she visited my mother in Savannah. She and her husband Sven invited me for a wonderful weekend at their estate in the country, but the couple didn't have children, and I didn't have the courage to ask if they had friends who might like their kids photographed.

Admiration of my car by many people proved insufficient to advance my plan to storm Swedish society. So, three weeks after my arrival in Sweden, having not ended up in a castle and unable to afford a hotel, I wound up in a hostel that turned out to be a ship called *Af Chapman* tied up in Stockholm harbor.

Af Chapman exuded history but most appealing to me was the price of admission: two Swedish crowns a night, when five crowns equaled a dollar. *Af Chapman* had been named after Vice Admiral Fredrik Henrik Af Chapman of

the Swedish Navy. She was one of the last great steel-hulled full-rigged sailing ships. Built in England in 1888, she had traveled the seas as a cargo vessel and made several world cruises as a Swedish Navy training ship prior to World War II. During the war she served as a barracks for Swedish sailors and became a hostel in 1949.

The great white ship was moored at Skeppsholmen, a de-militarized naval base on an island in Stockholm harbor. To get to and from it, lodgers had to pass through a gate guarded by a sailor. Skeppsholmen itself connected to Stockholm by a narrow bridge that also led to the stately National Museum, a repository of some of Sweden's classic treasures from the Middle Ages to the present. The street then passed a few dignified buildings leading to the truly grand Grand Hotel, the most luxurious accommodation in town. It was a twenty-minute walk from *Af Chapman* to the center of the city.

The harbor side of *Af Chapman* provided a view of the charming, tiny, congested, cobble-stoned 17th century Stockholm, parts of which dated back to the 14th century. This was the location of both the Royal Palace and an abundance of cafés, bars, restaurants, and antique shops selling anything that could be considered the opposite of Swedish Modern.

Af Chapman preserved seafaring traditions in her accommodations. The cabins were what you might expect on a Navy training ship with maximum efficiency and minimum space. Historic authenticity was also retained by the temperature of the water that came out of the showers — just above freezing — a clever strategy guaranteeing that soft, warm-blooded people from southerly climes would move out sooner rather than later.

The "Captain" of the *Af Chapman* was a tall, formidable woman, Miss Johansen. Her demeanor was stately; she was unruffled by anything, iron-willed, and politely dictatorial. She had that quality that we called "command presence" in the Marines, and she was determined to turn young bargain hunters like me into Vikings. There was to be no lolling about in your bunk, wasting the day on her watch. Rigid discipline was maintained and all cabins were locked down between 11:00 a.m. and 3:00 p.m. There was also a set time when it was possible to get back aboard *Af Chapman* enforced by the sailor at the gate. Miss Johansen would have loved my grandmother.

She and I got along very well however, as she realized that I was not the usual economy traveler. Perhaps because I asked so many questions about the

old ship, Swedish history, and politics and had a fancy camera she might have thought I was a journalist. My Mercedes parked nearby may have suggested that I was certainly not the usual backpacker but rather an upscale foreigner deserving of respect. Or did she somehow get it in her head that I was going to write a story about *Af Chapman* and, of course, her Skipper?

This misunderstanding earned me a lot of useful information from Miss Johansen that included her telling me about a group of ten Swedish photographers who appropriately called themselves TIO (ten) Fotografer. These men were the most famous members of what in 1958 was an active photography scene in Sweden. Several of them were included in Steichen's famous *Family of Man* exhibition at New York's Museum of Modern Art in 1955. What made them unusual for Sweden was that four of them had lived and worked in Paris in the early 1950s and the group had a much broader view of the world than a lot of other talented but more locally oriented artists. There were photojournalists as well as commercial photographers among the ten and, like Magnum, the agency was owned and operated by the artists. A few of the members lived and worked in other Swedish cities but most lived in Stockholm.

My visit to TIO offices was a success; they were not at all antagonistic toward a foreigner who might in theory be a competitor. In fact they were friendly and curious about the Leica-bearing, Mercedes-driving freelance photographer. Famous foreign visitors often dropped by the TIO offices, and one day Edward Steichen came by as I was there; Mr. Steichen remembered me, which elevated my status among the members. My portfolio of photographs of the children of the elite of Savannah, however, did not impress the group and they were no help on the subject of how to get to the Countess and Princess set for jobs. I was pleasantly tolerated, though, and eventually became a close friend of Pål-Nils Nilsson, one of the TIO founders.

My first effort to transfer officially from children's photographer to photojournalist found me at the Swedish Foreign Office Press Department trying to get accreditation in the form of a press pass. I had learned at TIO that Swedish Railroads would issue free tickets for journalists to work on stories. My interview didn't take long, however, and I was politely told that proof of affiliation with a news organization was required. My letter from Alexey Brodovitch wasn't official enough for the proper Swedes. What was obviously needed was a press pass from somewhere else that had my picture on it. The woman inter-

viewing me, Mrs. Fornander, inadvertently gave me a hot tip by volunteering that she was surprised that a photographer like me wasn't covering the European Track Championships that were about to start in Stockholm.

"Oh, of course, that's on the top of my list," I responded and I went off immediately to buy a newspaper and figure out what she was talking about. This soon led me to the Klocktornet Stadium Press Center with every camera I owned hanging around my neck. I was an impressive sight, clanking along with three Leicas, with every lens I owned attached. To this staggering collection of equipment, I added a Rolleiflex, an even bulkier twin lens reflex camera, the same model that I had used to photograph Picasso.

In the office in the basement of the stadium, there were reporters and photographers from many nations milling around in confusion. I stood in a long impatient line that eventually led to a harried woman handing out credentials. She spoke English, but it was impossible to understand her because of her strong Swedish accent. I was also reluctant to hear questions such as: "Do you have the letter authorizing your picking up the Press packet?" I kept repeating: "What? What?" Finally she said something clear:

"Are you Mr. Williams?"

"Williams?" I answered, "Why yes, that's me!" and I got out of there as fast as possible with a packet she handed me that included Press passe No. 98 for Europamästerskapen I Friidrott 1958 — European Track Championship Games. I was in.

When I went to the stadium with my pass, I had permission to get close to the action in a roped off area that was unavailable to the public, but I chose to go as high in the stands as possible. Near the track, close to the athletes, was where the thief and fake photojournalist didn't want to be.

Presumably, somebody might be looking for the other Mr. Williams. There, I thought, I could also get wonderful panoramic shots of the stadium's awesome architecture even though the athletes competing below were the size of ants. But even the 200mm lens that I recently purchased at Molander, a well-stocked local camera store, was completely useless at this distance from the sports action, and my pictures turned out to be worthless.

Fortunately, there was enough space above "Sports Illustrated Magazine" to type in Frederick C. Baldwin. The next day, I found a coin-operated laminat-

ing machine at Stockholm Central Station, and prepared the card for a lot of wear and tear.

On my return to the Foreign Office, my Sports Illustrated Pass had a magical effect on my formerly unimpressed friend Mrs. Fornander. She passed me through an invisible gate from dubious to acceptable or innocent to fraud depending how you looked at it.

Although this was not the first time I had pushed the boundaries of propriety, I had to ask myself how far I was willing to go. Steal a working journalist's press pass? There must be better ways of crawling out of the bottom of the freelance barrel. My quest for Free Love was in the same shape. Nobody was going to make a sexy Swedish movie based on what was going on in my life. Senka's presence in Monica's apartment became another cold shower that I couldn't tolerate. Our relationship continued but under difficult circumstances.

During my stay aboard *Af Chapman*, units from the Soviet Baltic Fleet visited Stockholm. Several cruisers and destroyers anchored in the harbor and launches brought Russian sailors from the ships and unloaded them next to *Af Chapman*. The welcome ceremony at the landing was not a newsworthy event for any publications that I could think of, but when all the smoke blew away from the salutes fired by three antique cannons near *Af Chapman*, I got into conversation with a man who seemed interested in talking to me. After finding out I was an American, he began to explain in English about the visitors. He seemed to know a great deal about them, the military significance of the salutes, and the non-aggressive but cautious relationship with the Soviet Navy in sharing the Baltic Sea with Sweden. In fact, he kindly invited me to join him for dinner at his home with his family. Delighted by the offer of a free meal but being new in Stockholm, I was not anxious to try following him in what was left-hand drive Swedish traffic in 1957, so I agreed to drive the two of us to his home in my car and he parked his car inside the gate next to *Af Chapman*.

On the way, my new friend introduced himself. He was Chief Inspector Hammerby of SKP (Swedish Security Police). Good God — the J. Edgar Hoover of Sweden!

Relieved to discover that I was not being arrested for stealing the Sports Illustrated press pass — I learned that the Chief Inspector, in England once on a visit to Scotland Yard, had met a complete stranger on a bus who invited him

home to dinner. This experience had deeply impressed Hammerby and he began taking foreigners home to his family.

The meal was very pleasant. Mrs. Hammerby provided us with classic Swedish pancakes that I still remember. They were rolled up like enchiladas, sprinkled with powdered sugar and topped with lingonberry preserves, a dinner delight in Sweden, not a breakfast treat. After dinner, we all looked at Chief Inspector Hammerby's slides of various trips he had made to England and France on business. Then Hammerby and I left around 11:30 p.m. to return to *Af Chapman* to pick up his car. The car, however, was on the inside of the gate and the sailor on guard would not let the Chief Inspector in to get his car out. He would let me in because I had an *Af Chapman* Hostel pass signed by Miss Johansen; the Chief Inspector's credentials were no good, even though they came on a long chain and were extraordinarily official looking. Hammerby was furious and had many strong words for the sailor — in Swedish. I assumed he was demanding a call to the Admiral of the Navy to settle this outrage, but the upshot of it was that the sailor was not about to disturb Miss Johansen. There seemed a simple solution: I would go in with my pass, taking the Inspector's car keys, and drive out the gate with his car so he could escape. This was OK with the sailor, but my new friend was so angry that he stormed off in a taxi.

The next day, his car was gone. I never found out what happened to it, but Chief Inspector Hammerby and I remained pleasant acquaintances and saw each other from time to time. We didn't discuss the *Af Chapman* incident.

As much as I enjoyed my stationary cruise on the *Af Chapman* — the rules began to bother me. The Hammerby fiasco opened my eyes to some of its drawbacks. Nonetheless, I left the hostel on the friendliest terms with Miss Johansen, and I frequently visited her at coffee time, the Swedish version of English teatime, to catch up and deliver gossip to this formidable lady. She was well informed about her guests and through her I met Pete Peterson, a California-based filmmaker who was making TV commercials for Canadian Club whiskey. Among the things Pete and I talked about were the exacting qualities of color film and the special lighting it required. This was all fascinating, and useful, but it scared the hell out of me. I didn't know what he was talking about half the time. Curiously we were to meet again under very different circumstances.

Needing a new place to stay, I moved headquarters to the suburb of Lidingö, near my TIO friend, Pål-Nils Nilsson. I took to sleeping in my car in the woods near his house. Pål-Nils' wife, Inga, also became a good friend. They were kind enough to let me do my laundry in their washing machine, and also provided me with a hot shower.

As a foreigner, I was required to check in with the Swedish Police every six months, but I decided to visit the Police Chief of Lidingö early. This officer was surprisingly friendly, and in time we became good friends; he occasionally invited me over for dinner. He was also glad to hear about my meeting with Chief Inspector Hammerby. I took pains to reveal to him my sleeping arrangements to preserve my peace of mind and to avoid being treated to late-night surprise visits from the cops.

In late August the woods were quiet and the trees didn't care what time I came and went. Neither did the police after my friend the Chief put me on the "Do Not Disturb" list. My history of sleeping in cars beginning in a Hillman Minx on Picasso's doorstep was now upgraded to the custom-fitted reclining leather seats of the Mercedes. This was a perfectly comfortable place to roll out my sleeping bag.

As our friendship deepened, Pål-Nils and I had long talks about different approaches to creativity. Barbro Nilsson, Pål-Nils' mother, was a famous textile designer and his father had been a sculptor. Art came to him as part of his heritage, and, unlike mine, it was not a platform for rebellion. Our approach was so different. His beautifully crafted photography was made with a Hasselblad, an instrument that encouraged careful contemplation because in framing images you gaze into a mirrored reflection of the subject. My rangefinder Leica was used like a quick draw weapon, able to catch a subject rushing by at 1/250 of a second. Fascinating conversations began to emerge as we discussed our different approaches to photography and life.

I had no plans yet, but ideas of heading north were under consideration. My early childhood dreams of reindeer herders were rising to the surface. Finally, as the weather got colder in September, Pål-Nils and Inger began to worry about my sleeping in the Mercedes. I was invited to park my car in their driveway and myself in a warm bed in their guest room. It seemed appropriate to me that Pål-Nils should use my car when I began to investigate his cold country. We had all become close friends.

By this time I knew all the photographers at TIO quite well and would occasionally go with them on exploratory excursions. The great French photographer Edouard Boubat once visited Stockholm — major photographers tended to drop by TIO when they were in town — and I was invited by Rune Hassner, one of the best TIO photojournalists, to come along with Boubat to photograph a stock car race in the south of Sweden. I suspected that they were really inviting my car but I was welcome to come along to drive it.

The special qualities of the event we were going to, called *Ragare*, escaped me. It was the opposite of the sleek Grand Prix look of speed and grace. Power was represented by souped-up battered versions of ordinary autos. The two race forms were as different as ballet and wrestling. In spite of a vibrant carnival atmosphere at the track, the whole business seemed like an American transplant of a Demolition Derby, and it didn't appeal to me.

When we returned from the races, Boubat and Hassner printed their film and put up a little exhibit of this work at TIO. I was allowed to develop my film there and I made contact sheets of the day's work but didn't show my results. It came as no surprise to discover that their photographs were good and mine were bad. The experience made it clear to me that I had much to learn if I were going to survive as a photographer. It would be best to start the process immediately. What I needed was not going to rub off by hanging around experienced photographers and getting to tag along by courtesy of my Mercedes. I had to get out and do my own work.

The question was, where to go and what to photograph? Images of the unusual people of the north in the *National Geographic* had intrigued me as a boy and now it all came back. The mysterious, nomadic Laplanders, who journeyed across northern Scandinavia with their reindeer herds, fascinated me. And, after all, reindeer sleds had been the transport of choice for Santa Claus, so maybe that influenced me.

I began to do more serious research at Nordiska Museet, in central Stockholm. The people that I had referred to as Lapps, a name that had been used since the 13th century, was a designation that was not only inaccurate, but I learned was offensive to the reindeer herders. In their language, which is of Finno-Ugril origin, a combination of tongues that included the Magyars of Hungary, *Sæmieh* means reindeer people. The word Lapp only means "a patch

of clothing," a description that was suggested by their colorful multi-colored and patterned dress. Sami is the correct abbreviation for these people, and Lapland is the modern geographic designation of where they live. In 1958, these semantic issues were rising in the public consciousness and there was debate in linguistic circles about the source of the eleven different languages once spoken by the nomads who followed the reindeer across the Arctic and Sub-Arctic regions of Norway, Sweden, Finland, and the Kola Peninsula of Russia. For more than five thousand years they had been more interested in feeding their herds on the Arctic tundra (a Sami word) than observing national borders, a condition that was no longer possible.

The museum displayed ancient drums and beautifully decorated knife scabbards and buttons carved from reindeer horn. The following text, given in Swedish and English, described the dominant racial characteristics of the Lapps: "unusually low skull, triangular shape of the face and dark hair with brown eyes... they are descendants of a special Palaeoarctic race said to lie between the white and the yellow races." Additional material revealed that the Sami from the south of Swedish Lapland were not able to understand those to the north in their own language.

That only got me started on the complexity of their culture. More immediately relevant to my interests were the outlandish brilliantly colored medieval outfits on display. This was still the traditional and highly photogenic dress code among many of these exotic herders. And I thought that the spectacle of thousands of reindeer, those big, antlered mammals, being rounded up by colorfully dressed families of Sami for their annual inventory would make a stunning picture story.

But to get there was a long and expensive trip, so I went to consult my new friend, Mrs. Fornander, at the Press Office. What she knew of the Sami turned out to be not much. The far north was not of exotic interest for her, or of any interest at all to most Swedes. They seemed to care little for Lapland or the Arctic. Mrs. Fornander had never even been to northern Sweden; her personal orientation was south and this was not unusual. Even Pål-Nils, who had done extensive work in far-off places, had no experience in this exotic part of his native country in 1958.

I had read an astonishing article in an American magazine that described an experiment by a Swedish psychologist that illustrates the point. The head of a Swedish mental hospital took a small group of non-violent, deeply depressed patients who refused to speak, to a small village in Tuscany. The medical treatment consisted of the patients sitting in the sunny village square every day, where they observed the Italian scene and were observed by the doctor. Presumably, they sipped espressos, drank wine, and ate food that was lubricated with the oil of olives rather than fish. Within six months, a miracle had occurred and the Swedes were chatting away, having a great time — and soon returned to Sweden — pronounced cured. The south does wonders for Swedes.

Although oriented south, Mrs. Fornander was helpful in finding me the most northerly tourist lodge in Lapland — Abisko Turiststation located on Lake Torneträsk. This sounded like a perfect target destination for me to learn more about these northern dwellers. It was roughly 1000 miles north of Stockholm. Thanks to Mrs. Fornander, I was issued a free round-trip ticket on Swedish Railroads (known as SJ) by the Press Office.

By the end of September, I was on my way to investigate Lapland. As for Monica, she and I had maintained a somewhat disconnected relationship that was dependent on the coming and going of her roommate Senka, but nothing more had developed between us. We were still involved, but my restlessness was growing, my savings were shrinking, and it was time to go to work.

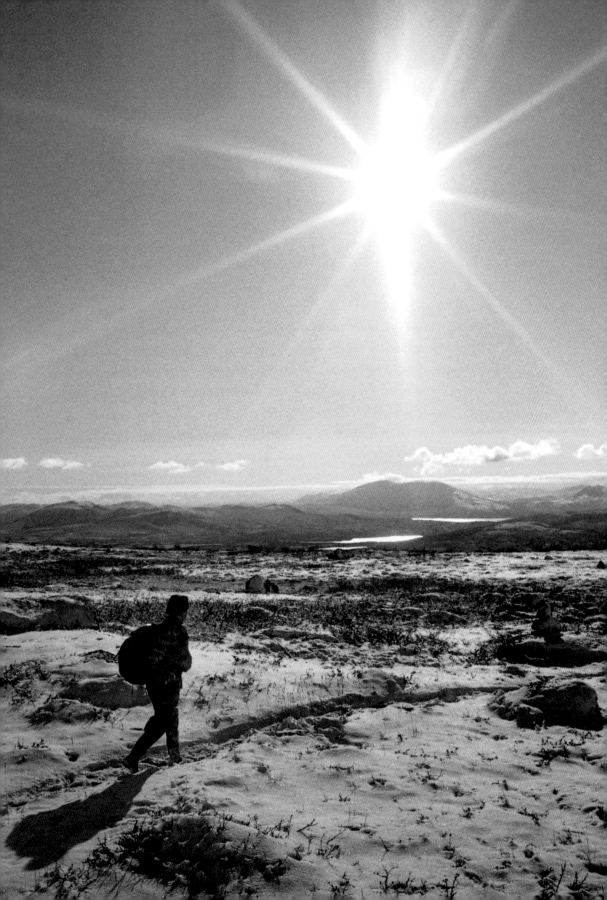

11 – NORTH TO LAPLAND

My train route to Lapland following the Baltic coast took me to SJ's northern limits. Along the way, only Uppsala, the famous university town, was a familiar name; then on to Sundsvall, swinging east to Vännäs and up to Boden, mysterious dots on the map, before we crossed into the Arctic Circle to Gällivare, and on to Kiruna, the site of giant open-pit iron ore mines. Finally, after traveling for 20 hours, the train stopped 160 miles north of the Arctic Circle. I got off at Abisko.

I remember very little of the train ride, most of it a blur of groggy glimpses of scenery streaking by at 70 mph with intermittent breaks for food delivered by pleasant SJ vendors who made their way through the cars. The gentle jiggling of the railroad seemed to have sedated my curiosity, and I realized upon arrival in Abisko that I had slept on and off for most of the way.

A two-minute walk down a path from the train station led to a lodge that had once been a barracks for railroad construction crews until it burned down in 1949. Rebuilt as a hotel called Turiststation, it maintained a touch of its rugged past. When I checked in, the clerk asked whether I would like to rent sheets or a pillow for an additional fee. I was able to decline this offer because my kit included a sleeping bag recently purchased in Stockholm to keep me warm in my Mercedes. It was filled with reindeer hair — just the thing for Lapland. Down the hall from my room there was a bathroom and a shower with blessedly hot water — an upgrade from my accommodations aboard *Af Chapman*.

After an uninterrupted night's sleep, it was time to wake up and plunge into my journalistic investigation of Lapland, the new operational theater of my

imagination. This morning, before the newness wore off, no detail would be overlooked.

At breakfast I joined a group of friendly young Dutch and German backpackers and some older Swedish tourists. Long communal tables gave us a magnificent view of Lake Torneträsk and the mountains to the north — framed through large picture windows.

Our meal began with smoked reindeer, a Lapland treat; it had a sweetish smell, more subtle than the one coming from my sleeping bag. Knäckebröd, translated in English as *crisp bread*, seemed to be a culinary building block: dark brown and saucer shaped, it should have been called *iron bread* and require a dentist's prescription before putting it in your mouth. Following the example of others, I laid hardboiled egg slices on the Knäckebröd and embellished it with cod fish eggs squeezed from a tube like toothpaste. This was the famous *open sandwich* or smörgås in Swedish.

I also tried enhancing smörgås by applying butter and a touch of lingonberry jam. It had been a cloudy cool summer in Sweden and so the yellow berries had not received enough sun to produce sufficient sugar to make them anything but tart. Lingonberries are loaded with Vitamin C — a necessary addition to the diet of people who lived above the Arctic Circle where fresh vegetables were rare.

My culinary investigation continued: slightly sweetish red salami, cucumbers, tomatoes, yogurt, three kinds of hard yellow cheese, one more orange-colored, another softer one with holes in it; four kinds of smoked and tinned fish including pickled herring and gröt (porridge) that tasted like it sounds, and of course, coffee completed the meal. (Swedes are big coffee drinkers.) Missing were pancakes, a delicious Swedish tradition, but as I had discovered at the Chief Inspector's house, served at dinner rather than breakfast.

Outside, the serene nature lifted me to a more spiritual level. The glaciers that once covered this area millions of years ago had advanced and receded, scrubbing and scraping the insolent peaks that had once poked at the bottom of the sky and leaving behind what could be called polite mountains with no overly dramatic crags. Between the very deep Lake Torneträsk and the 1,163 meter high Mt. Nuolja (which has a long connecting elevated saddle to another peak) was the area known as Lapporten — Lapp Doorway. The nearby peaks

were beautiful, decorated with patches of snow that gleamed in the clear autumn morning light. Depending on weather and the shifting sun, the calm, reflecting lake gave them back again and again — always in different moods.

What a perfect place to take a long walk, observe the abundant birch trees gradually changing their colors, or to quietly read a book. My mood, however, was more adventurous than contemplative. I had come to find Sami and there were no reindeer herders at the Turiststation. I also couldn't afford a longer stay there so I rejected the gentle attractions of Lake Torneträsk.

Through my photographer friend, Pål-Nils Nilsson, in Stockholm I was given the name of Lennart Johanssen, a railroad worker who lived with his family less than a mile down the tracks toward the Norwegian border. He was an amateur photographer about my age and I looked him up. He and his wife, Inga, and two small children lived in a small wooden house, painted red. They invited me to stay in their "guest room," which turned out to be the kitchen, where a long bench-shaped cupboard that opened at the top served as a seat during the day and my bed at night. It was there I rolled out my sleeping bag.

We got along very well. Happily, Lennart not only spoke English but also knew what was going on up and down the railroad, including names of places and dates when the Sami families would be gathering reindeer.

Lennart was much more interested in being a photographer than a railroad worker, and he avidly recorded the natural scene around Abisko. Lennart and I brought together two different worlds, and we were pleased to learn from each other. He was an encyclopedia of local information, and I was connected to photography sources that he could only dream about. Endless discussions about film, development techniques, lenses, and cameras filled days that he wasn't working on the railroad.

With Lennart's help I drew up a list of reindeer roundups that he had learned would take place near the railroad line so I could get to the sites easily. Although the movement of the herds determined when the roundups would take place and exact timing was uncertain, Lennart could alert me approximately where and when.

Within ten days of meeting Lennart, I had photographed two reindeer roundups along the railroad. I had seen a roundup at Harrå followed by one at Rensjön (Reindeer Lake), both located near the railroad tracks. More accurate-

ly stated, I had done my best to photograph them. With Lennart's guidance they were easy enough to find — a fifteen-minute ride by train — but once I got there my difficulties began.

Not surprisingly, my fellow travelers from Abisko Turiststation, the Dutch, German, and southern Swedish tourists, had also come north to see the reindeer roundups. Floods of tourists had arrived, and the Sami didn't like tourists.

At Rensjön I had been told by a Sami woman not to take her picture. She didn't speak English or Swedish, but I understood her perfectly well. By chance, I was helped by the presence of none other than Pete Peterson, the commercial photographer from California, who was working on his Canadian Club whiskey television ad. He had a lot of equipment, an assistant, and a dizzy blond model. So when I got into trouble I pointed to Peterson as if to say, "See my boss." This strategy deflected attention from me for a while.

Pete later told me that he had had a hell of a time with the Sami. One old lady had chased him with a stick, and he finally had to complete his assignment by dressing up his blond, blue-eyed Swedish assistant in Sami clothing, the elaborate costume that resembled a medieval jester's outfit.

During the roundup at Rensjön, a young Sami man began yelling at me. Clearly, he had been drinking heavily. Lennart had told me that it would be unusual to see drunkenness among the Sami, because many belonged to a conservative Lutheran religious sect called Læstadians, founded by Lars Leve Læstadius, a Swedish botanist turned preacher, who decried the evils of drinking, theft, and fornication, describing the horrors of hell to the unrepentant. His fiery preaching created an evangelical movement that swept from Sweden to Norway and Finland in the middle of the 19th century.

I found a Swedish tourist to translate the drunk's ranting. "Sami are not Eskimos, Indians, or Africans. They're Swedes!"

"Of course," I explained, "I am reporting on all of Sweden. That is why I am photographing Sami. They are Swedes."

"You haven't asked permission to photograph," he cried out.

"But," I explained, "there are 50 Sami to ask, and I no speak Samisk." Then he objected to the huge amount of money I was getting to photograph Sami.

That did it. The man was out of control — clearly not a follower of Læstadius — a preacher I was beginning to admire. Other Sami were starting to notice the ruckus, so I broke off the dialogue and walked away.

After a few minutes, I noticed a family who looked reasonably friendly, and I put down my cameras and joined the children and the old ladies, helping to chase reindeer into the enclosures that I learned were special to each family. The family's reindeer could be identified individually by cuts in their fur and notches in their ears that were registered as a sort of license plate. These marks were invisible to me in the swirl of animals, but I followed the others, taking the lead from those wiser in the ways of reindeer.

It became a game, and was actually quite a lot of fun. The Sami seemed amused to see the foreigner working — taking hand signal instructions from small children and old ladies, all in the midst of the grunts of swirling reindeer.

Then my luck turned. A young Sami man joined us. His name was Per Pirak, a teacher from the secondary school in Kiruna, and he spoke English. When we took a break from corralling the animals, he asked me who I was. I quickly explained that I was *not* a rich tourist, and that I was interested in learning about the life of reindeer herders and photographing them. When I got out my notebook Per became even more helpful. As a good teacher, he fed my curiosity, explaining that mixed in with the nomadic reindeer herders there was a new generation of reindeer keepers. In the old days, the head of a Sami group kept his reindeer with him and the family traveled with the animals, which were much tamer then. A permanent corral was unnecessary. The old corrals were temporary constructions used for milking and protection from wolves. Here, the corral was permanent, providing a place for the semi-annual accounting of the family's wealth. This was a new generation of herders who no longer made the long migrations of the past.

Pointing to a Sami working near us, "That old man comes from the District of Karesuando," explaining that, "he's dressed in the national dress of the Northern Sami. The origin is medieval and much brighter and more colorful than Sami of Central and southern Lapland."

A four-year-old boy was trying his hand with the lasso. He wore a child's version of the cap with the same huge pom-pom on the top. "The pom-pom is to brush away mosquitoes," Per continued. "In the mountains in the summer, mosquitoes are fierce. A shake of the head is like a horse swishing its tail." The pom-pom could be worn down over the face for warmth in snowy winters, shaggy dog style.

Life among the nomadic Sami is so difficult, that many Sami girls are marrying Swedes and moving to easier conditions in the towns. This is gradually forcing the Sami to change the character of their lives and in the south of Lapland large reindeer co-operatives were being set up.

Land use rights have affected herders, and the role of government in their lives had begun to change long-time herding traditions. Co-operatives in the south allowed reindeer herding to continue to compete economically in a modern market. The use of supplementary feeding and other technology increased herd sizes on smaller pasture areas and this attracted outsiders. It was no longer exclusively a "family affair" as additional labor was hired to support this business model. In some cases, small-scale herders were forced to abandon the work altogether as the economic costs of maintaining reindeer became too high.

Around Abisko, once the roundup was completed, the Sami departed for their many different breeding grounds, literally the home turf of their reindeer. This was a process that started with a ride on the local train that took them to specially designated stops that were not marked on the SJ timetable. At each point, Sami men, women, children, families, dogs, and reindeer carcasses were unloaded to start their trek home, for many of them a two or three days march from the railroad. They fanned out from their last link to modern Sweden, their individual parades led by easily recognizable, large white-gelded reindeer, with bells around their necks. Draft animals followed, carrying the bulk of raw meat and camping gear. What was left departed on the backs of every Sami who could walk.

By now it was the middle of September and the reindeer roundups along the railroad were over. The next and last gathering was months ahead, deep in the mountains and nowhere near roads or rail.

There was much to think about. Frankly, I was disturbed to find that my relationship with a childhood fantasy had been shaken by my lack of success in making friends with the "mysterious nomads of the north." Perhaps my naivety bothered me even more. Meeting Per was good luck, but the drunk Sami at Rensjön voiced a prevailing attitude toward outsiders that made me uneasy.

Lennart Johanssen told me about Sami being stalked like exotic animals by tourists who poured up from the south during summer holidays. Many Sami no longer wore their colorful dress when they came to Kiruna, except of course,

"tourist-Sami" who allowed photography for a fee. Even the name of their medieval dress had been scrubbed to fit modern sensibilities and Sami sensitivity. The Lappdräkt (Lapp dress) became Nationaldräkt (National dress). Learning more of their history revealed a far darker story than the romance I had imagined. The Sami had experienced hundreds of years of discrimination by the Swedes. The problem began with land use. The Sami grazing culture was butting against permanent land holdings, in which Swedes were encouraged to move north to settle land for farming that had been used for migratory reindeer herding. Tax questions had also plagued the Sami for many years as they migrated with their herds across different countries. Also working against them was that education in the Swedish language was required in schools and the different Sami languages were banned. All of this added up to an attitude of edginess with respect to foreigners as well as Swedes.

The future didn't guarantee any more success for me than the past, so I started thinking things over and making contacts to explore other possibilities. I moved from Lennart Johansson's to Kiruna, a city of 15,000 people, fifty miles back down the railroad to the south. After contacting the Tourist Bureau, by good luck I was able to meet the Mayor, who invited me for dinner with his family. In 1958 there was curiosity in the far north about Americans who had come that far and were curious about them. This, combined with the hospitality of Swedes living in remote places, provided opportunities unavailable in the big cities.

My visit to an urban version of "above the Arctic Circle" provided a shock — the voice of Elvis Presley was swinging and swaying out of every portable radio. On weekends in Kiruna, young people were stepping out in Elvis' *Blue Suede Shoes*.

For my stay in Kiruna, Per Pirak had arranged a meeting with Nicklaus Skum and his bride Barbaro, a Swedish girl who spoke English. He was an artist and the nephew of the late Nils Nilsson-Skum, the celebrated Sami painter. Nicklaus showed me his uncle's books with illustrations of work that revealed more than the obvious color and exoticism of the reindeer herders. Although Skum's art was naive, it was powerfully charged with depictions of the traditions of the nomadic culture. The reindeer herds that spilled out of the forests and mountains in Nils Nilsson-Skum's drawings were touched by the same vi-

sion that inspired the decoration on their tools — knife sheaths, buttons, and so many utensils made from the bones of animals on which they depended for survival. I was told that this style of unsentimental abstraction traced back to early Sami drum drawings from the 6th century.

Although not called artists, the women shared this tradition by creating intricate jewelry made of silver and pewter that decorated the belts and bright wool and reindeer skin clothing of both men and women. Perhaps the colors celebrated the brilliant light of summer and cheered the Sami during the un-ending winter darkness. It seemed to me that they resembled jesters, jokers, and bishops to appease the power of nature. To the Sami, equally distinctive but different colors and styles marked their identification within the race that spoke so many different languages from the south to the north of Sweden and to adjacent Sami in Norway and Finland and those remaining in the Kola Pen-insula of Russia.

Probing for secrets as I had with Picasso's drawings three years earlier, my pursuit of the Sami culture and mindset was an upside-down affair. Nothing about their lifestyle and history related to me. Their wisdom was drawn from well-preserved survival techniques, centuries of exposure to a climate of ex-tremes, and a nomadic life among animals. Survival in the cold as a Marine was one thing, but this was quite another. Among other things, I couldn't speak their language; there were 40 names for reindeer in Samisk and I knew only one. My camera was a passport to the world, but here I had no visa.

The work of Nils Nilsson-Skum gave me a glimpse. Nils Nilsson-Skum was an artist *and* a reindeer herder, able to articulate his culture and its meaning. If I could find a pathway into this world, I could decide what to do next. To get into Sami life was not a straight climb up the Everest of my imagination; did I even want to try? It was very discouraging.

Meantime, I learned that there was going to be a big roundup toward the end of October, but no one knew any details because, as always, scheduling was determined by the weather, and the reindeer set the timetable. So I re-turned to Stockholm to develop my film and think about the next step. I thought that seeing Monica, in spite of the possible problems involved, would be a happy relief.

What I discovered in Stockholm was a terrible shock. Monica wanted a formalized relationship. This meant that *free love* needed to be reinterpreted. My financial state certainly didn't offer security, but she wanted the emotional certainty of a commitment. In my case *free* was an essential part of my agenda; freedom from my past as well as freedom to keep all options open with respect to my work, which meant marriage was not something I could deal with. I would support and could understand her needs as long as *engaged* meant committed but not married. Maybe that's the adjective I was looking for, *committed love* replacing *free love*, so I gave in. If I had been in a better humor, I would have written an article for *Time* magazine on the subject

The next blow I received in Stockholm was devastating. My pictures of the Sami reindeer herders were a disaster; among the rolls of film — hundreds of frames of Sami reindeer herders' backs and butts — there were no intimate, action shots, nothing in close: no sweating Sami lassoing swirling reindeer or a picturesque grandmother chasing a calf with a stick. There was nothing in my photographs that might take these exotic herders into the hearts of magazine readers. There were a few pictures of children dressed up in *Nationaldräkt* outfits staring at me, and lots of "not much of anything interesting."

The Skum drawings revealed how an artist could project his feelings about a culture in a profound way. My images gave no feeling about the Sami or how I felt about them. Or perhaps they did; I was obviously scared to death of these people and photographed them from the psychically safe distance of *too damned far away.*

Depressed, I reviewed my options. Looking at my finances, I found that there was exactly enough money left to get my car, all my baggage, and me back to the U.S. If I returned home, having flunked journalism, I could pick up children's photography. That idea made me nauseous. Staying in Sweden and having another fling doing the same thing among the Countess set had the same effect. So I went to see my friend Mrs. Fornander at the Foreign Office. I explained that I had to go back to the north. The story of my broken camera and faulty shutter that ruined all my pictures was told with a fervor generated by the terror I felt. I hoped it didn't show. Could I assure her that there was any reason that the Sami would be more receptive in the future? I wasn't even sure when the big roundup might be. These were truths I had to face.

"Very unusual, very unusual," she kept murmuring to herself. Then there was one more "very unusual," before Mrs. Fornander authorized another free round-trip rail ticket back up a thousand miles to Kiruna. Maybe she remembered the flowers I brought her when she issued my last tickets. Another miracle — or was it?

Leaving her office and grateful for her kindness yet again, I had been given another chance; but a chance at what? Going broke and having to ask for a family bailout? Another hitch in the Marine Corps would be preferable to that. So I drew from my dwindling cash, invested in more film, and headed north to throw the dice in one of the most important gambles of my life. Apart from these very strong reasons, there was another reason. Quitting, I decided, was a kind of suicide. It wouldn't be immediate, it might take ten or twenty years, but I would die. My head cleared. How could I get close enough to the Sami people to make significant photographs of them? Our histories and cultures were to-tally different. I wasn't like them in any way, but I needed to find out what that meant. What was there to be learned from the differences?

Arriving in Kiruna, I returned to see the Mayor, and we had another talk. He confirmed that a big roundup would take place around the end of October, and he offered to help make arrangements for me to get there.

In the meantime, I got permission to photograph the huge iron mine near Kiruna, a place that gave the town its excuse for existence. The Luossavaara-Kiirunavaara AB mine, known as LKAB, the world's largest, offered amazing vistas that overwhelmed the presence of the workers. It provided a mechanical presence and a scale of equipment and work places that was the opposite in every respect from the existence of reindeer herders. I felt good about the expe-rience of photographing as I adjusted to the rhythms of the men in the mine. Unfortunately, I had no way to develop the black-and-white film.

On October 24th the Mayor called and told me to be ready at 7:00 the next morning. He provided a map of an area called Tjuorek, and clearly underlined, in the middle of it, he scribbled "Be prepared to camp out. This is the biggest roundup of the year," explaining that hotel and other housing accommodations were non-existent. And he told me that he had hired a taxi to take me twenty miles to the end of the road, where I would begin hiking to Tjuorek.
I immediately sent the following letter to Florence Kiesling at Lensgroup, a small photographic picture agency in New York:

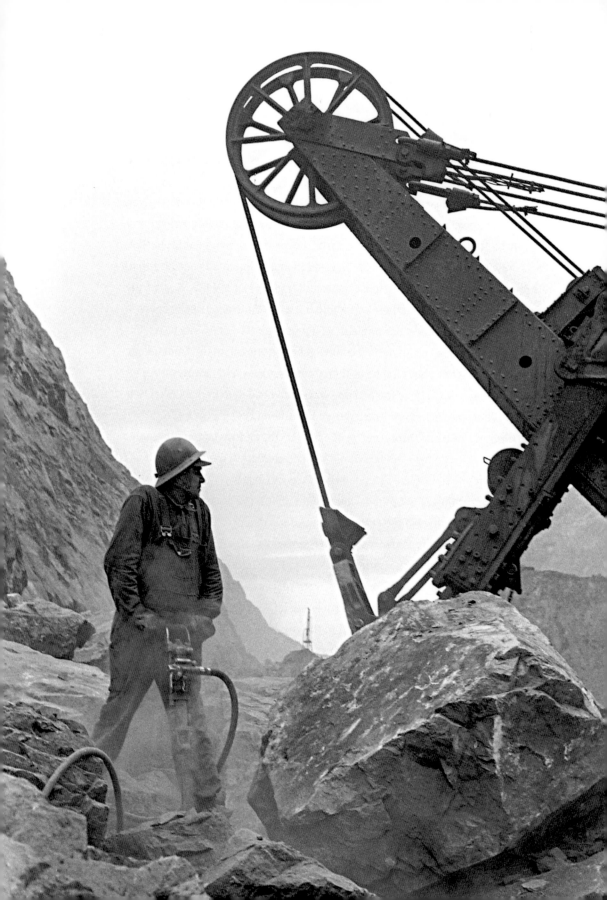

"You may remember my visit to your office last July, just before my departure for Europe. Tina Fredericks from the Ladies' Home Journal *sent me over and you advised me to sink my teeth into as many picture stories as possible and get some experience. This I have done; my appetite is still strong and so are my teeth. You also advised me not to plague you until I got home and maybe you asked me not to plague you at all... However, my biggest problem is not available material. I am sitting on top of some fascinating stories but I have to sell something quick, even if it's one of my cameras..."*

Then I went on to tell her that I was preparing to make a journey over the mountains to photograph the largest reindeer roundup in the world. Ebullient phrases described the excellent relationship that I had developed with the extraordinarily colorful nomads by assisting them during earlier roundups, which had provided me with the means of communicating with them on the best of terms. At the end of the letter I also revealed that the Swedish Foreign Office had given me permission to photograph the Nobel Prize ceremonies due to take place in a few months. Without learning how she would respond to either of these story ideas, I airmailed the letter and got ready to go north.

Next morning, when the taxi got me to the end of the road, I said goodbye, got out my Silva pocket compass, and began to navigate across the tundra. The topographical map was full of names, well-marked hills, bogs, and small lakes, but there was no dotted line to Tjuorek. I would have to find it. Fortunately, it had snowed recently so there was no difficulty in following footprints that obviously led somewhere by some people who wanted to go there. Around me there were tall hills that I assumed corresponded to the higher elevations on the map. Feeling like Peary heading for the North Pole, I was very excited. It was a lonely 15-mile hike, but I felt good to be on the move. As the hours passed, however, I got a bit nervous because there was nothing to be seen of animal or human life in this desolate landscape. The running dialogue with myself got wilder as I trudged along the path to God knows where — hopefully Tjuorek — whatever and wherever that was.

Finally, late in the day, I came around a hill, and there, suddenly spread out before me, was a snow-patched landscape peppered with thousands of dots; a vast area, no village, no buildings, just a three-dimensional living carpet. One of Nils Nilsson-Skum's drawings bathed in the warm colors of a clear

October afternoon came back to me. Getting closer, the dark specks became a herd of animals, gathered in what I now truly believed was the largest reindeer roundup in the world, some 12,000 strong.

Not sure where I would spend the night, I was prepared to camp in a snow bank. I had my sleeping bag with a ground cloth, warm clothes, and enough food to get me through a few days and nights. It was cold by now, but nothing that I hadn't dealt with in Korea; so I approached with confidence.

In the distance before me, I saw that Tjuorek was not a village, just a group of simple structures covered in skins, stretched over long poles set in a circle and connected at the top like tepees — dwellings that the Sami called *kotas*.

As I approached the encampment, I had a big surprise; I met a woman whom I had apparently assisted at the Harro and Rensjön roundups. And, amazingly, she was one of the Skums, a relative of the artist. This time there was no translator, but the woman and her husband flagged me down, and made it clear that I was to follow them to their "guest" *kota*, where I was invited to stay with five other men. Once more, hand signals provided all forms of communication. I also met their dog, a Tjuorek, a wonderful thick-coated animal looking like a medium-sized Husky. She was a very friendly welcoming animal and thoroughly sniffed me from head to foot while I spread my sleeping bag over the reindeer skins on the floor of the *kota*.

Apparently, my schoolteacher friend Per had intervened on my behalf. The young Skum artist had also given me a passing grade and all this fed into the Sami gossip machinery, so upon arrival I was more or less expected. They also knew about the Mayor's help. It was all a welcome surprise for me. Even the dog seemed to have gotten the message.

Then a surprise – one of the Sami called out in a loud voice: "Communist! Communist!"

Was there a Sami from the CIA?

Again, "Communist!!" even more intently.

Did they think I was a Russian? What wild bulletin had come in on the gossip hot line? Maybe they thought I'd slipped over from the nearby Kola Peninsula from USSR. So I queried in a loud voice:

"COMMUNIST?"

Immediately the dog came over. It turned out that when anyone said "Communist," the dog knew she was being called because her name was Unis and what was said in Swedish was: "Come Unis."

Sami dogs are indispensable in keeping track of and rounding up reindeer. They are all the same breed, medium-sized animals with heavy coats that are tough, smart, and highly valued. But they are not coddled and seem to live on occasional scraps. According to the Sami, rough treatment keeps them alert. Being a sucker for dogs, especially a fuzzy ball of friendly fur like Unis, I shared a chunk of cheese with her.

In the *kota*, reindeer hides were stacked on layers of birch branches to create insulation from the frozen earth. In the center of the circle was a small fire where coffee cooked and reindeer meat was boiled; smoke escaped through the small open top of the structure. As in Korea, the sanitary facilities consisted of a nearby slit trench.

Unis was turned out and we all settled in soon after dark. By now it was cold outside, below freezing, and I was very happy to be in my warm reindeer hair sleeping bag sandwiched between reindeer hides. After a long day and a good hike, it was a happy home.

Deep in the night I felt something slithering next to me. I groggily smiled to myself and realized that my friend Unis had come in from the cold and would make a nice warm pillow. She was delighted with the idea and snuggled under my head. Unis was cool, with bits of snow still clinging to her fur. But then she began to thaw out.

Suddenly, I sat bolt upright! She had done me a special honor. Unis had perfumed herself by rolling in the slit trench. Unfortunately, she had also perfumed me before I was able to shoo her away. I no longer smelled like a reindeer.

In the morning, the work started. I was associated with the Skums, but soon found that all the Sami here were friendly and made no objections when I started photographing. Even the drunk from Rensjön was there but said nothing. Fresh snow had fallen during the night and the air was crisp. By noon, white clouds from the hot breath of circulating reindeer began forming over the big corral. Photography lessons at Rensjön and Harrå had been learned well, and this time I got into the middle of the action, working as close as possible to the Sami men who were busy throwing lassos (*suohpan*) to catch individual rein-

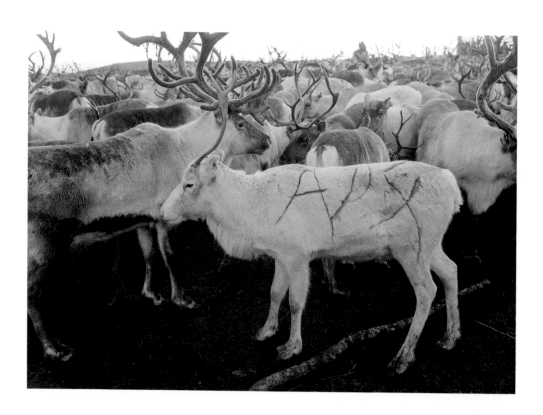

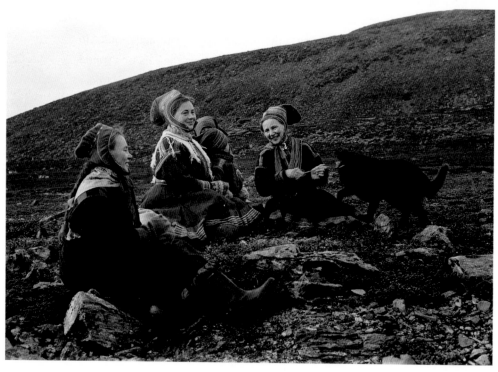

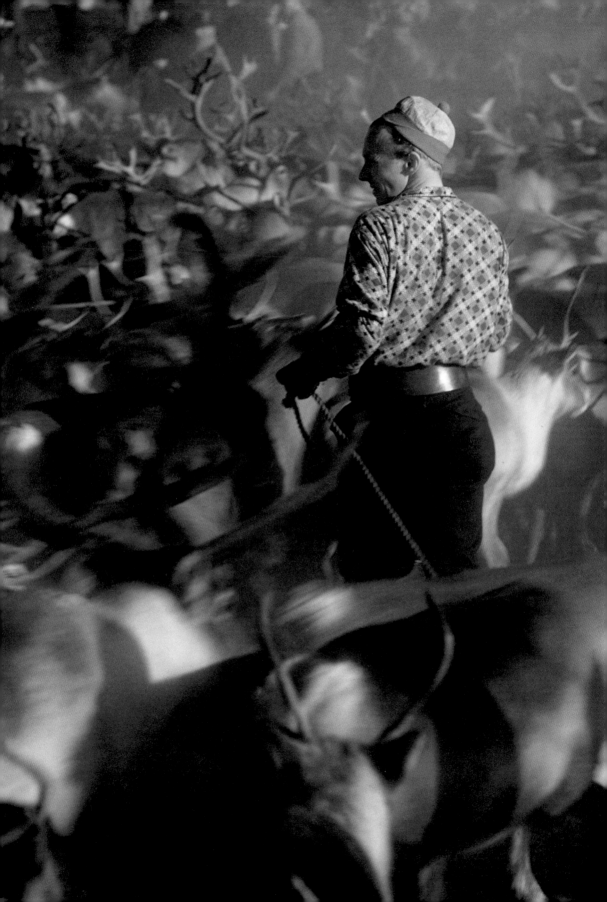

deer that belonged to them. The job here was to find and catch the animals and then move them to family enclosures nearby.

The light snowfall gradually changed the ground from slippery to muddy as the day warmed. One Sami was wearing U.S. Navy waterproof trousers — another had heavy rubber gloves to keep the rope from cutting his hands. The reindeer ran and ran in circles. There was no sound except for a beating noise from their hooves and an occasional low-pitched grunt. The men worked silently. I stood still in the middle of the circle as the animals and men went around me as if I was a tree; if I made a sudden move the reindeer rushed away. The corralled herd always moved counter clockwise. I knew this because Nickolas Skum had told me that artists often made drawings of animals circulating in the wrong direction – a great joke among the nomadic Sami.

The action was intense: I watched a young Sami, face splattered with mud, looking for his mark with lasso under his arm. He got ready, found the reindeer, began his throw, completed the swing, and the lasso connected. The big, strong reindeer pulled him off balance, and he began to run after the animal, playing out the rope. Slipping on melting snow, stumbling, the man almost had the lasso snatched from his hands before his partner grabbed the reindeer, put another rope around its neck, and they both dragged the animal to their family enclosure. Over and over through the day this went on.

The noon sun swung low in the far north in late October. Swirling figures became silhouettes. They no longer seemed real; even the intensely bright color of the Sami dress was overcome by the piercing light. Slippery wet stones became gold nuggets as they were drenched in the late afternoon sun. The day was closing. The moon was up and there was a frantic rush to finish before sunset. The red ball in the sky intensified the furious activity. It was 3:30 p.m. and the sun was beginning to sink; it was down by 4:00 p.m.

Over the course of the two days that I was there, 12,000 reindeer were identified and divided up by a hundred men, women, and children. With the inventory complete and each family knowing what it owned, the herd was turned loose to go to winter feeding grounds. It was one of the most remarkable events I had ever witnessed.

Returning to Stockholm, I had the Kodachrome processed, edited the slides with the help of Pål-Nils, and then sent a selection to Florence Kiesling at Lens-group in New York. What happened next sent me around with another bunch of flowers for Mrs. Fornander.

Florence wrote back that she had received my slides and sold a four-page spread, of all places, to *Sports Illustrated* magazine. She also agreed to be my agent in New York. But more important, the press pass thief had fulfilled the Picasso mantra by overcoming fear, acting and going through the door – at least the first door, to a measure of success as a freelance photographer.

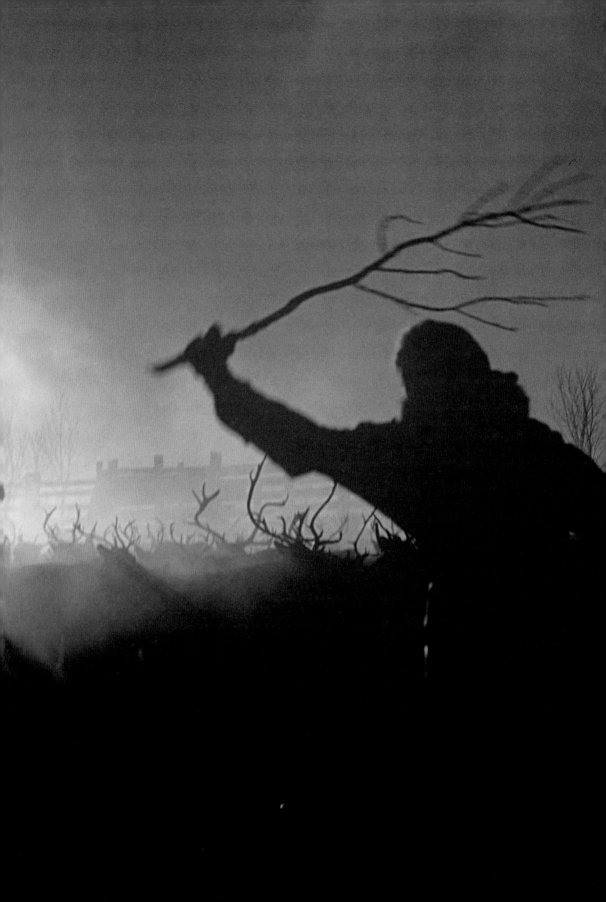

12 – NOBEL PRIZE

My new "formalized arrangement" with Monica made it possible for me to move in and for Senka to move out of Grev Turegatan 64. In addition to stabilizing our relationship, and improving my love life, this also improved my economic condition since I could also develop black-and-white film in her bathroom and didn't have to beg and borrow occasional darkroom space from TIO Fotografer.

Publication of the reindeer story in *Sports Illustrated* was a huge step up for me, a leap in the direction of journalistic respectability. But its appearance did not attract a single assignment; I had to generate them.

What to do next?

Back in Stockholm after my adventure with the Sami, I looked around for events to cover. The wild claim that I had made to Florence Kiesling about covering the Nobel Prize became the obvious choice, and it took on new importance because Boris Pasternak, author of the enormously popular novel *Doctor Zhivago,* had just been awarded the Nobel Prize for Literature. The award created a sensation, but it was uncertain whether Nikita Khrushchev, First Secretary of the Communist Party, would allow Pasternak to leave the Soviet Union. It was equally uncertain that with my experience I could get anywhere near the event, but it was something that I was now determined to try. After all, I had just proved that improbability was not my enemy but my best friend.

I wrote a letter to Florence Kiesling claiming that I could get into the Nobel Prize ceremonies in December; this was hot air, of course, but I couldn't think of any other way to launch myself. I suggested to Florence that she get me an assignment with *The New York Times*. But in order to avoid an anticipated "No

thanks!" from the *Times* I took the precaution of telling the Nobel Prize Press Office that I already had the assignment, just to get things moving. When I was told that pictures would be available for the *Times* from the photo pool, I said, "This is outrageous. The *Times* would not put up with such treatment." They had to have their man on the spot — and that should be me.

As it happened, I knew Werner Wiskari, the *Times* correspondent in Stockholm. We occasionally had lunch together. Werner knew that I was faking my *Times* relationship, but he was amused rather than outraged and didn't blow the whistle on me. So, miraculously, I was assigned to be one of three pool photographers who would cover the event, and most important, I could attend the special dinner at the Stockholm City Hall where the laureates would dine with the Swedish Royal family.

This good news was passed to Florence, and I also told her that I was willing to photograph the event "on speculation," in other words without an advance commitment from any newspaper or magazine.

It looked like clear sailing, but then the weather changed. The *Times* and the other daily newspapers in New York were in the middle of a labor dispute with the deliverymen and a strike was threatened. Would it be resolved before the prize ceremony in December? And there was additional bad news. Because *Doctor Zhivago* provided a sympathetic portrayal of Russians who opposed the 1917 communist revolution, Pasternak was expelled from the Writers Union of the USSR. He then refused the Nobel Prize and would not come to Stockholm.

There were other problems. The Swedish Foreign Office became involved in the affair and wanted information about my assignment. I told them I was having an argument about how much the *Times* would pay. This was true because, according to Florence, they didn't want to pay anything. These were up and down days. I was told that I probably would not be able to get into the award ceremony at the Concert Hall in the afternoon but could photograph the banquet. What had gone wrong? Were separate bureaucrats in charge of the two events? Apparently, so I found the gatekeeper (whose name I have lost), who could make it possible for me to photograph the presentation, but he said that he had frankly forgotten that I wanted to get in and I would have to get pictures from the Press pool. Before I could get that situation resolved, I had to dash off to rent tails as members of the press were required to wear full formal

dress. This was one day before the first American Nobel laureate, Dr. Joshua Lederberg, was to arrive.

I had planned the story in my head and knew that one of the important pictures was showing the laureate getting his check. As there were three Americans sharing the Medical Prize, I wanted to confirm how the protocol worked. Would they all get checks at the same time at the Nobel Foundation? The woman in charge of the Press Office was too busy to see me so I asked a junior official. She looked horrified and said that no one had ever photographed the check-giving before.

"That's the point of the story," I explained.

She was so upset that she told me that I would have to make an appointment with the Executive Director of the Nobel Foundation, Nils Stahle, who turned out to be a crusty, irascible, old ex-diplomat.

I apologized to Mr. Stahle for taking up his time on such a busy day and thanked him for seeing me to discuss details of my story. "Your advice will be invaluable," I nervously jabbered away.

He was bored but didn't throw me out and wanted to know what I had in mind. Explaining that my plan was to follow a Nobel laureate through his stay in Stockholm and give the viewer the feeling of how it feels to get the Nobel Prize, "the human side of the story."

"I'm interested in recording the small details rather than just the pomp and ceremony." I went on and on and he was still bored. My departure was imminent. Noticing that he wore a family crest-bearing signet ring on his little finger and desperate to get his attention, I scratched my long nose with my right index finger in order to flash a similar ring that I wore, hoping that a secret signal of gentility would pass between us, but nothing helped. I was about to get flung out.

I went on desperately explaining to the director, "There are many details of behavior that American laureates and their wives would not be aware of; for example, how to act in front of the royal family." With that he popped up out of his chair, did a formal bow, and danced around, explaining, "I am going to teach them about these things myself."

"Yes," I said, "Everybody should learn that; there are so many subtle nuances to be learned. My father was an American diplomat." And I recounted a

story about the wife of one of my father's attachés, who was asked at an embassy ball to dance by a high official. "She looked at her card and said, 'I'm sorry, your Excellency, my card is all filled up.' A horrible mistake. She should have said, 'All my dances are free,' and showed him the card."

Stahle began to thaw. I asked him if the laureates received their checks at the ceremony. (I knew that they didn't, but I was fishing.) And he said, "No," but then, as if struck by lightning, he announced a brilliant idea. "The human touch," he said, "Why don't you take pictures of the laureates receiving their checks? They get them here at the Foundation office and then they go to the Wallenberg Bank." From then on, he was most helpful, and I apparently got an "A" rating from the Nobel Foundation.

The 1958 Nobel Prize in Physiology or Medicine was shared by three Americans, one half jointly to Dr. Edward Lawrie Tatum from the Rockefeller Institute in New York and Dr. George Wells Beadle from Caltech in Pasadena, California, and the other half to Dr. Joshua Lederberg from the University of Wisconsin, one of the youngest recipients ever to have received the prize. After getting their arrival schedules from the American Embassy, I began going to Bromma Airport to meet the laureates one by one.

Dr. Lederberg's arrival was first. He was to be greeted by a group of Scandinavian scholarship recipients from the University of Wisconsin. They showed up with a student band from Stockholm's Technical University. But Dr. Lederberg's evening flight was five hours late, so I was treated to an endless repetition of the university's song *On Wisconsin* as they practiced and practiced; tooting into the night. This literally blew away any chance I had of making a personal connection with Joshua Lederberg, but I got ready to try again with the next laureate, who arrived on December 7th.

Having no idea what a Nobel laureate in medicine might be like, I assumed that anyone receiving such an honor would not necessarily be excited about meeting me. So I began researching, looking for clues on to how to connect with the scientist.

Dr. Beadle was credited with developing the *one gene, one enzyme theory*, whatever that was, demonstrating how genes controlled the chemistry of the living cell. Neither Dr. Beadle's Nobel-worthy scientific achievement, nor his personal history revealed any clever keys to conversational ease with him, but

I joined the other reporters and photographers at Bromma Airport to meet the doctor and his wife and I pushed through the crowd to greet them. George and Muriel Beadle were a complete surprise. They were warm and friendly, and seemed pleased that I had come out on a miserable cold night to meet them. We had a short talk, and I volunteered to become their guide around Stockholm whenever they liked during their stay. They seemed delighted with the offer, and two days later I picked them up at the Grand Hotel — across the way from *Af Chapman.*

We took off in my Mercedes Cabriolet — washed and shined — to my favorite bar, Gamla Stan, in the Old Town near the Royal Castle. This was a well-known hangout for artists and writers. I wasn't a regular there because I couldn't afford to be, but, luckily, I was able to introduce the Beadles to a couple of photographers I knew from the TIO Fotografer and an editor from VI magazine. The Beadles loved meeting my "close friends," who, in turn, were impressed to see me hanging out with the Nobel laureate and his wife. Everyone had a marvelous time in the noisy, smoky, pickled atmosphere, which I explained was a landmark tavern where creative Swedes had been unwinding for the last three hundred years.

It turned out that Dr. Beadle was an avid amateur photographer, and he took pictures everywhere on the nights we were together, steadying his camera on top of parked cars, and bracing against sign posts in a most professional way, getting available light exposures of the bright lights of Sturegatan, Stockholm's main drag. Muriel Beadle was a writer, who produced non-fiction books and worked for newspapers; she was curious about my struggles as a photojournalist. The couple seemed truly to enjoy their escape from officialdom and having them become friends and showing them off to colleagues was a real treat for me.

December 10th, 1958 was the great day; the Nobel Prize ceremony. There was to be a rehearsal at 10:30 a.m. in the Stockholm Concert Hall, where the awards took place, and where they all attended *"How to Bow to the King School,"* to learn all the niceties of royal protocol. This was a crash course in the details of Swedish decorum, even the simple act of clinking glasses proved to be a complicated drill with strict rules about timing, seniority, eye contact, and proper positioning of the drink upon the precise uttering of the word

"Skål." As for royal introductions, they were to be delivered with a level of formality that would require the brain of a Nobel laureate to explain and would soon provide me with a huge surprise.

Sadly, I missed the morning tutorial, but Nils Stahle must have pulled some strings because I suddenly had permission to be at the Concert Hall; the news was delivered by the same embarrassed lady who had sent me to see the director.

At 4:30 p.m. on the dot, ceremonial horns began to blow a special fanfare as the king and members of the royal family made their entrance. After the royals got settled in their seats, the ceremony began. As an orchestra moved them along with a brisk march, the laureates then made their entrances, accompanied by members of the various Nobel committees. When the Americans made their appearance, the orchestra played the *Star Spangled Banner*. Each laureate was introduced to the assembled royals, and then made what was officially described as a "reverence" — a deep bow — which they had learned earlier in the day.

After the bows, the prizewinners took their reserved seats and laureates from previous years marched in; after making their "reverences," they sat behind the new prizewinners.

Everyone in the hall was dressed in formal clothes; even the stationary TV cameramen wore white tie and tails, providing dress code uniformity. Even so, as they recorded the affair behind their huge bizarre-looking modern apparatuses, they looked out of sync with the old-fashioned formality of the occasion and the classic gilded decorations of the Concert Hall.

Presentation speeches were made by members of the Nobel committees representing each of the awards, and they introduced the prizewinners, explaining their achievements. After each speech, the laureate rose from his chair, made a short address, and then walked to receive from the king the Nobel Gold Medal, a diploma, and a receipt for the prize money. Each winner then carefully backed away from His Majesty — one doesn't turn his back on the king — and returned to his seat.

In an hour and fifteen minutes, the presentations were over, completing the first part of the great day.

Unlike the British, the Swedish royal family had a relaxed and egalitarian reputation. It was not unusual to see its members out and about in public, particularly the young princesses. On the occasion of the Nobel Prize ceremonies, however, all the pomp and circumstance of royalty came out, and every formality was exercised with strictest protocol, particularly in the presence of the king and queen. Nothing important took place without the prerequisite bows, toasts, and ornate preambles.

At 7:00 p.m. that night, photographically speaking, I "hit the beach." This was my big moment, the night of the banquet at City Hall. With two other photographers, I reported to the kitchen adjacent to the dining hall, dressed in white tie and tails. We were inspected by a bulky major domo, who informed us that we would be allowed into the presence of the guests on three occasions — for three minutes each time — to take photographs. From his point of view, however, our real job was to stay out of the way of the busy cooks, assistant cooks, soup chefs, sous-chefs, pastry decorators, waiters, and security people. Our nine minutes were on the bottom of everyone's agenda.

Rigged out in full dress, taking my photos was a precarious business. I was virtually bolted into my rented suit with an ill-fitting, stiff-as-a-board starched shirt, which meant that leaning over, bending in any direction, put everything in jeopardy. I should have been practicing maneuvers that would enable me to operate cameras, pencil, and notebook for nine minutes without exploding, but I was constantly moving, trying to stay out of traffic. Press photographers didn't fit the tempo of the kitchen; there was no tolerance, no respect, for the press here. We were boiled white-shirted lobsters, and not on the menu.

My adrenalin was up, however. I was ready. The major domo signaled, and waved us in.

We entered.

It was if I had woken up in an exotic dream as I made my way from the scrambled confusion of the kitchen into the serene social stratosphere where the king and the royal family sat calmly among the celebrated prizewinners and distinguished guests.

Three-foot tall candlesticks stood as golden sentinels, softly illuminating a garden of flowers that decorated the long head table. The candlelight, mingling with that from chandeliers, warmed the walls of the appropriately named Gyl-

lene Salen (Golden Room). Eighteen million gold and glass tiles reflected a radiance that bathed 120 people with a light that was both regal and comforting.

A huge mosaic at the north end of the room depicted many events in the country's history, including, at its center, the mythic figure of Mälardrottningen (Queen of the Lake Mälaren), who sat on a throne staring forward with huge eyes and wearing a gown that resembled something out of Byzantium. The painting blended with the elegance of Renaissance Venice with romantic notions of Swedish nationalism that had been prevalent at the time of the City Hall's construction in 1923. Among many historic events, it also depicted the immigration of Swedes to the USA.

In the mural, the Queen of Lake Mälaren held in her lap prominent buildings of Stockholm. She sat floating on a wavelike design, seemingly impervious to the crowds of supplicants pressing toward her from the right, riding on camels and elephants, and jammed between minarets and other symbols of the East; on the left, representations of the West, including a steamship, joined the Asians in paying their respect.

This amazing room, elevated by both the presence of the royal family and the Nobel laureates, looked down on a spillover crowd of 750 additional guests below on the huge Blå Hallen (Blue Hall) that wasn't blue at all, the designer having changed his mind about the final look, liking the effect of the brickwork. But the original name on the plans somehow stuck.

In the Gold Hall, each laureate and wife were sitting with a member of the Swedish royal family. There were assorted ambassadors and government ministers scattered around as well. When I got over the shock of passing into this world of gold, I finally began taking pictures, and I noticed that Muriel Beadle was seated right next to King Carl Gustaf of Sweden. She caught my eye and beckoned me over. To my amazement, Mrs. Beadle turned to the king and said: "Your majesty, this is the young photographer I've been telling you about." I bowed, as best I could, and was rendered "introduced to the king."

As I backed respectfully away, the major domo, who had already rushed my two colleagues back to the kitchen, informed me with deep respect that I was no longer required to retire. Then, suddenly, a man appeared at my side and introduced himself as the press attaché from the American Embassy; he offered to carry my camera bag, having been dispatched on the spur of the moment by the American Ambassador, who had observed the whole business.

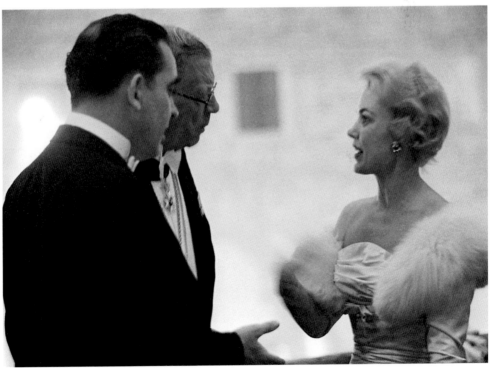

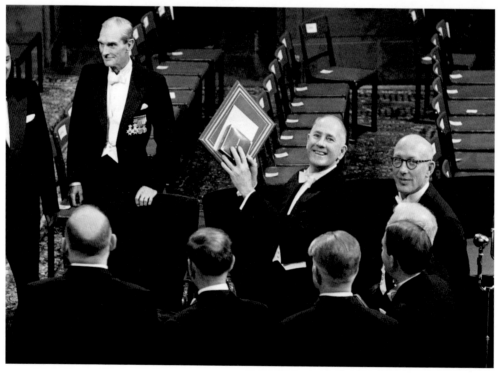

The royal introduction immediately elevated me, albeit temporarily, to a Press Knighthood for the evening. One bow in the right direction and I was in.

Then, two women sitting in front of the king with their backs to me, turned, looked at me and began to chat among themselves in Swedish. One was Princess Sibylla, the mother of the two princesses, Christina and Birgitta, and young Prince Carl Gustaf, who was to become the King of Sweden. It turned out that the royal ladies thought that I looked like their cousin King Baudouin, the young monarch from Belgium, who also wore dark horn-rimmed glasses. On the strength of this, I was allowed to stay for the party downstairs after the dinner, and happily mingled with many important people, including the attractive young princesses. This did not, however, vault me into Swedish society, and I would never see any of them again.

The great excitement of the Nobel Prize ceremonies wound down, but happy activities continued the next day. I followed the three American laureates as they went to the office of the Nobel Foundation and traded in their receipts for checks in Swedish kroner for the $40,000 in prize money.

Unfortunately, *The New York Times* remained on strike and my photographs had no chance to appear there. Florence sold my story to a scientific publication, which was some consolation, but meeting the Beadles and my introduction to the King of Sweden by Muriel Beadle was to have an important impact on my future. It set me up to plunge into further adventures that would take me once more to the Arctic.

13 – ARCTIC ISLANDS OF LOFOTEN

The Nobel Prize ceremony was a journalistic challenge that pitted an unknown and inexperienced photographer against the bureaucracy of one of the world's most venerable institutions. Its walls had been breached, and I had managed to insert myself into an event that provided a friendship with a Nobel laureate and his wife as well as an introduction to the King of Sweden. But to my surprise, after it was all over, I wanted to escape. Part of my performance felt brilliant, and taught me that I was capable of entering into and momentarily maneuvering in the straitjacket world of Nobel Prize formality. But I suddenly wanted to plunge in the opposite direction, into a vast blackness, the opposite of the golden glow of the Gyllene Salen (Golden Room). I longed to go north again, but I couldn't explain this feeling either to Monica or myself. Perhaps darkness would swallow me up along with my scheming plots, lies, and deception and I would briefly escape my domestic arrangement with Monica, that now seemed cramped. She stoically accepted my decision, respecting my need to be free. With my new credibility as a "Nobel Prize journalist," Mrs. Fornander granted another request for a ticket to Lapland, this time, she was astonished to learn, in the dead of winter.

A few days after Christmas, I took another interminable train ride to see Lennart Johansen, my railroad worker friend, and I found myself in a world uninterrupted by sunlight. Here, with no shadows to mark day from night, time flattened out, broken only by meals and long conversations about photography and dreams. Lennart wanted to know, "But why the Arctic in the dark?"

My response was, "I'm curious."

Lapland had been as far away from the familiar as I had ever chosen to explore. I had found a few successes here, enough to encourage further exploration.

"What's at the end of the railroad?" I raised it as a kind of metaphorical question, but Lennart had a very specific answer.

"Lofoten,"

The railroad that passed his house crossed the Swedish-Norwegian border a few miles to the west and ended in Narvik, Norway. There, off the coast, Lennart told me, were some islands, "a magic place with breathtaking land-scapes that had attracted painters from Norway and Sweden for a hundred years." This was Lofoten, six main islands and a thousand rocks that extended west of Narvik — a hundred miles north of the Arctic Circle and parallel to the coast of Norway.

As I began to investigate, I discovered that Lofoten and the entire Norwe-gian coast was ice-free year-round due to the Gulf Stream that was driven by strong westerly winds and the Norwegian Current that combined to bring warm water north. Warm, however, was a relative term. Lennart made it clear that "there are no swaying palm trees here," but ocean currents at about 35°F were enough to make the Lofotens the most temperate place on the planet in relation to its latitude.

Topographical maps verified that there were no green cultivated areas, no conifers, only peat moss seemed able to survive this barren place. But there was a vibrant fishing industry that had been in place for a thousand years, depending on a migration of cod that came south from the Barents Sea to spawn in March. Fishing, at the time a major industry in Norway, attracted fleets of fishing boats large and small from as far as Bergen, eight hundred miles to the south.

I began to hear more tantalizing stories about Lofoten. It was a twelve-month kaleidoscope of extremes that had its beginnings in black January, when even dismal darkness had its magic moments. As winter moved on, the light began to soften from black to purple, occasionally teasing the sky with streaks of gold. Gradually, as the crazy tilted Arctic eased one day into the next and the sun crept higher, it would fill the fjords until darkness was replaced by dazzling twenty-four-hour daylight from May 25th to July 17th.

But it was now deep winter and time to move on. I really had no choice; I couldn't sleep on the Johansen's makeshift bed until spring, so I moved on to

the seaport of Narvik on December 31st. There, I celebrated the arrival of the New Year in bars, where everybody told me the same story: "Here, the sun won't peek over the horizon for the first time until January 5th. Lofoten, it's just ice-covered rocks, it's freezing cold, there's practically no light, and most of all, it's January in the Arctic." I was officially discouraged, privately discouraged, and the weather was discouraging. It snowed, fogged, and sleeted, and the fishermen and sailors I met in the bars of Narvik all delivered the same message, "Wait for the midnight sun, then you can see Lofoten. It's beautiful." But I had a different agenda. Once more, I was going to have to go as far from the familiar as I could stand. Picasso would approve.

On January 4th, I set off from Narvik for Lofoten on a coastal steamer. The little ship pulled away from the dark and foggy dock at 9:00 a.m. It was small but comfortable. The sea was calm and we weren't rolling around like a cork as I had imagined. There was a pleasant salon, cabins, a dining room, and hearty Norwegian food — cheese and cold cuts and brown bread packed with nuts and healthy seeds. This was my first Arctic sea voyage, and on such an agreeable vessel it was nothing like a storm-tossed Viking experience. Instead, there were a few bored traveling salesmen reading Norwegian adventure magazines in the lounge.

Around 11:00 a.m., I noticed that it was a little light outside, so I went on deck. Suddenly my disappointment was gone.

The snow and fog had blown away, leaving the cold January air brilliantly clear for miles in every direction. Sailing between the giant snow-covered peaks of Narvik Fjord, our little boat was transformed into a ship of destiny. The sun wasn't visible yet — it was too early in the year to see the sun itself — but its rays hit the tops of the tallest peaks. A few stately giants, vertical walls of granite, magnificently capped in gold, basked in the early winter light. I stood on deck — fascinated and freezing — as we passed through Narvik Fjord, winding through hundreds of small rocky islands and mountains. Then, on the edge of the world, on the horizon, jagged black teeth floated in a gold mirage; it was Lofoten — Alp-like mountains dropped into the sea, gigantic remnants of glaciers that receded 10,000 years ago.

The spectacular effects of the sunlight declined and vanished by 2 p.m., but at 10 o'clock, nature put on its evening show. The sea was still as a pond.

In the crystal Arctic air the stars cast an eerie light and the wake of the ship cut an effervescent path past the towering islands on our port side. We were now in the midst of Lofoten. These mountain islands had the look of monsters with a few twinkling lights where they rose from the sea. It was hard to imagine that people could live in such places.

We reached Svolvær, population 4,000, around midnight. Disembarking, I found lodging at the Seaman's Home, which provided a comfortable warm room for seven kroner (US$1) a night; the toilet was down the hall. No English was spoken here, however.

The sun finally had peeped over the horizon on January 5th, beginning an anxious new season in my own life. The fishermen I met were curious about me. One asked in English: "Are you a press photographer?" "Yes," I said. "Can you take a picture in a minute?" "No," I said, "they're very slow," explaining that my Leicas weren't Polaroids.

"I was in Hoboken in 1935, and I have a brother in New Jersey, been there thirty years," explained another. This became a familiar line of conversation in Lofoten.

My next stop was *Lofotposten*, the largest daily newspaper in northern Norway, where I met editor Bjorn Paulsen, my first tutor about life on the islands.

"In March, Svolvær's harbor begins to fill up with fishing boats," he explained. The cod migrate down from the Barents Sea, coming south to spawn and by the middle of the month you can walk across the harbor — deck to deck." Paulsen ran his finger on a map from North Cape to Bergen in the south. "For a thousand miles every fishing village in Norway sends boats to Lofoten. But last year, the cod season was bad." Small independent fishermen are gamblers, betting on the cod every year. After a few bad seasons they'll start to pay more attention to their farms, tiny plots of land on rocky islands that can barely support sheep and a few cows. They're not scientific about agriculture, but they are the cleverest fishermen in the world. However, when they're farming and one of them hears that another fisherman has made a thousand dollars in a week — that does it. He forgets about fertilizer, mortgages his boat, and goes fishing again. If he's not lucky, he loses everything."

I set out to see what Paulsen was talking about.

Craggy peaks facing west protected tiny settlements dotting the many islands strung along Lofoten from the raw Atlantic gales. Some communities were connected by roads, but all were largely dependent on the sea for transportation. Comfortable seaworthy little ships, like the one that brought me from Narvik, delivered supplies, passengers, freight, mail, and milk, and their service was continuous.

One day, I boarded a local milk boat for a dot on the map called Røst composed of a cluster of 365 tiny islands or skerries, literally rocks. They barely contained enough earth to be officially designated as islands. Featured by tourism promoters in Oslo as the "Venice of the Arctic," these were more accurately described on local sea charts as "hazards to navigation."

Located at the southern tip of Lofoten, Røst's main population lived on three flat islands very close to one another and unconnected by bridges. Unfamiliar with local customs, I stood for an hour at the main pier, wondering how to get across fifty yards of water to the Seaman's Home on the adjacent island before discovering that it was common and acceptable to ask a fisherman to stop what he was doing to ferry the boatless traveler across the water.

Unlike many of the other islands, Røst was exposed to the full brunt of the weather — no trees, no mighty rocks to meet the gale. It was like living inside a wind machine. The housewives hung their washing in special houses made of slatted wood, to keep the laundry from blowing out to sea.

Not surprisingly, the history of Røst was connected with storms. In 1432, a Venetian ship was wrecked there, and some said there were islanders of Italian descent. But looking carefully, I had no luck spotting anything remotely Mediterranean in the "Venice of the Arctic." The gravestones in the cemetery overlooking the sea contained only Norwegian names, and most of those were of women, the men having disappeared in a sea that provided them with both their livelihood and their permanent resting places.

The next island north, Værøy, was singularly mountainous. Within sight of its northern shore was the world-famous Maelstrom, eulogized in Edgar Allen Poe's short story, *A Descent into the Maelstrom*. This is not the funnel-like whirlpool described by Poe and Jules Verne, and mentioned by Melville, but it remained a formidable danger for small boats because of its powerful currents — up to 30 mph — and wind. Like most places in Lofoten, it was untouched by

tourism in 1959, and there were no souvenir shops selling Maelstrom memorabilia, no guided tours, and no place to stay.

Værøy was, however, the home of giant sea eagles, with wingspans up to nine feet, as well as cormorants, puffins, and thousands of other birds. I never spotted a sea eagle, but I did meet a cordial man called Benjamansen, one of the island's leading citizens. We met because it was impossible for a stranger to avoid being spotted on the island, and the curiosity of the people and their basic hospitality served as my Værøy introduction. As the owner of the fish-packing factory, which employs most of the population of Værøy, Mr. Benjamansen took it for granted that his duties included looking out for slightly disoriented strangers. I was taken in by the Benjamansens as a matter of course for a meal and a bed as there was no commercial accommodation.

Returning to Svolvær, I found that the fishing boats had not yet begun to fill up the harbor, so I continued my exploration. Editor Paulsen introduced me to Net Larsen, the 42-year-old district Veterinarian, who described himself as "the doctor for all the cows, sheep, and other animals that populate my 50-mile territory." He invited me to join him on his rounds. We started by car from Svolvær bound for Rystad, population 25, a remote fishing village thirty miles across the island. The route took us between two peaks traversed by a pass, where we discovered that a ten-foot avalanche blocked the road. Larsen looked at the snow with a practiced eye and announced, "From here on we walk. This always happens here when I go on a call." We climbed over, looking warily at the mountain above us that had unleashed thousands of tons of snow.

Around the bend in the road, we found a bulldozer covered with a canvas. "It's up here just in case," he said. We trudged on and two miles down from the bottom of the pass we found a farmhouse where Larsen telephoned to get the bulldozer operator to come and clear the mess — it would take two days. He then called his client, the farmer, to pick us up by boat down at the coast. A small fishing boat met us a few miles away, where the road met the sea.

There was no dock, so to ride out to the boat, we had to get into a round-bottomed tippy little dinghy with only about three inches of freeboard separating us from the Arctic Sea. A freezing bath for my cameras and me was a dreaded possibility. Larsen was unconcerned.

We made it safely to the fishing boat, snuggled in the tiny cabin, and were offered steaming cups of coffee laced with condensed milk. We continued in comfort to our destination.

On arrival, I enthusiastically jumped, slipped, and came ashore with two wet feet. The air temperature was 20°F. The farmer's wife hung my soaked socks and soggy leather boots near the wood stove and made me put on a pair of her husband's heavy hand-knitted wool stockings, over which I added a pair of borrowed rubber boots. Everyone was amused. Leather was warm in the snow, but here, near the sea, rubber boots were part of the wardrobe of every man, woman, and child. I was out of uniform.

When we went out to the dark, damp barn rich with the smell of animals, the entire family joined Larsen as he quickly determined that one of the sheep had an infection and needed a shot of penicillin. The two cows were also inspected. Larsen held one of the cows by its head and put his nose a few inches from the animal's mouth. "Come and smell for yourself," said the cow-wise veterinarian. "This one's quite different from the other. I'm checking for copper deficiency."

Taking a sniff myself and nodding in an "oh yes" kind of way, I frankly couldn't tell the difference between one cow and the other; I didn't have the nose for humid hay breath.

When Larsen finished, we went to the farmhouse for coffee, sandwiches, and cakes. It was a family affair in a solid house with a radio that crackled words I couldn't understand, a telephone that had connected us, a boat at anchor, a couple of cows, and six sheep. My boots and socks were dry and as I began to take off the borrowed socks, the farmer's wife said "No. You must keep these. You must have extra of socks in this weather."

Would someone from my own society give a stranger something that they had made with their own hands? Amazed and grateful, I wondered what it was like to be brought up on a remote rock with the harsh weather and a tough life as parents? Clearly, it bred kindness and generosity, but this grace seemed a contradiction to the climate, or was it spawned by it?

On my return to Svolvær, things had changed. Like the belly of a pregnant cod, the population of Svolvær had begun to swell as it became Norway's codfish capital. It was February and more boats were arriving. By mid-March the non-residents of Svolvær would temporarily double, then triple. Everywhere

I met seamen who had been to Galveston, New Orleans, Boston, and Brooklyn. As merchant seamen they were world travelers, yet many came back to make a precarious living as fisherman in Lofoten. Why? I determined to find out.

On one of my visits to the offices of the *Lofotposten*, I met a crusty old reporter, Kare Skevik, who, during World War II, had been a radio operator with the Norwegian underground and a hero. His team had alerted Allied intelligence about activities of the German battleship Tirpitz, hiding in fjords near Tromsø and a menace to Allied convoys. British bombers eventually destroyed the ship at its Norwegian anchorage in November 1944.

Skevik loved to tease young foreigners like me. When I asked about the cod fishing, he suggested, "Why don't you do a story from the point of view of the fish and get a jump on those other reporters?"

"Is the water clear?" The answer was: "very clear" and "very cold."

That night, lying in bed at the Seaman's Home, I couldn't sleep, mulling over the idea of an underwater perspective. The next day, I started asking questions. Taking his joke seriously amused Skevik and he began to help me. A call to Gunnar Rollefsen, the director of the Scientific Undersea Fishing Research Center in Bergen, on January 24th got the ball rolling. I not only needed diving equipment, I needed basic training. Snorkeling in the warm waters of the Caribbean had not prepared me for being fully underwater, much less in a sea a few degrees above freezing.

To everybody's surprise, director Rollefsen supported the project. 1958 had been a bad year for cod fishing. As one fifth of Norwegian exports were fish products, the decline was a major concern to the government. Small independent fisher-farmers claimed that purse seine netting by large, fast commercial trawlers scared the fish away. Laid out in a large circle, the purse seine net is drawn together, closing like a purse. It scoops up huge numbers of fish. The independent fisherman's union won the debate in Parliament and the government banned the purse seine, without scientific evidence that cod were frightened either by the purse seine itself or the larger boats. Gunnar Rollefsen thought my pictures might be useful. With his encouragement, I contacted the Naval Attaché at the U.S. Embassy in Oslo by phone. Lt. Commander Wetterlaufer USN didn't have any diving equipment under his jurisdiction, but said he would do what he could.

Having been introduced to King Gustaf at the Nobel Prize ceremonies a few months earlier gave me the confidence to say to Commander Wetterlaufer that he could contact the American Embassy in Stockholm should he need a reference. The Commander went to work with efficiency and within days I had confirmation that the Royal Norwegian Navy had cleared the project.

On January 30th, Commodore Sars, Chief of Staff of the Plans and Policy Division of the Royal Norwegian Navy, sent me a letter stating that the Royal Norwegian Navy would supply equipment required for the diving along with the assistance of their Chief Diving Officer, plus two enlisted men to carry out the mission. The condition was that I could only dive in the presence of the Navy personnel. Since I had no scuba training whatever, companionship by the Royal Norwegian Navy was more than welcome.

A letter to my mother on February 8th, 1959 described my mood:

I'm on my way back to Stockholm: It's amazing to find out that I can operate with a chance of success in places where I can't speak the language, have no connections, little money, and am a total stranger. I have nothing but my brain and my cameras. I was afraid of getting stuck thousands of miles from home with no ticket back and no money to buy one. Fear dogged me. It's wonderful to discover that you don't need as much as you think... I have friends now in the Lofotens who are helping me find stories and three weeks ago I was a stranger. I have learned so much in these last few months...

Since my Leicas would be useless underwater, I needed other photographic equipment suited for the new work. Pål-Nils at TIO helped me contact Hasselblad, the Swedish manufacturer of high-quality cameras. They loaned me a Superwide camera with a special underwater housing. Adding to my gear, the Rolex distributor in Stockholm gave me an underwater watch in exchange for a mention of Rolex in any future publicity. Color film, chemicals, and processing tanks were packed into two enormous suitcases that added 114 lbs. of overweight to my luggage. The washbasin at the Seaman's Home would be my future lab where I would process both black-and-white and Ansco Color film.

Two weeks later, I was flying to Bardufoss airfield in northern Norway; it was spectacular; the weather was clear. The SAS pilot invited me to take photographs from the cockpit, and as we approached Lofoten he took the big DC-6 off course a few miles and brought the plane down to 1000 ft. so that I could take a picture of the fishing fleet at work.

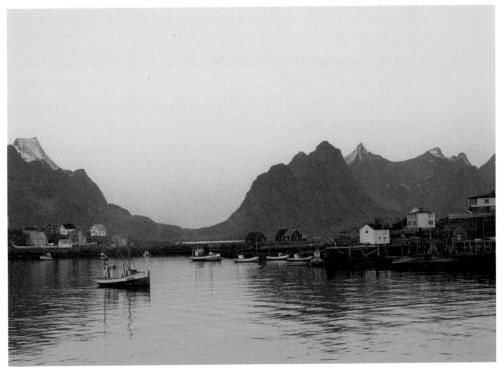

From Bardufoss I went on to Norwegian Royal Navy headquarters at Harstad. There I boarded the destroyer *Arundel* to make the eight-hour voyage to Ramsund, a naval base in the Lofotens. I was allowed to enjoy the trip from the bridge with the Captain, and arrived in high spirits feeling very important. Docking at Ramsund, we were met by Lt. Sten Wickman, the diving officer who was assigned to be my coach and make sure that I didn't embarrass the Navy. Sten was a man about my own age and we got along well; we had the same sense of humor. Two friendly sailors in their twenties, Svendal and Borman, both trained as frogmen, joined us. The next day we left by coastal steamer with a ton of equipment bound for Svolvær. All of the men spoke good English and the twelve-hour boat ride gave us a chance to talk.

The frogmen had been diving for bombs in Narvik Fjord and had recovered 36,200 pounds of souvenirs from World War II. I hoped that they wouldn't be bored with codfish.

One of the men asked, "What got you interested in diving in nets?" I explained the journalistic value of a new angle on a familiar subject, and the interest expressed by Dr. Rollefsen's fisheries research center.

I asked Sten Wickman, "How do you think fish will react to me in the net? Think I'm a seal?"

Wickman laughed: "Don't worry about what the cod think. Worry about what the fishermen think. You can't tell how they are going to react to something new. Fishermen are friendly, but they take their catches very seriously. They might decide frogmen frighten fish."

He laughed and laughed. Was I being tested? Could he be having some fun with a neophyte diver with screwy ideas?

When we arrived in Svolvær, we were met by Lennart Johanssen, my Swedish photographer buddy from Abisko. It turned out that SJ (Swedish Railroads) felt that tourists might be interested in Lofoten and commissioned Lennart to make a picture story of the islands and our expedition.

The presence of a Norwegian Royal Navy troop of frogmen got Svolvær excited. A platoon of girls began to shadow the young divers. They had a great time with girls, but I had bad luck with the weather. For ten days in a row, like pearls on a string, one gale after another blew into the Lofotens. It touched the islands in special ways, plunging them from black to gray, then to green and

blue, switching to brilliant dancing gold in a matter of minutes. Weather so bewitchingly beautiful on land, could be deadly at sea, so we stayed in port.

One day I stood on a bridge in Svolvær for an hour photographing the same scene over and over again, chilled to the bone but too fascinated to leave. As Lennart Johansen had said: "Weather attracted painters to Lofoten. They chased the shifting light with their brush strokes." But bad weather was hell for diving.

At six o'clock one morning, dim lights began to appear in the dark, where there should have been nothing to see but black water. The uncertain coughing of cold engines, then the deep hollow bleat of diesels steadily caught, seemingly waking other dark hulks. By 6:30 a.m. there was enough light to see the fleet, hundreds of small fishing boats tied together, jammed into the harbor. More lights popped on. On a still morning the steel exhaust stacks often blew smoke rings in the cold air. And soon you caught a whiff of coffee mingled with the acrid smell pumping from the clumsy-sounding diesels. By 7:30 a.m. the harbor was empty. Since my arrival in early January, the population of Svolvær had grown from 3,800 to 15,000. Now, 1000 boats were on their way to a starting line, where a Fishing Police Boat waited to raise a signal flag. The time that the nets remained in the water was rigidly controlled in areas where fishing was allowed. The Fishing Police signaled the start of fishing. The rule was that fishermen must have their nets set by 6:00 p.m. The following morning, it was a race again to drop the nets on the nearest shoal of cod.

The larger boats, 20 feet long and over, were equipped with electronic echo sounders that signaled the presence of schools of fish. Sometimes close quarters navigation in the fjords was necessary because several boats were getting the same density of pings, and the skippers were paying more attention to the fish than who was crossing their bow. On a Saturday before Easter, 50 boats snarled their nets. Tons of fish were lost. All the nets had to be hauled up together and many fishermen celebrated Easter Sunday by removing rotten cod from torn nets.

By noon on my first day of watching the fleet, the boats were on their way back to Svolvær. The next few hours were spent folding nets, icing down fish, and hosing gore over the side, after which it was time for a coffee break. Gallons of coffee were consumed, along with a daily swig of cod liver oil — and a slug of Norwegian brandy when they could get it.

An hour before the boats reached Svolvær, the cook on each boat had selected a fish for dinner. By the time the boat was unloaded, dinner was ready and the entire crew of five or six crowded into the forward bunkhouse to eat. The meal was always cod, beef being scarce and expensive in Lofoten. Sometimes a kettle of codfish soup with potatoes was the attraction, another time it would be boiled cod with boiled potatoes. The next day it might be fried cod, but it was always cod and there were always potatoes. The Norwegian fisherman's diet contained few green vegetables, but it was reported to be healthy. Codfish, after all, were vegetarians and their flesh was full of vitamins. For the fishermen, the cold they worked in required a high-starch diet — potatoes and more potatoes.

The removal of the codfish tongues, a culinary delicacy, at the dockside was the job of young boys. As the fish came from the boats they were decapitated and the heads thrown onto a pile. A small boy secured the cod head on a post by sticking a mounted spike through its tongue, then cut it free, adding to his monument of cod tongues.

It was Easter vacation and nearly all males, except babies, accompanied their fathers. There were even ten-year-old boys working as fishermen. Since most of the fishermen were not from the Lofotens, they lived on their boats, but on Sunday they came ashore to drink coffee in cafés, sitting quietly reading a newspaper or looking into space. They seemed lost out of their boats. At dockside, they jammed the telephone office calling their families back home. The movie theater was packed with young fishermen enjoying American cowboy films that always came to Svolvær.

Like the fishermen, I dined almost exclusively on cod. My taste buds soon became corrupted, however, and I began eating goat cheese and chocolate cake for breakfast as an esthetic balance to the daily diet of cod and potatoes. But my Sundays were devoted to experimenting with more exotic Norwegian cuisine. Dinner at the Hotel Lofoten provided *Specials* ranging from stewed whale meat to fresh fried reindeer or codfish tongues dipped in batter and fried. This Four Star Viking menu required a hearty appetite, but I adapted, sustained by excellent bread and Norwegian beer.

The coming of spring in Lofoten was marked not only by a change in the atmospheric light but a modification of the landscape. Some cod is refrigerated and shipped out to be sold fresh. But all over Lofoten, dried cod, *stockfish*, be-

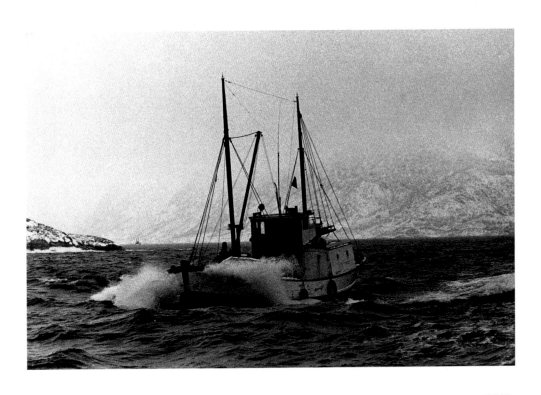

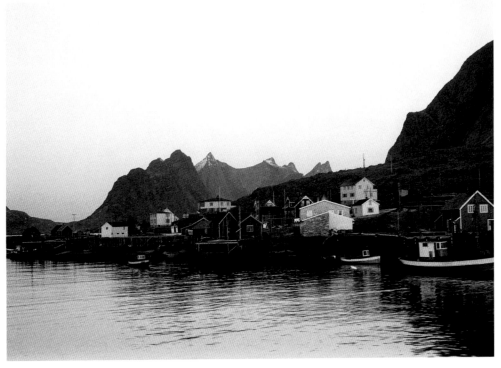

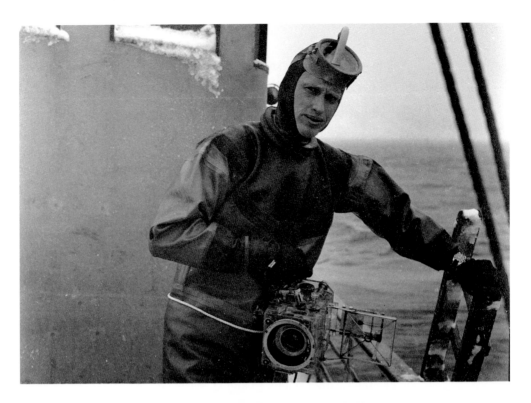

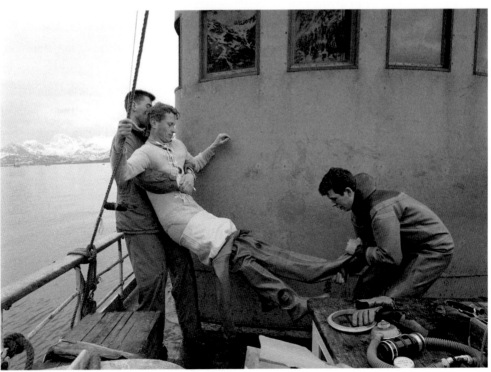

gin to fill up outdoor pole racks. Ton after ton of cod was hung on wooden tiers to dry. The fish, minus their heads, were cut open, tied tail to tail, and would be drying until summer. Eventually losing 80% of their original weight after a few weeks of hanging, the flesh was hard enough to withstand contamination by flies and the hunger of seagulls. Ice crystals protected cod from decaying during the first weeks on the rack, but as the season progressively warmed, a distinctive odor began to fill the air. By the end of March thousands of tons of cod were hanging exposed to the elements and a gentle breeze from the drying racks provided a pungent experience.

Stockfish had been exported from the Lofotens for a thousand years. It was the Vikings' ultimate global commodity. Petrified cod can be soaked, boiled, hammered, and chewed into an edible form and has a shelf life of ten years. No part of the fish is wasted. Even heads, with tongues removed, were dried and processed as fertilizer. The roe and livers were used as food and the meat was frozen and dried.

Finally, the weather stabilized and Lt. Wickman, Svendal, Borman and I swung into a diving routine, accompanied by Lennart Johanssen, ready to document it all. Each morning we were up at 4:45 a.m. and aboard the Fishing Police Boat by 5:15 a.m. Two hours later we arrived at the grounds in Ostensfjord and by 8:45 a.m., I was squeezing into my diving gear.

There were no dry runs, no training routine, or camera experiments underwater. Because of the bad weather, it was learning on the job. Although one of the frogmen was always suited up and ready to go in case I got in trouble, they often stayed dry aboard ship nursing their hangovers. Their adventures on land were far more rigorous than those in the sea.

As the nets were hauled up, I was in the water. The big problem was keeping warm. The 35°F water required wearing a heavy nylon under-suit topped by a dry rubber suit to keep from freezing. Once in the suit, I was comfortable, but getting into it was hell. The one-piece rubber suit was put on, believe it or not, by squeezing one's whole body through the neck hole. The frogmen didn't seem to have trouble with this, but they had to help me get my 6 foot 3 inch body in. Also, once in the suit, it was not a time to remember things that should have been done before getting sealed up.

The diving suit gave me the feeling of being a Marine mummy, sealed in my own tomb, out of touch. It was impossible to communicate anything except

through shouts and hand signals and I began to get lonely. My head was sealed in rubber, a facemask over my eyes, and either a snorkel or a mouthpiece connected me to my air supply.

The thick layer of nylon and rubber disconnected me from land-based experience. The heavy weights, the flippers on my feet, and the triple air tanks forced me into another existence. Once in the water, however, the whole contraption made sense and a completely different feeling took over — the thrill that early aviators must have felt as they flew from the familiar, a new feeling of independence spread through me as I felt the cold pressure of the sea on my body as I dived deeper and deeper. It seemed that the whole Atlantic and a million fish were in my private domain. Only my underwater Rolex watch and a strong nylon line attached to the ship connected me to reality.

Sometimes I swam out to nearby fishing boats, dove under and suddenly appeared on the surface next to the net being taken in.

The fishermen were surprised, and soon they were pointing, then shaking their heads, and then laughing. The word soon spread, and it wasn't long before we were all local celebrities. Before the season ended, fishermen began to realize that the Norwegian Navy sailors and the tall American were connected, and we began to be recognized on shore. The frogmen got some special attention because the *Lofotposten* had reported that they had located underwater and supervised the hauling up of two sunken fishing boats. Then, one day, an old man knocked on my door at the Seaman's Home and asked in English: "Are you one of the divers?"

"Yes. I'm the photographer."

"Could you make a dive for me?"

"What's your problem?"

He looked very sad and said: "I was fishing in Ostnesfjord last week and I leaned over to hook a fish in the net and that's when it happened."

"What happened?"

"I lost my teeth — they fell in the water — can you get them for me?"

I couldn't simply refuse his request, so I asked him, "Did you put out a marker buoy?"

"Why no, I never thought of that."

"Next time you go out, set out a buoy where you lost your teeth and I may be able to get your teeth back." He looked very grateful and nodded.

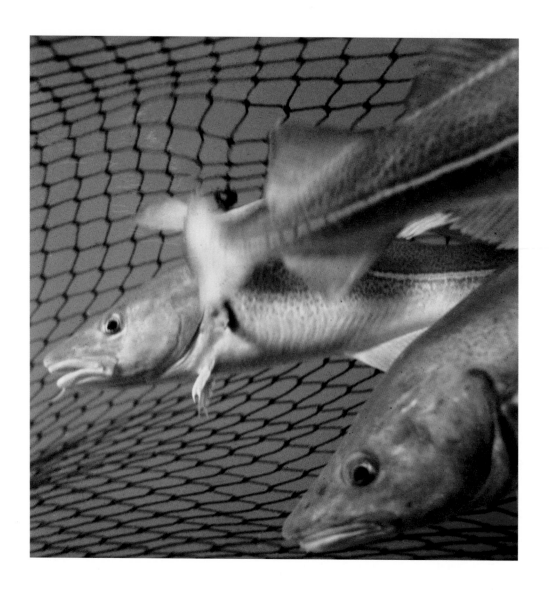

Some of the ideas for photographs I wanted to make for this story —fishing seen from the fish's point of view — proved impossible. For example, I had permission to dive from a fisheries research vessel, and I thought it would be fascinating to dive into a purse seine as it was lowered into the water and be drawn up with the fish, snapping pictures all the while. But this was madness. Among other things, the nets were dropped to a depth of a hundred meters or more — 300 feet — too deep for me to dive. Lt. Wickman had been to such depths, but even for a diver of his experience it was extremely dangerous. The Norwegian Navy has strict regulations about depths below 50 meters, which would make it necessary to have a portable decompression chamber on hand. Certain pictures I did make required deeper dives. For these I used either the triple air tanks or a hose forty meters long attached to an air cylinder on the ship. I found that the hose was best for shooting in the bottom of the purse seine as the air tanks tended to get caught in the netting. Other problems made accompanying the fish up in the net excessively dangerous. The net came to the surface rapidly, which made it impossible to go through a normal decompression cycle. (At any depth below 20 feet or so, a diver has to rise slowly, in stages, so gas bubbles don't build up in the bloodstream, causing what's called "the bends," an exceedingly dangerous, even life-threatening condition.) Even some fish suffer damage from a quick trip up; their eyes pop out.

Going into the net, I realized the wisdom of diving with the hose. Things inside got crowded and the net itself changed shape, billowing and drawing with the sea swell. My camera often tangled in the net and it was difficult getting down through the overlapping folds of the purse seine, closing and opening with the motion of the sea. Also, each net is originally laid in a wide circle, several hundred yards in diameter, but when the purse is closed, the diameter shrinks to no more than a few yards, with a load of fish trapped in the bottom. I felt trapped myself.

The fish in the bottom of the net proved to be as troublesome as the net. They were so curious about the new Marine monster that they kept lazily swimming up to my camera and facemask. Unable to focus so close, I jabbed back to make them swim away.

Hoping to compare the behavior of free-swimming fish to those caught in a net, I approached a shoal of cod at forty meters. The fish moved slowly in every

direction. They were about one meter apart and weren't at all disturbed by my presence. Beginning to photograph with my Hasselblad Superwide, I felt something gently but persistently bumping my back. Checking my watch to see if my twelve minutes for the dive was up – I felt another, and I turned to find a big one-meter long cod persistently poking me with its snout. After being poked several more times I poked the cod in return. This didn't bother the fish at all. But before I could continue this game of poke-a-cod, there were four unmistakable jerks on the line and it was time to return to the world above.

This was my last day of diving with no chance to further experiment with the cod, but I filed a report with my scientific mentor, Gunnar Rollefsen in Bergen. The Director of Scientific Undersea Fishing Research Center was delighted with my bumping cod story. As a world expert on cod, he was widely known in Marine biology circles as the only man who had been able to induce female codfish in his laboratory to release her eggs by tickling her in some special way.

When I visited Dr. Rollefsen later, he explained that when codfish mated, one of the fish swam up to the other and bumped the other behind the head with its nose. If the cod was ready to release her eggs, she would turn over and they would swim, belly to belly, locked together with their pectoral fins. At some point, the female would release her eggs in a long stream and the male would release sperm to fertilize them. Dr. Rollefsen came to the conclusion therefore, that it was possible that I had been approached by an amorous codfish. He described this as a remarkable event and I decided that this was the highest compliment that I had ever received either from an eminent scientist or a fish.

Perhaps he was kidding, but I immediately wrote an article for the Swedish daily *EXPRESSEN*, the pictorial magazine *VI*, and a Norwegian newspaper and was able to mention the Rolex watch, and the Rolleiflex and Hasselblad cameras I had used. The story wasn't quite ready for the scientific press, but such a fine tale was not worth debunking when the great scientist enjoyed it so much. Dr. Rollefsen also published some of my underwater pictures in a scientific paper. I don't think, however, that he mentioned my fish appeal.

When the season ended, and the fish swam away from Lofoten, the water was cloudy with cod fish roe. The gambling fishermen had won, coming up with record catches, so maybe the superstitious fellow thought the frogman had

brought them good luck. I asked one old fisherman whether he thought the frogmen frightened the fish.

"No," he said. "I don't think so. You can expect these crazy American tourists to turn up anywhere these days."

I was sad and totally exhausted. We were all exhausted. The two young frogmen, Berman and Stendhal, having consumed half of the beer and chased most of the young girls of Svolvær, badly needed military duty to get some rest. After twenty-two days in Svolvær, Lt. Wickman was pining for something more interesting to do, and I had been getting crazier by the day praying for good weather. My disposition was working in direct relation to the barometer. There had been eight dives during the entire period.

After the last dive I wrote my brother Gamble: *It became apparent today that it was time to go. This morning I went to breakfast. I ordered what I have every morning for the last two months: a cheese sandwich, a ham sandwich, and a slice of chocolate cake. I ate all these things in the order named but when I got to the cake, it had lost its charm. It didn't taste like anything in particular, not bad not good, just another piece of cake. I'm going to try again tomorrow morning and if the cake doesn't measure up to its previous standard, I'll shove off. There has to be something to look forward to. There are of course girls and alcohol. Norwegian beer is good but in order to bring a rosy hue to life I have to consume so much that the next day is not worth living through. The girls are very young and eager, but I found that chocolate cake holds up better for the long haul.*

Lennart Johanssen had returned to Abisko two weeks earlier and I joined him after leaving Lofoten on April 14th — to sleep non-stop on his bench for two days and nights.

Finally finding enough energy, I returned on the train to Stockholm with 14 rolls of Ansco Color film. A few months later, I sold the Lofoten photographs, the underwater work, and an article to the *National Geographic*. The lie I had told everybody that I was working for the magazine became true. I had found the Holy Grail for beginners like me.

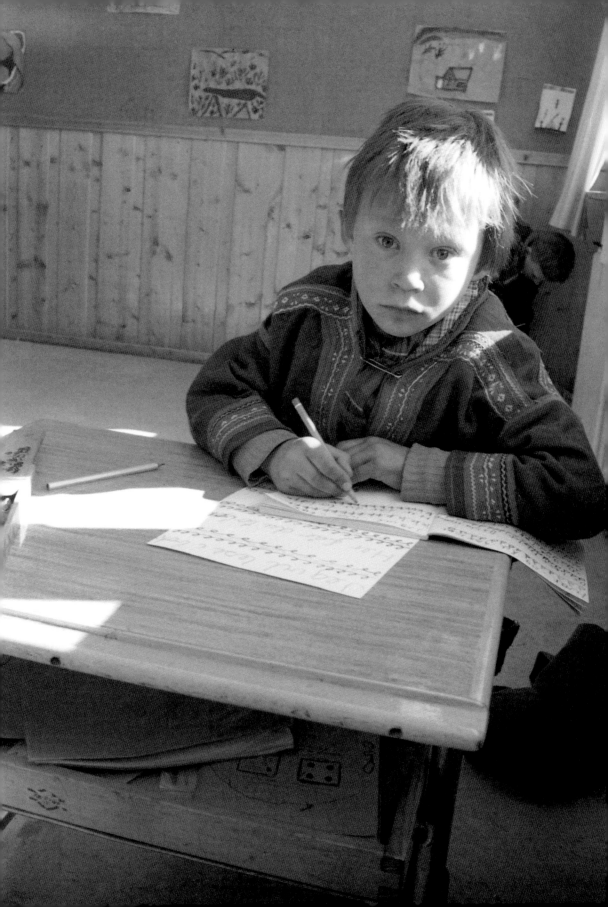

14 – KAUTOKEINO

My return to Stockholm allowed me to replace hyper with normal as sleep restored exhaustion. Monica was back in my life. She softly accepted my weariness and was an immediate comfort. Equally important, long discussions with my friend Pål-Nils Nilsson cheered me up. He had become interested in the Sami as the result of my success in Lapland. I was quite proud to have influenced an artist so much more experienced than me. I had even earned a nod of respect among the TIO photographers.

But within a few weeks, as my strength came back, restlessness returned. I was getting bored. Stockholm in the spring seemed darker than Lofoten in the dead of winter, and Pål-Nils' curiosity about the Sami raised new questions in my mind. Talking to him was like reopening a book that I hadn't finished, and it became clear that my reindeer experience should be taken to another level. The memory of Nils Nikolas-Skum's drawings still haunted me.

At the Sami fall roundup in Tjuorek, Sweden I had learned about the presence of a large group of Norwegian Sami in a place called Kautokeino, which in Samisk means "between the reindeer grazing grounds of the winter and the summer pasture by the sea." Kautokeino was the traditional midway gathering point for their long migration to the coast. The Norwegian Sami come there around Easter, which is also a time of celebration and when many marriages and baptisms take place. Kautokeino seemed to be the logical place and Easter the proper time for me to find a way to join the spring migration. I hoped to discover there the kind of excitement I could no longer find in Stockholm.

I researched my trip in Oslo, but it didn't go easily. At the Norwegian Tourist office nobody had the vaguest idea about what went on above the Arctic Circle. Information about the interior of the north was inaccurate or non-existent. Tourist maps described roads that later turned out to be dirt tracks or snow trails. But I persisted. I discovered that to get to Kautokeino, I had to fly to a town called Bodø from Oslo then travel north by coastal steamer to the Arctic port of Alta, the largest town in Finnmark, a huge county bordering Russia in the east, Finland to the south, and to the north and northeast it jutted out into the Arctic Ocean (Barents Sea). Although the largest county in Norway, covering an area greater than Denmark, it was the least populated. Finnmark had been inhabited by Sami for thousands of years; it was the place to find them.

Packing my gear, I set off on my new northern adventure, and without much difficulty reached Alta. Getting from there to Kautokeino, however, was another story. During winter and early spring, the final, unpredictable 78-mile trip inland was usually made by reindeer sled, or on skis, but I found that a new "bus" service operated on Mondays and Thursdays.

The "bus" was tracked like a tank to traverse ice, snow, or mud. A plywood box bolted to the vehicle's frame held twelve passengers, who sat facing one another on two backless, cushionless wooden benches. When the door closed, two tiny sealed windows fogged up. Tears of condensation gathered on the glass then froze, becoming icy cataract lenses that obliterated the outside world. We lurched and heaved in this airless container for six hours before reaching our destination — Kautokeino, a village with a permanent population of five hundred situated 168 miles north of the Arctic Circle in the interior of Finnmark.

Kautokeino was set in a featureless, treeless landscape — as if some bureaucrat had stuck a pin in the map and said: "Build it here." But in fact it had been "rebuilt here," because the occupying Germans had burned houses, barns, hospitals, and churches in a scorched earth policy in 1944 at the end of World War II that leveled not only human habitation but killed off animal stocks as well.

The Kautokeino district had the highest percentage of nomads in all Lapland. This included Norway, Sweden, and Finland where there were many reindeer breeders but few nomads. The result was that the 85% of the Sami population who were not nomads had difficulties. The stationary Sami who

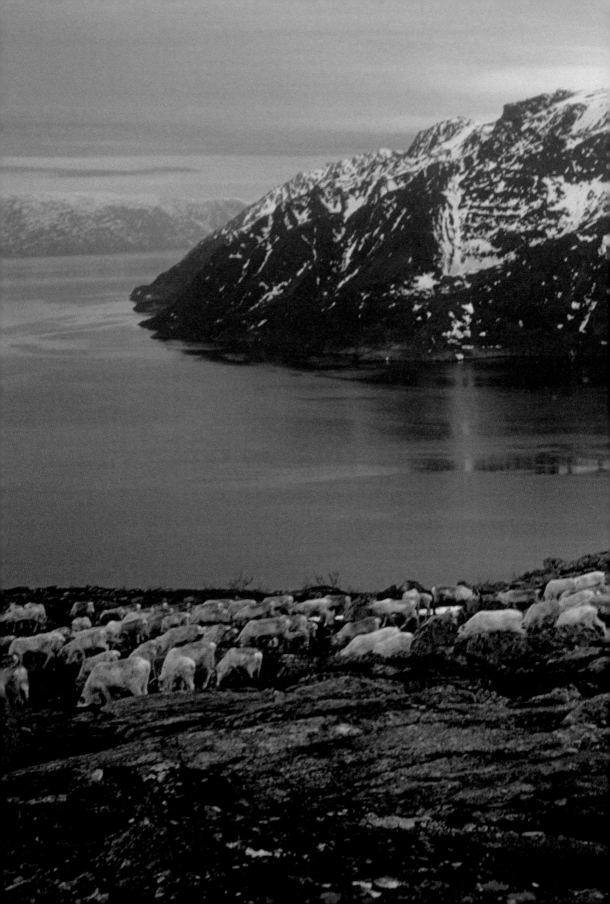

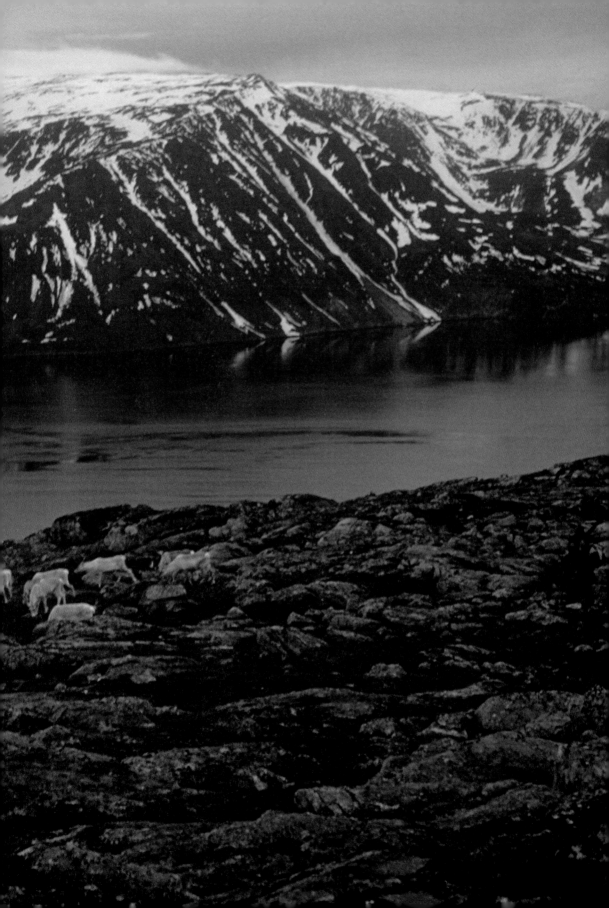

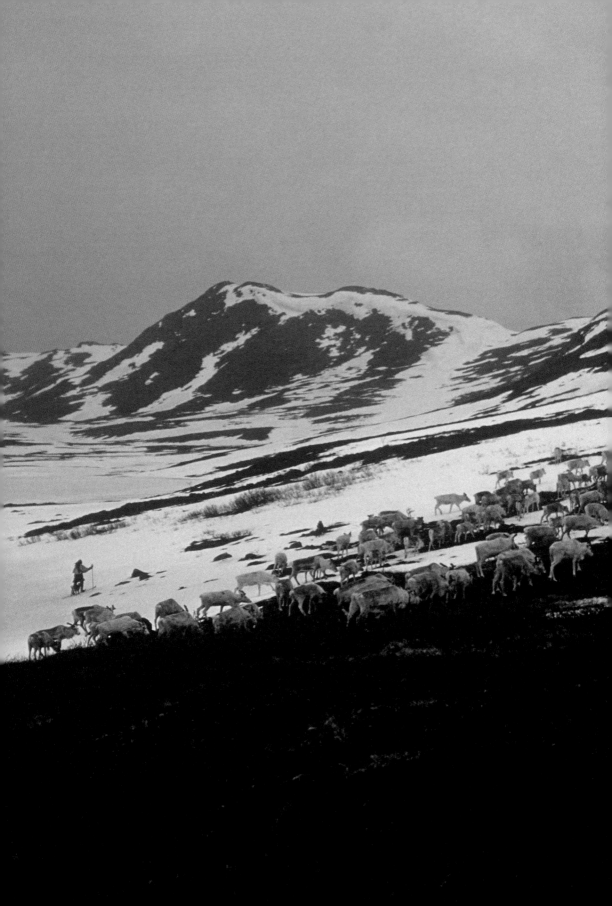

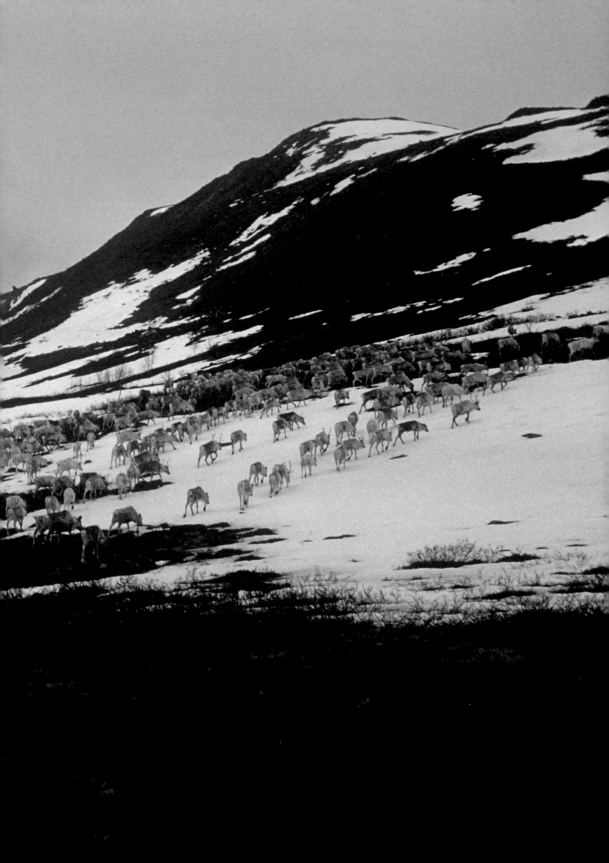

had formerly lived by fishing and hunting were now forced to work in the towns because game had become very scarce. Both the Norwegians and the nomads to some degree looked down on the sedentary Sami. The majority of the Sami, therefore, had to change their way of life, in fact their whole attitude toward life, to fit into modern Norway. The reindeer herders, on the other hand, had less frequent contact with Norwegians and, ironically, they were not at all uncomfortable with strangers.

The very traits that make the Sami fascinating to anthropologists and tourists alike created difficulties for them in a modern culture. As in Sweden, their uniqueness caused them some embarrassment. Strangers found them irresistible camera subjects and the Sami who lived near the tourist routes along the coast were subjected to an ever-increasing amount of ogling. Like the tourist-Sami in Kiruna, some had turned this into a good business, but others resented the attention and refused to be photographed.

It was the Sami nomads, however, who economically and socially led the Sami community in Norway. The hard Arctic weather has conditioned them for a culture built around reindeer. They were magnificently suited to this difficult life; they knew how to survive in appalling cold in bleak terrain where it seemed impossible to sustain life. This survival story had a great appeal for me. I wanted to learn from it and metaphorically apply it to my own struggles.

I found a room at the government-run Guest House in Kautokeino, and proceeded to settle in and learn as much as I could about the nomadic Sami and their ancient ways. All around me preparations for Easter were animating the town.

Kautokeino's red-painted wooden barracks-like structures, built after 1945, gave no hint of a past that included a Swedish church that had been founded in 1701 prior to the modern creation of Norway. But at Easter, traditional Sami culture brought the new church, built in 1958, to life with celebrators ablaze in brilliant costumes. Women had been working for months preparing; sewing new reindeer hair jackets, ribboned broadcloth tunics, and getting men, children, and themselves ready for Easter. Sparkling homemade jewelry and brilliant shawls imported from Italy were for sale at the Kautokeino general store: Oriental scenes and Venetian gondolas embroidered on the rayon seemed perfectly at home with each other, even against the colorful abstract patterns of the Sami dress.

In Kautokeino, the Lutheran Church was the epicenter. I attended several weddings and saw some of the forty-six children confirmed while I was there. Sami parents give reindeer to children on their confirmations. In fact, children accumulate reindeer from infancy. At baptism, a baby is awarded two reindeer, a male and a female. As nature takes its course and with good fortune and rich relatives, young Samis might find themselves at the altar with a sizeable herd of their own. A Sami marriage, however, is the greatest reindeer transaction of all, for the husband, in addition to getting a bride, also gets all her reindeer as a dowry.

At one wedding I attended, outside the church, bride and groom were assaulted by beaming relatives who rushed to get photos of the bride clutching a huge bouquet of plastic roses. Then everybody climbed into or onto a tractor-pulled wagon, jeep, truck, car, or horse and reindeer-drawn sleds and every vehicle took off for the party, where Sami women rushed into the reception hall and out of the nearby storage loft, getting more and more food for an overflow crowd of 150 people.

There was only room for thirty guests at a time to gorge on the barley soup, boiled reindeer meat, bread, margarine, and homemade cloudberry jam. Dessert was a mixture of dried prunes and apricots transformed into a gelatinous mixture served with cream. It looked horrible but tasted delicious. At the end of the feast, bride and groom were presented with a symbolic wedding gift, a 10 kroner bill ($1.50). They had, after all, got the most valuable gift of all, reindeer. When the Lutheran pastor left, prohibition left with him and the party got rolling.

At three in the morning, a pair of young men from the reception passed the Guest House where I was staying. The noise was terrible, and I leaped out of bed having no idea what was happening. But it was only *yoiking*, my first experience with this Samisk vocal expression — and the celebration went on for days. Many had come hundreds of miles for the great Sami gathering, their only chance to get together during the entire year.

The economy of the interior of Finnmark was well below that of the south, and in many ways this has had a beneficial effect. The Norwegians living in Kautokeino were not better off than the Sami and consequently economic life was more balanced between the two cultures. The Sami here, in contrast to the ones living in Sweden, were hospitable, and very much in charge.

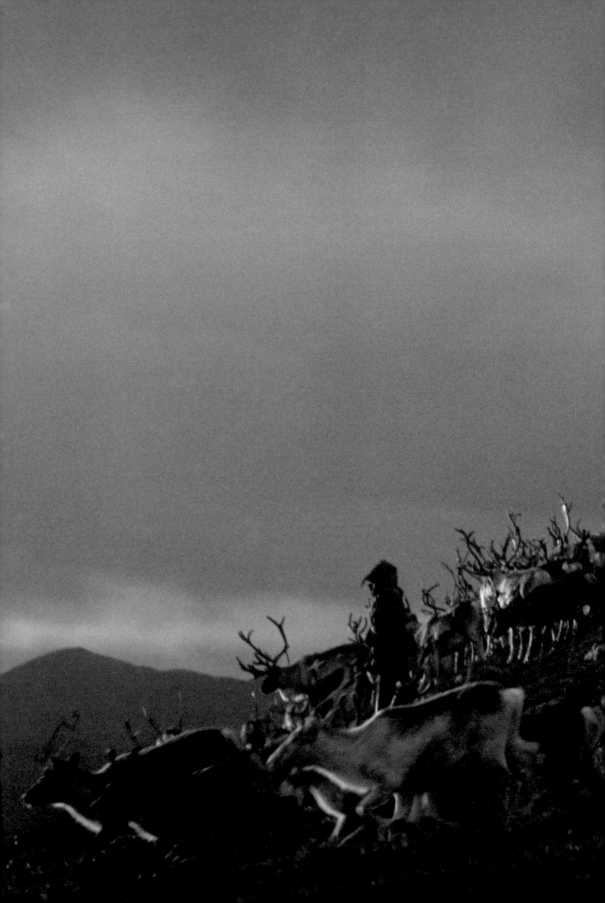

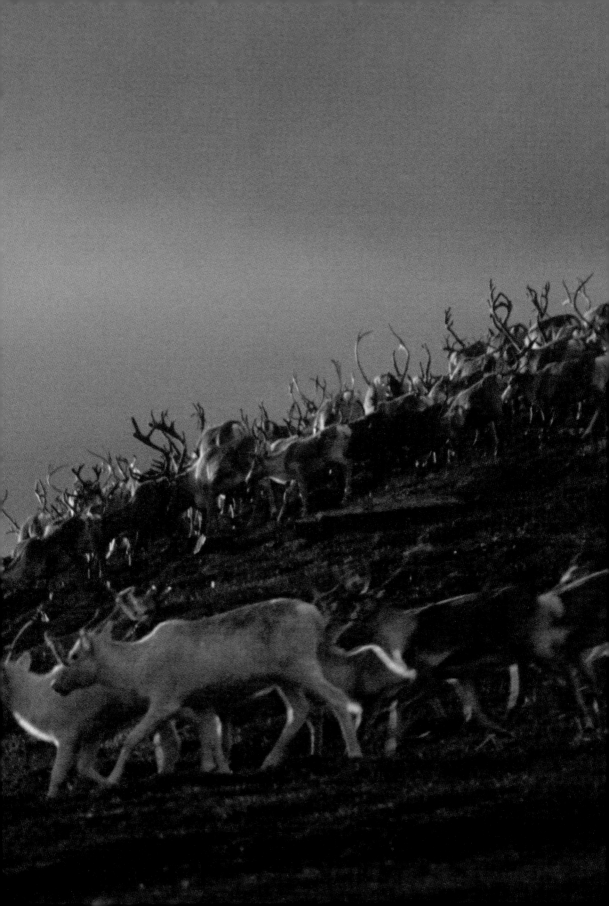

The Sami were friendly to me. Ironically, reindeer herders here who had the least contact even with native Norwegians were the most comfortable with strangers. People in Kautokeino were happy to have their pictures taken and here, unlike Sweden, everybody wore the national dress — even Norwegians — because it was so practical in cold weather.

The Guest House where I stayed had a few Norwegian tourists, and young Sami boys and girls would come into the front hall of the Guest House silently watching us strangers. This went on for hours, tourists and Sami staring at each other. The hotel guests were curious to see the seldom-seen nomads, and the children were just as curious to see the seldom-seen tourists.

One of the tourists I met was Hilma Murberg, who had opened a store several years before in Lille Larrisfjord on the coast. We liked each other at once, and since he spoke English I was able to get a lot of information from him. He told me about his early experiences in Lapland, and that he had always been interested in making friends with the nomads who occasionally traded at his small store. He liked them, and as it was also good for business, he encouraged them to come to his house for social visits. But the first Sami trait he discovered was their sense of time. Friendly Sami began to drop in on him, and it wasn't unusual for them to make a visit at 3 a.m. Hilma said that he was obliged to limit his hospitality.

My inability to speak in any language the Sami understood provided me with no insights into their culture. For three weeks I interviewed anybody who could understand me: officials, teachers — Sami and Norwegians. Teachers' stories were particularly revealing about the difficulties faced by two such different cultures. In the new Normal School (only Norwegian spoken) teachers attempted to deal with the same cultural differences that I was trying to understand. Ninety children age seven to fifteen — boarders dumped into an alien and highly regulated life. It was confusing for children who usually didn't speak Norwegian.

They learned Norwegian after a year, but school routines made no sense to them. Little in the school books related to their culture. Norwegian food was alien; they didn't like vegetables, preferring simple boiled reindeer meat that wasn't plentiful here.

Sami children had difficulty with pencils but even the smallest child could use a knife. I saw a five-year-old girl extract a piece of reindeer bone marrow

and poke it into her mouth with a knife twelve inches long. However, Sami children excelled at arithmetic. Keeping track of reindeer numbers was an intrinsic part of their culture.

Used to the harsh environment of nomadic life, children saw no reason to take off their clothes at night and taking a shower was considered a hardship. According to teachers, Sami children had more vivid imaginations than Norwegian children. Their paintings were less inhibited, more abstract. Children relied on fantasy to play games needing few toys. Most games related to nomadic life. Instead of *Cowboys and Indians* it was *Reindeer Roundup*. One child was a dog, another a reindeer, and still another was a Sami herder trying to lasso the animal. Children happily played with things around them — stones, pieces of wood, or a reindeer horn. Their imaginations filled in the rest.

Participating in the Easter celebrations and learning about the children broke the codes that I had found so difficult to predict with the Swedish Sami and opened pages of possibility.

Easter was over and the Sami would soon be off on their lonely treks. The snow was thick but the light had returned. The reindeer herds were nearby and it was the time to join them. During my three weeks in Kautokeino, I had been able to make friends with officials, teachers, and regional Norwegians; I found everybody cooperative. A particularly important contact was the local head of the Reindeer Police, a division of the Norwegian Police Force charged with maintaining law and order in North Norway, overseeing environmental protection, and looking out for the herders and the reindeer. He agreed to find a nomadic Sami who would allow me to go with him over the mountains with a herd on the spring migration. We negotiated what he said was a fair price that I should pay the Sami, the cost of two very large reindeer, or about $100. He said he would look around.

With luck, I would now travel with the reindeer and the Sami herders to their summer grazing grounds off the coast of Norway. This was not a sure thing, reindeer herders were not in the tourist business, but the Reindeer Police soon telephoned me that I could join the Sami near a place called Levdun. He said that a car would pick me up from the Guest House in half an hour to take me there; my introduction to nomad life was suddenly at hand.

I was deposited with rucksack, skis, and sleeping bag on what seemed to be the most desolate road I had ever seen. I hoped that this was the right place,

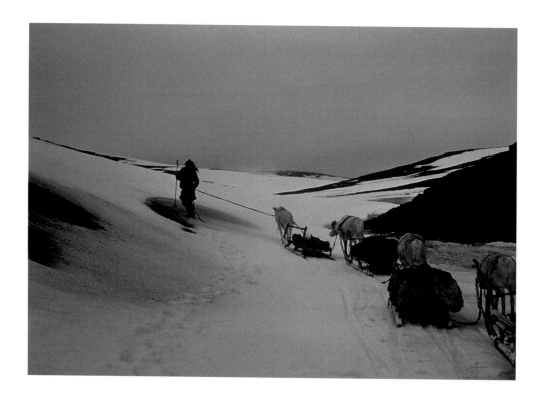

because there was no sign of anything at all, and no way of knowing for sure whether this wasn't going to turn out to be a major cultural misunderstanding. My topographical map of the Finnmark plateau was jammed with rocks, bogs and 10,000 lakes in the Kautokeino area alone. Levdun was underlined in red but there was no sign of it from where I sat. I considered renaming it: "What the hell am I doing here?"

Anxiety began to creep in, and then I remembered what Lennart Johanssen had said about "Sami time" the year before in Sweden: "You might fix a date to meet at noon on Wednesday, but if it snows or his favorite reindeer is sick, it might be Thursday. Or who knows when?" Developed over centuries of experience, their internal clocks were set by intuition, not like the one I had strapped to my wrist. Time for its own sake meant nothing. As Lennart had cautioned, "Sami clocks are wound by circumstance." His voice joined others: "Sami are hard to pin down."

Also, among these people, there were no simple words like *yes* and *no*. If you asked about: "Meeting the American at Levdun, Yes or No?" They are

equipped to say: "I will not do it" or "I will do it" in seventeen different ways. I had been told that a simple *yes* or *no* does not exist in Samisk.

As I waited, scanning the horizon for Levdun Mountain, or what I hoped was Levdun Mountain, I suddenly saw a speck; soon, it became a small figure on skis, and then behind, two then four sleds being pulled by reindeer. They were trotting down a snow bank. Fifteen minutes later I met Nils-Peder Sara and his brother Anders, who I would get to know very well.

My concerns about Sami appointment habits were unfounded. Nils-Peder had appeared exactly as the Reindeer Police had promised.

"Buris Buris," I said, which meant "Hello" to the Sami in Samisk but "Thank God you are here" to me.

"Buris Buris," was the reply.

This was Nils-Peder Sara, a friendly man who looked 40 years old but was 32. He told me that he and his brother, Anders, were moving the herd alone. Anders would join us later, but the rest of the Sara family was traveling by bus and boat to summer grazing. Then he asked me where I had come from, how I

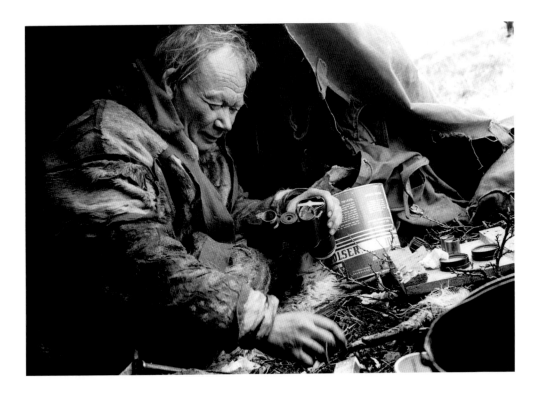

had come, and how much it had cost. He had other questions about the weather and snow conditions in Kautokeino. Finally satisfied, he went off to gather firewood for a "coffee cook." This would make our meeting official.

We were camped in an open area near the road, but a small fire was quickly laid, and we sat around sipping coffee and getting to know one another. Nils-Peder spoke rather crude Norwegian, but ironically this was why I understood a lot of what he said. We spoke slowly and used simple words, which were perfectly suited to my own brand of pigeon Norwegian. Most Sami spoke at least three languages; Samisk, Finnish, and Norwegian or Swedish, depending on which country they lived in. Samisk, however, and to a lesser extent Finnish, are the languages spoken at home. Many were self-conscious about speaking bad Norwegian in public. To further complicate the situation, the Sami in southern Lapland cannot understand the Sami in the north, but this was no problem for me as "Buris Buris" was the only Samisk I knew, and it worked just fine.

At Levdun, I began to learn more deeply about Sami culture and life. My lessons began with something personally relevant, on a level I could understand, the "coffee cook." Cooking coffee was an essential Samisk ritual. The Scandinavians in general drink a lot of coffee, but nothing like the Sami. Nils-Peder had a hand crank coffee mill and he took the beans out of a little decorated reindeer skin bag and ground them. The crushed beans were dumped directly into a boiling kettle. Sami coffee comes strong and often. Its fine when you get used to it: I did get used to it, and later learned a few secrets to ease its consumption, but the first cup was a blow to my uneducated stomach.

A few hours after we met, Nils-Peder's dog got into a lively argument with another dog, and I turned around startled to discover that his older brother had arrived on skis. A man with a face of a fairy-tale troll, he had few teeth and the little hair that remained had been combed by the wind. This was good-natured Anders, a man who seemed ancient at thirty-eight.

Anders put some more wood on the fire and Nils-Peder soon curled up in a blanket with his dog as a pillow and went to sleep. It began to rain, but Nils-Peder was oblivious. The water dripped off his nose, but he didn't wake up. This was a remarkable feat, one that I hoped I wouldn't have to emulate. We were in a bog, and the depressions between the little mounds of earth were beginning to fill up with water. It was getting quite wet, but Nils-Peder slept on.

After finishing his coffee, Anders went over to a cluster of Dwarf Arctic Birch trees, three or four feet tall, that were growing nearby, and cut several armloads of branches, which were dumped on the ground. He then began unraveling the ropes and canvas that covered the sleds. The sleds were unloaded, and then dragged into a circle. I helped Anders stand them up, front end to front end, the runners facing out to form a tepee-like pyramid, which he then draped with the canvas. Extra skis and a few small poles filled in the spaces between on the upright sleds. The two canvas coverings were then lashed to the runners, making a neat tent in about ten minutes. Inside, some birch branches were laid down and we threw reindeer skins and blankets on top of the branches to complete our home. Another coffee cook celebrated the event, this time, much to my relief, indoors.

The whole tent wasn't more than eight feet across at the bottom and six feet tall. A fire in the middle made life comfortable. The smoke billowed out of an opening in the roof and everything was fine provided I didn't try to stand up while the fire was starting. A small cloud of choking smoke came from the wet wood until it caught and quickly became an intense blazing little fire. At first, I also had difficulties in moving in and out of the tent without stepping in a box of margarine or kicking over the coffee. The space was better suited to my smaller companions, who were at least a foot shorter than me.

About 10:00 p.m., it was still light, two Norwegians who had been expected arrived by car. Nils-Peder woke up to greet them. They had food for the brothers: bread, a can of Norwegian hot dogs, tobacco, and cigarette paper, but most important, two bottles of brandy. The visitors were only there for half an hour, but before the car left, the brandy was half gone. I decided it was time for bed, so I got into what Anders called my *sourpuss*, a slight corruption of the Samisk word for sleeping bag, derived from the Norwegian *soveposen*. It wasn't bedtime for the brothers; for them the party had just started. The Kautokeino Sami are normally friendly, and with a bottle of brandy already demolished, camaraderie picked up. I had zippered myself into my sourpuss and hoped that I wouldn't be invited to this party. The brothers began to *yoik* and I knew I was in for it.

A *yoik* is the name for a sound that escapes from happy Sami, and theoretically falls under the category of music. It isn't included in the general repertory of Western music and for an American to create anything like a proper *yoik* it would be necessary to undergo intensive training. However, someone with a

cold, combining a Hopi Indian chant with Japanese Kabuki, could theoretical-
ly produce a recognizable synthetic *yoik*. The *yoik* is a vehicle for self-expres-
sion and the Sami have *yoiks* for different occasions. The usual one, in my lim-
ited experience, and the occasion for this particular *"yoiking"* was the presence
of alcohol. Later research, however, indicates that this wailing chant can be
quite beautiful; it comes from the heart and harkens back to the Arctic life with
all its moods. There are special *yoiks* for people to fetch back nature's good
spirits or ward off its angry spirits. It is basically liturgical shamanistic music
and dates back to pagan times.

I first learned about *yoiks* in Kautokeino from Mikkel Bongo, a Sami musician
who had elevated *yoiking* to its rightful status of folk music and invented a musi-
cal instrument to accompany *yoiks*: the one-stringed margarine box. He played
the instrument by plucking at a thin wire strung from a stick that was nailed into
the wooden box. From this simple instrument comes a humming sound that
complements the weird *yoiking* itself. Mikkel Bongo was very skillful and has ac-
companied himself while *yoiking* at a Norwegian Folk Music Festival in Oslo.

Nils-Peder and Anders, however, were in a different class. Their *yoiks* were
the variety that brought despair to pious churchgoers. The words were in
Samisk, so I understood nothing, but as Nils-Peder began to add Norwegian
words, I understood that the lyrics involved Samisk-American solidarity. I was
invited to have a drink. Afraid this might happen, I snored loudly and sunk
deeper in my *sourpuss*. I had zippered it up as far as it would go, but friendly
drunken hands jostled me out of my faked slumber. One bottle that was offered
me had some heavily sugared liquor in it and, what was left of the other, tasted
like the unspoiled rough-natured monster that it was — 65% natural spirits.
Somehow, after the first jolt the stuff wasn't too bad. This led to my first *yoiking*
lesson and it wasn't long before we were all *yoiking*.

The next morning I woke up with a strange buzzing in my ears. It turned
out *not* to be the symptoms of brain damage from too much bad brandy, but
Anders shaving with a battery-powered electric razor. It was still raining so
our departure, much to my relief, was postponed until afternoon. The addi-
tional buzzing in my ears had nothing to do with Anders' shaver.

The reindeer herd of the Sara brothers was a small one. It was grazing on
the top of the mountain nearby, and my guess was that there were about 500-

800 animals. I wanted to ask Nils-Peder how many reindeer he exactly had, however this is considered to be very rude in Sami society. It's like asking a Texas rancher how many cattle he owns, but another reason for it is that the Reindeer Police are fond of gathering such information for tax purposes. As a result, you get a conservative figure if you ask about any Sami reindeer numbers, if you get any number at all.

Several weeks before I met the Sara brothers, I had been anxious to get aerial photographs of the herds. One day when I learned that my friend Lt. Col. Hans Lund, a well-known Norwegian pilot, was flying to Kautokeino, I telegraphed to ask whether it would be possible to fly with him to get aerials. He agreed, and began to locate some reindeer herds so that we would waste no flying time.

Lt. Bjorn Hansen, the garrison commander of the tiny Kautokeino airstrip, had scouted the area and he marked some herds he had spotted on an aerial map. When the Sami found out about this, however, there was a lot of discussion about whether the photo flight should take place. They were not anxious to have their reindeer photographed and counted, so they tried to dissuade us by arguing that we would fly too close to the herds and spook them. Also, they said, the females were close to calving and the plane would upset them. We assured everybody that Lund and I didn't care how many reindeer anybody had and that from the air one herd looked like the next. 'The problem of getting too close to the animals was solved by inviting a prominent Sami to make the flight with us.

On the day agreed, Lt. Col. Lund arrived in a Norwegian Air Force De Havilland Otter. We were scheduled to take off at 11:00 a.m. but at 9:00 a.m., our Sami friend was downstairs in the Guest House, downing one beer after another. He was nervous. It was his first flight. By departure time, however, he wasn't nervous at all. He was so relaxed that he was unable to walk or talk. We reluctantly abandoned our guide and took off to find the reindeer.

In a few minutes we were flying along the huge fence that marked the Finnish border. The fence had been built jointly by Finland and Norway to keep the reindeer herds from mixing. We found several reindeer herds on the Norwegian side of the border, and near one of them we saw two animals sitting in the snow.

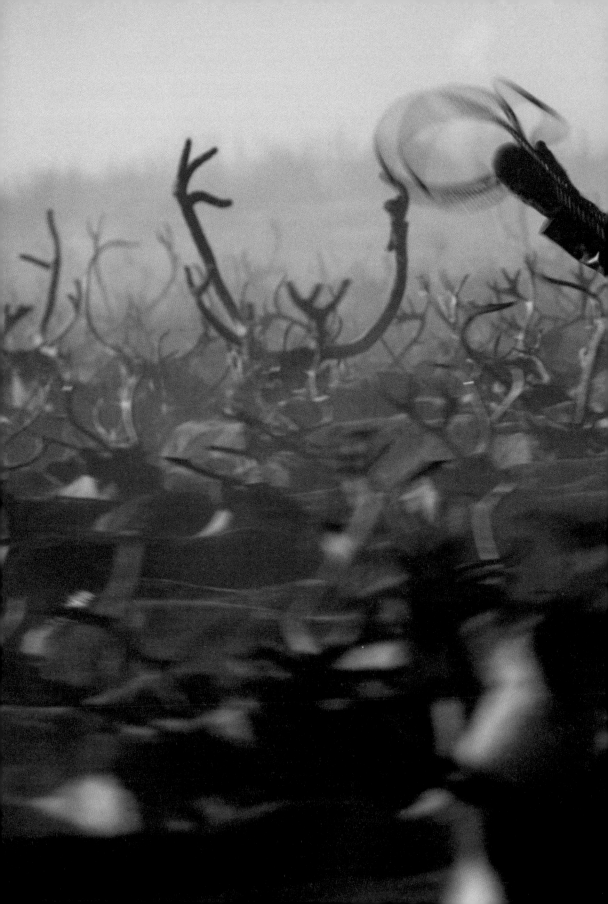

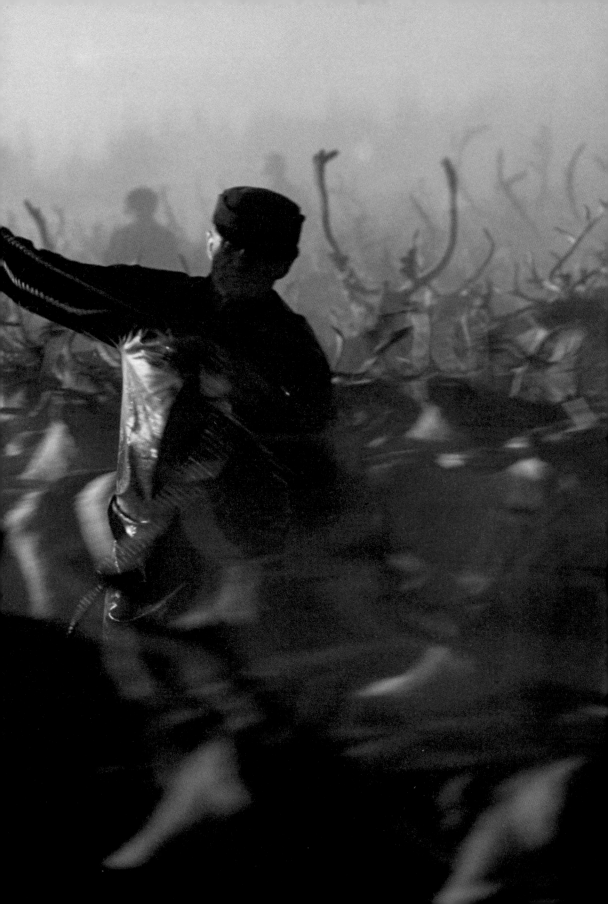

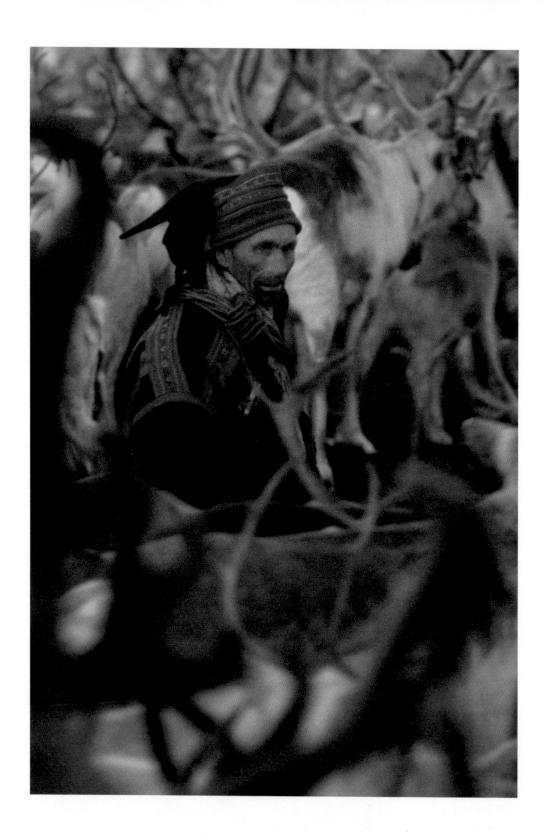

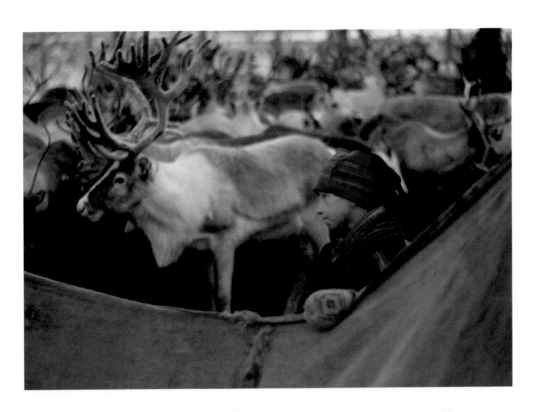

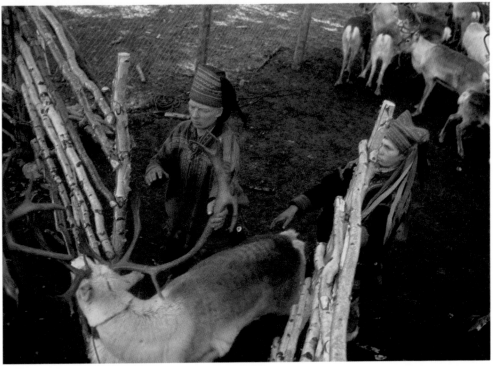

"Wolves?" I yelled.

It was hard to tell from the plane.

"Not wolves." The colonel shouted in my ear.

Lund explained later that they were foxes because they were on the windward side of the herd, where the reindeer could smell them; foxes posed no threat. The reindeer would have become frightened and run off if the animals had been wolves. This was his diplomatic way of telling me that I couldn't tell a fox from a wolf.

I was in the co-pilot's seat and when the colonel saw something he thought was interesting, he dipped a wing, pointed it out, and down we swooped. This had the most amazing effect on my stomach. I'm not good in small planes, but in a few minutes we were headed back to Kautokeino: not a minute too soon.

On the ground later and back with the Sari brothers, Anders saw me photographing his reindeer herd with a 200mm telephoto lens; he became curious. Looking through the lens produced a gasp of approval from him. Then he produced his 7x50 binoculars and sorrowfully asked me to look; I couldn't see a thing; the prisms were completely fogged with condensation. Then, pointing to my camera, he made hand signals that indicated he needed the telephoto to replace his binoculars. He was having trouble keeping track of the reindeer in the mountains. Although I was reluctant to refuse anything to my new *yoiking* companion, I felt equally reluctant to part with my lens. The lens itself wouldn't have done him any good anyway but this was a critical moment in relations between Lapland and the U.S. Anders, however, came up with another plan and went to work. He began dismantling his binoculars with a reindeer slaughtering knife. I sat in amazement watching him take it apart, clean the prisms, and put it together again. Apart from a few mangled screws, the binoculars were as good as ever — and did a much better job than my lens would have done.

When it stopped raining we set out on the track headed northwest toward the coast about 7:00 p.m., one brother following the herd and the other leading the sleds laden with supplies and me. It was now the time of light and we were not clock-bound. Soon we would have the midnight sun and I began walking as much as possible, to keep warm. Relieved to find that a reindeer sled had been set aside to carry my skis and rucksack, I knew that I could ride if neces-

sary. The crust on the surface was hard enough to hold me up, but only for a few steps, then down I went, only to stand up hopefully, then disappear again in four feet of snow. I stayed close to the sled and when in trouble I jumped on.

In spite of my experience with reindeer in Sweden, my understanding of the animals as personal transportation was limited to seeing Sami men and women wrapped up in skins swishing around Kautokeino on passenger sleds, hauled by high-stepping reindeer — a romantic Currier & Ives scene with a dash of Santa Claus thrown in. Now, I warmed up by walking for a while and when the snow got too deep I gratefully boarded my cargo sled, and I immediately began to feel more nomadic. My reindeer, tethered in front of the sled, plodded through the deep snow. Then, surprise, as we settled into a brisk clip going downhill, the animal lifted his tail and showered me with little marble sized pellets, as if to say "welcome to the far north."

When I got cold again I decided to dismount the sled and try the Sami skis. Problem; they had no bindings as we know them. A crude strap across the top of the ski holds down the front of the Sami shoe, which has a curled up toe. When necessary, the shoes can be easily slipped off the skis, a great advantage when the skier is moving over terrain where there are frequent bare patches of ground and the skis must be removed quickly.

Spring had come early this year to the Kautokeino area. The frozen lakes had a deceptive covering of soft snow, and water came through the ice in certain places. Some rivers had begun to break up, and free water was rushing through narrow spots that we had to cross. This required expert judgment on the part of Anders, who was leading the parade. The brothers traded off following the herd that was nearby but taking a different route through the mountains. The four sleds were connected, with Anders guiding the lead reindeer. The reindeer pulling my sled, which was the last in line, like all the others, was attached by a leather guideline to the back of the preceding sled. This made fording streams tricky business; all the sleds had to get safely across in one go. Anders put on his skis and made a quick reconnaissance. He was quick to make up his mind, wading across the yellow green water pulling the lead reindeer behind him. Each reindeer in turn started up, and before I knew it, my animal was charging into the water with me on board and ready for a cold bath. Suddenly, my reindeer was in the water, across the stream and as the

animal came up on the opposite bank, the forward part of the sled was lifted and out I came – dry! Not a bad ferry ride.

Anders was also dry even though he had waded across; his reindeer skin trousers and shoes were waterproof. Sami clothes are made for this kind of trip. Reindeer hide shoes — with hair on the outside — for pure snow conditions, and oiled and hairless for wet conditions. The shoes are flat, with a stitched-on sole, and are made by the women, as are all the clothes. Provided the materials are ready, it takes a woman about eight hours to make a pair.

The Samis' trousers are also made of reindeer hide and, like the shoes, are tanned or not, depending on the season in which they are worn. Both men and women wear these shoes. The leather clothes are sewn together with a tough thread made from reindeer ligaments that are cut from the carcass in flat strips about a foot long and as wide as a pencil. After drying, the women split the ligaments with their teeth and stretch the threads by hand across their thighs. Taking one end in hand, they then twist the threads into a single long strand by rolling the end against their cheeks. The loose threads at the bottom of the strand are joined to another group of threads and rolled together to form a single long strand until the seamstress has a substantial ball of tough waterproof thread. A man wears out at least five pairs of shoes a year, so a lot of thread is required.

Remembering discussions in Kautokeino about the role of women in Sami society, I had found that it was much the same in both Norway and Sweden. Sami women in both countries make the clothes and shoes, cook the food, and do housework when they live in houses. A lucky housewife might have a sewing machine, but that was the extent of automation in Sami domestic life. Although wives had to make five pairs of reindeer shoes for their husbands, many women made extra shoes to sell to tourists. In Kautokeino, I had bought a magnificent pair of elk skin boots as well as a reindeer skin coat. Although the boots were not finished before starting this trip, my new coat slipped over my clothes nightshirt style and was light and warm, well suited for this trip. My leather ski boots, purchased in Stockholm, were a disaster. Nothing about them addressed reindeer migration reality.

By now we had been climbing steadily for four hours heading over the mountains to the coast. On the road at Levdun there had been budding bushes. Spring had come, but in the mountains we quickly climbed back into winter.

There was only snow and no sign of vegetative life. The herd was separated from us, taking a shorter uphill route, impossible for sleds. Occasionally we heard the faint sounds of dogs barking and the tinkle of bells. Anders would stop and listen. He could tell by the rhythm of the bells how fast the reindeer were moving. Then he gave out a long mournful cry, a human imitation of an old steam locomotive. He listened, waiting for Nils-Peder's answer. Nothing. The sounds were lost again. We went on.

In half an hour we reached a difficult stretch that blocked an easy ascent. Anders said we would go up a draw between the mountains. We had been working around their base, but this time it was straight up — a seemingly impossible route for a reindeer sled. We hadn't gone far before the animals were panting. We untied the tether between the sleds, and I led two reindeer while Anders led the others. At times we were climbing a 45° slope and I thought the thin legs of the reindeer pulling the heavy sleds would snap at the extreme angle. Up and up we went. I forgot about taking pictures; pushing and pulling the animals.

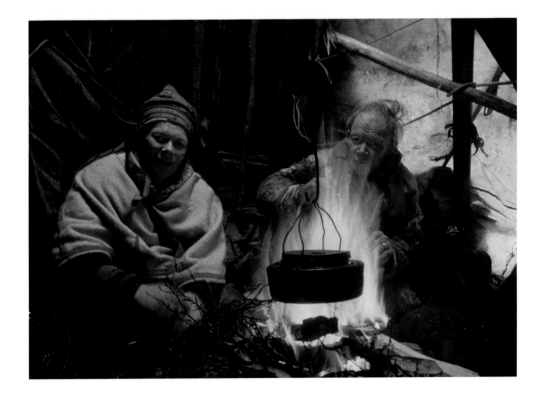

It wasn't long before we were all gasping — animals and humans. But Anders wouldn't stop. Sweat was pouring down into my glasses and I couldn't see where I was going. One crest led to another and that one led to still another. Animals had to be prodded and pulled all the way. They flopped down panting in the snow after every effort. Reindeer are strong, but they have little endurance. They must stop frequently. They quickly regain their strength, but it was dangerous to push them too hard. If they became too exhausted they might lurch to the side, turning over the sleds, which would drag everything crashing to the bottom, breaking the animals' legs and smashing the sleds.

Anders kept going. I was exhausted and I couldn't imagine what he was trying to do. Hill 902 in Korea returned to haunt me. The reindeer by this time were stumbling and their tongues were hanging out, as was mine. Anders finally stopped. After we caught our breath and I mopped up my glasses, he pointed out the cracks in the snow high above us on the mountain. We had passed under very bad snow. He said that in a few days it would avalanche. He wasn't taking any chances.

We came to lakes in the mountains. Some of them had begun to melt and there were curious blue spots on the ice. The light was strange, playing tricks on my eyes. There were no shadows anywhere, no definition to anything; black jagged rocks looked like soft gray shapes floating in the air. The sky and the snow were exactly the same color. I glanced at my watch and was surprised to find that it was after ten o'clock at night. Soon the midnight sun would be coming to replace these nights of shadowless light.

Looking over the side of my sled, I discovered to my horror that I was gazing down into thin air. Anders had taken us over a narrow saddle connecting two mountains — a short cut to avoid having to go down into a valley several hundred feet below and then up again.

Coming off the saddle, we had to descend a sharp decline, and I got ready for a plunge; no breaks on these sleds; a hot ride it was. My reindeer decided he wanted to be first to the bottom. Unfortunately, he was tied to the sled behind him. This didn't slow him down, at least not until he got tangled in the tether, with the result that the sled in front began going sideways. This had a bad effect on that sled's reindeer, which jumped out of its harness, inspiring the others to do likewise. The result was complete chaos and we found ourselves at the bottom of the hill in a pile.

Anders, as always, was philosophical: we straightened out the mess, no damage done, and continued on our way. I was apprehensive about the condition of my Leicas, which had been buried in snow several times already. Worse things were in store for them. These dramas happened frequently: I discovered it was normal to flip four or five times a day in the mountains. For this reason sleds were tightly lashed with rope and canvas.

Most of what had happened as we passed through this difficult passage, I had been unable to record on film, but it all began to soak into me in a strange way. In a sense it was like Korea, when rain first penetrated our outer garments, leaking around one layer, until it reached the next and it finally got to you. This was not literally what was happening here, thank God, but my feeling about the harshness of this land, its dreary lack of color, the struggle of men and animals, and the taste of sweat: the experience bypassed my camera but was stored inside me somewhere.

I was also learning a good deal about reindeer. My reindeer had a mania for going over rocks. He would swerve out of line as far as he could, apparently to get the sled hung on a rock. Was this part of the animal's private war with me? On reflection, however, I realized that the reindeer probably went for the rocks in hopes of finding food underneath them in the shallow snow. Reindeer were running the show: it was their requirements to survive that I needed to understand.

A reindeer's hoof, which measures larger than the hoof of a moose, an animal twice its size, spreads very wide and is used like a spade to find moss under the snow. Its width also helps keep the animal from sinking too deeply in the snow. When moving quickly, the reindeer trots, putting his rear feet in the same holes that he made with his front feet, the one going out as the other goes in, like clockwork. You think the front and back feet are going to hit, but they never do. As the result, a reindeer herd on the move forms a blur of mechanical precision. But when the herd stops, the intricate patterns of their legs break up, and lose much of their beauty. A reindeer herd stands dead still at rest and the animals look rigid and awkward, like stuffed museum pieces. When I tried to capture this in photographs, my feelings about the animals changed; I saw them less as photogenic subjects than something else more abstract and personal.

In the next hour we climbed up into clouds that hung low over the mountains. The fog cut visibility down to about 150 feet, but Anders continued navigating, finding signs that he recognized in familiar aspects of the land. The routes over these mountains were well-worn paths in his memory, but to me every bump and mound looked exactly the same.

It was increasingly difficult to see anything. Even Anders was beginning to have trouble. He turned back over ground that we had already covered, and picked a new route. I had heard of Sami who dug into the snow for a week to weather a storm, because it can be fatal to go in the mountains without proper visibility. One of Anders' nephews fell into a crevasse on Seiland glacier and lived on a small piece of cheese for eight days before he was found. He died shortly after being rescued.

Anders began to *yoik*. I took this to mean that he had found his way again, but I wasn't sure that it wasn't his special *yoik* for being lost. We came to a lake; Anders stopped and got out his binoculars. He sat on a rock without saying a word, scanning the distance. In half an hour we heard a sound, then another more clearly: it was a dog barking and then the very faint tinkle of a reindeer bell. Nils-Peder and the herd came into sight heading our way. Anders looked at me with the smile of a railroad conductor who might have said, "The Silver Meteor's right on time, sir."

"We are going to camp here; get some wood for the fire," he said.

I thought to myself, "Where are the trees?" They didn't exist.

Anders pointed to some dwarf birch vines creeping along the ground, but I couldn't imagine how a fire could be built with these wet runners. Uprooting a huge pile, he tied them in bundles, and then chipped bits off a dry pine log that he got from the sled. The chips were placed on the windward side of the stack of birch bundles and a match was struck. Almost immediately there was a roaring fire: the dwarf birch contains inflammable oil that makes it highly combustible whether it's wet or dry.

By the time Nils-Peder arrived, the coffee was on, the tent was up, and my boots were off. The moisture was steaming out of them and my socks and feet were toasting nicely. Anders shook his head and declared my boots "No good." He produced an extra pair of Sami shoes, filled them with hay, and told me to put them on. There was no harm in trying, but they couldn't possibly fit my big feet. I wanted to put my stockings on, but Anders indicated: "No socks."

The shoes didn't fit, but Anders was determined to fix that. Out came some more hay, and after a short struggle, pushing and pulling, my naked feet reluctantly settled into the shoes. The top of each shoe was then bound tight with a long brightly decorated woven web. Over this was wrapped a four-inch wide strip of red flannel, like the old World War I leggings. When the whole operation was completed, I stood up and walked around, amazed to discover how warm and comfortable these shoes were. The front of the shoe curled up like something you might expect an elf to wear. Of course, I could also now slip the shoe into the single strap fixed on the skis. And they were completely waterproof. I admired my round Sami-like footprint in the snow. The oiled reindeer skin made the shoes slippery on wet rocks, but other than that they were far superior to my modern ski boots.

The secret of the Sami shoe is the hay that's packed inside them. It keeps a warm pocket of air around the foot and absorbs moisture. The shoe hay (marsh grass) grows in shallow water, is cut in the summer, dried, and then braided for storage. To use it, the grass is unbraided, tossed to separate the strands, and then packed into shoes. Sami on the move may not take their shoes off for several days, after which they pack them with fresh hay, drying the old hay by the fire to be used again.

Anders and Nils-Peder settled around the fire, joking and *yoiking* about the fog. My feet were warm for the first time in many hours and we all got ready to enjoy our first cup of steaming coffee. This was the moment I had been looking forward to. I was also very hungry. My rucksack provided some sausages and bread. And Nils-Peder threw some reindeer leg bones on the fire. Anders and Nils-Peder accepted my food silently. This surprised me, but I learned that while Norwegians and Swedes are generous with "thank you's" — conversations ring with "tak, tak," "tousand tak" — the Sami give and receive without acknowledgment.

Nils-Peder fished a reindeer bone out of the fire and split it with a big slaughter knife. What could he be up to? Maybe something special for the dogs? No, something special for me — reindeer bone marrow. Accepting, I observed the Samisk custom and didn't thank him.

The bone marrow, about the thickness of my little finger, was speared by Nils-Peder and delivered on the end of his knife. I took it off with my teeth, as Nils-Peder had done, and then swallowed it. It tasted like slightly warmed over

lard. Although it was a great delicacy among the Sami, I never worked up any enthusiasm for it.

Dried reindeer meat, however, was a four-star treat, even though hard as wood. Shaved off a larger piece in paper-thin strips and eaten with unleavened bread and margarine, it is tasty, very nourishing, and light to carry. I also found that the Sami coffee that had once been a digestion problem for me became a gourmet specialty with the addition of melted goat cheese. Dropped into a mug of hot coffee, the cheese forms a gummy residue in the bottom along with bits of sugar and coffee grounds. Saved for last, and scooped out with a finger or a knife, it makes a delicious dessert after a meal.

Sami dogs were highly regarded, but not pampered, as I had discovered in Sweden. Occasionally, the dogs were fed a batch of red cement-like mush, a mixture of meal and dried reindeer blood. Most of the time, however, they scrounged for scraps. Anders had an old red dog called Ruofsu (Rusty). He was not as smart as Nils-Peder's animal. The Sami are not careful with breeding reindeer dogs and they often get dogs like Ruofsu, considered lazy and a bum. Nils-Peder described him as a "house dog" and tried to sell him to me for 50 kroner. I declined. I had to be faithful to my true love, Unis back in Sweden.

On my journey with Anders and the sleds, time had lost its urgency. The same was true for measuring distance; when going up and down in this rough country, climbing and descending the mountains, distance as measured on a map is meaningless. As the trip went on, the orderly divisions of days and nights also began to disappear. Linear information was irrelevant; time stretched, unbroken by darkness and unaffected by calendars. Time began to be marked by the warmth and comfort of coffee breaks. We ate and we slept, and what time we did those things depended only on how hungry or tired we were. One day I forgot to wind my watch and didn't give a damn. That must have been the moment when my switch from mechanical to organic time was finally completed.

As we went along, it wasn't unusual to find Nils-Peder and the herd gone when I woke up. Usually there was a note scratched on the sooty black coffee lid, telling us where we were to meet him. Sometimes it was Anders who left this "Sami telegram" as he described it, but usually it was Nils-Peder. More and more, Anders was staying behind with me, while Nils-Peder went out on the lonely march with the reindeer. Nils-Peder had five children, and most of

the reindeer belonged to them. Every spare moment he found was spent working with the herd. He would even sleep a few less hours in order to find time to put the children's marks on the animals, cutting initials on the reindeer's sides so that he could recognize them from miles away. He took no chances on losing any animals before he got them to summer pasture.

Anders, on the other hand, was a bachelor and he didn't have much ambition. We talked for hours in our peculiar way and enjoyed comfortable male silence. As the "coffee cooks" came and went, an easy friendship began to sustain the bleak hours of snow and rain and fog. Up here the monumental desolation drew people together.

We slept during the day and moved during the dusky part of the day called night. The reindeer preferred it this way. It had to do with their being able to find the lichens they fed on and could smell through three feet of snow.

Many "coffee cooks" later, we reached the top of the last mountain and looked down to the sea. There was Seiland, the mighty mountain island, our destination. We were all excited. I could see down in the deep valley, thousands of feet below, the fjord and the little dots that were houses. For many days, the reindeer and the dogs and the Sami and I had struggled over these barren mountains, where we had never seen another living thing. Suddenly, here was Lille Larrisfjord, population 150.

Other Sami herders were converging on Lille Larrisfjord, having brought their herds safely across the mountains. Soon they would see their families again. For hundreds of years, the Sami had been moving their herds to the offshore islands of Norway. The reindeer were edgy, particularly the females. Every reindeer in this flock had been born on Seiland and a deep instinct moved the females toward the island to calve. The trip was far from over however. In fact, the most dangerous part was about to start. The entire herd had to swim three kilometers across to Seiland. Half the animals could be lost in the next seventy-two hours.

For the last few days, the female reindeer had been increasingly hard to handle. They were getting near the coast and many were on the verge of calving. They smelled the salt water and saw the island. The herd was moving much faster now and Anders and Nils-Peder were having difficulty controlling them. If any of the females should calve before getting to Seiland, the Sara brothers

would be in deep trouble. The Sara herd could not legally calve on the main-land because the government strictly controlled pasturage in order to balance the interests of farmers and herders. If this happened, the brothers would have to abandon those mothers and calves and make the swim over to Seiland with the rest of the herd. There was also a chance that many of the reindeer would be "lost," mixed into other herds. It was difficult for Sami to take notice of a few extra reindeer, mingled into another 500 to 3000 animals. And if a stranger's reindeer should calve — well, new additions were marked very promptly.

There were other problems: the three-kilometer swim across Vargsund to Seiland could only be made at high or low tide, when the swift current in the middle of the fjord was at its slowest. The weather needed to be as mild as pos-sible. Water too increased a reindeer's chances of drowning. This was true par-ticularly after a bad winter like the last one, when a shortage of food in the mountains made animals weaker and more susceptible to shock in the cold water. The Sami could lose their fortune on one swim. The plan was to bring the herd from our present position in the mountains, down several thousand feet into the valley, move them past the settlement of Lille Larrisfjord, then up the mountain that looked out over Vargsund to Seiland.

This mountain formed a finger that ran parallel to Seiland; its top was flat, a 1000 ft. shelf; an ideal place to hold the herd until the tide was right for the swim. When we started down from our last camp in the mountains, a group of friends in Lille Larrisfjord were alerted. These were *Verdi*, which in Samisk means friend, but these are special friends, without whom the Sami would have great difficulty. *Verdi* were Sami but fishermen by trade. They spoke the same language and were of the same race, but in every other respect they were more like Norwegians, rejecting Samisk dress, living in permanent houses, and tied to the Norwegian lifestyle.

These people were indispensable to the herders; they got supplies to them when they were on the move and they delivered innumerable services to solve the staggering logistic problems of the nomads. In the case of Nils-Peder and Anders, the *Verdi* in Lille Larrisfjord supplied boats to move the herd across the fjord. They didn't do this out of friendship alone. The *Verdi* charged the Sami 30 kroner ($5) or the equivalent in reindeer meat for each boat. But the work was done for more than money.

Lille Larrisfjord was up and waiting for us when we passed by. This was the big annual event and the swim as always was a subject of great speculation. Would we make it? Was the current, the temperature, the weather right? How many reindeer would drown?

While all this was going on, Nils-Peder was having a terrible time with the wild females in his herd. They became separated from the males; frightened by the activity in Lille Larrisfjord, they had started up the wrong mountain, but not all of them. One came down the mountain and made a solitary swim to Seiland. Another had jumped the gun and calved. The bulls were standing near our last camp, looking bored while Nils-Peder and his dog chased the expectant mothers for miles over the mountains.

Nils-Peder's dog was magnificent. It was a pleasure to see him work, Nils-Peder yelling and pointing his ski pole while the dog maneuvered the reindeer, shifting as Nils-Peder screamed, keeping the animals in a tight herd. He was a king among dogs. Nils-Peder told me that he wouldn't take a thousand kroner for him — the going rate for a good reindeer-herding dog.

It took Nils-Peder the whole day to find, catch, and bring in the females. The herd was finally reunited at 4.00 a.m. The sun was coming up and we started moving the animals immediately. With luck, we could catch low tide at 6.00 a.m.

The flock stopped frequently on the way down — the females looking over the fjord toward Seiland. The *Verdi* joined us about 4:30 a.m. to help move the herd. Reindeer are rather timid beasts and it is only necessary to stand in their way and they will stop or change direction to avoid you. We made a human fence and with the crowd of *Verdi* it was easy to control the herd. It was easy going and by 8:00 a.m. the reindeer were at the water's edge. There were six rowboats, two of them with outboard motors waiting to help.

The herd was moved down to a fence that ran from the water to the mountain, which was a sheer cliff at this point. Here, the herd was gathered and the two lead reindeer were lassoed and secured to two long lines that Anders held from the back of a rowboat. He rang a bell that had been taken from one of the lead reindeer. The animals were accustomed to following the sound of this bell, and Anders rang the bell deliberately and unhurried, simulating the clang from a slowly moving animal.

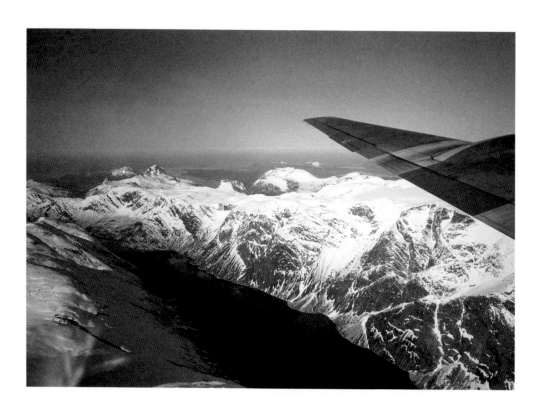

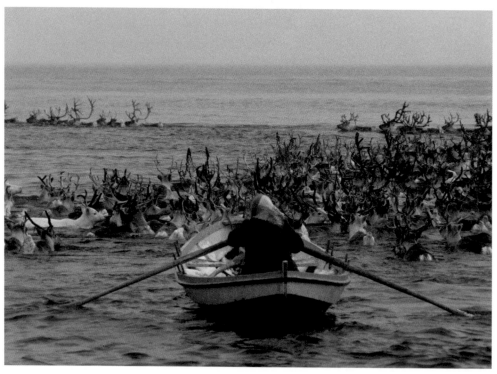

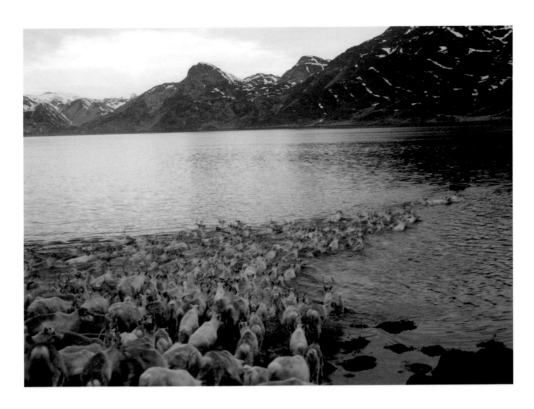

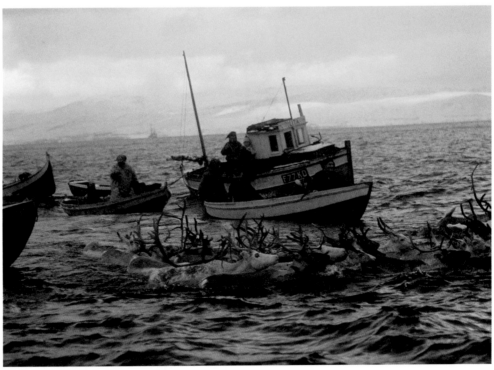

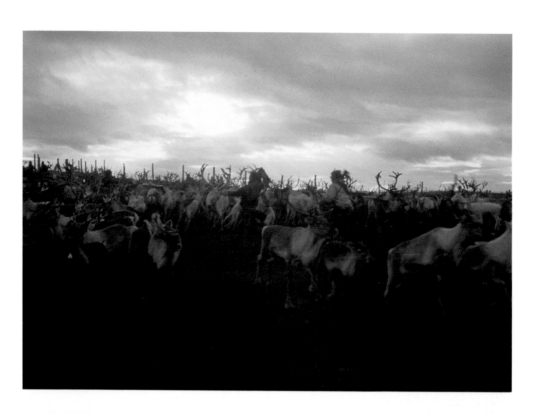

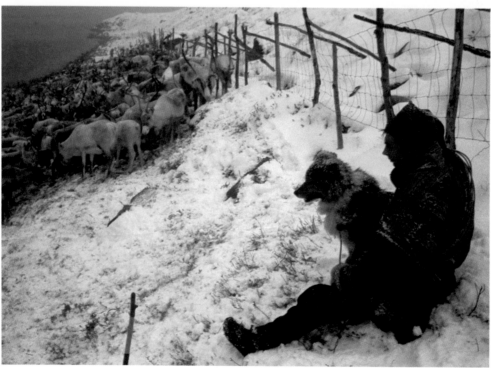

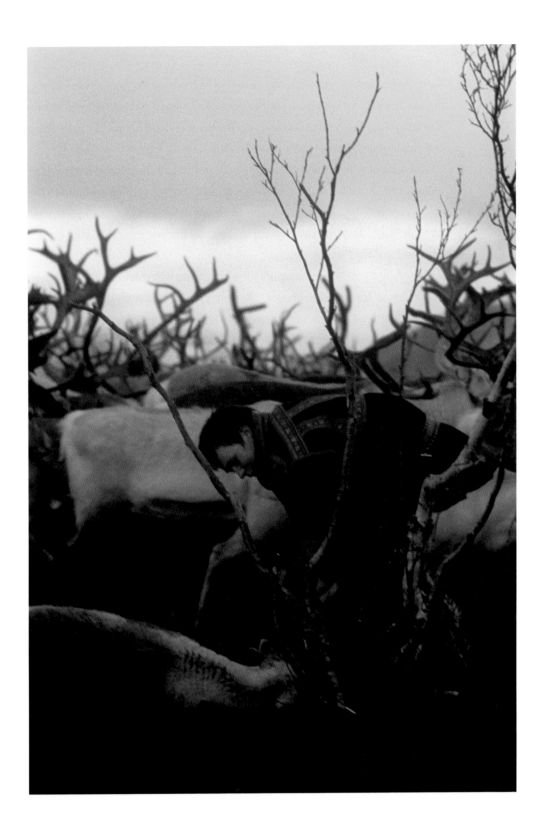

A number of females had already gathered at the water edge. They kept looking out toward the island across the fjord. The Sami and their helpers slowly moved around the herd and closed in. The animals were stopped by the fence and there was nowhere to go except into the water.

Anders increased the tempo of the bell, pulling on the reins of the two lead animals, the Sami began to shout, dogs barked, the lead animals went into the cold water and the swim was on. Other animals quickly followed. In a few minutes the entire herd was swimming in a tightly packed group striking out for Seiland Island across the water.

It was not long before some of the younger and weaker animals were being dragged into the small rowboats. We pulled three into ours and each time I thought the boat was certain to swamp. The Leicas almost went overboard. There was lots of yelling and in the bow of our boat the dog was barking while Nils-Peder tried to catch an exhausted reindeer. There was a trail of reindeer hairs in the water streaming out from the herd. Some of the smaller animals swam away from the herd, frightened by the pursuing boats. This caused a great deal of trouble; the animals were more maneuverable than the rowboats, and the reindeer had to be lassoed from our tippy little scows.

But finally every reindeer made it safely to shore either in a boat or swimming. The animals came out of the water at a specially prepared fenced enclosure. They looked miserable, their coats matted and pouring off cold water. The ones in our boat were untied and dumped into the shallow water to join the others. In an hour it was all over.

In the enclosure, Nils-Peder and Anders began catching some of the reindeer to mark a few they had missed before. The men lassoed the calves and cut their marks and notches in the reindeer ear. Nils-Peder told me that he knew 1200 different marks.

It didn't take the brothers long to finish their work. The last elusive reindeer were captured and one was slaughtered to be roasted later to celebrate the crossing. Not an animal was lost. The one female which calved on the mainland and the one that made the long swim earlier were recovered. Anders and Nils-Peder had been lucky and the crossing had been a good one.

After another hour the reindeer were released and they headed for the rich summer pasture on the mountain island. Anders and Nils-Peder built a fire

and cooked coffee. Then they put a reindeer skin on the ground and spread out in the sun. Nils-Peder went to sleep with a cigarette still burning in his mouth. This was the first rest he had had for two days and finally he could do so in peace; he was on the green grass of Seiland. I don't know what he dreamed about but there's a good chance he was counting all those newborn calves he was about to own. We all went to sleep and did not wake up until the sleds arrived in Seiland by boat. A few bottles of brandy also arrived and I learned sadly that I would have to miss the party in order to make connections with Hammerfest on the north coast of Norway and begin my journey back to Stockholm. I had a parting drink and reluctantly hitched a ride back to Lille Larrisfjord to catch the morning coastal steamer the next day.

As I began to slip from one world to another, for the first time I caught an acrid whiff of sweat and reindeer. It was me. Luckily, I had been invited to stay in Lille Larrisfjord with the storekeeper, Hilma Murberg, whom I had met in Kautokeino. Tonight, I would drop off my gear, go to the public bathhouse for a relaxing steam bath and shower, and then I would sleep in a bed. At the same time I felt a deep sadness. I really wanted to be back with Nils-Peter and Anders having a drunken celebration. This would have been an appropriate conclusion to our trek. I should have been a part of it. I was invited. Coming back to my own world, a lonely feeling crept into me. I was deserting something that I couldn't explain to myself.

These thoughts occupied me as I crossed to the mainland. What had I learned about the Sami? Could I honestly now say I knew anything beyond the details of our trip? As the village got closer, I decided that the only thing I could understand — right now — was how it felt to be a very dirty, tired American, speaking a few monosyllabic words of Norwegian with a Sami accent. Would the rest of my education come to me later, creeping from deep inside to be more completely understood?

Surprisingly, Lille Larrisfjord was deserted. There was no problem finding Hilma's store, but it was empty, no one there. So I knocked on the side door, where my friend and his wife lived, and in a few minutes his wife appeared, looking quite startled.

"Sorry to have disturbed you." I thought they must have been taking a nap. "I'll just drop off my rucksack, go take a bath and clean up."

She looked even more puzzled, but showed me my room. She quickly departed, glancing back at me in a most peculiar way. Then it dawned on me: good heavens, their clock read three o'clock. It was three a.m.; I had awakened her in the middle of the night!

Maybe I was becoming an adopted Sami after all. Certainly I missed my two Sami friends, their dogs, and the herd. I would probably never see them again. But I knew that if I ever got a cup of coffee as black as ink, with a touch of goat cheese melted in the bottom along with a few grains of sugar delivered on the end of a knife — they would all be back with me.

Over the years I have been haunted, not by the photographs that I took on this amazing trip but by the photographs I didn't take, the ones that it didn't even occur to me to take. Buried under the layers of this experience is one that worked to the top of the pile, that strange moment when Anders, his dog Rusty, the reindeer, and I were suspended in a featureless world that had no horizon, where only gravity indicated what was up or down. It was not only eerie but also extremely dangerous, because a move in the wrong direction could have plunged us down the mountain or created an avalanche. It was as if we were moving through a cloud, and except for an occasional black rock poking up, we were suspended in a white shadowless mystery created by mist and the quality of the Arctic light at this time of year. It was neither day nor night. It was a white-out. Anders, however, had traveled this route since childhood and those occasional black outcroppings spoke to him. I have come to feel that they were more than navigation points, they were spiritual markers that had guided his Sami ancestors for a thousand years; their voices told him what to do. On reflection, Anders' *yoiks* may not have been a call to his brother but a shamanistic conversation with the rocks. Of course, this may be all romantic conjecture, but my regret is that I couldn't stop, photograph each one, and write a poem about the messages that they might have passed on to me.

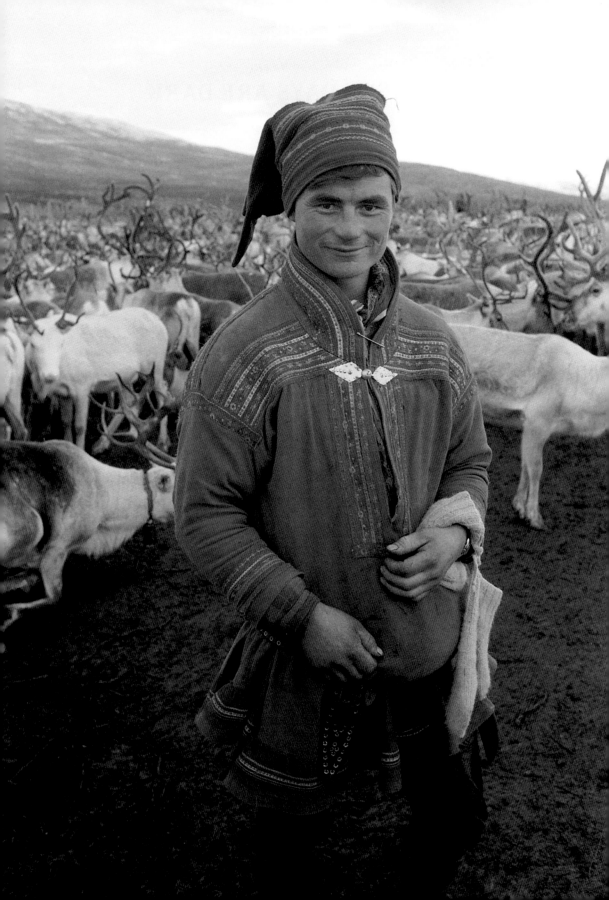

15 – WHERE DAYS ARE DARK

Although dozens of letters passed between me and the *National Geographic*, the final disposition was described in a polite note from Jim Root, stating on June 28th, 1960: "... at this moment, the Lapp coverage is inadequate for a color series. But we will consider this further when your additional material arrives." No additional material was sent, because I set off in a different direction, and the story of reindeer migration with the Sara brothers was never published.

Although none of these trips were alike — life in the Lofotens, and reindeer herders in Sweden and Norway — all were driven by curiosity and excitement, and pursued by the devils of doubt. I still needed stories to tell and sell, but at the end of each adventure, I crawled back south hoping for a warm reception from Monica. I wasn't disappointed. But restlessness quickly set in. So when I caught my breath, the process started again. My personal compass was once more set to the north — the far north.

It's amazing how much the *Publication of the National Geographic Society*, as it is officially called, had affected me as a child. The magazine had a powerful influence on my eight-year-old mind. It conjured up visions of exotic exploration, and its heroes flew from its pages straight into my imagination. Many of them had been involved with the Arctic; Roald Amundsen, Lincoln Ellsworth, Richard Byrd, Umberto Nobile, and Fridtjof Nansen. These larger-than-life figures set up a base camp in my brain and took up permanent residence. Their quest for the North Pole and studies of Arctic life made it a place that influenced some of my strongest fantasies. And one of the most appealing of these places, not least because of its name, was Spitsbergen, the largest of five is-

lands that make up the Svalbard archipelago. Svalbard means *Cold Edge* in Norwegian and Spitsbergen is *Jagged Mountains* in Dutch. Although Spitsbergen was discovered by the Vikings in 1194 and by the Dutch in 1596, I was determined to re-discover it in 1959.

Glaciers cover 60% of the area, and neither a tree nor a bush grows on this land. The permafrost along the coast is 300 feet deep and inland it reaches 1500 feet. On West Spitsbergen, there are five communities, three of them Russian: Barentsburg, Pyramiden, and Sveagruva, and the other two, Longyearbyen and Ny-Ålesund (Kings Bay) are Norwegian. In 1958, they were all coal-mining towns. Coal was discovered here early in the 20th century and had been in continuous production since 1916. In 1959, the community was entirely devoted to mining and was popular with Norwegian men looking for relatively high pay and low taxes — 4% compared to 30% in mainland Norway.

The mines interested me because they provided a place to find a polar experience in the dark without having to spend the winter on a rock accompanying a polar bear hunter. The plan was to visit the mines on the last coal ship heading for Spitsbergen, visit the mines while it loaded, and return on the same ship.

Although it was difficult to book a trip on a coal freighter, I got passage after showing the Oslo Tourist Office correspondence referring to Navy collaboration in Lofoten. Then a trail of telegrams sent me to pick up my ship in Tromsø, the largest city in northern Norway, some 200 miles above the Arctic Circle

While waiting for my coal freighter in the old whaling port of Tromsø, I discovered something very special there — at the time, the most northerly brewery in the world. The Mack Brewery, established in 1877 and its pub, Øl Hallen, was the place where skippers, for generations, had recruited crews for their ships. In the pub, old-timers wearing felt hats, coats, and ties gave the dark place a touch of formality. It seemed to be lit by whale-oil lamps, giving the atmosphere a respectful shade that wasn't uncheerful. The good spirits of the old men gave it light. A young boy drinking *Orange Saft*, a sugary soda, sat with his father quietly looking lost, but three young men wearing fishermen's hats took the mood back to fun as they upended tankards of beer. Here, I could be with remarkable men with attributes that I had read about with awe as a child — old polar bear, walrus, and seal hunters, whalers, sailors, and cod fishermen. It was as if a 1936 *National Geographic* had come to life.

The furnishings, like the men, were spare and rugged. Hard wooden chairs, drawn up to tables, were fixed to the floor with iron pipes. Men in heavy woolen sweaters, thick work clothes, and rubber boots slogged their way through the crowd to the bar for beer, often collecting an extra stein for an old-timer. The grizzled old Arctic hunters seemed to live out their days drinking beer and telling stories about Greenland and Spitsbergen. There was no food available, not even boiled seagull eggs, whale or reindeer meat, or codfish tongues — nothing to distract anyone from the business of drinking, smoking, and talking.

I felt that everywhere here were the ingredients of future stories. Beer flowed down from huge vats overhead — fresh and good — washing and blending with tales of hunters, ice, and polar seas, tales often delivered in English and flavored with blood and brine. In other lands, Øl Hallen could have been a breeding ground for exaggerated impulses, shouting matches and punch-ups, but these tough old men were easy-going, even gentle. Membership to their club only required sharing a beer.

Among them, was Henry Rudi, King of the Polar Bear hunters. He would talk to anybody who cared to listen, having retired after 40 hunting trips and over-wintering in Svalbard and Greenland 25 times. Rudi had collected 713 polar bear hides along with unrecorded numbers of Arctic fox, walrus, and seals.

His stories had an influence on me, not because of the kills but the realization that I couldn't imagine such a life, much less survive, and then live in happy retirement amiably chatting with the likes of me. I loved to tell stories myself and there was something about Rudi's stories that transcended esoteric cleverness. They were down-to-earth — democratic — anyone could do these things if they had the right stuff.

This was such a stark contrast to what I thought I wanted. It began to erode things that I thought were important: my secret yearning to be a member of the Explorer's Club — the elite domain of the most recognized adventurers located off Fifth Avenue in New York, where I might be associated with those who had earned rather than inherited a special status. It wasn't that I was giving up elitism; rather I was in the process of redefining it. Øl Hallen was a working man's Explorer's Club and a beer got me in.

Henry Rudi had been a hunter in Spitsbergen, where I was heading. In these remote islands where the north coast is only 600 miles from the North Pole, there were neither trees nor bushes and the sun disappears completely

from October 27th to February 16th. Here, men bunched up in pairs or lived alone in wooden huts to hunt. One of them actually asked me if I wanted to accompany him on his next over-winter hunt. I hoped he was kidding.

I was never tempted to over-winter in Spitsbergen, either in a hunting cabin or perched out on a rock, but my conversation with Rudy had made me curious about this island, 600 miles from the North Pole. What was it like in the dark? I had to see it.

I left for Spitsbergen on November 1st, and arrived at the Russian coal-mining town of Barentsburg on November 4th, before embarking on a fishing boat for Longyearbyen the same day.

The Spitsbergen mines produced low-sulfur-high-energy coal. A mine I had visited in Belgium had shafts reaching down some 4,000 feet, and with temperatures underground more than 100°F, but Longyearbyen's mines were dug laterally into the side of mountain — a raw muscular process using hand drills. Here, the temperature was a little below freezing. But what brought me to Spitsbergen wasn't to compare coal mines — I wanted to experience something beyond Lapland and Lofoten. Tales from Mack's Øl Hallen had touched my imagination.

Ironically, November in Spitsbergen wasn't all that dark. The atmosphere was so clear that a sky blanket of fluorescence illuminated the snow-covered mountains. The eerie outdoor brilliance made it possible to navigate or read a newspaper. Shooting stars arrived regularly. An Aurora Borealis provided a silvery Zeppelin shape that shimmered, green lights that changed like dripping watercolors on a wet paper as the sky kissed the world. Then it all changed again as fog or storms dressed heaven in coal-mine blackness.

November wasn't as cold as I had imagined either. That same warm finger that curled up from the Gulf of Mexico to the North Atlantic, passing the Lofoten, eventually reached West Spitsbergen. This kept western Svalbard ice-free for months after the same latitude in Alaska was frozen solid. The eastern islands of Svalbard: Edgeøya, Barentsøya, Nordaustlandet, and Kong Karls Land, were icebound in the winter as well as summer. This was the land of polar bears and hunters.

Although I was not dressed correctly for the party, I made short visits to the outdoors taking inspiration from this environment, absorbing it until I couldn't stand it any longer. After mentally toasting Henry Rudi and the other Øl Hallen

characters, I retreated to the grim barracks-like buildings that housed 230 trapped humans who seemed so disconnected from the place they inhabited.

The hospital at Longyearbyen proved more interesting than the coal mine and there I met a remarkable man, Dr. Ejnar Vinten-Johansen, a Dane. He and his wife, a trained nurse, ran the hospital, open to anyone who could get to Longyearbyen, 810 miles south of the North Pole. All the facilities here had been destroyed during World War II by German naval bombardment, and everything seemed somewhat makeshift and impermanent. But there was room for four patients, with one private bed as well as a surgical theater, an X-Ray machine, and a shortwave ultraviolet machine for the treatment of rheumatic troubles. The medicine, received in the autumn, supplied them until spring.

Isolation and improvisation were not new to Dr. Vinten-Johansen. He had served in Burma and before that in Greenland. He was also an optometrist, and a sanitation inspector; at Longyearbyen he filled every imaginable role to make life tolerable for all living things, going so far as making sure there was enough fodder imported from Norway for the world's most northerly cows. He ran a film program that brightened up Sundays, and fostered miners' talents, serving as art critic, encouraging them to make drawings and paintings of things that excited them, even things they saw in the movies. "It's not easy to be stimulated in darkness — too many shadows — they need to paint bright feathers on the heads of Indians. It doesn't matter that they've never seen a cowboy — huge hats are fun."

The doctor told me that most of his medical work involved accidents connected with mining — small wounds, contusions, and fractures. But in 1948, 15 miners had been lost in an explosion. More fatal accidents followed in 1952 and 1953, with a total loss of 21 miners. The greatest danger to this community was a large-scale accident in the mine, but some years ago the people voted on whether they wanted a new recreation hall or a new hospital. They chose the recreation hall. Three years after my visit, 21 lives were lost in another explosion in November 1962 and the mine was permanently closed the next year. (Today it is the repository of an extraordinary seed bank, the Svalbard Global Seed Vault that holds 1.5 million seed samples of major food crops.)

Next to mine accidents, the other most serious hazard up here was the treatment of neurosis, and Johansen was not a trained psychologist. "In the winter,

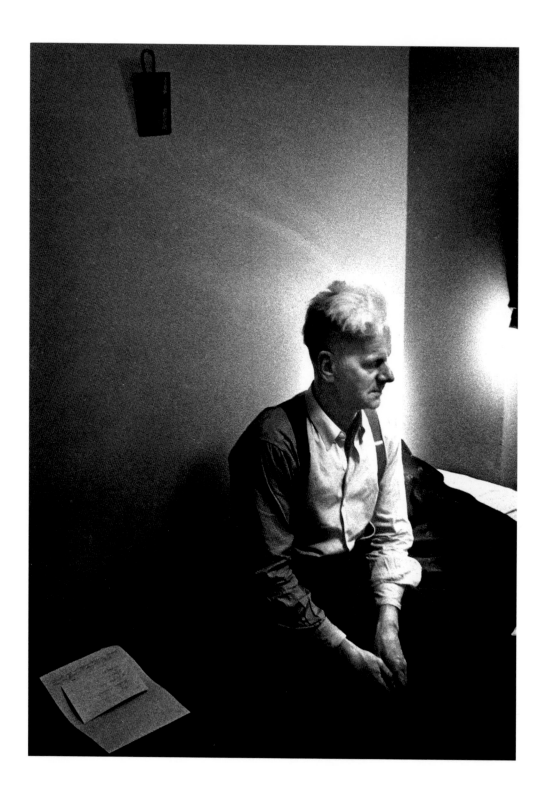

we have psychotic and sleeping problems. Depression is prevalent. Your ship's next round-trip won't be for six to eight months," and, he added, "Five bottles of Class II Pilsner a night and one bottle of whiskey a month is the maximum escape tonic allowed... In Greenland and Burma, I also saw depression. It's about not being able to change anything — everything's the same — seemingly forever... Soon we'll be stuck in the dark... For many, 116 days of darkness is difficult. The men are in it for the money — serving time. But," he added a smile, "Those who stick it out for fifteen winters are awarded the 'King's Medal of Merit.'" This amazing man inspired my deep admiration. He had described another test I couldn't pass, staying on this job for many years through long pitch-dark winters. Dr. Vinten-Johansen must have accumulated a chest-full of such medals.

On November 15th, I boarded the last ship for Harstad, Norway and sailed south away from the dark gloom of the hospital and the coal mine. It was a joy to be able to curl up with a book in a warm berth, devouring the books that I had brought along, re-reading about the region and its remarkable history.

Aboard ship, I found myself totally absorbed as the past pulled me into another world. My warm bunk swallowed me up — I didn't know where I was — soaking up the books and combining them with my recent experience, allowing the huge things I was reading about to leak into my consciousness in a way that was going to change my life. As I snuggled up to the past, I was shipping out toward a place that was lit up with illuminating fantasies about Spitsbergen — in daylight. Ideas came to me as the ship churned south through the freezing sea, taking me closer rather than farther from Spitsbergen. My tiny pinch of experience, 79° N from the Pole — in the not-as-dark-as-I-thought — spiced the most preposterous ideas based on the dramatic history of the region. But Dr. Vinten-Johansen left a seed as well — one quite different from my others — and one that would someday emerge in a surprising way.

The history of Spitsbergen should be called the Wild, Wild North, and it provided new story ideas. My glimpse in the dark and its remarkable past set the scene for transformative possibilities. Ancient Icelandic writings claimed that Vikings had discovered Spitsbergen by as early as 1194, and there were possibly Russian fur traders operating from the monasteries of far northern Russia coming to the islands. Spitsbergen, however, officially was put on the map of the world when Willem Barentsz, the Dutch navigator, cartographer

and Arctic explorer after whom the Barents Sea was named in the 19th century, discovered it. In 1596, Barents found that the seas around Spitsbergen were teeming with whales; Greenland Right, BowHead, Humpback whales, and pods of white Belugas.

There were also walrus and seals of different varieties. The sea was in fact a gold mine of commercial oil- and skin-bearing animals. Not surprisingly, the Dutch and the English went to war to settle who had the right to loot this remote, frozen, yet amazingly abundant place. Soon, the French, Basques, Norwegians, Danes, and Hanseatics, caught on. and joined the pillage from 1611 to 1720 on the western coast of Spitsbergen.

Naval warfare, especially the battles between the Dutch and the English, left 16 ships on the bottom of the long and often shallow fjords that lay on the north side of Spitsbergen. Was it possible to find some of these ships and dive in what I assumed was clear, not very deep water to make great new discoveries? All I needed was special sounding equipment, scuba gear, underwater lights, several assistants, and a proper host vessel. After all, the Norwegian Navy had loaned me their Chief Diving Officer and three enlisted men for almost two weeks to photograph codfish underwater in Lofoten — why not a couple of wrecks in the fjords of northern Spitsbergen?

Spitsbergen was also teeming with photogenic animals, including a special short-legged reindeer that was native to the archipelago, and herds of weird-looking muskoxen, a shaggy beast that resembled a buffalo. Then there were the Arctic fox and even an indigenous mouse, but that was not a top priority. The most interesting animal of all, of course, illuminated by so many tales from Øl Hallen, was the polar bear, possibly the biggest, depending how you measure them, and certainly the most beautiful and majestic bear in the world. They were reported to be scampering all over eastern and northeastern Svalbard, which put them number one on my to-be-photographed wish list.

More than simply finding and observing the King of the Arctic, however, I determined that photographing polar bears underwater was going to be my next project, principally because it had never been done. In addition to the bears, I could also photograph walrus, and a number of different kinds of seals, which bob up all over the place in picturesque settings with snow-capped mountains, glaciers, and icebergs. Additionally, in summertime there

were flowering plants in abundance, an astonishing variety of what you might call vegetative throw rugs, as nothing grows much taller than one inch even on the warmer west coast of Spitsbergen. Of course, there were also millions of birds — more than 140 species of them. The richness of the cold sea provided a soup of living nourishment that hosted a large cycle of feeding: the abundant plankton fed a vast supply of fish; the fish were meals for marine birds and seals; and the seals were hunted by the polar bears. Smaller mammals and remains left by the big hunters were picked over by Arctic foxes in a great circle of survival. This process went into high gear when the light returned, so my next trip would be planned for the summer, when Spitsbergen became the land of the midnight sun.

My return from Stockholm to Spitsbergen in November of 1959 should have brought reality into sharp focus. My approach so far had been a tangle of half-baked ideas, stumbled into by exploiting chance contacts, using not very subtle scheming, but with dedicated persistence and a good deal of luck. Journalistic fantasy continued to fuel my efforts, taking me even further north, thousands of miles away from any source of cashable checks. I was dreaming up schemes to photograph sunken ships and polar bears from underwater. My camera was going to ensnare me in a giant morass of technical complexity and fundraising difficulty that I had not remotely grasped. Zigzagging back and forth, leaping around, and fighting reality like a hooked fish, I continued with no clue what I was getting myself into.

As I struggled to find a way to return north, my files from 1959-60 show that in my desperate effort to find paying assignments I was corresponding with my agent, Florence Kiesling, in New York about story ideas that were all over the map, literally and figuratively. Examples:

January 5th, 1960— A journalist buddy gave me the name of Aleko Lilius in Casablanca, Morocco who knew about villages where Acrobats, Snake Charmers, and Prostitutes were trained." Nothing came of this.

February 24th, 1960 — from J. Errera, Commissionaire à l'Energie atomique, Ministère des Affaires Etrangères et du Commerce Extérieur, Bruxelles, Belgique: "... I have the honor to acknowledge the receipt of yours... concerning your intention to publish a picture story about the irradiation of tsetse flies..." The experiment subjected the male flies to Gamma rays from a huge reactor. The flies were

then to be flown to the Congo where they were released to impregnate millions of females with sterilized sperm — sex duds — which would lead to solving a major medical problem. This project was put on hold forever.

April 1960 — I spent a few days with the Lapland Home Guard; having heard that they had 200 pack horses trained to walk with snow shoes. Spent some time with the Home Guard but never saw pack horses with snow shoes.

May 1st, 1960 — Lt. Colonel Hans Lund, (Norwegian Air Force), World War II hero and famous wolf hunter, flew me in his DeHavilland Otter along the Norwegian-Soviet border. After a couple of hours we saw a lonely reindeer, but no wolves. This exciting non-adventure landed us in the Norwegian papers: it must have been a slow news day because we got our picture in the paper for trying, but no animals, no pay check.

(Actually, it wasn't a slow news day, and when we landed at the airbase in Bodø we found a lot of activity that had been stimulated by another flight *over* Soviet territory.) We didn't know it at the time, but that same day the American pilot, Gary Powers, had been shot down in his U-2 spy plane over the Soviet Union, an incident that brought about the collapse of the Paris Summit between President Dwight Eisenhower and Chairman Nikita Khrushchev. (Powers had been scheduled to land in Bodø.)

My survival strategy for future stories in Scandinavia now even more depended on my network of contacts. To begin, I reinvested in my "people assets." These included press attachés at various U.S. and Scandinavian embassies, Norwegian military brass, airline, and shipping public relations people, Arctic experts from institutes and universities, reporters, photographers, policemen, and small town officials and bureaucrats with whom I had developed relationships. Finally, there were friends such as Lennart Johansson, the railroad worker from Abisko, who were ultimately indispensable because of their generosity. Most necessary of all were people who could provide me with free tickets on airlines, ships, and railroads in both Sweden and Norway. In order to travel in countries that were roughly 1600 miles long, this transportation was essential.

I had used rail and coastal steamer travel very successfully to get me up north and back again to Oslo and Stockholm, where magazine offices, technical support for my equipment, and sources for financial aid were located. My free journeys on those carriers became my model for developing relations with

press officers at Scandinavian Airlines System (SAS) and some of the small regional carriers by proposing stories that involved them.

One of these stories came out of my stay in Tromsø, where I learned of the history of the flying ambulance service based there. Norway's long coastline, with its endless fjords and 50,000 islands, was dotted with thousands of tiny settlements of fisher-farmers. Lacking connecting roads, boats served as the principal transportation, but air service could provide the only quick response to medical emergencies in these difficult-to-reach communities. Through my friend, Col. Lund, I met Vigge Widerøe, founder and manager of Widerøe Flyveselskap, Norway's oldest airline, who gave me permission to go on one of his company's emergency ambulance flights.

In Tromsø, Widerøe Flyveselskap kept a flight crew and a plane ready day and night. The aircraft could be warmed up, checked out, and on its way within 30 minutes. This service was part of the Norwegian health plan. Not surprisingly, the ambulance pilots were seen as heroes in North Norway. They were exceptional aviators and navigators, appropriate skills when working in severe and unpredictable weather conditions.

After catching an SAS flight from Oslo to Bardufoss, then boarding a coastal steamer, I booked myself into the Seaman's Hall in Tromsø. I began waiting for calls for a flying ambulance. There was no telephone in my room, and when, day after day, no messages came through from Widerøe Flyveselskap, I imagined the host of disasters I was missing. Every day for six days I nervously checked with Widerøe, but it turned out there was no communication problem; the Tromsø area was having an epidemic of good health.

On October 17th, my landlady excitedly delivered a message at 4:00 p.m. and I dashed down to the airfield. There, I met Captain Yngve Jostein Svendsen, a thirty-three-year-old pilot who had made 158 ambulance flights the previous year. Eighty percent were pregnant women.

At 4:40 p.m. right on time, we took off from Tromsø heading for Sørlenangen, a tiny community, only recorded on the most detailed of maps. It was only thirty-two miles away — plotted point to point — but distances here were deceptive. It wasn't possible to fly above the weather, so we dropped down and made a route as if we were a boat, flying in and around a number of fjords, following the channels, a trip that would take twenty-four hours by boat.

It was also getting quite dark in the fjord, the sun having passed under the mountains hours before. This made everything more complicated. It was supposed to be a twenty-minute flight, but rough weather and the darkness slowed us down.

The aircraft was a DeHavilland Otter, the same kind of plane used by Col. Lund on our reindeer inspection. This single-engine plane, renowned for its flexibility, was equipped with floats to land on water. The aircraft had a Pratt & Whitney 600 hp. engine, a range of 960 miles, and a top speed of 160 mph. It could carry large loads and land and take off in rugged terrain. This famous bush plane had the same relationship to rugged Norwegian life as wide-bodied pickups had for western American ranches. I was installed in the co-pilot's seat, which gave me a chance to photograph as well as fly the plane if necessary. This was not something I was anxious to do. There were innumerable knobs, levers, switches, and dials, all of which had something to do with staying airborne and I knew that if I sneezed, twitched, or tried to take a picture and touched something we would immediately go into an uncontrollable spin. Besides, I hated small planes. As a child, I discovered that if I sat in a swing and turned the ropes like a rubber band in a toy plane, the resulting gyration gave me more nausea than fun. This was why, even in my childish dreams, it never occurred to me to become a fighter pilot. My stomach was built for infantry.

As we crossed Ullfjorden, we had a 40-knot gale blowing from the south. Visibility was terrible so the Otter had to be brought down to sea level. We proceeded like a fast boat, traveling at 85 mph between the high dark walls of the fjord, navigating by spotting blinking navigational buoys in the water. One mile to the north, the wind was blowing a gentle four knots, but crossing into an interlocking fjord, it came at thirty knots from the opposite direction.

Throughout the flight, Svendsen was talking on the radio to the Tromsø weather station about weather conditions. He was advising *them*, rather than the other way around. The ride was a bumpy one and the roar of the engine on the nose was deafening. The smell of the engine permeated the cockpit with the queasy essence of castor oil — a scent that I didn't associate with equilibrium.

When we got to Sørlenangen, it was quite dark, but we were able to land on the water with the aid of a group of fishing boats that had lined up shining every light they had to create an illuminated "runway." It worked perfectly —

Svendsen had obviously done this before — and soon a rowboat came out to the plane, delivering a very pregnant woman and a friend of hers who was acting as nurse. Soon, we were taxiing into the fjord. The patient was strapped onto a litter and made comfortable and we took off.

The weather was getting worse — high winds and virtually no visibility — but we had to get our passenger to the hospital. Svendsen was forced to fly "on the deck," staying low to avoid the bumps, swishes, drops, and lifts of the wind as best as he could. The others all seemed okay, but in minutes I became hugely airsick. In the greenish glow of the instruments, it was not clear to Svendsen that my green appearance had nothing to do with the instrument panel. With great urgency, I signaled that I needed a bag of some kind to take care of what I knew was going to be an unfortunate expression about how I felt about bumpy airplanes. The noise in the cockpit was so great that my voice couldn't be heard, but by pointing at my mouth and my stomach alternately I made my plight clear.

The seasoned Arctic pilot knew immediately that something had to be done or his instrument panel was going to get badly messed up. He couldn't slow down or his pregnant passenger, who was already in labor, might have her baby in flight; and there was no clear air to be found at another altitude. So, calm and cool, he managed to get the attention of the nurse, told her with hand signals what I was suffering from, and she abandoned her patient to come to the rescue of the instrument panel. She found my camera bag, that was about to serve double duty but fortunately the application of a wet towel to my brow, and muttering soothing words in Norwegian, saved the day. Twenty minutes later, we managed, barely, to land safely in Tromsø without disaster.

My flying ambulance story ended happily for one new Norwegian citizen. The experience didn't add anything to my bank account or my photojournalistic reputation and I never got further news about the baby but at least they didn't have to name it Barf. Because of the lack of light and other problems, the pictures remained forever with a "FOR SALE" sign hanging on them. The experience with Captain Svendsen was added to my growing repertoire of failed adventures that sometimes helped me as stories told at a cocktail party. In my anecdotes, however, I never fail to mention the reflexes of the quick-thinking pilot and nurse, who, for me, will always carry forward the tradition of the heroes of North Norway.

16 – OBERAMMERGAU

"I just spent Christmas with Jesus and his friends."

This was the unusual opening line in my letter to Dave Doren, a writer friend. Dave and I had been discussing story ideas a month earlier at lunch in Stockholm, where I had gone after my adventures in North Norway. Among other things, Dave mentioned the Oberammergau Passion Play, which he told me had been produced — with a few lapses during wars — every ten years since 1634. Townspeople in Oberammergau, a village in Bavaria, promised God that they would produce a play to honor Him if He would spare them from the bubonic plague that was threatening the region.

They did avoid the plague, and made good on their promise by producing a play about the life of Jesus as a thank-you, repeating it every ten years there-after. In subsequent decades, they would also thank God for bringing droves of tourists to Oberammergau; the play was a solid hit.

I learned of it in the fall of 1959, and discovered that the next production of the play was scheduled for the summer of 1960. I thought it would make a good photo essay to see what the actors were doing as they prepared the new version of the play on Christmas Eve and Jesus' birthday. Holiday time in Bavaria would also be a cheerful contrast to Spitsbergen in the dark.

I drove 1,500 kilometers from Sweden to Germany non-stop, and even on Germany's superb autobahn it took about 20 hours. I arrived blurry-eyed and very tired. The town was full-up with tourists, but I was lucky and got the last room at the Grand Hotel, checking in late on December 23d.

The next morning, I awoke cheerfully despite having found no hot bath water in my room the night before, and compensated by ordering breakfast in

my room. A waiter, clad in a black cutaway coat with a starched shirtfront as round and white as the stomach of a goose, arrived carrying a coffee pot, three tiny rolls, and a postage stamp square of butter on a silver tray. This was as *grand* as it got at 7:30 a.m. in Oberammergau — not a promising start.

Needing to get some information and press credentials that would give me access to the play's preparations, I arrived promptly at 8:00 a.m. at the Tourist Bureau, which was open only half-a-day on Christmas Eve. A guide from the Festival Press Association was provided for me until noon that day, after which I proceeded on my own. Appointments for the day, December 24th, had been set up with German efficiency:

10:00: See St. Peter (woodcarver) decorating tree at home.

10:30: See Mary Magdalene working at tourist shop selling trinkets.

11:00: See priest about taking pictures during Mass.

11:30: See authentic Oberammergau woodcarver in workshop.

13:00: Lunch. You are on your own.

16:30: See Mary (mother of Jesus). Be prompt. Only has 30 min. for Press.

19:00: Will be with Mary Magdalene's family for opening of presents

21:00: Judas reads Ludwig Thoma's Christmas Hymn to guests at Hotel Alti-post.

22:00: Jesus and his five children opening presents.

December 25th, 1959

01:30 Christmas Eve Mass.

08:30-10:00: Christmas (early) Mass.

My guide was a pretty girl of twenty and I asked her hopefully: "Are you interested in journalism?"

"No," she said, "I'm sick of reporters."

It had begun to snow so I changed the subject: "Do you like to ski?"

"No, I'm not interested in skiing."

I took a new tack. "Hate to bother people on Christmas Eve. You must have things to do."

She replied: "It doesn't matter what I do. I don't get off until 12 anyway," and went on to say, "It's going to be difficult to get people to cooperate on Christmas." But I was ready for that one.

"Yes," I said, "but it's difficult to do a Christmas story anytime except on Christmas."

That killed the small talk and we got down to continuing our now silent tour until noon, after which my now mute guide departed. I thought it would add appropriate color to include the Christmas Eve ceremony, but the priest refused to give me permission to photograph in St. Peter & Paul Church. He was an old man, hobbling around with a cane, and was described by my guide as "not very modern." "Mary Magdalene" was found, as promised, in the tourist shop, which, like many others in Oberammergau, featured carved and painted Nativity scenes with Jesus, Mary, and Apostle statues stacked like cordwood in the windows. But "Mary Magdalene" was so shy that I mostly got pictures of the top of her head.

A meeting had been arranged with an "authentic Oberammergau woodcarver," who turned out to be a huge seventy-year-old man about seven feet tall who paid little attention to the photographer, which enabled me to maneuver freely around him at work. The language barrier prevented us from having any conversation, but I did meet his two young grandsons with long hair who would also be in the Passion Play.

Then I was told that "St. Peter" didn't like the press. "We will be lucky to find him at home," said my guide. But when we turned up at his beautiful old house filled with his sculpture, we were met with a pot of fresh coffee and piles of cookies. And my guide translated in amazement "St. Peter's" warm words: "You are welcome anytime," he said, "Perhaps you will come to the Passion Play this summer?"

Back at the tourist office, the mood stiffened. No one was interested in my problem with the hostile priest.

"That's not our affair," said one official. The general consensus seemed to be, "Take it up with God, and be on time for your next appointment with 'Mary,' she is very busy." That was the last word from the Tourist Press Office.

My resentment toward "Mary" and the recalcitrant priest was building up into a total distaste for Oberammergau. The Christmas spirit was beginning to feel like Monday morning at the office, and the rushed schedule fed my physical fatigue and it spread like poison: I began thinking about quitting from my own self-assignment. The rumors I had heard in Stockholm about old Nazis having parts in the play floated back. And I began even to question my own story idea: what difference did it truly make what the actors of the Oberammer-

gau Passion Play did on Christmas Eve? Then, reflecting on the cost of getting here, the long drive, the Grand Hotel, I decided to continue.

At my next appointment, "Mary's" mother met me at the door of their house. She took my coat. "Möchten Sie ein glas Wein?"

Then in English: "You like some cookies?"

"Danke schön," I replied.

A glass of warm, spicy Christmas wine was produced, having been brought to the correct temperature by dipping in a hot poker, and seasoning it by adding a clove.

"Another glass?"

"Danke, Danke."

My Christmas spirit was on the rise. I liked the woman; her neat middle-class house was in perfect order, and she had prepared well for her daughter's next role — making Christmas cookies, an activity suggested in advance by the Press Office.

"Mary" appeared half an hour later. She spoke English and, like her mother, said: "Would you like another like a glass of wine?" Again I accepted.

Then the mother brought over the cookie dough, and "Mary" began rolling it out. She immediately made a mess of it, and Mother came over to assist. "Mary" started laughing: "I don't have any idea how to make Christmas cookies."

The more wine I drank, the more enchanted I became with "Mary." She was only twenty-one and lovely. Dressed in a Bavarian costume, she was getting lovelier all the time; no, quite sexy.

When it came time for me to leave, she asked "Would you like to deliver Christmas packages, around five o'clock?"

Anxious to be of assistance, and to see her again, I told her to pick me up at the hotel when she was ready.

I went back to the Grand Hotel in a Christmassy daze to take a nap, and before dozing off I began to mull over the charms of "Mary." Wouldn't it be something if I made love to "Mary?" Isn't that awful? I make love to "Mary" in Oberammergau on Christmas Eve? What if we had a baby? It would arrive in the middle of the Passion Play. The infant could play baby Jesus. All this madness was galloping around in my mind before I passed out.

When I woke up it was 7 o'clock and time to visit "Mary Magdalene." The other "Mary" had never showed up at the hotel, perhaps saving me from a risky moment. I woke up feeling mature, ready to understand anything, and even forgave the Grand Hotel for the cold water in the bath tub. I was in a good mood.

When I arrived at the home of "Mary Magdalene," I discovered that the family was in the midst of their gift-giving celebration. Her father let me in to the living room, where he was lighting candles on the tree. Only this warm glow lit the room. Then sparklers were added and lit, igniting a cheerful shower of illumination as the family entered and gathered around in a deeply quiet moment. After a few minutes, the family began to prepare for the next moment of celebration — music.

The youngest boy, the eleven-year-old, played the violin. "Mary" and her other brother played the guitar. For a quarter of an hour, they sang hymns. Then the youngest played a solo, but he became a bit distracted as his eyes peeked around, hunting for presents piled in different parts of the room. The others pretended not to notice. Suddenly, they all broke out laughing — the signal to switch on the lights and begin opening their gifts. One of the most beautiful of them was a gold and red Madonna that the oldest brother, a nineteen-year-old, had carved and painted for his father, who was also a woodcarver.

It was a happy time and I was made to feel part of the event, drawn into "Mary Magdalene's" family's warmth and dignity. My stay was longer than intended. It was hard to leave them. But I was getting tired. All I wanted to do was to avoid collapse and let all the pleasant warmth of the day come up to the surface. But I had to get to my next appointment. It was 9:30, so I skipped "Judas'" piano recital for the tourists at the Altipost Hotel, the second largest in Oberammergau, and owned by the man who was playing "Jesus." My official schedule called for me to see "Jesus'" family open presents, so I proceeded directly to the owner's apartment in the hotel.

"Jesus" was about fifty years old, although his mother "Mary" was only twenty-one. This struck me as odd, but, then, I hadn't read the script. I arrived at the family suite a little late and many of the presents had been already opened. This time, I did feel a bit like a stranger. Introduced around, I badly wanted to leave, but I hung around for a few minutes of civility.

The "Jesus" family suite was lively. They were all removing an impressive collection of modern technology from the wrapping paper: radios, movie cameras, even the keys to a Volkswagen. The kids were having a great time and Papa got many grateful hugs and kisses from adoring daughters. In my own bid at playing Santa Claus, I presented each member of the family small gifts that I had brought along; liqueur chocolates, hearts and flowers for the girls, and a small animal for the boy, plus a liter of vermouth for general consumption.

The girls each paused from unwrapping presents. "Oh how nice, Merry Christmas," said one.

"I love chocolate," said another politely. They were well brought up.

Then "Jesus" said in perfect English, "Oh, how terrible. I don't have anything for you. This is Christmas," and he rushed off to find something.

"Here is a hand-carved Nativity scene. This was made by a dear friend who was going blind. I felt personally responsible for him and paid his bills."

"Oh," I said, "How sad. This makes the present so valuable," I told him.

"Jesus" posed for my picture with the carving under a dangling bulb, and the glaring light gave the moment a strange starkness.

Knowing I was there because of his role in the Passion Play, he took special trouble to point out a painting and a sculpture of him in his previous performances. But he needed to get back to his family, and I was finding it slightly embarrassing. As my guide had pointed out, Christmas Eve is no time to go poking into a stranger's home, so I made my thanks and goodnights and set off for the church.

The mass at 11:00 p.m. was packed with tourists and Oberammergau townspeople. We stood stacked against one another for two-and-a-half hours and my impressions of the beautiful old church were made through a haze of fatigue. It was freezing cold and my feet were wet from a slog through the snow. In the flickering candlelight of the midnight mass, no forbidden pictures were attempted; anyway, it was not possible to see anything more than a few inches away. There were only momentary flashes of gold and red in the baroque church. Here, God's revelations were transmitted through frozen feet and aching legs, though my ears were filled with waves of inspiring music filtered through a wool cap and scarf tied around my head; the singers and musicians were hidden from view. It all melded into pain tempered with fragments of music.

It was with great reluctance that I abandoned my bed the next morning, having asked the hotel porter to call me at 7:00 a.m. so I could get to the early Christmas mass.

Profiting from the previous night's experience, the next morning I went up to the balcony to find a seat with a view of the whole church. From the moment I arrived, I felt in the presence of something different, something special. The midnight mass had been touched with Heaven and Hell, the two main fortresses of Church control. But today the Church began to fill with the blessed compensating light of day: Christmas morn slowly re-gilded the baroque church, gradually spilling in through the huge side-windows, touching the stooped figures of people praying.

The balcony was shoulder to shoulder with bearded old men. They seemed as old as the ancient baroque church itself, immovable, pulled onto their knees by the irresistible gravity of God's house. I could feel the pull myself; but then the music started.

The sounds of a full orchestra and two choirs, one of children and the other adult, poured over me. It filled me up and I was finally warm. Last night my freezing feet stuck me to the stone floor — I was bound to an earth that pressed me with weariness and pain. Today was different; it took me to a place where I could even feel sympathy for the cranky old priest. My anger and disappointment dissolved as the gradual golden hue of Christmas morning illuminated the chambers. I responded to the grandeur of this baroque Church moment. The old priest presided over an elaborate altar that was now beginning to reflect flashes of gold as the shiny ornamentation picked up the light. The priest knew all about this magic and its means to power and control. He had long since given in to it and was, in fact, its servant, maintaining what had been passed on to him.

The people of Oberammergau have a hit; no wonder the story's been selling well for two thousand years. Yes, "Jesus" owns the second-best hotel in town. And his best friend is "Judas," the piano player. I was ready to make a pass at the "Virgin Mary." The ironies went on, and frankly my compass was spinning. Was I having a religious transformation? I had a lot to think about, and it was time to leave to figure it all out.

I left my car in nearby Stuttgart at the Mercedes factory for a few repairs, so I caught a plane from Munich to New York the same day. There, I traded Jesus and his family for Santa Claus and my family. I was also able to finally meet face to face with my agent, Florence Kiesling, of Lensgroup in New York to get her insights and guidance in shaping my career. Monica would catch up with me after I returned to Sweden. She was understanding about my need to reconnect professionally in New York as well as travel south to see my family.

My agent later wrote me and included this detail about a follow-up story on the Passion Play: "You mentioned the Oberammergau story. Well, I had it with *Jubilee*, but they turned it down... Seems there is a lot of anti-Semitism in the air (in connection with the Passion Play), which I found when I tried to sell it... Tried *Pageant* too, but the editor there calls it "politics." This I interpreted as the presence of a few old Nazis who were in the cast, that I had been warned about. Didn't sound like I was going to be returning in the summer.

17 – THINKING ABOUT POLAR BEARS

It's hard to explain to a mother why a son would choose such a life, achieving a cash flow that was in a constant state of extremis. Well, it didn't make much sense in so many ways, and I found it difficult to explain why I had done the underwater work in the Lofotens, bathing with the codfish in the freezing Arctic, and flirted with the "Virgin Mary" when I went to visit the actors in the Passion Play in Oberammergau.

I tried to maintain a balancing act within my family, showing them that I could live an independent and different way, while escaping the inevitable censure of those who might see *living differently* as the first cousin of *irresponsibility*. Could they understand what I was trying to do? It was so easy to pick holes in my agenda.

So, rather than discussing the details with my family, I had topped up my journal and sent the details of Oberammergau to my friend, Dave Doren — something that I did on Christmas day while the music of the morning Mass was still ringing in my ears.

To me, the stories were exciting and fun, but they pointed toward dangerous emotional shoals. My most hilarious, hair-raising, satisfying exploits would probably look like shipwrecks to my mother. Risk was not a suitable companion to introduce to her. And, as for my brother, he would surely cite "cash flow" problems and suggest, "Have you thought about doing advertising work?"

And when they learned about the next project I was thinking about — photographing polar bears underwater — they would certainly think that I had asked Santa for a Halloween "trick or treat" to go under the Christmas tree.

But Santa did have a present for me. My talks with Florence Kiesling in New York were encouraging. We discussed a strategy for her to sell my stories. She gave me a list of contacts with magazine editors who might be receptive, and she thought that my search for diving equipment to do the polar bear story no longer seemed insane. So after a few days in New York, I loosened up and traveled down to celebrate a nice reunion with my family on my uncle's plantation in South Carolina. Then I returned to Stockholm to put my crazy ideas together.

A letter from Sweden to my brother Gamble summed it up:

I'm looking for underwater gear to locate sunken wrecks... I'm not optimistic but I did find a drug gun that makes kittens out of tigers — at least that's what it says on the label. I borrowed the gun from Prof. Wirstadt at the veterinary school in Oslo, but his experience is with unruly cattle not polar bears.

While in Stockholm, I contacted TIO Fotografer's Sven Gillsäter, a popular writer, filmmaker, and photographer for Swedish magazines and a veteran of photographing Komodo dragons in Indonesia. Perhaps he would join me on the expedition; he might bring valuable experience to the trip. Do the giant lizards equate with polar bears: why not? I didn't know Sven well, but felt that the invitation was appropriate as TIO had been supportive. He might also offset a plague of bad luck I had been having in getting the project underway. First, in May, the seal-hunting ship from which I planned to photograph the bears and other Arctic wildlife was sunk. A new ship would have to be found. Then, the Norwegian scientist, an expert on Beluga whales, who was supposed to master the use of Professor Wirstadt's air-powered dart gun, had never got around to shooting the gun or working out the correct tranquilizer or dosage for its use. Our intention, to add scientific legitimacy to my story, was to shoot the polar bears and tag them while they slept — a first step to eventually measuring bear populations, something that had never been done.

We had another setback when it appeared that we didn't yet know which tranquilizing drug we should use. Professor Wirstadt had suggested nicotine sulfate, but had never experimented with it. Through Florence Kiesling, I contacted the gun manufacturer, the Palmer Chemical and Equipment Co., and received the following reply from Mr. Palmer himself:

It is obvious that Prof. Wirstadt is so far out in left field that I do not believe I could help him with any suggestions. Nicotine sulfate is one of the most lethal

drugs that can be injected into any living thing. We have never used it and certainly would not consider using it. I am sorry but I cannot offer any help.

Then, disappointments were topped by tragedy; Bjorn Dahl, the diver who had agreed to help with underwater photography, dropped dead from a heart attack in June.

So, for all the above reasons, Sven Gillsäter's recruitment was more necessary than I ever imagined. I clearly needed lots of help.

Telegrams from Olaf Applebom, Director of the United States Information Library in Tromsø, a friend from earlier trips, confirmed that he would be able to find me a converted fishing boat to take us to Spitsbergen. That was the first step. When Sven and I arrived in Tromsø, we naturally visited Mack's Øl Hallen, headquarters for Arctic possibilities, and had the good luck to meet Johan Sørensen, an amateur filmmaker. He knew the tiny island of Byørnøya (Bear Island), where we would be stopping on our way north, so we invited him to come along as guide. Johan seemed a promising addition, but the whole team was all put together so quickly that nobody got to know their fellow adventurers well or at all. Our trip had the makings of an ill-planned disaster, which, as it turned out, was not far from the truth.

On July 15th, the three of us departed on the eighty-five-foot motor ship *Støtt*, for the first leg of our journey to Byørnøya, roughly halfway between Tromsø and Spitsbergen. It was impossible to get to Byørnøya except by such a charter; no other vessels called there regularly. Its only human population was a dozen or so radio operators who manned a weather station. Curiously, there were no polar pears on Bear Island. It was simply a rock in the ocean, thirteen miles long and ten miles wide, shaped like an arrowhead pointing at Norway.

After two days, *Støtt* had covered the two hundred plus miles, delivering her three crew members plus Johan Sørensen, Sven Gillsäter, and me. Bear Island was a treeless, barren place 74° north, named by the Dutch navigator Willem Barentsz to commemorate his sighting of a polar bear in 1596. Names on the map described its history and character: Russian Harbor, Misery Mountain, Walrus Bay, Coal Bay, and Bird Mountain.

Støtt dropped anchor at a small harbor at Herwighamna on the north coast, and we rowed ashore in a dinghy to visit the meteorological station. There we found thirteen Norwegians and a Dane, the total population of the

island, who displayed a gallery of impressive beards. They were young men, the youngest twenty and the oldest thirty-one, except for the fifty-one-year-old cook, an old Arctic hand who had been a hunter in Greenland.

Because herring fishermen visited the island at certain times of the year, there were ample living quarters and we were invited to move in; the fishermen had moved on to Greenland. Raised boardwalks connected the station's three buildings — the meteorological equipment, the boathouse, and the living quarters —making it possible to move between them during winter snow or summer mud. To sustain them against the furious gales that blew in this latitude, the buildings were strapped to the ground with steel cables.

We asked the men if they didn't get lonely up here, but they explained that the fishermen sometimes brought mail, and they chatted with them and other passing sailors on the radio. The Dane said: "We don't have time to get lonely; so much work," and he emphasized, "There's good fishing in the summer."

Three operators were off duty and they took us on a sightseeing tour in their wooden outboard. We set out to visit an English coal mine that had been started in 1916 but abandoned in 1925. Buildings from the settlement, called Kolbukta, were standing but, inside, planks had fallen from the walls, and there were pieces of kitchenware, uprooted bathtubs, and more; piles of dynamite were scattered about the powder house. Outside, the rusted hulks of two locomotives and a weaving narrow-gauge track twisted by fifty years of freezing and thawing ground led to a high pier, where the disconnected tracks dangled like strands of spaghetti into the sea. Here, ships once came from England to load coal. Kolbukta was located two miles south of Mt. Misery (536 meters), Byørnøya's highest peak.

Despite its modest size, about 130 square miles, Byørnøya had more than 700 lakes and ponds. Many of them were only three to six feet deep and some were full of fish. One of them, Lake Ellasjöen, was our next stop, and we hoped to take pictures and maybe catch an Arctic Char (Röding), a delicious treat. The Dane and three Norwegians came along and we towed their boat behind *Støtt*.

The weather was clear until we got near Cape Harry, where it began to drizzle. We went ashore anyway. Maybe it would blow over. Weather was unpredictable. Here, the Gulf Stream that warmed the Lofotens met the cold-air currents coming from East Spitsbergen and the Barents Sea, producing fog and

rain. A clear, sunny day was rare, even in summer, when a combination of wet *here* and sunny *there* was normal.

The six of us hopped into the outboard and started for shore, landing on a beach of stones shaped like cannonballs. The boat was dragged above the high-water mark, and, after climbing a steep red cliff, we found ourselves a short walk from the lake. The weather got worse so I gave up photography and concentrated on fishing. The fishing, however, proved to be the same as the photography. Rain was leaking down the back of my neck and we all decided to return to the boat.

Sizeable breakers were now rolling onto the beach. The Captain of *Støtt* had upped anchor and was patrolling up and down, taking no chances, but none of this concerned me. I was in the hands of Vikings.

The outboard was loaded with our gear, and we pushed it down the smooth black boulders and pointed it into the surf. Suddenly, a wave caught and flipped the boat around, turning her broadside. Before we could get her pointed out again, a bigger wave lifted us and smacked the boat onto the beach, and one of those cannonballs smashed through the wooden planking. In a few seconds, all the camera equipment was sloshing around like pieces of soap in the bottom of a bathtub.

An hour later, Arne Svensen, *Støtt's* Skipper, rescued us and two hours after that we were at Byørnøya station conducting a prayer vigil over the photo equipment. The next two days were exclusively devoted to removing sand and sea water from our gear. Sven's Arriflex movie camera should have caught pneumonia and died — but through some mechanical miracle, the movie camera and two of my three Leicas finally operated.

We made one more land trip, crossing over the jutting peninsula to Kvalrossbukta, where we found the remains of a Russian hunting camp with whale bones and a rusted-out machine for cooking blubber.

Finally we headed for Fuglefjellet (Bird Mountain), on the southern tip of the island. Weather was still uncertain, fog continued to stream across our bow. Then, everything would change, and a few miles away we were bathed in sunshine.

We sailed past Mt. Misery and suddenly the scenery was different. Instead of the cheerless bogs and flat reddish rocky land, cracked and splintered by

extreme weather, there were great rock-islands standing off the coast. And, there was life on this side of Byørnøya. Flight after flight of Eider duck, auks, and Red Billed Puffins flew by us on their way to land. There were big Glaucous Gulls living in the rocks and as we approached Sörhamna (South Harbor), we picked up several hundred screeching escorts when the cook threw garbage over the side.

Rounding Cape Malmgren, we saw in the distance the great south capes darkly silhouetted against the sun. The horizon was clear, but hugging the distant land, creeping up the great black mountain, a snake-like rope of illuminated fog crawled off the capes. Then it tumbled down in a dazzling cascade, twelve hundred feet to the sea below, where it piled in a hump before flattening on the sparkling water to continue on its way. The fog was beautiful, but we all hoped that this would be the last of it. In half an hour the remaining fog blew away from Fuglefjellet, leaving only a few persistent wisps hanging on at the summit.

As we approached the darkened mountain, it took on color. The top and sides of its sharp cliffs were trimmed in green, velvet moss. Large areas of black-and-white patches formed patterns on its face. As we came closer, these patterns, like magnified dots on a newspaper photo, turned out to be row upon row of auks. Looking through my binoculars, I saw that the eroded rock face was layered with thin, sandwiched rocks, forming thousands of horizontal steps, and there, jammed one next to the other, were more birds than I had seen in my entire life. In the foreshortened view of my binoculars, they seemed to be standing on each other's heads; every black body distinct against a white background, a huge mountain cake with vanilla icing that turned out to be bird guano.

Worn into the cliff face at water level were sandy beaches and coves, protected by high sentinel-like formations rising two hundred feet out of the sea. The water was clear to the bottom and the green moss growing on the mountainside gave the whole scene a lush, tropical feeling. It didn't seem possible that such a place existed so far north. The wild-looking mountains, poking into the clouds, made this Arctic cape look like a South Seas movie set. Coming closer, we saw that birds were stacked from the water's edge all the way up the cliff face until they disappeared twelve hundred feet above. Every pinnacle was covered with long-necked auks silhouetted against the sky and the jagged

cathedral spires. A dark avian cloud moved continuously from the cliffs to the water and back again.

Arne Svenson anchored *Støtt* and we prepared to make our second amphibious landing. After putting on our oldest clothes, we each stretched a pair of socks over our rubber boots, tying them on to provide traction on the slippery guano that covered the rocks above. Reflecting on our recent disaster, every lens and camera was wrapped in chamois and secured in plastic bags before we put them in our rucksacks. Sven had a climbing rope and we boarded the rowboat, ready to go ashore.

Johan spotted a cliff that was climbable. "Here we get close to the birds," he said. In the spring, fishing boats often come from Tromsø to gather eggs to sell. Johan had been on such trips, so he led the way. The *Støtt*'s cook landed us safely on a flat, slimy rock at the base of the cliff. Johan went up first with the rope. Camera-filled rucksacks were hauled up one by one. The rock was layered in natural steps, a geological stack of pancakes, and with the rope secured above it was easy to climb up to a shelf, look around and proceed to the next. It was simple but not very pleasant. Every inch was dripping with bird shit. There were also birds perched on our hand-holds. Eggs were everywhere.

The auks waited until they almost got stepped on before flying off. Some of them refused to abandon their chicks until the last second, and then panicked and took off, dropping eggs, young chicks, or worse on my head. My hat also began to look like a guano birthday cake.

One auk arrived from the sea below with a small cod in its beak. Another was pushed out to make a place. Some hens had five or six chicks, others had one. As we climbed through these nesting sites, chicks got mixed up, separated from their parents, or orphaned; it was bird-mountain bedlam. As auks took off and left their chicks, the infants became prey for huge Glaucous Gulls, who were on constant patrol, gliding along the cliff face looking for an easy meal. I tried to move as quietly as possible, but every step created chaos on this fantastic rock.

The Glaucous Gulls lived in the rocks, just above the auks, but their chicks, unlike the auks, were cradled in seaweed nests. On approach, the baby gulls hissed and spat upon me. Poking my finger at one, a chick nipped me as hard as it could. The auk chicks had seemed quite helpless; they toppled over on

their rocky ledges and remained there — sometimes right-side up, sometimes upside down — looking feeble, trembling on the bare rock.

As we approached the summit of Bird Mountain, the view was spectacular, and literally breathtaking. My nose was attacked by the overwhelming smell of bird guano and rotten eggs, and my ears were deafened by millions of birds crying, bleating, and screaming in an amphitheater formed by the giant rock cliffs. The roar began to play tricks on me. Every few minutes, I turned, thinking that Sven and Johan were yelling at me.

Three hours later, Sven, Johan, and I were picked up by rowboat and taken out to *Støtt*, our ears ringing, filthy from head to toe — three dirty, stinking, satisfied, happy photographers. The next day, after saying goodbye to our friends at Byørnøya station, we set sail for Spitsbergen.

Bad weather and fog dogged the trip from Byørnøya to Spitsbergen. Johan and I both became seasick. It was a great relief to sight land, but it turned out to be the island of Edgeøya, 150 miles due west of where we were supposed to be. The next day we were moving up Isfjorden (Ice Fjord). At 4:00 a.m. I came up on deck to have a look around.

Captain Svenson announced: "We're in Longyearbyen."

The water was slick as glass and on shore no soul was stirring. Nothing looked familiar. I had been in Longyearbyen in November when it was dark, so my bearings were off. Still, it didn't look right. Captain Svensen began maneuvering for a landing when he noticed that a coal barge moored nearby had a large red flag with a hammer and sickle in the corner. He threw the engines into full ahead and we made a rapid departure. We were about to land in Barentsburg, the Russian coal mine town, also located on Isfjorden. Svensen wasn't anxious to visit the Soviet port unannounced. Four hours later, we arrived in Longyearbyen without further excitement.

Twenty-four-hour daylight revealed a new Spitsbergen. It was described in my guidebook as a place that looked like Norway eight to ten thousand years ago, when the last ice age was receding. Even now, the sixty-percent that wasn't covered by permanent ice was punctuated by jagged saw-toothed peaks that looked as if they had ripped through the surface of ice, land, and sea. The immediate effect was spectacular and grim, un-softened by foliage of any sort. And the land and the weather played with each other in an ever-changing, un-

predictable drama; covering, then revealing, before blanketing and obliterating. We were being treated to Act One, with many more surely to come.

As I had discovered in November, Spitsbergen, largest island of the Svalbard Archipelago, depended on coal for its economic existence. Before coal, it was a no man's land, with a history of hundreds of years of international conflict and exploitation; whales, walruses, and other animals were the source of wealth and the cause of war.

In 1925, the League of Nations brought about a diplomatic resolution that became the Treaty of Svalbard: signed by thirty-nine countries, it ceded the area to the Kingdom of Norway. But the signatories were given the right to pursue mining, non-military interests, and scientific polar investigations under the jurisdiction of a governor of the Svalbard region, appointed by the King of Norway.

The administrative capital of Svalbard at Longyearbyen housed the Governor's office. It was necessary to contact him before coming to Svalbard as there were no tourist accommodations of any sort. I had asked Hans Aanstead of the Office of Cultural Relations in Oslo to telegraph the Governor and get the red carpet dusted off, as he had done the previous November. But Hans forgot, and the Governor was furious. Not having been informed about our arrival, he refused to help in any way. This was not only extremely embarrassing but also reduced our options to do certain things: no hook-ups with existing expeditions, no drop-offs at picturesque photographable sites, none of the kind of luck that the Governor's help might generate and the kind we desperately needed.

We were stuck in Longyearbyen as *Støtt* couldn't refuel on the weekend, so we took off for the weekend, setting out on foot in clear weather to find a herd of muskox that a German expedition had been trying to locate for two weeks. We only had two days but had nothing to lose. We couldn't pass up the possibility of seeing these animals, the last surviving ice age throwbacks that kept company with woolly mammoth millions of years ago. By chance, a Canadian journalist friend, Fred Bruemmer, who I knew from Lapland, was at Moskushamn (Muskox Bay) doing a story on the animals. We found Fred wide awake at 1:00 a.m. at Advent Fjord; no one goes to bed when the weather is good in Spitsbergen.

"I saw muskox four days ago about twenty miles from here," Fred told us. He agreed to guide us; "We've got about a 50/50 chance of finding them," he said.

In spite of looking like overly shaggy bison, muskox are more closely related to goats and sheep than oxen. Aggressive, and with long sharp horns, they form a defensive perimeter when in danger, with the calves on the inside of a circled herd. They have a reputation for charging their usual adversaries, which are wolves in Alaska and Northern Canada. Although there were no wolves in Spitsbergen, their instinctive defense strategies remained — and who knew how they felt about photographers.

Muskoxen were imported in 1929 from Greenland, where they were hunted. Their long soft woolen coats, which hung to their feet, kept them warm and provided luxuriant scarves for tourists in Alaska. This had not yet become a cottage industry in Spitsbergen, however.

"The minus side of muskox," Fred informed us, "from which the species gets its name, is the smell. The male has powerfully stinky urine and he'll pee on you if he gets agitated. Females can't do that," he added.

We learned that muskoxen fed on grasses and lichens and grouped in herds of ten to twenty animals. "In summer they graze easily, and in the winter, in snow, their sharp hooves punch through snow to get at grass below. This also allows them to break through ice on the ground to get water to drink — even in winter at -20°F."

The Advent Valley, where we hoped to find some muskox, was a long basin three miles wide stretching fifteen miles east of Advent Fjord. According to Fred, "There are ten valleys that come into Advent from both sides, all of them dead end." And he continued, "If the muskox had gone this way, it would take a month to find them. On the other hand, if they stayed where I saw them, we have a chance, unless they went into one of the ten side-valleys," added Fred. There were as many *if*'s as miles, but we were eager to try.

We made camp at 2:00 a.m., slept for three hours. Then, "Wake up! It's 5:00 a.m." said Fred, our alarm clock. We rolled up our sleeping bags and soon found muskox tracks, but according to Fred they were probably from an old bull. "When he gets too old, the old guy is chased out of the herd by a younger male."

The tracks were encouraging and I needed encouragement. Advent Valley became grim. Crossing mud, rocks, and snow that was black with coal dust,

we found no sign of any living thing, except the occasional tracks. After five hours we came to a hut on top of a glacial deposit, elevated 50 feet above a river. The unlocked hut was stocked with food, fuel, and blankets. It had been built, supplied, and maintained by the *Store Norsk Spitsbergen Kulkompani*, the Norwegian Coal company that operated the mines. It was for hunters and hikers like us, but ones who weren't in a hurry. I had told Arne Svensen aboard *Stott* that we would be back on Monday by noon, and with his charter cost at $60 a day, I was anxious to be late.

Nobody except Fred Bruemmer was in condition for long hikes, and our lack of sleep didn't help the rest of us. Neither did Johan's weird sense of fun. While visiting the hut, he slipped a five-pound can of pineapples into my rucksack when I wasn't looking. When we later took a break, this joke felt better in my stomach than on my back.

"From here on, we might see muskox," Fred told me.

It was a beautiful day, almost 70°F — hot for Spitsbergen. The melting glaciers fed numerous streams that were running higher and stronger than usual. Water sloshed into my rubber boots, but after five crossings, I gave up making detours trying to find shallow spots. Fred took off his boots and trousers and forded icy streams bare-assed, quick-time. I tried this only once.

Three hours out from a second hut that we found, we saw two wild reindeer. Fred told me, "These reindeer are chunkier and shorter-legged than the ones you saw in Norway." But I was more interested in my tired legs than theirs.

"Reindeer herds are protected from hunters," Fred told us, "but they have been decimated by packs of wild dogs, which were originally pets abandoned by Russians during World War II. There was a bounty on wild dogs, but this stopped because so many un-wild dogs were imported from Norway by hunters to collect rewards."

It was now three o'clock in the afternoon; then it became 5:30 p.m. We had arrived at the place where Fred had seen muskox. Nothing there. We stopped and considered our next move. My feet were wet, cold, and blistered, and Sven and Johan had similar problems. I was secretly losing interest in finding the companion of the wooly mammoth.

"Muskoxen!" Johan bellowed, running and pointing down the valley. And there they were. Through my binoculars, I saw a group of animals lying by a

stream about a mile away. We came down from the high ground and started for them. I forgot about my feet.

In half an hour we were five hundred yards from them; one muskox stood and faced us, then the others got up. As we got closer I saw two calves, then the whole herd stood and faced us, forming a tight, protective circle around the young, as predicted. We moved forward slowly, twenty yards at a time, stopping frequently to take pictures, until we were 100 yards from them. It wasn't certain what would happen next. There were fourteen of them, including calves. A very large, grizzled-looking muskox came out a few yards in front of the herd.

Fred warned us about the old bull: "He's the one to watch out for."

Through my 400mm lens, I could see his gray, shaggy head lowered. He kept his shining black eyes on us at all times. This was mating season, a period when males are extremely aggressive.

"Bulls will even charge birds that get too close."

Moving slowly, we got to eighty yards, and the animals turned and ran. They stopped after fifty yards, and again formed their tight circle.

"I'm surprised that the old bull hasn't charged us yet," said Fred.

The pursuit of the muskoxen now became a routine; we advanced, they retreated. I was getting more confident. The herd took off once more, splashing across to one of the islands formed by the many glacial streams.

The water was only a few feet deep, so Fred and Johan decided to block off the big muskox's retreat. The herd was jumpy because of our numbers, so Sven and I hid behind a rock. Fred and Johan than skirted the herd, putting the muskox between themselves and us.

From what we could see, they were getting close, much closer than before. The back of the herd was visible, but I couldn't see Johan or the old bull. Fred was in sight, twenty yards from the muskox, in a good position to get photographs. It was frustrating to be so far away, but I was happy to be behind my friendly rock.

Then, through my binoculars, I saw fleet-footed Johan doing a hundred-yard-dash toward Fred, who also became athletic. They flew through the river, water going in every direction, but their wake was a dead eddy compared to the churning spray that inspired them — fourteen muskoxen close on their

heels. Then the herd came to a halt, and likewise Fred and Johan. I yelled congratulations to Fred, "He didn't have a chance to pee on you."

We spent three hours with the strange, hulking beasts; then reluctantly returned to *Støtt*. At noon on Monday, we arrived back in Longyearbyen, very tired, satisfied, and on time. Mission accomplished after a thirty-mile march in nineteen hours. I was sad to leave Fred Bruemmer, my journalist friend from Lapland, but happy to be in my bunk on *Støtt*, cruising up Kings Fjord to Kings Bay (Ny-Ålesund).

We said goodbye to the crew, the engineer, cook, and Captain, who had brought us as far north as we could get on July 25th. But how were we going to find a way to go further north? Støtt was paid off and returned to Norway. We were now on our own, about to try to execute the second but most uncertain part of my plan.

We had been deposited in Kings Bay, the most northerly community in the world, with streets inches deep in coal dust that was tracked into every building. No trees or bushes were to be seen, and the place had a worn-out look with coal-mining gear and other equipment lying about everywhere.

Little steam engines carrying coal and ferrying workers back and forth between the mine in the distance and the dock looked like enlarged toys puffing along a narrow-gauge track. Some buildings were painted rust-red, but all doors and windows were neatly trimmed in white, someone's desperate effort to perk up the gloom. Overall, it was a man-made mess sitting in the middle of a magnificent Arctic landscape. My visit to Spitsbergen in the dark the previous November was to a different planet.

Kings Bay had been the jumping-off point for three early 20th-century attempts to reach the North Pole. Richard Byrd's airplane flight and Roald Amundsen and Umberto Nobile's dirigible journeys had all begun here. The mast that had once served as the mooring for Amundsen's *Norge* and Nobile's *Italia* dirigibles still stood — a brash, rusted, man-made steel finger poking and challenging the sky and the weather. Now, it was employed as a radio antenna — one that signaled so much history for me.

While Sven, Johan, and I were wrestling with our own doubts and incomplete preparations, those actors who had played for me on the pages of the *National Geographic* when I was an eight-year-old began to become alive. The

story of Byrd as a boy preparing for a polar future, sleeping on a cot on an outdoor veranda in winter, returned.

In April 1926, Richard Byrd had arrived at Kings Bay with a Fokker tri-motor airplane stowed on board the ship *Chantier*. He was in a race to beat Roald Amundsen to the North Pole in his airship *Norge* (Norway). Amundsen's plan was to fly over the Pole to Alaska. On May 9th, 1926, Byrd and his pilot, Floyd Bennett, took off from Kings Bay in the *Josephine Ford*, named after the wife of his sponsor, Edsel Ford.

They returned after seventeen hours and announced that they had reached the North Pole. In the United States, they were given a ticker-tape parade in New York, and both Richard Byrd and Floyd Bennett were awarded Congressional Medals of Honor. Bennett had Floyd Bennett Airfield named after him in New York. I knew this history but I had it wrong.

It turned out that aeronautical and meteorological experts became skeptical about Byrd's claim. The navigation logs didn't check out. Years later, on his deathbed, Floyd Bennett revealed to his friend, the Norwegian pilot Bernt Balchen, that he and Byrd had flown in circles over the ice and the mountains of Spitsbergen never left their sight — information that challenged the integrity of my childhood dreams. A man who had helped shape what I considered *manly* turned out to be a fake with respect to the North Pole. I was following their quest and doing it in the same place, Kings Bay, in the shadow of the mooring mast that became a powerful symbol for me.

On May 11th, 1926, two days after Byrd's flight, Roald Amundsen unhooked from this same mast and took to the air from Kings Bay with Umberto Nobile as pilot and American explorer Lincoln Ellsworth as crew members in the Norge. They reached the North Pole a day later.

Kings Bay's history sent me a message — loud and clear: this is a place where little goes as planned and results are a roll of the dice. Still, it remained the jumping-off place for so many polar expeditions, all of them lavishly equipped compared to ours. There were no accommodations for visitors at either Longyearbyen or Ny-Ålesund, no hotel, no place for adventurers to linger as they figured out a plan. There were also no polar bears. The bears lived hundreds of miles to the north and east. Here, even for the outsized characters from the past — so much depended on luck. For us, it was all we had.

Our best hope was a meeting we were granted with Einar Grimsmo, the head of the Kings Bay Coal Company. He had sent me a letter promising to help, but I had already flunked out with the Governor, something that eroded my credibility with Johan and Sven. Was I, after all, just a "big-talking" American? Had they signed on for a ride to nowhere? I didn't like the way they were looking at me because I wasn't sure they weren't right. So when we went to meet with Grimsmo, I felt that my reputation was facing a possible death sentence.

Mr. Grimsmo met us with one of his assistants, an engineer named Johansen, and he asked me casually:

"Do you think you'd like to rent Mr. Johansen's boat?"

Sven Gillsäter's eyebrows briefly lifted behind his heavy rimmed glasses, expressing a rare moment of surprise before returning to his usual superior Swedish composure. Johan looked as if somebody had offered him two free beers at Mack's Øl Hallen and he was ready to accept with an amused "Tak tak" (Thank you).

It emerged that Engineer Johansen owned a little converted fishing boat that he would rent for what we thought was a bargain, and when we inspected it we liked what we saw. She looked sturdy and seaworthy to me, and seemed appropriate for these waters — an opinion based more on hope than knowledge. Sven agreed, with similar reasoning, but Johan, with more experience of such things, carefully tapped the hull here and there, started the engine, and asked a bunch of questions. I felt much better, in fact I felt great!

Johan was elected to go to Boat School with Engineer Johansen for two hours, while Sven and I went to buy and borrow supplies. Grimsmo loaned us an old Norwegian Army rifle, an antique single-barreled shotgun, a portable battery-operated Ericsson radio with short- and longwave bands, a saw, and an ax. We bought an extra fifty-five-gallon drum of diesel fuel, six 20-liter jerry cans, ammunition, and a pile of canned goods: flatbread, cheese, jam, cooking oil, coffee, chocolate, dehydrated everything-food, taste-enhancing sauces, as well as taste-killing sauces, a bottle of whiskey, potatoes, beer, margarine, and innumerable cans of fish and meat; the list went on. I insisted on fifty rolls of toilet paper. Since my experiences at the Chosin Reservoir in Korea, I was taking no chances in this department.

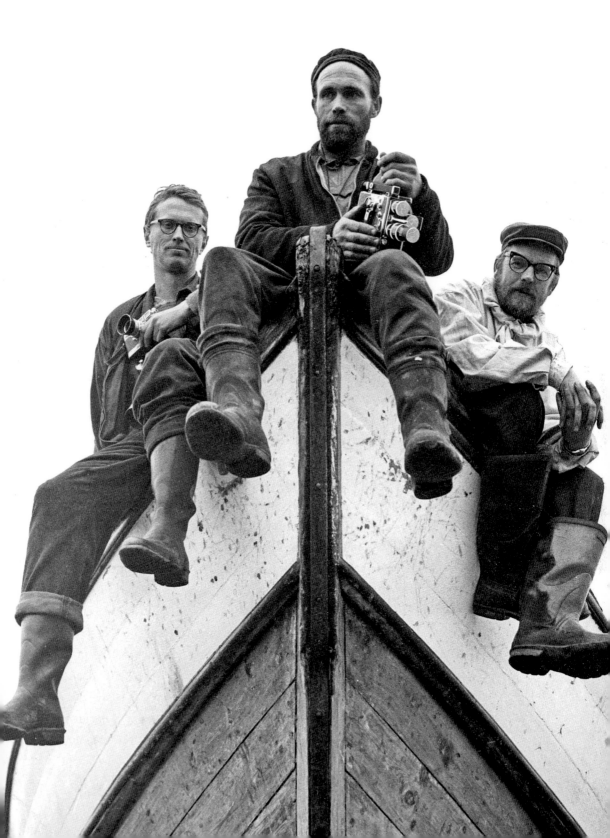

18 – TITANIC

The cockpit of Engineer Johansen's boat had originally been designed for fishing with nets that were stored in an open cockpit that had been replaced with a plywood cabin ten feet long containing two bunks and a stove. Just in front of it, a tall wheelhouse contained the wheel, compass, and engine controls. A short, fat, little vessel thirty feet long and ten feet wide, she had a draft of five feet, and seemed strong and seaworthy. We loaded all our provisions aboard, strapped the 55-gallon fuel drum and my diving gear snugly in the stern and were ready to shove off.

At noon on August 1st, 1960 we chugged away from Kings Bay (Ny-Ålesund). Johan, Sven, and I crowded into the wheelhouse. The 15-horse diesel banged away under our feet, pushing us along at a comfortable pace. We were struck silent by the moment — sharing the realization that from here on all the great cities of the world, every village and hamlet, lay to the south of us as we left Kings Bay. The banging and clanging of our double-stroke one-cylinder diesel engine, however, did not aid our euphoric mood. The exhaust pipe ran up through the roof of the wheelhouse on the starboard side. The rattling pipe was very disturbing, but before anyone said anything, Johan went below, found a piece of wood, and wedged it between the pipe and the roof. Peace was restored and I began to understand that here was a man who was going to be a major asset on this trip.

We couldn't get over our luck in renting this boat. Engineer Johansen had not only asked an amazingly reasonable price but also implored us as we took off, "Should you have an accident, save yourselves, don't worry about the boat." We were very impressed with his attitude, and of course vowed to do

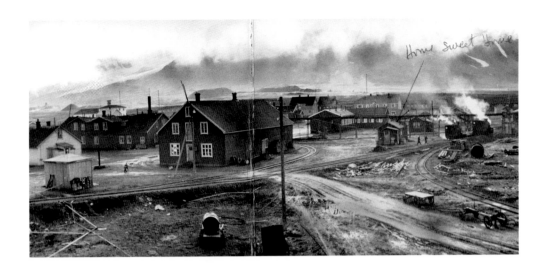

everything in our power to make sure that nothing should happen to it. I named her *Titanic* as a reminder to be careful in the ice.

Later on the trip, after encountering some miserable weather, *Titanic* became a bobbing cork and Sven renamed her *Arctic Puke*. I objected, preferring the more dignified *Titanic* but Sven continued to describe her in his journals with this distasteful name. Perhaps *Arctic Puke* sounded more romantic in Swedish, but maybe it just revealed our different styles.

We headed west from Kings Bay and rounded Cape Metra, leaving the protected waters of Kings Fjord. From here on we were on our own, just short of 11° south of the North Pole, heading north, carefully checking off and estimating our progress against the sea map as we clipped along at an estimated seven miles an hour. For more than twelve hours we moved north, following the desolate 60-km long stretch of barren mountains and glaciers, without inlets or protective harbors of any sort. The black rocks along the shoreline had been sculpted by the surging of a freezing sea and even on this beautiful day the coast was ominous, teasing us to come close, to get sucked in by the swelling sea to a boat-crushing shoreline. Even with the weather calm and clear, this was a formidable stretch for the inexperienced.

It had been clear and bright for a week now, the midnight sun shining continuously. The temperature was remarkable — a little over 600 miles from the North Pole, it was 70°F, twenty-nine degrees above normal.

Soon we settled down into a routine of two-hour watches. A sliding panel separated the wheelhouse and the cabin, so it was possible to wake the relief

or pass forward a cup of coffee to the watch. But for the first few hours, all three of us had stayed crowded in the tiny wheelhouse, too excited to go into the cabin. As I took over on my first watch, Johan marked our position on the map, "The compass setting is 350° NW by North," pointing out the cape to aim for. "Keep the bow lined up on it," adding that he had seen five seals and warning me to look out for the driftwood that he had seen floating over from the Siberian coast of the Soviet Union.

There were no names to give comfort on this barren coastline, only jagged 2000-foot peaks and fingers of glacial ice poking into the sea along a long stretch of rocky wind-blasted shoreline, on the way to Hambukta and Magdalene Fjord, the first place we might be able to anchor for protection from unpredictable weather.

The weather remained clear, and with a growing confidence we began to adjust to each other under new circumstances. None of us had any nautical experience, but Johan Sørensen had received two hours drill on the art of small boat handling so he was elected Captain. Sven Gillsäter and I were "seamen." Time would tell if we became a team as we moved north, carefully recording our progress on the sea chart.

Alone on my first watch, the flat calm sea provided no competition with my fantasies as we headed toward the Pole, and it seemed reasonable to believe that I was carrying on a tradition that had filled history with legitimate heroes. Keeping my compass setting, pointing the bow at the correct cape, checking the marking on the nautical map, and keeping alert for driftwood, I could now return to my fantasies.

"*Do you suppose, Father Pablo, that this is the same unknown, the same proving ground of many men of dash and inspiration who had sailed here before me? Could I be one of them?*" My two-hour watch placed me on duty on that sparkling sunlit day, and I was lucky enough to be the one who steered *Titanic* into the magnificent snow-capped entrance of our destination, Magdalene Fjord. "*Oh God Pablo! You would be as proud of me as I am of myself.*"

Magdalene Fjord offers a protected harbor that extends into West Spitsbergen four or five miles and is set in a semi-circle of snow-capped mountains. Jagged like serrated knives, they rise straight from the sea and cut the sky at three thousand feet. We found a beautiful sandy beach and decided to go

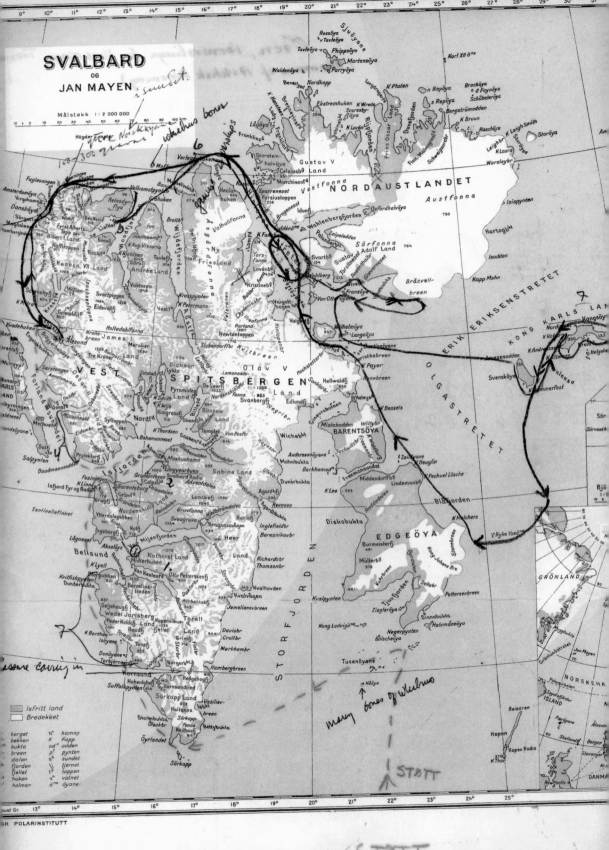

SVALBARD
OG
JAN MAYEN

Målstokk 1 : 2 000 000

STØTT

STØTT
TITANIC

ashore and investigate. Anchoring safely near the beach, Johan, Sven, and I rowed ashore in our tiny skiff. We took cameras and the rifle on the off-chance that we might encounter a polar bear and began photographing this spectacular place. We were so pleased with ourselves. Our self-confidence extended a feeling of brotherly bonding. Then it happened.

Just at the moment when we were surveying our realm as "Kings of the Arctic," a monster hove into sight: *Ariadne*, a large white German cruise ship containing 1000 tourists, steamed into Magdalene Fjord.

Ariadne dropped anchor and lowered several huge motor-powered life boats, each one larger than *Titanic*. A crew of sailors came ashore to build a landing pier. In no time, boatloads of tourists stormed the beach, carrying binoculars, cameras, umbrellas, and walking sticks; one old lady was eating a banana. They became busy looking for souvenirs, collecting colorful rocks and poking for bones. They took pictures of the monument erected by the Norwegian government to mark the graves of dead hunters; the very ones whose ghosts had been our private escorts on our contemplative survey of this wondrous place.

I felt betrayed by reality; we felt we had risked our lives getting here aboard our brave little craft and here were 500 *Bürgermeister* and their *Frauen* stepping ashore from a luxury cruise liner. Having struggled so hard to reach my latest Everest, how could I accept that there was an escalator on the other side of the mountain? How could reality be so brutally whimsical? I thought I had learned about "trick or treat" truths but the joke was on us and there was nothing to do but laugh.

As if to rub in the joke on us, we spotted a crew member dressed in a fuzzy nylon polar bear suit scampering about to the great joy of the tourists, who delightedly snapped his picture. We restrained Johan from shooting the absurd creature, and Sven photographed the dressed-up sailor. Like it or not, our polar explorer status was not much more authentic than that of the tourists, but when they asked where we were from, I felt compelled to glamorize our presence. "Actually we just made it; sailed from New York and survived after encountering several hurricanes."

Later, as we watched the tourists going back aboard their ship, I felt an uncomfortable connection with them. After all, we, too, were just looking for some "exciting northerly sights;" they simply had more comfortable transportation.

As we explored further down the beach, beyond the perimeter of the tourist invasion, we found two tents set up. There were piles of equipment with *Midlands Alpine Expedition* printed on crates. The occupants of the tents, who turned up a few minutes later, turned out to be two young Englishmen who, as indicated on the crates, were climbers. They had suffered a serious act of piracy.

A month before, they told us, they had returned from the high glacier to their base camp on the beach to find that their emergency supplies had been rifled. Sugar, beer, chocolate, biscuits, tea, cigarettes, some of their tinned meat, and all of their matches were gone. No matches could be a death sentence on Spitsbergen. But *Ariadne* had also made a trip into Magdalene Bay then and they had asked an officer from the ship if it would be possible to get matches. Matches and a number of other essentials were provided, and at that time one of the tourists, a brewer from Hamburg, donated several cases of beer to the expedition. The climbers had been invited aboard ship and given a meal with the crew, a most pleasant change from the canned fare of mountaineers.

A similar invitation was issued to *Titanic*'s crew by *Ariadne*'s photographer and we eagerly accepted. As we looked forward to some good German cooking, the photographer returned very embarrassed: "I apologize; the Captain said it was impossible." No reasons were given, but Johan thought it was because the tide was going out and the ship would have to move shortly.

Instead, we had a party in the *Midlands Alpine Expedition* tent. It was the birthday of one of the two climbers, Harold Manison, and we brought bread, tea, and beer from our supplies and wished them good luck. The week before, they told us, Harold had fallen 65 feet into a crevasse on the glacier, completely ripping off a fingernail and spraining his wrist. They described the experience as though it were an amusing incident. "We were a bit delayed as my wrist wasn't quite up to wielding an ice ax." Although we had known these young Englishmen only a few hours, we were sorry to leave them. They were ready to rejoin other comrades up on the glacier and began to pack their gear. At this latitude, as we had found with Fred Bruemmer, even brief human encounters were more profound than I would have expected. I had also forgotten how refreshing it was to speak English when sharing a new experience.

After four hours in Magdalene Bay, the weather began to change. Apparently, it had been in the 70s for a week, with bright clear days and 24 hours of

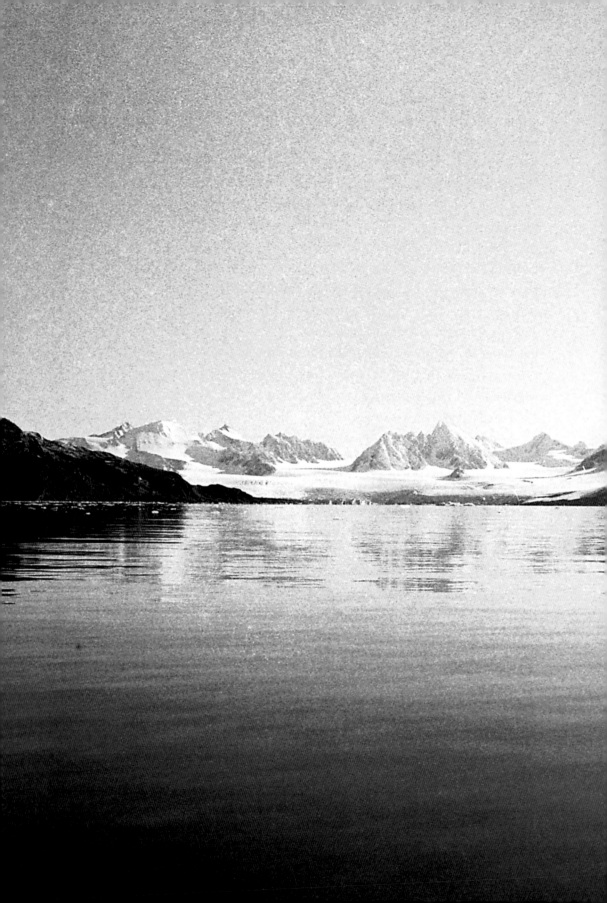

light. Now, the wind shifted, the sun disappeared, and the temperature plunged. It began to drizzle and snow flurries blew in. Magdalene Bay quickly lost its charm. The Englishmen broke camp and slowly began their lonely climb in a gray gloom to their high camp on the glacier. These gritty climbers were tough and cheerful and they made me realize how glad I was to be on the warm dry *Titanic*. When I got a letter from Harold in November, I admired them even more.

...Our trip was quite satisfactory on the whole. The only outstanding incident being the night we left you. The weather, as you may remember, being quite atrocious. The first part of the journey inland took us across the boulders, this being merely strenuous. The next part took us up Franklin Glacier, which due to the action of the rain was completely devoid of its covering of snow, forcing us to cut steps in the bare ice on the slightest of slopes. On attaining the top of the glacier we then began what can only be described as a nightmare march across a snow field in poor visibility, high winds, rain, etc. On arrival at no. 2 camp, we were well and truly "buggered" due to rain, falling in melt streams and minor crevasses as well as sliding about in various undignified postures on ice. We found that a tent erected for our benefit had blown down and my spare clothing was wet. One of the others then got out of his sleeping bag, put up a tent up and made a brew of pemmican and within an hour life was worth living again...

All the best, Harold Manison

About 13 miles from Magdalene Bay were a group of islands that formed the northwest shoulder of West Spitsbergen; Danes Island (Danskøya) and Amsterdam Island (Amsterdamøya) were clumped together in Smeerenburg Fjord.

Deteriorating weather gave us a good reason to put in at Danes Island. I had read about this place during my trip from Kings Bay in November; it was rich in extraordinary events both small and large. A favorite story I read was about a British expedition that moored off Danes Island in 1773. A fourteen-year-old midshipman from HMS *Carcass* slipped ashore in the fog to go polar bear hunting. He found a bear, or the bear found him, and the confrontation grew deadly. When the midshipman aimed his musket, his weapon misfired. The bear was about to make a meal of the young sailor, but the fog lifted just in time for the ship's Captain to come to the rescue by firing a cannon that frightened off the bear: the young man, Horatio Nelson, lived to become England's greatest naval hero.

Danish whalers in 1631 had named the island Dansköya. We put in at one of its natural landing places, Virgo Harbor (Virgohamma). This time we were tourist-free, but there were artifacts enough here to supply 10,000 of them. In this small amphitheater of crumbling rocks were strewn about the remains of several of the most imaginative and foolhardy expeditions to reach the unconquered Pole ever attempted. This was the launching pad for two men who made extraordinary attempts to reach the North Pole by air around the end of the 19th century — a Swede, Salomon August Andrée, and an American, Walter Wellman.

Andrée had been experimenting with hydrogen balloons in his native Sweden. In 1896 he brought his French-made balloon, *Eagle*, and a construction crew to set up camp on Danes Island. He had support from the King of Sweden and Alfred Nobel, and built an elaborate prefabricated wooden structure for hydrogen-generating equipment on the beach at Virgo Harbor, a place named after his supply ship. Unfortunately, after *Eagle* was inflated, Andrée was unable to make more than a short abortive journey because of the unfavorable direction of the wind.

He was determined, however, and returned with a second expedition in the summer of 1897. Sven, Johan, and I were standing at his base camp, the place from which he and two companions departed on 14 July 1897. Airborne again, *Eagle* headed for the North Pole from Virgo Bay. Sixty-five and a half hours later and two hundred miles north of Danes Island, the airship sunk to the ice pack, having accumulated too great a weight of frozen mist on a leaky fabric gasbag. The three men found themselves stranded on the pack ice 400 miles short of the North Pole. The crew began a hideous slog to White Island (Kvitøya), the most northeastern of the islands of the Svalbard archipelago, dragging a sledge, a wood and canvas boat, rifles, and what supplies they could.

In 1930 two Norwegian walrus hunters found three human skeletons and the *Eagle*'s detailed logs and undeveloped photographic film. The men had died mysteriously and suddenly, too quickly to record what happened to them.

Danes Island was also the launching site of a remarkable and controversial American journalist, Walter Wellman from Chicago, who organized two failed attempts by sled to the Pole beginning in 1894. In 1906 Wellman again attempted to reach the Pole, this time with a hydrogen-inflated airship. He made three ill-fated attempts by air that began a short distance from Andrée's camp.

In fact, it was impossible for us to tell exactly what remains belonged to which expedition: there were huge machines to manufacture hydrogen to lift Andrée's balloon and the three Wellman dirigibles, and piles of long snaky curlicue strips of rusty iron that were part of the ingredients for making hydrogen. The Wellman expedition had imported 75 tons of scrap metal to be dissolved in 125 tons of sulfuric acid to fuel the hydrogen-making machines.

For me, to be standing where the visionary lunatics had stood was something I wanted to discuss with Sven and Johan. Were we junior visionary lunatics? Was I Wellman junior?

Wellman was seen by many as a promoter, more serious about creating sensational, circulation-boosting stories for the *Chicago Record-Herald* than satisfying science. History has characterized him as an overblown opportunist, even a buffoon, while the Swede Andrée is seen as a scientific Polar Saint: but they both failed. None of these matters seemed to interest either Sven or Johan.

Was my polar bear quest more Wellman or Andrée, or both? This question began as a whisper but grew louder. Reading about this history on my way back to Norway last November had set the scene and introduced the actors, but now, standing where they stood, they became alive.

I recorded the following in my diary:

The power of this experience and its effect on my imagination comes from the sheer size of the Arctic stage. Here the background measures me. Nothing is reassuring; everything is physically bigger than any reality I have ever experienced. Even war, which is deep and deadly, was played on a tiny stage, limited to what I could imagine or see from a foxhole. Death came from tangible things — bullets, shrapnel, fire; things that humans shape to kill humans. Here, death can come from massively powerful invisible forces — cold, wind, water — that are always present.

War provides this too, of course, when bad weather kicks in to deliver more misery. When it's wet and cold, when it rains for a few days — not dramatically but in a gray endless way — I never fail to say to myself, "you poor shivering bastards out there, whoever you are, my deep regrets." It's the strongest memory I have from Korea, one that I can't get rid of. It's my 'blue period', dear Monsieur Picasso. A dreary winter day or a summer downpour and it's all back.

Yet here I am, 600 miles from the North Pole, in unpredictable weather. It's cold and wet and it doesn't take me back to that same place. I'm not sure why.

Maybe it has to do with the scale of the Arctic theater. Korea was so closed, and this is so open, and I'm in the middle of the stage and it's my own choice.

Half a mile away from Danes Island was another landmark, Amsterdamöya, which had been settled by the Dutch. In 1607, Henry Hudson, an Englishman employed by the Dutch, landed in Svalbard on one of his attempts to get to the Spice Islands of the Far East, via a polar route in the summer. Instead of China, he found thousands of whales.

It wasn't long before Dutch whalers came to hunt huge double-spouted Greenland Right whales that grew to sixty feet. The fjords were literally churning with whales; so numerous that it was unnecessary to hunt them at sea. They were killed, dragged ashore and cut to pieces; the blubber was as thick as 16 inches, peeled off with huge knives attached to long poles.

The whalers began to squabble over the best harbors and hunting areas and soon fighting broke out. The Danes sent warships to protect natural resources that they had claimed since Viking times. The English and French sent whaling fleets and warships to northern Spitsbergen, and the area became one of Europe's least known power struggles.

We had found Danes Island thick with the remnants of modern history, and when we reached Amsterdam Island we found that much remained of the 17th century town of Smeerenburg — Blubber Town in Dutch. The Dutch first wintered here in 1633, and as the whaling industry grew, the town came to have a population of 2000, with a church, shops, and a fort. During its hundred-year existence some 15,000 ships visited the settlement.

The remains of oil cookeries built of brick, used in the 17th century for melting down the whale blubber, were still standing as high as a man and fifteen feet across. Whale oil lit the lamps of Europe and the Americas. The other main product from these whales, baleen — the bristle-like hair-filtering material inside their mouths — was used for corset ribs and hoops for petticoats, and was so valuable that baleen from a single whale might pay for an entire expedition. At the end of the 17th century, the slaughter was over. The Dutch had killed 60,000 whales and the species became so depleted that whaling in the area ceased and Smeerenburg became a ghost town.

From Smeerenburg we began to move east across the top of West Spitsbergen. We made good progress, and days and nights of continuous daylight light

were measured only in our two-hour watches. The clock lost its meaning as we inched across the map at the top of the world; Norskøyane, Flathuken, Raud-fjord, names of places without people and with no references for me, just points to check on the map. The two-hour watches, spent running the boat, merged into long bouts of concentrated reflections on what I had read about and seen in Danskøya and Smeerenburg. The constant pounding of the engine below my feet, a nautical heartbeat, hammered me with questions, again re-corded in my diary:

How could Andrée, the careful, meticulous Swedish scientist, make so many mistakes? He built but never tested. His careful academic training turned deadly as he allowed himself to be sucked blindly into being "first to the Pole" or first to show the spectacular possibilities of balloon flight. But was there something else?

Frankly, parts of my plan are equally absurd. Have I built my own hydrogen machine to float my ambitions north? As we chug along the Hinlopen Straits, with the weather beginning to worsen, I start thinking about the wet suit and scuba that is stowed aboard Titanic. The idea is to find some of the seventeen ships that I know were sunk in the whaling wars. Fervent letters back to my agent and the National Geographic are filled with details about these vessels.

Perhaps our keel is actually passing over them now. Should I peek over the side of the Titanic, to spot a wreck that has been waiting for me preserved in the freezing clear water for 300 years? Should I pop into the clear water to take un-derwater pictures? In the Arctic, it's easy to become excited by the juxtaposition of extremes, beauty and gloom, a world that flips you actively from delicate to crude, from grim to uplifting. It's not possible to be just an observer here, like it or not, you are a participant. Does this explain my urges to go beyond reason-able boundaries? The norm here switches me from enchantments to despair and back to enchantments. Maybe the human response to surviving these unknowns becomes a narcotic that eases one into the feeling that extremes — unknown boundaries — are the norm. Is there any art in this?

Or is the tiny Titanic propelling us into peril because of my own arrogance and ignorance? Am I a mini-Andrée-Wellman obsessed with a huge idea, chal-lenging something for the sheer hell of it? My excuse is linked to my freedom ma-chine; I am going to record it with my Leica.

Then there's that other traveler, the fourth companion on this trip, our unpredict-
able Lady Luck. In these parts she can be loving one minute and kick your ass the
next. Maybe I am becoming a gambler, hooked on the excitement of finding ways
to stiff arm the worst while grabbing the good stuff quickly. This trip is an irre-
sponsible, ill-planned, underfinanced gamble. When does exuberance overcome
common sense and become recklessness? I'm too excited to be scared, but there's
something happening. The water is opaque and beginning to foam with agitation.
The straits are getting rougher. There are clear moments, then thick curtains of
mist and fog roll in, and it all goes gray. The same thing is happening in my head.

Everything is possible because of what I learned from my visit to Picasso. I
was clever, used my imagination, and talked myself into achieving what I want-
ed; I had the gall to do it. I had discovered Egoland and felt welcome.

Then the weather got worse, bringing down the curtain on my reflections
and my Wellmanesque comic opera. My fantasies were no longer compatible
with what was going on in the world around me, outside my head.

The sea was blowing up; the wind was from the northwest, a cold unpleas-
ant blast coming across the great ice pack somewhere over the horizon. I kept
checking the sea map for a harbor, and then I noticed a legend printed on the
map in English, "*NOTICE: The soundings east of Amsterdamöya are mostly very*
uncertain. Great care should be exercised in these waters."

Heavy waves were rolling in on us from aft on the port side/aft quarter.
This was our first test in rough weather; *Titanic* seemed seaworthy but we had
to travel parallel to the coast; the waves were coming at us abeam, and I was
having difficulty keeping course. Every fourth wave was a big one and I had to
spin the wheel to put the stern into the wave. This worked if I was quick enough
with the wheel. But it was bringing us closer to the rocky coast. Searching the
map for a harbor, I was suddenly pitched onto the floor of the wheelhouse. It
seemed that Titanic would go over. I heard a crash on the stern, then another
down in the engine room, and then the diesel began racing like mad. We right-
ed and I banged on the sliding compartment yelling for Johan:

"The propeller's gone."

No propeller; the engine would rev too high and burn up. I kicked the valve
for the fuel line to stop it. The engine coughed and quit and immediately I real-
ized that I had done something very stupid.

Another wave caught us and we were pitching over again, now completely at the mercy of the sea. We bobbed and pitched and another wave caught us from the side. The little dinghy, tied over the fuel drums on the stern, went halfway under water, but we righted again, water pouring off the deck back into the sea.

Johan dove into the engine compartment. He stuck in a "starting cigarette," a small ignitable container of gunpowder, and gave it a crank; the engine was hot and coughed, slowly coming to life. He jammed the gear into forward and hopped up, taking the wheel. *Titanic* moved forward again, under control.

"You kicked the gear lever into neutral when you slipped. The propeller's OK."

I was the perfect idiot.

My relief came soon and I turned in gladly.

Four hours later, back on watch, the weather hadn't improved. There was a funny smell in the wheelhouse and the white mist blowing over the bow was steam, not salt spray. The engine was running smoothly, but was getting very hot. Johan couldn't find the trouble. He discovered oil running freely out of the engine from a valve knocked open from a falling Jerry can. This was remedied, but at any moment I expected the engine to quit, and we were miles from the nearest harbor. The water pump seemed to be the problem. The oil was checked every few minutes and the engine pounded on.

After two agonizing hours we dropped anchor at the opening of Woodsfjord at Welcome Point (Velkomstpynten). We were probably not the first crew to understand the appropriateness of this name.

With *Titanic*'s limited set of tools we were unable to remove the water pump to repair it. And with no radio, there was only one way to get help; find an expedition in the area. We went up on the beach to build a signal fire that might attract some help. Spitsbergen, where nothing grows more than three inches tall, is treeless but rich in driftwood. Beaches are often found covered with thick pine logs, some three feet in diameter with Cyrillic letters cut into their ends. This is Siberian timber, presents from the Soviet Union that have gotten loose from loggers in the rivers and forests of Arctic Russia; the ones we avoided on the way to Magdalena Bay. We built three signal fires and heaped moss on them to make smoke.

We were on top of the world, 10° from the North Pole, not the best place to break down alone. But in Oslo I had obtained a current list of Spitsbergen expeditions from the Norwegian Polar Institute and I had marked them on our map. Luckily, our map indicated that there was a combined expedition of the Tromsø Museum and the Norwegian Polar Institute nearby.

After four hours of waiting to see if anyone spotted our smoky fires, Johan and Sven set out to find the expedition's camp. I stayed behind to keep the fires stoked, but crapped out at midnight after piling wood and moss on the fires for the last time. At noon, Johan and Sven pulled up beside our beach in a large motor launch, having found the expedition on Reinsdyrflya after an eight-hour hike. Our rescuers towed *Titanic* to the expedition camp for urgent repairs to the water pump. At the camp we also asked for advice about places to find polar bears. We met a man called Hollenbeck, from the Norwegian Polar Institute, and Sven and Johan began to describe our hopes and plans in Norwegian. I only caught bits of the conversation.

According to Hollenbeck, ice conditions were very unusual this summer. Abnormally warm weather made many parts of Spitsbergen practically ice-free for the first time in fifteen years. This made a marvelous opportunity to reach places normally ice-locked for the entire year, but bad news for us because polar bears normally moved on ice floes, feeding on seals. Hollenbeck told us there might be bears in the Hinlopen Straits, but they would be less numerous than in normal years.

At 9:00 p.m. Hollenbeck checked his watch, and said it was time for a broadcast between ships; news about the weather, gossip, and various locations of people in the area. (With no two-way radio, *Titanic* was at the lowest end of 20th century technology.)

The sputtering transmission revealed that a group of ornithologists on King Karl's Land were having difficulties with bears; they couldn't even get out to their slit trench without an armed escort. Curious and hungry polar bears had their hut blockaded.

King Karl's Land is the only area in the Svalbard group where polar bears cannot be hunted, and they were plentiful. We had once considered going there, but this information vaulted the islands to the top of our list. "What about King Karl's Land?" asked Johan?

"You boys are crazy if you try to make it to King Karl's Land in that boat," Hollenbeck was emphatic. All heads turned toward *Titanic*, a hundred feet from shore, dead in the water, with a conked out engine. "I don't know how your mechanic feels about the boat but I think it's too risky."

Mechanic? Good God, he thinks one of us is a mechanic. My Swedish photographer companion glanced at me but I didn't say a word. Of course, our "mechanic" had to be Johan. He was, after all, from Tromsø, gateway to the Arctic, and although not a seaman by profession, he came from a Norwegian sailor city, and Sven and I assumed that he must have accumulated more nautical know-how than he realized. Compared to us, he was Fridtjof Nansen and Christopher Columbus rolled into one. To prove the point, Johan and the mechanic from the Tromsø Museum Expedition started working on *Titanic*'s engine and within an hour they had it running.

Hollenbeck's views were discouraging but accurate. Our boat was too small and poorly equipped to make a trip to King Karl's Land — twelve hours over open sea. Then there was *Titanic*'s engine. Every time the engine was cranked up, a "starting cigarette" ignited the diesel fuel with a controlled explosion of gunpowder. There was no handy rechargeable battery to do the job. But we had a finite number of starting cigarettes stored in a tin, and there was no place to get more. Despite this, we were too inexperienced to think that engine trouble might become a problem and instead worried about the weather improving. Fresh mugs of coffee cheered us up and erased the memory of our sizzling diesel.

Our generous hosts permitted us to stick around and we kept hoping that something more positive about the location of polar bears might turn up; King Karl's Land was clearly too far to reach in little *Titanic*. The ornithologists' ship *Brandal* was anchored nearby preparing to go to King Karl's Land to pick them up, but the Captain had no enthusiasm for towing *Titanic* over to the islands. Besides, if we got there, how did we get back? Our visit out to *Brandal* wasn't a complete flop, as the cook gave us a fresh Arctic char. It was the lure of the char that had resulted in drowning our cameras on Byørnøya. I still hoped to taste one, and we took it aboard *Titanic*.

Back ashore, Hollenbeck tried to cheer us up and pointed to a beautiful white gull that was walking around outside the tent door about six feet away.

"That's an ivory gull, very rare. Notice that his eyes, beak, and feet are black. It's a nice bird, doesn't make a lot of noise like most gulls." He told us

that ivory gulls, which live only at latitudes above 70° North, feed off the scraps of polar bear seal kills, and are often found hanging around scientific expeditions and tourist ships hoping for handouts. This ivory gull had been around for a week and was quite tame, so none of us worried about missing a chance to photograph it.

Conferring quietly, Johan, Sven, and I decided to try for King Karl's Land, and went ahead with preparations. "I'm not happy about your decision as this is a very risky trip," Hollenbeck said, but he generously donated some extra fuel.

We loaded fresh water and fuel, and just before shoving off, Sven remembered that the rare ivory gull still wasn't on film. We made a special trip ashore, lugging tripods and cine equipment only to find that the gull was gone. I felt very wise, having got my picture, and smugly told them what they already knew: "You don't get a second chance, etc., etc." But, we did get a second chance: as we approached *Titanic*, there was the ivory gull, sitting on the wheelhouse, having a fine meal. If I had had the shotgun instead of my Leica, I would have made this rare bird extinct, for he was enjoying the last remnants of our next dinner, the much-prized Arctic char.

On August 6th we were again on our own. We left Reinsdyrflya grateful to Hollenbeck, but knew that we could expect no more help from expeditions where we were going. We were on our own.

The weather was once more sunny and calm. It was pleasant sailing as we moved southeast down the Hinlopen Straits. This tricky channel separates West Spitsbergen and North East Land (Nordaustlandet). More than sixty miles long, it varies in width between eight and forty miles. Huge glaciers dump a constant supply of giant icebergs into the water along almost the entire length of the strait. The temperature, the amount of precipitation, and the shape of the land determine the form of the glaciers. These enormous ice masses ran back, interlocking with many others, hundreds of miles inland. They grow from the accumulation of snow on their tops, even while melting and breaking up from underneath. On North East Land the ice was in some places 1800 feet thick. Where the glaciers met the sea, some jagged ice walls stood 300 feet above the water and as the sun was now shining for twenty-four hours, the ice warmed, expanded, and then boomed like cannons as tons of ice caved into the sea; they were receding.

We passed thousands of icebergs; some of them were huge, spectacular, beautiful crystal castles, others were grimy little cakes of surface ice and snow,

soon to melt. There was ice in all forms, elaborately sculpted, scalloped patterns, ice swans, chocolate swirl icebergs, streaked with layers of black dirt; boxcars, intricate, variable creations washed by the movement of sea and wind.

Titanic moved through the clear water, passing thousands of organisms swimming by, jellyfish more than a foot wide, worms two inches long with transparent bodies and red heads, swarms of dark beetle-like creatures propelling themselves through the water with little black wings.

When the permanent ice, which didn't support life, breaks up in the spring, a transformation occurs that provides vast quantities of zooplankton to fuel the summer influx of birds and whales. In late summer, vast swarms of sea snails travel the currents of the North Atlantic. Hordes of them, scooting along, propelled by two fins and tiny toeless feet. When they reach the high latitude of Svalbard, they graze on the phytoplankton and the surface of the water can become discolored by the density of these organisms. There were also sea snails that once fed and attracted Greenland and Bowhead whales to these waters, the vital food that had sieved through their baleen plates.

Humans could not survive fifteen minutes in this water, which was a fraction below freezing. The more simple-celled sea creatures, however, thrived in the frigid salt water, nurturing a dynamic inter-dependent chain of feeding. Each species was both hunter and hunted, each experiencing life briefly, propagating and passing on to the next stage.

It was such a privilege to be able, at 10° from the top of the earth, to see and feel so much of this complicated drama. The stage is spare, vast, and nothing seems hidden. The hard nature regulates itself; the influence of the surface ice scours everything at the tide-line, apart from the driftwood; the beach has been scraped clean by these forces. The clarity of the water passing under *Titanic* gave me a glimpse of so many unfamiliar life forms and their dynamic interaction — something impossible to imagine in crowded human settings to the south.

Great jungles of algae growing on the shallow bottoms of harbors that we had visited fed animals in the water that nourished fish, and they in turn fed the seals that the polar bears hunted.

After the return of midnight sunlight in April, Spitsbergen becomes home to one of the largest seabird populations on earth. Millions of birds visit Spitsber-

gen, 140 species, and only a few are vegetarian. They feed in the sea, finding a summer soup of nourishing food.

Flights of auks and puffins came our way. The birds would detour, circle us once to have a look, and then they were off again. The Eider ducks were teaching their young to swim near the shore. We watched the females convoying a long string of ducklings. As we approached, the black and white drakes took off, but the mother hens stuck with their young, the little ducks paddling like mad to get away from *Titanic*. Then panic subsided and school was back in session. Diving lessons commenced, as an Eider hen dove, then one after another little bottom turned up and down they went. Soon the water was clear of ducks, and then in a minute they began popping up like corks until there was once more a flock of thirty ducks paddling about.

These diving ducks stay near the coast. The females are brown with markings that provide good camouflage in the tundra. Their nests are lined from fine down that the mothers pluck from their own breasts. There was illegal traffic in gathering the Eider down. Soon after hatching, the ducks gather in large protective nurseries, where they are trained for the long flight south in a few months.

All day the fog had followed us down Hinlopen. Over the bow it was clear and beautiful, but as we rounded the southern coast of North East Land we met fog coming toward us. Caught in a trap, we anchored by a sandy beach, a quarter of a mile long, protected by moraines — great piles of sand and gravel rising over 600 feet on one side and with a glacier on the other. The moraines marked the forward advance of the glacier.

We dropped anchor at 1:15 a.m. just as the fog caught up with us. Arctic fog is unpredictable, lasting weeks or hours, so there was nothing to do but wait. Sven and I went ashore to look around and found a fresh set of bear tracks as we stepped out of our dinghy. I had absentmindedly departed without the rifle. We had never seen bear tracks before, but these were unmistakable; great prints a foot wide, sunk deep into the sand and new. We returned to the boat for the rifle and from then on it would be packed along with our photographic equipment.

The tracks led up the gravel moraine. Another set of tracks led down to the beach not far from the one we had been following. The bear had been there earlier in the day but was probably several miles from us by now. There were also reindeer tracks in the same area and I found a beautiful pair of antlers,

bleached white, sticking out of a glacial stream, frozen solid into the rocks. I couldn't pull them free. Nowhere in Spitsbergen did the earth thaw more than a few feet. Here, to my amazement, I also saw thousands of seashells, the kind I would expect to find in the Caribbean. We saved some and they were later identified as remnants of a different age when palm trees grew here, and the ancestors of alligators lived on Spitsbergen — 55 million years ago.

Sixteen hours later the weather cleared and we upped anchor at 5:15 p.m. and continued down the southern coast of North East Land. We planned to move east along the great Bräsvell Glacier (Bräsvellbreen). Here we would strike a course 75° Southeast toward King Karl's Land, depending on good weather. The visibility was once more crystal clear. We were in high spirits.

The first watch was enlivened by an unusually large number of seals. We had long since run out of fresh meat so Johan decided to shoot one. To shoot a bobbing seal head from the moving deck of *Titanic* was difficult. A number of rounds of ammunition were expended, but the seal population remained the same.

There are two kinds of seals to be seen, the ringed seal and the less common bearded seal. The latter sport luxuriant moustaches that are used to feel around the sea bed in search of shrimp and crabs. These seals are loners and we would occasionally spot one sitting on a small iceberg, floating by, catching the sun. But the ringed seals are sociable animals, surfacing and diving for fish and popping up again to look at us.

Ringed seals are the favorite food of polar bears, but they have to be caught on the ice because these sleek torpedo-shaped animals can outswim their predators with ease. On land or ice they are vulnerable and awkward, so they never stay very far from water. I had heard in Tromsø that the polar bears would lie and wait in the heavy ice for a ringed seal to pop his head out of a breathing hole. The bear would hold his paw over his black nose for better camouflage and when the seal appeared he would swat the prey out of the water with a powerful stroke of his paw.

Around 8 p.m. we were approaching the jumping-off spot for King Karl's Land, but Johan heard a strange skipping sound in the engine. We decided that the safest thing was to return to a nearby island to check the engine. Two hours later we were anchored off a desolate rocky beach at Franzøya. Johan

began energetically unbolting the engine with Sven assisting. Four hours later they were still at it. The engine was by now in several pieces and Johan announced that the trouble was in the fuel injectors, which had been fouled. The jets were removed, taken apart, cleaned and replaced. This engine had previously made a sound, peculiar to Johan's ears, but now it made no sound at all. The unit was removed, studied, adjusted, replaced and cursed, no less than six times. After each effort, the engine was cranked to no avail. This was the state of affairs around 3 a.m.

To start *Titanic*'s engine, the flywheel was turned over with a hand crank. This action pushes the piston up, engaging a camshaft that actuates the fuel pump and squirts diesel oil that is compressed by the upward moving piston to a precise moment of maximum pressure. Then, a starting cigarette explodes the fuel, forcing the piston down, and the engine begins turning over on its own.

At 5 p.m. the next afternoon, all three of us were still sweating over the engine, painfully reassembling the fuel pump by trial and error. Diesels can be difficult to start for many reasons. One problem is that diesel oil has a tendency to build up ice crystals in the fuel filters, choking off the starting process in cold weather.

The God-forsaken island of Franzøya was an unfriendly place, with cold gray rocks and smashed pieces of driftwood. It wasn't hard to imagine what it would be like in a storm. We were 79° and 50' North with no nearby expedition to save us. This was growing into a full-scale nightmare. At 9 p.m. we took a break to try to get the fisherman's shortwave band on our portable radio. We heard nothing. Perhaps there were no ships in the area or our aerial wasn't long enough. Ironically, we easily got Stockholm on longwave — the loud, clear voice of Radio Sweden telling us about terrible weather in southern Scandinavia, record rainfall, then bouncy Swedish country music that didn't take us away from our troubles. Too soon the futile cranking of the engine started again and reality was back.

Normally the engine would start on one cigarette, but after all these unsuccessful attempts, we had used 25 cigarettes and there was a real danger of exhausting our supply. Every false start took us one cigarette closer to disaster. We slept briefly but not well during this hell. Then the work began again, mainly falling on Johan. He knew far more about old marine diesel engines than

Sven or I, but it was also hard to do nothing, listening to the engine catching and dying. I tried not to count as the starting cigarettes dwindled, but subconsciously I kept score.

Then, a cigarette caught and the engine reluctantly came to life, banging uncertainly, finally pounding away with sweet noisy determination. Sven and I hollered and cheered, pounding Johan. The warm friendly noise of our engine rose above the cold washing sound of the waves and wind. The horrible spell was broken. It was 11:25 p.m. We had been out of commission for 25 hours and it seemed like two weeks. We were exhausted, particularly Johan, who had done most of the work, so we turned in.

At 1:30 a.m. on August 12th we struck south for the great mountain island of Wilhelmøya, which rose 700 feet out of the sea. I was on duty at the time and found a beautiful little harbor just off a swift narrow channel that lay between the two islands that make up Langøya; it was nonexistent on the chart. The water was shallow but we were protected on all sides from the weather. The spot was just about perfect, so after anchoring at 5:45 a.m., all hands turned in. We were still tired from our experience at Franzøya and looking forward to sleep. Nothing could happen to us here. Johan and Sven were contentedly snoring before I had finished blowing up my air mattress; it was my turn to sleep on the air mattress between the bunks.

I woke up at 3:00 p.m. with a most peculiar feeling. No wonder, my air mattress was trying to float along with pots and pans and camera equipment.

"We're sinking!" I yelled.

In a second everybody was up. Sven and I piled cameras on the bunks. Johan disappeared into the engine compartment, and successfully got the diesel going. The fly wheel was half under water, and soon was throwing out a spray of salt water. By the time I got to the engine, Johan was getting an unpleasant shower bath as he tried to hook up the belt that operated the bailing pump. The pump didn't work very well; it had to be greased and primed before it would function, which Johan did, while simultaneously getting soaked to the skin with freezing oily bilge water. I passed buckets to Sven who dumped the water over the side. Finally the pump took hold and gradually the red water line on the hull became visible again as *Titanic* rose from the sea. Thousands of gallons of sea had leaked into the boat. After hours of pumping, she was dry.

A seacock had somehow opened. The device was like a stopper in a sink, useful in draining water out of the ship when in dry dock, but having the opposite effect when she was afloat.

The cabin was a mess, but none of the photographic equipment was damaged. Fortunately, everything stored on the floor was in steel ammunition boxes or heavy plastic bags. *Titanic* was providing us with at least one disaster a day. We decided it was time to take some precautions, so Johan and I went ashore with our ax to take out an insurance policy. We found a piece of driftwood about twelve feet long and Johan started working on it with a woodsman's skill. In an hour he had created a crude but workable mast. On the stern of *Titanic* we had a large piece of canvas that wrapped my diving equipment; this could be fashioned into a sail should we have further engine trouble.

To check our sea chart, Johan and I climbed to the highest point on Langøya, a little rocky hill several hundred feet up, and plotted a new course to King Karl's Land. Estimating distances with my trusty Silva pocket compass, we lined up Wilhelmøya and several other recognizable landmarks, and marked a course to Svenskøya, the first and most westerly of the King Karl's Land group. Not exactly scientific precision, but good enough we thought.

Returning to the ship, we found that Sven had tied my bamboo fish harpoon to the wheelhouse and nailed two boards together at the stern to fashion a

radio mast. I cut insulation from a spool of electrical wire and strung it between the masts. Because unstable ionospheric transmission prevails in the Polar region even shortwave signals were unpredictable, and we wanted to receive essential weather reporting from Radio Svalbard. With our jury-rigged antenna, our radio reception miraculously improved. We now also received news reports in English from the People's Republic of China.

Our insurance package was lashed to the deck just in case, and we were ready to leave. The anchor went up at midnight — or however one describes when the sun is still in the sky. The weather was calm and the light was bright, but I couldn't help wondering what the next disaster would be. We didn't have long to wait.

At 1:12 a.m. steam began to pour out of the exhaust port in the side of the boat. There was no place to anchor, so we continued for another forty-five minutes to avoid the worst places to land before we stopped the engine.

Johan was sure that he could fix it and I went forward to give him a hand. Sven manned the coffee pot, occasionally sticking his head out to keep an eye on the ice: we were drifting in convoy with a flotilla of icebergs, moving quite rapidly southeast with the current from the Hinlopen Straits.

The engine room was cold and the movement of the boat, dead in the water, made us both a little seasick. It was a nasty place to work, but the job wasn't too difficult. It was the same trouble that had crippled us at Welcome Point, the water pump, but the nuts and bolts had been loosened so we were able to easily remove it. The malfunction was the same as before. The main gear that drove the water pump had sheared the keyway, a little piece of metal that locked the cam in place. This made the pump slip instead of pushing air. Johan found a good use for the lead fishing weight that had produced no Arctic char in Byørnøya: the soft metal was cut and pounded into the right shape to create an emergency keyway. The pump was fixed in three hours and we were off again.

Watching the little jet of sea water squirting out of the side of *Titanic* was transformative. We had once more beaten the odds, but we also knew that the journey ahead, out into the Barents Sea to King Karl's Land, was a big gamble.

19 – KING KARL'S LAND

The next leg, crossing to King Karl's Land, was a scary 60 miles. There were so many uncertainties: our inaccurate chart, navigation by a pocket compass, and a boat propelled by an ailing diesel engine. We planned to proceed South East 75°, keeping the Bråsvellbreen (Brasvell Glacier) in sight on the port side. We estimated we would be able to see the 555-meter (1665 feet) mountain of Wilhelmøya for six hours. We hoped, providing the weather lasted, to spot the peaks of Svenskøya, the first of the King Karl's Land group, in a few hours after losing sight of North East Land's ice mountains. It was a gamble, but we would never have a chance to get so close again.

As *Titanic* moved eastward, the wind came from the northwest. It was cold, and as the hours passed, low clouds gathered and on my watch the sea began to chop. There were lots of sea birds, giant albatross feeding around us on the winged snails. There were hundreds of icebergs to avoid. Some of them provided perches for tired birds, and occasionally, seals. The horizon picked up the golden reflection of the sun and many times I was fooled into hoping that this was a first glimpse of Svenskøya. Gradually, all these pleasant distractions disappeared and there was nothing but the wildly oscillating needle of the boat's compass to entertain me.

We had been sidetracked before by the erratic behavior of the compass and had worked out a correction that we thought would solve the problem, not realizing the extent of magnetic deviation at this latitude. Magnetic north was more west than north from our position, and our compass was nervous about the whole thing. Sometimes our navigation could be checked by direct sight-

ings of recognizable land masses and then compared with the map. Readings were more accurate with my little Silva pocket compass, but this only did its job away from the boat and its 6000 lbs. of iron ballast, which influenced the behavior of both of our compasses, neither of which had the ability to correct for magnetic deviation. Also, in place of proper charting tools, we used a matchstick to mark off distances on the sea chart, not exactly the path to accuracy.

As the waves grew bigger, it became increasingly difficult to keep on course. I was relieved by Sven, and returned to a none-too-comfortable cabin. *Titanic*, bless her, had been rolling, but now she was doing a tango, rising up with one wave and swooping down into the trough of the next.

Some of the heavy equipment lashed to the deck was coming loose and needed to be lashed down again. In the cabin, utensils, pots and pans, dishes, bottles, and assorted crockery had cut loose, and in the midst of all this, my stomach joined the revolution.

Things didn't improve. Johan took the wheel in a light fog trying to keep the stern of *Titanic* into the weather. The birds and the icebergs had disappeared. The wind shifted and we made little headway. We should have sighted one of the islands by now, but only clouds appeared on the horizon. Finally at 1:00 p.m., I was at the helm, we sighted a dark gray mass on the horizon, just a little different from the surrounding clouds. An hour passed and the form of a mountain definitely took shape. It was Svenskøya, westernmost of the King Karl's Land group, sighted after nineteen hours at sea. But we still weren't there. The wind had again changed; the weather was hitting us from the starboard side. This required the usual maneuver, getting the stern into the big ones. Just as Sven came to relieve me, the laminated wooden steering wheel came apart in my hands. Sven seemed surprised to see me trying to steer with the wheel in pieces, but we got it back together with red electrical tape.

The northeast side of Svenskøya was rough, but on the lee south side of the island at 11:00 p.m. we were chugging along on smooth water. At plus or minus 6 knots, with no smoke and a cool engine, *Titanic* was temporarily resplendent in beautiful clear weather.

At 2:00 a.m., Sunday August 14th, we dropped anchor at Cape Walter close to a sand spit covered with Eider ducks. Everybody relaxed. Celebration over-

came fatigue and we enjoyed one of Johan's special dinners: meatballs (canned) made bearable by the addition of salt, dehydrated onion soup, and steak sauce, beer, canned apricots, and coffee. Then the greatest treat — the sleeping bag. Polar bears would have to wait.

At noon, Sven Gillsäter woke us up, offering us breakfast in bunk; hot coffee, and a Jarlsberg cheese sandwich. Sven's cheerful start for the day didn't reflect what was going on outside. Snowflakes whipped past the window. To port, the Eider ducks were battened down on a frigid beach. The starboard side was no more cheerful. Long fingers of spray were picked up and carried across our protective island. We felt safe in our warm cabin and grateful that we weren't plowing through that sea looking for shelter.

The day passed comfortably inside *Titanic*, but outside the icy shafts of wind discouraged anything but the most urgent business. Johan perked up our spirits by preparing a meal even more delicious than the last. Cooked duck, hash brown potatoes (dehydrated), cranberry sauce, and a fine sauce composed of duck grease drippings, some mysterious lumps that were once dehydrated peas, water and flour. There were still a few bottles of Mack's Export Beer from my favorite brewery in Tromsø and we were as well fed as anyone could ask.

About 7:00 p.m. the wind died down and we had a chance to move. It was time to try exploring to the south. Pulling up the anchor, I gave it a pull, looked up, and let it go, ducking below for my camera, yelling as I went:

"There's a polar bear ashore."

There was a moment of mighty confusion on our tiny trawler, as three photographers grabbed for equipment, collided, and scrambled up on deck to set up tripods. The bear didn't pay the slightest attention to us, continuing to chew quietly on the remains of a bird carcass thirty yards away. The bear was probably a yearling cub and very yellow.

The bear stood eating for fifteen minutes while we took pictures; occasionally looking up at us, rolling his head, and sniffing the air. It seemed friendly, and when we yelled he obligingly shifted and posed for more pictures, before giving us an aquatic show, splashing into the sea.

Titanic's engine was already running, so we upped anchor and gave chase. The bear was completely bewildered, swimming in large circles, paddling with his forelegs like a dog, with his rear legs extended as if he were using them to

steer, looking over his shoulder as we followed. We were only twelve feet away, photographing every movement he made; and then the bear swam full speed for a sand island. As he came out of the sea, he shook a shower of water from his soaked fur, creating a dark path of wet sand as he loped up the beach, water streaming off his body. We then left him in peace and went on our way.

Completely comfortable on land or in Arctic seawater, the polar bear is well conditioned to hunt in ice, is a great swimmer, and has been spotted 100 miles out at sea according to my Mack's Øl Hallen advisors. The bear's body is tapered, the head smaller than other bears, and with short powerful legs suitable for swimming. Adult polar bears are padded with five inches of fat, insulation from the freezing sea. A short tail and small ears help reduce heat loss. Under the yellowish summer coat, the polar bear's skin is black: the animal's hair is hollow, and hunters speculate that the hairs act like fiber optic tubes, light-gathering mechanisms that transmit warmth to the black skin; another heating device for this incredibly well adapted animal.

As we passed the southern tip of the island, Cape Hammerfest, the channel leading out from our shelter was disturbed by the wind and it was difficult to gauge its depth by sight. In a moment, an ominous crunching told us that the bottom was a little less than *Titanic*'s five foot draft. We scraped up a great cloud of mud, but managed to come off the barrier with no apparent damage.

An hour later Johan spotted another polar bear, a small white dot in the distance. We steered for shore, anchored and put over the dinghy. After beaching, we crept around a low rock ledge, keeping out of sight of the animal. We climbed higher, moving cautiously toward the bear's last seen position. I stuck my head up and there he was, thirty yards from us. Johan had the rifle, just in case. We ducked, hoping to get still closer; it was difficult to get good pictures from our position. This bear was much bigger than the previous one. We emerged from behind the rocks to find an astonished polar bear below us, standing on his hind legs trying to get a better look. He hissed, and then departed, moving off unhurriedly.

We gave up the chase after the bear disappeared around the point. Returning to see what he had been eating, we found no meat, no mangled bird bones; perhaps he had been eating kelp that lay rotting in the tidal pools. A polar bear skull provided a tooth that I extracted for my dentist as a souvenir.

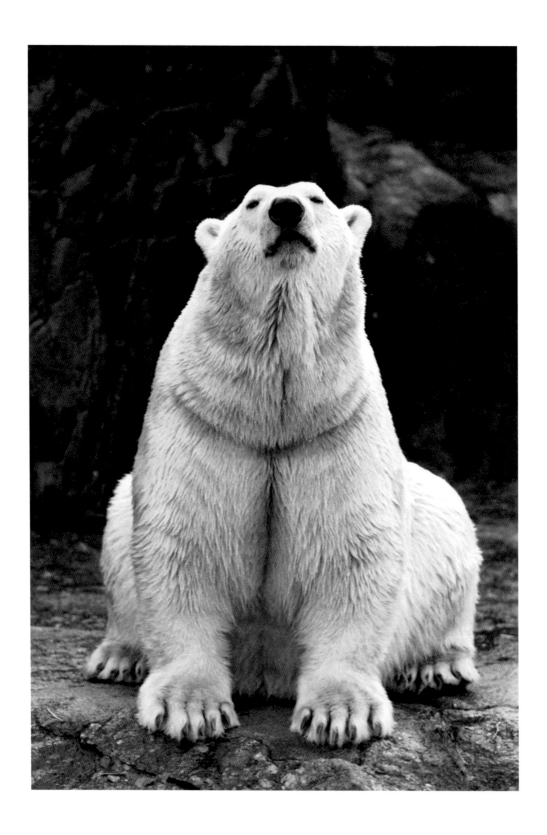

The weather became calmer, and the crossing to Kongsøya, the next island, was still rough but possible. Here again our sea charts gave us surprises. We had planned to pass along the lee side of Kennedyøya Island, but the island was nowhere to be seen, except on our map. Instead, there was a long partially submerged finger of sand that forced us to detour miles out to sea.

Finally we reached Kongsøya, the site of the hut that we had been told about, where the ornithologists had been besieged by polar bears. We thought this might be a good place to consider as headquarters while we explored King Karl's Land, so we brought *Titanic* into a little cove that formed a partial refuge. The sounding line measured nine feet of depth, not a lot of water, but enough. Here we were protected from southern and easterly weather, and we anchored and took the dinghy ashore, hauling it up a little rivulet that cut through the five-foot embankment piled high with rotting algae.

We found the hut at the base of a magnificent snow-streaked mountain. The ornithologists had been rescued, and they left the hut's doors and windows nailed shut. While Johan and Sven opened the place up, I scrounged for firewood. The garbage pit had been partially excavated and there were plenty of tracks around the area, but no bears in sight at the moment.

The inside of the hut was as bleak and inhospitable as the outside. An official plaque indicated that the Norwegian government had built it in 1936, but unlike the well-stocked huts we had found in the Advent Valley, this one was nearly naked. Luckily we weren't stranded seamen, not yet at least, but if we had been we would have found a sack of rotten potatoes, an empty coffee can, empty brandy and beer bottles, and some coal to cheer us. There was no wood, nails, food, or even matches. We got a fire going, however, and hot coffee and sandwiches revived us, after which we slept for four hours on land for the first time in what seemed like many days.

Johan woke us up with the startling news that *Titanic* was pounding on the rocks. During our sleep the wind had blown up and the boat was straining at the anchor chain like a frightened dog. Every time she rode out a wave, down she would go in the trough until she abruptly stopped. Through the binoculars I could almost hear the sickening Wham! as she hit bottom. Abandoning everything, we raced for the boat, having no idea how long this had been going on or how long she could take it.

There wasn't any apparent damage, but we pulled anchor immediately and, thank God, the engine, for once, started on the first cigarette. Our troubles weren't over, however. Groping for a deeper channel with the sounding line was hopeless. It was too rough. Every surge of the waves lifted us then dumped us on the rocky bottom. There was nothing to do but go forward out of the trap; every delay pounded us again and again. An agonizing half-hour passed before we were free of this miserable spot. Johan dropped Sven and me in the dinghy a half mile down the beach and we got ashore without an accident. We returned to the hut, nailed it shut again, packed our gear and were out of there. The weather was getting worse and we could barely see *Titanic* patrolling up and down along the shore through the snow flurries. This would have been a headquarters in Hell — no thanks! We managed, with luck and care, to return to *Titanic* dry.

Again we struck for the south side of Kongsøya, and found a place protected by the side of a narrow peninsula that formed a perfect jetty, high rocks bordered by a beautiful sand beach. It was 4:00 a.m. and Johan and Sven wanted to sleep. Our internal clocks were mixed up and they were anxious to get a.m. and p.m. straightened out, so we anchored and they settled down in the cabin.

The weather was clearing, though, and I couldn't sleep so I loaded cameras and rifle into the dinghy and rowed ashore to look around. The fog lifted, and there, perched on a cliff, with the mountains of Kongsøya rising in the background, was a beautiful bear. The sun caught its white coat, illuminating him against the grim background. Returning to *Titanic* with the news, I woke my companions and we were soon perched on the shore atop a rock that protruded into the sea.

It was crowded there and at one point, Sven and I tripped over one of the tripods. The 400mm lens was caught, but the Arriflex movie camera crashed down. Miraculously, it escaped damage. The bear was accommodating about posing for us, but it was drizzling now and the rocks were cold, making this an uncomfortable place to work. Also, we wanted to lure the bear closer to us and needed some seal meat as bait. Johan took the rifle and moved to the edge of the water, flattening himself on a rock. When a seal popped up fifty yards away Johan fired, and we had some fresh meat and the bait we needed.

We stored the seal in the dinghy, and went along the shore for close-ups. Scrambling over rocks on all fours, we found ourselves an elevated perch. The

bear was twenty-five yards away, and we began to shout to make him do something. He shuffled off with that happy-go-lucky lumbering gait that makes polar bears appear so deceptively good-natured.

The last few days had been filled with lots of things but little sleep, so we went back aboard and slipped into our bags for four hours of solid rest. At noon, we moved *Titanic* down the now quiet coastline to Pikebukta, where we found a nice bay; shallow, but free from much-feared rocks. We took advantage of the calm sea and anchored. Around the bay, we saw a number of shallow streams feeding into the sea there and went ashore for fresh water. Making a reconnaissance and crossing a long boggy stretch of ground, we began to climb a mountain. There were streaks of snow on its flanks, and up on harder ground we found several sets of bear tracks. Some were old and barely readable, but others were fresh, maybe a day old. Climbing higher, we crossed the face of a small glacier that rose to the top of this volcano-like mountain. We had a magnificent view of waterways collected from the melting snow and ice, silvery in the sun, and making graceful loops and curves through a beautiful valley below. But the wind cut cold so we soon moved down to a warmer spot.

Through my binoculars, I spotted three bears, but they were miles away. Then we spotted a fourth bear only a mile or so away, but he stopped, picking up our scent and reversing course. We decided to return to the beach, two miles back. Under different circumstances, I would have stopped along the way to photograph the surprising bunches of purple saxifrage growing in flat clumps, brightening up the stark landscape. There were white Svalbard poppies and other flowers, but this wasn't a time to think about botanical picture-taking. Rushing past the spectacular view, I was in a hurry to get to the beach. The bears had likely smelled dinner and were possibly headed in our direction.

Having filled the water cans, we returned to *Titanic* greatly encouraged and planning a press party for the bears, sending invitations through the air via the aroma of sizzling seal fat.

Pikebukta was shining clear, nothing stirred. The smoke from our stove sent a friendly finger straight up into the sky. In fifteen minutes it was all different. It was freezing, icy, and with blasting wind outside the cabin. We were drifting, and Johan was worried that the anchor chain would break, but we rode it out for half an hour and things calmed down.

Stuck in our tiny cabin riding out the weather for a gray day and a night, Johan again added cheer by fixing a sumptuous dinner: Seal Chops à la Sørensen, done in a marvelous sauce composed of tomato catsup, soy sauce, and Canadian Club Whiskey. What does seal meat done this way taste like? Mostly rye whiskey, with a hint of soy, a smidgen of tomato, and a whisker of seal.

Our supplies were now running low; sugar, margarine, and chocolate were gone. A small amount of coffee remained, but, worst of all, the engine-starting cigarettes were beginning to rattle in their can.

At 11:00 p.m., twenty-two hours after our arrival, we went ashore and started several huge driftwood fires. Seal fat was put on to cook, to attract bears but the wind whipped the tantalizing smells out to the Barents Sea toward Russia. Bad luck with the weather, as usual.

On Friday, August 19th, the wind was still strong but visibility had improved. It was time to move, but the engine wouldn't start. One precious starting cigarette after another the diesel was still dead. The engine was dismantled, and we found the fuel jets very dirty; reassembled, off she went — pomp, pomp, pomp — to everyone's relief.

Titanic moved along the coast to the snow-covered glacier of Victoriabukta, and through the binoculars I spotted bear tracks. Sven and I went ashore, leaving Johan behind to record our progress with his smaller, handheld Bolex movie camera. Sure enough, we quickly picked up a bear trail and followed it up a steep crusted slope until we climbed to a crevasse in front of a deep black hole tunneled into the side of the snow-covered hill. I unslung the rifle, got within a few feet of the opening of the cave and tried to peer into the dark, hoping my eyes would adjust. Something seemed to move inside; then came a loud hiss. "Get the hell out of here" in polar bear was an unnecessary salutation: I was already in mid-air, making what seemed like a twenty foot standing broad jump down the hill. I had been three yards away from a mother polar bear, possibly with a cub. I hadn't done anything so dangerous or stupid since visiting an enemy bunker in Korea, with pistol and hand grenade, ten years earlier. Fortunately, that bunker was empty, but this one was not.

Polar bears mate in April and May, and it takes over a week of sexual activity to induce ovulation. (Is there a word in the English language for sex that lasts that long?) The fertilized egg then remains in a suspended state until August or

September. During these four months, the females eat enormous amounts in preparation for pregnancy, doubling their body weight or more. When food becomes scarce in August, because of the breakup of the ice pack and a shortage of seals to hunt, they dig a maternity den in a snow drift and enter a dormant state similar to hibernation. This was probably what we encountered.

We decided to refine our technique to lure this bear from its ice cave toward the cameras. Johan brought a bucket of bear bait from the boat, and he and Sven set up movie cameras a hundred feet from the hole. I tried to bring the bear out by lobbing rocks into the hole from my position twenty-five feet above on a high safe ledge.

The rocks went in, but the bear didn't come out. Changing my tactics, I substituted seal fat for the rocks, and lobbed a few strips with great accuracy in and around the hole. This elicited no interest from the bear, but great interest from a sea gull. It swooped down and immediately carried away the piece farthest from the hole. Then it scooped up another strip very close to the den. Then, the greedy bird popped out of sight and waddled into the hole for another morsel. The result was spectacular: suddenly squawks and a cloud of

feathers exploded from the hole, and the gull catapulted out of the polar bear's ice cave minus part of its plumage.

There were four other caves in the area, but we lost interest in inspecting bear holes and concentrated on replenishing our supplies of bear bait, Johan shot another seal in the water. I hated the idea of seal killing and was much relieved when he missed the first one.

Around 3:00 a.m., I spotted the biggest polar bear that we had seen, probably a full grown male. One of the hunters I had met told me that the big bears had long foreleg hair, which apparently is attractive to female bears. Unfortunately, I couldn't check his forelegs; this animal was half a mile away. Bad weather from the north kept us from getting close.

By Sunday, August 21st, we were getting worried about time. September 1st was when we needed to be back in Kings Bay. We had been warned that all hunting, sealing, and scientific ships return on September 1st, because on the east coast of Spitsbergen, winter pack ice can come rushing down from the north with ship-crushing speed at any time after this date. This gave us ten days. We had some photographs and some motion picture footage, but none of

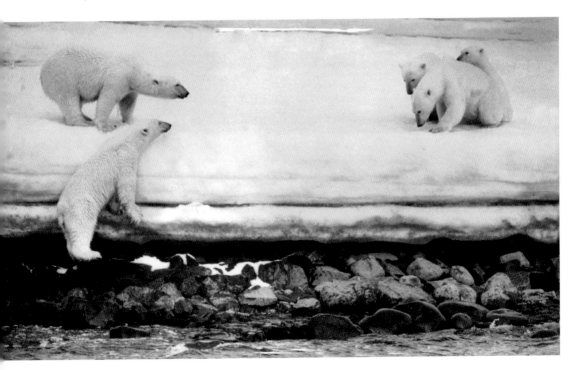

us were satisfied. Gambling for a little more time, we decided to have one more look around.

At 1:00 a.m. *Titanic* moved westward. The weather was working in our favor, with a faint wind blowing from the southwest. At 6:00 a.m., we spotted a female with a big cub. We dropped anchor in a cove that gave us a clear view of rolling gravel hills, with high cliffs looming in the distance. Johan got *Titanic*'s wood stove going, and strips of seal meat were laid over the stove pipe. More sizzled in a frying pan. The stink was terrible, but not to these bears. They were a long way off, but they could clearly smell us. Through the binoculars I could see the cub come forward, anxious to investigate the tantalizing odors. But mom made some sort of signal to the cub, which obediently moved to the rear. This parental control was remarkable, because the bears in King Karl's Land were probably starving, forced to feed on what they could find: birds, carrion, and seaweed. We found plankton and grass in their droppings.

The wind direction was right for our bear-baiting activity, so we patiently waited to see if our plan worked and we could lure some others. Everyone was exhausted, however, so we remained on board and stood one-hour bear watches. I had just woken Sven at 9:00 a.m., when I saw one coming. We were all very quiet and stayed in the cabin, hoping that the bear would be attracted by the fat stench. It was interested and sniffed the air, but then the animal turned and disappeared behind a gravel ridge. Sven reported three bears on his watch, but a light mist had closed in again and they never got close enough for pictures. "A handsome sight," Johan reported: Sven and I were too sleepy to look.

We moved our anchorage again, west toward the bear holes previously visited. I rowed ashore with a bucket of seal fat, planning to lay a trail for the bears. Beaching the dinghy, I tied a short length of rope around a sealskin and dragged it along behind me as I climbed over the rocks. I worked inland, leaving tidbits of fat along the way, until I reached a high ridge, about a thousand yards from the beach, where *Titanic* was no longer in sight.

I spotted two bears through my binoculars; they were at least a mile away and I watched them for fifteen minutes. Which way were they coming? It seemed as if they were slowly moving toward me, but I wasn't sure. If the bears were coming my way they would eventually intersect my trail. Certain now

that a bear was behind every rock, I made my way back down to the beach with the rifle loaded and a round in the chamber. Still dragging the sealskin, blubber side down, I arrived safely.

Shortly after I got back aboard *Titanic*, we all saw three bears — a mother and two big cubs — 500 yards down the beach. This was our chance. More seal meat was thrown into the boat, and Johan and I jumped into the dinghy and rowed ashore to spread it around. Sven put more fat on the fire because the bears were already moving in our direction. I was sitting in the stern of the dinghy, with the rifle across my knees, and I could see what Johan couldn't: the bears were trotting in our direction, noses in the air, closing in very fast. As we were just short of the beach, the bears arrived in time to meet us: Johan seemed shocked and practically lifted the dinghy out of the water with his first mighty stroke of the oars. I flung out sealskin, fat, everything we had onto the beach and we started back to *Titanic* at high speed. The three bears plunged in after us, inspiring Johan to do even better than his best. I loaded a round into the magazine and snapped off the safety. I thought that at any moment one of Johan's mighty efforts would flip an oar out of the ill-fitting oarlocks. He kept up an Olympian stroke, and I was able to hold my fire. We leaped for safety onto *Titanic*, and the trio swam back to shore.

We thought perhaps the bears weren't finished with us, or our delicious treats, and prepared for their return, setting up on tripods two movie cameras and my Leica with the 400mm lens. For once the weather was clear and sunny, providing perfect conditions for photographing. This was also my great chance to get the pictures that I had only dreamed about — underwater. I quickly dug out my wetsuit and zippered into it. I loaded film into my Rolleiflex camera, put it in its underwater housing, and brought the air tank up from below.

My plan was to go into the water, submerge to about ten feet and get pictures of the bears swimming above me as they approached *Titanic*. Johan and Sven would lure them close to the boat with strips of seal fat. To make a floating bear bait and provide a marker in the water so I could get a good underwater position for the feeding frenzy above, we nailed a seal chunk to a 2x4 inch board, and tied it to a rope with a 50-pound piece of scrap iron for an anchor. Before pitching myself into the water, I wanted to get some surface pictures without dribbling salt water all over my cameras. The bears had returned; they

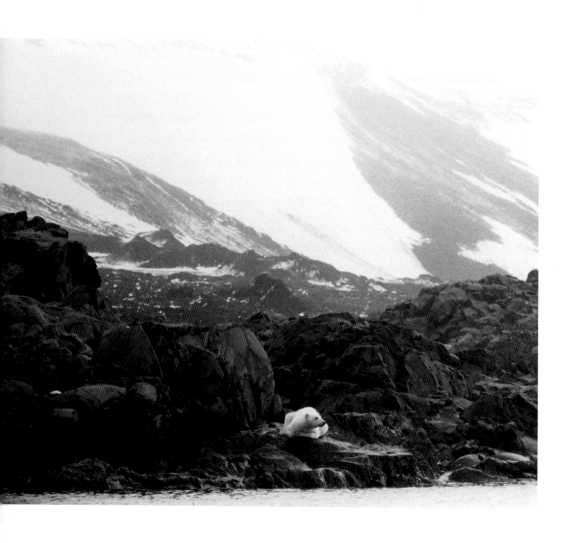

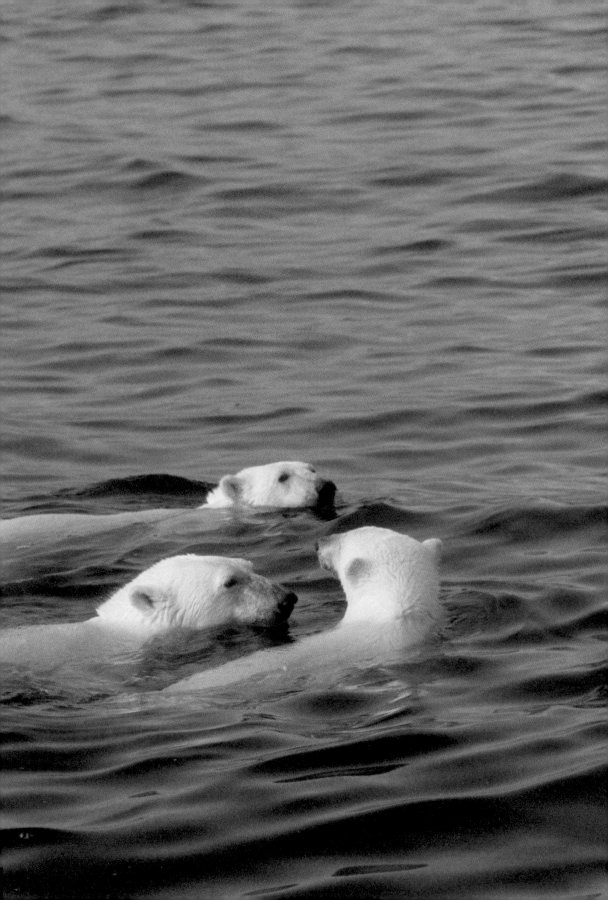

were now at the water's edge and after sniffing around, first the mother and then the two cubs plunged in and swam out to *Titanic*. The mother had the cubs under strict control. She led, swimming first, and grabbing the biggest piece of seal fat that we had thrown in the water. The three would return to eat on shore, the cubs dividing what the mother left for them, not without a few roars.

The ritual repeated itself and I got ready. We were running out of seal fat, which floated, but had the disadvantage getting picked off by the big gulls. We still had meat, but it tended to sink. Now I threw a piece of meat in, and mother bear performed a new trick. Just as I was about to ease into the water, the bears started putting their heads under water, searching for the food. Mom, spying a big chunk that had sunk out of sight, heaved up her huge furry rump and dove straight down forty-five feet to the bottom. She appeared again on the surface with the meat, fifteen yards from the boat. It dawned on me that in my black rubber seal-like suit, I was perfectly dressed for the occasion: unfortunately, it put me in the wrong place on the food chain. As it seemed unlikely that Mamma bear would paddle around posing for my underwater photos, and with no assistant to use the dart drug gun to tranquilize her, I decided to wait for another day to pull off my underwater exploit. I unzipped the front of my wet suit — it was getting hot — and returned to conventional photography.

The big female now became aggressive. She attempted to join us on *Titanic*, but Johan discouraged her by firing a shot point blank in front of her nose. The muzzle blast backed her off, and she and the cubs retired to shore to think things over. Then, quite incredibly, two more bears appeared; a mother and a yearling cub, perhaps the same animals we had spotted earlier in the day. We upped anchor and moved *Titanic* closer to the shore. More meat was thrown into the water, part of it midway between the families to see what would happen. The polar bears greeted each other with roars, snarls, and hisses, baring their teeth. They approached within a few yards of one another. There was noise but no fight. Unlike aggressive males, the females were just conversational.

The cubs quickly lost interest in the discussion and retired a short distance away to take a snow bath. It was extraordinary to see these big wild predatory animals playing in the snow like puppies. The two newcomers rolled over, all four legs in the air, stretching, rolling in the snow. They seemed to be enjoying the refreshing cold on their hides. The temperature was just above freezing,

and this was one of the few snow patches on the island. The mother with two cubs casually watched the other bears twenty-five feet away. One of the cubs lay with his head resting on his mother's rump. The other began to roll in the snow, throwing his legs far apart and grinding his 400-500 pounds into the packed snow bank.

Then all the bears swam out to us. Soon we had five polar bears paddling around, six feet from our cameras. The two mothers kept the groups separated as each returned to shore with meat. Johan threw my bear feeder over the side and immediately the gulls went for the meat nailed to the 2x4 plank. Johan shot two of them. The bear trio came out to investigate, ignoring the floating birds and seizing the meat. They swam for shore, dragging board, rope, and anchor clanking over the rocks. There was no interference from the other hungry pair, only a minor skirmish over leftovers between the cubs. The other bears picked up some scraps overlooked in the water, but there was no fighting.

The weather was still clear. We watched the polar bears with fascination for five hours: our trip was justified. Then, because rescue parties might start looking for us, we reluctantly departed, determined to return *Titanic* to Engineer Johansen on time and in one piece. Our adventures, however, were far from over. Wind and fog, our familiar enemies, once more intruded. We rounded Cape Anderson hoping for refuge. The surf lashed at the cliffs with intensity unequalled by our previous experience. We headed for our old cabin site, but the trip, which should have taken two hours, took four. We anchored, but not for long. The strain on the anchor chain was terrific. We could not risk breaking it, so we moved on. The sky blackened. Visibility was about 500 yards; rain pelted us as squall after squall hit. At times we could only see just beyond the bow. Salt spray, rain, and the vicious sea made it impossible to stay dry in the pilot house. Two of us had to stay on watch, one to keep an eye on the engine while the other steered. *Titanic* chugged through the storm, trying to escape, first to the east, then to the west, but there was nothing but white water at both ends of the island. The gale was blowing over the land and we cruised between two of the highest mountains, as close to shore as we dared. We saw a large flock of gulls resting in the same area, so this was the calmest spot.

As it was too risky to anchor, we cruised back and forth for eight hours. Thank God we had not started for the Hinlopen Straits and home. We would never have survived the full force of this gale in open water.

By Tuesday, August 23rd, the wind had dropped considerably. We were finally able to anchor. For safety's sake, Johan constructed an extra anchor from ballast and we kept the motor running, just in case.

On the slopes we could see from the water, there were familiar holes in the snow. I spotted a polar bear through my binoculars, and then saw another emerging from one of the holes. The first bear was 500 yards from the second, but he went along investigating each hole. They all seemed to be preoccupied. The second bear retired to his hole and Johan and I launched the dinghy to try to get to shore for photographs. The surf on the beach was still very rough, too dangerous to land, so we contented ourselves with rowing the dinghy as close to shore as possible and trying to grab some shots from afar. The light was so dim that we were pushing the limits of black and white film, and it wasn't possible to use telephoto lenses because the little dinghy was bouncing too much.

The first bear eventually got to the second bear's hole. The noise of the wind and sea obscured the dialogue from us, but the inquiring bear's sniffs no doubt were met with a roar, a familiar message. He moved on, taking his time, and finally settled in a soggy mud bank. It was too difficult to make good pictures, so we returned to *Titanic*.

It was August, a time when the female polar bears were returning to the holes we were trying to photograph. This was where the females waited until one or two cubs weighing about a pound and a half each were born in December. Remarkably, the birth would happen without the mother waking, and the cubs nursed until March when the family emerged for the first time.

The next day at 4 p.m., we started out for Svenskøya, the first leg of our journey home. The sea was high, but wind and visibility were good. The trip over was not difficult and we stopped at the north point of Svenskøya at Arnesenodden, where we took apart the troublesome water pump, greased it for good measure, and topped up the tank with the last remaining jerry can of diesel fuel.

At 2 a.m. we started the hazardous run to the Hinlopen Straits. Fog closed in almost immediately, but the wind was moderate and the sea calm. All through the night fog held us in a drizzly gloom. At 2:30 p.m. the sun appeared again, shining like a dim bulb through the overcast. The sun at this time of year makes an elliptical dip close to the horizon at midnight and according to the clock and our map it was in the wrong place. We radically changed course

away from Novaya Zemlya, the Soviet nuclear test site. The boat's compass had again become a nautical roulette wheel.

The fog lifted and not long after we sighted land, but it looked unfamiliar. The weather improved steadily, however, and as *Titanic* cut through the calm sea, hour after hour, we found ourselves on the east coast of Edgeøya, moving up toward Barentsøya. This was a safe course, but 130 miles south of where we were supposed to be — the same damn island that *Støtt* had sighted when we made our detour from Bjørnøya to Longyearbyen.

Watch after watch passed, bringing us closer to the Hinlopen Straits. Good weather was such a relief. The sea was as calm as a pond and the air fresh and clear. It was once more exciting to be in the wheelhouse, watching a radiant world go by. The approaches to the strait were jammed with icebergs, and we then threaded through a narrow ice-free passage, and found the channel clogged with ice shavings no bigger than cocktail cubes. This ice formed a silvery carpet that lay between square chunks ranging from a few tons to beautiful crystal leviathans that rose twenty feet out of the water and a hundred feet long.

Once more there were birds; black and white skuas, gulls, and Arctic terns, the only terns in the high Arctic. They hover and pick insects off the tundra in the same way they pluck small fish from the edge of the sea. They breed in colonies on the flats and are extremely aggressive. When we had previously met them ashore, they would swoop down at our heads in a fearless attack, defending their territories and chicks.

When the midnight sun gets low in the sky, the terns begin to abandon their nests, taking off to winter, or rather to extend their summer, on the other end of the globe, in Antarctica, making the longest migratory journey of any bird.

We also spotted barnacle geese that normally nest on the ledges of seacliffs. These are truly Arctic birds, and they breed nowhere else in the world. Their inaccessible nests protect them from the Arctic fox, but we saw them on full parade, feeding on the low-lying vegetation of the tundra. The goslings followed the hens in straight lines like little soldiers. They had learned to fly and soon they would migrate to the north of Scotland for the winter. In earlier times, the Catholic Scots believed barnacle geese were born of plankton. That technically made them fish, so they were therefore edible on meatless Fridays.

At 11:30 p.m. we dropped anchor in a relatively quiet bay, but the wind was blowing from the stern. This gave *Titanic* enough forward momentum to drag the anchor chain under the boat, where it caught under a loose end of metal stripping that extended along the keel. We were able to cut it off, but it had apparently banged loose the stripping in a previous disaster. Although this didn't seem to create any immediate difficulties, we regretted that the boat was damaged.

After dinner we went ashore, and discovered the unmistakable tracks of a polar bear. These tracks are scary looking, because they are so big; the bears distribute their load on snow or thin ice with feet like snowshoes. We spotted this animal about 200 yards away, sitting on a very picturesque cliff, so we returned to move *Titanic* to a position where we could sneak up on it undetected, or so we thought. By this time we considered ourselves veterans as far as polar bears were concerned; this being our 21st sighting. We were anxious to get close to the animal without scaring him away. With the exception of the bears that we had fed, all the animals so far had fled from our human scent. Coming ashore again, we crept and crawled as quietly as possible; tripods, Arriflex, Bolex, my Leica attached to a 400 mm lens, and rifle, all jangling and banging as we tried to make a stealthy approach through the rocks.

Soon, we climbed a boulder and found ourselves looking right at the bear; and the bear was looking at us. To our delight, we discovered that he didn't seem at all afraid. In fact, he was openly curious. I focused my big lens, and in a moment everyone was busily at work.

The bear slowly stepped down and up onto another rock to have a better look. Wonderful! We clicked away. Then our subject became even more curious and came casually strolling toward us. When he was thirty yards away, Sven cursed. He was out of film. The bear was getting closer. Indeed, it was filling up the eyepiece of my long telephoto lens. Johan was still hard at work. I switched to a shorter telephoto, and soon there was too much bear in that one too. I switched again. Johan put down his Bolex and grabbed the rifle. The bear was slowly but steadily closing in. Sven was getting out his Hasselblad and was not fully aware of what was happening.

"Shall I shoot?" asked Johan.

"No," said Sven, "I need to get a picture."

Suddenly the bear was fifteen yards away and he was no longer looking like a big friendly animal. Sven looked up from the hood of his Hasselblad in time to see nothing but trouble starting for us. The lazy ambling stride changed to a trot. Sven and I got ready to evacuate. At ten yards the bear picked up speed and Johan fired. Wounded, the animal swung around and charged off in the opposite direction. Johan tried to get another round into the chamber but the bolt jammed. We found the bear a short distance away, and put him to sleep with another shot.

It is the custom of most Norwegian hunters to use a cut-down version of the Model 1886 Krag-Jorgensen carbine, a handy little weapon that would forever find fame as the rifle carried by Teddy Roosevelt's Rough Riders in the Battle of San Juan Hill in 1898. And this was the weapon we had — albeit with a malfunctioning bolt. The relatively small 6.5 mm bullet makes this rifle a pea shooter for an animal the size of a polar bear. It takes a brave or foolish man to stand up to a bear at close quarters with this weapon. But we felt more depressed than lucky about killing it. We skinned the bear, a long, dirty, cold job and regretted every minute of it.

I despised the occasional "big game hunters" who came trophy hunting in these parts. Shooting fish in a barrel was an accurate analogy under all the conditions that we had seen so far. But this hungry bear was coming after us and we had no choice. In spite of the dramatic circumstances, and a relatively ineffective weapon, I couldn't justify this as anything but basic self-preservation. It would have been interesting to discuss this with Sven and Johan, but it didn't seem to fit the mood of the moment and my diary, by default, became my closest confidant.

We started back through the Hinlopen Straits in perfect weather, only to get caught again in fog soup. This and our lunatic compass complicated matters. We started north on the east side of Hinlopen and found ourselves twelve hours later going south down the west side of the strait. A day was lost with this detour, but we finally made it out of Hinlopen and were cruising happily in the right direction when a new crisis arose. The boat was sinking. Apparently the strip that we had pulled from the keel opened up leaks, with the result that *Titanic* had to be pumped out every two hours, enough to keep us floating. After this, smooth sailing fair weather and familiar landmarks; Mosselbukta,

Velkomstpynten, Amsterdamøya, Danskøya, Magdalenefjorden, slipped by watch after watch. I even got some sleep.

We rotated sleeping in the two bunks when we weren't under way, jamming into the cabin, with the air mattress between the bunks. Getting stepped on was one problem, but in addition to waking up floating, the latest hazard was to be awakened by the hiss of air escaping from the air mattress that separated a warm, sleeping-bag-encased body from the cold hard deck. The gradual hazy transition from sleep to wakefulness was sacred to me because that's when I passed from dreams to reality, and this moment had a profound effect on how each new day was begun.

Johan and I didn't talk much or in depth because my Norwegian was primitive, but as the trip chugged to its end, he revealed a certain playfulness toward me. Close human contact aboard *Titanic* had finally produced intimacy in the form of a joke — playful "stopper pulling" from Johan. His removing the plug from my air mattress gave me a chance to bellow, "Stopper pullers belong in hell," delivered in the spirit of a teenage pillow fight. But nothing, despite the circumstances of this extraordinary trip, budged the slightly superior de-

meanor of Swedish Sven. In fairness, *Titanic* had so many disasters on this trip that there had been little time to squeeze in jokes, but I badly missed the chance to lighten the dialogue.

Finally, our journey took us by Kappa Metra, bathed in glorious shades of gold. The low slanting light reminded us that the days of the midnight sun were almost over after five months, and it provided a glorious ending to our amazing trip.

A silver-colored Esso oil tank in the distance signaled our approach to the joys of civilization. It was 3:30 a.m., Tuesday August 30th when we tied up to the dock in Ny-Ålesund, rather sad to be back but very lucky. We had one quart of diesel fuel left in the tank, five starting cigarettes, very little food, and sixteen rolls of toilet paper. We were back safe and, incredibly, one day ahead of schedule. At 9:00 a.m. sharp I reported to Einar Grimsmo, anxious to reassure him that all was well. We would never forget his help, and especially Engineer Johansen's generosity and concern for our safety. Grimsmo enthusiastically welcomed us, and after an exchange of pleasantries, enquired about *Titanic*. I reported that there needed to be a few minor repairs but "The ship is sound."

"Johansen will be sorry to hear about that," he said, which struck me as odd, but I assumed he was being ironic. But Johansen *was* disappointed. *Titanic*, insured for a huge sum of money, would have made Johansen a rich man, had we been considerate enough to sink it.

The midnight sun was gone until next April, so it was time to wrap things up. Johan and Sven got the next boat to Norway, departing on M/S *Lyngen* on September 3rd for Tromsø.

Engineer Grimsmo kindly allowed me to stay on in an empty house owned by the coal company. I decided not to go back right away because there was a dim possibility that a pod of white whales would swim into Kongsfjorden. This was the time of year that they were supposed to appear. If they were spotted I might persuade somebody to take me out and drop me overboard to try for some underwater photographs. Every day I would dutifully go down to the dock, look out to the fjord, *not* see any white whales, then walk back to the house, a bit relieved, and take a nap or write. White whales were no longer a serious quest. There were too many pieces of my Svalbard puzzle to fit together, and I explained it to Picasso through my diary this way:

What I really want to do is get some sleep and quietly and unhurriedly try to put the Titanic saga in perspective, get it down on paper. It will take me a couple of weeks to make sense of my notes but much longer to come to grips with the trip. Among many things I want to think about is my relationship with Johan Sørensen and Sven Gillsäter.

Johan has a sly humor and it comes out in actions rather than words, which are few and not usually in English. He's a "stopper puller" but I have enormous respect for his common sense and toughness. His reflexes are quick and to the point. He often made the difference between missteps and full-blown disaster. I would have welcomed him in my rifle squad in Korea. His reserve had much to do with language. Things are more complicated with Sven. He and Johan seem like comrades — communicating in Norwegian/Swedish, of course. There were things that I wanted to share, but I couldn't understand how and where to enter the conversation with the two of them.

Instead of finding out about them, this communications barrier began to tell me about myself. Was I too quick to jump into things that might be objectively seen as insane? I remember something that Walter Wellman wrote: "Perhaps it would be better not to try to go on with the expedition... but we Americans like to do things rapidly."

What are the differences in the cultural and social style of my shipmates and me? Flamboyance and exaggeration are not in their character. I am attracted to excitement if I can twist out a bizarre story. But my tale-telling couldn't survive the obstacles of incomplete language transmission.

Sven is a far more experienced photographer, well established in his profession, especially in Sweden, so I was never sure how he saw me as the organizer of this grab-bag, underfinanced effort. I raised $2500 from Sports Illustrated and the National Geographic and much in-kind help from a network of friends that I had developed along the way. Sven provided $200 toward the cost of the charter of Støtt.

Sven never faltered, was intrepid and professional as an adventure mate. However, as physically close as we were, crammed in a tiny cabin and constantly surviving together, his reserve never lifted beyond being slightly bemused about my presence in a situation that I would have thought should make us brothers for life. But this didn't happen. We were friends, with a strong common link that never progressed toward any form of intimacy.

The trip, of course, was amazing — extraordinary in so many ways, but in retro-spect a lonely one. But is this inevitable with a language problem? How can such a process of survival and mutual reliance not be the strongest kind of bonding experience? I have a sad and persistent feeling — never expressed — that I was the "odd man out." Perhaps this situation has to do with the dynamics of three. Maybe it's a common condition that humans stack two against one — and again maybe it was my fault, but I remember that in Korea, foxhole relationships are made up in twos. Survival depends on twos not threes.

I departed on September 18th aboard the coal ship *Jakob Kjode* for Narvik where I joined Johan Sørensen on a trek to spend time with the Sami reindeer headers. We got caught in a blizzard, spending five days in a tiny pup tent in Finnmark. We had another adventure. My Norwegian must have improved, and our reunion was warm, even if the tent wasn't. Maybe my theory about twos is correct.

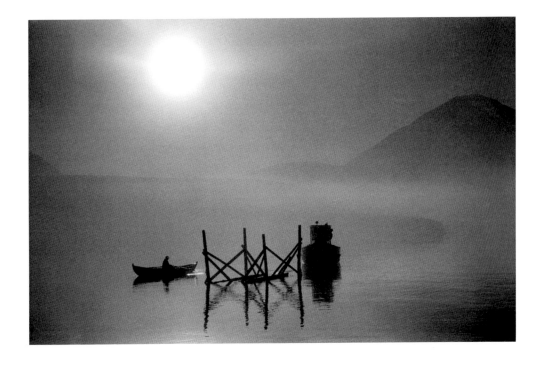

20 – TEXAS AND MEXICO

The Spitsbergen trip gave me a lot to think about. My experience was like diving into a huge wave that taught me physically about its power — it rolled, turned, sucked me under, and spat me out with a force that was bigger than anything I had ever imagined. It was time to have a look at myself in calmer waters — surroundings that were familiar — and then figure out how to return to the real Spitsbergen, not the Spitsbergens of my imagination.

Part of the puzzle was what to do about my relationship with Monica. From my point of view she was an indispensable haven. She made it clear, when I checked in for repairs this time, that I had to do something in regard to her status. She was happy to continue in the nurse/lover role, but wanted our relationship to be formalized with some kind of symbol, perhaps a ring. Despite my big adventure in Spitsbergen, not much in the way of photography or stories had been sold; my confidence was shot. But there was much more that I wanted to do, and I realized that I needed her help. So we exchanged gifts. This was the Swedish custom.

I went to a jeweler in Stockholm and bought her a plain gold band. For me, a ring on my finger was out of the question. She bought me an electric razor — this seemed a little odd but followed Swedish tradition — a reciprocal gift. That made things official and allowed me to eat my cake, and it didn't have to be wedding cake. For Monica, the ring worked; she felt respected, validated, whatever it was she needed. For me, I never used the razor. I'm not sure why. Maybe it was because it operated on the wrong voltage: 220 volts didn't work in the USA. Even in Europe it was necessary to find adaptors to fit different out-

lets. Perhaps I didn't want to trim my imaginary beard, the one that had been so helpful in seeing Picasso and a lifestyle that required freedom.

After my return to Stockholm, I enjoyed a pleasant reunion with Sven Gill-säter. During my prolonged stay in Kings Bay and the short Sami encampment with Johan, Sven had been stirring up a lot of local publicity. To my surprise, I returned to a certain amount of notoriety: Sven had included me in his descriptions of our adventures in Spitsbergen and there I was on TV clips from Sven's filming. A few interviews followed, as well as a round of dinners that included writers and even a press officer from the American Embassy. It was fun and adjusted my mood in a positive direction, but after a couple of weeks I had soaked up the recuperative possibilities of Stockholm and was ready to move on.

I decided to return to the U.S. This meant that I would temporarily abandon Monica and my Mercedes as well. Monica, perhaps feeling more secure with a ring, was philosophical about my departure. As for the car, the corrosive damage done to it on the salt-laced roads of Swedish winters needed to be repaired. Fortunately I had made friends with the Public Relations Director at Mercedes-Benz, so I drove to Stuttgart and left the car at the factory where it was born. We both needed a trip home.

Then, I had to get my cameras, all my diving gear and myself from Germany to New York. At Stuttgart airport, when I checked in at Pan American Airways with a dramatic amount of overweight, my ticket price suddenly doubled. Canceling the flight, I dragged my luggage into the men's room, unpacked my bags, re-dressed myself and emerged wearing four sweaters, two pairs of my heaviest trousers, ski boots, and my reindeer skin parka. Strapped around my waist under my parka was my lead weighted diving belt. All this was topped off with a black lamb wool hat, the kind that kept Genghis Khan's ears warm on the steppes of Mongolia. The new me weighed about 300 pounds.

I rebooked a new flight on TWA and waddled aboard the plane to New York. Preparing to sit down for the twelve hour-flight, I shed some of my bulk, because otherwise it was impossible to fit into the seat. Next to me, my astonished companion, a thin Egyptian gentleman traveling from Cairo, had clearly never seen anything like me. He was curious and talkative, and also very tolerant about my bulging out partly into his seat. I was as polite as possible, ex-

plaining that all of us overdressed at the North Pole. He said that he hadn't realized that anybody lived so far north.

"Oh yes," I explained. "There are quite a few of us living up there these days. Lower taxes."

He was very surprised to hear this, and seemed to want to hear more, but I was very tired — exhausted in fact — and I didn't want to talk my way across the Atlantic. So I politely asked him:

"How are the Pharaohs doing?"

He patiently explained that they hadn't been around for several thousand years. "I'm surprised to hear that," I said, and admitted that it was hard to keep up with events at the North Pole. And then I passed out. I woke up half a day later bathed in sweat near New York City. As we landed, my neighbor seemed anxious to get away from the loony sitting next to him, and silently slipped away.

I stayed in New York a few days, where Florence Kiesling helped to edit and caption some of the photography I had sent her. Then I went down to Washington to write a story for the *National Geographic*. They gave me a desk but the highlight of each day was having lunch in the cafeteria where I had a chance to sit with pretty secretaries. They seemed enchanted by my adventures, whereas in the section informally reserved for editorial workers, the men, who were full up with tall tales, were uninterested. After a week, I was promoted to a final lunch with senior editors in a private dining room where black waiters served in white coats. This honor indicated that my story and photographs from Lofoten had been accepted by the *Publication of the National Geographic Society*, which was the official name of the magazine at the time. The trip to the men's room after lunch confirmed that I had been promoted to Heaven. There I discovered that there were three ways of drying your hands, starting with a set of little cotton towels with individual name tags reading *Gilbert H. Grosvenor, Gilbert Bell Grosvenor*, and *Gilbert Melville Grosvenor*, followed by a couple of others. Next to the little towels was a larger towel marked *Staff*. Over the sink was a paper towel machine that I assumed was for me.

My story ideas were now being better received, and I was able to develop relationships with some of the editors that I met, particularly Senior Editor Andy Brown. Sitting in his paneled office with a large animal head that pro-

truded from over his desk, he provided me with some fatherly advice: "Fred, when you write an article for the *National Geographic*, remember it's like writing home to Grandma." The *Geographic* editorial style has changed over the years, but that description indelibly stuck.

I then continued to Savannah to see my mother and touch base with everything that was different from what I had experienced for many months. It was now easier to meet some of the requirements of my past, those magnificent ghosts lurking in my family history. I had been brought up on tall tales of my aristocratic forebears, so it was comforting to be able to bring home some tall tales of my own. My mother's stories of our family's extraordinary importance over the centuries perhaps started with Charlemagne, I can't quite remember but I do recall my fierce old Southern grandmother telling me when I was seven that "in my veins ran the blood of the best."

I often wondered whether the nobility of these ancestors got topped up occasionally at a five-star blue blood bank, and whether the ne'er-do-wells, scoundrels, and deadbeats had been erased from the family genealogy. But my tendency to see my own history slip in their direction had always remained a dark possibility.

After a short time in Savannah, I wrote to Monica that she should come to the United States to be with me. She quit her job and came to join me. I had finally told my mother about our relationship, and she seemed to accept the idea. When they met, my mother liked Monica, who was charming, had such good manners, accepted everything, and challenged nothing. My mother was a woman of the world and accepted what might be considered "unconventional" as long as a certain level of propriety was maintained, so when Monica arrived in Savannah she went into one of the guest bedrooms and not in with me.

Soon, I was itching to move again. I bought a battered Nash Rambler for $300 in Savannah, and after two weeks Monica and I headed for Texas. I chose Texas on the basis of a chance meeting I had with a very interesting man in Norway, after Spitsbergen. He was Arthur Dulles Stenger, known as A.D., a real estate developer from Austin, and an avid hunter and adventurer. While I was looking for polar bears aboard *Titanic*, A.D. was doing the same thing, but his trip was by several magnitudes more bizarre than mine. Traditional hunting with a gun had lost its excitement for A.D., so he decided to go beyond col-

lecting trophies to decorate his walls. Stenger took up roping animals — lassoing them just for the hell of it — beginning with a bull moose in Alaska; the moose chased him up a tree. This just whetted A.D.'s appetite, and he decided to rope a polar bear, so he headed off to Norway, which was where I picked him up.

A.D. had also found my friend, Olaf Applebom, the director of the USIS Library in Tromsø, who put him in touch with Torleif Markesan, a professional hard-hat diver. Markesan was commissioned by A.D. to build a fifteen-foot, pine-planked, open boat to be powered by a 12 hp. Johnson outboard motor. A.D. only spoke "Texas" English and Markesan only understood Norwegian, but he was contracted, sight unseen, to accompany A.D. for the summer months. They were dumped in waters on the east side of Spitsbergen during the summer of 1960.

The wiry bald-headed Texan spent the next three months in an open boat with the hulking Norwegian, who had also been a professional hunter in Spitsbergen. A.D. called Markesan "Tullie" and they communicated by drawing diagrams on toilet paper. In the process, a lifelong friendship developed between two men who couldn't talk to each other — at least not with words.

A.D. and I had returned to Tromsø at the same time in late September 1960, and when we met he invited me to come to Texas for a visit. Almost as soon as I got back to the States, I phoned him from New York, and found that he was serious about my coming to Texas, but I wasn't sure what I was getting into. Texas was a place that I knew little about, almost mythological, and shaped by every cowboy film I had ever seen, all of which I incorrectly assumed had been filmed in the Lone Star State.

When Monica and I finally arrived in Austin, we discovered that some of the exaggerated qualities that I was expecting from a Texas land developer who roped polar bears were quite different than what I had imagined. Some things about A.D. Stenger were even more exaggerated than expected. Reality turned out to be downright weird.

Stenger was evangelical in his approach to the animal kingdom. He wanted to share his enthusiasm for wild creatures, and deeply felt that a nine foot tall, majestically menacing stuffed grizzly bear on its hind legs was something that was important to provide for the schoolchildren of Texas. So, in addition, he also magnanimously offered a jaguar and a mounted marlin to be displayed as a public service in the lobby of Austin's Paramount movie theater. Surely this would provide valuable insights for the schoolchildren of Texas.

Stenger was widely known in Austin, despised by some for his outsized individualistic politics, chiefly aimed at authority of any kind, particularly government policies that might inhibit A.D. doing whatever he damn well pleased with his land. In spite of being considered a right-wing buffoon, A.D. liked everybody and most people who knew him well liked him. His quirky individuality, curiosity, and talent for seeking the unorthodox brought him some unusual friends.

His unorthodoxy was not a pose laid on for effect; it was straight from the heart. In a society where individualism was highly admired, and where almost nobody achieved it, his friends saw A.D. as a kind of folk hero because his style was so utterly contradictory to accepted norms. Even Texas clichés couldn't be made to fit. He wasn't tall or ruggedly handsome. He was a small wiry man who was ordinary looking — even ugly — but he could handle himself with a horse or rope as well as any cowboy. There was even something comic about Stenger's personal style. He didn't drive a pickup truck; he preferred to carry lumber, tools, cement sacks, blue prints, and the various accoutrements of being a hands-on builder/developer/architect in the trunk of his late-model Lincoln Continental, an elegant car that he treated as a truck.

The Stengers were not rich, though A.D. had been one of the first to buy land and develop housing projects on a large tract south of the Colorado River in Austin. As a result he could be described as "land poor." During his days at the University of Texas, his wife, Ella Jean, had supported A.D. If he had been a movie character, it would have been appropriate for him to be married to an eye-popping beauty; Ella Jean, however, was one of the plainest women I had ever met, but she was kind, tolerant, devoutly, fundamentally Baptist, and sensible to the point of total boredom. On a graph to measure quirkiness, she was a flat line and her husband was off the chart.

A.D.'s professional organization consisted of Ella Jean as bookkeeper and manager, and Chuy, a grizzled old Mexican who A.D. described as his Vice President. Chuy spoke practically no English. I am certain that A.D.'s basic communications skills with Torleif Markesan had been developed through years of experience with Chuy, because his own Spanish was limited to about twenty words, including *si* and *no*.

Stenger had once worked in an aircraft factory, where he learned to apply aluminum to the skins of warplanes. Joining the Navy, he became a Seabee, and

was involved in removing mines from captured harbors in the South Pacific. After the war he enrolled at the University of Texas School of Architecture, but didn't get his degree because of a misunderstanding with his professor over the design of his final project — a railroad station built, not surprisingly, of stressed aluminum. His professor pointed out that A.D. had failed to provide two sets of restrooms, for "white" and "colored," which was traditional at the time in Texas and the South. Stenger refused to make the change, explaining that: "this would screw up my design."

This statement had nothing to do with A.D.'s politics, which were conservative, even in some cases wildly reactionary. But his politics as well as everything he did in life stemmed from a passion for determining his own way of doing things. Stenger had the ability to adapt, bend, and distort any information to fit his particular streak of independence. He was one of the brightest, and at the same time most ignorant, men I had ever met. A bewildered admirer once described A.D. as "curious as a pet coon" and at the same time as "irritating as a burr in your boot."

Progressive politics were plentiful in Austin during this time, and some of Stenger's closest friends were famous liberals of the era. One was John Henry Faulk, a well-known Texas humorist who had been cast to become the next Will Rogers and was a rising star at CBS in New York until he was snared by Senator Joe McCarthy as a potential Communist and blacklisted in the 1950s. John Henry's "crime" was attending a rally for Spanish Republicans, who were supported by Russian Communists, during the Civil War. As a result he was fired. John Henry took CBS to court and, with famed attorney Louis Nizer acting for him, won a celebrated judgment against the network. The cost of the legal battle, however, wiped out the former TV star. On his return to Austin, unknown to the entertainer, Stenger built John Henry a house. When it was finished, he went to see John Henry and handed his astonished friend the keys to his new home, with an affordable monthly payment schedule. John Henry Faulk lived in that house for many years.

A.D.'s hospitality was delivered on the same scale as his generosity. Monica and I slept on two of his couches for many months, stays that were extended by weekend jaunts to the Texas Hill Country, where A.D. and I would go out on photo shoots that involved fishing and hunting.

The Stengers had many friends, but there were a few special people whom A.D. particularly respected. In addition to John Henry Faulk, among them was Captain Bob Snow, a former Texas Border Patrol officer and Texas Fish and Game Ranger. Bob was way past retirement age but was still a very impressive man physically; tall, thin, and ruggedly handsome. He looked like the cliché of a rustic Texan and to top that off he was a classic old-time story teller.

Bob was a natural motivator of the young, and so good at it that he was often hired by rich businessmen from Dallas or Houston to provide models for their teenage sons' rites of passage. One fifteen-year-old, the son of an oilman deemed to be tilting toward delinquency, was sent to Bob for a week of basic training. The two of them were camped in the wilds of someplace, sitting around the campfire, and the boy reached out and grabbed the coffee pot that was boiling away in the red-hot embers. Of course, the metal handle was searing hot, and as his fingers made contact, he screamed: "God damn it!" and kicked over the pot. Bob rose silently, went to the tent, and returned with his .45 caliber revolver. Carefully taking aim, he fired, blowing the coffee pot out of the fire, and then fired again as the pot landed. Bang! And it flew into the air again, and landed in another spot. Six times the pot was shot until all that was left was steaming mangled metal. Bob walked back and quietly said to his astonished pupil: "Son, out here when your buddy gets in trouble, you help him out."

Stenger adored Bob Snow and the feeling was mutual. The two of them had an effect on me as well. At one point, the Stengers' extended hospitality became so embarrassing that I felt a move was necessary. (In any case, I was beginning to have nightmares about being eaten by the giant Alaska King Crab five feet in diameter that was mounted above my sofa bed in the Stengers' living room.)

Bob Snow arranged for Monica and me to stay in an unused cabin on the Dan Ault Ranch near Kerrville. Traveling from Austin on the modern highway, it was barely noticeable that we were entering a country of canyons and mesas that stretched from one endless set of limestone hills to the next. In geological terms, we were passing over the Balcones Escarpment and entering the Edwards Plateau. The land was a special place that Texans often referred to as "God's Country." One had to slow down to catch its subtleties; it was not grandiose, dramatic, or overpowering.

When we left the asphalt, opened the first gate, and entered a remote pasture on the Dan Ault Ranch, Monica and I immediately found ourselves in a different world. And the first sign of that was an unpaved, sharp-edged limestone boulder-strewn track that I knew hated the tires on my car and took a devilish delight in proving it.

The world we entered had once been a place where German immigrants came, organized by colonization companies that promised the dream of owning generous grants of rich farmland in the 1840s. It was advertised, then, too, as a kind of "God's Country," but the Germans' survival involved fierce struggles against the unforgiving nature of the Texas Hill Country. The road itself provided an appropriate introduction; a reminder of an era when farmers had smashed their plows against rocks an inch below the surface.

In this rough land German settlers died by the thousands through starvation, fever, and Comanche Indian attacks as they attempted to live out their dreams here. But in 1961 my mind was filled with the good news about Texas, served up in heaping helpings by A.D. Stenger and his friends.

The land was kind to my imagination, and I was about to become as evangelical as Stenger. We found a clear, fresh stream flowing by our cabin. This was the source for drinking, bathing, washing clothes, and cleaning cooking pots. There was plenty of firewood from fallen live oak limbs. There were no beds in the cabin, but we suspended some rusty old box springs with nylon ropes from the rafters and spread our sleeping bags there; it was like a metallic hammock with extra sag in the middle. The sun was our clock. We rose at sunrise and went to bed after dusk. A kerosene lamp provided a few extra hours of light. The nearest electrical outlet was in a store five miles up the jagged track that terrified me every time I got up enough nerve to bump-a-jump to the closest place where I could buy groceries.

I loved this world; it allowed me to cast myself in the most flattering terms as an instant pioneer in the best traditions of the wildest part of my imaginary West. My feet were the main mode of transportation as I tromped up and down the hills looking for animals to photograph. But even with slimmest results, my head was in another world as I tried to capture it all with my camera. I was finding a peculiar beauty around me, although the pictures didn't turn out to be very interesting. My inspiration was to have a few great tales to take back to

A.D. Stenger and Captain Bob Snow. The changing season provided powerful help in the form of surprises. The days were bringing, bit by bit, more warmth to the Texas Hill Country and out from under the dark and coolest places, life was stirring and emerging. Six days of human habitation began to warm up the cabin as well.

Monica did well in Texas. Ella Jean adored her and A.D. didn't know what to make of her Swedish charm, delicacy, and uncomplaining attitude. She was a transplanted flower, but seemed to thrive on things that women weren't supposed to be good at in Texas. She floated along not noticing that life was scruffy, dirty, un-feminine, or crude. It was if everything were the same: people, places, and circumstances. Life could be salty or sweet; she didn't seem to notice, and the people she met adored her and gave her high marks for her calm acceptance of anything that came her way.

Sometimes Monica stayed in Austin with Ella Jean Stenger. They had become great friends, and I was often alone in the cabin. One morning, before dawn, I woke up and lazily began to amuse myself, swinging back and forth in my metallic hammock, congratulating myself on creating this delightful sleeping arrangement, living so close to nature, gently swaying, safe from the Alaska King Crab in the Stengers' living room. I wasn't quite sure that the rusty wires, nylon ropes, and rickety beams wouldn't cut loose one night and dump me on the floor, but even if the whole thing collapsed, it wouldn't be much of a fall — three feet at most. I needed to pee, however, so I reluctantly unzipped my sleeping bag and turned on my flashlight to find my boots. At the same time, I heard a strange rustling noise and discovered that I was not alone. My companions were a number of snakes slithering around on the floor; rattlesnakes, I don't quite remember how many. It was probably four. I think they were looking for rats.

Now, certain that the ropes would part at any moment, and I would drop among the snakes, I lay there sweating and even more urgently wanting to pee. This went on until dawn broke and the snakes finally went home, back to the stone foundations where they normally lived. From then on, I slept in the car, and had good dreams about the comforting protection of the Alaska King Crab back in Austin.

In addition to rattlesnakes, there were wild turkeys, armadillos, javelinas, rats, squirrels, skunks, white-tail deer, innumerable tiny invisible blood-sucking creatures, and — most important – wild boar to keep me company.

In the early 20th century, some ranchers had imported European boar to Texas from North Carolina for hunting purposes. They had attempted to contain them with robust fences, but short of penning these ferocious animals in Alcatraz, there is no way to keep boar from breaking out, under, or through a fence. The population multiplied and spread throughout the Hill Country, thriving on an abundant supply of acorns from the scrub oaks.

As a former state Fish and Game Ranger, Bob Snow's interest in the boars was based on complaints from local ranchers who alleged that the animals were menacing the angora goats they raised. My own interest was more personal; it turned out that the original pair of imported European wild boars, the Adam and Eve of the Texas horde, had been a gift of the King of Italy, who had presented the animals to the American ambassador to Italy, Lloyd Griscom. Ambassador Griscom happened to be a friend of my grandfather, Robert Gamble, and lived in North Carolina, where the original boar family settled.

This information was pieced together from Bob Snow and my mother, and its accuracy may be questionable, but the tale had Texas written all over it and sparked my interest in capturing the ferocious animals on film. I sweated up and down and through some rugged country, but I only spotted one big sow with several offspring, who roared by me in the brush. There was no way I could get pictures this way, so I escalated the absurdity by deciding to shoot a pig. The only weapon I had, however, was an underwater spear gun that I had brought along with the intention of eventually skin diving in Mexico. The untried spear gun was a pneumatic type. Anxious to figure out how it worked, I assembled the weapon and started pumping. This required having the shaft of the spear in place, but something went wrong and the shaft released on its own, puncturing a large hole in my right palm. Had the point been attached it would have gone right through my hand.

I headed immediately for Bob Snow's house in New Braunfels to get patched up. My story brought him to tears, he laughed so hard. After getting a tetanus shot, I went to Austin to spend some more time with Monica at the Stengers' house until my wound healed. My lunatic performance, however, had surprising results. Captain Snow told me that he was going to lend me his dogs to track down wild boar and Stenger provided a nickel-plated .45 caliber revolver for proper hunting.

Ten days later I was back at the cabin with four hound dogs ready for the next round of adventures. The particularly ugly bitch with only one functioning eye was most intelligent; she had me figured out in a minute. Following those barking dogs up and down limestone hills, I was training for the Olympics. There was lots of dog activity, but I never saw another wild boar. The dogs were on vacation and were having a great time chasing deer. After five days, I ran out of dog food, so, putting my borrowed pistol to use, I shot an armadillo. The dogs wouldn't touch boiled armadillo. Just in time, Bob Snow, A.D., and Bob Ramsey, a rancher and trained wildlife expert, arrived.

In two days the dogs found a 200-pound wild boar, and began harassing the animal, circling, barking, and staying away from its tusks. We were all on horseback, and this gave Snow and Ramsey a chance to get their lassos on the distracted boar. Once its head was roped, the other roper went for a hind leg. Used to helping cowboys rope cattle, the horses knew exactly where to position themselves for the throws. At this point Bob Ramsey dismounted and prodded the boar into a wooden box, a sliding door was dropped and we had him.

The boxed boar was dragged over to a short closed canyon, and Stenger and I got into position to make photographs. The boar was then released, and I was able to get a picture of Stenger going up a tree — using techniques he mastered with moose roping. Bob Ramsey topped the action by taunting the now-free and furious boar, providing me with a shot of the boar passing between his legs as he leaped in the air. The dogs saved him from a further attack by jointly harassing the boar. No wonder the old bitch had only one eye.

I got some amazing pictures, but the material was too fantastic to be taken seriously by any magazines. For all its idiocy, amusing yourself by playing with wild boars stretched credulity, which, of course, was the whole point. Our fun didn't stop with wild boar. It was soon extended to golden eagles. These majestic birds were allegedly making off with baby lambs in the Hill Country, and ranchers there had hired a pilot with a Super Piper Cub aircraft to shoot them in the air.

Bob Ramsey arranged for me to join one of these missions. The Piper Cub landed on the highway near the gate of his ranch to pick me up. My seat was behind the pilot, who was also the shooter. The little plane had a 12 gauge auto-

matic shotgun mounted on a bracket extending from the pilot's seat through the open window. We took off from the highway and soon found an eagle; after that it was a World War I dogfight, as the bird cut under us and the pilot radically banked and maneuvered the plane to get in a shot. I took as many pictures as I could before becoming violently ill. The flight didn't last long, and the bird won; the pilot had no interest in prolonging what I was doing to his plane.

Again I began to write in my journal to my imaginary father Pablo:

I realize that the things I am doing are ridiculous by my own standards. They are part of a grander male experience. In spite of the absurdity, and perhaps because of it, I have come to grips with myself in a new way. Swept up by new Texas friends, this is such a happy contrast to the constrained relationship of my Swedish companion in Spitsbergen. Here, exaggerated, impulsive, and idiotic behavior is not a sin, but acclaimed in certain circles. In some ways it's OK to be stupid in Texas, as long as stupid is big or funny enough to convert into a good story.

South of the Big Bend Country in Mexico, across the border from the Texas town of Eagle Pass, was the Hacienda de San Miguel in the state of Coahuila, Mexico. Calling it a *hacienda* did little to describe one of the largest horse ranches in the world; 650,000 acres of brushy grazing land ideal for raising cattle and horses. The ranch belonged to an American, George D. Miers, who for some reason held a Mexican diplomatic passport as well as a standard American one.

Miers had been in Mexico since the days of Pancho Villa and he had supplied countless cavalry mounts for the Mexican Army. It was said that he could supply a division of perfectly matched horses with whatever markings suited the tastes of the Army. Naturally, my introduction to the old gentleman was arranged through one of A.D. Stenger's contacts. I went down to meet him in March at roundup time — the highpoint of the year. My picture story would take advantage of the presence of the Mexican cowboys, who were also eager to show off their skills in the saddle. At roundup time, they became infected with the wild excitement, the vital energy of the free and beautiful animals they were trying to capture.

I drove down to Eagle Pass, where I was picked up by a small plane and about a half an hour later we arrived at the ranch. The pilot said it would take over forty minutes to fly from east to west across this arid, wild, and roadless ranch.

I never actually met Mr. Miers, but spent the night at the main headquarters as the guest of the ranch manager, Charlie Sellers. The place, like the land it was built on, was sparse and minimal. My final destination, which we would reach the next day in a pickup truck, was twenty miles down a rutted dirt track. There, a group of cowboys, all of them Mexican, were working out of a chuck wagon — the mobile home of the day — rounding up the horses by day, sleeping on the ground, and taking their meals dished out from the chuck wagon, which moved along with them.

Despite the "romance" of the cowboys, my story would be focused on the horses because 12,000 mustangs was a tremendous number even by the standards of the 19th century, when North America's wild horse population reached its peak. Legendary Texas author J. Frank Dobie declared mustangs as "different from domesticated horses as a panther is from a pussy cat." His countless stories described their ferocity, intelligence, and beauty. They were descendants of Spanish stock that came to the New World with the Conquistadores and were thought to be part Arabian.

The mustangs on Miers' ranch were the largest concentration of wild horses in North America. The herds lived as they did on the plains, divided into small groups of 25-50 mares ruled by a stallion. A stallion maintained his harem with iron discipline, keeping his *mestenas* in a tight group that he would keep far enough away from competing stallions to avoid confrontations.

Having arrived on the scene, I looked at my situation. Most of the work would have to be done on horseback, and I would have to keep up with Mexican *mesteneros* (mustangers) who were as accustomed to work on four legs but I was only comfortable on two. I hadn't been on a horse's back since childhood. My photo gear was another matter. I carried two cameras with five lenses and a tripod. In order to avoid being tangled in my own equipment, I packed everything into two foam rubber-lined army gas-mask bags, tied to the saddle. The gear, along with seat of my pants, was going to take a terrific beating bouncing behind the saddle. Later, developing more confidence, I strapped the bags to myself.

Then there was my Spanish, all ten words, and dealing with the cowboys, who were proud, tough, and didn't particularly like *gringos*. The work they did was hot, dusty, and dangerous; seven days a week, fifteen hours a day and they earned $15 a month. No wonder they didn't like Americans.

The cowboys conducted the roundup in pairs, fanning out at full gallop, chasing the stallions and their mares into a trap that consisted of a massed herd of 50 domesticated horses that had been brought along for this purpose; there the newcomers quickly mingled. This was done, over and over, until the foreman decided that the men had accumulated the horses they needed. It was amazing how wild mustangs in flight were calmed and immediately settled down by the domesticated horses. All of this I followed on a galloping horse.

The land was flat, with an occasional gully or outcropping. It was rough, dry, and hot, even in March — with very little vegetation except mesquite and cactus. Because of the heat I packed rolls of exposed color film in the middle of my sleeping bag.

The main problem, however, was not the climate, but my transportation, which even to my unpracticed eye, had serious defects. The scrofulous beast that was supposed to be my horse appeared to be blind, deaf, dumb, and broken down in all respects. Although I had brought a tripod to steady my camera, I was tempted to use it to clobber the damned horse. I needed another horse, but the Mexican cowboys seemed to get a kick out of watching the *gringo* struggle with this uncooperative mount, despite the fact that I had a letter from the Mexican Consul General's office in New York asking everyone to extend me cooperation. I showed it to the horse and he ate it.

The night of my first sunset with the group, after the cook had killed and boiled one of the numerous stray goats we came across, everyone spread out their sleeping bags and we sat around the campfire eating corn tortillas, washing down the whole thing with a Mexican version of coffee. Then the singing began, except for me. I couldn't sing and didn't know any songs. The cowboys sensed that I was tuneless, but never failed to ask for a contribution. This wasn't graciousness; it was part of my torture and especially embarrassing because I knew that they knew that this *gringo* wasn't at home on the range.

Then I thought of my Sami friends, who had taught me some weird *"yoiking"* on the reindeer migration the year before.

"Si, I sing!" I announced to my startled *compadres*.

It was clear that the only thing that would serve the purpose "melody wise" would have to be off the charts. Gathering all the extra pots, pans, spoons, knives, sticks, and bottles, I gave one to each cowboy. Explaining as

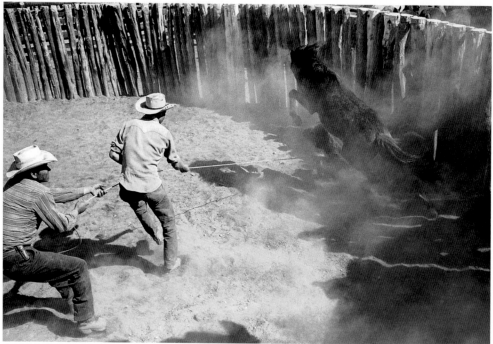

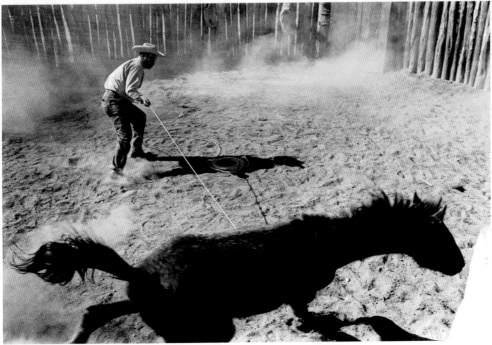

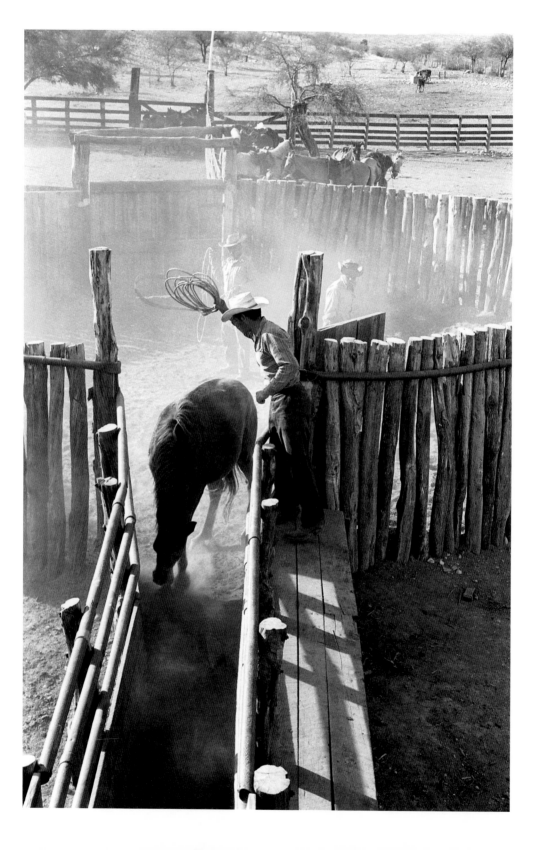

best I could, and instructing each musician to make a special sound with his "instrument" or with his voice; we were going to have an international concert combining the finest traditional music of Lapland.

One fellow was to sound like he was getting sick, another giving birth to twins, getting his throat cut, a jackass braying, etc. I then started directing, my left hand banging out the rhythm with a long handled spoon on the coffee pot, my waving right hand leading the orchestra as I let out my interpretation of a yowling Samisk *yoik*.

Mexicans are musical by nature and they needed no encouragement, throwing in a *"mariachi"* flavor, they further spiced up an already exotic recital. A couple of cowboys almost burned up, falling into the fire laughing and they kept me up half the night doing it over and over again. In the morning they were still laughing. Before we saddled up, however, a new horse was suddenly produced for me, and from then on I was an honored guest among the mustang catchers. Instead of *gringo*, I was now *maestro*. That was the end of my equine troubles.

21 – **FISHING IN MEXICO**

When I returned to Austin, stories of my Mexican cowboy orchestra earned high marks from A.D. Stenger and his friends, one of whom got me to "tell it all" on a local TV program, where I also threw in some tales of polar bears. More importantly, however, my photographs of the mustang roundup turned out quite well and were sold to *Esquire* magazine. Visiting the Stenger home again also provided me with inspiration for my next "assignment." I saw again the giant Alaskan crab above the sofa that had plagued my nights, but now I took in a huge marlin trophy that was mounted on the wall opposite. It called out to me. I had recently read Ernest Hemingway's *The Old Man and the Sea* and the image and the story clicked in my mind.

I had actually met Hemingway once. In 1953, my brother Gamble and I visited Cuba. We were on our way to Haiti, where I would make my first attempt at snorkeling. But the most interesting moment occurred in Havana at the *Bodeguita del Medio* bar, where I met the author, a year after *The Old Man and the Sea* was published. (He won the Pulitzer Prize for the book and in 1954 received the Nobel Prize for Literature.)

I don't remember what Hemingway and I said to one another, and my snorkeling in Haiti didn't amount to much, but when Stenger described one of his fishing trips to Mexico, I decided to combine the two things and become the first person to take photographs of marlin and sailfish from underwater. After somehow accomplishing this, I would travel to Idaho to find Hemingway, offer him my pictures as a gift, and pick up the conversation where it left off in Havana.

This was the way I would meet, interview, and photograph the great writer, just as I had Picasso. But unlike Picasso, it wasn't trying to meet the author

that I was afraid of, it was the fish part. I had no idea how I was going to manage this. I had a dream, I was using my imagination, I was scared shitless — this was not cod trapped in nets.

Monica and I packed up and were soon on our way to Mazatlán on the Mexican coast opposite Baja California Sur. Crossing the border at Villa Acuña, we passed into the clutches of Mexican Customs on a weekend. My cameras and diving equipment, from their point of view, were a prince's ransom of declarable items. Paying a local boy $2 to carry my gear would have spared me a lot of inconvenience and expense, but I didn't do it so we were stuck in a ramshackle hotel in the tiny border town, filling out complicated paperwork that held us up until Monday. This was a stupid mistake. I had been in Texas too long, and the exaggerated self-assurance I had learned there didn't work in Mexico, so I began to change my ways.

Villa Acuña was an ancient town. Perhaps Cortez himself had laid out the waterworks and the sewers too, and had they possibly combined over the centuries? What was a certainty, however, was for a *gringo* to drink the local water was playing Russian roulette, with a pistol pointed at my guts. Monica knew this, and had been instructed by her doctor father on the horrors of non-Scandinavian water. She had loaded herself with a good supply of Entroviaform, an intestinal bug-killer, and she chucked those down with daily regularity and encouraged me to do the same. As a reluctant pill-swallower, I resisted but watched horrified as she belted down Entroviaform followed by a glass of tap water. This was like applying a Band-Aid, then shooting the spot with a pistol. The results were similar, but the blast came from the other end. The poor girl became very sick. She was uncomplaining as usual, but I could have worked up a higher degree of sympathy if she hadn't been so accommodating to those Mexican bugs.

Finally we were on our way in the Nash Rambler, an automotive equivalent of *Titanic*. As with the boat, we began to have water pump problems — major overheating, deadly smelling vapors poured out from under the hood as if we were a steam engine. Johan Sørensen was far away, but his spirit guided me: we stopped by a bridge and lowered a red plastic bucket into the brown torrent. I couldn't wait for the mud to settle out because coolant had to go into the hot engine while it was still running; I didn't want to crack the block. The muddy water did the trick, and we were soon off to the next town, where a mechanic fixed the water pump; Mexican mechanics can fix anything.

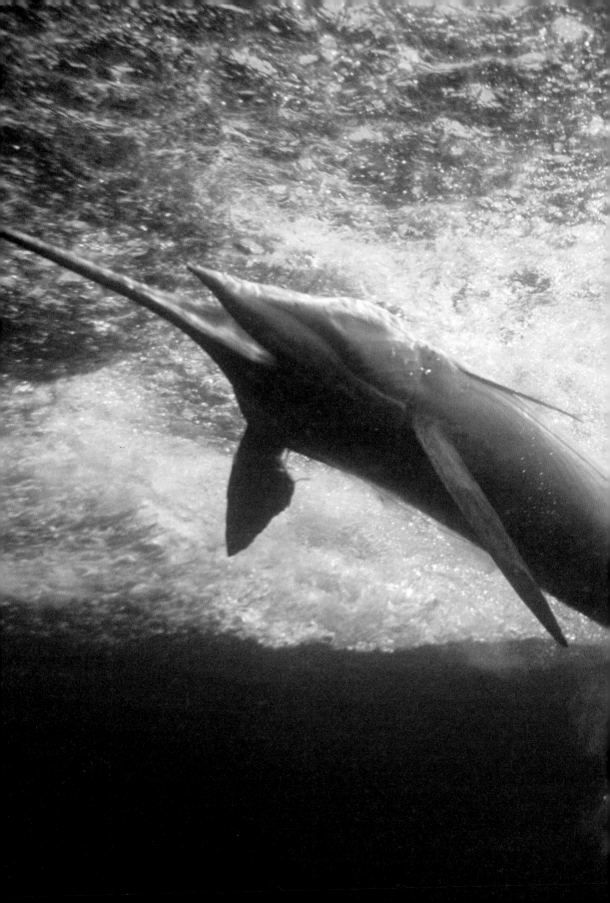

Approaching the Sierra Madre Oriental from the east, we found the mountains sparse and thinly forested, but tipping over the top to the west side we met the weather and winds of the Pacific. The world became tropical. From silence to sounds of the life coming from the green dense, dripping, cloud-cloaked jungle.

After two days we arrived at Mazatlán, a sprawling waterside city with a delightful mild palm-studded climate, on the same parallel as Honolulu. Streets busy with cars, people, and horse-drawn carts wove their way through a low-key mixture of colonial and humdrum modern architecture. Mazatlán's main attraction for me, however, was the huge fish trap where the Sea of Cortez and the Pacific met off the coast. There, A.D. Stenger told me, marlin and sailfish could be found in abundance.

First, we needed a place to stay; hopefully one that was free. This was not a "sleep in the car" kind of a trip. Among other things, my equipment needed to be safe. So I went along to the Tourist Bureau, and showed them a fistful of "to whom it may concern" letters from *Sports Illustrated*, *Esquire*, and other American magazines as well as the one from the Mexican Cultural Attaché in New York procured earlier. The ladies in the agency were both charming and helpful, and we soon found ourselves in the Hotel Belmar in a room that was comfortable, secure, and, best of all, free. The arrangement didn't include meals, however, so we soon became familiar with the street vendors who operated behind the hotel and provided tasty varieties of inexpensive fried tacos.

Eating on the street would seem to be a danger for tourist stomachs, but the flies that buzzed the streets of Mazatlán weren't crazy about the boiling oil that fried the tacos. If you were careful about drinking only bottled water and avoiding salads you had a fifty-fifty chance of holding stomach afflictions at bay.

Having solved the logistical problems, it was time to go fishing. The docks were headquarters for many sports fishing boats. With no way of evaluating one skipper over another, I began with the most prominent display sign on the dock: The Indian Fleet of Mazatlán.

Louis Patron, owner of the Indian Fleet, thought I was crazy when I told him I wanted to photograph marlin and sailfish from underwater. "Look at the stern of this charter boat," he said, and he led me down to a boat that had what looked like a bayonet, driven into the solid mahogany transom, a foot above the

water line. "When we go into dry dock every year, we pull five or six of those out of every boat. That marlin's spear drove through three inches of solid wood."

Although he was dubious about my ultimate goal, Louis agreed to let me tag along on some of his charters. He said that in Mazatlán, in May, the marlin and sailfish were jumping in the great fish trap of the Sea of Cortez. "It's best to make a couple of dry runs, in order to learn something about their behavior." So I headed out on my first trip on one of Louis' boats, which had been chartered by Marshall Barth, a corporate executive from Los Angeles, who graciously let me come along.

I began to learn about fishing from José, the Captain of our boat, who sat on top of the cabin to get more elevation for fish spotting. He steered the boat with a bare foot, stuck through the window. The mate was also on top of the cabin, scanning, ready to assure me that what I saw was a bird, a turtle, or a shark, not a billfish. Often on a calm day, marlin or sailfish would lay on the surface with their tail and fins exposed, sunning themselves. The crew could spot the sickle-shaped fin of a marlin snaking through the water from half a mile away. My Spitsbergen experience counted for nothing here.

The first marlin was a complete surprise, a blind strike; no one had seen it in the water. The line tore off the big Penn Senator reel with a whine — a sound that goes straight to the heart of any deep sea fisherman. Marshall Barth freespooled the reel, released tension on the line as the crew leaped into the cabin. The boat accelerated, Marshall set his drag, and the sun canopy was thrown back as Marshall whipped his pole back and forth. The fish was hooked and the battle was on. It took Marshall forty-five minutes to bring in the fish. The marlin would come close to the boat, Marshall reeling in like crazy to keep the tension on the line, and we thought we had him; then off he would go, taking line like a tiger on a thread. Finally the great fish was boated. Marshall was triumphant.

As I watched the speed and power of this beautiful fighting fish, a 200-pound blue marlin, I thought to myself, "I'll need a submarine to do this job." From here on, I realized, anything can happen, and this is where my problems began.

I went out several more times with José and his mate, but didn't get my feet wet. It was going to be impossible to use an aqualung; I wouldn't have enough mobility with a heavy tank on my back. I'd have to be snorkeling. A billfish normally feeds by stunning its prey with its beak, used as a whip not as a bay-

onet. But I didn't want to be spanked *or* bayoneted, the unintended target of a frenzied marlin.

Marshal Barth had gone home so I was now fishing with different men and different crews. I had good luck with the fishermen; they were, without exception, cooperative, but now it was time to see what was going on below the surface. It was time to do a wet reconnaissance. And on my next trip, shortly after we hooked into our first marlin, I jumped in. The fish was a 100 yards from the boat. Following the line out to the fish with my Rolleimarin camera, I had barely approached the marlin and shot my first picture when the big fish came straight at me, and then swerved off about fifteen feet away and headed for the bottom.

The fish was gone. I looked around for the line, but it was gone too, pulled by the big marlin. I yelled to the boat, but they were all occupied with the catch, which was now 300 yards from my position. I swam hard toward the marlin, which was zigzagging all over the ocean, and I was getting pooped; the boat was half a mile away. Waiting for the boat to get around to picking me up, as I floated, I began to meditate about sharks. There had been a lot of them in the area, but somewhere I had heard from some hopelessly misinformed person that a shark is a terrible coward and stupid and can be frightened by blowing bubbles. So I started practicing making bubbles. After paddling around for a half an hour, intense loneliness was creeping in the direction of panic. I was twenty-five miles out at sea, peering down through the clear Pacific water at my flippers toward a bottom that just got darker and darker, and all the while the boat was getting smaller and smaller.

I didn't have to test my bubble-making skills. I was finally retrieved, with no shark bites, no marlin spears; everything was fine, but I didn't let on that I had become a very nervous swimmer. I had made *one* photograph, so it could be done, but there must be an easier way.

The marlin that day had put up a fantastic fight when they got it back at the boat. "You should have been here, the action was terrific, and you could have gotten some great pictures," I was told. I decided to change my tactics.

Thus began a long drawn-out campaign to capture the billfish at peak action underwater. This involved six weeks in Mazatlán and six more in La Paz Baja, California.

As the weeks went by, the fishing was wearing on me — but in a completely surprising way. The sleepy, 5 a.m. breakfasts at a Chinese restaurant — the only place open at that hour in Mazatlán — was getting weird. Here I again met more "sea creatures" — this time — sliced and diced into my fried rice. They began to say: "Why don't you leave us alone? Switch to vegetarian. Try dry land." Was I getting 'underwater fatigue'?

I wrote in my journal: *My God, the fish are beginning to talk to me — and I thought it would be so easy to just say, "Hello. Mr. Hemingway" the same way I wrote Picasso. I need to finish this dammed job.*

Every night — depending on my luck — I was developing Anscochrome color film in my hotel room. By 7 a.m. I was aboard another charter boat and we were off. By this time the captains and crews knew me and told stories about me, so it became easier to find fishermen to take me along but harder to want to go. The fishing grounds were 20-25 miles out in the Sea of Cortez so there would be no action for at least two hours. Dropping onto the nearest bunk, I would be fast asleep in two minutes. Hearing the now familiar sing of the line streaking off the reel, the sudden roar of the engines, shrieks and yelling, I dozed on. I had learned to judge whether the fish had gotten away or whether I had to go to work.

After twenty-five boat rides, I had become a strong sleeper. At the right moment, however, I was up, put on my fins, grabbed the Rolleimarin, and was in the water, shouting a last request not to boat the fish until I get some shots. In the water it was a different world; I became acutely alive as a fish made its final death struggle.

Some of the crews were a problem. I was no longer a novelty for them. Most would cooperate, and one huge old man who worked on the dock gave me a bear hug every time he saw me, but there were those who were concerned that somehow my fooling around in the water would result in the loss of a catch for a customer. That was not good for business, and a few times I was the cause of fish being lost, but the paying fishermen were good-natured about it, enjoying the circus I provided. A few boats, however, refused to take me out; the captains were sure I'd be killed and they didn't want the responsibility.

The charter customers were sometimes a problem, but for different reasons. Their experience varied from novice to expert. Every fisherman was as different as the fish. The crews were professionals, but they couldn't always

control the situation quickly enough to make conditions in the water reasonably predictable. Sometimes I wouldn't dive in if the marlin was very big or the fisherman didn't know what he was doing. Decisions were based on circumstances beyond my control and the conditions of any dive depended a lot on luck. It was a rare day that I got more than five or six pictures.

One day, I was out with two Texas bankers. I don't remember which one was doing the fishing, but I was in the water. I maneuvered around to watch the fish; each has its own personality, some are more aggressive than others, regardless of size. The marlin seemed to have worse tempers than sailfish. A lot depends on where the fish is hooked and, of course, how the fisherman and the boat's captain play it. Some captains open up the throttle after a fish is hooked. The fish is literally dragged along the surface, fighting, of course, but the motion of the boat keeps the fish skipping on the surface and the action is terrific — for a few minutes. The fish puts up a spectacular show, but when exhausted it comes into the boat like a whipped dog.

This particular sailfish was a good size, about 125 pounds and full of life, giving a fierce battle a few yards to the stern of the boat; my favorite position to get the best pictures. As usual, the minute I got into the water the sailfish swam to the opposite side of the boat. If I went to port side, the fish always went to starboard, probably thinking I was a shark. The Texan with the rod was having a battle with this one, and I decided to dive immediately to get the action. Having no aqualung, I stuck my bottom up and my head down and swam down to a depth of 15 feet, where I usually began taking pictures. As I started down, I felt something rushing by me, but my head and mask were pointed straight down, so I saw nothing. I jerked up, looking toward the surface, still not fully realizing what had happened, when I saw the bubble-filled water churning with the rush of the sailfish as it went by me. There was more boiling activity and as quickly as it happened, the fish was on the other side of the boat. As I popped up to the surface I still hadn't completely realized what a close call I had had. The Captain crossed himself, the mate mopped his brow, and the Texans looked thoroughly shaken. The sailfish had charged me as I was going down and the Texan with the rod reacted instantly by hauling back fiercely. He was unable to hold the sailfish, but the jerk of the line was enough to deflect its head, and the three-foot spear missed me by a fraction.

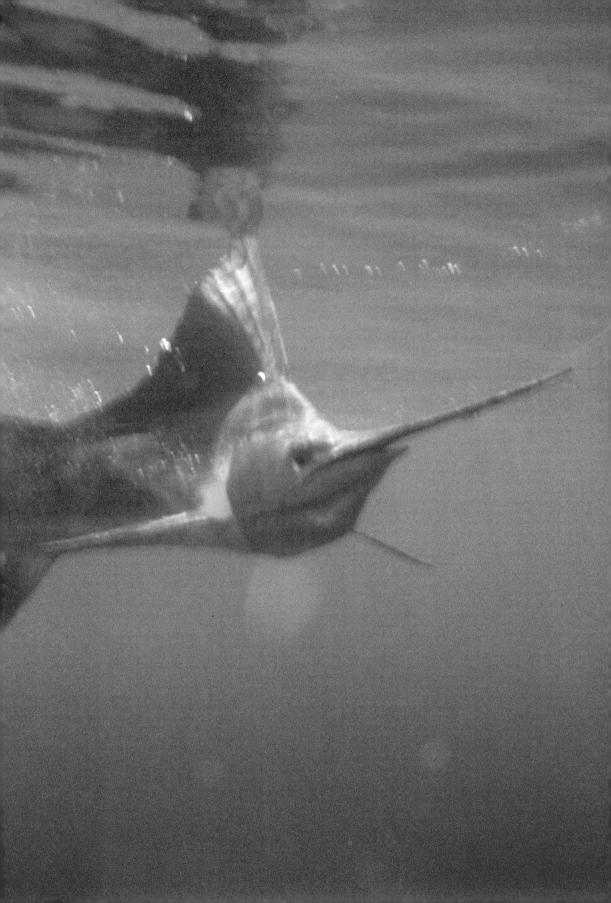

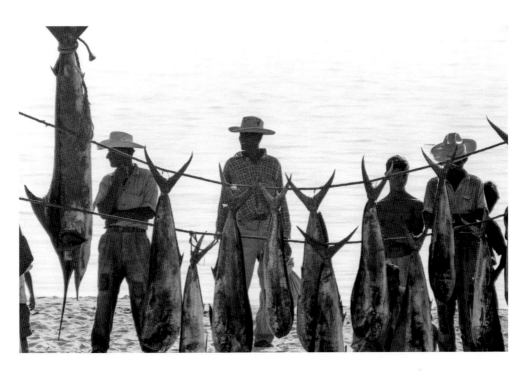

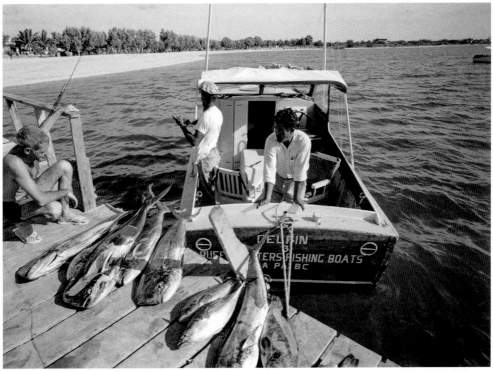

Four times this happened under much the same circumstances. My respect for billfish became fully developed. Once, while fishing with Bill Stuart, a TV producer friend who had heard me grousing about not being able to get good close-ups, generously arranged a special trip for photography and hired a boat from Mike Maxemin. Bill was pleased to be able to accommodate me as well as have a go at his first billfish.

We set out and he quickly hooked up with a particularly lively marlin. Finally, I could work with the fish as long as I wanted; he and the crew would delay bringing the fish on board after it was exhausted. Bill was a terrific jokester, a condition that I had always enjoyed on dry land, and here he decided to be amusing about some of the things I had been complaining about. Bill would yell "Hurry up, we haven't got all day." Then he remembered that I had been trying to get a close-up. The marlin was practically dead at this point, or so he thought, and there was no harm in a practical joke. So Bill yelled, "How are you doing?" "Fine." "Well, here he comes," and Bill threw the line into free-spool, releasing the brake on a thread of fishing line that separated a deadly spike and me. Well, sensing the relaxed pressure, the marlin found a burst of energy and moved. Fortunately, I had a head start, and then Bill woke up, but not before the frantically lunging marlin's bill had cut a four-inch groove in one of my swim fins.

Toward the end of my stay in Mazatlán I had another opportunity to have a boat to myself. One of the charter operators, Gil Avilez, lent me one of his boats and came along to do the fishing himself. Monica came along for the ride. We hooked a sailfish early, but I was disappointed to find a shark on his tail. The next fish we caught was cut loose by the propeller before the action could be photographed. We saw more sharks than usual that day. Normally, during the course of a day, we might see ten, but today they seemed everywhere. The crew warned me, but I was so disappointed at losing the first two fish that I was ready to jump in no matter what. I had my own boat for a day and this was too good a chance to worry about sharks. We hooked another sailfish and I was soon in the water getting some nice pictures. It was a real luxury to have the time I wanted with a fisherman who knew what he was doing. I shot a whole roll of twelve exposures. Getting out of the water, I loaded a new roll of film and went back in again. By now the sailfish was dead and the water was full of blood. Then I found myself surrounded by three sharks.

This was a bad situation. Blood has a very strong effect on shark behavior; they tend to go into a feeding frenzy under such conditions. The sharks were not very large, perhaps five to six feet long. I had drifted away from the boat, but I reckoned that I probably couldn't get back into the boat anyway without a very bad bite, which would have left me bleeding to death twenty-five miles out at sea. Gil Avilez and his crew immediately threw out freshly baited hooks trying to snag my tormentors. My face mask has a narrow field of view so it was impossible to keep all the sharks under observation. I would look at one four feet to my left, then turn to see another circling a few feet to my right. Looking down, I'd find one three feet from my bottom. I decided to stay on the surface, which, according to the experts, was not the place to be. The sharks didn't pay the slightest attention to the mullet being thrown in by the crew; they didn't even seem interested in the bleeding dead sailfish, focusing on me as the main meal of the day.

Over the weeks, I had begun to develop sympathy for the billfish. They were beautiful and gallant and I began to hate seeing them killed for sport. These sharks, on the other hand, seemed hideous at close quarters, monsters with flat broad heads and expressionless pig eyes, behind which were brains the size of Ping-Pong balls.

They would eat tin cans, shoes, Coca-Cola bottles, anything — including me. I couldn't think of what to do. I blew bubbles every way I could. I yelled to Monica to throw me a line. Unfortunately, she obeyed my order to the letter and failed to hold on to one end of the rope. What did she think? Was I going to tie up the sharks or try to lasso one? Then I decided the best thing was to do nothing — stay calm and move slowly toward the boat, praying they wouldn't hit me before I got there. The only way to keep my nerve was to cut them down to size with my camera. The focusing prism of the Rolleimarin reduced everything to a $2\frac{1}{4}$ x $2\frac{1}{4}$ inch image, so I concentrated on focusing on the sharks and shrunk them to the size of tropical fish. After my eighth picture I found myself close to the boat, and the Captain threw the engine into fast forward, creating a cloud of bubbles in the water. This briefly scattered the sharks, and at that point I grabbed another rope that had been thrown overboard and rose out of the water like a hooked marlin — along with my fifteen-pound Rolleimarin, light meter, and flippers, right into the boat.

I nearly turned in my flippers after that experience. Then we moved across the Gulf of California to Baja, California and after a few weeks of languishing

in La Paz's plush Los Arcos Hotel, my nerves gradually returned, but not completely. I was fishing with a friend, Bill Callahan, an Irishman who ran a charter fleet in La Paz, and he was questioning me about the day's underwater excursion. It had been a good day, a curious one in fact.

I had been photographing a hooked sailfish and was surprised to see the hulk of a fish flash by me. For a minute, I got a taste of the old shark panic, but the fish turned out to be a marlin — a big one, swimming free. He kept his distance, about twenty feet, and I got a few pictures of him as he circled around me. I was curious to see how long he would hang around and I set the movable dial on my Rolex diving watch to time him. It was amazing that the fish was so curious. He kept it up for fifteen minutes. I couldn't help but feel a bit nervous, but I kept on working until a big shark showed up and I got out of the water.

Bill seemed surprised that I had been unconcerned about being with a big free-swimming marlin and various hooked sailfish, but would run from a shark. "You have been in the water with thirty-three billfish and that didn't kill you, and you know how stupid a shark is. Besides, he's a born coward. What's the matter with you?"

"Callahan, old buddy, the shark may not be such a bright fish and he may be a coward, but since I began this job I have become a brighter fish and a bigger coward; besides, a shark has brave teeth."

The sad postscript to this story was that Ernest Hemingway and I didn't have our conversation. On July 2nd, 1961, just as I was completing my underwater homage to him, Hemingway returned from the Mayo Clinic to his home in Ketchum, Idaho, and, suffering from acute depression, killed himself. Thinking about Hemingway had kept me going during some tough parts of my long underwater siege, but now I was ready to dry off and try something else. I had my dream, had used my imagination, overcome my fear, and acted. I was very sad that I couldn't deliver my gift and meet another great man I didn't know but who I admired.

I was upset that he had killed himself, something I had nearly done myself, but for different reasons. Hemingway chose to depart from life, but I chose to emphasize it by testing myself in a way that I thought he would completely understand. He canceled a conversation that I deeply wanted to have. I had risked everything to earn it and felt cheated not to get it.

Back in the States, I sold the billfish work to *Argosy*, an adventure magazine, and *American Sportsman*. Then I went to Washington, visited the editors of *Smithsonian Magazine*, and wound up with a cover story using my bird pictures from Bear Island.

On that Washington trip, I took the opportunity to talk to a shark expert, Dr. George A. Llano, who at the time was at the National Science Foundation as Associate Program Director in the Office of Antarctic Programs. I had eight transparencies of the three sharks that I had encountered in the Sea of Cortez and got them identified; they were white-tipped sharks. The 6x6 Anscochrome color transparencies were not very good, perhaps a little shaky, but Dr. Llano found them valuable, and I gave him the slides I deeply regret that bit of impulsive behavior because, irrespective of their quality, they became very important to me. The lesson learned was that even bad photos might become valuable; as time passes they can create surprising pathways to the past. Those images touched circumstances that had to do with my relationship to the sea, a place where I was a vulnerable stranger asking permission to connect intimately with a world that I only understood from above its surface. Those souvenirs profoundly described a moment of survival where all the rules were different. My bad shark pictures also were reminders that Lady Luck had helped me out one more time.

My Nash Rambler had been parked in Culicán after the roundtrip air flight to La Paz, Baja California, so our return to the United States had been made via Arizona rather than Texas. I was, therefore, unable to brief A.D. Stenger about my billfish adventures or my next disaster.

When we crossed back across the blessedly sanitary borders of the USA, where Entroviaform is unnecessary and intestinal bugs are considered immoral, illegal, and un-American, Monica and I celebrated the moment by stopping at a supermarket and buying a gallon of cold homogenized, pasteurized apple cider. It was Arizona and hot. I sucked on this cool jug all the way to Tucson. Just on the outskirts of that great city I had an internal explosion. All those unnaturalized bugs from Mexico got into a terrific battle with the homogenized bugs from Arizona and the combat was furious. I was forced to the side of the road immediately, without concern for my convenience, privacy, or dignity.

The situation was desperate, and with the exception of some vague blue mountains on the horizon, there wasn't a crevice, ditch, bush, or cactus high

or wide enough to conceal my situation from the stream of never-ending traffic. Monica stood shielding me with a blanket from the passing cars, while I expelled the combatants and negotiated for peace on any terms. Monica held up her end of the blanket admirably; I might have been doing Indian meditation exercises for all she cared. She exercised merciful detachment in the face of acute fundamental embarrassment. That is a good thing to be able to remember about a person. Monica's cool compassion had been unflappable during those low moments in Mexico and Arizona.

There was one subject, however, that Monica had on her mind a good deal of the time, if it wasn't on her mind at all times. It came up and slid into the conversation about once a month: "When do we get married?" This subject had been on the books for years. It would take too long to describe the seismic rumbling that had been designed to inch me toward the altar, but which never quite got me married or permanently busted up. What I needed was more time — twenty or thirty years. I was perpetually torn; there were things that I couldn't stand, yet I couldn't stand the idea of not having her around either. She was a mystery, fresh, unique, beautiful, original, and direct. On the one hand, she was sometimes very bright; for example, she learned Spanish quickly and was basically conversational before we left Mexico. Some of the things she did drove me crazy on a daily basis; once, the spaghetti was boiled in a pot holding detergent-laced water, underwear having preceded it too recently. And when all my photographic equipment was left unlocked once again, we were back on the other track. My frequent bad temper and rollercoaster lifestyle was accepted by her, but marriage frightened me more than sharks.

So, once again, Monica and I separated and, once again, I moved in with my brother back in New York. I felt alienated. Gamble was trying to advise me on a domestic route to economic salvation. He offered to introduce me to a guy who made a nice living photographing commercial products, stockings, for example. Gamble saw better cost accounting procedures as my greatest need. He reckoned that my time allocation per story, divided by my earnings, minus any authorized capital expenses, came out with a decimal point in the wrong place on the cash flow chart.

Although my agent, Florence Kiesling at Lensgroup, was pleased with my progress, I began to dread the endless visits to picture editors at magazines.

Florence would set up the meetings, but I had to do the sales job. Editors were so busy, so swamped with free-lancers. I kept asking myself, "Why don't my dreams act like seeds in fertile soil? Now, I'm a pro, but it isn't easier. Besides, I'm tired and so damn lonely."

It was then that my thoughts turned to Monica. She was beautiful, and she had been my safe base. She had lovely skin, a small elegant head, and a certain mysterious detachment about her, a delicacy. She was also honest. I hated the loneliness without her, and felt that I couldn't continue my education without her — those long terrible testing periods, reindeer migration with the Sami, polar bears, marlin, wild horses, and sharks. Yet I wouldn't marry her because we couldn't talk. And we had no mutual friends; either she was too shy to speak with my friends or her friends bored me. Yet she accepted the uncertain life I had made for myself. When we got back together after one of my excursions, we would have a wild session of lovemaking; but we had no communication afterward. I would soon get edgy, and then take off once more, back to "school," back to forcing my way into new worlds. Playing with the toys of the big boys, or so I thought.

I went to Savannah, but Monica had moved to Atlanta to get a job. I returned to New York to think things over.

On Thanksgiving, Gamble and I went to a party at Norman Mailer's apartment. We knew Norman through his new wife. This was a particularly high-powered event. Mailer, the Pulitzer Prize author and famously aggressive journalist, novelist, poet, playwright, and counter-culturist, had recently married Jeanne Campbell, the daughter of the 11th Duke of Argyll and granddaughter of the press baron Lord Beaverbrook. (She was reported by the most scurrilous elements of the British press to have had affairs with John F. Kennedy, Fidel Castro, and Nikita Khrushchev during the same year.)

The party was packed, mobbed, and it was impossible to speak or hear or see. All my senses were blocked, except for the very acute one of being crushed. It wasn't the resigned, indifferent crushing you get on rush-hour subways. It was more aggressive. These guests, it seemed to me, had the capacity to bash their way to any goal, any level, even if in this case it was only a trip to the bar. I could see the top of Norman Mailer's head at the center of it all, a few feet away. The calypso band accompanied the roar of chin-wagging guests with an elevated beat, but here I was, at the climax of my month in New York — mute,

conversationally paralyzed. Here, I was entombed with the best and the brightest. I couldn't think of anything to say to the beautiful and glamorous jammed next to me. "Hi, want to talk about marlin, wild horses, or polar bears?" I couldn't get up any speed — no forward movement. I crashed and became the loneliest man on the planet.

The next day I called Monica in Atlanta and told her I was on my way. I didn't know whether she would see me or not. She accepted.

We got married in Christ Church in Savannah in December 1961. The wedding reception was held in my mother's handsome house. Friends of my mother as well as mine toasted the new couple. Monica's family remained in Sweden so the wedding reflected only the conditions of my mother's background. Neither Monica's past nor my current lifestyle had a place here. The elegant reception was conducted in a house filled with ancestral portraits, antique Persian rugs, family furniture, some of it collected in Lausanne and Florence. There were also beautiful decorative screens painted by my mother that discreetly revealed her artistic talent and sophistication. As the coffee flowed from the gleaming Georgian silver service, *New* was declared tolerable; Monica was welcomed.

I wanted to invite some old friends from the Georgia Ice Company, the foreman of the engine room, Johnny Clanton, and Buddy Waters, the mechanic. "They wouldn't feel comfortable," my mother informed me. So a special event was created at the factory to celebrate with my pals from those first difficult days fifteen years earlier. I have never forgotten this and regret I didn't have the courage to stick to my instincts. She was probably right. They might have felt out of place in her home, but I would have been more comfortable than embarrassed, and perhaps they would have had the same reaction. It would have been the right thing to do.

When a friend congratulated me, saying, "Now you can be considered a serious person," I interpreted this as meaning I was now under control of some higher power. Again, I had to rip myself free of the velvet grip of the past and the process began almost immediately. I was no longer lonely, and I eagerly jumped into the next adventure, that was bigger than ever. My dreams were back.

22 – PREPARING FOR POLAR BEARS

My experience in Texas and Mexico had restored my confidence. The "odd-man-out" mood that had crept into my bones in Spitsbergen was chased out by my flamboyant relationship with A.D. Stenger. A dose of Texas bravado and generosity melted down a chilly core of self-doubt. Texas had been an environment that I had needed. Now, I was ready for more polar bears. This time I had to be prepared, at least as prepared as I could get with no money. After my success with billfish, I was further inspired to pick up where *Titanic* had left off, finally accomplishing my dream of getting pictures from a new angle — under water.

My principal asset was a pocket full of bear pictures and a hell of a good story — a combination that had tested well in Texas.

At the end of August 1961, I came up from Savannah to New York to see if I could find a more practical approach to working in Spitsbergen — starting with a proper hunting ship with a full crew, capable of surviving bad weather and ice.

My first stop was the New York office of the Arctic Institute of North America, where I looked up Dr. Walter Abbott Wood, the director, who was also a member of the Explorers Club. I had met him through my brother, but he had also known my father in Switzerland, where they shared a passion for mountain climbing.

Although the Arctic Institute of North America was the logical place for help, advice, and moral support, it was the Explorers Club that deeply attracted me. The club was a repository of like-minded mad adventurers and established heroes, whose congeniality was stirred like a well-mixed martini at a fashionable address on East 70th Street. Its ornate Victorian interior was beautifully

appointed with stained glass windows illuminating the saints of exploration. Tooth and tusk on the walls commemorated a Noah's Ark of exotic animals that had been slain and stuffed — power symbols to honor the explorer-members of the club. Exquisite Persian rugs hushed the occasional traffic. It was Texas with old-world taste, with white heroes and a few "friendly natives" depicted here and there. I loved the idea that the Explorers Club's testosterone spirit converted red blood to blue. It reflected the grandest aspirations of what I was expecting to come my way had I survived St. Mark's. Good stories were in but bragging was *out* and even the mightiest exploits were writ in tiny type. A self-congratulatory hint was the loudest voice ever needed and a sprinkle of self-deprecation spiced things up. This position was earned by adventure rather than social or economic circumstance — or so it seemed. Ironically, I thought that I had grown out of such thinking, but given a chance, it all came roaring back. But things weren't as I imagined. I got it wrong. An important detail was missing. I was either institutionally or academically inadmissible, just a crazy kid with wild stories. This was never stated but all my hints and hopes produced no key that would open a polite door of silence. Dr. Wood's reaction to my stories was discouraging. It seemed that the places I had been and the things that I had done were indications of reckless immaturity rather than scientific rigor. And so, without advanced degrees or scholarly support for my undertakings, I flunked getting help from the Arctic Institute of North America and Explorers Club membership. This was a big disappointment, but they were probably right. My investigation and documentation of the lives of polar bears needed to be reformulated. Nobody was taking my project seriously. This wasn't Texas. And so, having found that my lack of "academic credibility" according to Dr. Wood was a liability, my approach changed: if I didn't have it, I would recruit it.

I began with an acquaintance of mine, DeCourcey Martin Jr., an odd fellow who happened to be a trained biologist, and directed a commercial analytical laboratory, Shuey & Co., in Savannah. His company inspected merchant ships and determined from odors in their holds whether there were toxic undesirables lurking in their cargo. Although social gossip in Savannah described him as a "ship sniffer," his work was complex and scientific. His skills might seem better suited to a well-trained hunting dog, but DeCourcey's academic credibility was substantial.

DeCourcey was a bachelor from nearby Bluffton, South Carolina, with a manner that was courtly beyond comprehension. His elaborate salutation was theatrical, a cross between the Elizabethan court and *Gone with the Wind*, with a touch of Madame Butterfly. During earlier visits to Japan, he had taken its culture to heart. Conversation with DeCourcey included deep sweeping bows both rhetorical and actual. In spite of his somewhat bizarre social behavior, he was a pleasant fellow and, most important to me, he was able to supply an impressive list of contacts that I put to work immediately.

Dr. Gene Odom, a professor at the University of Georgia, was one of the top biologists in the nation and an early leader of the ecological movement developing in the 1960s. Both *TIME* and *Newsweek* had written about him and DeCourcey offered to introduce me. We drove to Athens, Georgia to meet the scientist. Although polar bears didn't inhabit the coastal tidelands of Georgia (his area of special interest), his work was holistic, with an inclusive approach to ecology that left him open to systems that operated elsewhere.

Dr. Odom told us that he was happy to help, and began by suggesting the names of other scientists who were to become crucial to my project. He was the first scientist with a national reputation who actually thought that my revisiting polar bears had possible merit. He supported the idea that my having traveled widely in the Arctic already and photographed bears had great value.

Dr. Odom's encouragement was a huge psychological boost, and with his advice and a letter of recommendation, I set off for Washington, D.C., where government and other institutions seemed to offer promises of support for my now more scientifically based investigations in Spitsbergen. To decorate my résumé, I invited DeCourcey Martin to be my first "scientific" collaborator.

In early September 1961, I moved in to become the frequent house guest of my friends Robin and Eleanor Glattly in Washington. Their guest bedroom and coffee table became headquarters for all my future Spitsbergen fantasies. Their hospitality was essential to the project. Unable to judge whether my polar bear story was behind the times or ahead, I began looking for an angle that took me beyond the obvious — a story with larger implications.

At this time, the Cold War atmosphere was blooming with mushroom clouds from the Soviet Union. Newspapers and magazines were filled with news about atomic bomb tests on Novaya Zemlya, a Russian archipelago

roughly 600 miles east of Spitsbergen. The Soviets had set off 31 devices, 21 of them on Novaya Zemlya. One Soviet 50-megaton device set off on Novaya Zemlya was equivalent to 2500 Hiroshima bombs. Clouds of radiation circled the globe. Countless magazine and newspaper articles in the United States documented the Soviet threat to world safety. Although the winds had carried the radioactive clouds in an easterly direction around the globe, I knew from experience that the ocean currents brought ice, snow, and Siberian timber in the opposite direction. They came from Novaya Zemlya directly to places where I was interested in finding polar bears. Here, we could chase radiation as well as bears. DeCourcey Martin's résumé fit the picture perfectly.

With Dr. Odom's letter in my pocket, I decided to try my luck by contacting Senator Richard Russell, not only a fellow Georgian but also Chairman of the Senate Armed Services Committee.

Putting a dime in the slot of a pay phone was as easy as pulling the bell at Picasso's Villa de la Californie in Cannes; but again came trepidation, voices screaming, "What the hell are you doing?" As the coin hit bottom, the ringing started and then an elderly voice announced that I was connected to Mr. Leeman Anderson, Senator Russell's Administrative Assistant. The following breathless spiel drawled out of my mouth without pause, driven by non-stop panic and it went something like this:

"My name is Fred Baldwin and I'm from Savannah. I recently had a conversation with Dr. Gene Odom from the University and discussed with him a situation with polar bears that I had visited in the vicinity of the North Pole last year. I'm planning my second expedition to the polar bears in a place called Spitsbergen, which is only about 600 miles from the Soviet nuclear tests on Novaya Zemlya. I'm bringing along a biologist who has experience measuring radiation and we feel it would be important to determine the effects of the bomb fallout on these animals and other aspects of the Arctic environment. The Soviets will probably be doing more testing and I wanted to get some advice from the senator to whom I should direct inquiries and whether he felt this would be in the national interest..."

This description only partially does justice to my condition as I stood on the street in Washington making a call from a public pay phone to the office of one of the most powerful and senior senators in the United States government.

As I had with the Ku Klux Klan, I did my best to adjust my accent to languid softer tones while all same sweat glands were getting a workout, just as they had when I visited Picasso seven years earlier.

There was a long pause, and then, in a very quiet, almost raspy whisper in a deep Georgia accent, "I don't believe that the senator has ever had a request about polar bears. Could you get over here by one o'clock?" I made my way to room 3521 in the Senate Office Building (later named after him) with dispatch.

Leeman Anderson was an ancient gentleman. He had been with Richard Russell before I was born, and came to Washington with the senator when he was first elected in 1933. He looked at my polar bear pictures and Dr. Odom's letter very carefully and took note of the word "fallout."

"I think that Senator Stennis should see these, too," and he called Dr. Tom Fontain, an administrative assistant of the powerful Mississippi senator. Dr. Fontain was out, but clearly I had set off something of my own.

The next call was to the Pentagon. Leeman Anderson made contact with somebody. It was not a long conversation because the recipient instantly recognized his voice. I heard my name mentioned and the only question the Pentagon asked was whether I needed to be picked up or could I make it on my own. The appointment was set for that afternoon. I was given a name, Captain W.R. Anderson. Hurrying off in a taxi, I wondered whether this person might be a relative of Leeman Anderson, they seemed to be on such friendly terms.

After navigating through the Pentagon, I discovered a huge office with several smaller ones facing onto it. The receptionist was a very attractive WAVE Lieutenant (in those days Navy women were called WAVEs) who recognized me immediately. Had we already met?

"Oh, Mr. Baldwin, how are you this morning?" and she directed me in the friendliest fashion to the first office on the right, where I found Captain Anderson, a Navy four-striper with a badge on his uniform that indicated he was a submariner. He asked me if I would like a cup of coffee. Plunged back into military mode and clearly outranked, former Sergeant Baldwin USMC, appropriately responded, "Yes sir, if you're having one."

As Captain Anderson went for coffee, I noticed that there were photographs of submarines on the wall and quickly realized, "Good God, this guy is *Bill* Anderson, skipper of the *USS Nautilus*, a nuclear sub and the first one to pass

under the North Pole." He was a national hero. When the Captain returned, I got another shock; on the coffee cup was a Navy seal and circled around it was "Office of the Secretary of the Navy."

On invitation, I brought out maps, photographs of polar bears, and a raft of information that I had assembled documenting the currents of the Bering Sea along with descriptions I had written about Novaya Zemlya. Captain Anderson knew the area well and provided encouragement and more coffee. We had three cups. I was about to jump out of my skin with excitement. The Captain was patient. After I began to wind down a bit, he excused himself again, saying, "Let me see if I can help you."

In a few minutes he returned with three little memos. All of them said the same thing.

Mr. Frederick Baldwin of Savannah, Georgia is planning a scientific and photographic expedition to King Karl's Land, Spitsbergen, starting late May or early June 1962. Mr. Baldwin is interested in determining projects that he might be able to accomplish for the Navy during his expedition, including those that might be eligible for official sponsorship.

I would appreciate it if you would have appropriate officials meet with Mr. Baldwin regarding the above. Mr. Baldwin will be in contact with your office regarding this matter within the next few days.

The memos were addressed to three Rear Admirals, head of the U.S. Navy Hydrographic Office, Chief of the Bureau of Ships, and Chief of Naval Research. At the bottom of each memo was the signature of Fred Korth, Secretary of the Navy.

When I stuck that dime into a pay phone to call Senator Russell's office that February morning, it turned out to be a slot machine pouring out possibilities and setting up a string of events that would again change my life. I hit the jackpot. Every psychic battery in my being was recharged. This huge, badly needed boost came at a time when my long journey seemed impossible. September to February had been seven rough months, a few peaks and then down into another valley. It was a huge help to be dropped off at 20,000 feet by the U.S. Navy when I chose to climb Mt. Everest.

Ultimately, the U.S. Navy did not immediately dispatch me on a ship to map polar bears, and the Bureau of Ships was unable at the last moment to

find me an icebreaker. Nor did the Office of Naval Research push polar bears to the top of their shopping list, but the Picasso mantra had once again done its job; I was stimulated and moving forward.

It was still a tough climb, but eased now because people looked at me in a new way. Anderson's "Fred Korth" memos didn't immediately take me to where I wanted to go, but my phone calls were returned and I was listened to with respect. My academic credentials were still incomplete, but I was now seen as a person with contacts; bureaucrats were polite. Like a Hollywood filmmaker, I told the scientists that I had the money and the money people that I had the scientists.

I developed an endless list of referrals, each one generating more contacts. From September 1961 to June 1962 I had written hundreds of letters, proposals, applications, sending project descriptions to every suggested name or organization. I now restarted my writing with Dr. Peavey at the Committee of Polar Research at the National Science Foundation, then the Woods Hole Oceanographic Institution, National Science Foundation's Program for Psychobiology, Wildlife and Conservation American Fauna, New York Zoological Society, Union Internationale Pour La Conservation de La Nature; and the list went on and on.

Some of my contacts wrote back with requests that were beyond understanding. One zoologist wrote: "The issues to be clarified must rely on enumeration and morphometric data. In order to reinforce decisions other characteristics should receive a share of attention... etc." Other requests were down-to-earth, clear even to me, "Just in case you run across a bear skull, tooth, or turd; please collect it for us." I promised to do my best. Another respondent asked if I could "obtain stomach specimens for analysis of food habits; various other tissues, such as endocrine glands, gonads and reproductive tracts would yield information on the present physiological state and reproductive condition of the species." Gonads! Good God, what would the old hunters at Mack's Øl Hallen think about that?

One man was particularly helpful. Dr. Harald J. Coolidge, Executive Director of the Pacific Science Office of the National Academy of Sciences in Washington made many phone calls and wrote letters supporting my expedition. He referred me to Dr. Harold E. Edgerton at MIT, inventor of the electronic flash, whose own photographs became classics of modern art and science, and who

sent me a very kind hand-written letter advising about underwater equipment, none of which I could afford.

During all this time, I still had only one legitimate scientist in hand, my friend DeCourcey Martin. From Texas, A.D. Stenger sent a telegram on January 10th, 1962 that read, "Count me in." He wanted to film the whole thing, but that didn't boost my roster of academics. Then, in April — finally — a zoologist from Penn State University in College Park, Pennsylvania, Dr. Martin Schein, came aboard. Now, I had a real-life scientist with credentials, and he intended to bring along a bright young graduate student, Fred Hart, from the same institution. It turned out that Dr. Schein was a renowned expert on wild turkeys, but he had never laid eyes on a polar bear outside a zoo. For those trained in the rigors of scientific research, however, switching animals was perfectly acceptable. So now I had DeCourcey, Schein, and Fred Hart aboard, and funding was a possibility.

By April, Peter Applebom, the USIS (United States Information Service) chief in Tromsø who had helped me find a trawler to take us to Spitsbergen in 1960, found me a boat. I needed money fast, so the frantic letter writing and phone calling intensified. But we had a huge problem. Although we were now legitimate, we were out of time. Budgets and allocations should have been made six months to a year earlier. Over and over again, I was told that funding might be available for the summer of 1963 but not 1962. Every day that passed made raising the money now less likely. It was more realistic to regroup for next year, but if I did that one of the key scientific components of my expedition was gone — the immediate radiation effect of recent Soviet atomic trials in the Arctic.

Tired and discouraged, I returned to Savannah and tried to overcome my depression with a peculiar diversion. My Washington pal, Robin Glattly, and I were gun enthusiasts, and we shared a passion for the look and feel of the wooden stocks of fine rifles. The Winchester model 54 carbine that I had bought to take to Spitsbergen had a beautiful walnut stock. Robin, a skillful woodworker, taught me how to give the walnut a deeply lustrous finish. I loved to work on it and dream about polar bears. A wooden stock makes the connection between the steel of the weapon and the body of the shooter. It's where face, hands, and shoulder come into contact, and it lets your eye and brain de-

cide in comfort what to do at the very precise moment of squeezing the trigger. The combination of a beautifully grained walnut stock and deadly power intrigued me.

Working on the rifle became a major hazard to progress, a symptom of my obsession with pointless perfection. I wrote to Robin in April, "I haven't written because I'm still fooling around with that beautiful stock. Last week Andrés Segovia came to play in Savannah. I had tickets so I went to the Symphony. I took my rifle stock along to get the maestro's advice on how to achieve the most lustrous finish. After all, he has to take care of his guitar and he might know something about penetrating oils and stains. Besides, he would appreciate the fine fiddle back design on the walnut. I couldn't get to see the maestro, but I ran into the first violinist of the Savannah Symphony Orchestra, a man I called Sr. Giovanni Scardino. He thought I had lost my mind bringing a gun to the concert, even though I had left the barrel and the receiver at home. After he calmed down he gave me some good advice based on his experience with his violin. I have worked all week getting it right. The results are magnificent. Using a deep penetrating aniline stain produced the most beautiful color. It's a tar stain that's no longer manufactured. I finished the job yesterday and took the rifle to test-fire. Guess what? The rifle kicks like a mule, and you would expect it to sound like a cannon, but it doesn't. All I get is a sore shoulder and a high C. It's the queerest sound that ever came out of a .306 caliber rifle. At any rate, I am back at work on the stock. Sr. Giovanni Scardino thinks that a dollop more linseed oil in the mix will bring the tone down an octave. I hope so. Now, this damn rifle goes off with a kind of castrated sound that isn't a bang at all. Well, anyway, back to the hardware store."

This description of me firing the gun may be slightly exaggerated, but the manic refinishing of the stock was not. Rubbing the walnut, polishing, polishing, and more polishing somehow became a substitute for my feeling of helplessness.

Not beeing very hopeful, I made another trip back to Washington. Motivation was dimmer than ever, one more leaden footstep forward in the fog toward the summit. I pushed myself, but I had just about run out of the last drop of energy that my positive contacts had provided me. I was ready to quit. My last sights were set on the U.S. Army Research and Development Command Office of the Surgeon General. I didn't expect much.

I met with a Colonel Howie. The memory of that meeting is brown and dark. The building was businesslike, and there was no cheerful, pretty WAVE Lieutenant seated in a spectacular space. The Colonel seemed much like his office, in no way inspiring. That described me too. Feeling already defeated, my delivery was flat — no enthusiasm. The Colonel just got the facts; no details of my meetings with Senator Russell, Captain Anderson, or yarns about *Titanic*. My story was just about what I intended do with two zoologists, a biologist, a ship, and a filmmaker from Texas. I showed maps of ocean currents, records of Russian nuclear tests, and closed with a flat declarative: "I need money." It didn't take long. I was tired of my own spiel.

The Colonel heard me out patiently. Then he said, "It's the end of the fiscal year and we have some money left over. I think we can support you." Suddenly, the fog blew away; I had taken one more step and there I was at the summit.

It would be appropriate to recount here that I later had a drunken celebration with my friends, the Glattlys — a fantastic dinner. But there is none on record, either in memory or in my files. The rest of that day all blew away, along with the Colonel's first name. I must have sunk into a grateful coma, until I had to wake up and fill my life with a million details with respect to the trip.

Looking back on my success with Colonel Howie, I may have sounded more plausible by reducing the length of my spiel and my impulsive delivery, but it was probably just the dumb luck of arriving at the right moment in his department's fiscal year. He made a grant for $36,000, signing it over to the American Institute of Biological Sciences, which we had lined up as the "pass-through organization," a familiar strategy in academic grants. Dr. Schein secured additional funding from the New York Zoological Society. Suddenly now, scientists who wouldn't talk to me in September were asking for information. A letter of April 11th, 1962 from David H. Johnson, Curator, Division of Mammals, at the Smithsonian Institution read in part, "Dr. Theodore Reed, Director of the National Zoological Park, tells me that he does not know of any zoos where underwater observations of polar bears have been made... He says it would be of value for zoo designers to know how far the swimming bears can leap out of the water. You might determine this by suspending bait at different heights on the end of a boom." Were they getting polar bears mixed up with porpoises?

I scrambled to borrow diving equipment. One maker of scuba gear, Healthways, supplied their latest wet suit and aqualungs free. It was disappointing

not to get their new two-person submarine to chase polar bears, but they claimed the batteries wouldn't operate in freezing Arctic water. Dr. Coolidge of the National Academy of Sciences came through again, recommending that I contact a friend of his at *LIFE* magazine. Editors there advanced me film, an automatic camera, and $1000 in return for first look at the pictures. *Sports Illustrated* and *National Geographic* provided $500 to secure second look rights for polar and wildlife pictures. Florence Kiesling, my agent handled these details. A contact in London got me a $750 advance for European magazine sales.

We were off and running. On June 22nd, 1962, through our Washington contacts, DeCourcey, Fred Hart and I were provided transportation from New York to Oslo on a MATS flight (Military Air Transport System) and then on to Tromsø via Bardufoss. Carrying hundreds of pounds of diving and camera equipment, we flew at an attitude that was roughly the equivalent of the height of Mt. Everest — at least, I did.

Stenger and Schein followed later. I kissed Monica, mother, and Savannah goodbye. Finally, I was out of the gate like a thoroughbred at the Kentucky Derby, jammed with realities into a race that was so different than life in the barn. Winning was mostly on my mind.

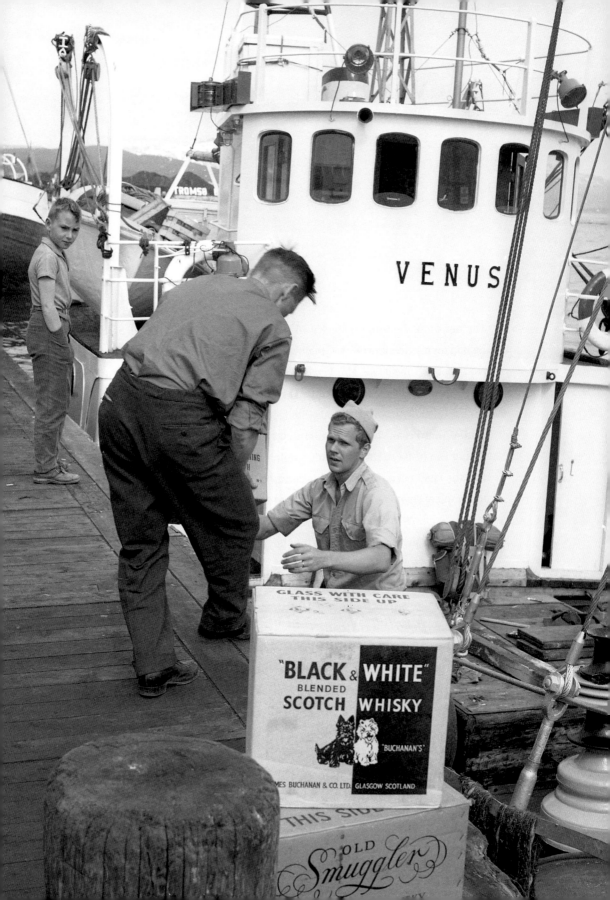

23 – VENUS

The news was buzzing at Mack's Øl Hallen about our plan for Spitsbergen. As he had on my first journey to Spitsbergen, Olaf Applebom had again arranged a charter. This time it was *M/S Venus*, a seal and walrus hunting ship, with a crew of five, and a bow reinforced for ice. In addition to DeCourcey Martin, my "ship sniffing" friend from Savannah, Stenger had arranged to bring along Torleif "Tullie" Markesan, his Tromsø hard-hat diver companion from his polar bear roping trip of 1960. He also made available the open boat and outboard motor that they had used. Tullie took his vacation to join us and give Stenger a chance to complete segments of the film he had shot on his bizarre trip. Fred Hart, Dr. Martin Schein's young graduate student from Penn State, had come with De-Courcey and me to Norway. Unfortunately, Schein himself was delayed, but was scheduled to join us later.

My dream had come true. We would follow the same route as we had with *Titanic*, again sail for King Karl's Land, again find polar bears, and this time get underwater pictures.

The Tromsø newspaper welcomed us with a smile: *The American government is using their money for many peculiar purposes — among others, a cage that cost 800 Norwegian Crowns ($125) is made for photographer Fred C. Baldwin to sit safely in, when he is taking underwater pictures of swimming polar bears in King Karl's Land this summer.*

A tongue-in-cheek question asked: *"And what are you going to do with the cage afterwards, Baldwin?"*

My response in the article was: *"Sell it to another idiot."*

News was also buzzing among the old hunters as well, and a reunion was arranged at Mack's Øl Hallen. Johan Sørensen and Olaf Applebom helped us celebrate. I felt like "king of the mountain," although we hadn't gone anywhere yet. Equally amazing, the trip was picked up by U.S. newspapers, including *The New York Times* on July 1st.

The next day, we met the bus from Bardufoss Airport delivering A.D. Stenger and my diving equipment. Texas returned with Stenger: while unloading gear, A.D. picked up a crate containing air bottles and it hissed. A.D. leapt in the air and the box crashed to the ground and hissed again. "Goddamn! Thought it was a rattlesnake."

Our $150-a-day charter was scheduled to leave the next day, but Captain Kåre Pedersen said that the crew was unhappy about leaving on Friday, a terrible jinx in Norwegian maritime circles. "But it's Friday the sixth, not Friday the thirteenth," I countered. So we compromised: *Venus* pulled away from the dock in the afternoon and headed for the small harbor of Torsvag, where we would wait until midnight. Then it would be Saturday and *Venus* could sail safely from Norwegian waters. In the end, the delay was only a few hours, giving us a chance to relax and get to know one another aboard the ship that would be our home for the next two months.

Venus seemed to be a comfortable ship, eighty-five feet long and seventy tons. Her 150-hp. diesel engine pushed her along at a noisy seven knots (eight miles per hour), and her oak hull was built for ice, with a bow reinforced with steel strips. *Venus* was a first-class vessel compared to *Titanic*, the three-man nautical lean-to, in which Sven, Johan, and I had barely survived.

The Captain, sad to leave his wife, was now quite drunk but all was well, we were moving through calm waters, listening to Tullie strum his guitar. Suddenly there was a new sound, a deep rasping and scraping sound. *Venus* groaned to a stop: we had just run aground. Everyone took the situation calmly, but as the cabin began to tilt to port my mood edged toward concern. The Captain was churning up kelp trying to get off the rocks. We were stuck in a fog fifty meters from a blinking beacon that should have warned Peterson that we were in shallow water.

After an hour the Captain quit trying. The tide was running out and the list increased, Stenger's boat, secured on the port side of *Venus*, filled with water. I

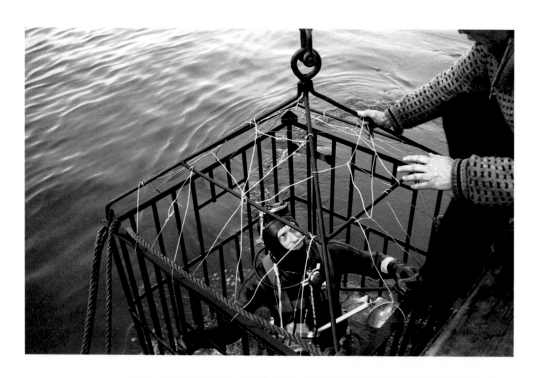

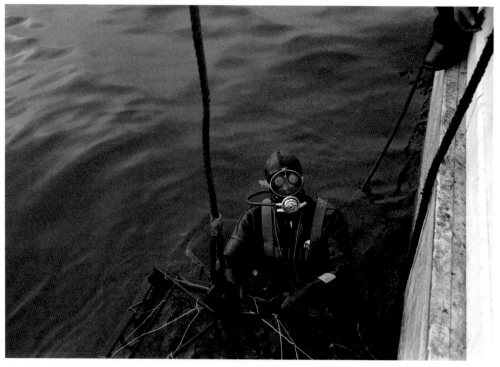

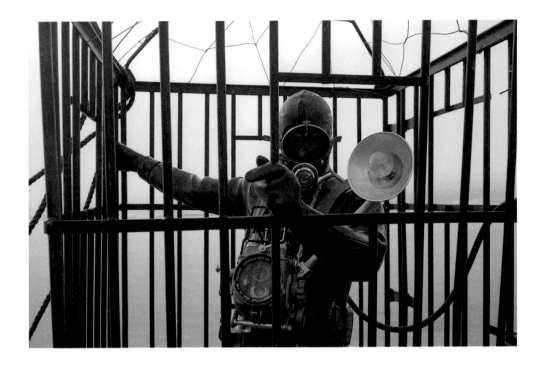

had been told that Torkel Kristensen, our navigator, was a good man and the Captain was an expert seaman, but with charts, a warning marker a few yards away, and an echo sounder, "Why were we stuck?"

By now it was noon and still low tide. I tied my Swiss Army knife on a string and hung it from the bulkhead. It showed that we were listing about 30 degrees, so we moved our gear up onto our bunks and the cabin remained dry. A.D. and I bailed out his little boat, launched it, and rowed around *Venus* to record our plight on film.

We finally floated off the rocks as the tide came back in. Although we later learned that a two-meter length of steel reinforcement on the bottom of the keel had been scraped off, we sustained no leaks. The Captain celebrated by giving me two bottles of VSOP Cognac. I accepted them, theorizing that there would now be less for him to drink, but realizing that there was now a new element in our unfolding Arctic drama.

The sea was calm as we headed north. At DeCourcey Martin's request, *Venus* stopped in mid-afternoon and he dropped his plankton net ninety meters straight down. He delivered his catch of tiny organisms into bottles. We were still in waters warmed by the Gulf Stream. Tromsø would have looked like the coast of Greenland if it hadn't been for the Gulf Stream. DeCourcey reported that he found more plankton here than in the South Pacific. This was no surprise to him, however, since cold water is especially rich in plankton. He also caught some codfish and happily examined their stomachs to discover soft shell crab, worms, and many dozen fingerlings.

Next morning at breakfast, I felt myself sitting on something lumpy. To my amazement, I found a .32 Colt automatic pistol under me; it apparently belonged to the Captain. Tullie had hidden it under the cushion the previous day, after giving the skipper a stern talking to and taking away his private stash of whiskey. What appeared to be a plentiful supply of booze and guns on this trip gave me worrisome hints about the future.

On our way to South Cape, West Spitsbergen, a couple of hundred miles short of our six hundred-mile journey, we hit the ice pack, a bleak, dreary sight. It was made up of fine chips at the edges, then the slush got thicker, and soon we found ourselves passing icebergs seventy feet high. They had been missing on this leg of the sea journey in 1960.

Retreating to my sleeping bag after dinner, I skipped breakfast, ate one boiled potato for lunch, and was still seasick. On the fourth nauseous day, the weather was pounding us from the port side and I woke up to find two inches of water sloshing around the floor of our cabin. Seawater was pouring in through chinks in a shoddy wall that had been added to make up our sleeping space. Fortunately, nothing was damaged. Finally, calmer seas found me at the mess table with DeCourcey, who chose this moment to explain to A.D. and me how to build an atomic bomb.

Upon arrival at Kings Bay, we had a variety of visitors; old friends from my last expedition, including Prof. Hollenbeck our savior from the Norwegian Polar Institute. It turned out that our drunken Captain didn't like the Institute and he began giving Hollenbeck a hard time. The crew intervened, and our Captain finally backed off and soon passed out. He awoke later and went ashore with us, but after dinner, back on board, Tullie reported, "We have no Captain." Pedersen was again witless. A.D. and I went into his cabin to have a look. He was sitting in his cabin crumpled over. A.D. and I brought him out on deck. Hopefully, the cold air would revive him. A.D. asked him whose whiskey he had been drinking. Pedersen explained that he had paid for it, but "It's for the expedition," and he said that we could throw it in the sea. The Captain demonstrated by heaving a case of Black and White Blended Scotch Whiskey over the side before we could stop him. It floated tantalizingly away from *Venus* for fifty yards before sinking. A.D. and I burst out laughing. The Captain was very angry and then he began to laugh as well. We removed all the booze from the hold and stacked it in the extra bunk in DeCourcey's cabin. I told Pedersen that he could have the whiskey back when we finished the trip.

We wasted a day waiting for Pedersen to sober up. He had been drunk five out of twelve days by July 18th.

Heading north from Kings Bay (Ny-Ålesund), the world's most northerly community at 79°N, our next drama involved DeCourcey, who wandered off to gather snow on a glacier. He found it necessary to gather samples from 80°N and took off to do so alone and with no food. He had a compass, but apparently didn't check his position on the map before he left. Distracted by Pedersen's behavior, I wasn't paying attention. DeCourcey had inflated a yellow rubber boat I had brought along, went ashore, and left it as a marker on the beach for

his return. When we realized he had already been gone such a long time, I got the engineer to give three blasts on the horn every half hour to help guide him in. Thank God, he was spotted two hours later. He was paddling the rubber boat with his folding shovel, wearing his rain hat and a Norwegian Army field jacket. He had become disoriented ashore and had trouble locating the ship. If he had broken his leg it might have taken a week to find him. We made a rule: from now on no one goes out of sight without telling others exactly where he is going and is carrying the right equipment. DeCourcey had apparently fired his pistol in answer to the ship's horn, but nobody heard him.

"Yes" he explained about his pistol, "that's to shoot myself if I break my leg. Don't worry about me. If I get lost, leave me. I'm dead." The characters in this drama were beginning to reveal themselves.

We fought heavy ice all day, three to four feet thick. The Captain and Torkel did a good job. We hit a number of clear patches of water but only for a few miles. Going through bad ice was like playing pool. Hit one chunk, it moves another, a small hole opens. The ship's tonnage, propeller backwash, and forward motion were all used to maneuver the vessel. Some ice looked impossible, some *was* impossible, then Pedersen stopped the ship and waited — a tantalizing three hundred yards away from a patch of clear water. The wind was from the east, though, and the passage closed in with ice. When the whole thing looked at its worst, Pedersen started the engine, moving the ice easily. The man was an ice wizard — when he was sober.

At one point we spotted some bear tracks in the snow, and to see if we could attract them within view I burned some seal fat in a bucket. The dead seals got their revenge by stinking up the atmosphere, but no bears appeared.

This was the worst ice in years. A.D. was getting edgy, wanting to stir up something, which would have been fine if there had been anything to stir. We were stuck, and soon we had to leave to pick up Schein in Longyearbyen. Our turkey zoologist had a crowded schedule and could only be with us for two weeks.

As tensions mounted, I found myself in the galley unburdening frustrations in my journal. The galley was the domain of Alfred Antonsen, our forty-five-year-old cook. He had created an environment that helped ease frustration with a non-stop supply of coffee laced with a can of condensed Viking Melk

(milk) and piles of cookies served on a luminescent green plastic tray that looked like it might glow in the dark — if it ever got dark.

Beaming with good nature, he threw himself into good humor with a kind of mood jujitsu that I needed to learn for myself. And when he was thanked for anything, his black eyes lit up and he bellowed in a loud cheerful voice: "Va-sha good mister" (you're welcome).

Alfred was part-Sami and had long black hair and sideburns shaved to a point like Rudolph Valentino. Above all, he liked to see people eat. By Norwegian fishing boat standards he was a master chef. His meals bubbled with grease and good nature, and large amounts of both were dispensed. He had been a chef on *M/S Lyngen*, the funky little passenger ship that would soon bring Dr. Schein to Kings Bay from Tromsø.

We took our meals in the dining salon, where the table was fixed to the floor atop four iron pipe legs. A guardrail around the edges kept crockery from flying about in rough seas, and the top was finished with green Formica. The table was surrounded on three sides by benches topped with long red plastic cushions that gently hissed when you sat on them. Among other furnishings, my battery-operated Zenith Trans-Oceanic radio also lived in the dining salon. When the ship stopped, we often tuned in on shortwave bands, getting roars of static with intermittent music or news. But when the ship was moving, the cacophonic clatter of the engine was too much for the radio.

For sleeping, I shared a double-decker bunk cabin with A.D., who had the lower one. The term headroom was a misnomer: A.D.'s bunk was about two feet above the floor, then there was another foot-and-a-half of space, and my bunk completed the sandwich. I had about the same distance above me before I hit the roof of the cabin. The bunk had a coffin-like feel, and my sleeping bag was always clammy and cold, but wearing quilted underwear solved the problem. We did have a small stove in the cabin but left it unused, deciding that it was better to freeze than boil. Perhaps the cabin's only convenience was excellent proximity to the WC. A steel door led to a warm place — a solitary refuge, excellent for reading except for the uncomfortable toilet seat.

A porthole connected our cabin to the galley. When food was being cooked, a warm, fragrant, greasy, choking cloud was received in the top bunk. In the morning, the prevailing odor was sizzling bacon fat, but there were so many

breezy chinks in our cabin that by lifting my nose out of the sleeping bag, I could catch freezing blasts with one nostril and warm cooking zephyrs with the other. My nose acted as a carburetor, merging the drafts.

On July 23d, I made the decision to reverse course. We moved northwest up the Hinlopen Straits, back past Wildfjorden, swinging south at Amsterdamöya, to return to Longyearbyen. Everybody but A.D. agreed; he was vehemently against the plan. He thought we had plenty of time to find some bears and still get back to pick up Dr. Schein on August 2nd. He was due to arrive there as a passenger on *Lyngen*; Tullie, his vacation over, would be dropped off to go home to Tromsø on the same boat. But we had been stuck in the ice trying to get to King Karl since July 18th. We had seen one distant bear and in the Captain's and Tullie's opinion, this was a poor place for bears because they were scattered all over the ice. We had a better chance to find them on the open water fringes of the ice pack. I feared that if we did get to King Karl and became stuck in the ice, we'd be unable to pick up Dr. Schein and get Tullie aboard *Lyngen*.

A.D. thought I was crazy and I thought he was crazy. "Stay here a few more days and see what happens. You're selling out your original plan." A.D. added, "You've got no faith."

"That's correct, A.D." That was my decision.

At the moment the argument was moot anyway. We were stuck. The Captain thought that the bad ice we were experiencing was because we had left port on a Friday. He wanted to get a little rest before starting his fight with this ice. My mood varied with the condition of the ice. A.D. finally came around to my way of thinking and said that I was probably right.

As we waited for a break in the ice, we had some beautiful clear weather. One day I counted at least fifty bearded seals from the lookout barrel up on the mast. They were stretched out sunning themselves on an ice beach extending several miles from the Bräsvellbreen glacier. They clearly felt safe there; good visibility gave them a chance to spot an approaching bear. They were always looking. But this didn't help them with humans.

Endless hours of scanning for bears led us to finding seals as targets for shooting instead. That day was about shoot and shoot, rationalizing that we would defray the costs of the trip by selling the skins. Two males bound by frustration, Stenger and I took it out on the seals, re-energized by the pointless

power of killing. It became a game: who was the best shot? Ironically, I remembered Johan Sørensen having taken aim to purposelessly shoot a seal from *Titanic*, and I had sent up a little prayer, saying, "Please miss." Now, frustrated by a drunken skipper and with my chance of getting photographs good enough for *LIFE* magazine cooling off on this bloody whiskey tanker, I took it out on the seals. Here we were, stuck, stuck in the damned ice!

Our troubles were beginning to feel truly heavy after twenty-one days aboard *Venus*. A.D.'s birthday on July 24th provided a bright spot. He was forty-two. The Captain gave him a box of cigars. I provided a girlie magazine called "Cocktail," with personal inscriptions from expedition members and crew, and a box of condoms to give him something to live for. Our chef produced two chocolate creations with strawberry jam in the middle. But other diversions that used to be fun were dead weights.

Thanks to the unpredictable deities of the North, we finally came free of the ice and made our way down Hinlopen Straits; it was snowing, with poor visibility of about a thousand yards but not too bad to travel. The ice was broken up — huge icebergs, fifty to seventy feet tall — all around us but enough

clear water. We were able to move at cruising speed passing Wahlenberg fjord, a very beautiful place; a long fjord filled with jagged, colored icebergs. The sun was shining through holes in the overcast and creating a miracle of shimmering light on the glaciers. Pink, rose, green, blue, and yellow incandescent reflections flashed as we passed. Red sandstone-smeared ice created decorations, but also distractions. Every round chunk of ice at great distances teased our eyes, looking like a polar bear.

Snuggled in my sleeping bag, I kept waking, sensing somebody creeping into the cabin. A groggy suspicion: was the Captain looking for whiskey? Next, I detected an aroma — a flavor, strong, pungent, one part garbage can, with a bit of sewer and dead fish. It mingled gradually with strange dreams. Half awake, I remained uncertainly in my bag — a perfume from hell wafting by my nose. Then I discovered that it was only DeCourcey, cooking monsters from the deep on our stove. Actually, he was drying out endocrine glands, gonads, and reproductive organs of creatures he had netted, treasures for a wide range of scientist friends back home.

As I was recovering from this smelly awakening, A.D. came to tell me that he was about to dynamite an iceberg and he wanted me to film it from the ship. It was part of his script. One of Stenger's missions aboard *Venus* was to fill holes in the film about his 1960 adventures, when he and Tullie had set out to rope a polar bear. His documentary readjusted his "true life story" as it went along. Sometimes the reenactments led to different and more interesting dramas than the original ones as high comedy was unintentionally inserted into the story.

By now, the Captain had recovered and was anxious to please. He had personally selected a huge iceberg for A.D. First Mate Torkel Kristensen thought it was a stupid idea, and was against it. Tullie was disgusted, a rare position for him, and I was simply disgruntled; I had had only five hours sleep, which may be enough for the body, but not for the soul.

The movie script was supposed to follow a prank that A.D. had played on an iceberg in 1960. Due to a temporary shortage of excitement on that trip, A.D. had become restless and decided to substitute an iceberg to lasso rather than a polar bear. The results were impressive and educational. The iceberg Stenger chose was finely balanced, with almost the same amount of ice below the wa-

ter as above, making it very tippy. Consequently, when he roped it, hundreds of tons of ice flipped on him, nearly crushing A.D., Tullie, and their little boat. A.D. loved this dramatic moment, but it also cut short their filming. He would recapture it today, not only throwing a rope around the iceberg but blowing it up with dynamite. The Captain's selection was a monster with a huge base that extended many times its size underwater — perhaps a relative of the one that sank the original *Titanic* in 1911.

The filming began, and when A.D.'s rope lassoed the berg, two and half kilos of dynamite went off with a roar. A massive shower of spray flew up a hundred feet in the air, entirely obscuring the iceberg as it cascaded down upon us. When the mist cleared, there was A.D., grinning at the camera, with the iceberg sitting in the water as tranquil as if nothing had happened. It scared the hell out of a flock of seagulls and provided the crew with the best entertainment so far. But this iceberg was not a flipper. A.D.'s rope trick was filmed, however, and he felt that he had another cinematic winner.

Later, unchastened, A. D. told me that he didn't really think it was the right iceberg, but he wanted to make Captain Pederson happy, so he blew it. That gave me such a good laugh that I felt almost human again, after three cups of coffee.

It was July 28th, a few days before we were scheduled to meet Dr. Schein. We were traveling through light ice quite close to the shore when Bitte, the engineer, rushed to our cabin. He had spotted a bear about two miles across Lomfjorden. I grabbed my equipment and rekindled the "stinkpot." The wind carried smoke to the east, directly at the bear, which seemed to be coming toward us.

Venus started forward and lurched to a stop. Bjørn Hansen was at the wheel, the Captain on the bridge. The engines heaved but to no avail. We were stuck aground again. Bjørn requested help with the small boat. Ten minutes was all he needed. We were already in Stenger's boat, ready to go after the bear, but I said OK and Tullie hooked a rope to the small boat and tried to pull *Venus* off. No luck.

Tullie took soundings with a lead line. There were only 2.5 meters of water at the bow and about the same ten meters ahead. But the ship drew 3.5 meters and was being pushed forward. We were stuck, and trying to go in the wrong direction. In the meantime, the bear was out there but no longer heading toward us.

The animal alternately disappeared and reappeared. For the next three hours, Tullie, Fred Hart, A.D., and I took turns trying to spot him from the lookout barrel on the mast. Tullie finally located the bear, and we set out in A.D.'s boat. We hadn't gone a third of the distance when ice stopped us. The animal was still a quarter of a mile away but obscured by icebergs. A.D. wanted to start across the ice to get closer. Tullie was against the idea. I didn't want to risk my cameras on such ice. Fred Hart agreed. So A.D. set off alone with his movie camera to record coming events or to take a bath, whichever came first. He took the boat hook, a long pole with a steel head. With this he was able to vault across the water gaps separating the broken ice flow. Hopefully, if he met the bear, he could defend himself with his pistol.

We watched him travel about a hundred yards without too much trouble and waited for him to disappear in the water, but he didn't — not then at least. Tullie was alarmed that he had no rifle. There was a good chance that a female with cubs was on the ice. Tullie thought that he had seen a cub but not the mother. A mother bear would mean serious trouble, so I decided to join A.D. with my rifle.

My usual camera assortment was reduced to one Leica and a 200mm lens. Following A.D.'s tracks, I quickly realized the advantage of a boat hook, handy for testing the strength of the ice and vaulting across open spots, some of them five feet wide. Every leap was a gamble against an ice bath. The camera was packed in a plastic bag and wrapped in chamois inside my army surplus gas mask bag. No disasters: and I soon caught up with A.D.

The day was beautiful: the clouds in the north turned deep purple and then ultramarine blue. The sun peeked through a couple of times, reflecting in water pools collected on the ice. This could make spectacular pictures.

In an hour we crossed bear tracks. A half hour later, A.D. spotted the bear about a thousand yards away. We got behind a small ice chunk and watched him. He saw us, or smelled us. The bear stood up occasionally to have a better look. He was moving cautiously, slowly, looking, smelling, stopping, and moving again in our direction until he was roughly five hundred yards away. A.D. started filming with a 6" lens. The bear was too far away for my 200mm lens but through my twelve-power binoculars he looked huge — an old fellow, I guessed.

He had a dark muzzle; the hair on his face was thinning, the black skin showing. A.D. admitted he was glad we had a rifle. The bear soon sat down for a few minutes but always looking toward us. I would look around us every now and then to see if we were being stalked by another bear, but we were alone. Suddenly the bear jumped into the water. I could hear the splash, and then he hopped out shaking himself. There was ice in the way so I couldn't see anything, but in a moment he appeared in clear view with a ringed seal in his mouth. A.D. was filming. The bear carried the seal away from us for two hundred yards and finally stopped to eat it. He was quickly surrounded by a flock of seagulls. We tried to get closer, but he soon saw us and bolted. Judging from the noisy seagulls, he must have left his meal behind.

It was after midnight, so we decided to rejoin Fred Hart and Tullie. We had just gone about a hundred yards when A.D. saw that the bear was following us. We dropped down on the ice to prevent him seeing us. The bear was still too far for the 200mm lens, so I decided to return to the boat for the 400mm. It would be a reasonably safe trip, so I left behind my camera and rifle and took along only the boat hook. Fred Hart and Tullie had been watching us through binoculars, but what A.D. and I had missed was that the boat was now completely jammed in ice. *Venus* was also stuck a half a mile away, unable to help. All we had with us were three chocolate bars, a bottle of whiskey, a chunk of Jarlsberg cheese, and some flatbread.

When I got back in the boat, I made sure the 400mm lens was safely packed in a waterproof steel ammo box: I grabbed another chocolate bar and more movie film and took off with Fred for A.D.'s position. Tullie insisted on staying with the boat to make sure it didn't move off with the ice flow. Fred took the boat hook, and we made the trip back without difficulty. In the meantime, the bear had caught another seal, but this time the view was even more obscured by ice and we couldn't see him easily. But then the bear came closer, and lay down on top of an iceberg to finish feeding. We tried to approach, but again he took off. We followed him for a while and then A.D. stepped through the ice. Fortunately, he only got one boot full of ice water, and the Bolex camera was dry.

After helping A.D. warm up his icy foot, we decided to let the bear go his own way and started back to find out what we could do with the badly stuck small boat. We did our best, but even with four strong backs and a powerful

urge to get to the warm, cozy *Venus*, we were unable to budge A.D's boat. Tullie suggested waiting for the ice flow to change in the morning tide before getting out. He was probably right, but that meant sitting in A.D.'s open boat for many hours with one sleeping bag between the four of us. Three of us voted for expending some immediate sweat, and good-natured Tullie agreed. The drill was that we would get out on the ice, break apart a twenty-foot ice section two feet thick, push the boat forward, and then do it again. For the next six hours, we did the same thing over and over and over again. The nice warm *Venus* was a tantalizing sight but we still had a long way to go.

Ice breaking required precise judgment. Thick ice required pushing to move the boat. When the ice was thin, however, we moved quickly because our combined weights made it sink fast and the boat scooted forward. The trick was to scramble in just before water reached the top of your rubber boots. Fred Hart fell in the water once and I managed twice.

The boat hook was our most useful tool, but we only had one, so three of us pushed, shoved, and lifted. The weight of the boat itself, with its Johnson outboard motor, was used repeatedly to ride up on and break off great hunks of ice, opening up narrow channels where there were none before. We had learned from Captain Pedersen.

We communicated with grunts, groans, and action. Helping your buddy was a basic reflex. Ice collapsed from under me, I jumped onto the side of the boat — standard procedure but a few seconds too slow. Straddling the side, one leg in, arms gripping the side of the boat for dear dryness, my weight tipped me tantalizingly close to the water. I couldn't get leverage to swing in, my right leg dangled just above a bath. Tullie came over to help, then A.D. That did it. The water line came up to my ass. I went into shock laughing. When they realized what was happening, I climbed in after my fourth dip. We finally made it to *Venus* and had a fine breakfast of fried bacon and eggs in dry clothes at 08:00 a.m. I cleaned my rifle carefully as it had become a substitute boat hook. After fourteen hours I sank into my heavenly smelly sleeping bag.

Half a day later, DeCourcey reported that the Captain was sober. He had other amazing news: attempting to free *Venus*, Pederson had put a cable on a grounded iceberg to winch the ship two hundred yards forward, with the result that the grounded iceberg and the vessel were now united. Further, the

stress on the cable had broken the cast iron guide and the cable snapped, whipping back and hitting DeCourcey. Happily, the huge pressure that parted a steel cable and fractured an iron guide only broke DeCourcey's glasses. The frame was broken but not the lenses, and miraculously, DeCourcey wasn't hurt. The cable could have cut his head off. He was very nonchalant about it.

After a dinner of hamburgers and fried potatoes, fireworks entertained us, courtesy of the Captain. He decided to work on the iceberg with some dynamite purchased for Stenger's movie scene. First, he exploded twelve sticks, busting a small flow ahead of us. Then he pumped fuel from the rear tanks into the forward tanks in the bow. *Venus*' stern now rose above the water by a meter. We were still stuck fast on July 29th. Efforts were being made, however. The propeller was turning. The bearings might burn out but the Captain was still trying, and remained sober.

Finally at 02:05 on July 30th, with clear weather and just a few clouds in the sky, *Venus* came afloat and was moving again. From my perch up in the barrel, however, I saw no bears. I wasn't helped by the fact that when we were under way, the pulse of the pounding engine coupled with the sway of the mast I was perched on made the world do a fancy jig in my powerful binoculars. This was a hard place to see anything if the engine was going. Good news: we should be in Longyearbyen by morning; bath, mail, reports from the outer world. Bad news: we've been out twenty-six days and no polar bear photos to show for it. Passing south along this dangerous coastline of Eastern Spitsbergen, memories stirred in me. I recalled the excitement I had felt as our little *Titanic* sailed north in 1960, moving onto a gigantic stage where weather and our diesel engine became the leading characters. Today the stage was the Captain's cabin of *Venus*, where alcohol on the rocks had top billing.

When we landed in Longyearbyen on July 31st, I found mail, including letters from philatelists requesting our "Expedition Stamp" on self-addressed envelopes. I began saving whiskey labels for them. We also learned officially that this was the worst ice summer in twenty years — a lot of winter ice with no storms to break up and drive out the pack ice.

Returning to the ship, I found there was a concert in Fred Hart's cabin. Tullie was playing his guitar while Bitte, the engineer, made music with his left hand tapping a coffee spoon on the neck of a beer bottle, while gently tinkling

a glass with his right. This was a musical farewell for Tullie, who would be departing with the arrival of Dr. Martin Schein. We were exchanging a trusted mate for an unknown quantity. Tullie had spent his vacation with Stenger, and although he received $100 a week, this did not describe their relationship. Tullie moderated A.D.'s more extravagant behavior. He wasn't a brake on A.D.; he was more like a shock absorber, making it possible to tolerate the ride. Tullie hadn't learned much English since 1960, but communication was possible because of his strong and reasonable character. He projected sensible solutions without saying much. Tullie understood the rules, recognizing the power of the Arctic nature that shaped them. Stenger poked his nose in every hole that caught his fancy and Tullie didn't because he knew what was in those holes. Nonetheless, they deeply respected each other. They had complementary differences. I would miss this remarkable man.

During the docking of *M/S Lyngen* the next day there was considerable confusion. Our crew responded professionally, giving up our berth at the dock in order to make space for the passenger ship. This nautical politesse was influenced, according to Bjørn Hansen, by the strict procedures enforced by the Port Captain, who would, theoretically at least, be on hand with stevedores to dock *Lyngen*. There was another ship, *Signalhorn*, however, still tied to the pier. Her crew had been celebrating with our crew, and when *Lyngen* steamed into Longyearbyen she didn't stir. *Signalhorn* was a hundred feet long and *Lyngen* double that so there was not enough dock for both ships.

Fred Hart, DeCourcey, and I were out on the pier to meet Dr. Schein, but there was nobody else. When *M/S Lyngen* came steaming in bearing down on us, the helmsman doubtless thought that we three were the Port Captain and stevedores. Just as she was about to crash, a Volkswagen Beetle came burning down the dockside and screeched to a stop. Out popped a natty looking Port Captain just as *Lyngen* and dock were about to become one. Somehow, *Lyngen* slipped in for a perfect three-point landing. Nobody seemed concerned, indicating the possibility that this was the way *Lyngen* landed every time.

After we found Dr. Martin Schein, we all had a celebratory breakfast aboard *Lyngen*, a remarkable leftover from another age, a small and formal ship, fitted out with mahogany and plush. She had been built in 1936 and survived the war. Today her passenger list was full: one lone Frenchman — suit

and tie — four aggressively friendly Americans coming to shoot polar bears, and all the rest Germans. The Americans, who reminded me of the marlin fishermen of Mazatlán, came with fancy equipment, but were dilettantes compared to the Germans. They were decked out for the Arctic with special cameras, binoculars, and marvelous windproof clothing with lots of zippers, under which was more marvelous clothing with more zippers. One man wore an orange zipper suit with a red-and-white striped stocking hat that displayed more color than anything in all of Longyearbyen.

Dr. Schein filled us in on relevant news: *The New York Times* had reported Soviet plans for nuclear bomb tests on Novaya Zemlya and naval maneuvers in the Barents Sea. At the general store, Schein bought rubber boots and rain gear and after a couple of hours moved into Tullie's old bunkroom with Fred Hart.

When we got back to *Venus*, my fears about what happened when the Captain was left alone were confirmed; Pederson was drunk and making trouble. He claimed that A.D. was not really a part of the expedition, and had not paid for his trip. I arrived in time to witness A.D. in his long johns putting the Captain to bed. This tender moment had apparently been preceded by a serious one.

During my absence, Pedersen had been drinking in the galley and A.D. came in and took his glass away. The Captain then invited A.D. to his cabin to have what he thought was going to be friendly chat, but the Captain started a long harangue that the Texan didn't understand. Pederson then got out his .32 automatic pistol, put a round into the chamber and continued ranting in Norwegian until he passed out. The pistol was on the table, so A.D. took it and removed the bullets.

Having tucked in the Captain, A.D. began raising hell about my not having him under control. A.D. was understandably upset by all this and said that he was writing in his diary that much of the failure of the expedition was due to my not delegating authority to various people. He said I had no business going with Schein to get clothes. I could have sent somebody else. In a way A.D. was right. Things were not under control and the Captain was a major problem, but I couldn't figure out what to do about it. My goal was to get our work done in spite of him.

"Getting rid of Pedersen means losing *Venus* and it's his ship."

"Stay out of situations that encourage drinking" countered A.D.

"Like what?"

"Keep the ship moving is my favorite solution, and to accomplish that, I'm putting A.D. Stenger in charge of melting the fucking ice!"

Two days out of Longyearbyen and we still couldn't go north, so we tried south; that didn't work, so it was north again. Was this a bad dream? Waking up didn't clarify the confusion. Only the compass knew. North? South? Sleep was snatched while looking for holes in the ice.

We were cautiously moving down Freeman Straits. Martin Schein was on watch. I was glad to have him finally aboard, but I missed Tullie, an Arctic version of a good Marine platoon sergeant, the man that every infantry officer depended on. Dr. Schein was the new, untested officer. He was our credible academic, essential to funding, but I was waiting to see how turkey expertise transferred to polar bears. Schein however seemed pleasant, confident, and probably aware of his "new boy" status as he went on his first watch.

At 08:15 – Schein gave out a yell, "POLAR BEAR!"

"Good God, this guy's bringing us good luck." A.D. and I didn't even look, just started getting equipment out of the cabin and onto the deck, including my pistol. Schein reported a mother with two cubs, but it was a mistake. The bear faces that he saw through his binoculars were actually seagulls. Fred Hart then reported that he saw a bear swimming, but no cubs — a young bear, maybe two years old. We immediately put A.D.'s boat over the side.

A.D., Fred Hart, and I took off in A.D.'s outboard. The bear was easily overtaken. In a short time he learned how to avoid us, and our bear education commenced, close up. He took a series of short five-second dives. This didn't shake us off, so he soon learned that he could turn much more quickly than we could. Fred Hart was running the motor. He was not an experienced boatman. Both A.D. and I were yelling at him "turn left, turn right, not so fast, reverse."

We wanted the bear on ice for pictures. We tried for half an hour to get the animal on a flow that wasn't too high. Finally, the bear was herded to a low, flat piece. Again we chased him round; then he hopped up, scampered across the ice and plunged off — terrific, just what we were looking for.

It was freezing and the water became choppy. After an hour my hands were stiff with cold. Changing film was clumsy, slow, and impossible while wearing

gloves. After two hours of the same tricks, the bear got tired of swimming and no longer tried to escape. But he kept the iceberg between us. A.D. and I got on a big chunk twenty feet across.

The bear lay in the water fifteen feet away looking at us. I got seal fat from the boat and threw it on the ice. This attracted four big gulls, but the bear didn't go for it. Then he changed his mind, raised half way out of the water, climbed onto the ice, and gobbled the fat. But there was no snow on the ice to give him firm footing so he slipped back into the water. Had the bear got up on the ice and charged us, I don't think I could have drawn my pistol fast enough to shoot, but he was a young bear and by now seemed tired.

The bear remained in the water and we sat on the ice, watching each other. We named the animal Diving Bear.

We got back in the boat and varied the routine. I sat in the bow of Stenger's boat and we drove right at the animal, trying to get extra close-ups with my Hasselblad Superwide, the distance set at three feet. The first pass scared the hell out of me. We came in faster than I expected, my legs were dangling over the side, the bear turned, growled, and swiped at the passing bow with its paw. I clicked the shutter as I got my legs back in the boat. This was repeated until I finally got what I wanted.

The bear got tired of playing ring-around-the-iceberg and taught us a new trick. He dove under the ice, came up on the other side then struck out for open water. We circled around, heading him to ice; then he dove, not going under the ice, but reappearing in the same spot. Now we were able to move in very close and I got more pictures of an emerging bear looking at us. Seagulls cooperated by working into the composition. We picked up Schein, who threw in more meat and seal fat. After four-and-a-half hours, I was not seeing any possibilities for taking different pictures. A.D. asked me to film him.

A.D. wanted me in the back of the boat. I stood up, braced myself, and began to move to the stern. With his hand on the tiller, Fred Hart had to stand to see around me and steer. A.D. shouted an order, but Fred slipped on some fat lying in the bottom of the boat, and accidentally shoved the outboard hard over. We swerved, and I toppled into the water along with A.D.'s Bolex, two Leica's, and a Hasselblad. I just managed to throw the movie camera back into the boat as I went overboard. Because I was soaked, we returned to the *Venus*. Our film star, Diving Bear, continued unmolested.

The result of that spill was that two Leicas and a Hasselblad with a 150mm lens were dead; also a 35mm wide-angle lens for the Leica, the same lens that had drowned in 1960. Some film was also ruined. After cleaning off my pistol and hanging up clothes to dry, I declared the end of the day for me.

Bjørn Hansen roused me to ask if the crew might go ashore to shoot a reindeer, we needed fresh meat. Bjørn said it would take half an hour. We were impatiently waiting for the tide to go out. I was concerned because powerful tidal currents developed in Freeman Straits and it was easy for a ship to get caught here in heavy ice and crushed. I reluctantly said OK. I woke up again at 22:00, couldn't sleep. A.D. was still out cold. Stenger's boat was gone and I saw the straits ahead were clear of ice, finally. There was a slot to get through. The Captain was on the bridge and Bitte was in the engine room, but no one else was aboard. We waited and waited. At 24:00 I asked the Captain to start blowing the horn. The ice was closing the strait again. Fog moved in and with every horn blast I got more and more angry.

Finally, after another two hours, Stenger's boat came into view. Bjørn, De-Courcey, Fred Hart, and Scheinwere towing seven headless reindeer — two young males, three young females, and two calves — behind the boat. My disgust was complete when Schein told me that Bjørn had personally wiped out the entire reindeer colony. The poor beasts were too stupid to run. They stood watching each other being slaughtered. Bjørn Hansen returned whistling and humming, supremely pleased with himself.

Hansen's brutal stupidity cost us our chance to get through Freeman Straits and was illegal in Spitsbergen. According to Schein, Bjørn hightailed it up the mountain when he spotted the animals, managing to do the dirty work alone. Bad end to a good day.

At 08:00 we sailed for Midtakodden on west Barentsöya, stopping just south of Duckwitzbreen. A.D. was convinced that he saw polar bears. Hart, Schein, and I loaded into the small boat and went ashore. What A.D. had seen was a herd of grass-eating bears with horns, which led to another reindeer incident.

With reindeer in sight, Schein decided to tranquilize one with the dart gun, to check out its efficiency. He and A.D. set up target practice, making a cross in the snow, and promptly lost the practice dart. Schein had two ways to deliver the darts, a CO_2 gun and a powder gun – a regular one charged with

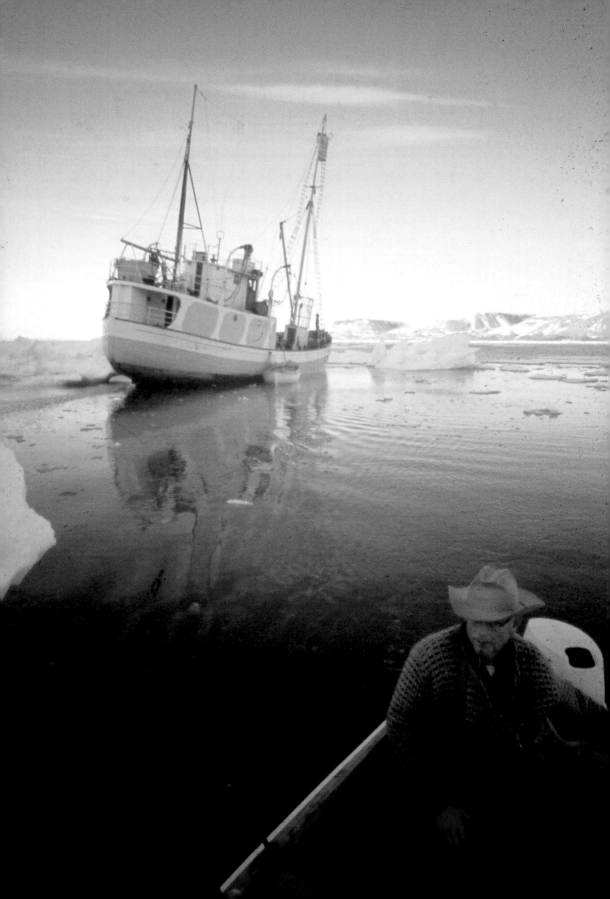

gunpowder. Both were shooting erratically and short. Schein's zeal for tran-quilizing reindeer required mastering the delivery systems. His efforts so far were not impressive. It was going to be important to work out how to operate these guns as well as to determine drug doses that would put a polar bear down safely if Schein ever got close to one. These tests would be the first step to make it possible to track polar bears' unknown migrations in the future. Af-ter much stalking of four male reindeers, Schein finally hit one, but the needle bounced off. Meanwhile, Fred and I searched for lost needles.

The weather was clear but I noticed that fog and ice were coming in from the west and south. A.D. was filming Schein, his new star. I told them it was time to leave, but they asked for "just one more try." A.D. was in the middle of capturing a future TV epic, and was not interested in fog. Finally, Schein hit a reindeer with a half load of tranquilizer — called Anectine —and the reindeer keeled over in three minutes. But the dose was too high and the animal died five minutes later.

As killing reindeer in Spitsbergen was illegal; we had to get rid of the body. After dragging the beast for a few feet — it weighed a ton — we decided to try artificial respiration. Maybe the victim wasn't dead after all? Our problem would be solved if the beast just got up and walked away. This was not the case, however, so we dragged the poor animal over to the shore and dumped him into a crevice. We slinked away and kept quiet. DeCourcey was collecting monsters of the deep, so he noticed nothing.

We headed back to Freeman Straits and the weather was clear and sunny. About 14:00 the sun was so warm that steam was rising from the white painted wood. Reindeer for lunch, I had to admit, was delicious. The crew spent most of the previous day chopping up parts, dividing it among themselves and hid-ing it. We were now smugglers of both booze and illegal reindeer meat.

By August 9th, we headed southwest down the now foggy Freeman Straits and were almost caught by ice. A large floe converged on *Venus* with the five-knot current and we made it out with about one minute to spare. The Captain was justifiably leery of this area.

At 16:00, a very excited A.D. Stenger yelled: "Ice bear, ice bear!" A.D. and I stayed on *Venus* and Fred Hart and Schein took Stenger's boat to work with the animal. I set up the 400mm lens near the bow and saw a very large bear — big-ger than any we had seen. A.D. and I yelled instructions to Fred Hart and the

bear herding began, but this bear would not herd. It was undaunted by the presence of the outboard, which didn't appear to frighten it at all. Fred Hart fired a shot in the water to redirect its course, but the bear was not impressed. This polar bear, the fourth we'd seen, had a mind of its own. It would only be possible to move this bear in the water using *Venus*.

The bear paddled with his forelegs, using his hind legs to steer, something the New York zoologists had told us they were curious about. As the bear climbed on an ice floe, three seals fled. The bear leisurely crossed other ice floes; unlike Diving Bear, he did no tricks. He would get up casually on ice floes, and was quite relaxed about his retreats from us, moving slowly.

Next, we put Schein back on board *Venus* so he could tell the Captain how to maneuver the animal in the water, and Fred Hart, A.D. and I took off in the outboard. Content to remain at a respectable distance, we didn't crowd the animal, letting *Venus* do the pushing around. The ice floes were numerous and some two to three hundred yards across, but there was room for *Venus* to maneuver in the water between them. No wind, calm sea, and although the sky was overcast, there was sunlight striking the mountains on the horizon. We had made dangerous moves in the small boat with our last bear, based on the young animal's behavior, but this was a different story.

Our walkie-talkie connected us with Schein on *Venus*, and the bear was herded onto a large floe. We went around to the other side in the outboard and waited for the animal to come to us. Schein tried to feed the bear from the deck of Venus, but he wouldn't go after the fat chunks in the water. We threw more fat on the ice and the bear, he's already on the ice, sure enough, started chomping it down. Small pieces he gobbled on the spot, larger chunks he dragged off a few yards to feed on.

A.D., Hart, and I got on the ice island about thirty yards from the bear and I was setting up my tripod when we saw to our amazement Captain Pedersen and DeCourcey Martin coming across the ice, our skipper leading with his .32 automatic pistol in hand. DeCourcey followed, wiping off his glasses. We learned later that DeCourcey had been quietly minding his own business when the Captain invited him in Norwegian to come along. DeCourcey, always polite, followed him, unable to understand what had been said, and perhaps unwilling to ask where they were going.

Our intrepid Captain was armed with a popgun just strong enough to enrage a bear if he was unlucky enough to hit him. DeCourcey had only a long bamboo pole, and they were closing in on a very large polar bear. We watched them with horror. We yelled and screamed, telling them to get the hell back on the ship. If he were to annoy the bear with his pistol, our scrawny little Captain, a meager package of booze-flavored bones and gristle, would get it first for sure. The bear would then devour DeCourcey for his lunch. To make matters worse, the bear was between Pederson and our group. If he charged one way, or the other, we would be shooting at each other while trying to hit the bear. My Winchester carbine was a good defensive weapon, but not accurate for such a long shot.

Through my binoculars, nearsighted DeCourcey seemed to be unaware of what was happening. He occasionally lifted his glasses to peer blindly in our direction, polishing them and squinting some more. More yelling. DeCourcey and the Captain finally disappeared behind a wall of ice. The bear ambled about and finally, after finishing the meat we had baited him with, disappeared as well. Why were DeCourcey and the Captain still behind the ice? Where were they? Finally, they appeared, without the bear in sight, they had seen it and returned hastily to the ship.

With the distraction of DeCourcey and the skipper out of the way, this was my chance to get intimate bear pictures in sequence. I planned to set up the Praktica electric drive camera on the ground and use a remote shutter control device from a safe distance. I chipped a hole in the ice, placed chunks of fat around the camera to attract the bear, secured the camera on a mound of snow and strung a shutter release wire to an adjoining iceberg. I wrapped the shutter release switch around an oar stuck in the snow to secure it. Halfway through setting this up, the situation suddenly changed.

All at once, Fred and A.D. in the small boat, and the big bear, were all heading in my direction. My back was turned to them all and I hadn't noticed. Fred shouted a warning and pulled up beside the floe I was on. The bear was approaching fast. I grabbed my rifle and jumped in the boat, abandoning everything. The bear became distracted with the treats I had left behind, and all was well.

I returned to the floe to finish setting up my tripod and telephoto lens while Fred Hart kept me covered with his rifle from the boat. Then he and A.D.

pushed off. The bear wandered around sniffing for more food. Now I was ready and in a good position, but then, trouble. The electric cord running to the camera lost its slack. The oar had pulled out of the snow, dumping my rifle, which had been propped against it, into the snow. Worse still, my iceberg had begun to separate from the one with the automatic camera on it.

Fred yelled; "Bear's coming."

I untied the switch, stepping out from my lair and was exposed on the ice. I had the rifle, but there was snow down the barrel, so, keeping one eye on the approaching bear and holding onto the camera switch, I removed the bolt of the rifle, blew snow out of the barrel and reloaded while slowly walking toward the camera and keeping the cord slack. No cover now.

The bear approached the camera position and I started pushing the button. This sequence kept up for five minutes. In the meantime, A.D. and Hart were on another iceberg a hundred yards away, filming the unfolding saga. The bear went from piece to piece of seal fat at the base of the camera, ignoring me. He sniffed the camera. I was sure that he would leave a nose print on the lens if he didn't fog it with his breath.

My iceberg continued drifting away from the bear and the camera. As I walked toward the bear that was now on my floe, I could see little tufts of snow were blowing in his direction so I knew he could smell his next meal. To keep slack on the shutter wire and avoid tearing the camera out of the snow and dragging it into the water, I kept walking toward him. He was still busy eating. I took my rifle off safety, continued clicking pictures, walking, and keeping the wire slack. The distance between us remained the same, but it was only a matter of seconds before I would reach the edge of my ice island or the bear would notice me and decide to change his diet.

He kept chomping away, but suddenly there was no more fat and a very large polar bear started in my direction. He was twenty, nineteen, eighteen feet from me and I had to make a decision: shoot at the bear's feet and try to frighten him — with uncertain results — or shoot and kill him, which I did not want to do. I took a chance and shot at his feet, and the muzzle blast, the shock of the two-hundred-and-twenty grain bullet from a 30-06 rifle hitting the ice, created a small explosion of snow right between his forelegs. Ice and snow flew in his face. Backing up rapidly, he then turned around and trotted off. I was happy to see him go.

A.D. had filmed it. I yelled for him to go and pick up the camera and miraculously nothing and nobody got wet. I apologized for not providing a more dramatic finale. We returned to *Venus* for supper. It was 21:00. Hot coffee and food were on our minds, but we received a surprising welcome. Our Captain and reindeer-slaughtering Bjørn were complaining about the plight of the poor bear. Bjørn explained that it was cruel to run a bear around the ice for so many hours. It certainly was heartening to see Bjørn on the road to reform. The Captain pleaded with me to leave the bear in peace, "take it easy, take it easy," he kept repeating. I pointed out that polar bears were strong. Besides, we had been feeding them like pigeons in Central Park.

After supper we decided to make another experiment with the tranquilizers, and try the dart guns loaded with Anectine. We were close to the iceberg where we had last seen the bear, but the animal had disappeared. I felt very badly as Schein and Hart hadn't tested their dart gun, but then Hart spotted the bear again. I told Schein to do what he liked. The bear was his.

The bear finally got up on a large floe of ice, and Schein shot him with the dart gun from Stenger's boat as he was getting out of the water, range thirty feet. Three minutes later the bear collapsed on the other side of the floe, just short of the water, thank God. Schein and Hart timed the reaction of the drug, and in eight minutes after the injection they reckoned that he was more or less fully out. He snored peacefully for a few minutes as the Anectine paralyzed his rear leg muscles first and then worked up from the legs, reaching the head last. He was never completely out, immobilized, but struggling with the effects of the drug. It was pitiful to see this huge animal lose control. He involuntarily emptied his bowels, his eyes were open, and he seemed to know what was going on, but he couldn't do anything about it. The next step was to mark him. But none of us trusted the anesthetic enough to go up to the bear and do it firsthand. There was a chunk of ice for cover. I suggested using it to slip up behind him. If he couldn't see you, the bear wouldn't be so disturbed. Schein was unwilling to do this.

So they remained in the boat, safely away from the bear. The problem was that they had only marking dye cartridges that would work in the CO_2 gun. But this gun was not very powerful, so the cartridge would do nothing more than squirt red dye on the animal's fur if it hit, which it did not. Several darts were

lost. Then they loaded up the other, more powerful, gun that fired the dart with a gunpowder charge. The dye marker flew in a high arc like a bow and arrow and overshot the bear by twenty feet. Desperate now to succeed, Schein then loaded up a huge syringe suitable for basting a Thanksgiving turkey with red India ink and approached the bear, bringing the boat close to the floe. He squirted red ink all over the boat and himself, but got none on the bear. The wind was too strong; it kept blowing the ink back. He loaded up again, and this time he got out of the boat and onto the ice, approaching the bear from the front. The bear stirred and Schein squirted and jumped. He marked a lot of ice magenta, and a little bit of bear. A.D. offered to paint TEXAS on his side and even I couldn't keep quiet, but Schein wasn't up for advice. He then decided that we should try to mark the bear from Stenger's boat, and he did. We then retired a hundred yards away to measure the bear's recovery time. In any case, we declared this an "historic moment" since this was the first polar bear to be marked — however indistinctly — for scientific purposes.

In the end it took fifty minutes before the bear was on his feet. The use of his muscles returned in reverse, his front paws first, then his rear legs. He shivered uncontrollably, and then did a lot of yawning. His first steps were very shaky and he seemed quite groggy, but moved slowly and seemed completely okay. He sat down fifty feet away. We were hoping he wouldn't try to swim. After rolling in the snow several times, he finally withdrew to the far corner of the ice floe to alternately get up, sit down, and lie down. As he was quite far away, Hart went onto the floe and recovered the drug needle. Schein only had five of them big enough for polar bears. We finally returned to the ship at 24:00. Schein and Hart went up to the wheelhouse to keep observing our bear. I got my cameras unloaded and was ready for bed.

Unfortunately, the Captain was drunk again, as I predicted, and I tried to avoid him. He came around to the cabin, however, before I was even undressed and said he wanted to talk to me. I reluctantly joined him in his cabin for a drink. He started off with a lecture on cruelty to beasts. The final touch was when he started telling me that he wanted to live — not die. He had gone to so many dangerous places for my pictures and this all got mixed up with the poor bear. I kept eyeing the .32 automatic, remembering A.D.'s experience. The pistol was nearby. I was also armed, however. The pistol reminded me to mention

that if he was worried about living he would do well to stay off the ice with po-
lar bears.

When he left the cabin to speak with a crew member, I took the opportuni-
ty to pour most of the contents of the whiskey bottle into the sea and make my
escape. I went up to check on Hart and Schein. They were still watching the
dozy bear and writing up their notes. Then I heard A.D.'s laughter down below
and knew that he had just been caught by the Captain — and was desperately
attempting to depart with good humor.

I hit the sack finally. Just as I dozed off, Schein told me the bear was up on
his feet and close to the ship. I woke up A.D., who had wanted to photograph
the bear's faint red mark. A very sleepy A.D. decided that he didn't need that
shot after all.

Shortly after, at 02:30 August 10th, the bear, of his own free will, dove into
the water, came up on another ice floe and dove again. He then disappeared
for good. He was a good bear and I wished him luck. We named him Big Bear.

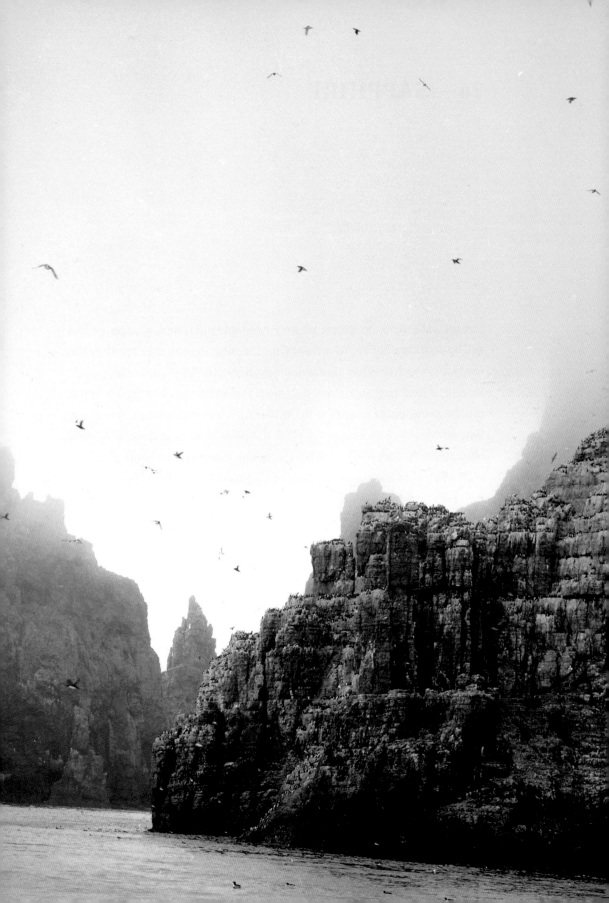

24 – SAPPHIRE

Stenger woke me up to tell me we were tying up to *Blueback*, a sealer we had met up with once before. We were at Cape Lee, near the Caltex camp. They had two bears, which they had shot near Freeman Straits. "Did I want to see them?" My reply: "Hell, no!" and returned to sleep. I was getting sick of aspects of this trip. I was beginning to agree with the Captain about killing bears. Schein and Hart were on deck picking at the skull of a polar bear, examining brains and other contents. They had traded bear parts with *Blueback* for a bottle of cognac. Blueback had followed us since Cape Lee. I prayed that their two bears weren't the animals we had worked with.

A.D. and I went to work on the steel bear cage that I had brought on board to protect me while photographing the animals underwater. We hadn't tried it yet. He thought the cage could be used while the ship was running, herding the bear toward us with his outboard while I took pictures from the cage. We reinforced the bottom of the cage to keep my feet from slipping through the bars and finally put it over the side. With the ship moving at four knots, I was worried that the cage would pull away from the ship like a sea anchor, but with three-quarters of it submerged, it seemed to be okay. I dressed in my Heathway's wet suit with long johns underneath and a vest from my Swedish suit.

A.D. had decided to join me in the water, and although he had retrieved Japanese mines underwater as a Seabee during World War II, wearing a wet suit was a new experience for him. In theory, one's body warms the water that enters this suit, but if the suit doesn't fit snugly, too much icy water enters and the body is refrigerated.

We both went in. A.D. got very cold because his suit was too big, but mine was tolerable. We reckoned that the cage would work with a few changes. A.D. and I both took our cameras down underwater in the cage and we were very encouraged by the possibilities. Now we needed another bear.

But before we could go on the hunt again, I was expecting a visitor. My brother, Gamble, had expressed an interest in this trip, and I was happy to oblige him. He had done so much for me, including sharing his New York apartment. At the same time, this was my chance to show off a bit as expedition leader rather than just being kid brother. We had enjoyed many adventures together over the years. When we were both in Paris after Korea, we headed south to go skin diving on the island group Îles d'Hyères but wound up on the Île du Levant — wrong island. It turned out to be a nudist colony — the wrong kind of skin diving. In 1953, we went to Cuba where we met Hemingway at his favorite bar before heading for Haiti for more skin diving but no nudists this time. Sometimes he dreamed the adventures; sometimes I did. He worked on Wall Street, but his interests and curiosity extended beyond the financial world. He spoke three languages fluently and had an amazing memory. Gamble's brilliance, good looks, and charm seemed to get him what he wanted more easily than I could manage.

Gamble was flying out from New York to Oslo, then Bodo, going by boat to Tromsø, where he would then board *Lyngen* to join us in Spitsbergen. He had sent a telegram with details of his arrival aboard *Lyngen*. He was due on August 17th at Longyearbyen. We had an appointment to talk on the ship-to-ship radio, but he was "at dinner" when I called. We had to stop *Venus* to make a call because of the engine noise. I finally reached him. He'd been fishing all night. They must have been off Byørnøya (Bear Island). Gamble described meeting some attractive French girls aboard who were being policed by a fierce mother. I warned him that radiophones operated as a party line with about a thousand fishing boats, sealers, and expeditions tuned in. We were interrupted, then reconnected, and he claimed, "We've been jammed by Russians" — a bad joke in these parts.

On August 13th, at about 06:00, Fred Hart woke me up and filled me in on activities of his watch. They had been considerable. The Captain was drunk again. He had come up to the wheelhouse during a stop, took Bjørn to his cabin

and got him loaded. Bjørn can't say no, so he had returned to the wheelhouse, clobbered. He was then drunk *and* on duty. DeCourcey gave Bjørn a temperance lecture that angered the man, who began giving wild signals to the engine room, "full speed, reverse." Luckily, Bitte knew what was going on and ignored them, so we continued through the ice at half speed. Fred Hart took over the wheel. The Captain had been drunk for three days. Where was he finding the booze?

According to Schein, who was on watch, Bjørn arrived for duty badly hung over at midnight, after a great effort to get him on watch in any condition. When I came up on the bridge, Bjørn had passed out on the couch in the chart room. I told him to go below because he was drunk on watch and had been relieved. That message was delivered to him in a quiet tone several times. Then he shouted, "Why should I do that?" That did it. Grabbing Bjørn, I picked him up and heaved him through the door. He went crashing onto the deck above the ladder. By this time I was furious and making quite a lot of noise. I grabbed him again and dropped him down the ladder into the galley. He hit a good number of pots and pans on the way down and managed to wake up the cook. Bjørn picked himself off the galley floor. I hadn't been so worked up in years.

I was fed up with this "whiskey tanker." We had a good crew except for the Captain and Bjørn, who had no backbone and was sucking up to the skipper, a raving alcoholic, just to earn his steersman's papers. But I was getting violent, so I retired.

The joyful voice of A.D. soon woke me up, along with everyone else who happened to be within a mile: another polar bear! Sure enough, there was a small bear swimming along beside *Venus*. A hot discussion broke out between A.D. and Schein, who insisted that it had been agreed that this bear was his. He wanted to shoot the bear with the dart gun before it became exhausted, to measure the effect of the drug. A.D. was afraid they might kill the animal before we could get underwater pictures.

I told Schein that the bear was his. We would work with the animal after he was finished. A.D. gave in with good grace. I got on my frogman suit as a concession to A.D. in case the darted bear went into the water while under the anesthetic. A dramatic rescue of a drowning polar bear would do wonders for Stenger's film.

We took off in the small boat, but Schein insisted that neither *Venus* nor the outboard come too close to the animal. We followed until the bear climbed up on a big ice floe. It seemed not at all disturbed by our presence and soon found a seal carcass, the remnants of another bear's meal. The bear settled down and started chewing, not paying much attention to us. We were about 100 yards away and the water was choppy. It was snowing, so we couldn't see very well. I returned to *Venus* to get my 400mm lens and then went back to the iceberg. Still, conditions were not good. We decided to wait and watch. The bear began to perform, rolling in the snow. But the lumpy ice field between us obscured much of our view. After an hour, however, the sun began to shine through the overcast. This had the makings of a good situation.

Schein, Hart, and A.D. took the boat around to observe the bear from the other side of the floe and maybe shoot it with the dart gun. I had climbed onto the floe and because the light was so good I gambled on staying put; I felt secure with my carbine and pistol.

The bear moved in my direction and then climbed on an outcropping and went to sleep. The sun came out and the situation was perfect — fresh snow, gray snow clouds in the background, and moments of bright light. I moved a few hundred yards closer and got the bear with the sun in just the right place. Fred, A.D., and Schein joined me on the floe and we all cautiously approached the animal. The light was perfect. The bear occasionally lifted its head straight in the air and took a sniff, but would soon settle down again. I set up my tripod within fifty feet of it. The animal, probably born three years previously, had most likely never encountered humans. I was falling in love with this beautiful animal — such a lovely bear.

Schein slowly approached the sleeping bear with his dart gun. Finally he was ready. A.D. was filming. Schein shot and the dart went SWOOOSH over the head of the bear by six feet, lost forever in the snow. We all grinned and made faces at Dr. Schein, the famous marker of bears and shooter of icebergs.

Another dart whistled by. The bear looked up but soon went back to sleep. Schein tried again. This time he hit, and the bear scampered off. The dart fell out, but Fred started timing the action of the drug. The bear was heading toward the water. We all raced to the boat. I grabbed my facemask. I didn't want anything to happen to *this* bear. Eight minutes had passed and the bear was

swimming peacefully: it was obvious that the dart had glanced off, tranquilizing more snow. A third shot was prepared. This time Schein shot the bear as it was coming out of the water. He didn't miss. Again stop watches clicked. The bear was down in thirty seconds. We rushed to the spot where it had fallen, hoping that the dose was not too strong, killing the bear as it had the reindeer.

Schein prodded the bear with an oar. It was out cold, but with eyes open. We got busy and tied up the animal. Stenger put a stick in its mouth just has he had with wild boar, and tied its jaw shut. Our little bear turned out to be a female. Schein checked her respiration and heartbeat. The animal defecated, as had Big Bear, but was sleeping peacefully. We got a tarpaulin from the ship and slipped it under the animal. DeCourcey got out his Geiger counter and found that the bear was moderately radioactive, but not even as much as my watch with its radium dial — maybe she would glow in the dark.

Fred Hart measured feet, neck width, length, skull size, and the lady was thoroughly imposed upon. After all the relevant data was collected, we dragged the bear on the tarpaulin to the edge of the floe, where the ship had been brought, and hoisted her aboard with the winch.

As we pushed our captive into the diving cage on deck for safekeeping, A.D. yelled: "Get your ass in there, Sapphire!" Why he called her "Sapphire," a character on the popular radio show, *Amos 'n' Andy*, I don't know, but she became Sapphire on the spot. Sapphire was my insurance package. This was our fifth bear and she was ours. She would provide diving pictures when light and water were right, then we would release her with many thanks. At least that was the plan.

There was a heated debate whether to untie the animal. Fred was for maximum security. A.D. voted for releasing the bear (in the cage), but she solved the problem by getting one of her paws loose. Finally the animal was free, though caged, and surprisingly good-natured under the circumstances. We gave her a large supply of seal fat that she ripped apart, holding with two claws and tearing with her teeth. After this meal was completed she licked all the fat from between her claws. A well brought up polar bear.

The next day Fred Hart shot a big bearded seal to keep Sapphire fat and quiet. The forward part of the ship was roped off to keep the crew from disturbing the animal. She was quiet — no hissing or growling. The loaded dart gun

and rifle were ready and we now stood watches armed. She slept most of the day and was not disturbed by the rifle fire when Fred shot the seal. She seemed to be a good-natured young lady.

Sapphire was thirsty and drank about ten liters of water that first day. A beautiful animal, she enchanted everybody. The crew fed her all sorts of crap: bread, chocolate, sugar; the cook gave her some Jell-O. Schein shook his head and worried about stomach aches. The men assumed that if Sapphire ate something, it must be good for her, including a chocolate bar complete with wrapper.

Sapphire was gentle now. I gave her water and she didn't growl, just looked at me and then lapped up the water. The water pan was tilted so I straightened it out with a boat hook and poured in water from a bottle. She didn't swipe at either the hook or the bottle. Then I fed her, cutting up seal fat, which she loved, and out came a paw and snagged it away from me. So she was being well fed, but badly needed a bath. She was very bloody from all the seal meat she had rolled on in the cage, and messy from the Jell-O, cookies, and jam sandwiches that had been thrown to her.

Preparing ourselves for photographing the bear underwater, DeCourcey and I, who both wore eyeglasses, had brought along correction lenses that he was gluing into our diving masks.

This strange fellow, who I knew well and didn't know at all, had wonderful qualities *and* peculiar ones. He went out of his way to seek out strangers, was always helpful, and was a devoted correspondent to a long list of scientific acquaintances all over the world. He had ready a stack of letters and small packages for posting in Longyearbyen: plants for Fosberg, plankton and algae for Wilce at the University of Massachusetts, and intestinal parasites for the biology lady in London.

DeCourcey was polite to the cook and crew members, but hardly spoke to the rest of us. He also had very little to say to me about his sister, brother, or father. It would seem that those he knew well, he avoided. I don't think that he disliked anybody; it was a proximity problem. Intimacy gave DeCourcey claustrophobia. And that was a problem aboard *Venus* — there was little space and no escape, except for an occasional stroll alone onto the ice, which would have been suicide, or a chance meeting with a fellow scientist.

DeCourcey diligently recorded the names of those he met along the road, particularly scientists. When he met someone, he often found they had a friend in common. And he was generous, sometimes with things he didn't own: he once impulsively gave a book from the supply of reading material I had brought for the expedition to an Englishmen we met in Hornsund. One scientist who had been his beneficiary had been so impressed that he invited DeCourcey to Japan on a free trip.

DeCourcey traveled the globe, floating on currents of scientific activity — trading what little he had, or didn't have, for the pot he hoped to find at the end of the rainbow. My "pot at the end of the rainbow," — this trip — wouldn't have existed without DeCourcey; his introduction of me to Dr. Gene Odom had been the first step.

After a few days with us, Sapphire was getting a little less gentle, so we were all careful around her. Her cage was near the entrance to crew's quarters and she could reach through the bars and easily maul somebody as they went by. Sometimes she hissed if you got close, taking a swipe at Schein one day when he was giving her water. The crew continued to feed her remarkable things, however. We found a dead guillemot in her cage, one that had been shot at Bjørnøya and dangled in our rigging for six weeks; it was ripped apart, partially eaten. We decided that she needed to be photographed before the crew killed her with jam sandwiches and other un-bearlike food. Schein was worried about her diet and decided to seek some advice. Calling the New York Zoological Society, where they had some polar bears, seemed a good idea. The radio waves from M/S *Venus*, a speck in the ocean 10° south of the North Pole, via Svalbard Radio in Oslo, then an overseas operator in New York, might connect us.

"Hello, hello. This is *Venus* calling." A little static. "Dr. Osborne, please."

Then the line was transferred to Dr. Osborne's secretary.

"This is Dr. Martin Schein calling from Spitsbergen. May I speak to Dr. Osborne?" A little more static. Then, with crystal clarity, "Dr. Osborne is in a conference, would you please call back in an hour! Thank you."

CLICK! and that was that.

Although we felt ready to dive, the sea was not cooperating. Swells were pitching the boat badly. I wasn't in the mood for this uncomfortable work on a dreary day. In order to dive, I had to warm up every drop of water invading my

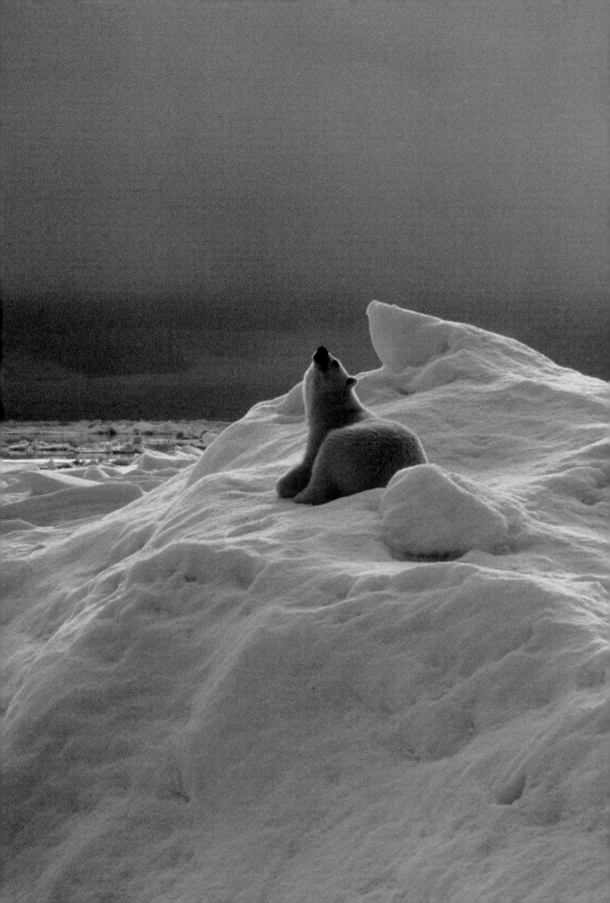

wet suit; it arrived one degree below freezing — cold enough to kill me from hypothermia in fifteen minutes. I needed good weather, sunshine, and calm seas, but it was overcast and snowing lightly. At supper, I was kidded by all. Schein said: "You'll have to rest another four hours before diving and by then it will be time for breakfast."

A.D. also wanted to dive and so, lousy weather or not, I agreed to try. Among other things, Schein was about to go back to the States and we needed him to take some test film back to the *LIFE* magazine laboratories for processing, but first we had to get the cage containing Sapphire into the water. Then we had the problem of how to retrieve her when I finished photographing? Sapphire had been very active lately. She was potentially dangerous. Normally we moved the cage about by holding onto the bars, but we now did this tricky job with a couple of oars. After I suited up and arrived on deck in my rubber suit, the cage had been lowered into the water with the top of it just at the surface. The door had been opened. Sapphire had already been launched. She was swimming quietly alongside the cage, with Fred Hart and Schein following in Stenger's boat and for the moment they were doing a good job of herding her near the cage.

Sapphire badly needed this swim. She was filthy, with large, brown patches of dirt and feces on her, and her rather yellowish summer coat had turned to ochre. She needed the exercise as well. This wasn't going to be easy; the sea swell was banging the cage against the side of the ship. The weather was still heavily overcast with intermittent snow.

With Sapphire out, the cage was hauled up to deck level and in I went; closing the door behind me — then I was lowered into the water. The water was clear but there wasn't much light. My light meter reading was so low that I had to use flash. As the swell rolled the ship, it took my photo ports — the little windows built into the side of the cage to accommodate my camera — out of the water, and my lens aimed at the sky. Then I plunged back as she rolled. I was connected by a long rubber hose to an air tank on the deck of the Venus. God help me if this got tangled or pulled tight with the ship's gyrations. More troublesome, Fred and Schein couldn't get Sapphire near me. Finally, she came over, and I got a shot of her paddling by from underwater. Thank God, the flash worked. A.D. stood on top of the cage to pass me flash bulbs as I fired them, but

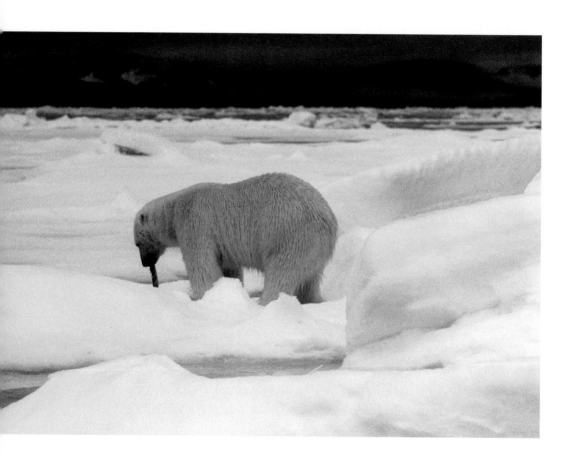

the next time Sapphire came close I had a misfire and the third time there was so much wash from the outboard's propeller that bubbles obscured the bear. By this time I had been in the water for an agonizing hour I was very, very cold. I would have quit but *one* picture was not a test roll so I stuck with it.

When the ship was moving I was jammed against the side of the cage by water pressure, and it was almost impossible to get the underwater shots I wanted. Stenger stood on top of the cage interpreting as I stuck my hand through the top of the cage: UP, DOWN, SLOWER. He relayed my signals to the crew controlling the winch. At one point, I removed my facemask to talk to Stenger — a mistake. Now unable to push it back onto my face to get a good seal, I was getting seawater in my mouth and eyes.

I came up for a rest, paced around on deck, and waved my arms and stomped my feet to warm up, but I was as cold on deck as in the water. Then A.D. took over the little boat, with Schein and Fred on the winch. I went back in.

Schein and Hart started razzing A.D. when Sapphire wouldn't cooperate. She got smart, cutting back or swimming under them just as the outboard got close. Stenger soon mastered both Sapphire and the boat. In ten minutes he had her set up for my second shot. We developed a system: when Stenger chased the bear out of photography range, Schein would tell Hart to winch up the cage. As I came out of the water, *Venus* took up the chase, increasing speed; then, as we closed, *Venus* slowed and Schein sank me. Repeating the routine, Schein then handed me a fresh flash bulb after each shot and lowered me again. Sapphire became interested in the flash of light and came directly up to the cage. Now she was too close and I missed some amazing pictures.

Finally, at 23:00 twelve pictures were taken and I got out of the water with two frozen feet, a slight leg cramp, and shaking limbs. Stripping down, I found it was warmer naked on deck than in the water. Retreating below decks, I attempted to return to warm-blooded mammal status. Captain Pedersen brought me a hot cup of coffee. This gesture surprised and touched me. I began to see him in a different way.

When I reappeared thirty minutes later, Sapphire's recapture was in progress. Stenger roped her around the neck, passed the rope through the cage and poor Sapphire was dragged in. The door was closed by pushing it with the bow of the outboard, after which it was wired shut, and hauled back up on deck

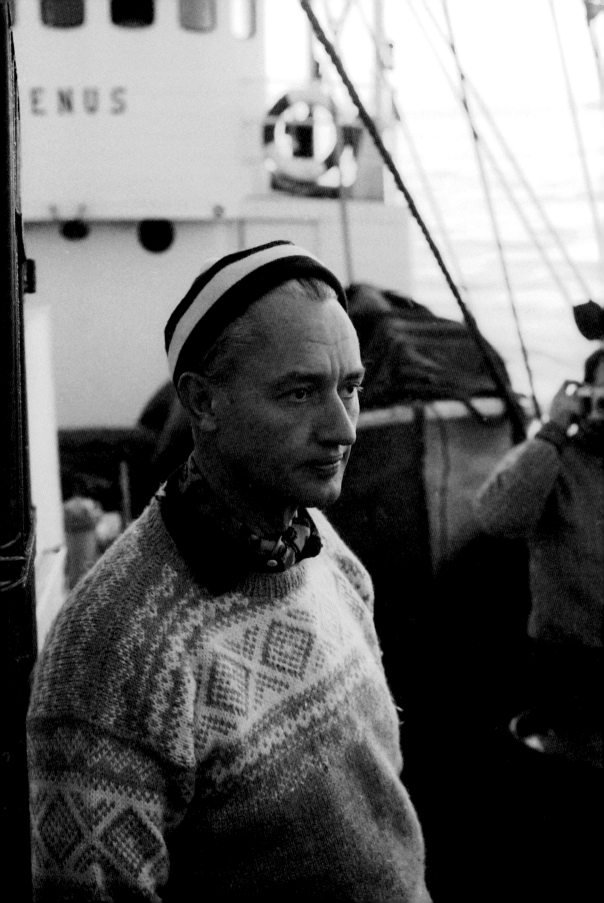

with Sapphire safely inside. This landing operation was not as smooth as described here, but it worked.

I was relieved to see her back but also a little depressed. Sapphire probably didn't like this routine any better than I did.

My gear was washed off, the camera unloaded, and the film packed to be sent to New York. I hit the sack at 03:30 but couldn't sleep. I got up after an hour, to see *Lyngen* in the distance.

At 06:00 *Lyngen* arrived on schedule and we put over Stenger's boat to deliver Schein to the passenger ship and pick up Gamble. We had an American flag attached to the oar that served as a mast. As we approached *Lyngen*, I could hear the "Ooos" and "Ahhs" as tourists poured on deck to admire Sapphire. We were thoroughly photographed. Gamble was busy, of course, saying *au revoir* to the ladies.

The successful transfer was made. I was sorry to see Schein go. He was a good sport, passed all the tests and bore up well under pressure. He had graduated from turkeys to polar bears.

Gamble was in great form and came aboard with lots of tales about the women he had met on the trip. He entertained us all, including crew members, for an hour after his arrival. Gamble told DeCourcey that the news from home was that his father had been bitten by a rattlesnake (*klapperslanger* – Norwegian translation for the crew) but was okay. DeCourcey expressed as much emotion as if Dad had purchased a new hat. "Oh," he said and that was it.

Gamble also gave me a letter from Monica, who was supposed to join me in Europe after Spitsbergen. He withheld any news of her but told me that she had explained everything in the letter. I had a peculiar feeling about this, but didn't open the letter until finally when things quieted down and the expedition went to bed. Monica was pregnant. I read her letter and was very happy that there was such good news. I was so tired that very little emotion could get through to me — but this did. I learned that everybody was concerned about my reaction. Aunt Mildred wrote: "Stop worrying and start knitting."

I went to bed at 07:00 very much collapsed, feeling fine about everything except being on this ship. I was anxious to go home and get things started for the new baby. My uncertain lifestyle needed to be examined. A new direction was in order.

When I told A.D. "I got a letter from Monica," he said: "Is she pregnant?" "Hell yes!" He thought I was kidding and I had to explain it to him several times. I saved my news from the others, preferring to savor it, and after lunch I sent her the following telegram that ended with, "Thank God no poodles, canaries, cats, or goldfish for us. Delighted. Love, F."

Venus finally got down Kongsfjorden into Kings Bay. After docking, we found a place to take a hot shower and cleaned off two weeks of crud. It was raining and snowing. Kings Bay was not at its best.

Returning to *Venus*, we found a congregation of children as well as a crowd of miners and their wives gawking at Sapphire. Without permission, they had boarded the ship and some were very close to the cage. I chased them away. Every day the caged bear got more dangerous. She needed to be released soon. Our engine was being repaired so we couldn't leave the dock as planned.

By August 18th, I was fed up with nearly everything about *Venus*. I woke up at 10:00 to find that all the crew members were aboard but the Captain was reeling around again. We had a long talk, first at the rail, then in his cabin. Pedersen's face was bloody and banged up. He wanted a bottle of whiskey and I refused.

I got the full story from Fred Hart. About 05:00 our Captain and First Mate Torkel were returning to the ship. Just as they arrived, for some unknown reason, the Captain began punching Torkel. Torkel covered up his face but the skipper continued to pound on him. Finally, Torkel lost his temper, grabbed Pedersen and began to beat him up. Bitte got the Captain away from Torkel, spirited the boss into his cabin, confiscated his pistol, and locked him in his own cabin. Fred had witnessed the fight and said that Pedersen was covered with blood.

At lunchtime, we let the Captain come into the wardroom and he asked me again for whiskey; getting quite violent about it. Remembering that his pistol was hidden, I stuck with prohibition — no whiskey. Pedersen's face was a mess, and secretly I felt sorry for him, but I was not about to let him get sloshed again.

He said that the ship was not leaving port until he got a bottle of whiskey. The comedy was reaching a climax. I went up on the bridge to consult with Torkel and found that the engine had been repaired and we were good to go. Torkel said that I was right; that he would take over *Venus* and would go wher-

ever I wanted. In the meantime, up came the Captain, yelling that this was the end, and that he was sailing back to Norway.

Torkel then suggested that a half bottle of whiskey would quiet him down and we could leave as planned. The Captain was staggering around, yelling orders. No one was paying any attention. Deciding it was better to have a drunken Captain than a mutiny, I gave him a bottle of cognac. I was *not* returning to Norway. We would all help run the ship.

After receiving the cognac, he became calm and suddenly friendly, saying that he would do anything we asked. He would even give us a free day of charter and insisted that we all have a drink with him, rounding up DeCourcey, A.D., Gamble and me, "his fine comrades."

He had won his battle and felt relieved. "Why can't you understand – all ice skippers drink." His dignity was at stake. "I am Captain and owner of *Venus*." He had a point. I just nodded yes, yes, yes. A.D. was closest to the door and after telling him what a fine ice skipper he was, took off. DeCourcey vanished with a bow. Gamble and I were stuck.

Every time he said "Skål," I spit the drink back into my glass. Gamble had some "just in case" sleeping pills and he brought me two Seconal tablets. I broke one open and it dissolved in my glass in a murky cloud. Gamble unfortunately dropped a whole capsule into the cognac bottle and there the little red pill floated and floated. To me it looked the size of an iceberg. It refused to melt. Retrieving the pill, I dissolved it in my glass and poured the contents into the bottle and I topped up the Captain's glass.

"Skål, Captain!" and we finally got the hell out of there.

This was the signal to head north – *not* south to Norway. On the bridge, Torkel told me that Pederson's wife, Margit, could control him, and when she said stop, he always did. In some weird way I was actually becoming fond of him; he was like a lost child.

I recorded the following in my diary: *A few hours ago, we passed Magdalena Bay. The weather is cloudy but there's fresh powder snow on the mountains. Standing alone, memories run by like an old film. How could the same place feel so different two years later? The Titanic experience – three individuals and our dysfunctional engine – a drama played out in a theater so overwhelming that the actors were resized by Arctic reality and dwarfed by its history. Aboard Venus*

the actors are close up – magnified in relation to the same place. Drunkenness, life within a ship is such a different theme. And now there's a new star, Sapphire, our beautiful four-legged dirty blond heroine. She's my hope, and at the same time I'm exploiting this helpless animal to photograph her. I have always been a sucker for dogs, now it's a polar bear. Would I do this to a dog?

Gamble took the first watch and quickly spotted a seal. I heard a gunshot and went out to find that he had bagged another dinner for Sapphire. A.D. skillfully skinned it, working with his pocketknife. After A.D. finished, we sat down for coffee. Gamble came off watch, joined us, and launched into a description of the technique of skinning. "You use the curve of the blade with an arched slashing motion." Now, Gamble had never skinned a seal, but he can talk with assurance on many subjects, ranging from how to grow an orchid to skinning a seal. His voracious reading and phenomenal memory made him an entertaining narrator. I came to the grumpy conclusion that since Gamble had never skinned a seal, this technical know-how might be best kept to himself until he had a chance to try it out. (Note to myself: *Grow up Fred. No sibling rivalry permitted 80° North.)*

Gamble stayed in the spotlight when *Venus* was stopped to receive a radio transmission. A telegram had been sent to him in French. It was from one of *les jeunne filles de Lyngen* who wanted Gamble's address. Norwegian telegraph operators do well in English, possibly German, but French takes a little longer. As our ship lay dead in the water to receive this radio transmission, an hour was wasted.

I continued confiding in my diary: *I'm troubled again but instead of being irritated, I would like to look at things in a different way — how it is possible to have one of Gamble's babes affect an expedition six hundred miles from the North Pole. Obviously, Gamble has long-range charm. There is a lot of big brother–little brother stuff going on. This is nothing new but I had hoped that playing this game at the top of the world, under new conditions, I could change the rules. Here the stakes are higher. Circumstances enlarge frustrations and Trivia becomes a giant.*

It was time to think about important matters. If we were to do any more underwater bear photography, we needed to find a replacement for Sapphire. She was getting to be a dangerous bear. She had taken to climbing all over the cage

and had managed to work the bars apart. She could now stick one foreleg and her head and shoulders out. We reinforced it with some 2 x 4 inch timbers but it was only a matter of time before she could get out. And our star deserved to go home.

All that day, we suspended the bear watch due to no ice and bad weather. When I woke up, we were anchored at the southeast corner of Nordkapp. There was a hard snowstorm blowing from the northwest. Visibility was terrible. Even on the protected side the water was very choppy. Snow covered everything and we all lay around the ship wondering what to do next.

Supper featured Gamble's seal. It was gourmet fare: A.D. ate seven pieces. The cook thought the meat was third class, but it was high cuisine compared to the seven-week-old codfish we had been having. And as for the rotten mutton that had been hanging behind the smokestack, only a starving polar bear could enjoy *Mutton à la Diesel*. The quality and variety of food aboard *Venus* was declining rapidly. We were out of carrots, lemons, tomatoes, and cabbage. The cook wanted to re-provision in Kings Bay, but the Captain didn't want to spend more money. We were even getting low on fuel oil, and the beer was also gone.

After dinner the weather cleared slightly, although the wind continued to howl. A.D. and I were getting jumpy. We needed to get off the damned ship. We had moved around the Southern part of the island of Nordkapp, so we decided to go ashore. I put on all the warm clothing I owned. The wind was blowing so hard that I decided to risk only one camera with three lenses. This and three rifles were loaded into Stenger's boat, and Gamble, Fred Hart, A.D., and I took off for shore.

Gamble, A.D., and I proceeded inland, approaching a saddle that connected with a high ridge to the right, which Fred climbed. We were quickly separated by the snowstorm, continuing our separate ways for about forty-five minutes. All we saw were a few pathetic flowers struggling in the snow. It was a dreary place. We couldn't see Fred and I got worried, so I fired a shot in the air with my carbine. Gamble warned me about wasting ammo, but my signal worked. Fred answered with a shot and joined us ten minutes later.

We finally headed back to the ship. We were all tired. The ride back was against the wind, and although the wind ashore had seemed warm, it was freezing at sea. Fred reported that the winds at the top of the mountain were about fifty miles-per-hour. At sea, on the windward side of the island, the snow

hitting my eyes was like little needles. We finally made it back to *Venus* at 01:00 on August 21st — a fateful day.

When we got back aboard ship we found an empty diving cage. Sapphire was gone. What had happened? Had Pederson released her? The Captain had been mumbling about how we should set her free. He actually had the nerve to tell me that he would allow me to dive with the bear once more, and then she would be released. We actually all shared this idea, but it was my expedition and I would not accept it as an order from Pederson.

Gradually, we pieced together the following sequence of events: Earlier that evening, DeCourcey had discovered that one of his steel draglines hanging over the side had a dull weight on the end. He hauled it in to find that he had hooked a sixteen-foot basking shark. The non-hunter, DeCourcey had bagged the biggest catch of all. The monster was winched aboard and De-Courcey slit it open and took some samples: liver, stomach, and other organs. The shark's body was left on deck.

Sapphire evidently got wind of this tasty meal nearby and began working on getting out of her cage. How she escaped no one knew, but the next thing anyone saw was Sapphire on the top of the cage. When we later examined the cage we found that the bars were intact, but the timbers that had been used to repair the top had been pushed to one side. Still, no one could see how the bear could have escaped. But got out she had, and when DeCourcey came on deck he found Sapphire chewing on the shark. She stayed around for about ten minutes, and then took off, diving off the side of the ship and swimming to shore on Nordkapp Island.

We arrived on *Venus* about fifteen minutes later, and when DeCourcey quickly filled us in on what had happened, we looked back to shore and could see Sapphire rolling happily in the snow. We were wet, cold and depressed. A.D. and I went to our cabin to warm up. I got my wet, frozen clothes off and cleaned my rifle.

A.D. and I were thinking the same thing. We had to try to recover her. She was our insurance and only guarantee to getting any work done during these last dreary days. Everybody was tired and cold, but we decided to give it a try. We had to try. So we got dressed again, and put together a crude plan. We would take the outboard ashore, locate the bear, and somehow drive her into

the sea and herd her back to the ship. Gamble was a good sport and volunteered for this mission of desperation.

We set out at 02:00, much to Fred Hart's dismay. He thought the plan was crazy in such weather and remained on *Venus*. Sapphire had disappeared from view, but we set out. As soon as we rounded a sheltered point we met by the full force of the gale. The wind and waves lifted the little boat and crashed it down with a terrible bang. We were in trouble: survival in such water and with no other way to get back to the ship would make any accident very dangerous. Further, our otherwise unreliable Walkie-Talkies no longer worked.

Luckily, the water was calmer near shore, and after half an hour we spotted Sapphire about fifty feet away up the side of the island lying in a snow patch. The immediate problem was how to land in the gale. Unfortunately, this end of the island was a loose pile of boulders with jutting rocks rising sharply up six hundred feet — an impossible place to land. A.D. finally picked a spot about three hundred yards downwind from Sapphire. Wearing A.D.'s hip boots, Gamble jumped in and held the boat while I scampered into the water and onto a rock. We pushed A.D. off the beach quickly before a wave caught him. The plan was to move Sapphire toward the shore. Gamble and would I flank the bear, driving her down to the water, and there A.D. would take over and try to herd her back toward the ship.

Climbing turned out to be steep and clumsy: I was overloaded, with a rifle and too many clothes. The black smooth rocks were slippery and loose. We climbed up an avalanche, a huge heap of rocks ranging in size from cannonballs to chunks twenty-feet high, all set at unfriendly angles. The snow and wind were blowing in my face. I was sweating and my glasses fogged over. When they were not fogged, the snow blinded me. Clumsy and blind, dressed for the boat but overdressed for this effort, I was a mess. Gamble was having less difficulty, and the further behind I got, the madder I got. Soon I had to call a halt.

Gamble was having a good time. I was not. He was enjoying our adventure, taking it in stride and repeatedly warned me: "Look out, the rocks are slippery. Watch out this one is loose." He kept up a running commentary on conditions. I was nearly blind but I remained silent. Finally, after a tough half-an-hour of climbing we were nearing where we were supposed to be, above the bear. Gamble said: "We better stop talking, were getting close to the bear."

We finally arrived at a place where there were two more or less tractable routes over the rocks. There were dangerous-looking boulders perched on the side of the mountain. Going high was the safest way I told Gamble, but he took off on the low road. He may not have heard me because the wind was howling. He continued down.

I didn't follow him. Moving on for fifteen minutes, I lost sight of both Gamble and A.D. in the boat. He might have been getting low on gas and gone for calmer waters to fill up from one of the jerry cans. Finally, I saw Gamble a hundred feet below me. About fifty feet directly below him was Sapphire, but he couldn't see her from his position. I yelled a warning. He unslung the rifle. I managed to get down to him in fifteen minutes. Sapphire went first one way, then another. Gamble then threw some rocks and moved to the left to outflank her. Scrambling down to his level, I yelled to herd her down to the water with rifle fire if necessary.

"Don't let her up the mountain. We'll never catch her."

If we had stayed above and on both sides of her we had a chance of driving her to the sea, where A.D. had returned with the boat. I was fifty feet behind Gamble when Sapphire started moving down a narrow cut of rock. This was okay as long as she didn't head uphill at the end of the corridor. I yelled to Gamble, "Shoot if she goes the wrong way." I couldn't shoot because Gamble was between the bear and me. She started up out of the corridor and I yelled, "Shoot." Gamble did, but too late.

Gamble aimed at a boulder right next to her and the angle of the shot ricocheted the bullet right into her foreleg. I caught up with Gamble and he was shaken. "I don't think she's badly hurt," he said, and went up to have a look. I fired twice behind her to see if I could move her, but she didn't stir. Her leg was broken. There was nothing to do but put her out of her misery. I took careful aim, "Goodbye, Sapphire."

We rolled the bear into a crevice and left the scene. Both of us were disgusted with what we had had to do.

A.D. picked us up from a boulder jutting a little way out into the sea. This was tricky. There were a couple of underwater rocks, which A.D. had to avoid, and he also had to come in just as the waves were full. First, Gamble jumped into the boat and A.D. gunned the outboard just in time to save the boat from

crushing on the rocks. A.D. made another pass. I handed both rifles to Gamble, then the wave brought the boat a little closer and A.D. yelled, "Jump boy." I did and landed sprawling in the boat. We got the hell out of there. A.D. was solicitous about the bear and told Gamble that she was too dirty to use anyway, even underwater. Clearly, he hoped that we wouldn't take it too hard.

We returned to the ship. Fred and Torkel had been about to come for us in the ship's lifeboat: they thought maybe we had flipped, but Stenger had handled his small boat superbly. We hit the sack. A.D. and I were exhausted and slept most of the day.

Later, I poured out my thoughts in my diary: *Suddenly, I feel that I can't keep anything under control: the Captain, Bjørn Hansen, or my brother. By the standards of survival required here, I am no leader of men. I'm disgusted and no longer want a chance to prove myself. This is something that I don't want to do anymore. All the bullshit, striving, ego-driven adventures suddenly add up to having to kill this beautiful animal because I want to be a LIFE magazine photographer. Packaging wonder, building on absurdity and brutality doesn't make sense. The Picasso mantra is made of a self-serving pile of shit – that has led to disaster. Ego, tell me about ego!*

The Captain said the wind was coming in very hard from the northwest and he was afraid of being trapped by ice. He said that he wouldn't go into one of the fjords in search of more bears because he didn't know the waters and the charts were not accurate. Torkel also hadn't been in this area. Also, if we had found a bear in such weather there was nothing we could do with it, so we gave up and headed for Storfjord between the island of Edgöya and West Spitsbergen. I no longer cared.

We were a weary lot, all of us, expedition members and crew. Fred Hart and I discussed our situation and decided that we were all so beat that we probably wouldn't see a bear even if it were standing next to the ship. Maybe there was still a chance, but as we approached the Hinlopen Straits, I decided that I was sick of it. I hit the sack and found sleep more compelling than work. Breakfast, lunch, and dinner were no draw for me; pleasant banter was out of the question. The Sapphire disaster fed on me. This was my last bear watch. We saw no more bears, and we were on our way home. The bloodbath was over and the photography done.

Before this trip and during it, I had believed that it was possible to shape my life by struggling toward a goal, doing it with imagination, and overcoming my fear to act. The mantra had led me to shoot and kill the very thing that had seemed to make my dream come true.

The last six days of the trip went unrecorded in my diary. *Drunk* had been written so many times in it that I had a literary hangover. Terrible weather on the return to Norway glued me in my sleeping bag, heartsick and seasick. Everyone on the expedition was affected by the pitching ship except DeCourcey Martin, who was out dragging for monsters of the deep — a dangerous, miserably wet, cold job that he did alone. Every three hours, he went aft to catch plankton as freezing sea water poured over the open fantail. DeCourcey finished strong.

When we arrived in Tromsø, I was still in my sleeping bag. Unknown to me, Stenger had packed all my diving gear, and it was ready to go when finally I rose from the dead. We had had many battles, and strong words had passed between us, but none were harsh enough to break the delicate membrane of friendship.

Gamble raced from Tromsø to Paris to meet somebody; business or pleasure I don't recall. Schein became a prominent expert on polar bears and I saw a film about him at Montreal Expo 1967 on his work in Alaska. Fred Hart disappeared forever, but "Tullie" remained in contact with Stenger for many years, and A.D. and I were to share adventures far into the future. Olaf Applebom wrote me a letter indicating that details of our trip had reached Tromsø even before our return. Tales from *Venus* were safely archived into the old-timer tall-tale-telling at Mack's Øl Hallen.

DeCourcey Martin remained in Savannah, Georgia as president of his own scientific company. But we never saw much of each other or reminisced about Spitsbergen when we did.

On January 11th, 1963, *LIFE* magazine featured pictures of Sapphire and Big Bear in their domestic and Spanish editions. Subsequently, my polar bear photographs were published in many books and magazines and they continue to sell. Leadership of the expedition took me in new directions, but the experience with Sapphire re-oriented my compass from north to south in more ways than one. After two previous exits it was time to try Savannah again, this time as a father, a role that I could barely imagine.

25 – CIVIL RIGHTS

March 10th, 1963 was a time of change for me, I became a father. Frederick Breckenridge Baldwin, known as Breck, followed the family tradition by having an ancestor as a middle name. Great- (who knows how many greats) grandmother Leticia Breckenridge had picked Robert Gamble (my mother's grandfather) over Merriweather Lewis (of Lewis and Clark fame), so I dropped her surname in. Changing from a rebellion against the past, I chose a name that had connections and currency in a place like Savannah, where Monica had been living in my mother's garage apartment since our marriage.

There were new realities. After six years of struggling for professional recognition, at age 34, it was time to find a more sensible route. The stepping-stones to success had been slippery. Sapphire got me into *LIFE* magazine — the Holy Grail for struggling young photographers — but the circumstances of her death had opened up painful insights. The battered Picasso mantra became less certain. Having a dream, using my imagination, overcoming fear, were a combination that had helped take me where I wanted to go, but when acting required killing the source of what good luck and perseverance had brought me, I needed to re-examine everything. There was a new life to be considered and I was certain that the wild ride that I had just completed was not a model for a responsible future.

Surprisingly, I began to get attention on the home stage. This was new for me. The Savannah Morning News picked up my trail. Anna Hunter, an artist, family friend, and the arts reporter for the paper, telephoned my mother. Anna was delighted to get a story that only a mother could tell, and one Sunday an article appeared with the headline: Freddy Baldwin Returns from the Arctic.

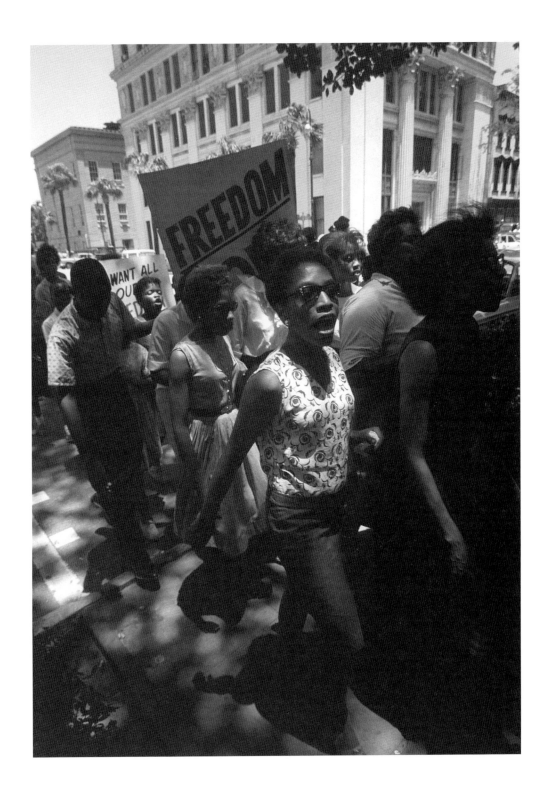

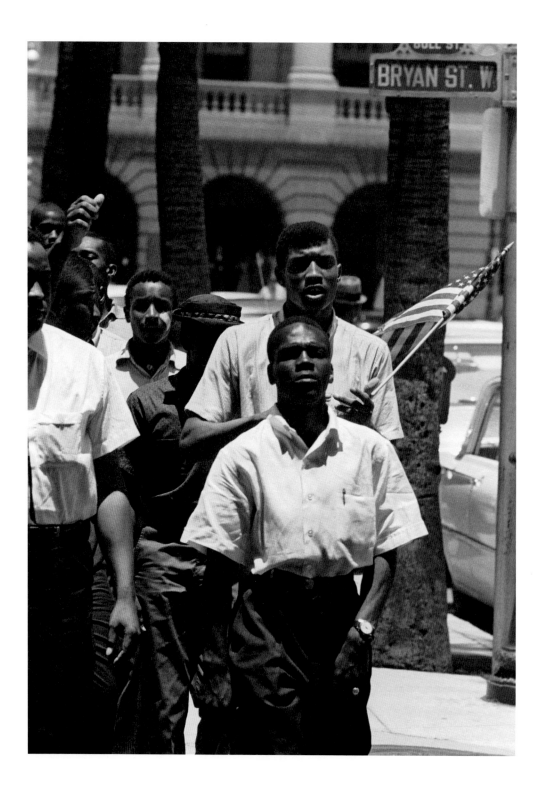

Slightly embarrassed, I was happy to trade some small notoriety in Arctic circles for the warmth of hometown approval, but not as Freddy Baldwin.

Then, the Savannah Public Library invited me to do a slide show. My action-packed lecture spared the audience no details about freezing polar seas, marlin spikes, and shark bites. Just to make sure that nobody missed the drama, I used my rifle as a screen pointer. I evidently departed somewhat from the usual lecture format, and Miss Ola Wyeth, the dignified elderly Chief Librarian, gave me her breathless blessings by saying, "I've never in my life experienced anything like this."

Even the Oglethorpe Club, Savannah's most prestigious white, Anglo-Saxon all-male eating club, invited me to become a member, although that road pointed in a direction more suited to my mother and brother than me.

The unchanging sameness of Savannah that had stifled me previously was offset by my new status as international adventurer. Acceptance dulled old grievances about my painful relationship to the "factory" but also dimmed my powers of observation of my family's dependence on it. I accepted it. If the toilet got stopped up, I accepted that it was normal to "call the factory;" if a light bulb burns out, "call the factory." The city was stirring, but while I became absorbed in my new role as a local exotic and enjoying my new celebrity, I didn't notice the cracks in the road that were about to open up.

At the time, the deep rumblings of the Civil Rights Movement in Georgia and elsewhere somehow never reached me in Europe. I had missed the moment when black youths "sat in" to desegregate downtown lunch counters on Savannah's Broughton Street in 1960, or the "freedom rides" of 1961, much less the desegregation of the University of Georgia. In a speech I made many years later in Savannah about this period in my life, I explained that, "the polar bears I was photographing in the Arctic didn't tell me about what was happening with black folks in the South. They were just too white." So as I walked downtown to the post office on a bright June day in 1963, taking pictures of the city for an architectural book I was planning, Savannah's elegant past was on my mind, not President Kennedy's speech about Civil Rights on June 11th, or other momentous events taking place throughout the South.

Protesters suddenly appeared marching down Bull Street in downtown Savannah, waving American flags and carrying signs: FREEDOM OR DEATH,

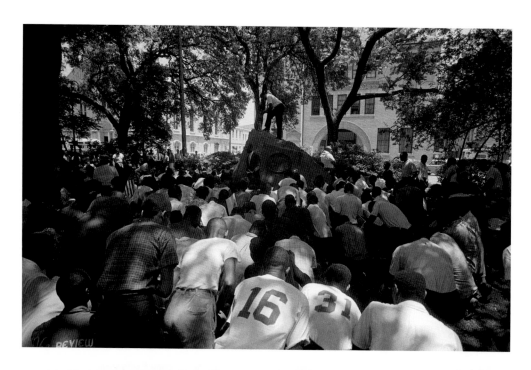

DOWN WITH SEGREGATION, and WE WANT FREEDOM NOW! Four hundred young men and women, mostly students, were singing *We Shall Overcome.*

Heading straight for me in the front rank of the group was a short determined-looking young man with his head thrown back, a Crusader taking his chanting troops into battle. I later learned it was Benjamin Van Clark, a seventeen-year-old student from Beach High School, a member of the NAACP Youth Council.

The marchers passed, paying no attention to me. Then they converged on Tomochichi's Rock in the middle of Wright Square. Ironically, this was a monument to the Creek Indian chief who had made it possible for James Oglethorpe to establish Savannah through peaceful cooperation in 1739. I began taking pictures of the crowd with no idea what was going on. There were a few young, thuggish-looking white guys standing together, one with a churlish expression and a cigarette dangling from his mouth. They looked dumb and dangerous, but there were rough-looking black kids too. One had a tire iron clutched in his hand, his eye on the white guys. I briefly checked for familiar faces from my encounter with the Klan six years earlier, but this was a new generation scowling at change.

In spite of these signs of potential trouble, the crowd was quiet and respectful as they listened first to a black minister and then to a charismatic individual who turned out to be to Hosea Williams, the leader of the Chatham County Crusade for Voters (CCCV). He spoke about freedom and discrimination while standing on the Tomochichi monument. The memorial served as an appropriate platform for an appeal to peace and cooperation. Then, the crowd knelt and began to pray.

The audience was mixed, but mostly black and of all ages; a little girl with her arm around her father, middle-aged women and men wearing T-shirts with their employers' names printed on the back. They were taking a lunch break for freedom.

Everything was under control. Singing songs such as *Ain't Nobody Gonna Turn Us Around* and *We Shall Overcome* seemed to keep people calm; it united them. I felt comfortable taking pictures in this setting. I listened, photographed, and then, between the prayers and songs, talked to some of the black kids. But not everybody was in step with the mood. A young acquaintance of mine, Albert

Scardino, the future publisher of the *Georgia Gazette* and a Pulitzer Prize winner, had joined the march, and he told me later, "I came down Broughton Street and was getting ready to turn the corner onto Bull Street, when a short Cracker stepped off the curb and said to me: 'I'll never forget your face and one of these days I'll find you in a dark alley.'"

My experience was different. One of the black students, Otis Johnson, arranged for me to meet later with Hosea Williams of CCCV, and Williams remembered seeing me at the rally, photographing and chatting with some of the policemen in the square. He was curious about me, and wondered how I knew some of the cops. "We were in the Marines together in Korea," I explained. "Now I'm a magazine photographer." Our conversation drifted to military experience, and I later learned from Andrew Young that war had brought Williams into the Civil Rights movement: he had been in combat in Germany and was badly wounded when a direct hit killed everybody else in his foxhole. He spent thirteen months in the hospital and was finally returning home to Georgia on crutches when he stopped to drink from a water fountain in a bus station, the only one available. It had a "Whites Only" sign over it, and some white toughs saw Hosea and roughed him up. He decided then and there that he wasn't going to fight for democracy, almost get killed in Germany and then come back to Georgia and not be able to get a drink of water because he was black.

Hosea and I were to become friends, and it was he who opened the door to the Civil Rights Movement for me. Almost 50 years later, Otis Johnson, the young student who had introduced us, became the mayor of Savannah and told me, "We thought you were taking pictures for the FBI."

Students like Johnson, and professional leaders such as Williams, who organized them, were driving the smoldering unrest coming to the surface in Savannah. They got me involved, and soon I attached myself to the movement, donating my photographs to the CCCV for use in *The Crusader*, the organization's newspaper.

Again, my camera took me to where I would never have gone without it. Ironically, I didn't have to travel to the Arctic to discover unfamiliar lifestyles or people who were fundamentally different from me; I discovered them in my own backyard and in my head. Although African Americans represented a culture that I had been exposed to all my life, I began to see its people from a dif-

ferent perspective. Economic discrimination was not news to me, nor was segregation or class division, but the difference lay in my becoming intimate with these realities in a totally new way. And I was making photographs in a new way — for a cause, a cause that I knew was right. I found myself working in a spirit that drew on conditions that I had observed and experienced in my family's factory, but now I was surrendering my secret God-given white self-importance; that was new.

These revelations were insignificant, of course, compared to Hosea Williams' experience — beaten at a water fountain in a bus station. My reflections began with quieter comparisons. For example, why was the word Negro allowed to represent anyone who had a single drop of African blood, irrespective of skin color, education, accomplishments, or national origin? No grays, only black and white defined how whites related to blacks in the 1960s irrespective of class and circumstance. The Sami culture had sixty words for reindeer. Why were names for people with various amounts of African blood in such short supply? Why weren't people who were half white called white? Why were people with one drop of African blood called black?

Among the many questions relating to being black or white in the South that began to intrigue me was the relationship between my mother and her cook, Mrs. Rachel Brown. Although my mother called her only by her first name and so did I, changing that to a more respectful address would have confused long-standing, delicate codes of communication. But I began to see Rachel as a professional — not just "the best cook in town" — holding up an essential pillar of my mother's reputation as a leading hostess. Under different circumstances their relationship could be described as a friendship. But in the South, mutual respect, admiration, loyalty, and concern for one another's welfare — a condition held by both of them — could not comfortably be described as a friendship when a black woman and a white woman were involved. Yet that's what it was.

My arrival in Savannah began a new chapter in my education. Starting with the University of Virginia, my career could be described as a series of escapes, orchestrated with tools that were dramatic and sometimes desperate. I had once departed for Oregon with a friend to work in a plywood mill rather than spend another summer at the farm and go to summer school to make up

all my failed courses. My exile to the factory in Savannah was endured with the help of fantasy flights in an MG sports car, prior to my final departure to Korea via the Marines. Even returning to Armstrong Junior College after Paris was a planned escape that took me to Harvard and Columbia. Learning photography in Savannah allowed me to leave the country and try my hand at photojournalism — and freedom.

Now, I had a family. I wanted to return, not escape. That's what made me want to open my eyes to a place that had previously supplied only pain or a rent-free temporary refuge. In my photography of the Civil Rights Movement, I found myself acting not just as a recorder, but as someone bound up in events far beyond my past existence or immediate experience. For the first time, I documented simply and directly what I saw, irrespective of its value as a career boost. I was not on an imaginary assignment for *LIFE* magazine. My camera became my reason for being. It was not a passport to a "good story to tell." This earned me a currency that was new to me; I felt it had true value.

After working with CCCV for a few weeks, I discovered that I was not the only white volunteer. Eight undergraduates, six boys and two girls, arrived from Antioch College, a pioneering advocate of gender and racial equality in education since the mid-19th century. (Coretta Scott King had been a graduate). They had come to help with voter registration and were taken in, living with black families.

There were other well-intentioned responses to the stirrings of change. Secret meetings between the wives of lawyers and university professors of both races met at clandestine tea parties to get to know one another. An organization called the Savannah Greys was formed.

The Episcopal Bishop and the Catholic Monsignor were talking to black leaders and businessmen. Mayor Malcolm Maclean, a liberal and a friend of Attorney General Robert Kennedy from their days at Yale, did not want Savannah to become another Birmingham, where one of a series of three bombings by the KKK had killed four black children at the 16th Street Baptist Church and the notorious racist police chief had responded to the demonstrations with beatings, fire hoses, and police dogs.

My friends Dr. and Mrs. Waring began to post me on the gentile whispers of change from their point of view. Henrietta Waring was a member of the Savan-

nah Greys, but these under-cover social contacts had nothing to do with what I was seeing.

My contact with the burgeoning movement in Savannah continued to be Hosea Williams, who would call me periodically and tell me where to meet him. And on one of my underground tours of voter registration, I met "Big Lester" Hankerson, who became a number one hero. "Big Lester" was a longshoreman by trade and had a formidable reputation. Rumored to have killed six men, he looked like he could have done it with his bare hands. But "Big Lester" had taken to the path of non-violence and he described his conversion, "One day I was downtown paying some bills, and I stopped to listen to Hosea. I liked what he was talking about, how people had money to buy food but couldn't go in places to buy it on account of their race and color. Now they had blacks cooking food, serving food, but we're not good enough to sit down by them to eat. That's what woke me up, and then I said, 'Well, if we are cooking the food, and serving it, and we got money, then why can't we sit down by them and buy me a steak and enjoy it... You couldn't get in Morrison's Cafeteria. They locked the doors on us, so we just laid down in front of the door. They had to tote me from that door. I had money enough to buy five or six steaks. I ended up going to jail that very day, and I've been in the movement ever since."

"Big Lester," Hosea, and Henry "Trash" Brownlee formed what Lester called his "Street and Bar Committee" for voter registration. Their specialty was targeting apathetic males who were avoiding trouble in the old ways, by not sticking their necks out and simply hanging out. But "Big Lester" was more immediate trouble, and he and his committee flushed men out of bars, barbershops, cafes, and the all-black Longshoremen's Hall on West Broad Street, as well as anywhere else that future voters might be found.

They would drive around Savannah in a big black four-door Dodge that he called the Ballot Bus. One of the youth leaders, Benjamin Van Clark, described how Lester "loved that Ballot Bus. And guess what? I have seen him go on the corner and grab dudes, and say, 'Look-a-here man! You registered to vote?'"

"No."

"Come on — get in."

"Lester, I can't go nowhere with you right now!"

"You gonna get in here!"

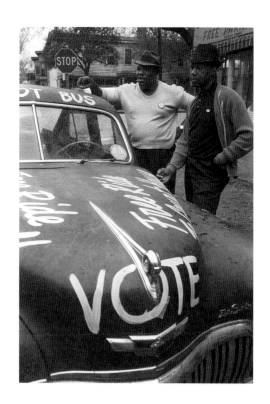

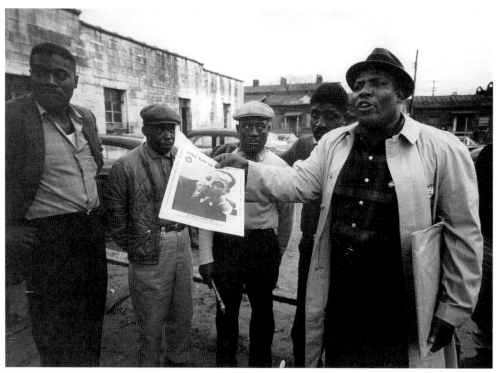

Savannah's black bars were not places where I felt welcome, but in the presence of "Big Lester," I was invisible, taking pictures close-up as the "great persuader" plucked each former drinker and future voter, one by one, from bars into the Ballot Bus. There was nothing ambiguous about this vehicle. Huge white letters advertised the mission: "VOTE. Free Ride — No excuses!!" It delivered hundreds of black citizens to the courthouse to register for the first time.

"Big Lester" was part "persuasive diplomat" and part bouncer but his door-to-door dialogue was often less threatening than humorous: "Come on old man, come on, come on, where did you say your pants are? In here? All right, come on, very good, okay, you don't need a hat on." He told me once that, "I remember we went to this house and it was an old couple and they wanted to go, but then didn't, for fear that their lives would have been in jeopardy. Well, the old lady, she had a job, but she was working for some whites. She said, 'Well, if she find out I go (register to vote), she might fire me.'"

So I say, "Don't you worry, I got a job for you."

She said, "What kind of job?"

And I said, "I'm going to let you drive the Ballot Bus."

For many months at the Registration Booth in the courthouse, long lines filed though the hallways. Sometimes they were students, who could register at eighteen. But soon a flood of black men and women of all ages jammed the building. Progress was slow because many roadblocks were placed in the way of registration, such as taking a literacy test, an obstructive device written into the constitutions of many southern states after 1898. This required the would-be voter to be able to read or write English. A voting registrar conducted the test and he or she could reject or accept the results without explanation. Sometimes parts of the state constitution were read aloud to the applicant, who was required to make an instant interpretation, again allowing the registrar to judge who passed the test.

Well-organized daily meetings to keep voter registration alive were held in the handsome First African Baptist Church on Franklyn Square, where money was collected to keep the voter drive going. Signs were created, handbills printed, and a startup newspaper was distributed. It all cost money, which the organizers had little of.

The First African Baptist Church place was not new to history. It had roots

The First African Baptist Church place was not new to history. It had roots reaching back to 1794, and was one of the oldest African American congregations in the U.S., originally founded by an ex-slave who had bought his freedom. The present structure was built with bricks made by slaves and freedmen in the 1850s after they had labored in the fields all day.

Among those who now gathered there were people too old or infirm to march. Money was collected to hire taxis for those who could find no other way to get to the courthouse. A few yards from where the organizers were working, there were holes in the floor forming a design meant to look like a tribal symbol. These were air vents for a 4-foot space beneath the sanctuary floorboards where runaway slaves had once hidden. The church had been a stop on the Underground Railroad during the Civil War.

Throughout the year, there were rallies to boost morale and enthusiasm. By mid-summer the marches increased their intensity. The strategy changed. More people took to the streets and young black students were issued Certificates of Courage that they earned by blocking the Tallmadge Bridge, the major north-south span that connected Georgia and South Carolina across the Savannah River.

As the long hot summer got warmer, the Savannah Police Department fielded its Riot Squad. It was a strange experience for me to photograph this force, armed with "special occasion" shotguns because, again, I recognized the Captain as well as a few other cops — all fellow ex-Marines.

The thermostat was raised from hot to very hot as protests began to include night demonstrations. The nighttime demonstrations were important because they attracted people who worked during the day. Hundreds more activists began to be locked up on a routine basis. It became a badge of honor to be dragged off, and the city jail was packed with young black men.

Henry "Trash" Brownlee said he was willing to die. "Many a night I thought I would die. You talk about a scared black man! But you listen to Hosea Williams you'd be willing to die."

Lt. M. E. Kendrick, Captain of the Riot Squad, an ex-Marine who had served with me, later said: "I wouldn't want to live 1963 over again. It was frightening. You stood out there like a big, brave hero, but you didn't know when somebody was going to hit you in the face with a broken bottle, sling a piece of glass at

you and cut your throat. Of course, there was always the possibility some policeman might go berserk and start firing off a few rounds, because sometimes they worked us 18-20 hours a day."

There were extraordinary acts of self-control and courage demonstrated by many young blacks. Provocation was not met with retaliation. Whites spat, cursed, insulted, and in some cases physically assaulted them. One young man, Benjamin West, was beaten at a sit-in at the Kress store. His jaw was broken but he refused to retaliate.

The CCCV went to lengths to disarm its troops. Dr. Rick Tuttle, a demonstrator and CCCV volunteer, reported that Hosea Williams and Ben Van Clark persuaded the young men to drop their knives, switchblades, and brass knuckles into a basket so that it could be said that none of the demonstrators had weapons. It was a miracle that things weren't worse. At the same time it was appalling that it had to be as bad as it was.

At one point that summer, Hosea Williams was jailed, a strategy implemented by Municipal Court Judge Victor H. Mulling and aimed at breaking the movement by neutralizing Hosea's leadership. Mulling stated in an interview that, "Hosea Williams was the prime mover in the disorders. I concentrated my efforts on him." Hosea stayed in jail thirty-one days, an action that broke the back of the demonstrations, which diminished rapidly. The last one, on July 13th, became a prayer meeting in Forsythe Park.

Finally, enough people came to the conclusion that change was inevitable if the city was going to survive. But bringing an end to racial segregation was complicated. Radically different points of view made it extremely difficult to contain events. The fear of change gripped Savannah in 1963. Blacks wanted it but most whites were desperately afraid of it and both sides were split on how to achieve it. Things quieted down during the summer of 1963, and I began to do advertising photography for a new golf development on nearby Hilton Head Island in South Carolina. My work with the Chatham County Crusade for Voters continued, but by 1964, the marches had stopped, everybody was out of jail, and the CCCV was concentrating on voter registration and building a community base for the organization.

Hosea invited me to attend meetings in black churches in the summer of 1963 and I provided a record of what was going on out of sight, the organization and planning of important aspects of the movement. Coretta King, Rev. Martin

Luther King Jr.'s wife, came to speak at the First African Baptist Church. As the only white person present, I felt privileged to be there. Political thunderstorms were sweeping the South. The CCCV had not been able to get Dr. King to Savannah because funds were stretched and the strategy was to dismantle segregation, piece by piece, on the local level. Dr. King was only used for certain events and for special purposes. Hosea Williams finally persuaded Andrew Young, Dr. King's closest advisor, to bring him to Savannah to speed up what Hosea felt were dragging negotiations with the city.

The famous "We shall overcome" speech from the steps of the Lincoln Memorial had already been delivered on August 28th, 1963. Dr. King was probably the best-known black man in North America when he finally arrived in Savannah to make a speech at the Municipal Auditorium on January 16th, 1964.

In 2008, then Mayor Otis Johnson gave me his reaction to Dr. King's speech, "My grandfather, my brother, and I went to the Municipal Auditorium in January 1964. It was one of the proudest moments of my young life, to see in person our "Moses." He went on to explain, "King's influence was surely felt in Savannah, and some months before the Civil Rights Act was passed by Congress, the black and white leadership had negotiated a pact to end the segregation of lunch counters, theaters, and other public accommodations in the downtown area. Nevertheless, several restaurants and other businesses closed rather than desegregate. You can mandate desegregation, but you cannot mandate integration; integration must be an act of the heart, not a legal issue. Even today, eleven o'clock on Sunday morning is a segregated hour in Savannah. There has been some desegregation of churches, but most people worship with folks who look just like them."

When Dr. King was assassinated in 1968, however, Christ Church, the beautiful old Episcopalian church in downtown Savannah, threw open its doors and welcomed all races to a special memorial. As the oldest church in Georgia, founded in 1733 by General James Oglethorpe, this was an important act symbolically, although many other white churches did the same. (Ironically, under Governor Oglethorpe's original plan, Savannah was a slave-free colony. When Oglethorpe returned to England in 1750, however, the ban on slavery was lifted.)

In 1963, Christ Church membership included the pillars of society. The rector, Rev. Bland Tucker, was a wise and gentle man, and it wasn't surprising

that under his leadership the church would act with a heartwarming and appropriate spirit that went well beyond good manners. The gesture gave me great hope at the time when good intentions faded as quickly as they arrived. But another experience ten years later showed me that changing old attitudes doesn't happen quickly. In 1973, my mother's funeral service was conducted in Christ Church. Before her death, her remarkable cook, the same Rachel Brown described earlier, visited my mother regularly when she was completely incapacitated, alone in a nursing home at the very end of her life. This dignified black lady, who had been a servant, was nonetheless a true friend to a dignified white lady. My brother and I invited Mrs. Brown to sit with the family at the service, which she did. Seeing this, one of the stalwart regulars at my mother's Sunday Canasta parties came over to tell Mrs. Brown that she didn't belong sitting with the family, that she should take herself to the back of the church. It would have been even more embarrassing for Mrs. Brown had I blown up in Christ Church, so I joined Mrs. Brown in the back of God's house. As far as my mother's friend was concerned, the incident clearly spoke about returning a black woman to the back of the bus. My mother would have been furious.

The dramatic events in Savannah during the summer of 1963 were overshadowed by the violence that occurred in other places in the South. And the city establishment's memory of those days has mellowed into a feeling that Savannah was too refined, too enlightened, to sink to the level of other Southern hot spots. Some have the idea that indignities here were delivered in a more genteel fashion than in more vulgar places. Those who experienced the local violence, however, took another view.

After Dr. King's speech in January 1964, I began to look for something beyond photography. Being comfortably integrated into the elite put me in a position to do any number of things, to find ways of working that might become more interesting than using my camera to document social situations. I could harvest new ideas, find ways to solve community problems, bringing people from both sides, black and white, who might come together to do something. The CCCV had provided contacts that could be combined into my new life.

Hosea Williams, Benjamin Van Clark, and Big Lester had moved on to other trouble spots. A telegram from Hosea in early April invited me to come to St. Augustine, Florida. He was getting opposition from the local Ku Klux Klan as he be-

gan to organize marches. He wanted me to come down. I was intrigued to go, but I had found a group in Savannah that I thought could bring a whole new approach to dealing with serious race issues in the city. And in my professional life, I was steering away from socially-oriented photojournalism and working successfully with advertising for golf resorts, concentrating on making a good living and raising a family. I was also following a new cause, so I didn't go to St. Augustine. Secretly, I regret not going; it reminds me even today, of not getting off the truck in Koto-ri.

In the early months of 1964, four black ministers who were dealing with juvenile delinquency among black youth in Savannah asked me to join their effort. They had seen me photographing and talking with various leaders during the marches and thought I had something to offer. For me, these men seemed to hold the keys to an effective strategy for basic community problems: provide better education, housing, playgrounds, and jobs for young people. It was a perfect cover to work on preparing for long-term social change that couldn't be criticized because it was aimed at improving the lives of children. My job, as I saw it, was to integrate the group with key individuals from the white establishment. My first task would be to raise money so they could take the program from a discussion stage to creating a workable plan and finding ways to implement it.

My first recruit was the Director of the Savannah Chamber of Commerce, William Schandolph, who would be instrumental in finding other key committee members, white ones of course. I contacted the Southern Education Foundation Inc. in Atlanta about the idea and they encouraged me to apply for a grant of $30,000. I began to look into ways of providing a structure beyond the few concerned ministers, making it possible to raise more money and provide an institutional platform to give them more freedom of action as well as community status.

To me this was an appropriate next step during the cooling-off period after "the long hot summer." The timing was right. I wrote a plan to submit to the group along with details about the Atlanta foundation. I consulted a number of bright, experienced, liberal friends in Savannah, and found two socially involved Catholic nuns who were also interested in helping young people. All of them were white. Another recruit was Douglas Kiker, who was reporting on civil rights as a journalist in Atlanta and knew how to get the press involved.

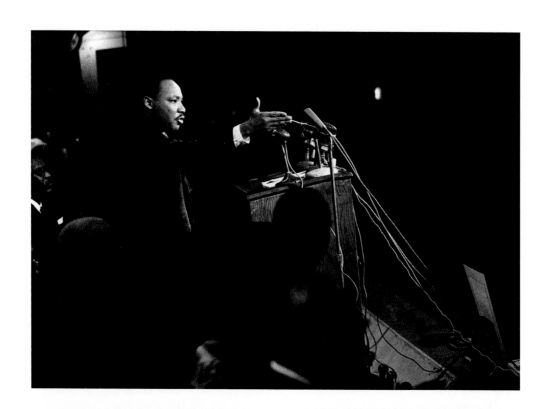

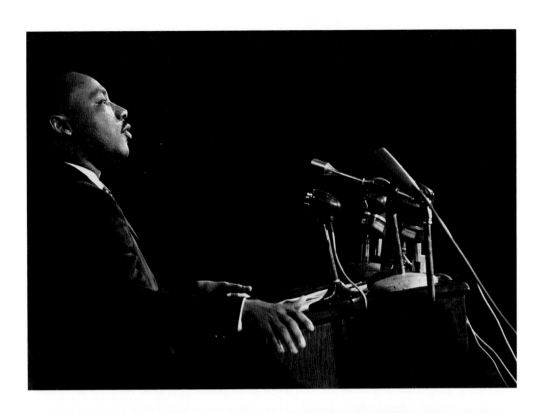

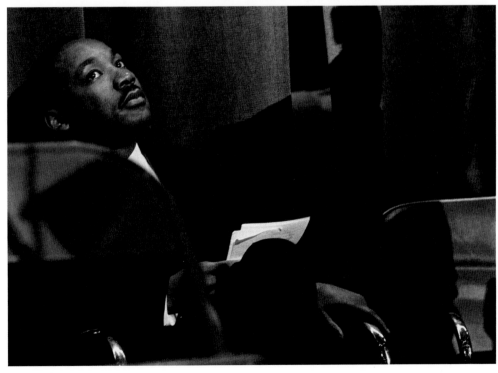

(He soon moved to Washington to be the Director of Information at the Peace Corps, and later worked for NBC Nightly News.)

Using lessons I had learned on my expeditions in Europe, I began creating my own networks populated with new black friends and blending them with my social contacts in Savannah. Building something that hadn't existed before was my dream. I was using my imagination, overcoming personal unease, and acting. The old Picasso mantra had returned to re-energize me. I wasn't afraid of any part of the scheme. Perhaps I should have been, because my plan contained a gigantic flaw.

As the new kid on the block, I had been inspired by black activism I witnessed, but I didn't have a clue about the politics of the moment. I didn't see myself as part of the same old problem — a white guy directing the show. Good intentions, bright ideas, and a few photographs were not a down payment on paying off a couple of hundred years of white dominance, oppression, and arrogance. So it was a total shock when the black ministers, the president of the Chamber of Commerce, and a few other whites, declined the offer of $30,000 from Atlanta. This was something I never saw coming.

The liberal mayor of Savannah, Malcolm Mclean, was not prepared to see yet another group, no matter how well meaning, put pressure on City Hall to adjust problems. He was much too savvy to buy my scheme, and I was much too naive to think he wouldn't. It never occurred to me that the mayor was up to his neck in political hot water and didn't need this gift from me. From their point of view, the ministers fighting juvenile delinquency felt that a new independent group might offend the mayor, and so they backed off. The president of the Chamber of Commerce withdrew his support when he saw the others declining. My grand scheme collapsed.

Today, Savannah enjoys the distinction of being a Southern city that avoided the worst possibilities during that long hot summer of 1963, but the majority of Savannah's registered voters were able to show where they really stood by voting Mayor Maclean out of office in the next election in 1966. A businessman, the first Republican since Reconstruction, became the next mayor. And while many African Americans were elected to office beginning in 1967, Savannah was not to vote in its first black mayor until 1991, and then by only 256 votes.

When I interviewed Mayor Otis Johnson in 2009, a black state senator and three black state representatives represented Chatham County. The majority of

Savannah's City Council was black. Three county commissioners, three school board members, and several elected judges served. Blacks were on all appointed commissions and boards. But it had taken forty-five years to get them there.

In 1964, it was hard to imagine that this was going to happen. Otis Johnson told me that in 1960 he had no dream of even going to college, much less becoming mayor of the city one day. In many respects the city has undergone huge changes since the 1960s, but in other respects things have remained the same. Otis Johnson's predecessor, also African American, described his experience with Savannah's elite by acknowledging that he would never be accepted into Savannah's elite society. "I've never been to the Oglethorpe Club," Mayor Adams told the Washington Post: "Never been inside. And I'll never be invited inside."

I had been allowed in the Oglethorpe Club, but my great lesson in political reality had come from the streets. Eventually, after the painful shock of the failure of my noble social scheme and an interval of reflection, I was able to expand my Picasso mantra. Have a dream, use your imagination, overcome your fear, and act: as a postscript, I added: know your friends and enemies.

In time I collected oral history from participants who shared with me different perspectives and have laced them into this story. Other perspectives unfolded as more stories were collected. Feay Shellman (curator at the Telfair Museum of Art and Sciences) and I gathered descriptions from all sides of the battle that eventually became a book, *We Ain't What We Used To Be*, that accompanied an exhibit of my photographs at the Telfair in 1983.

A friend, David Pearson, the Vice President for Public Relations at Sea Pines Plantation (on Hilton Head Island), a new resort in South Carolina, had become Deputy Director of Information for the Peace Corps in 1963. I had done photography for David and I also knew his boss at the Peace Corps, Doug Kiker. So when David asked me whether I would be interested in a job with the Peace Corps, I went to Washington to interview for a staff position, grateful to be given a possible second chance to participate in a spirit that was sweeping the country and to expand my own growing appetite to serve beyond myself. This process took a few months but I had made up my mind to clear out of my mother's garage apartment, pack up Monica, Breck, and my life in Savannah to take a completely different direction — this time a 180 degree course away from photography.

26 – PEACE CORPS

When I got to Washington in 1964, with a year of intense civil rights involvement behind me, I had the feeling that the Peace Corps was a fit for me. It had been tailored by professional idealists, shaped for a new day of political reality, and drew large numbers of talented, bright men and women to a new kind of government service.

In 1961, official documents described the Peace Corps as conducting a "quiet talent search" to find leaders for its overseas operations. By 1964, it was a well-oiled machine. The overseas jobs intrigued me. Although my father and two uncles had been diplomats, that career didn't appeal to me because I felt that with modern communications important decisions were made in Washington rather than in the field. The Peace Corps seemed a different story, offering on-site personnel quite a lot of latitude for personal initiative. That *did* appeal to me. After all, I had been both Captain and crew of my own small ship since leaving college. Still, compared to many who had been selected for the job, my vessel was more rowboat than oceangoing steamer. And since I was aiming to go not just as a volunteer, but as what was called a "Representative," a leader, I would be evaluated in relation to stiff competition and lofty standards. There were stringent requirements and I needed to pass interviews at a very high level.

I rated myself as follows on the listed standards for the job:

First, the Peace Corps Representative must have much the same motivation of the volunteers in order to provide the personal leadership necessary in a Peace Corps project. No problem; I gave myself an A.

Second, the Representative must have had a successful career in the United States in which he was willing to leave to serve in the Peace Corps. Yes, I had a successful career if they didn't ask too many questions. B+

Third, he must have the capacity to be responsible to the Ambassador, serve as a mission director and at the same time seek his friends and associates outside the American community as well as within. Sounds possible. B+

Fourth, he must forego all diplomatic privileges and immunities, except certain customs and tax exemptions, all hardship allowances, all PX privileges and live at a standard usually below that associated with the diplomatic community. Been living that way for years. A+

Fifth, he must have the diplomatic skills to deal with host governments even at the presidential and cabinet levels. B-

Sixth, he must have the administrative qualities needed for difficult and complex operations and the creative ability to make the most effective use of volunteers requested by the host government. D- would be generous.

Seventh, he must know the language of the country to which he is sent (or learn it soon). My skimpy, although convincingly accented French, and garbled phrases in Swedish-Norwegian that only a few Sami reindeer herders could understand would not serve me well. F

Eighth, he must exemplify, mentally and physically, the dynamic image of the United States. It wasn't clear to me what this meant, but all ex-Marines considered themselves dynamic. I ran a few miles every day, could still remember my USMC serial number, and was fond of polar bears: wouldn't that qualify me as an 'All American Boy'? Of course it would! "Gimme an A."

That grading averaged out to B-, not a score that would stack up against outstanding individuals described in the *1st Annual Peace Corps Report*, such as: Arctic explorer and mountain climber. ROBERT BATES. 51. He has explored the Yukon, Alaska, and the Chilean desert, and participated in two attempts to climb K2 (in Pakistan). He has co-authored two books and numerous articles. A magna cum laude graduate of Harvard, he received his Ph.D. from the University of Pennsylvania. In recent years he has acquired fluency in the Nepali language. Mrs. Bates has a degree in social work; was overseas with the Red Cross in World War II and has been secretary of the American Alpine Club. He will serve in Nepal.

There were others, and they all were different versions of Dr. Bates. Every one of them seemed to have been invented by a Hollywood scriptwriter. Of the first 200 interviewed in Washington, only 11 met the Peace Corps requirements.

To my surprise, I discovered that on paper my peripatetic background looked good: Arctic explorer and expedition leader among the polar bears; international experience in Europe and Mexico; independent freelance photojournalist who had learned to survive in the field; and decorated Marine infantryman from the Korean War — all topped off with my latest efforts as civil rights organizer and chronicler from Savannah, Georgia.

That version of Fred delivered by my reporter friend, Doug Kiker, Director of Public Relations at the Peace Corps, apparently looked promising to the Peace Corps administrative gatekeepers. But would these tall tales hold up to scrutiny from experienced and picky evaluators? Would they discover that the author was an ego-driven adventurer who had dangerous tendencies toward self-destruction in exotic places? Was he suffering from post-traumatic ego-expansion due to service in the Marine Corps, a branch of the military that was renowned for self-congratulatory exaggeration? Would his outsized ego butcher the emerging idealism of young volunteers devoting two years to the improvement of the lives of people called "host-country nationals" in fifty-one countries around the world? Theoretically, the Peace Corps had ways of finding out, and my exam began with Mrs. Nan McEvoy.

Mrs. McEvoy was an attractive, exceptionally bright woman from San Francisco in her mid-forties. She was a member of a well-connected family who owned the *San Francisco Chronicle*. She was also a close friend of Katharine Graham, the publisher of the *Washington Post* and Adlai Stevenson, the former presidential candidate and Ambassador to the United Nations. She was comfortable working at high altitude and not likely to be taken in by tall-tale-tellers.

My meeting with Nan took place in her comfortable office at the Peace Corps in Washington. We sat in large overstuffed leather chairs facing each other. As the interview began, Nan asked a few probing questions. Her strategy was simply to encourage the applicant to talk and then see where they went. Her questions and my answers have faded from my memory, but what I do remember vividly was that while I was unloading my adventures and philosophy of life, Nan was making figure eights with the eraser of her pencil on the

arm of the leather chair. That was not a good sign, but I kept gazing into her unblinking eyes and trying my best to handle her cool, abstracted unemotional questions. It was impossible to tell whether she was impressed one way or another, just more deadly quiet, then another question, and more figure eights with the pencil eraser. She was allowing me to hang myself in a most gracious way; my exuberance versus her calm. After about forty minutes, I left her office with no idea whether I had flunked or passed. More appointments were scheduled for me, however, so I assumed I might have made it over that important first hurdle.

Next, I had an interview with a Regional Representative for Africa, a sharp, combative woman from New York, who asked me directly, "Coming from Georgia, how do you feel about Negroes?" I thought the question was stupid and condescending. My involvement in the civil rights movement was already on paper under her nose so I made some kind of joke rather than going into details. Either way, she didn't have a sense of humor and it emerged that I was not destined for high places in Africa.

I then had a meeting with Bill Moyers, who had previously been Vice President Lyndon Johnson's Administrative Assistant, and finally I had an interview with Sargent Shriver, Director of the Peace Corps, and, of course, President Kennedy's brother-in-law. None were as extensive as my talk with Nan McEvoy. Shriver asked me whether I had any executive and administrative experience. I told him that I was on the Board of Directors of the Georgia Ice Company, which was technically correct but a complete exaggeration with respect to any decision-making experience. I told him about leading the second polar bear expedition, picking scientists, raising money, organizing the trip, and so forth. The talk with "Sarge" was completely different from the one with Nan McEvoy. It was a hot, virile, active, masculine, fast-paced chat. I imagined that it was like a short conversational game of touch football played in Hyannisport with the Kennedys. I got "administrative experience" tossed to me and I threw back "polar bears" and kept moving. I was out of his office in thirty minutes.

In a couple of weeks I received a letter in Savannah indicating that I was cleared for an assignment after a vacancy opened up. But what kind of a job and where? By good luck, or possibly due to Nan McEvoy's canny insight, my final stop was an interview with the Director of Far East Operations, Lee St. Lawrence.

During World War II, Lee had been a U.S. Army commando dropped into Yugoslavia to work with the partisans against the Germans. After the war, he survived in Europe by selling black market cigarettes. (This impressed me. He had combat and survival experience.) A few years later he was working in the Congo and then in Laos for the International Cooperation Administration, a U.S. agency that provided technical assistance programs abroad. He had earned a Meritorious Service Award for personal heroism for service in both countries. Lee had so many good stories. In the Belgian Congo during the civil war in the late 1950s, and while driving his car, he was stopped by a group of rebels. The car in front of him was occupied by Belgians and the rebels took the Belgians out of the car and hung them on the spot.

Lee was white, like the Belgians, and he was next. All whites looked alike in these parts, but he got out of his death sentence by persuading the rebels that he wasn't Belgian. "Je suis Eisenhower," he proclaimed. This name they recognized, and he was allowed to proceed un-hung. Later, when St. Lawrence was working in Laos, his house was burned down by partisans of the Communist insurgent group Pathet Lao. When they found out it was Lee St. Lawrence's house, they came back, apologized, and built him a new one. They liked Lee.

Lee came from a working class Irish family in Boston, and was a brilliant student later admitted to Oxford. His further education took him to Trinity College in Dublin, Institut d'Études Politiques de Paris, and the Johns Hopkins School of Advanced International Studies.

Lee became my boss when I was appointed Peace Corps Director in Sarawak, a former British Colony in Borneo that had just recently become part of Malaysia. Lee told me, in no uncertain terms: "If you fuck up, I'll fire you, and if you do a good job, I'll make you a hero." That was my send-off to a whole new life.

Training for my Sarawak position was minimal; ten days of Malay language instruction in Washington. That was it. It was embarrassing to discover that the first director in Sarawak, anthropologist Dr. John Landgraf, had spoken several Malay-Indonesian dialects of Borneo as well as French. Prior to his Peace Corps assignment, he had spent two years in Sarawak and North Borneo doing research, and was in charge of New York University's Southeast Asia research program. I was about to take over from the second director, a professional administrator who had experience in the Far East with the Agency for

International Development (USAID). His wife spoke fluent Mandarin, having been brought up in China by missionary parents. This was more than helpful because almost a third of Sarawak's population was Chinese, and they controlled much of the commercial life of the country. By comparison with these men, my credentials and experience looked pretty feeble. Still, off I went.

After a long flight on a Pan American 707, I arrived in Tokyo, and then went on to Hong Kong. A two-day break at the Mandarin Hotel provided me with an instant clothing overhaul, as Jimmy Chen Tailors converted me from urban American to tropical Southeast Asian. Like many who visited Hong Kong in those days, the most extensive high-end shopping mart in the world, I couldn't resist buying high-quality dirt cheap Zeiss binoculars that had more to do with my past than future. Finally, after several changes of transportation, I arrived in Kuching, the capital of Sarawak, on July 15th, 1964, thirteen thousand miles from home. Monica and baby Breck would join me a few months after I settled in.

It had been a long journey but my mood was high, savoring a new me, enjoying a special glow of confidence. I was no longer a freelance operator starting off with the usual mild dread of a new plunge into uncertainty. Here, I was the officially sanctioned head of the Peace Corps in an out-of-the-ordinary part of the world. I didn't have to overcome my fear, push myself out the door to get to the next speculative job. Good God, I even had a government passport and a Foreign Service rank that was quite high, Foreign Service Reserve 3, only two notches below Ambassador. Best yet, I was going to be well paid for the next two years, and I wouldn't have to steal press passes from *Sports Illustrated* photographers to survive. The former expedition leader, polar bear seeker, underwater adventurer had landed, sanctioned by Sargent Shriver himself.

During my briefing in Washington, I had learned that thirty-percent of the volunteers who had worked in Sarawak had resigned during the two years prior to my posting. Morale was low. This was one reality. Another set of possible problems had to do with the war between Sarawak and Indonesia, its neighbor to the south. On my arrival, I noticed military aircraft parked at the airport and the presence of well-armed troops. But my first big surprise was not meeting the military; it was *not* meeting the Peace Corps.

While I wasn't expecting a brass band, I did anticipate that someone from the Peace Corps would welcome me at Kuching Airport. Feeling a little deflated,

I got directions and hotel information and was soon on my way by taxi into the city, where I checked into the comfortable Sarawak Hotel. Thanks to the former British presence here, all of my transactions were uncomplicated since everybody spoke English.

It was evening when I arrived at the hotel, too late to reach the Peace Corps office, and my body was still twelve hours on the wrong side of being awake. So I crashed, completely out of gas. The big circular fan that swooshed air over my bed made the room cooler than I expected. Even as the light faded, everything outside still seemed pith helmet white. I slipped off to sleep with the feeling that in the morning Joseph Conrad and Somerset Maugham would join me for breakfast. Everything, so far, seemed exquisitely connected to what I had imagined while reading about the country.

Sarawak is located on Borneo, the world's third largest island. The name has an aura of mystery and remoteness; a synonym for exotic extremes, such as the "Wild Man of Borneo," a number of fake "wild men" who appeared as circus sideshow "freaks" throughout the 19th and early 20th centuries. Why

Borneo? Why not Timbuktu or Shangri-La? Even in my own family the legend persisted. It had been passed down by my South Carolina-born grandmother, who while on the Grand Tour of Europe in the early 20th century, saw a "Wild Man of Borneo" in a carnival somewhere in the Balkans; he was in a cage, viewable for a fee. My grandmother wasn't fooled, "He's not a wild man, he looks like he's right out of a cornfield to me." With that, the "Wild Man" brightened up, "Yes ma'am, is you from home?"

This piece of family lore, in spite of its patronizing racist tone, may have played a part in my curiosity about the region. Or maybe it was a sarong-clad movie star from one of the countless South Seas films of my youth that caught my imagination. But the real story of Sarawak was even stranger than the films.

James Brooke, a young Englishman, had served as a military cadet in India, was later commissioned, and then wounded in battle in Burma. Invalided back to England, Brooke recuperated, and in 1830 set out as a merchant mariner sailing the China Sea. After receiving a large inheritance from his father, Brooke purchased a 142-ton armed schooner from the Royal Navy, appropri-

ately named the *Royalist*, and set sail for the far eastern seas in search of adventure and riches. James Brooke visited Borneo, whose coastal areas were under the control of the Sultan of Brunei. At the request of the Sultan, Brooke put down a revolt of a local tribe of Sea Dayaks, also known as Ibans, one of the fiercest of the indigenous groups.

The Sultan gratefully made Brooke the first governor of Sarawak in 1841 and a year later, Rajah of Sarawak. After securing the port of Kuching and adjacent territory, Brooke managed to chisel more territory from the sultan, and much of what had been under his loose control became Sarawak. Brooke's status was eventually recognized within the British Empire as royalty, similar to that of an Indian Prince. Upon his death in 1868, the succession was passed on to his nephew, then to his nephew's son. Under the Brookes, the Rajah's territory was further expanded, mostly at the expense of the Sultan of Brunei. This was the state of affairs until the Japanese invaded, occupying Sarawak from 1941 until the end of World War II.

In 1946, the last White Rajah, Charles Verner Brooke, ceded Sarawak to Great Britain as a crown colony. This was the status of the country until it be-

came the largest state in Malaysia in 1963, and was then officially East Malaysia but also known as Sarawak. The tiny enclave of Brunei still exists as a sovereign state in that third of the island.

The southern and eastern two-thirds of Borneo had been part of the Dutch East Indies and only gained independence as part of Indonesia in 1950. That section of the island is known as Kalimantan.

The entire island of Borneo is home to five principal groups of Dayaks, a catch-all name that described indigenous forest and sea tribes that were racially the same but spoke different dialects. In addition there were several other forest tribes who were not related and spoke different languages: Ibans, Kenyahs, Bidayuhs, Murals, Melanaus, Kayans, and Punans. These tribes make up the majority of the population. On my arrival in Sarawak, there were also large numbers of Chinese, a few Indians, some indigenous Malays, and a sprinkling of expatriate British and Commonwealth civil servants who were still running most government offices.

In addition to this racial, ethnic, and cultural diversity, the original British Rajahs made everything more complicated by deciding to educate the people. They invited Anglican, Catholic, Methodist, and Evangelical missionaries to open schools and save the locals from the devil. This added another layer of complexity to Sarawak society as the four different Christian denominations joined Islam, Hinduism, Taoism, Buddhism, and various native animist beliefs. In place of multiple languages, English was made the common form of communication.

In Sarawak, the reign of white Christian rajahs and British colonial administrators ended a year before my arrival, when the Malaysian government from across the South China Sea was beginning to ease out the British-run administration.

Large areas of Sarawak were covered with dense rain forest jungle, uninhabited by humans. The heavy concentrations of population were located in cities on the coast of the South China Sea, collected at the mouths of the long rivers that extended deep into Sarawak. The indigenous Iban lived in longhouses sprinkled on the banks of a myriad of waterways that fed into the main navigable rivers. There were few roads, and travel by water still provided the best way to get around the country although some of the larger cities were connected by air.

Reading all this in guide books and Hedda Morrison's two books, *Sarawak* and *Life in the Longhouse*, gave me some idea what to expect, but these were only the most rudimentary lessons for what lay ahead. Not only was I about to encounter a huge diversity of cultures and political complexity, but also an incredibly varied geography. The rainforests of Borneo, from what I read, were almost beyond what I could imagine; the terrain was mountainous and there were different life forms at every elevation. The rivers and the fingers of rivers reached down from the heights, watering other worlds that hosted different species of fauna and flora. From the coast to the mountains, Borneo was home to more different forms of vegetation than any other place in the world, some of which were even then un-known and waiting to be discovered. I could hardly wait to see with my eyes what I had packed into my head from a crash course of heavy reading.

On my first day, I rose early, unable to sleep. I went up on the roof of the Sarawak Hotel around 6 a.m. and looked over a soft steamy scene of a city be-ginning to awaken as window lights began to softly flicker among the low white buildings. Everything referenced the past. It was Asia, but nothing like the jammed streets and skyscraper towers of Hong Kong. I had taken two steps back in time. The rhythm was slow and muted. As I watched, the lights of the city began to come on one by one, sleepy and subdued. There was barely enough illumination to tell whether I was seeing single light bulbs or kerosene lamps in the misty cool darkness of early morning. I was in the 19th century.

The city spread out below me, north to the Kuching River. As the sun's light came up, darkly brooding blue-gray mountains extending southwest from Ka-limantan, the Indonesian border revealed themselves. The small shops that all looked the same in the murky dawn began to show their individual fronts. On top of each there was another floor with three or four tall windows that reached almost to the long, tiled, sharply slanting roofs that connected all the build-ings in the block. The shops' high front windows were designed to provide air circulation, and were assisted indoors by slowly rotating ceiling fans.

I had read that Kuching was one of the wettest places on the planet, receiv-ing an incredible nine feet of rainfall a year. (New York City receives less than four feet.) I was expecting high humidity, but it was still cool, refreshing, and not yet damp in this early morning. I learned that the average temperature here was much the same from one season to another, ranging from 78°F to

86°F. The humidity was high, but much less so after dark. The day cooled after the deluge that one came to expect in the afternoon.

With my new Zeiss binoculars, I scanned the cityscape while I waited, peering into my future. I was half expecting to see Peace Corps Director Joe Fox scurrying to the hotel to get me, to officially begin my new life.

The light was now strong, shining off a horizontal banner with Chinese characters strung along the buildings. Bicycles began to accumulate in the streets, and more and more people appeared pushing carts, and riding in busses and cars. Everything seemed to be of a different scale and cast in the past. Fingers of smoke joined others rising and mingling in the moist air from hundreds of food shops. I was hungry. I wondered what they were having for breakfast. I gave up my search for Joe Fox, who never appeared.

Finally, after finishing a typical British breakfast of scrambled eggs, bacon, and fried tomatoes in the hotel dining room, I got directions to the Peace Corps office, and walked over.

The office was located above a modest Chinese restaurant and I climbed the stairs to meet the Peace Corps staff. I was a little irritated that I had come half-way around the world and was not greeted by anyone, but a stronger voice told me this was more amusing than irksome. So when somebody asked me politely, "What can I do for you?" I replied, "I'm looking for a job."

I was very disappointed that the surprised clerk didn't give me an application form, but recognized me as the new director. It turned out that Joe Fox hadn't been informed of my time of arrival, and had only learned two weeks earlier that I even existed.

Joe was out on business, but I met Dean Bowman, who would be my deputy, Dr. Don Paty, the Peace Corps doctor, and Frank La Salle. Frank was the representative 4-H, a division of the U.S. Department of Agriculture, and was in charge of a project that had been made part of the Peace Corps program that had 81 volunteers.

Dean Bowman showed me around, and we had a long talk at the Chinese restaurant below the office, where I met old friend *kon loh mee*, noodles with a splash of soy sauce enlivened with shreds of pork. I felt right at home. This had been my standard pre-dawn breakfast when I was doing the underwater work in Mazatlan.

Dean was a very diligent and effective administrator who had everything under control. He was knowledgeable, talented, and in fact qualified to do my job in many ways more than I was. He also probably thought that he was going to be the new director until I was parachuted into the scene, but if he was annoyed or disappointed, he never showed it and it never interfered with his performance. Dean's work providing bureaucratic sail trimming was to prove essential to the Sarawak office staying on course with Peace Corps Washington bureaucracy.

I moved into the Peace Corps director's house on Rubber Road in Kuching ten days after arriving. It was a wonderful open Malay-style house with two bedrooms, a bath and kitchen, and a dining room that extended into a living room in the front. Like most Sarawak houses it stood on stilts because of the high rainfall. The windows all had shutters but when they were up, breezes could come from any direction. The house was at the back of a long narrow lot: the driveway led through a front gate where two beautiful Chinese ceramic eagles perched guarding the entrance. In the house, there was nothing except a bed frame, mattress, with a mosquito net covering it. My predecessor, Joe Fox, had sold everything except the refrigerator, pots and pans, and the stove. I was delighted because I wanted to start from scratch. Dean Bowman and his wife, Ruth, and Dr. Don Paty and Anne, who lived down the block, told me that the local woodworkers could duplicate "Danish modern" furniture, but Copenhagen on the Equator was not what I had in mind. In any case, furniture choices were not on the top of my list of things to do, but neither was settling into the office. When I discovered that Dean Bowman could continue to administer the program, I decided to visit as many Peace Corps Volunteers as possible, as soon as possible, to provide me with a crash course on the state of the Peace Corps mission in Sarawak.

Soon after arriving, I had heard again that morale in the field was low. We had volunteers teaching in elementary and secondary schools, and instructing in agriculture (4-H and land development). Half of the teachers were working in remote areas, a third were in rural communities that were not remote and a sixth of the teachers were in towns. All of the agriculture volunteers served isolated areas. Why did 30% of the volunteers quit before their commitments were up? After all, they had worked under leadership that was far more experienced than I could offer?

To find out, I got into the Peace Corps Land Rover that had been assigned to me, and left Kuching. My first drive took me along the southern border of Sarawak. The paving gave way to dirt roads past Kuching Airport, and as I bumped along I could admire the nearby mountains that marked the southern demarcation between Sarawak and Indonesian Kalimantan.

At that time, small forces of Indonesian guerillas had been reported probing the border in the area where I was traveling. I learned that the trouble was recent. In 1962 there was an armed "confrontation" between the British Commonwealth territories and Indonesia because Indonesia's President, Sukarno, wanted to prevent the creation of the Federation of Malaysia that emerged in 1963. The principal military activity was fought on the island of Borneo. In 1949, when the Netherlands withdrew from their Southeast Asian colonies after five years of civil strife following World War II, a power vacuum was created that upset the status quo. Not everybody was happy about the outcome. Indonesia, having recently freed itself from Dutch colonial rule, was not interested in having a powerful new neighbor, the Federation of Malaysia, which combined Sarawak and North Borneo. President Sukarno saw a threat in increasing control by the British over the region. After all, Malaysia remained under Commonwealth military protection, and he felt that it was essentially a British political puppet. This was all something I needed to know because my workers posted near the Kalimantan border were potentially in some danger.

My first hundred-and-thirty-mile road trip ended in Simanggang, where I visited volunteer Ruth Sadowski, from Worcester, Massachusetts. She was an English teacher in her early 20s working in a secondary school. Like the majority of the volunteers in Sarawak, she was preparing children for the compulsory "Cambridge Exam," a test that determined the fate and direction of further education when thirteen-year-olds reached the eighth grade. A hangover from the days of British rule, it was identical to the test taken by U.K. schoolchildren, and was still amazingly Anglo-centric, including questions about the butterflies of Britain.

Many Peace Corps Volunteers were teaching English in the schools because this was the language that made it possible for young people to get a toehold in either public service or business. The teachers, therefore, performed an essential service that addressed a problem that was appropriate to British colonial

times, but not completely in sync with new realities. The colonial apparatus was still in place, but the Malays from outside Sarawak might have had different ideas about the future of what was now East Malaysia, a state rather than a country, and one not governed from the West. I had arrived during the period of transition, and it was not clear what direction these changes would take and how long things would stay the same. This period provided me with an opportunity to influence the Peace Corps program without Malaysian government interference, which had other things on its mind. It was clear to me from what I observed that the majority of the people of Sarawak, the native tribes, would have a slim chance of surviving the domination of the minority who had a different language, religion, and culture — unless they received an education.

Among the things I learned about the lives of volunteers was that their pay consisted of a monthly living allowance of U.S. $100 but that $1500 (minus taxes) was deposited in a U.S. bank annually. Volunteers were encouraged to travel in the region during their two-week annual leave, but Borneo was an island and it was expensive to leave it, which presented them with a problem.

Ruth Sadowski told me that she found current Peace Corps language training ridiculous. She had learned "bazaar" Malay (a simple, low Malay), and all her contacts were with people at the lowest level of Sarawak society, so her language skills were appropriate. But the newest group of volunteers had been taught "high" Malay (Bahasa Kabengsaan), and if their assignment were in a rural area they would have trouble communicating.

The importance of Chinese culture in Ruth's city of Simanggang was also a surprise to her, and she found that she had little preparation for understanding the complex racial tensions in such a place. Another weak point in her training was that there had been unrealistic emphasis on physical hardship, which was not the case in urban settings like Simanggang. Ruth reported that snakes were a particular obsession with Peace Corps trainers back in the States. "I've seen one snake in the year I've been here."

The long drive back to Kuching, so close to the Indonesian border, gave me a chance to reflect on the ongoing military emergency and the possible difficulties for volunteers like Ruth. I kept looking up toward the mountains thinking about the 34 military attacks and 13 border incursions into Sarawak by Indonesians a year before my arrival. The possible kidnapping of volunteers by Indo-

nesian guerillas was something I had to evaluate. Guerillas, Chinese Communist sympathizers working in some of the commercial centers, and Indonesian Army regulars provided a confusing set of possibilities. The lonely ride along this road made me realize how easy it was to slip back and forth across the long, unpopulated border.

I saw no signs of conflict, however, except occasional roadblocks. I passed convoys of Gurkhas and other British troops coming in my direction in trucks and Land Rovers. My Land Rover was the same model used by the police; theirs painted black, the army's painted green, and mine painted battleship gray. There was no "Peace Corps" marked on the side of my vehicle, and I hoped that "battleship gray" was the color of non-aggression to Indonesians.

I made contact with the British military in Kuching to work out an early warning system, and reevaluate the location of some of our volunteer assignments as well as create a map of possible danger areas where volunteers should not be posted. Ruth Sadowski was only twenty miles from Indonesia.

Working with British Brigadier Bill Cheyne, the equivalent of a one-star general in the U.S. military, was exciting. It turned out that he had under his command a unit — Commando 41 of the Royal Marines — that had fought with us in Korea at the Chosin Reservoir. As my understanding of military responsibility had never extended beyond fifty feet to my right and left, depending on visibility, I felt quite giddy working with the brigadier. We got along well.

To further my local contacts with influential people, I contacted U.S. Consul William Brown, who eventually became Ambassador to Israel. Bill was also an ex-Marine, had earned more than one degree from Harvard, and even more important, was well stocked on pertinent gossip. We became good friends. Our talks together provided me with a complicated picture of what was happening in Sarawak and Sabah as well as Brunei, the tiny oil-rich Muslim sultanate that still was under the protection of Britain.

So, the situation that I found waiting for me in Sarawak was more complicated than I had been led to believe during my orientation at Peace Corps headquarters and would require decisions to be made in the field rather than in Washington.

Compared to what was then happening in Vietnam, however, and the war I had known in Korea, the confrontation between Malaysia and Indonesia was

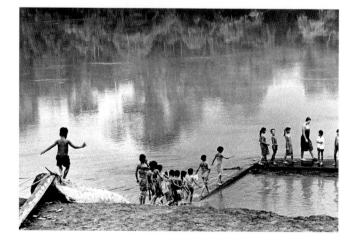

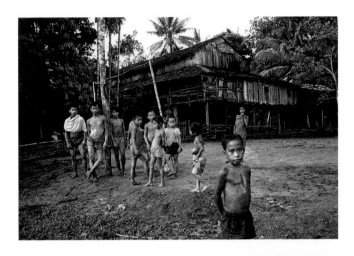

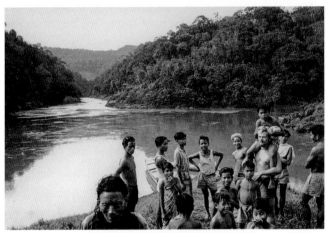

small-scaled, but for me it would become very large if something happened to a Peace Corps volunteer. I was developing a long list of political and military things I needed to know as I continued my trips to meet the volunteers.

To reach volunteers who were living in traditional longhouses in the deep interior of Sarawak, I first took a Borneo Airways DC-3 to Sibu, a commercial city inhabited by a large population of Foochow Chinese. I then made my way up the Rajang and Mukah rivers to reach our people, who were working on agricultural projects and in primary schools, again teaching English. Here, in almost every case, the training of PCVs to cope with rugged living conditions was fully justified; there were also more snakes.

Out in the back country, waterways were the roads. Competitive private services operated by Chinese businessmen moved goods and passengers in river craft of different sizes and capacity. The river trips often began on the mile-wide aqueous superhighways, near the coast, where the rivers were deep enough to handle ocean-going vessels arriving from the South China Sea. For journeys further inland, express launches left from Sibu at the mouth of the Rajang River. Their double decks accommodated hundreds of passengers. The boats were efficient and inexpensive, and all had Chinese characters advertising themselves painted on their wheelhouses. From Sibu to Kapit, cost $1 Malay. (At the time one American dollar equaled three Malay dollars.) Most passengers sat on wooden benches for the hundred-mile journey; a twelve-hour ordeal. I remember gazing with envy at the small children who lay in hammocks improvised by their mothers from sarongs suspended from hooks in the ceilings of the boats. Cabins were available for $4 Malay, but the accommodations were rudimentary and not much more comfortable than the benches.

On the rivers, the competition for passengers was keen. Even large boats were operated like taxi cabs: the Chinese launches chased each other up and down the river. There were many near-miss collisions as the boats raced to the banks of the rivers to pick up customers.

After my first trip, I learned what everybody else knew: it was wise to arrive at the dock early and to be near the front of the line for boarding, which made it possible to sit far forward in the boats and avoid the diesel smoke that often choked the passengers in the stern.

As the rivers narrowed, so did the boats. Further upriver, the larger diesel-powered water taxis were replaced by passenger-carrying longboats. These boats, which resembled much smaller canoes, usually began as huge logs, often thirty feet long, that were hollowed out with axes and fire. Benches were fitted inside. The larger longboats had a corrugated tin roof to protect passengers from sun and rain. A twenty-horsepower Johnson outboard motor was able to propel the longboats at a considerable speed; they were steered by a driver in the stern and directed away from rocks, logs, and other floating debris on the water by a deckhand in the bow.

Flotsam and jetsam were not the only hazards to river travel; there were rapids. The first one I met was the Pelagus Rapids above Belaga on the Rajang River. It was actually six contiguous rapids that were known for chewing up longboats and spitting them out downstream. Many who had dared the rapids had died along this tumultuous stretch. As we approached Pelagus Rapids, my longboat was cautiously unloaded and all the baggage and the outboard motor were carried several miles around the danger to clear water. From there we continued to Ng. Merit where Cecil Horst, a primary school teacher from Elkhart, Indiana, was posted. He was the only volunteer there and he had 100 Punan students in one of the remotest assignments in Sarawak.

There was no nearby town, only a five-shop bazaar reached by paddling upstream for twenty minutes. There, Cecil could find the canned food that he lived on. I noticed a few bottles of Pepsi Cola that were so old that I didn't immediately recognize the label. They must have found their way to this remote shop at the end of World War II.

Cecil explained that you had to keep an eye out for the old canned goods, the contents of which could create unpleasant surprises. If any of the cans were dented or seemed to be bulging, the food inside was spoiled and one could become very sick. The bazaar, and for that matter almost everything connected with the river, was run by Chinese, some of whose forebears had come to Borneo generations earlier as seafaring traders and remained.

In order to begin to discover what it was like for our volunteers to live in totally unfamiliar surroundings with no outside contact and little ability to communicate with others, I had to understand what they hoped to accomplish here. Their first goal, of course, was to learn the language. Cecil first trained in

Malay, but learned that he had to communicate in the unrelated Punan language out in this remote area. His tutoring was aided by utter desperation, which quickly produced fluency.

Because he found it difficult to make an occasional escape trip downriver to see another Peace Corps volunteer, Cecil poured all his hopes and dreams into his job and set high goals for himself. He knew that a command of English was the only thing that could take the children out of the jungle, to inch them up a path that would lead to secondary school. And that's what he aimed to do, even knowing that the deck was stacked against them; there were so many things for them to learn, and for him to learn in order to help them.

What I began to understand from Cecil was that the Peace Corps had only a small opportunity to prepare even a few young people to escape being stuck in the 19th century. Would it be possible to move them out of the *ulu* — the jungle — as English speakers? Where would a generation of non-Muslim descendants of former headhunters like Cecil's kids be in the future? I was hopeful for Cecil but uncertain that I would find volunteers with his commitment and courage. He became an example by which I would measure future volunteers.

What I learned was not only going to help me shape the program, but give me insights into the different human requirements that were appropriate to the great variety of postings. There was so much to learn. In Savannah, a place where I was part of the culture, I had still made mistakes. Here, the culture was a mishmash of mysteries, and I hadn't even had time to learn one of the languages. I felt comfortably connected to the volunteers because much of what I knew about life was colored by my various adventures — however misguided they may have been — but now it was time to reevaluate old tools and find new ones.

On my return to Kuching, I discovered another aspect of my new job that came as a surprise, a problem that I was unprepared for: Peace Corps staff wives. My arrival seemed to have been like Pearl Harbor for Dean's wife, Ruth. She probably had every reason to resent the person who might have taken the job of her capable husband, particularly someone who was deficient in the areas where her husband was strong. Nothing was said, but there was always a slight chill between us. This was my first encounter with the hazards of being in charge where wives were involved. Meanwhile, I found the job of trying to

match the requirements of working in an alien culture with the tasks and personalities of volunteers a more interesting concern. I didn't know what to do, so I waited and gave time and good manners a chance to work.

In order to gain the trust of volunteers, I looked for a way to establish myself through my own personality. Every volunteer could figure out in five minutes that I was not an experienced administrator. So I sought to get their attention through humor and include them in the process. I started a Peace Corps newsletter. Part of its purpose was to honor our volunteers in a special way. This could be small-scale journalism, but under no circumstances was it to be boring. The following story was republished by the *Sarawak Journal*, a monthly scholarly publication founded in 1870 by the White Rajah. Its editor, anthropologist Tom Harrison, apparently had an affinity for my ridiculous stories, which he apparently read regularly.

GENTLE SMILES AND SIGHS AWARD

This month I have the pleasure of honoring PCV Gail Marcelius of Rumah Sekapan, Belaga, who singlehandedly introduced softball into the lives of the Sekapans (Melanaus) — thus bringing about social change and influencing the ecology of life under the longhouse!

Gail equipped her team by removing the limbs of a nearby sapling, hacking them with a parang to regulation bat size and scrounging an old tennis ball.

It has been traditional for the taller and stronger member of the teams to be pitcher. The reason for this is because everybody fights to be pitcher and the big one always wins. Unlike the pitchers, it is necessary for the out-fielders to be short, as they are mainly positioned under the longhouse. This makes for a lot of action in the outfield as the pigs keep an eye on the ball at all times, going after it with a lot of hustle and very often eating it before the outfielder can get it re-trieved...

Tennis balls are hard to come by in Sekapan and therefore must be saved at all cost. The best way to extract the ball from a pig's mouth is with a cigar. All Prima-ry I children therefore play softball while smoking delicious homemade cigars.

By late November 1964, I had visited half of the Peace Corps sites in Sarawak, and after another month I began to put together a plan based on what I had learned. My goal was to have as much comprehensive information as possible presented in the training of newcomers, and to help place volunteers in jobs that suited their skills and temperaments. My conclusion was that the present volunteer population was more or less stable. The ones who had been unhappy about their assignments or had bad adjustment problems had already left. What I had to worry about was the next group of volunteers who were being trained at Hilo, Hawaii to come to Sarawak.

I also had the idea to make cameras available to the volunteers, so they could document their own work and make contributions to the newsletter. I made arrangements with a camera store in Singapore to sell 35mm cameras to volunteers at a heavily discounted price it was possible to get a Canon camera that was capable of professional results. If the volunteer bought a camera, Peace Corps would supply free film and processing.

When the film was sent to the Peace Corps office in Kuching, it was devel-oped and small snapshot prints were made, after which duplicate prints and the negatives were returned to the volunteers. The pictures were catalogued with lists of the photographs, and placed into folders with the name of the vol-unteer and the location of their site, which was marked on a huge map of Sar-awak in my office.

I also wanted us to gather information about the life and work of each volunteer. Where do you bathe, go to the bathroom, eat, sleep, and work? I wanted pictures of the volunteers, colleagues, and the most important person in their longhouse, village, or town. What transportation was available; where do you get food, drinking water, and wash clothes? What do you do for entertainment and who are your friends — other volunteers, ex-pats, local people, etc.?

In a few months the Peace Corps office in Kuching had a file on most of the volunteers in the country, a thriving newsletter, and other material. I was later to take copies of all this to Peace Corps training in Hawaii. All Peace Corps postings, of course, presented volunteers with unfamiliar things — food, housing, transportation — and all of them required flexibility and basic language fluency. But my illustrated reports provided training staff with a new tool for evaluation and appropriate placement, and they gave volunteers a visual preview of what they would find when they arrived.

What kind of volunteers met these requirements? What was their level of motivation? Did they need to work in groups or alone? How often did they need to escape the unfamiliar? My theory was that success, in some cases survival, required that volunteers be completely involved in their work — and have significant and defined work to do — and it was my job that to make that happen. Cecil Hodges' isolated and lonely posting was extreme, but it illustrated many points that all volunteers had to face. Hopefully, my two-dimensional reality-check — the photographs — would help me match appropriate selections to job placements. Frankly, I wasn't sure what to expect.

When I went to Hawaii to investigate how Sarawak volunteers were being trained, I found that all the bugs that my system had forgotten about since leaving the United States came back to attack me. They were obviously American bugs, hiding in Coca-Cola bottles, cheeseburgers, and airline food. They had joined me aboard Pan American Airlines. Fortunately I was also returning to the world of advanced plumbing, and after a few days Peace Corps medics brought me back to the same healthy condition that I had experienced in Sarawak.

Part of Peace Corps training consisted of a two-week field orientation in the Waipio Valley on the Hamakua coast on Hawaii's Big Island. Again, Peace Corps was testing its future volunteers in a setting of a lush undeveloped valley six miles long, flanked by two thousand-foot vertical green walls with hun-

dreds of silvery fingered waterfalls pouring down to the Waipio River. Here, prospective volunteers were sent to be cleansed of what remained of excess urban baggage with a "Tarzan and Jane lifestyle." Amenities were modest, but the stay was blessed by the sight of a towering emerald green peak at the end of the valley, where Hawaii's most celebrated waterfall, Hiilawe, descended to the lush fields below.

The clear Waipio River nourished the volcanic soil as it cut through to a black sand beach and emptied into the Pacific. This was the place where young Americans were being prepared for overseas realities, the rigors of the radically unfamiliar — a departure from consumer culture. It was supposed to be boot camp, Peace Corps Hell, but they were being trained in Heaven, a place that God had designed for romance movies, a place that Hawaiians had long since dubbed *Valley of the Kings*.

Among the trainers, I learned that the debate about volunteers learning high Malay rather than Bazaar Malay was still underway. And there were other inconsistencies. Hawaii's exotic Waipio Valley was in no way similar to Sarawak. Walt Disney had apparently collaborated with God on creating this gorgeous backdrop. But it didn't really make that much difference because it was impossible to replicate Sarawak without doing training, or part of it, in-country, which later became standard practice. My job was to match each candidate, as best I could, to my illustrated reports.

While observing the training at the Waipio Valley, I was in a wonderful mood. My photo-illustrated orientations seemed to be a success. But it was hard to resist the grandeur of the valley. On the last day of training I saw that a young woman with a large duffel bag was about to hike up the very steep road that exited the valley. I was heading back to Hilo in a Peace Corps Jeep, and she asked me if I would mind hauling her duffle to the top of the road as it was quite heavy. I did it with pleasure.

Apparently, this was a serious offence: all trainees were supposed to haul their bags to the top of the hill on their own. That night I learned that the young lady was about to be terminated because she had persuaded me to lighten her load. I was furious, and told the head scout that she was exactly the kind of volunteer I was looking for, one who had enough savvy and charm to get somebody to help her get an exceptionally heavy load taken to where she wanted it to go. "I want her for Sarawak," I said, and she was reinstated.

I managed to acquire another trainee who had been deselected from the Turkey project as a menace to Ottoman culture because she was too sexy. Apparently, her danger lay in the fact that fully dressed she made many men in her program wish that she were fully undressed. She had been rerouted to Hawaii and Sarawak got her too.

A few placements for Sarawak defied the clichés about "rugged" Peace Corps assignments. One trainee, who had a degree in anthropology, went to work in the heart of Kuching at the Sarawak Museum under the guidance of the famous curator-anthropologist Tom Harrison. His museum had an extraordinary collection of Native and Chinese antiquities. It was the opportunity of a lifetime. This young woman might have done well in a more rustic environment, but she blossomed at the museum doing research on objects from the *ulu* instead.

Other of my new crew of volunteers found teaching jobs in bustling trading towns where the students were mainly Chinese. Others taught English to the Melanau children and Malay children, many of whom were Muslims. Some of them went to charming, sleepy coastal villages close to the sea where their schools were built on stilts to cope with the tides of the South China Sea. There the inhabitants lived by fishing. Each place had its own smells, sounds, and distinctive rhythms.

Volunteers understood that learning to cope with cultural differences and having a job to do were the keys that unlocked their idealism. The 1960s were a time of change, and the Peace Corps in those early days appealed to young Americans who wanted to serve their country in a new and unexpected way. John F. Kennedy had persuaded many Americans that change was not a threat; it was a requirement to survival in a changing world.

On returning from the training and recruitment sessions in Hawaii, I settled into a very pleasant life in Kuching. Monica and young Breck had joined me, and my house on Rubber Road provided every comfort for my family. In fact, it was more comfortable than I would ever have had the nerve to ask for — a cook, gardener, and an all-around handy person. Ah Wah, a half-Malay, half-Chinese girl served in all capacities, including looking after Breck, who was now three years old.

The word got out that I was a sucker for stray creatures, and a variety of small animals would be delivered in paper bags at my gate by people with an

oversupply of puppies or kittens. Then my cats got into the act and from time to time proudly presented us with baby cobras, retrieved from the hedge that separated our house from the one next door. Fortunately, the snakes were dead by the time they arrived and I never met mom and dad.

Among our other pets was a fish named Ikan (the Malay word for fish), a bird named Tweet, a Rhesus monkey called Beauregard, who lived in a tree, and dogs so numerous that their names have been lost as well as the stories that brought them to me. Animals I loved, but not a zoo!

My most spectacular animal "donation" came to Rubber Road with volunteer Jim Wells, who arrived with a sick baby orangutan. The animal was suffering from a severe case of diarrhea. The baby had long spindly arms and legs and would lovingly wrap them around you in the most affectionate way. The sweet animal would cling to any warm body. The Peace Corps doctor was traveling, so I called my friend Dr. Danny Kok, a pediatrician, who never made house calls when my son was ill but when he heard about the sick orangutan, he was over in five minutes. My hosting of this charming animal was brief. After getting first aid, he was relocated to a special park that had been organized for orphans like this one. Apparently this wasn't an unusual situation, as adult orangutans were often killed for food by the jungle Ibans: fortunately this baby was rescued by Jim Wells.

The news also leaked out in our community that in addition to collecting animals I was also interested in acquiring indigenous artifacts. Gradually I began to have regular visits from local artists and people who were disposing of rugs, pottery, native carving, Batik cloth from Indonesia, weaving, Chinese furniture, beads, and brassware. The plates I used every day were Ming Chinese export ware and I served meals on celadon platters. My collection was also gradually filling with some of the remarkable crafts from the many cultures of Sarawak, among which were beautiful models of their boats made by some of the local fisherman. My massive dining room table had been provided by the extraordinary carvers from the Baram River area, who had hacked with axes the wild-shouldered buttress of a giant Tapang tree that had grown to 300 feet. The table top was seven feet long and four feet wide, made from a single plank weighing over three hundred pounds and held up by four carved ornamental dragon-dogs, to keep the evil spirits away.

A huge painted sculpture of a hornbill with a five-foot wingspan hung over my desk at the Peace Corps office. In addition to ancient beads, ceramic pots, and bronze work and trade ware imported over the centuries by Arabs and Chinese, my life in Sarawak reflected a land of extremely varied and creative artists.

One of the contemporary artists I met was an amazing Punan, Jok Batok, whose elaborately decorated doors I had seen in his longhouse while visiting Cecil Horst at Ng. Merit. Several months later, Jok Batok arrived in Kuching and I commissioned him to paint five 3 x 4 foot panels depicting his version of the history of Sarawak, including one on the Peace Corps. The artist's imagination and artistry caught the spirit of Sarawak. Traditional techniques combined with personal references amused me and give me pleasure to this day. This great "primitive" art was in no way primitive. My mother had missed a chance to collect French modern painting when she was studying art in Paris in 1911, but I didn't make the same mistake in the mid-1960s.

The drive from my house to the Peace Corps office took about ten minutes. I preferred to ride a bike, although the daytime hours were hot and humid. In the evening however, it was my transportation of choice, although it didn't provide enough exercise. Running was too hot for me in Kuching, so I took to swimming in the Olympic-size public pool. Sixteen laps would take me about an hour and kept me in shape. Even underwater I felt like I was sweating.

My predecessor, Joe Fox, had maintained good relationships with British ex-patriate officials who still ran the government of Sarawak. They had frequently spent time together at the Sarawak Club, and I was told that Mrs. Fox also entertained at home. But I chose to concentrate my socializing with the volunteers rather than the authorities. I did become a member of the club, where a pleasant Sunday curry, washed down with fizzy cool gin drinks, always sent me home for an afternoon nap that was closer to a coma than a snooze.

The Sarawak Club presented visitors with a uniform degree of paleness; almost everything – clubhouse decor, shoes, trousers, shirts, and faces – was white or beige or khaki. This was contrasted with the immaculate green surroundings. The blazing sun peeked under the shady verandah but never was able to brown the Brits, who had learned after hundreds of years how to avoid the perils of the sun. ("Mad dogs and Englishmen go out in the midday sun!") I actually liked the expatriates, but rationalized that my time was better spent

paying attention to Peace Corps needs with the volunteers rather than among the British, who were fading away; their colonial presence was being dismantled bit by bit by the new authorities of Malaysia in Kuala Lumpur.

One of the most attractive aspects of Kuching was the open market in the center of the city. Here, long rows of open tables were set up in front of kiosks that served Indian and Cantonese dishes, as well as Malay food, which was like Indonesian. You could get quart bottles of German, Chinese, and Singapore beer to go with offerings from any one of the multi-national food booths. The market was a popular hangout for visiting Peace Corps Volunteers, and I spent many evenings with them as they came to Kuching. It was a perfect place to cool off after a long hot day and the food was good, and inexpensive.

Occasionally, I went to the market to solve problems that volunteers brought me. Jim Wells, the tall, kindly volunteer who had rescued the sick orangutan, turned up with a romance problem. He was hopelessly in love with another volunteer who didn't share his feelings. We headed for the market, where I hoped he would be soothed by some good food and a large amount of beer, the lubricant of choice for unsticking the complexities of unrequited love.

The conversational tack I took, trying to be wise and helpful, apparently dragged out ancient stories from my past. It's impossible to remember how this applied to Jim's situation, but it may have related to his brother who was working in Vietnam as a war correspondent for *Newsweek*. In any case, a few weeks after my alcohol-aided therapy session, Jim appeared at my house — a moment I will never forget. This time he didn't have a monkey on his back, he was balancing his Peace Corps issued mattress on his head. This indicated that he wanted to resign and return immediately to the U.S. to enlist in the Marine Corps. Then, he would volunteer for Vietnam. It turned out that he was inspired by my Korean War stories.

My idiotic storytelling had created the most dangerous situation that I had yet faced in my Peace Corps career. My beer-laced tall tales were about to send Jim off to the Marines and — God knows what? It was 1965 and I had come to the conclusion that Vietnam was a disaster.

This set in motion a situation that was going to get me fired if anybody found out. Jim got two weeks leave and I made a deal with him: he could resign, but not before finding out what it might mean to serve in Vietnam. He was told

to contact his brother, fly to Saigon, and have his brother show him around. When he got back to Sarawak, he could decide what to do.

He took off; two weeks passed, and upon his return from Vietnam, enthusiastically chose to remain in the Peace Corps over the Marine Corps. As it was completely against Peace Corps policy to permit volunteers to travel to Vietnam, I was lucky that the word never got out. I took the pledge: no more beer and bullshit about the military with the volunteers, and was able to keep at least half the promise.

In 1965, Dean Bowman came to the end of his two-year tour and was replaced by Elmer Skold. Dean had done an outstanding job in Sarawak and his replacement would prove just as good. Elmer and his wife, Patty, were to become close personal friends. To make a gesture that indicated my respect for Dean's accomplishments, I treated the couple to a champagne dinner at the Sarawak Hotel, the only place available to make some pretense of stylish entertaining. The dinner was as lavish as I could make it, and it produced results that astonished me.

I opened my conversation by saying that I realized how difficult it must have been for Dean and Ruth to have suffered the disappointment of having me arrive, perhaps denying him of the director's position, which may well have been promised. On the second, or maybe it was the third, bottle of champagne, I thought I was doing a very good job of describing Dean's gentlemanly attributes and much admired abilities, when Ruth collapsed in tears. What had I said? Ruth told me that she had treated me horribly for a year and she was feeling terrible about it, and so forth.

This was a total shock for me, and I did my best to convince her that I completely understood her position — which in fact I did. This unfortunately produced more tears. The only point that makes the story worth recounting is that for me the episode had its educational aspects. First, it showed me how alcohol applied at the right moment and under the proper circumstances can be a blessing. Maybe it also demonstrated the qualitative effect of Möet & Chandon, but, most important, Ruth restored my faith in the value of patience and good manners.

On July 4th, 1965, a party at Consul Bill Brown's house celebrated the great day by watching a film about John Glenn's globe-circling achievement on *Friendship 7*, but my orbit was more on a more local level. Monica had been pregnant nearly nine months and a baby was due.

An emergency telephone call found me at the Browns' and I sped to Kuching Hospital to welcome the safe arrival of Charles Grattan Baldwin. I don't remember how much he weighed or how long he was, but he created a new and welcome space on Rubber Road. His coughs, sneezes, smiles, and eventual baptism at the Anglican Cathedral brought his grandmother to Kuching. Monica's life expanded socially beyond Breck, a house full of animals, and a continuous stream of home-sick volunteers to include the dignified and elderly ex-patriate community, the English accents I hadn't taken the time to get to know. My mother's diplomatic and social skills were activated and Grattan was the catalyst.

27 – **KILLINGSWORTH STORY**
BEN AND JEANNETTE

Family life was made very easy for Monica and me in Kuching; we were able to have a nurse, cook, and gardener for the first and only time in my life. The usual domestic chores were therefore extended to others with no sacrifice to my work schedule or travel. The usual parental maintenance required for a three-year-old and a baby boy had been transferred to Monica and the backup of our *amah*, Ah Wah. I definitely don't remember ever changing a diaper.

I loved my children, but I also loved a job that required traveling by Land Rover, riverboat, longboat, and planes to get to volunteers. I traveled a lot because I was curious and it was necessary. My own history had been filled with adjusting to new cultures, and I understood and related to the strivings of volunteers and their willingness to plunge into completely new and foreign experiences.

Toward the end of my two-year tour, the Far East Director asked me whether I would be interested in a job as Peace Corps Director in Mongolia. Although I was intrigued with Mongolia, I didn't want to do it. I had had enough of administration, and, thank God, I had been spared having to be good at it by two successive deputies who were good at it. But I might not be so lucky the next go round. I was not built for bureaucracy. I wanted to scribble on every official entreaty sent from Washington, "Fuck you, strong letter follows."

After I made it possible for volunteers to get cameras to record the details of their lives, the documentation of Peace Corps work assignments was done, and the good thing about it is that it was done by them, not me. I had taken a few snapshots of Peace Corps life, but none of it was a serious attempt to go beyond what the PCVs had done to record it. However, a professional documentary that

gave my particular slant on what I thought was special about the Peace Corps experience was a project that I was anxious to do. To wind up my service, I wanted to photograph, first in Sarawak, then in other countries of the region, what the Peace Corps was accomplishing. I had never taken leave, so I decided to spend some of that accumulated time documenting Peace Corps work up close — a very personal perspective.

To focus my project more closely, I chose to concentrate on a young couple from Texas, Jeanette and Ben Killingsworth. I had persuaded the Peace Corps Public Information Office in Washington to approve the publication of a book of my photographs and text with Ridge Press in New York and I believed that the Killingsworths would be ideal prime subjects – attractive, bright, energetic, and hard-working. With them, I could examine wide varieties of volunteer efforts that took place along Borneo's rivers, deep in the interior of the rain forest, and in the longhouses where people lived. Picturing these two young Americans in this setting would, I hoped, illuminate their obvious differences but also reveal the human connections that developed between idealistic volunteers and former headhunters located in one of the most remote places on the planet. What a story. I couldn't resist. I had found two volunteers who I thought might personify the most illuminating optimistic aspects of the Kennedy era and my own aspirations as well. I wanted to see what the Killingsworths could learn from the Ibans and what the Ibans could learn from them, a process that would also enrich me. They became points of comparison for what I might find in other Peace Corps countries as well.

I met the Killingsworths in a tiny river community on a tributary of the Kanowit River. There, Jeanette and Ben were organizing 4-H agricultural clubs. At that time 4-H was a non-profit youth organization with millions of members formed into clubs throughout the United States, mainly, of course, in rural areas. Aimed at young people ranging in ages 5 to 21, 4-H was focused on agriculture and projected an idealistic motto, "Learn to do by doing." Peace Corps training in Hawaii integrated 4-H programs to provide volunteers with useful tools that would provide them with added skills to improve the lives of the inhabitants of remote longhouses in the outback. The maintenance of this program was under a separate 4-H administrator, Frank La Salle, who was part of my staff but worked for the 4-H organization in Washington, D.C.

The Killingsworths had been in Sarawak for more than a year and from their base in the village of Julau, they traveled up the Kanowit and Julau rivers to meet with and supervise a dozen widely separated clubs.

The Killingsworths might have been mistaken for many young couples from Baytown, Texas. Jeannette was a pretty twenty-three-year-old graduate of Lee Junior College in Baytown. Ben, her husband, had graduated from Texas A&M University, departing with a graduate degree in math with an emphasis in computer science. Ben had also been in the Air Force ROTC as he wanted to be a pilot but this didn't work out, so he and Jeannette substituted the Peace Corps for military service. They had been married for three years when they were accepted for training.

Ben and Jeannette wanted to improve their Spanish and serve in South America, but Peace Corps wrote back they were looking for volunteers to serve in Malaysia. The couple were in the tenth group that was to be sent to Malaya, Sabah, or Sarawak, which together were now known as Malaysia because of a new federation of the area. The good news was that their training would be for three months in Hawaii. "We thought, well, we'd like three months in Hawaii — no matter where Malaysia is."

Toward the end of training, the seventeen volunteers in the Killingworth's group were given twenty-four hours of "contemplation time" to decide whether they wanted to continue in the Peace Corps for a two-year commitment.

Of the seventeen couples in the Killingworth's group, two couples were deselected, two had medical problems, and one trainee decided not to continue. The final send-off from Hilo included a gigantic vaccination of Gamma globulin delivered to each volunteer in both bottom cheeks and thereafter administered every six months by a Peace Corps doctor, plus a host of other needles that provided defenses from every tropical horror that Sarawak might deliver.

The Killingsworths were posted in Julau, a village made up of eight hundred Chinese, assorted Iban, a few Malays, and with a ten-shop bazaar on the banks of the Julau River. This tiny Sarawak government sub-station was in the Kanowit District, a vast drainage area of the middle Rajang River, connecting many other water highways that reached from the mountains, hundreds of miles to the east to the South China Sea in the west.

They were housed during their first months in a room that was no bigger than a large closet above a Chinese food shop. "They served bean rolls and tea downstairs. The smoke from the wood-burning stove came up the stairs and into our room. We were part of the chimney system," according to Jeannette, "but it was good for the 4-H program. We spent as much time as possible working to get away from the smoke."

The Killingsworths did their shopping in the Julau Chinese bazaars. Food was plentiful, but prices were high. Canned goods from the U.S., Australia, China, and England were available. There was Danish, Australian, and Singapore beer, lychee from China, abalone from California, Campbell soups, canned meat, vegetables, and Australian tinned butter. But no bread, cheese, or fresh meat was to be found. A sumptuous meal could be created of Spam, curried chicken, canned meatloaf, a few local vegetables, and lots of rice, topped off with a cup of tea, and, as Jeannette reported, "we had Nescafe for picky guests."

Entertainment was limited in Julau and it was necessary to be creative in the recreation department. A volunteer friend of the Killingworth's, Tracy Townsend, who worked on a community development project thirty miles upstream, built a badminton court and this became an important part of life in Julau. He and the District Officer and the Malay Agriculture Officer were serious players. Ben found his own amusement when he salvaged a large piece of plywood, sawed it into a circle, and fashioned a water sled that could be towed behind the Agriculture Department longboat. Wildly skimming along the Julau River, Ben emptied every longhouse along his route as inhabitants came out to view this new concept in fun initiated by the latest Wild Man of Borneo — from Texas.

Mail from home was delivered in about ten days. Newspapers and magazines from Kuching and *The Straits Times* from Singapore passed around by English speakers kept the Killingsworths loosely connected to the world. They read books when they had time from a locker full of thrillers and classics issued by the Peace Corps. *Children of Sanchez* by Oscar Lewis about a family living in a Mexican slum was one that Ben remembered. The foot-locker became the official public library of Julau when Ben transferred it to the Agriculture office. Turgid novels like Nabokov's Lolita were particularly popular. There was no air conditioning, fans, or full-time electricity, but Julau lit up from 6 –10 p.m., courtesy of a gasoline generator.

By the time I met the Killingsworths they had moved into far more spacious quarters: a two-bedroom house on stilts that they rented for nine Malay dollars a month (U.S. $3) from the *Tuai Rumah* (headman) of a nearby longhouse. Unlike their previous accommodation, there was a kerosene stove, "and we didn't get barbecued by the kitchen below us." There was neither a phone nor electricity; there was no plumbing, but they suffered no shortage of water because the area had an annual rainfall of one hundred and forty inches. The daily downpour arrived promptly for a couple of hours in the late afternoon during the rainy season. Water collected from the roof was stored in an aluminum tank supplied by the Peace Corps and was boiled for twenty minutes before drinking — without which all the antibiotic needles delivered in Hilo would have been in vain.

The Julau River was clean enough to serve as a bath, swimming pool, and laundry. Local women and girls spent their days clad in sarongs, and Jeannette did likewise. She found that four were needed to get through the day. "Depending how hot and dusty I got, I would go swim and clean up and then put on a dry sarong, then throw the wet one up on the veranda to dry." Jeannette's innate modesty was challenged daily; there were no shower curtains in Julau.

The people who worked with the Killingsworths, up and down the river, quickly accepted them. They made friends with expatriate New Zealand administrators, Dutch Catholic priests, Methodist teachers from Australia, and Malay government employees. The Chinese merchants were friendly. But the jungles of Borneo were host to both human and natural difficulties ranging from where to pee and poop to swarming insects.

These clean-cut young Texans from the other side of the globe had "come to the party" uninvited, but their gregarious nature made a favorable impression on the people that they worked with. The natives saw Peace Corps Volunteers as they did the British colonizers, as white-skinned people who could help them. And fortunately, the language the couple had learned, basic Malay, was not difficult to morph into rudimentary Iban, a dialect of Malay spoken by many of the people they met.

Ben and Jeannette traveled to the Iban longhouse villages together but often they split up and worked independently because there was so much to be done. The Killingsworths eventually visited fifteen longhouses along the Julau

YOU *CAN* SEND A GIRL HERE!

Jeannette Killingsworth might be mistaken for the typical American working girl: she's a charming 23-year-old, a junior college graduate with a handsome young husband.

That is, she might be mistaken for the typical American working girl if she was spotted in her hometown of Baytown, Texas. But half way around the world in the tiny tropical village of Julau, Malaysia, she's looked upon as somebody very *untypical* by the admiring Malaysian kids and their parents with whom she works.

Jeannette and her husband, Ben, are 4-H organizers. They've been in Malaysia since September 1965. They live at the mouth of one of the rivers which serve as major thoroughfares to their upriver constituents. They spend three out of every four weeks traveling by outboard boat, visiting the eight widely scattered agricultural youth clubs they supervise.

Jeannette and a young friend inspect a rice field during a visit to an upriver farm. In this field are several different types of rice, all at different points of maturity which makes for inefficient production, one of the problems of hand planting an uneven soil.

The Killingsworth home rents for $3.30 a month. The phone line lends a modern note to an otherwise rustic setting, but the phone doesn't work so the effect is more apparent than real. Here Jeannette fixes a flat on the family bicycle which she and Ben use for local land transportation.

A day's boat ride from home, Jeannette and Ben visit one of their youth clubs. Before the monthly meeting begins, Jeannette admires a local youngster. Though the 4-H get-togethers are designed for youths from 12 to 21, the arrival of the Killingsworths brings the whole town out and the meeting lasts far into the night. Jeannette and Ben help groups develop programs in nutrition, sanitation and sewing and aid them in adopting improved farming and gardening techniques. "To get people to do things for themselves — not for us — that's the problem," Ben said.

Peace Corps Photos by Fred Baldwin

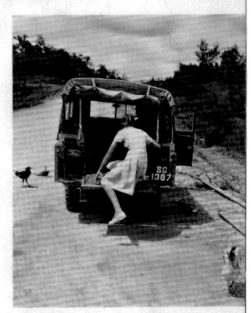

At the village of Melvan, two and a half hours by boat from Julau, Ben and Jeannette stop briefly for a cup of tea and a chat with the village elders. The Iban or leader seated center, proudly reports that his daughter has just successfully completed her 4-H sewing course.

Jeannette hitches a ride to Sareki, 40 miles from home, which is the nearest major community and boasts a movie, a market — with a variety of foods including luxuries such as bread and cheese — five other Peace Corps Volunteers and a hair dresser.

and Kanowit rivers three weeks out of every month. On two of those weeks they saw existing 4-H clubs; the third was devoted to trying to expand the program in new longhouses. A final week took them back to Julau where they filled out monthly reports, organized agriculture courses, and wrote away for materials and supplies to the Agriculture Office. When Jeannette finished paperwork, she still had work to do, "Feed the rabbit, get the water, pump up the alcohol stove, cook dinner, wash clothes, fix a flat on the bicycle, get groceries, hang out the clothes, and then do it all over again."

The Sarawak Agriculture Department longboat from Julau supplied the Killingsworths with transport to the longhouses. They would be dropped off in the late morning, be picked up on the following day, and then transported to the next longhouse. The schedule was intense, "It could take us an hour or an hour-and-a-half to get from one longhouse to its neighbor. After three weeks we were exhausted," said Jeannette.

For me, the very first literal step in adjusting to life in the longhouse was getting my 6 foot 3 inch, 200 plus pound frame out of a longboat to scramble up a slippery notched log from the river to the shore and avoiding a plunge into waist deep mud. The Killingsworths had become adept at the transfer. Each longhouse was perched high above the water on stilts, and comprised a row of connected apartments defined as doors, and containing ten to fifteen people. A long communal veranda called a *ruai* connected the doors, and the number of doors that opened onto it defined the population of a longhouse, which was, in effect, a small village under one long roof. Public life took place on the *ruai*. Children and very old people were there during the day, but in the evening it became the gathering point for the whole community. The longhouse dwellers worked together to accomplish most village tasks. They were supportive of the 4-H projects, and provided adult leadership as well as land and materials for the group.

Everybody contributed to the greater community and, Jeannette explained, "if anyone got out of line they would all have a meeting. Anybody could come. They'd talk all night until they came to a consensus. They had no aristocracy and the door of *Tuai Rumah*, the elected head of the longhouse, was the same as others." Women were also important decision makers, with a strong voice in the affairs of the longhouse and equal property rights.

The arrival of the Killingsworths in the Julau area was a special occasion, for reasons that became more evident as they got to know the Ibans. The people knew immediately that the 4-H training they were getting provided useful techniques for improving their gardens, raising cash crops, and adding to their nutrition. This was well understood and appreciated. But in addition, on a far deeper level, the work of the young couple touched on values that were part of the Iban animist belief system. The Ibans believed that the most sacred spirits dwelled inside the *padi pun*, their sacred strain of rice, and the Killingsworths were morphed into this belief system through their work in agriculture. Although the residents of many longhouses had become Christian, Western religion coexisted with rituals of the past. The Ibans actively and collectively believed in the interpretation of dreams, and the presence of spirits and ghosts that were intimately intertwined with their interactions with the mysterious, the unknown, and the future.

Iban animist beliefs focused on rice, their staple diet, which they believed possessed a soul and needed to be treated with delicacy and respect. They thought that after a person's death, their soul rose into the air and then floated down to earth in the form of dew to gently moisturize the budding rice plants. Perhaps the Ibans felt that Ben and Jeannette had arrived in somewhat the same way.

Some of these beliefs were so utterly delightful that I felt tempted to collect them for my own psychological tool kit. This story delights me to this day and I often tell it because it is such an ingenious solution and departure from guilt-based Christianity. Over the doors of many of the rooms of the longhouse there were hornets' nests. They were put there to keep out evil spirits. As everybody knows, evil spirits are very curious. They like to poke into the tiniest crevices to look for troubling psychic holes in human beings. The hornets' nests, which have many holes, are put up over the doorways and the evil spirits can't resist counting them all. There are so many holes that the evil spirits lose track of the count and have to begin again. This so distracts them that they never get around to entering the longhouse and bothering these inside.

I found more wisdom in this than wondering why Hilton Hotels don't have a thirteenth floor, or why a black cat crossing in front of me is such bad news.

The Ibans were also influenced by their dreams and any unusual daily occurrences in the life of the jungle. An odd noise in the forest or the configuration of a flight of birds might stop them in their tracks or cause them to revise their plans. This didn't seem unreasonable to me. Feeling the immense power of nature overshadows any illusion one might have of human control.

None of the longhouses that Ben and Jeannette served had schools attached, so primary school children were sent to the nearest towns to boarding schools that had recently been built by the government. Many of the schools, of course, had both primary and secondary teachers, but the Peace Corps only taught English to the older children because primary schools were taught in the native languages. The boarding school children returned to their home longhouses on the weekends by an efficient system of private river launches that connected places deep into Sarawak's rainforest.

When the Killingsworths conducted their 4-H meetings out in the longhouses, a big meal was always served. The Americans supplied much of the food and always brought special presents: sugar, canned fish, tea, and iodized salt from the bazaar in Julau. "The iodized salt was important because a lot of people in the outback had goiter problems because of the lack of natural iodine in their diets.

I asked Ben whether he ever brought rice, but he reported, "That would be an insult and considered patronizing." Foreign-made goods, however, were very welcome. The Killingsworths paid for the food from their personal $100 monthly living allowance. In Iban culture the exchange of gifts was very important, and the people returned the couple's gesture "in kind" with jungle greens, and different kinds of fruit.

Group discussions followed the 4-H meetings, and "We were asked all sorts of questions about our lives," said Jeanette. Once, she reported, they got a most amazing offer, "When they found out that we had been married for three years and didn't have children, the Ibans saw this as a great tragedy, and they would have given us one of their babies to take back home. We explained we were going to have some of our own when we got back to Texas," which in fact they did. (One of them was named after my wife Monica.) "The other side of that," Ben said, "was if the little ones were acting up, their parents would say they were going to give them to the white people; they were terrified."

"Then they asked how we prevented having kids. I explained about the pill. Many of the older women wanted to know where they could get *ubat* — a word that covered many useful things about not having babies. The older ones were tired of having children."

Prior to the arrival of the Peace Corps, these Ibans were feeding themselves with dry rice cultivation, supplemented by hunting in the jungle for wild boar, deer, and monkeys, which were tracked and killed with guns. The Iban loved twelve-gauge single-barrel shotguns and became skilled at using them, with the result that game became scarce. As an attempt to control this, district officers would only give new ammunition in exchange for empty cartridges and they maintained careful records. Firearms were restricted to one gun per door. But the Iban were still masters of the blowgun, a long hollowed-out wooden tube made from ironwood. The six-foot long blowgun could deliver a dart tipped with the deadly poison of crushed spiders accurately at short ranges. Each blowgun was an amazing work of craftsmanship; it was the traditional stealth weapon that had long functioned in killing animals and tribal enemies as well as the Japanese soldiers who strayed into the deep jungle during World War II.

Another formidable weapon of the Iban was the *parang*, a sword that was useful as both a domestic tool and for farming. It was often carried in a beautiful sheath, some with decorations of painted snakes or ornate Iban traditional designs carved on its wooden sides. Celebrating the old practice of headhunting, a parang might sometimes have a lock of human hair sprouting from its handle. During World War II, headhunting was resumed in Borneo, having been previously discouraged by the White Rajahs in the 1930s. Several skulls I had seen hanging in baskets in a longhouse had the characteristic round eyeglasses that I recognized as a staple accessory of Japanese officers I had seen in Hollywood war thrillers during the 1940s.

Each time the Killingsworths arrived at a longhouse was a special event. After the 4-H meetings were finished, the longhouse would have a *gawai*. There were different kinds of gawais; some involved communicating with the spirit world and dream interpretation, the expulsion of bad spirits, or the curing of sickness by a shaman. But the gawais celebrated in the Killingsworths' honor were huge feasts and I was fortunate enough to attend several where we washed down large amounts of tuak, a home-grown rice wine that was stored in ancient Chinese three-foot-high ceramic jars.

A good batch was clear, with a sweetish taste and the alcoholic potency of a light white wine. The jars, with a brown glaze often decorated with dragons, had been imported by Chinese traders and were treasured heirlooms; some were hundreds of years old, symbols of status and endowed with spiritual power. Drinking alcohol was not habitual among the Ibans, however and *tuak* was only used to greet special guests or during *gawais*.

Dancing was also a part of the *gawai*. Iban men did an aggressive step that varied from combative moves from headhunting days to mimicking a flying bird. The women lined up and provided an undulating rhythm to the music with ancient Chinese gongs and drums as well as an instrument that resembled a flute. The *tuak* and the dancing inspired other activities as well, including tattooing of the males. As drinking progressed, young women would dare young men to accept a painful tattoo. "They were mischievous as they could be," according to Jeannette. "It was a rite of passage and the women were instigators in getting those tattoos delivered." Tattoos were a kind of body jewelry, and the men painfully accepted the complicated designs — bluish flower-like designs on their shoulders and backs — as part of emerging manhood. A few old men had tattoos on the knuckles, indicating that they had made a contribution to the special house where the trophy skulls were kept.

Alcohol was handled in different ways by each native tribe. The Kelabit, for example, who lived in the north, near Sabah, had experienced severe alcoholism problems until 1946 when two Australian missionaries trekked in from Kalimantan to save them from the Devil. Their ministry actually worked, and the drunks gradually dried out as they embraced fundamentalist Christianity, with the devoted help of the Borneo Evangelical Mission.

The Kenyah, on the other hand, still consumed alcohol but reserved its use for ceremonial occasions, as I discovered while accompanying an Australian school headmaster to a longhouse in the deep jungle up the Baram River. When we arrived we were taken to a room that was dedicated to special visits. Seated in a place of honor, surrounded by dignified elders, I found that I had been placed in front of a particularly pretty young woman wrapped in a sexy sarong; I was immediately served a container of *borak*, a relative of tuak and born of rice but not like a sweet light white wine. In addition to a lot of loose material that I filtered out between my front teeth, it had additives that made it taste bitter, more like beer than wine.

While I was learning to cope with *borak*, the maiden began to serenade me with song, accompanied by someone playing a flute. My Australian friend explained that she was showering me with compliments and explained that protocol demanded that I respond with my own song. The *borak* kept coming and in my desperate hunt for a musical inspiration, I took it as it came. Again my problem was that I didn't know any songs appropriate to the occasion. *Jingle Bells* was out so *Happy Birthday* had to do.

More *borak* solved the problem, and as the maiden become increasingly friendly, we traded musical compliments back and forth. I think I rendered a rousing version of the Marine Corps hymn. My Australian buddy informed me that protocol further demanded that when I reached the correct level of *borakial* inspiration and everybody was gone, the polite thing to do was slip out to the veranda, where I would be guided to my destination by a gentle beckoning cough from inside one of the doors. That would be my evening's resting place.

Following directions, I lurched forward toward bliss, my ears alert, trying my best to catch the sound of a gentle cough. Finally, I heard something and entered a door. It was completely dark. Listening carefully, guided by my ears, I heard a cough, then another. Then I got many more; everybody was coughing. It sounded as if I were in a tuberculosis ward. I lifted up the noisiest mosquito net to discover a very old lady with a major respiratory problem.

Retreating to the ceremonial room and before passing out, I noticed that my Australian conspirator was chuckling in his sleep — obviously having an amusing dream.

The next morning we got a late start. The men were off working in the forest, but a delegation of young girls saw us off. Before boarding the longboat at the river's edge, the girls showered me with mud — then threw water on me. I wound up in the river and learned that this was all part of the Kenyah tradition of greeting new VIPs to the longhouse. The mud and the cool river water were very welcome, however, easing a gigantic hangover. The only bad part of the experience was that it also damaged the part of my brain that should have remembered the name of the Australian headmaster who had such an elevated sense of fun.

As I traveled among the Kenyah, Ibans, and other river people, I discovered that among their otherwise meager and simple possessions were treasures left behind on ancient trade routes that had once extended from Arab lands and Chinese cities across this territory. There were ornamental necklace-like strands that

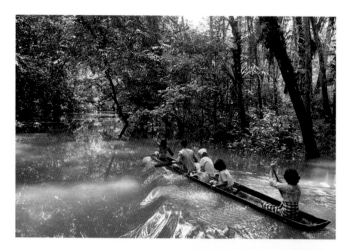

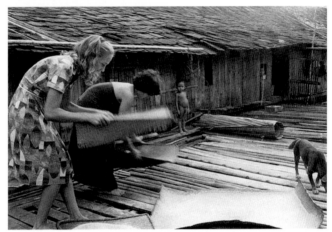

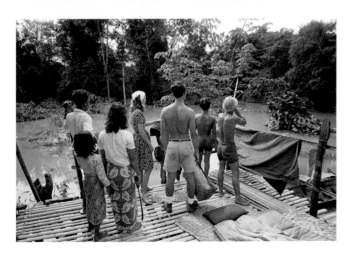

included Egyptian, Indian, Vietnamese, and Chinese beads and a variety of jars, used for food and fermented rice wines that were part of a long trading history with the tribes of Borneo. The traders had bartered these things for rattans, jungle resins, and hardwoods as well as more valuable commodities such as gold dust. Among the more exotic specialties they brought out of the jungle were monkey gallstones, rhinoceros horn, and hornbill casques, the decorative red growth that protrudes above the beak of the bird. For the Chinese, in particular this trade alone represented an astonishing ancient connection between jungle people and highest levels of the Celestial Kingdom. Chinese artisans carved the casques, colored them by rubbing the beak with the secreted gland of the hornbill to make part of the beak bright red, and then fashioned them into belt buckles and other ornaments for high officials of the Ming dynasty.

The difference between the open and hospitable nature of the Ibans today and their history was striking. Since their existence depended largely on dry rice cultivation on ground that had been carved out of the jungle, as their numbers grew, more land was required. The Ibans became relentless warriors as they expanded, decimating into near extinction neighboring tribes who also inhabited areas along the rivers. Rampant killing of men, women, and children, decapitation, and bloody hand-to-hand combat were facts of daily life for the Iban. Their reputation as the cruelest and most feared of the indigenous tribes belied their current status as people eager to increase food production by peaceful means, accepting the aid of Peace Corps Volunteers and other groups. The baskets of blackened human skulls stored in their trophy houses told the other story.

I have been haunted by that history ever since I read an account about a late 19th century Kayan Chief by Alastair Morrison, a prominent expatriate Sarawak official. It offered a deep insight into the disturbing nature of human beings, and I have to this day not resolved the questions that it raises in a satisfactory way. It records how a Kayan Chief called Aban Avit was taught how to shed blood by his father when he was a little boy. Said Aban:

"My father, a very great warrior and known and feared by the people of many, many rivers, wanted his sons to be as brave and fearless as he was himself. So one day he dragged out into the jungle old Ballo Lahing and tied her fast to a tree by rattans on her wrists and ankles. She was a slave-woman, captured when she was a young girl by his grandfather over in the Batang Kayan country, and at the time

I speak of she was very old, and weak, and very thin and couldn't do any work because she was nearly blind. My father told my brother and me, and one or two other boys, all of us little fellows then (I remember my ears were still sore from having these holes for tiger-cat teeth cut in them) well, he told us we must go out with spears and learn to stick them in something alive, and not be afraid to see blood, nor to hear screams.

I was really very fond of old Ballo Lahing; she it was who tied on my first loin-cloth for me. I remembered it well, for she laughed a great deal at me and then I saw how few teeth she had, and she often used to sing me to sleep. I couldn't bear the thought of hurting her, so I flatly refused to take a spear with me. But my father said I must; there was no harm in it; that it was right and I must take one; he pulled me by the arm and I had to follow. Then I was afraid she might see me and so I sneaked round behind the tree and just pierced her with the point of the iron, then she guessed what my father had tied her there for, and screamed as loud as she could, 'Oh don't, oh don't, oh don't' over and over again, and very fast. I pricked her a little harder the next time to hear what she would say, but she only kept on shrieking the same words. Then one of the other boys, smaller even than I, ran his spear right through her thigh, and the old people laughed and said that was good; and the blood ran down all over the wrinkles on her knees; and then I wanted to make it run the same way, so I pushed and pushed my spear hard into her; and after that I never thought whether it was Ballo Lahing or not, I just watched the blood; and we all ran round her piercing her here and piercing her there until she sank right down on the ground with her hands in the rattan loops above her head, which tumbled over to one side, and no more blood came out of her. Then my father praised us all loudly, and me in particular and said we had been good boys and had done well!"

This ghastly story, for me, hovers on the edge of what I can understand. It lies far, far away — thank God — from the central core of rationality. When I hear such tales, they become part of my memory, but over time they become bleached into something blander because, after all, it has nothing to do with *my* circumstances. It's someone else's horror story, in some other place, at another time, and in terms of Sarawak, it happened half a century ago.

The story is ironic, of course, because it describes the past of a people whose behavior was now peaceful, tolerant, and hospitable. Yet the tale has the lingering effect of an old wound. Why? The truth is that although it has nothing to do

with headhunters, my Sarawak tour, or the Peace Corps, it has to do with me and it came roaring back after twenty-six years.

At the very end of the summer of 1941, just before returning to St. Mark's, a friend came to visit us in Princeton. Rick Tillman, my best friend, was a good athlete, smart, and a leader in our class. He was much better than I was at almost everything, but we were friends because I had learned to be tough. Within the tiny confines of the First Form (sixth grade), seven boys scrambled in their own way to align themselves into a pecking order that defined social survival and dominance. There was frequent testing — knuckle punches aimed at your upper arm to produce an ugly blue bruise, a hickey; that kind of thing. The underlying principle of survival was based on competitive physical behavior and the reputation that went with it. And through this process Rick and I became friends.

When Rick Tillman found out about my snuggling in the bushes with Adelaide De Long, my twelve-year-old girl girlfriend, he was appalled at my description of our relationship. The memory of what I told him is gone but something of the tenderness of how I felt must have leaked out. I could tell by his reaction that Rick thought that what I was doing was inexcusably soft, mushy, stupid, and unmasculine. This was turning into a good story for Rick to take back to St. Mark's. I had to take action to stop it. I called up Adelaide and Rick and I went over to see her. We met in a little house in her backyard and after introducing Rick, I pulled out two water pistols, handed one to Rick, and we both proceeded to squirt her with vinegar. She was drenched; she didn't scream, beg us to stop, or plead in any way. How she reacted, I can't remember clearly. What I do remember in detail, however, was my pride in passing what I then took to be an important test of manhood, something akin to the "blooding" of Aban Avit. The time I spent with the Killingsworths bounced me around in many directions, as I ricocheted from their present, to Borneo's past, and to my own present and past. On one level the unpredictable range of human behavior reached an inner place that was very uncomfortable. But then, the natural majesty of the jungle touched another place deep inside me and joined the Arctic story, an opposite environment that had also provided an edifying clarity.

Like the high Arctic, nature here showered me with new perspectives. I counted myself lucky to be allowed into the richness of the Borneo jungle, and became almost instantly aware that for a place that supported an unimagined population of life forms, it was almost impossible to see many of them. The total-

ity of its abundance was obvious, but the denseness and overwhelming complexity of the undergrowth was blinding. However, memorable images abounded: a pair of gorgeous rhinoceros hornbills (the State Bird of Sarawak) once flew over me; I thought it was a low-flying plane making a loud swooshing sound overhead. Giant flying squirrels glided through the dusk on many evenings in the *ulu*. Two King Cobras slithered by in front of me without stopping to say hello. There were also a thousand blood-sucking leeches, millions of mosquitoes, and a billion sandflies that I met personally. Most of the rest I looked at and didn't see. I only heard about the snake that is able to glide from tree to tree; the mudskipper fish that can slither up on mangrove branches with the aid of its flipper-like front fins and lurk there to catch insect prey; tiny mousedeer with long pencilly legs no bigger than a cat; bearded pigs that climb trees to feed; a species of termites that chew up weeds and spit out the wads inside their underground nests to grow tiny mushrooms to feed their young. And I never saw the Asian two-horned rhinoceros that has been hunted to near-extinction because of its horn's value in traditional Chinese medicine. I also missed tasting bird's nest soup, made from the nests of several varieties of swiftlet that have been gathered for centuries in the caves of Sarawak. The nests are made of fine twigs stuck together by the saliva of the male swiftlet. My taste for bird's nest soup, however, was not developed because I couldn't afford it: the white bird's nests fetched $500 a kilo and it cost $100 a cup to spoon down a succulent portion in Hong Kong.

Among a superabundance of trees and flowering plants, I did see many orchids in the jungle, but certainly not the estimated three thousand varieties that were native to Borneo. If I had been a bird watcher, I could have spent my entire two-year tour peering into jungle foliage trying to identify six hundred and twenty known species, some with intriguing names such as Dulit Frogmouth, not to be confused with the Short-tailed Frogmouth. I was sad to have missed the Black-sided Flowerpecker, the Mountain Serpent Eagle, and the Bare-Headed Laughingthrush.It struck me that in the high Arctic, so close to the North Pole and so far from the Equator, and with a limited range of natural creatures, I could reasonably expect to see everything in plain view. Here, one degree from the middle of the world, crawling with life, I was blind to almost everything — jungle blindness — smelling it, feeling it with every sense, but finding it invisible because of its superabundance.

It was easy to believe that nothing was powerful enough to change the jungles of Borneo. But I was wrong. Clearcutting the rainforest for timber by large commercial enterprises was increasingly destroying natural habitat. Even the natives' own habit of single-crop cultivation was wasteful of arable land. And the drenching rains continuously depleted the soil's fertility in areas that had been cleared for planting, washing out nutrients. Ben and Jeannette's daily battle in their 4-H educational programs started at a rudimentary level but touched on an essential problem: how to develop and maintain agriculture that could feed both humans and animals raised as food. Among other things, their 4-H programs introduced a recycle system that taught people to use food scraps for compost and grow special crops to feed the pigs and chickens.

For example, I attended several meetings with Ben and Jeannette at which they laid out plans for expanded fish farms. The logic and design were simplicity itself: longhouses were always located on riverbanks. There was usually a natural slope down to the water, so they trained people to keep their pigpens at the highest level, which included the area under the longhouse. Chickens were kept below the pigs, and further down, in the shallows, were fish ponds and water gardens. The great benefit of this plan was that rainwater naturally washed all the pig and chicken animal waste down into the fishponds and other collection points, where it served as fertilizer. The waste materials broke down in the water, feeding varieties of Asian carp that were chosen because they thrived on this rich diet, a natural cycle that used recycled materials in a most economical fashion and with little labor expended. However, my hunger to try out these particular fish was not very high.

My Peace Corps responsibilities had to take into account that the largely uneducated, indigenous forest and sea tribes of Sarawak represented 68% of the population. But the Malays, who were 17% of the population, had served as politicians and junior administrative officers under the British and as police and military in former Sarawak and now they were taking over. The retail trade, export of agricultural goods, and river transportation were all largely controlled by the Chinese, who were in all the main coastal cities and also dispersed throughout Sarawak; they made up a large proportion of the professional men and women of the county.

This became clear bit by bit as I understood that disaster was linked not only to the shifting politics and economic changes, but also directly to the folly

of man's insensitive treatment of the mother of long-term survival itself — the jungle. Sarawak had an unimaginable variety of different life forms. Unlike Hawaii's Waipio Valley, this was a crowded Garden of Eden. There, everything seemed wide open, but here the garden was closed and nothing was quite as it seemed. The hot, moist atmosphere, dense rainfall that bred everything from mold to man surely grew from a base that was rich and nourishing, proportionate to the enormous, majestic, and vast jungle that sprang from it. But this was not the case.

The soil, in most places where Ibans and other hunter-gatherers lived, was cut by the complex of rivers and waterways that set Ibans free to roam and hunt and kill but at the same time trapped and tied them to the rain forest. Water brought mobility and trade, but as it trickled, poured, and eventually roared down the rapids of the mighty Rajang River and a hundred other rivers continuously washing the earth, it grabbed off bits of the life-giving soil.

Jungle roots and foliage barely hung on to nutrients before they were dislodged, picked up, dissolved, and washed away in the daily deluge carried to huge waterways hundreds of miles downstream. Wide-mouthed mangrove deltas split the flow and a rich brown cloud of nourishing mud finally emptied into the South China Sea.

Although the rainforest was overwhelmingly robust, the conditions that sustained it were fragile. The traditional slash-and-burn clearing of the forests was intended to grow life-sustaining rice, but it only worked when there was a vast forest and relatively few people. The forest topsoil was loaded, gradually regenerated by wet decaying vegetation, but when it was cut and cleared by burning, what remained was thin and only able to sustain relatively short spurts of crop growth. Depleted agricultural plots bled of nutrients took fourteen years to regain enough strength to harvest again, so they were moved every few years further and further from the longhouses. Few people grew enough for their own needs. Sarawak's rice was imported from Thailand, West Malaysia, and China.

In the post-World War II years, new demands for building materials in Asia created a logging boom in Borneo. Timber harvesting required fifty years to return land to what it had been. Its scars were evident even in the 1960s, as brutal swaths of commercial development, controlled by corporations, ripped out the

jungle, leaving the land naked and the majority native races with increasing uncertainty about the future. Economic exploitation was killing Sarawak as surely as Aban Avit had killed his slave nanny.

Spending time with the Killingsworths gave me a chance to examine one Peace Corps program at close quarters to see how this model worked. It wouldn't turn the tide of history, but it convinced me that I could to try to do something useful within the time and with the authority that was at my disposal, so I built it up. When I arrived, there were eighty-one Peace Corps Volunteers, and I increased the program to a hundred and eighty-two volunteers by the end of my two-year tour. Only one person had voluntarily resigned early, and two went home for medical reasons. Morale was good. But could enough of the educational benefits of 4-H programs or a rise in English speakers enable this people to rise from a jungle past and survive under wholly new circumstances?

Did I, or we, leave a model that was useful to the majority of people of Sarawak? Probably not.

Had I accomplished the First Purpose of the Peace Corps? *Helping the people of interested countries in meeting their need for trained men and women?* Did we train enough people to replace ourselves or did we fill slots for a few years? I never had a chance to search for the answer.

Goal Two: *Helping promote a better understanding of Americans on the part of the people served.* I knew the children of the Kanowit River District loved the Killingsworths, and there were other similar situations. In the beginning, the two were seen as exotics, but soon everyone who came into contact with them responded to their good will and hard work; first the children, then their parents, then the local leaders. This answer was a "yes."

The third purpose: *Helping other people promote a better understanding of Americans.* This was enormously important because a two-year commitment made it possible for Americans to be immersed in different lifestyles long enough to learn other languages and to take back to the United States many alternative ways of looking at the world. That worked — "yes." Was it worth putting my heart and brain into the fight? "Yes."

Ben Killingsworth recently described his experience in Sarawak: "I was affected a lot because we found the culture more open and inviting. They were not selfish. The word selfish was not in the Iban vocabulary. They didn't need it."

28 – PASSAGE TO INDIA

In September 1966, I left Kuching striking out in the old direction of documentary photography. My experience with the Killingsworths revived my interest in exploring the world with a camera. Two months of accumulated leave with pay gave me the freedom to experiment and I decided to do a picture book on the Peace Corps.

I was encouraged to work on it by Jerry Mason of Ridge Press in New York, who suggested that I cover the story from the point of view of the volunteer. This wasn't a particularly original idea, but perhaps my experience in the field would save me from picturing the kinds of clichés that I felt were coming out of the Peace Corps Public Information Office. Equally important from the point of view of expense, the Washington headquarters office agreed to process my film as I traveled.

This plan meant that Monica and I had briefly to break up the family, because it would be very difficult to fit the needs of two young boys into the uncertainties of such a trip. Fortunately, my world-traveling mother was delighted to come halfway around the globe to pick up Breck, Grattan, and Ah Wah, their amah (nurse) and take them back to Savannah. Monica and I accompanied them for the first short hop of this journey, and on it, three-year-old Breck got an amazing treat. Today, no one other than crew is allowed anywhere near the flight deck of a passenger jet. In 1966, however, I had flown so many times on Borneo Airlines that I knew many of the crew members. So Breck and I were allowed to join the Captain in his cabin for a few minutes as we passed over the Strait of Malacca from Kuching to Kuala Lumpur, Malaysia. It was the biggest

goodbye present I could think of giving Breck. The experience may have had a long-term effect on the boy; he has maintained a lifelong interest in building and flying model airplanes. Could it have started here?

My little family group continued from Kuala Lumpur to Beirut, where they joined my mother at the legendary St. George Hotel, overlooking the sparkling Mediterranean. Later, they continued to London and Dublin, then to Savannah, where the boys and Ah Wah lived in my mother's garage apartment until Monica's arrival a few months later.

Monica and I went on from Kuala Lumpur to the Philippines to begin my project. There, Peace Corps Volunteers were writing the country's education syllabus for all the primary schools — an amazing compliment to American influence at the time. In Sarawak, the Peace Corps had operated with unusual freedom, but for different reasons: the transition from Sarawak's being a former British colony to becoming the independent state of East Malaysia was not complete, and the new administration had not yet decided how much to regulate any foreign presence in its territory. America's presence in the Philippines was not totally welcome, but local gratitude for the people's liberation after a disastrous Japanese occupation from 1941 counted for a good deal.

Unfortunately, my two weeks in the Philippines photographing Peace Corps Volunteers on the job provided me with no insights into the undoubted complexity of life in that nation. My knowledge of what had been happening in Sarawak did me no good; the two situations were totally different. And as for the individual PCVs, somehow I found these young people boring, screamingly dull. Had I become a romantic, looking for true originals like the Killingsworths? Whatever the case, I decided to move on to Thailand, where I hoped to find some better subjects to photograph.

In Bangkok I found at least one interesting Peace Corps Volunteer, Donald Sweetbaum, who was teaching English. What I found most interesting about him was that after completing his workdays he was taking instruction in Buddhism. I became intrigued with what he was learning and through him I made arrangements to spend time with some monks — alone — while Monica visited a Peace Corps staff couple. In spite of not being able to communicate with the Buddhists in any common language, I began to sense everything around me having a strange aura, and my peripheral vision seemed greatly enhanced

without my being aware of it. It was like being on a kind of "high," and from a photographic perspective, it was if my normal lens became a fish-eye lens with 180-degree field of view.

Although my psychic life was taking loops and dives in Thailand, my photography drew neither strength nor direction from the experience. The trip did show me the difficulty and complexity of interpreting the volunteer perspective, particularly Sweetbaum's spiritual quest. Photographing the facts of his daily life was easy; recording the changes in his perspective was not.

Questions were circling in my brain like birds, but answers remained on the ground. My normal lens did not become panoramic, however, and my photography again turned up not much more than banal snapshots after a two-week stay. My hope was that insights would emerge from a much longer trip I then planned for India.

In the beginning of October 1966, Monica and I arrived in New Delhi on a Pan American flight very early in the morning. A fellow American passenger advised me to take as much Coca-Cola as I could persuade the hostess to give me before we left the plane, as anything liquid I drank in India would probably kill me.

Indian Customs agents pounced like starving dogs on my large supply of photographic equipment and everything else that I owned. Every object was laboriously recorded in the pages of an enormous logbook. There were then long discussions about the cash deposits that I must leave with the officials, evidently I was suspected of bringing this stuff into the country to sell illegally. I waved my U.S. Government passport in protest. Many hours later, we somehow managed to get into India without leaving cash deposits behind, and with my equipment, film, clothes, Swiss Army knife, Parker pen, and assorted other personal items still in my possession.

This was my first basic lesson: India was a country of more, not less — more regulations, more bureaucracy, more documents, etc. Other lessons quickly followed — ridiculous, charming, and outrageous. Lessons came in doses large and small. Checking into our modest hotel, we discovered that my status as a non-Indian — a European-looking type, in other words white — attracted persons who had something for sale.

A tall, thin elderly gentleman was selling rare antique Moghul drawings — elegant, colored scenes with elephants, maharajahs, and dancing girls that

were both exquisite and beyond what I could afford. The gentleman explained the history of the art and its great value, but it was hard to imagine why he was wasting his time on somebody who had checked into this cheap hotel.

I explained that I was impressed by the beauty of these Moghul drawings but couldn't buy any because this sahib was not a rich man. I told him, however, that I might be interested in buying fakes.

"Oh sir, that is not a problem," and he immediately produced a large supply of lovely little drawings identical to the ancient treasures that I couldn't afford. We had a deal. These experiences quickly introduced me to the realization that, in India, most situations offered alternatives that needed investigation and could lead to discovery.

My visit to Peace Corps headquarters in New Delhi put me in touch with more realities. There were one thousand volunteers sprinkled among a staggering half billion people, a ratio of one volunteer to 500,000 Indians. In Sarawak there were 182 volunteers to 700,000 people — a ratio of one to roughly 3,800.

The Peace Corps office helped organize flights to different district centers where I could rent a car and driver to meet volunteers in the rural areas. That is where 75% of Indians lived in 1966, and where the Peace Corps efforts were focused. Because I was officially sanctioned, I found it possible to stay in Indian Government Rest Houses around the country, but Monica and I also bunked with PCVs from place to place.

My local travel was usually done in a rented Ambassador, a little black sedan manufactured in India that turned out to be less grand than its name would imply. The tiny cars were not such a problem, but the terrifying road habits of my assigned drivers were. Once, on the return from a visit to Shimla in the foothills of the Himalayas, the driver turned off the engine to conserve gas, and put the car in neutral: we rolled 8,000 feet like a stone down to the Hindustani plains below. There were no emissions from the tail pipe, but there was plenty of smoke pouring from the brake pads as they were frequently applied to slow us down. Another peculiarity shared by all my drivers was the protocol for meeting oncoming cars in the dark. Normally, in the U.S., when approaching a vehicle at night, we dim the lights. Indian drivers, however, had the curious habit of taking one step further by turning the lights off entirely at the crucial moment of passing. No one ever explained the logic of this to me.

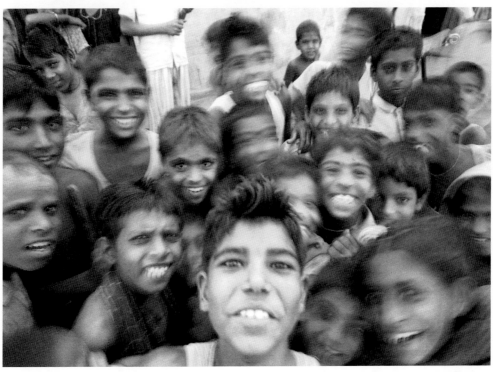

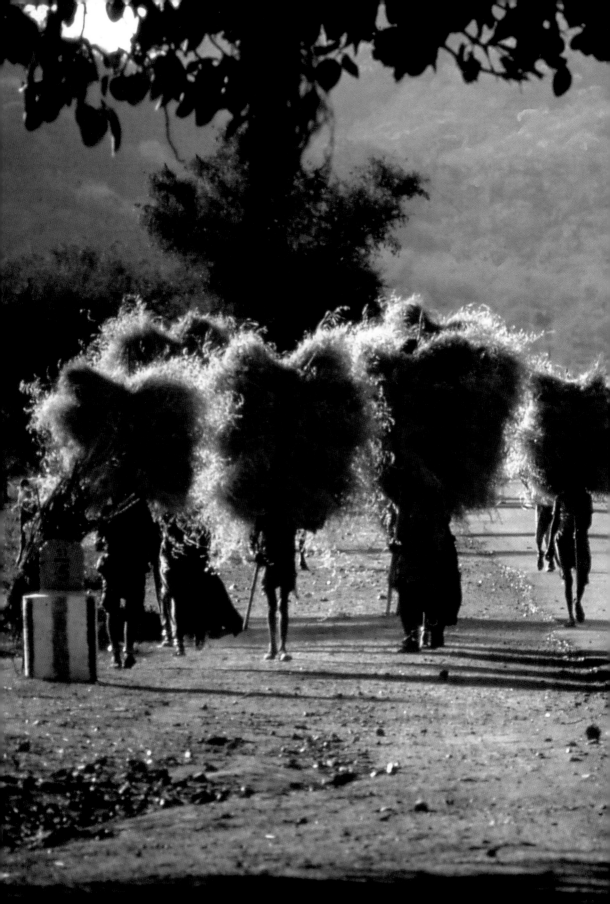

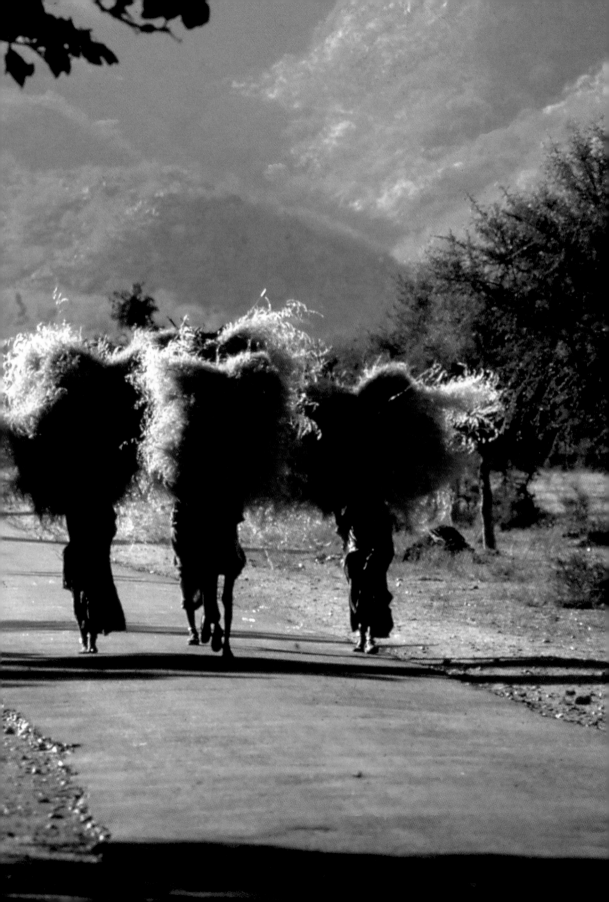

Some habits stemmed from rules learned from the British in the 19th century. To mail a letter at the post office it was necessary to stand in one line to buy the stamp and in another line to get the stamp canceled on the envelope. Should you want the letter to go out of India, you had to stand in a third line. In this way the bureaucracy was able to make sure — in duplicate or triplicate — that things went as they were supposed to go. It also, of course, made for more employment. But if you were used to American timing, you could go mad.

I found in India that there were communications misunderstandings that had nothing to do with language. Indians in any official position were fluent in English, but their speech was more like hearing the same note on a different instrument. Their responses were also disarmingly direct. For example, when we went to the airport in Hyderabad to catch a flight to New Delhi, I was informed upon arrival that my plane, a recently purchased Comet jet, was late.

"How late?" I enquired.

"Two weeks," I was told.

The plane I was scheduled to board had crashed. I assumed he meant a replacement Comet but we got to New Delhi by train. When it came to photographing volunteers in India, I thought that perhaps my approach needed revision. What I had tried in the Philippines and Thailand hadn't worked. Maybe I hadn't spent enough time in each country. Or had I not wrestled with and understood the central problems facing the volunteers? In India the central problem facing the country was all too plain to see: the huge and fast growing population was the dark cloud that hung over everything. A local Peace Corps Volunteer was clearly overwhelmed in trying to help a farmer's wife cope with ten children suffering from malnutrition. And larger efforts to help villagers with sanitation, medical, and agriculture solutions were unsustainable if the overall population couldn't be brought under control.

A Ford Foundation advisor I met in New Delhi told me about India's campaign to control the exploding population. The government was paying men to have vasectomies, and they also contracted with a German company to build a factory to manufacture condoms. When the factory was completed, the condoms were tested. Standard practice was to fill them either with water or air, but India had the world's largest population problem, so to make sure of their efficiency they were tested with both water *and* air. This proved too much for

the condoms and some of them burst, with the result that the government closed down the factory. I began to observe that the battle against India's national problem was destroying the morale and effectiveness of individual volunteers. Many seemed to have a gnawing feeling that whatever was done today would be compromised by the 32,000 Indians born tomorrow. Some of the most sympathetic and sensitive volunteers were sucked dry.

What kind of a story did I want to tell? Conversations with volunteers began to reveal a disturbing pattern of hopelessness. PCV Mary Anne Wilkerson worked in a village health program. She was supplied with nutrition biscuits to issue to lactating mothers, who had to eat 14 biscuits per day to maintain their health. Mary Anne used these biscuits to bribe mothers to stop breast-feeding their children after they were three years old. She was trying to get the children on baby food, which she got from the aid agency CARE. But she only had a hundred biscuits a week; she needed 10,000. As skin and other diseases from malnutrition ravaged the children of her village, Mary Anne was forced to watch some of them die. Her peace of mind was shattered, and there was not much she could do about it, the norm was difficult to accept. Some PCVs were able to do it and others were not: the process hardened many. In a curious reversal of feeling, some PCVs even came to hate Indians.

An agriculture volunteer I met worked on a farm run by American missionaries. They produced amounts of food per acre that were far beyond the output of similar farms in the area. This was a model in the region, demonstrating the most advanced planting, fertilizing, seeding, and water controls. They also employed Indians, but the volunteer told me that to get them to work they actually had to beat the workers, physically assaulting them. He was slightly embarrassed. He didn't really endorse this approach, but when I asked what he was planning after his Peace Corps tour, he said, "Oh, I'm coming back to work for the missionaries." I don't think he approved of violence but he somehow accepted the possibility that God thought it was OK to kick butts to get the job done.

Surprisingly, many PCVs were not fluent in Hindi, a difficult language. Unlike Malay, it was not easy to become conversational in Hindi with only three months of training. And this led to another problem: "It's easy to get along with supervisors," one told me. "They mostly speak English, and that makes

you lazy." But another said, "You have to speak Hindi to get through to another level, the people at the bottom, the ones I work with. The bosses sit in the office under the fan wearing a clean shirt and a tie."

It didn't take very long for me to discover that my photography wasn't capturing what was going on in the lives of the volunteers. They were in a fight that didn't look like a fight — and that was not easy to photograph.

During my first month and a half, I was overwhelmed by the task of trying to visually relate anything that the Peace Corps was trying to do to with what I was seeing and feeling. Every visitor to India experiences the extraordinary visual contrasts in daily life; brutal poverty and filth side by side with exhilarating beauty. Extremes co-existed with their opposites. In an instant one can see a naked holy man with a cow dung hairdo sitting on a sidewalk as a gorgeous woman in a fuchsia sari passes elegantly by. There was a flower poking out of every pile of shit. As I began to understand one thing, another flipped me as I tried to handle it with my camera.

Perhaps, I thought, I needed to focus on one discouraged PCV to somehow catch the moments of frustration that I perceived were revealing of their states of mind. Spend enough time with an individual. But this would have been like looking at one millimeter of a vast carpet and seeing nothing of a huge design that represented multiple ancient social sets and religions, jammed together, cursed and blessed by the hangover of British colonialism and the seething press of more and more people.

David Douglas Duncan had revealed the larger realities of the situation in Korea by photographing some of my freezing and exhausted comrades close up. But here, I realized, it was going to be necessary to get away from the individual volunteer to find the book's focus. Their work seemed too small, too modest, and too particular within the huge context of India; in short, it was simply not visually interesting. India was a rock concert, screaming sensationalism that overwhelmed the audience I had set out to define. The efforts of the volunteers were camouflaged by their insignificance. My photographs of PCVs trying to move mountains with a hand trowel were as anemic as India was overwhelming

Out of desperation I decided to take a break and visit a famous event, a camel fair that I had heard about in the state of Rajasthan, a place that had

nothing to do with Peace Corps. It was an enormous commercial and religious occasion that began on the eleventh day of the full moon in the month of Kartik. It occurred in a village of Pushkar (population 5,000) at the end of November. The modest community exploded; 100,000 people arrived with 50,000 camels and countless other beasts of burden. Maybe this was the visual and experiential shock therapy that I badly needed if I wanted to understand "village India." The Pushkar Fair was a dose of medicine that would kill or cure. I arrived on November 19th.

Accommodations were available at a Government Rest House that had once been part of a small palace, donated to the government by the Maharajah of Jaipur. This elaborate domed structure was on a discreet yet commanding site facing Lake Pushkar. The location may have been fit for a maharajah, but in its conversion to a Rest House it had been stripped to bare white walls and was sparsely equipped. Beds were "charpoys," a wooden frame on legs with knotted ropes strung across to form a mattress. Our sleeping bags and cool breezes, however, provided Monica and me with perfect comfort.

The location offered an unobstructed view of a vast area of sugar cone-shaped sand dunes formed by the strong winds that swept this arid land. They marked the beginning of a great desert extending west, meandering through Pakistan, Afghanistan, through the Middle East, until it swung south traveling across North Africa and ending at the Atlantic Ocean. This expanse of sand somehow unlocked me from a mental box, releasing me from the doubts that had dogged me during our tour of India.

The other amazing and refreshing sight, unequaled anywhere in the world, was the tremendous long strings of camels, barely visible as they approached Pushkar from the west. Dots in the distance kicked up plumes of sand that eventually met the smoke of thousands of cook fires rising from the jumble of the Pushkar Camel Fair at the southern end of the lake. The camels were completing a long journey, perhaps coming from as far away as Arabia.

Apart from the religious aspect of the occasion — a Hindu celebration — the commercial part of the gathering was devoted to trading in camels, cattle, horses, and bullocks. In addition to animals, on sale were saddles, bridles, tools, ornaments, and every conceivable trinket that might adorn either owners or animals. It was said that everything was for sale at the Pushkar Fair.

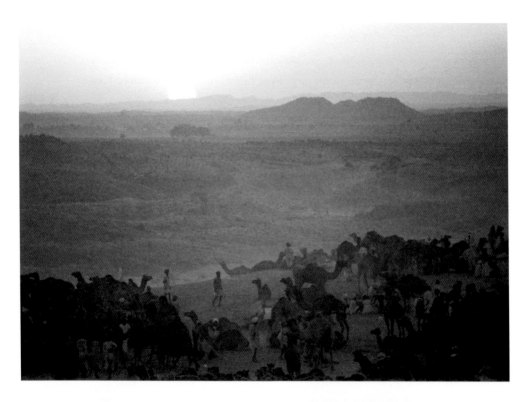

Goods came in from every direction of the compass. There were also camel races, music, dancing, and an ongoing fashion parade of the colorful clothing worn by the handsome Rajasthanis who lived in nearby villages, the women in deep red and purple saris.

Around the shores of Lake Pushkar, fifty-two *ghats*, or bathing steps, descend into the water. Here, pilgrims washed their sins away and cured diseases of the skin. There were also five hundred Hindu temples situated beside the lake, one of their holiest sites. According to the Hindu epic scripture, when Brahma came to earth after killing the demon Vajranabha with his weapon, the lotus flower, three petals fluttered down from heaven. The lotus, "pushpa," having fallen from Brahma's hand, "kar," provided the name for their resting place, Pushkar.

This was also one of India's oldest cities, with a recorded history that dated back to the 4th century BC. In this ancient, spiritual, and beautiful environment, I found that the sounds, sights, and smell of inspiration came from every direction. They combined to make the wildest, most awe-inspiring conglomeration of photographic possibilities, an intoxicating mixture of promise. During our eight days there, my spirits joined the pilgrims bathing in the lake and the insecurities that had plagued me were washed away. Clarity emerged as Pushkar became for me a microcosm of village India.

The feeling of being a speck on the earth remained, however. The weight of the crowds continued to be massive, but here I saw the gigantic totality, complexity, and contradictions of village India in a containable way. Brahma was generous to me. He didn't confuse me by providing too many lotus petals to count, unlike the wasp's nests that the Ibans had used to divert evil spirits from their longhouses.

Here, I was finally able to feel a complete India. The camel and animal fair combined with the holy waters of Lake Pushkar to provide sufficient density and complexity to give me the feel of India. In this desert that reached to other worlds, I could see the larger India because it was surrounded by a white sea of sand, a frame that emphasized the central core of its immense, compressed human energy. Here, I developed a strategy to photograph India.

Water became the organizing concept, starting with the snows of the Himalayas, flowing down the holy rivers to the canals of the Punjab, to the wells of

other regions, and ultimately to the PCV working on agriculture to battle mal-nutrition. Everything that had to do with water in India could be graphically interesting. Even the lack of water, the cracked ground of the desert, was photogenic. In my new concept, India would be emphasized rather than the PCV. The volunteer presence would be proportional to the whole: the needles, after all, were in the haystack, so I decided to picture the haystack instead.

Ironically, the Peace Corps Public Information Senior Writer in Washington used my photographs of the India volunteers in six articles published in Agriculture Magazine, with the approach that I had now decided to abandon. This was the "PCV solves problems" story as opposed to "PCV swallowed alive by India" reality that I had discovered. My film had been shipped to Washington and used, but there was no feedback on my new idea, and it died aborning.

Also, while I was away and unknown to me, there had been a financial crisis in Peace Corps Washington. A month later, I found that the subsidy to support the Ridge Press book had dried up because of budget cuts. This didn't bother me. I had learned too much. My project remained a jigsaw puzzle with more than enough remaining pieces to fit together a picture, but I never returned to India except for the part that never left me.

Peace Corps Washington asked me to continue to Afghanistan after India. A flight to Kabul was booked but at the last moment I heard about a Swiss bus tour coming from Nepal. It would stop in New Delhi then continue to Switzerland via Afghanistan. By good luck, I found two seats available and could go overland to Kabul. This sounded like a much more interesting trip than a hop by plane.

The comfortable bus was filled with young Swiss, one notch better fixed than the hordes of youthful backpackers heading for Nepal. Sitting next to the driver, I observed through a huge windshield a dusty road where transport was being whipped, led, pushed, peddled, or steered in two-way chaos. Lines of trees close to the roadside provided evenly spaced targets for head-on collisions. And in the ditches, there were numerous animals that hadn't survived the traffic, particularly camels.

We finally reached a wide swath of barbed wire, a No-Man's Land, neither India nor Pakistan. All documents, passports, permissions, visas, and luggage were checked here. Pakistani officials then discovered that Monica and I had

an exit permit from India indicating an air, not a bus departure. This began a three-hour harangue, first at a low decibel level but gradually rising as I once more waved my U.S. government passport while demanding to get through to the American ambassador in Islamabad by phone. Eventually, the official relented and we were allowed to proceed.

I have retained little about our ride through Lahore, Rawalpindi, and Peshawar, and I am not sure where daylight found us on our ride through Pakistan. All I can recall is that the styles of head covering of Punjabis and the men and women of the North-West Frontier Provinces were different. And I remember being captivated by the ways in which busses and trucks became rolling works of art, personal galleries dedicated to the whims and fantasies of their owners. One truck had a portrait of John F. Kennedy painted on its side. Every vehicle was different but they all subscribed to the idea that more, rather than less, was best.

We were on our way to one of the most romantic and historic mountain crossings in world history, the Khyber Pass.

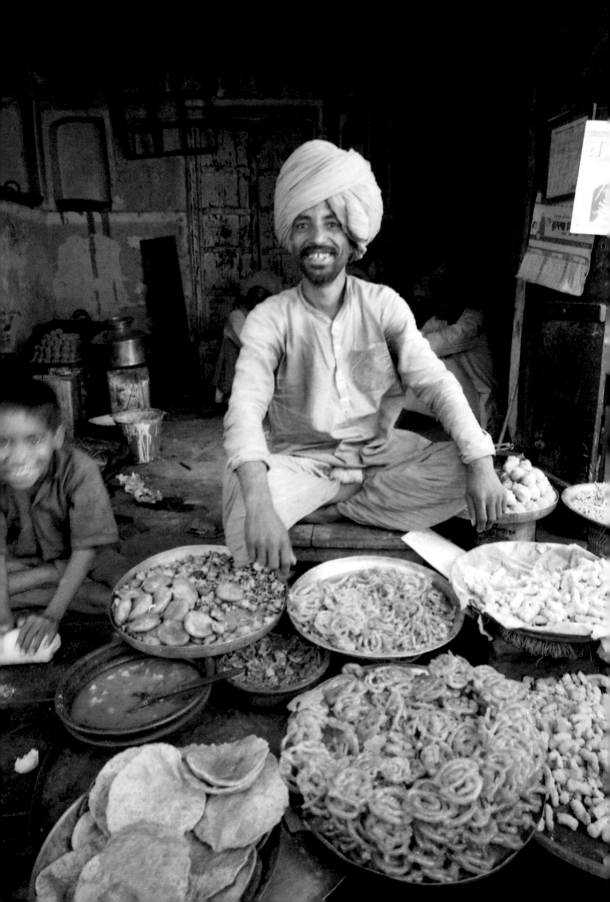

29 – AFGHANISTAN

Traveling west from Peshawar, we crossed a fertile green valley into the arms of a great brown chain of mountains extending southwest from the mighty Himalayas. As they descended from the roof of the world they become the Hindu Kush, then as a last barrier, the Safed Koh Mountains. Access to the vast plains of the Indian sub-continent was blocked from Afghanistan except for a few cracks in the wall, the most famous being the Khyber Pass, a natural toll gate controlled by fierce Pashto-speaking hill tribes (Pashtun or Pathans) rather than any national government. Although all but a few miles of the Khyber were in modern Pakistan, the pass was dominated by tribesmen who had opened or closed it over the centuries.

Violence circled the region like vultures. The Pashtun lived on both sides of the border. Fighting from bleak boulder-strewn crags, they had defended it successfully from the most powerful armies of the time.

The serpentine stretch began a steep climb from the flat plains of the Punjab, creeping for thirty-three miles until it reached an altitude of 3,500 feet. We passed through the Khyber Pass, a place that Rudyard Kipling described as a "sword cut through the mountains." For a thousand years it had wound up and around, twisting and turning through narrow jaws of rock that served those who controlled it with the power to levy a price on all who chose to make the passage. Even in our comfortable bus, this was not a trip to take for granted. There had been too many battles, ambushes, and much blood spilled here. Its scale was overwhelming — a truck in the distance seemed like a crawling bug. The modern black paved road included special lanes for camels and horses that referred to a past that was still with us.

So much history had piled up on the Khyber. Powerful invaders from the time of Alexander the Great in 326 BC, followed by Genghis Khan, Tamerlane, and the Moghuls who established their dominance in 1526 had come from the west. Coming from the east, the British had invaded from India and used the Khyber in an attempt to subdue Afghanistan in three wars starting in 1838 and ending with their final effort in 1919.

Tunnels had been bored through the mountains to ease the passage. They looked like mysterious rat holes from a distance, and when the bus reached them we plunged into a momentary blindness — a treacherous few seconds of blackness — then roared through to brilliant daylight framing more mountains in a black semi-circle as we rushed to meet another spectacular view.

The local public transport in front of us was a wonder. Dozens of people jammed inside vehicles designed to seat six, clinging to ladders or bumpers; men hung like fruit from a tree. Others perched among huge sacks on top.

At Landi Kotal, a village at the top of the pass, a few miles from the Afghanistan border, we disembarked and were immediately surrounded by villagers selling locally-made souvenirs; the most interesting for me was a Lee Enfield rifle, a weapon that the British had used during World War II. But it was a fake. Weapons were the local cottage industry. They seemed well made, with authentic-looking stamped serial numbers, but often there were errors that a gun collector would spot immediately; a Colt revolver that had C stamped backwards was probably not manufactured in Hartford, Conn. There was no way to test the quality of the metal, forged from technology passed down from the generations of local blacksmiths. I departed from Landi Kotal without adding a British Enfield rifle or a Colt revolver to my overstuffed baggage.

Just before crossing the border at Torkham, we passed more souvenirs of past conflicts — row upon row of pointed concrete pillars, dragon's teeth', that extended across the width of the gorge; tank barriers put in place by the British to thwart a feared German Panzer attack into the subcontinent during World War II. Ironically, the barrier now served against possible aggression from the Soviet Union — once an ally.

This was an area that was both menacing and exhilarating. It was very male, and there was nothing in sight that softened the sharpness of the jagged, twisting route. As the road passed an old stone fort at Ali Masjid, we stopped at

an eerie spot that had a dozen or more tombstone-sized regimental seals dedi-
cated to soldiers who had served in the Khyber during the 19th and 20th centu-
ries. One of these shields represented a unit of 5,000 British and Indian troops
and 12,000 camp followers who attempted to withdraw to India from Kabul in
1841. Here, on this same pass in freezing weather, the fierce local tribesmen
created a deadly trap that resulted in a military disaster for the Raj. Only one
survivor, a British military doctor, made it back to Jalalabad.

The Khyber Gorge was six hundred feet wide at this point. During their
Third Afghan War in 1919, a British soldier had written: "Every stone in the
Khyber has been soaked in blood."

All along the route from New Delhi through Pakistan up into the Khyber, we
had been following trucks that enlivened even the most boring stretches of road
with the decorations on them. To get stuck behind these vehicles was a pleasure.
Each was different in detail depending on their origin, all personalized to the
taste of the driver. We were following mobile museums of folk art bursting with
color; they had stylized scenes painted on them that seemed wildly inappropri-
ate to arid Afghanistan: steamships, jet aircraft, ancient sailing vessels, beauti-
ful birds. There was even a red double-decker London bus, along with the Taj
Mahal painted on the same truck. The trucks were mobile bouquets of individu-
ality. They added a cheerful accent to the grim surroundings.

An elaborate white-winged horse with a woman's face was painted above
the cabin of one truck. This was Buraq, the mythical symbol of transportation.
But it was also the celestial magical steed with wings of an eagle and the tail of
a peacock that had taken the prophet Muhammad from Mecca to Jerusalem, as
well as a side trip to Heaven and a visit to the prophets, Jesus, Moses, and
Abraham. He was advised by Allah to tell the people to pray to Him five times a
day. Then with a few more strides on the back of Buraq, Mohammad was dis-
patched back to Mecca. No wonder Buraq was so popular with truck drivers.

We arrived in Kabul at night and after a meal of rice, stewed lamb, and flat-
bread at a local hotel, I parted company with the Swiss. The next day I con-
tacted the Peace Corps and got a ride back to Jalalabad to do a story about an
unusual collection of volunteers.

The rugged gray cragginess of Afghanistan was consistent and oddly com-
forting — India had been like looking at five movies being projected on top of
one another.

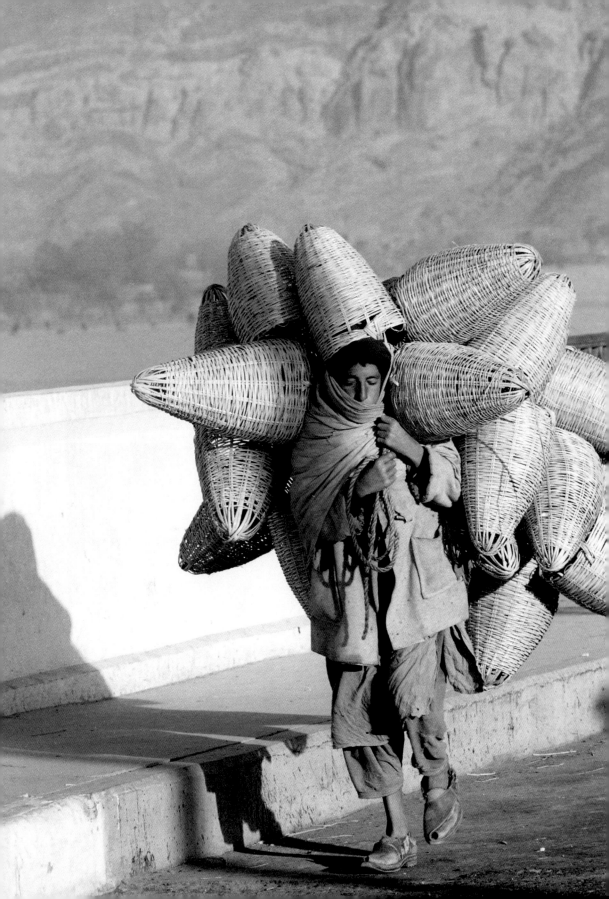

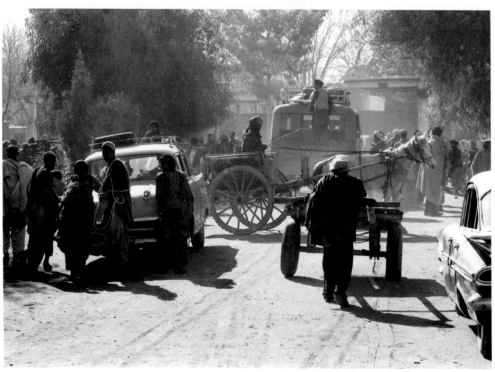

Jalalabad was protected from freezing temperatures and dust-chocking winds in November by the Safed Koh Mountains. The waters of the Kabul River made it a relatively fertile plain. For Afghanistan, Jalalabad could be seen as a special place. Trees set off the rough-hewn adobe-covered rock buildings that defined the mood and architecture of the city. Citrus fruits, date palms, and sugar cane as well as cereals were grown in the valley. These crops dotted the gray expanses of flatness leading up to the nearby jagged mountains. Fertile was technically the correct adjective to describe the surrounding landscape but "amazing under the circumstances" would seem more appropriate because here, gray was overwhelming in its competition with green.

On my arrival in Jalalabad I met the local version of a traffic jam — sardine-packed busses, a single individual standing on the back of his donkey with the ease of a veteran circus performer; camels bearing huge loads were led through the confusion. Carts assembled from junk, built from automobile axles, provided mobility on two rubber-tired wheels. Ingenuity, desperation, and the sweat of a single person propelled huge loads.

Long walks in Jalalabad helped me adjust to the new experience. There were few women on the streets. The few I saw were covered from head to toe in long loose burkas being taxied in a horse-drawn cart.

Picture-taking was easy. The Leica was inconspicuous, and there were no tourists, no backpackers in these parts. It was more, "Where do you come from?" than, "Why are you taking my picture?" Occasionally, men asked me to take a picture of them and a friend, and I would get smiling, arm around the shoulder pictures that might have been taken anywhere, except almost every man was wearing some kind of headdress. Turbans, caps, and assorted other head coverings represented different regions, but unlike India, they didn't represent caste, class, or religion.

The most familiar headgear was a turban, known as a *lunge*; it was warm in the winter and kept the brain cool during the intense heat of summer. The scarf-like piece of fabric could be four yards long. It was light, breathable cotton and a short length that escaped from its side could be used to shield the face from airborne dirt and high-velocity sand. Clothing used in the same protective way sometimes made men seem somewhat sinister as they instinctively covered themselves.

Less cumbersome for men to use was the *pakol*, a soft, round beret-like hat with a roll of wool that formed a bulging sausage-shaped rim around the hat and could be pulled down to shield the neck and face from the cold. The dominant Pashtun tribesmen wore this hat. I thought that a lambskin hat was very stylish until I found out that the best ones were made from the unborn fetus of the Karakul sheep, which diminished my interest.

An old man seemed pleased by my wanting to photograph him with his camel. His biblical look charmed me. Unable to say thank you in any of the thirty languages and dialects that were available in Afghanistan, I rewarded him with what was available — a big smile, which seemed to be acceptable currency.

One of my explorations of Jalalabad took me onto a long bridge that passed over the Kabul River. In the late afternoon I saw six laden camels silhouetted against the low light in a natural theater that changed as the shadows grew longer and longer. People and animals no longer seemed real — abstracted against the dimming ball of the setting sun. It was like listening to a beautiful song and wanting to learn the words. The rhythm appealed to me, but I couldn't dance to the tune. I simply took it in, just watching and watching, until I got cold and moved on.

It was Ramadan, the holiest period in Islam, the ninth month in the Islamic calendar that began as the new moon appeared in the sky — a period of fasting and religious reflection that lasted each day from dawn until the sun set. It was also a period of extreme stress as many workers were expected to carry on, not only without food but also without water during the daylight hours.

One of the Peace Corps doctors I met, Dennis Hamilton, took me to a place where the blessed arrival of dusk allowed men to break their fast with tea and saffron-flavored rice with shreds of lamb. Afghans were serious about Ramadan. With the exception of pregnant women, lactating mothers, small children, and the very old and infirm, the fast was mandated for everyone.

Dr. Hamilton explained that Ramadan fasting had spiritual aspects that transcended appetite. It was a temporary social and cultural equalizer that gave the devout a special perspective that connected all practicing believers — those who were fortunate to be full-bellied and those who were not. During this special time, they shared a deeply felt common experience that bonded them in the most visceral way — through hunger and thirst. The religious ritu-

al, for all my heathen reflexes, was subtly attractive to me, stimulating the memory of all those hungry and thirsty moments that I had experienced.

The teahouse that Dr. Hamilton took me to was filled with rough, turbaned, dusty tribesmen. They were seeking relief from a world outside that was harsh enough without fasting. There was no alcohol and no women. This was not a club. It was a dark and crowded public space, with men sitting at small tables. A single stovepipe angled up from a wood-burning stove in the middle of the room and even with the help of hot tea, nobody shed their warm clothes.

Framed pictures of both Asian and European women decorated the walls. They looked like pin-ups from the late 1920s, but they weren't erotic. One poster was almost identical to a display I had seen in the open market where fruit was for sale. It featured two wrestlers. They were bare-chested and burly, wearing tight wrestlers shorts; they flanked a shield bearing a depiction of the Taj Mahal, and capped by a young man's head at the top and scales at the bottom. It revealed super-manhood, strength, and was illustrated in the style of the most exuberant truck art.

A musician with an accordion sang to the crowd in a wailing style, like a piercing call to prayer. The imploring music seemed completely appropriate. It was easy to imagine that under the same circumstances in Cairo, there might be a woman doing a "dance of the seven veils" with a wildly gyrating belly to spice up the gathering. This was unimaginable in Afghanistan — but then, to my amazement, dancers did appear. In the middle of the crowd of the feasting men, two young boys were swaying, rotating, and undulating their bodies. Their lifted arms waved to the music and the crowd in the most erotic way. The boys both wore headscarves like those common among young women. The men watched the teasing dancers calmly, taking the performance for granted, as it was not an uncommon form of entertainment in Afghanistan and other neighboring countries. But this was not what I would have expected on a hungry and thirsty night during Ramadan.

My assignment in Afghanistan was to document an experimental program of the Peace Corps: the introduction of seasoned professionals into a country that had mainly been provided with what were called "AB generalists;" in plain English, recent college graduates. This was a bold departure from the past. The genesis for the Peace Corps had come from a challenge that President

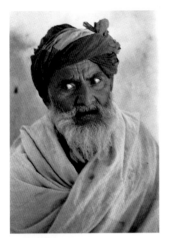

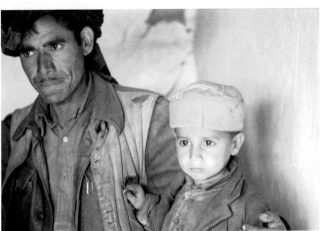

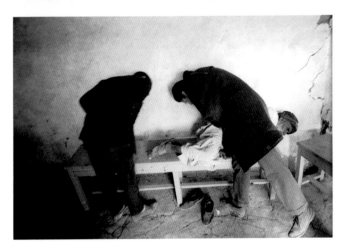

Kennedy made to America's young people to become involved in service overseas. That was true in the case of Afghanistan, as well. Now, however, the volunteers being sent were professionals; doctors, nurses, and highly skilled technicians. From an American perspective, the United States government was competing for influence in a country that had been an important trade route between East and West for centuries, balancing the influence of the Russians, who were building roads all over the country, and the Soviet Union would culminate their interest in Afghanistan by invading it in 1979. But there was another more personal reason, from the Peace Corps perspective – the American urge to fix things that was at the heart of: "Ask not what your country can do for you but what you can do for your country..." The dire medical needs of Afghanistan were like an open wound – irresistible to a new class of medical volunteers.

One new volunteer in Jalalabad was Dr. Robert Rodgers, sixty-six years old and recently retired as pediatrician, leaving a successful medical practice in Greenwich, Connecticut where he had been head of the city's board of health. His wife, Mildred, had also come as a volunteer and served as a teacher.

Although Greenwich and Jalalabad were not candidates for "sister city" status, there were similarities between one of the richest communities in the United States and the Peace Corps assignment forty miles west of the Khyber Pass. The two cities were about 47,000 in population and both were favored by good fortune in their own way. Jalalabad was Afghanistan's second city and for centuries, the vital trade that passed between Afghanistan and Pakistan came through Jalalabad.

In his new assignment, Dr. Rodgers had been named chief of the department of pediatrics and co-chief of the department of medicine at Nangrahar Medical School. The school had been founded three years earlier, and Rodgers's job was to teach students and to train counterpart teachers to gradually take over full teaching responsibilities. This, he felt, was going to take six to eight years to accomplish.

Other Peace Corps doctor programs in other countries had not fared well according to Dr. Rodgers, "Either no job existed or the programming was vague." Also, all the doctors that came were married and many came with their children, an unusual situation in the Peace Corps. As a result, numerous family

problems arose that were not foreseen or were poorly handled by supervisors. A number of volunteers quit.

Peace Corps was in a quandary. Could a volunteer be *different* but not *unusual* in the Peace Corps? Fifteen doctors and their families were placed together in training in Afghanistan and this was the first group to include non-Volunteer wives and children. It was an experiment: could the Peace Corps accommodate seasoned professionals as volunteers?

Whatever larger questions remained to be solved by the Peace Corps administration in Washington, my job was to picture the reality on the ground. Village clinics in Hesarshaie and Madrawal finally gave me a chance to observe intimate contact between Americans and Afghans. In this way, it was now almost possible to see something of what life for Afghans was really like. The instruments of medicine opened windows. There wasn't time to understand most of the ailments that I saw examined. I couldn't speak the language, knew little of Afghan history and nothing of its mores, so I turned over information-gathering to my camera, operating on instinct, recording what was in front of me, hoping that the information captured had value even if I couldn't grasp its complex cultural background.

One of the two village clinics operated by the Peace Corps was a 45-minute trip over a desolate rocky road from Jalalabad in the Peace Corps International Harvester Jeep. It was sloping trail-stretching over utterly desperate land that lay between thrusting ranges of intimidating rock that seemed to be cut off from anything that might have encouraged life. These stretches seemed to be filled with the shrapnel left over from a war that the mountains were having with themselves. There was nothing soft here, nor was there a blade of grass, a tree, or animal in sight; nothing until we finally found a sheep herder, standing with his animals. He might have been standing there since the beginning of time. But what were his animals eating? Rocks? And as the herder looked at me, he should have been thinking, "Who is that man taking my picture who knows all the wrong things and doesn't know what lives between the rocks?"

In the distance was Madrawal (population 4,000). Mud-covered stone walls gave the village a fortress look. The clinic in Madrawal seemed to be shared by animals as well as people, at least on the outside. The rooms inside were sparsely furnished, a place to examine old and young, men and women. From here the seriously ill were moved to Nangrahar Hospital in Jalalabad.

The Peace Corps doctors worked toward a plan that was sensible and possible, so I began to record those who came for help as Peace Corps Volunteer doctors and their Afghan colleagues, assistants, and translators worked among the men, women, and children. Swarms of mothers pressed against the windows of the clinic. Some were clutching their babies. Forty to fifty children were examined every day for respiratory infections, diarrhea, parasites, and other problems. The women's expressions ranged from anxious to aggressive. Desperation piled up outside the door as they jostled to get at the cardboard boxes of nonfat dry milk decorated with an American shield that was given away twice-weekly. The supply was running short of the need so it was carefully rationed. Many children were malnourished. Fortunately the village women were not shy about seeking help; they appeared here unveiled, and they seemed comfortable without the cover that normally obscured their faces with their burkas. They were assertive and strong when it involved the welfare of their children.

Inside the hospital areas, some of the women had anger in their eyes. It was no surprise: they were being treated by total strangers, white foreigners who couldn't communicate directly with them and became physically intimate doing medicine. A few taps on the chest with naked fingers, a peek into the ear or a mouth, a few quick questions and the intimate eavesdropping continued. Who were these people?

Nangrahar hospital and the rural clinics in the village of Hesarshaie and Madrawal are where two worlds met — rural Afghanistan and the Peace Corps. They were so different that it is almost impossible to see how they could understand one another. Even a partial visceral connection was almost impossible to imagine. The fine instruments of medicine were obviously the only way available to slice little holes to see what life for Afghans was even remotely about. The big categories of differences were like boulders that obstructed the view. This of course was my problem. The Peace Corps doctors knew what they were doing and they were working toward a plan that was sensible and possible. I couldn't settle for this because I so badly wanted to understand what it was like to come into the hospital or clinic for help from a world I could hardly imagine.

As I looked into the eyes of a tough bearded old farmer, who had probably seen much more than I could imagine, I saw terror. This was so easy to understand. Total strangers, white Christian foreigners who couldn't communicate

directly, had the right and ability to physically become immediately intimate through medicine. Even back in the U.S., I disliked visiting doctors where everybody knows more than you do — about you.

If this is going on in my mind in a culture where medical help is abundantly available, what is happening in the mind of a poor, frightened, uneducated Afghan man, woman, or child who believes in another religion? For them, every value has been shaped by circumstances that are different from those of the well-meaning, well-trained, strategically placed volunteer who had come halfway around the world to help.

One of the newly arrived Peace Corps doctors, Frank Baldwin, was a surgeon and I had a chance to photograph him in the clinic in Madrawal where he examined a child where the visibility was provided by the sun as there was no electricity in Madrawal. The child was then taken to the hospital in Jalalabad for an operation to remove his infected tonsils and I was able to get photographs of the procedure in the sparse operating theater, where a single electric heater fought the cold and a bright operating room light gave the place its official look.

For me, these were amazing opportunities to make a dramatic record of what can happen when Americans with advanced skills are able to contribute to help alleviate punishing conditions, and I took every opportunity to photograph everything I could.

The experience was like trying to view Afghan life by using a flashlight in a dark world and it was only possible to sense those parts of the scene that I could illuminate. I had seen a lot and it had been overwhelming but the lit spots only hinted at the vivid complexity of Afghan society. I felt like a tourist who hadn't read the guidebook.

After Christmas we left for Beirut for a brief stop before heading home, a place where we could thaw out on the warm and comforting coast of the Mediterranean and celebrate the New Year and unscramble the old one.

From the air, we passed over row upon row of mountains — some touched with snow — long broken horizontal ranges; a dozen of them extending to the horizon. Looking out at a hundred miles of sand and rock, the mountains framed by the plane window were barriers — row upon row of them. Tiny snaky lines that cut the valleys — traces of water had faintly marked the scene in their descent

from the highest points where moisture had gathered — blown from softer more humid places. It was a beautiful sight, particularly poignant on leaving, viewed in comfort at 20,000 feet, heading for a warmer place.

I had seen so much and understood so little except I was able to safely conclude that Dr. Rodgers and the Peace Corps medical experiment had found a way around those formidable barriers that had stopped every invader in the past and would hopefully continue to do so in the future.

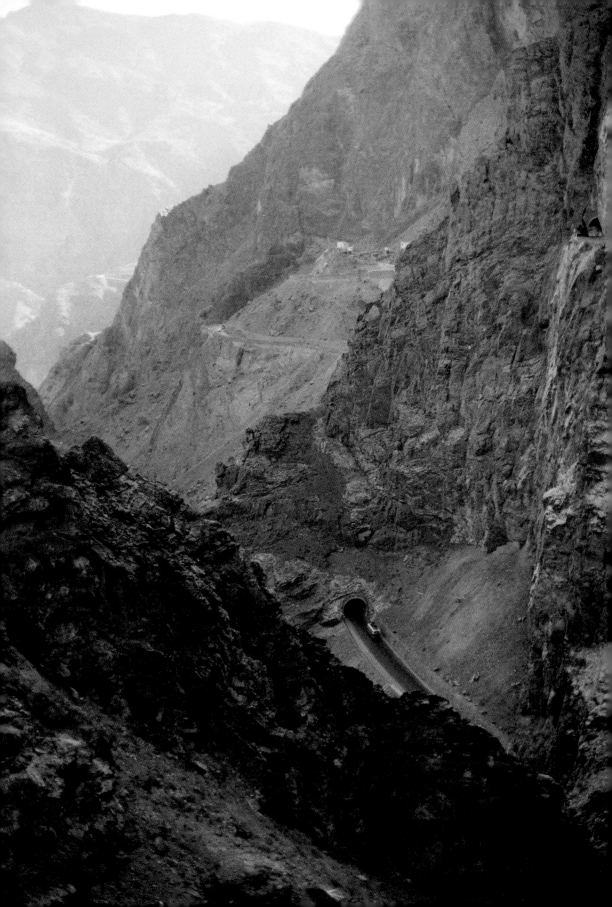

30 – RETURN TO SAVANNAH

In 1966, after finishing my tour of India and Afghanistan, we returned to Savannah and I restarted my life as a freelance photographer. I was now 37 years old and searching for a lifestyle that was both economically viable and that no longer required plunging into the extremes that I thought had been necessary to survive as an independent magazine photographer. I was still curious about the world, but dramatic physical risk-taking no longer seemed attractive or viable after the children were born. It had turned out that there were plenty of colorful stories within reach.

Even before going off to Peace Corps in 1964, Monica and I had sometimes managed to integrate family life into my photography. When Breck was a six-month-old, he came along with his mother on a long drive up to Asheville, North Carolina to cover a folk life festival. There, we made friends with Arthel Lane "Doc" Watson. The blind musician was not used to being interviewed *family style*, but was charmed and he invited us to visit *his* family after the festival. There, Breck was a big hit and an icebreaker. I have a photograph of him looking very attentive, lying in his wicker laundry basket, while "Doc" strummed him a personal concert under an apple tree in the back yard of his farm in Deep Gap, NC.

In Savannah, Monica started a pre-kindergarten school with a friend, and Breck was enrolled. Then, when Breck was five and Grattan three, they made charming models for some of my advertising work. My favorite shots often involved them at Tybee Island, at the beach flying kites. There's something exhilarating about catching the wind in a paper apparatus, stretched across a

couple of sticks connected with a string and controlled by a child; the zooming sense of freedom showed in the animated expressions of the two little boys flying as if *they* had wings. I loved taking these pictures, and they loved the kite flying. The proof was in the photographs.

We also went fishing often, and when they were a bit older, I bought a BB gun and the boys learned to shoot a tin can placed in front of a Yellow Pages classified telephone directory in the basement of our house, which became a rifle range. Then they graduated to learning to shoot my .22 rifle at tin cans chucked into the river, and floating by a friend's pier at Isle of Hope on the Skidaway River near Savannah. The bullet made such a satisfactory splash in the water even if you missed. This became a favorite Saturday afternoon pastime for the three of us and may have been a happy throwback to the days when my brother let me come with him to shoot his pistol at similar targets at Johnny Massey's place on the St. Johns River in Jacksonville when I was about Breck's age.

Both Breck and Grattan shared my love of animals, particularly dogs. They also inherited this from their grandmother, who lived a few blocks away and had a cocker spaniel, named Petit Choux (Little Cabbage — an endearing expression in French often used for children). Choux had pedigree lineage but our dog had come directly from the pound. Unfortunately, he had picked up bad manners in his former home. He once growled at me when I approached his food bowl. The boys christened him Pokey, presumably because his nose went everywhere; he used the toilet as his drinking bowl.

I tolerated this bum because I didn't want to interrupt the good memories I had of Mergatroid, Punana, Daulrimple, Wiltley, and all the other mutts of undistinguished lineage that we had had in Kuching. Democracy at the canine level ended, however, when my favorite Persian rug became Pokey's favorite place to pee. Totalitarianism took over. Pokey was banned to the back yard, but when I was off on a job, safely out of the house, somehow a new puddle would appear on my favorite rug. At least the damn dog had good taste.

In our two Savannah homes, we tried to replicate some of the special benefits of our Kuching situation. We didn't have a gardener or cook, but we did briefly have Ah Wah, our *amah*, who now served as a nanny. Somehow, we were able to persuade the immigration authorities that Ah Wah was needed to

continue training the children in the Iban, Malay, and Cantonese languages. I thought that she would fit comfortably with the oriental furniture, Chinese pots, Ming plates, batiks, and other Borneo treasures that had also arrived from overseas, but Savannah failed to provide the girl with any social opportunities. She returned to Sarawak after six months.

James Oglethorpe, the British parliamentarian who had founded Savannah, designed the city in a way that emphasized open public spaces where human-scaled buildings were configured around squares laid out in a grid. Our new house, that I bought in 1967 for $10,000, on West Jones Street, like the rented one, was not far from my mother's, which stood in the old historic district in an area that still conformed to the founder's dream of 1733. Monuments and memorials dedicated to the past marked the passage from one graceful landscaped square to another. The lots that led from them were modest in size, not meant to accommodate huge and ostentatious buildings, and the streets were shaded by huge oaks and flowering flashes of white magnolias that enriched the historic cityscape. It was a comfortable place to live. The modest houses had charm and those on a grander scale were well mixed with all the rest, like raisins in a cake. The architectural styles — Federalist, Colonial, Italianate, and Victorian — marked changing times and tastes as the city grew inland away from the Savannah River; the public buildings reflected the city's economic development during the 19th century.

Building in the historic part of the city peaked in the late 19th and early 20th centuries when the last great fortunes were made. This was a time when Savannah was an important shipping center, exporting cotton, turpentine, timber, and naval stores. Wooden sailing ships first carried these goods to the world; the first steam-assisted vessel to cross the Atlantic was the SS Savannah. She arrived in Liverpool in 1819, her engine fueled by Georgia pine.

After World War I, the city's economy began to weaken and the city, bit by bit, decayed. The recovery from the depression of the 1930s prompted many to leave the central core adjacent to the business district near the Savannah River. More and more middle and upper-middle class white citizens suffered a kind of "quality amnesia" and those who could afford it passed from the uniquely distinctive graceful structures of the past to the blandly obvious, trading their slightly shabby homes for exaggerated Greek-columned mansio-

nettes. These houses dotted Victory Drive, a long east-west double-esplanade of palm trees that celebrated the outcome of World War I and divided the old section of the city from the new.

South of Victory Drive, the architecture resembled many suburban communities in the United States as the decorative past was traded in for contemporary convenience after World War II. Luxuriant trees and shrubbery kept the feeling "Southern," but the architectural references to the city's history were absent.

My introduction to Savannah had begun in 1947 as an eighteen-year-old, spending the summer working in the family ice factory to make money before starting college. The YMCA for a dollar a night was my home because none of my family lived in the city then. At this time few buildings were being restored and the YMCA was no exception. It was a broken-down brick relic, catty-cornered from the De Soto Hotel. Indoors, a high stepping gait was needed in the hallways to avoid the sharp wooden splinters that lay in wait to spear the feet of anyone unwise enough to shuffle to the "down the hall" bathrooms barefoot.

I dimly understood the city's special qualities while living at the YMCA. The genteel and historic escaped me. I saw a shabby piece of old furniture with its stuffing hanging out, but by the mid-1960s, both the city and I had undergone enough positive changes to foster an appreciation for Savannah's uniqueness.

So, at the age of thirty-seven and a family man, I finally settled in one of America's most beautiful cities. The timing felt good as I returned for the fourth time. And, happily, Savannah proved to be very affordable, although in 1966, historic preservation had begun and the city began slowly to be appreciated as an undiscovered gem. Having returned from a "real" job with the U.S. government, my social status in Savannah was improved. Monica charmed everybody as she had in Texas and we settled in to enjoy the best of the urban South.

Although it was comforting to live in a physically beautiful place, I now had to confront my fiscal responsibility and try to finally see life through contented eyes. Could I do it? Why not? Having once made a living here as a children's photographer, I took a similar route again, taking up purely commercial picture-making. As it happened, Georgia's and South Carolina's coastal islands were booming with development as resort and recreational communities. My economic problems began to be solved as I became a highly paid pho-

tographer for the new retirement island communities, picking up where I had left off before joining the Peace Corps. Happily, my friend Charles Fraser's island resort Sea Pines plantation was booming. And David Pearson had returned from the Peace Corps to start up a public relations company, providing me with jobs both at Sea Pines up and down the Atlantic coast as well as Dorado Beach in Puerto Rico, St. Croix, Caneel Bay at St. John's in the Virgin Islands, and in several RockResorts in the Caribbean. I began to work for more and more brochures and magazines devoted to the "good life."

One year I produced two-thirds of the cover photographs for *GOLF* magazine as well as a major fashion spread for *ESQUIRE*. These were places where the history of slave labor on plantations was erased and contemporary living was geared to the upscale, luxurious, and new. Burgeoning beautiful golf courses provided a principal lure, and second-home luxury nests were built to house a new generation of privileged who flocked down to the wide sandy Atlantic beaches of the barrier islands of Georgia and the adjacent lands that were known as the South Carolina Low Country.

These new *Golf Edens* were guarded and gated. Prospective residents were screened for their financial stability, special committees approved the architecture, and golfing greens rules were strictly maintained. The developers took pains to make their resorts distinctive. At Sea Pines Plantation, alligators basked in the water traps, a public relations ploy that was carefully maintained to make the point that a golf course was really a conservation area and not just a rich man's toy. Savannah, on the other hand, had no need for a locked community; it had an invisible guard gate where strangers could come and go but would only be allowed to join exclusive clubs under far more complicated conditions — layers of old money, old connections, and old privilege rather than freshly minted newness.

But for me, my social life was as open and uncomplicated as going to a drive-in-movie — a family treat that I often shared with Monica, Breck, and Grattan. One typical such outing was described in my diary:

I just finished a big resort photo shoot and last night I celebrated with the family by going to a drive-in movie – Bathsheba Everdene, the flirtatious beauty, played by Julie Christie, was toying with three men in the film adaptation of Thomas Hardy's novel "Far from the Madding Crowd." Julie was teasing Alan

Bates and Peter Finch and this led to a fair amount of romantic chaos but noth-
ing compared to what was happening in the back of the station wagon as my
sons had a succession of fights resulting in Grattan swallowing his chewing gum
and most of some gooey liquid "refreshment" got spilled on the seat, all of which
was punctuated by rattling and munching around with popcorn, I finally bel-
lowed at the whole crew. The effect was instantly successful. Total silence —
peace — just as I'm settling back into a gorgeous Technicolor mood — Julie is
falling in love, Julie is about to get kissed, she is being kissed — Grattan is draw-
ing at the ice in his empty drink container (the remainder just got spilled) SLURP,
SLURP, KISS, KISS, KISS, SLURP, SLURP, domestic bliss. SLURP, SLURP, SLURP
and KISS, KISS, KISS.

I not only loved my boys, they amused me.

In those days there were individuals in the Savannah community who were fascinating throwbacks to a much older class-based culture with its own individuality and character. And there were those who left for places that required a more robust and outgoing temperament, like CNN founder Ted Turner.

One of my favorite Savannahians was Johnny Mercer. He flowered far beyond his roots as the recipient of four Academy Awards for the songs that he wrote for movies from the 1930s to the 1960s. He was a star in Hollywood and the founder of Capitol Records. One of his last great hits, *Moon River*, written in 1961, was filled with his feelings about Savannah and what he had absorbed from the black playmates and servants among whom he had grown up as a child. Johnny Mercer came from a distinguished old Savannah family and he kept his well-born relatives afloat after the family real-estate business crashed during the Great Depression. When Johnny became wealthy, he returned to pay off family debts long after it was a legal obligation. He was as charming and easygoing as his music.

When I photographed Johnny during one of his visits to see his family, we discovered that we both had a connection to Woodberry Forest School, although he had attended before I was born. We shared that neither of us had been the most academically successful in the school's history, and had developed similar styles of survival. We laughed a lot. My photographs turned out to be a success. He loved them and Johnny sent me a Christmas card with a warm note almost every year before he died in 1976. It was flattering to think that as

he wrote to me he might also be sending Christmas cards to his buddies Bing Crosby and Hoagie Carmichael, or a young actress he was in love with, Judy Garland. To me, he combined the glamour of Hollywood with the best of Savannah, kindness and generosity.

During my early years of return to Savannah, times were changing in Georgia. A new era was emerging. Atlanta had become the focus of New South, with a vibrant middle-class black community, important universities — black and white — a rail center, and an airline hub as well. Compared to Savannah, it was wall-to-wall prosperity. Savannah was not the New South. It was like an antique Persian rug, a bit faded and frayed but tightly and beautifully woven; qualities that pleased its connoisseurs, who protected the past and were content with its character. Aspects of Savannah's past accumulated over time like dust, delivered coat by coat, undisturbed by excessive movement, until they became permanent; a patina of conformity.

The old ways of Savannah returned for my family in full force when my mother moved back there in 1950 from St. Augustine, Florida, where she had lived for a mandatory six months in order to dump my step-father, a polo-playing, fox-hunting dum-dum; the resident squire of my mother's small farm in Virginia, near Charlottesville, where we had lived during World War II.

My mother had no trouble fitting back into the gentrified Southern mode. She had known people in Savannah since childhood, both through her exclusive boarding school, St. Timothy, where there were a number of Savannah girls, and by invitation to the events on the cotillion circuit.

This network of coming-of-age balls extended from New Orleans, to Savannah, Charleston, Richmond, and Baltimore. These were the ones I had heard about; they were the Pearly Gates to Social Heaven for the daughters of what was left of the old plantation aristocracy. It was all about "family," a network of "well-born" people called Aunt and Uncle, whether they were relatives or not. It wasn't about money; it was about memory. They didn't need a *Social Register*; everybody knew who everybody was, even if you weren't directly acquainted with them.

But even more important, my mother knew the secret codes; the inflections and words that you didn't say. And of course, there was the family business that seemed to have always been there, a dependable marker. It wasn't neces-

sary, but it helped to be moderately well off and to have a history. Upon entering my mother's house, one saw clearly that the past was important; the rooms were filled with old portraits. Some ancestors were not so well painted, but that gave them a feeling of authenticity. Among them, in the dining room, was an ugly painting of a cousin, Renate Long, pictured as a child. The painting was so disturbing that it was often covered up with a sheet because my mother's Cocker Spaniel didn't like the painting and would frequently bark at it. Cousin Renate had run a boarding house — or rather she took paying guests — in her huge broken-down multi-columned mansion in Tallahassee, Florida. The Grove Plantation, once the home of her ancestor, Richard Keith Call, Territorial Governor of Florida, had been built in the 1830s. My family spent Christmas there in 1938 and my memory is draped in Spanish moss that hung down in long gray beards from the enormous oaks surrounding the Grove.

My mother lived in tasteful harmony with her Southern past, but there were clues, European markers, which indicated that her experience lay well beyond the South, a worldly lady who made this clear in understated ways. Throughout the house there were numerous screens and decorated trays that my talented mother had painted. She had studied painting and drawing in New York and then in Paris as a young woman before World War I. Sadly, there were no works by artists who, during this same period, were busy producing art that became treasure. The house was skimpy on Picassos and Matisses. There was, however, a signed photo of the Duke and Duchess of Windsor, which was slightly embarrassing to me because I was aware of the Duke's unfortunate history of Nazi sympathies. HRH used to pass these autographed pictures out as currency to those enamored of the British royal family who housed, wined, dined, and entertained him in the early 1940s. He was named governor of the Bahamas during the war, a post that was as far from Europe as Churchill could get the abdicated King of England and his American wife.

But there was also a framed dedicated photograph of Ignace Paderewski, Polish pianist, composer, and statesman, one of the best-known musicians of his time, who helped create modern Poland after World War I as Poland's first president. He had become a family friend when my father was American Consul in Lausanne. Among many other photographs, on an antique Queen Anne table, was one of my mother standing next to my uncle's Curtis Robin mono-

plane in 1928. Another antique table held family photographs of mother, my brother, and me, standing in jodhpurs holding the reins of polo ponies and hunters in Pawling, New York; refugees from the sweltering Southern summers. Balancing the equestrian was the nautical, with formally posed photographs of the Baldwin brothers with our sailboats in Gibson Island, Maryland. Scattered around were souvenirs from a 1937 summer trip to Mexico; an alabaster head, and small terracotta pieces and obsidian arrowheads that could actually still be found at Teotihuacan around the Great Pyramids of the Sun and the Moon at that time. There was also a rather ugly simple little wash and pencil drawing signed by Diego Rivera set in an elaborate Mexican tin frame on the wall.

Among my mother's friends and acquaintances there were people who may have lived rather traditional and undramatic lives, but whose minds roamed far and wide. Some became close friends of mine and they patiently coached me in the complexities of living a more graceful lifestyle while reaching beyond restrictive local boundaries. These friends accepted my rebellions and understood that I had a complicated relationship with my family's entrenched feelings about class, a condition that I enjoyed, took advantage of, and yet rejected in many ways.

Foremost among these were a brilliant doctor and his extraordinary wife, who lived in a world of great books and ideas. They were aristocrats both by birth, temperament, and education. Dr. Antonio Waring, called Tono by his close friends, and Henrietta, a couple halfway between my mother's age and mine, were old friends and they invited Monica and me to their house once a week for long discussions on every imaginable subject. I drew deeply from this well. Sometimes there were others who added their special flavor to the mix. Danny Zarem, a highly sophisticated and intelligent young shoe store owner, an unwilling heir to a family business. He was trapped in Savannah until he could get his younger brother, Bobby, through Yale, after which he took off for New York and became the highly successful Fashion Director for Bonwit Teller. Danny, Tono, Henrietta, and I would sometimes break away from conversation and listen to Ella Fitzgerald records. Sometimes it was background accompaniment to a good conversation, but often Ella was the main attraction. Listening to Ella in Savannah under these circumstances seemed as appropriate as having a croissant in Paris.

Tono Waring had his sad side. He had graduated first in his class from Yale, won top honors at Johns Hopkins Medical School, but hated being a pediatrician. His true love was archaeology and as an amateur he was the recognized expert on the Creek Indians. He couldn't take up this profession, however, because the tradition-bound Warings were expected to be doctors, as had been his father, and his grandfather.

Henrietta Waring was a collection of contradictions tied together with qualities that made her an extraordinary woman. She was frail, and as delicately boned as a quail. Her fragility was the result of a terrible accident she had suffered as a young girl. She had somehow swallowed a bone that became temporarily embedded in her throat and caused a strange and ongoing paralysis that affected much of her body. She couldn't speak smoothly or easily, but what came out, though slightly slurred, was brilliant, witty, and full of life, displaying curiosity and compassion toward almost everything she saw. Her hands also shook slightly, but Henrietta was a talented watercolorist: some of her painting was collected by the local museum. Her movements were limited, but she was in love with life and especially accepting of anyone who tried to extend themselves intellectually or physically beyond the obvious; they were welcomed into her sunny orbit.

Henrietta needed assistance in walking and other personal chores, and her physical help often came in the form of Anne, a seemingly ancient black woman, who had somehow joined Henrietta from the marshlands of one of the nearby coastal islands. Anne spoke Gullah, a distinctive local patois of English mixed with an African tongue that made her speech both exotic and somewhat difficult to understand. Anne was jet black and looked like a witch doctor — which she may have been. What came out of her was full of mystery and as challenging to the imagination as was Henrietta. She was full of tales of ghosts and animals and magic and secret potions that came from her island. She had a laugh that burst from her, an explosion of mirth delivered only to those who she liked or felt comfortable with.

Anne was a black island queen and she took care of Henrietta as if she were one of her subjects. She was strict about what Henrietta should or should not do with respect to her health, providing brews and portions — all alcohol-based — that she made at home. Their relationship seemed like something that

went back to the stories that my mother had brought me up on in a world that no longer existed, when black house servants and their white masters often had relationships that were extraordinarily intimate. But this was the late 1960s and African Americans had other choices available. *Gone with the Wind* had long since blown away. Nonetheless, Anne loved Henrietta and Henrietta loved Anne.

There were other people like the Warings who came into my life in Savannah, and they made the past seem not only bearable but also exciting. There was a remarkable teacher, Joe Killoren, who taught me at Armstrong Junior College after the Marines. And an art director, "Pen" Pennington, who had come to Savannah from New York with a chronically bad heart; he needed to make a living, but knew that he might live longer if he worked in a calmer environment. Another friend, John Thorsen, was a deeply committed historic preservationist who lived in a firestorm of frustration because he wanted to apply his Chicago energy to refurbishing the architectural gems he saw everywhere. John was determined to shortcut the molasses-slow progress that he found in Savannah and buy, build, fix, and finance historic properties. There were other unpredictable and eccentric personalities. Bob Cooper was a musician and an extraordinary craftsman who built lutes for renowned artists like Richard Dyer Bennett while working for the Corps of Engineers: his wife, Emaline, was an English teacher. They lived a rich yet comparatively simple life that was filled with wit, fun, and music.

Savannah had close links with the coastal South Carolina area, although many there lived a completely different lifestyle. Many were the sons of sons of rich plantation owners, many my own age, third- or fourth-generation Yankees who found happiness in an escape from the serious activities that had made their grandfathers and great-grandfathers rich. They were the descendants of the barons of the golden age of capitalism, famous names from Chicago and New York. They adjusted to plantation life and found a perfect setting for "amusing lives." In South Carolina, it was possible to do this without much effort. Their cousins in Long Island, on the other hand, so close to the dynamos of power, were forced by geographic proximity to at least be aware of the engines that provided them with their special status. The Old South didn't impose the same burden. Being amusing was their stock-in-trade and the ingredi-

ent that set them apart from the simply rich or the boring rich who began to be their neighbors on the nearby golf islands.

In addition, there was always a supply of other amusing people temporarily imported from the manor houses of England, Lady or Lord this or that. These aristocrats, not quite as well-heeled as their American hosts, were happy to come and play with the plantation set. These exotics were occasionally available to Savannah society; the most amusing parts, of course.

Among the many people of all kinds I encountered in my new life in my old homestead, one in particular changed me profoundly. In 1966 I met Donald E. Gatch. Don was a young doctor who had married an English girl, Anita, whom he had found among the fancy foreigners visiting at a plantation in South Carolina.

The worlds of Anita and Don Gatch couldn't have been further apart. Anita had come for a plantation visit with Lady Jeanne Campbell, the favorite granddaughter of Lord Beaverbrook and, briefly, one of Norman Mailer's wives. After a two-week romance, Anita, a dark haired beauty, and Don, married, and they now had two children. She was a painter, an accomplished pianist, and had been trained as a ballet dancer.

Don Gatch was about my age and originally from McGrew, Nebraska, where he grew up on a small farm during the Great Depression. A philosophy student, he graduated from Nebraska Wesleyan University in 1953, and after an uneventful stint in the Army, he studied medicine at the University of Nebraska and became a doctor. He served his residency at Memorial Hospital in Savannah, and, fulfilling a dream of leading a useful and peaceful life, Dr. Gatch opened a tiny clinic in Beaufort, South Carolina, and took a position on the staff of nearby Beaufort General Hospital.

Don Gatch had witnessed cultural discrimination against Mexicans during his university days and decided that through medicine he could peacefully work on such problems. These were vividly manifest in his own back yard, Beaufort and Jasper, Counties where the economy no longer stemmed from the highly profitable production of rice in the South Carolina Low Country. Since Colonial times, rice plantations had required large numbers of slaves to harvest the crops. This ended at the beginning of the Civil War, when Union troops occupied South Carolina. Thousands of slaves freed by the U.S. Army received

government assistance for two years after the war, but most of these men and women were untrained, unorganized, uneducated, and ultimately abandoned. The white landowners had fled and those who remained were unable to support their workers. The area soon became one of the poorest in the United States. Sixty percent of the population of Jasper County had an average income of less than $3000 a year in 1960. This was where the beautiful Anita Gatch now lived with her doctor husband: Bluffton, Jasper County, South Carolina, population 356.

By 1966 the situation in Don Gatch's area had changed dramatically. The development of Hilton Head Island as a golf resort and retirement community had brought money and employment. Just to the south, Savannah remained one of the ports of call for a version of Southern gentility that sought to be authentically the same as always. The past gave the city direction, but Hilton Head Island had no such underpinning, being based on the concept that this newly minted Garden of Eden, laid out with two eighteen-hole courses and beachfront lots, was available for anybody who would pay and could meet standards that had to do with fiscal stability not family history. Ironically, the poor, Dr. Gatch's patients — whom he saw with such clarity — were totally invisible to their closest geographic neighbors.

Black people had lived on these coastal Sea Islands in complete isolation for a hundred years or more and when the golf resorts came, those that remained were soon walled off by the developers, except for those few who were able to secure jobs in the kitchens and gardens of putter's paradise.

My acquaintance with Don Gatch began a period for me that involved living in three different worlds. While I continued trying to fit into my new life in Savannah, among my mother's society and with my little family, I was using my photography to earn a living in a purely commercial way by emphasizing the charms of various country clubs and golf courses. I grew adept at bathing them with golden colors of the early morning or evening light. At the same time, I began following Dr. Gatch as he made his rounds among the poor and neglected, accumulating a photographic record of what I saw, which was so diametrically different from my other worlds. If adjectives should be applied, what began for me with "graceful," "amusing," and "profitable," soon introduced me to "desperate."

Donald E. Gatch was a self-appointed medical missionary. For more than a generation, he had worked in the shadow communities of blacks who lived so close

and yet so far from the affluent white communities of Bluffton and throughout Beaufort County in South Carolina. His practice came from the medically underserved black populations of several future and current golf islands as well as Beaufort County at large, and included an isolated white community on the Georgia side of the Savannah River. Geographically, Dr. Gatch's practice followed the deep fingers of poverty as far as he could reach. Press attention began finally to pull Dr. Gatch, interview by interview, into national attention: he eventually became the noted "Hunger Doctor." Involvement with him began to change my life as well.

Testimony before the Citizens' Board of Inquiry into Hunger and Malnutrition at a session in Columbia, South Carolina on November 9th, 1967 brought Gatch to public prominence. Based on twelve years' work in the South Carolina low country, Gatch publically exposed the widespread existence of chronic malnutrition, vitamin deficiency diseases such as scurvy, rickets and pellagra, and the broad presence of intestinal parasites — hookworm, roundworm, and whipworm — among young and old alike. He claimed that at least eight deaths in the Beaufort County area were due to these conditions. Gatch targeted discriminatory medical practices against poor whites and blacks by an apathetic medical community.

At one point, I introduced Gatch to Betsy Fancher, a senior editor from *Atlanta* magazine, who wrote an article for *Atlanta* magazine, illustrated with my photographs. She highlighted some of the outrageous conditions that he was uncovering. Quoting Dr. Gatch, "*A mother brought a nine-year-old girl to my office Monday. She apparently had had a ruptured appendix since Friday. We took her into the operating room. Again, I kinda snuck her in because it's against the rules to admit a patient without money. And when we got her on the surgical table one of the surgeons said, without any comment especially, 'This child has rickets.' And when we got in the abdomen and were doing the appendectomy, we found some roundworms. And he said, 'Of course, in these colored children the closer we get up the ileum in the stomach the more worms we will find because these kids don't have much to eat... And this is where they head. They get the food before the kids do.'*"

Dr. Gatch later told a *New York Times* reporter, "If you have a hundred or two hundred of these foot-long roundworms in your belly, they're going to take a lot of food."

In January 1963, five investigators, including Gatch, had undertaken an inquiry entitled *Study of Intestinal Helminth Infections in a Coastal South Carolina Area*. The report describes the failure of these infections to respond to antibiotics...*"It is apparent that the infection rates found in Bluffton are comparable to the highly elevated rates found... around the world;"* that included South Africa, Egypt, and the Cook Islands *"and may represent one of the areas of highest endemicity for the continental United States."* More than eighty-percent of the children under five in the survey were infected. Beaufort County health authorities accepted these findings as valid, and even deplored the conditions described, but for the most part returned to business as usual.

By the time I met Gatch, he was a man obsessed with his mission. It both blessed and cursed him. His search for a warmer and more graceful life among the moss-hung oaks of South Carolina in the 1950s had wrapped him in the woes of every person he had tried to help. Instead of peace he got pain.

Don Gatch's earlier goals for a "peaceful life" were not that different from my own, but I found myself deeply affected by the medical hell he was uncovering. The time I spent with him was stolen from lucrative resort assignments. There were aspects of Don Gatch's personality that I was not comfortable with. He was a whirlwind of zeal, and as I got closer to him and his work, I felt that he was headed for a plunge into the misery that he daily dealt with. Swirling around on the edge of this same whirlpool, I could feel the pull. What was the safe distance to maintain to keep from being sucked in? Buoyed by the double stimulation of the extraordinary conditions I was photographing, my own anger was growing. How could I put these pictures to work in rallying public support? Somehow, however, I was reluctant to travel too far away from my goals of a "new life" in Savannah. But I found myself inching toward a different way of looking at myself and what I wanted.

One day I followed Don to a men's room at a gas station and noticed a syringe in the trash. Was it Don's? Was Dr. Gatch was heading for disaster. Anita Gatch had already left with the children for Europe. Their marriage was breaking up. He was a man addicted to both his desperate work and drugs. Don Gatch was a man who seemed to want to fly from his insane world to another version of it — to leap off a cliff on the wings of LSD, heroin, or whatever might take him on a vacation from pain. He told me that he had long abandoned his

Midwestern Puritanism but now found new inspirations, cults that pushed him into work with the poor. This winding path led him to a fierce rejection of the commandments of thou-shalt-not, to a course of psychotherapy then beyond into various forms of mysticism, to the occult practices of the pharaos as his brain circled every possibility to gain peace, and finally to drugs. Everything he saw touched Gatch's raw nerves, not only because of the misery that he was dealing with but because every cry he made for help was met with indifference. Going to the press had been a desperate move, further escalating the odds against his goal of finding a solution to the plight of the local poor. Dr. Gatch went to war with the long-established norms of Beaufort County medical practice and he wouldn't be forgiven easily or quickly.

To get money to work on the health problems of the poor of Beaufort County, Gatch contacted the county health department, but they said "this is a problem that had been with the people since time immemorial. Until colored people got educated enough to wash their hands, there isn't any point in treating them." Don found that a National Institutes of Health grant was available but it had to be funded through a university, and the local universities weren't interested. The Rockefeller Foundation explained that it was involved with such matters in South America, but pointed out that the federal government was dealing with American health problems.

After Dr. Gatch's November 9th, 1967 testimony to the Board of Inquiry into Hunger and Malnutrition in Columbia, he returned home to discover the following attack in the editorials of the *Beaufort Gazette*: "Dr. Donald E. Gatch has done Beaufort County a great disservice. We suggest that he stop running his mouth and use his talents to alleviate rather than aggravate."

Gatch had become the most unpopular man in coastal South Carolina among whites. His white patients left him, the rent for his Beaufort office was doubled, and he was forced to close it down. He lost his staff privileges at the local hospital, fought the ruling, and got them back only to lose them again. Every other doctor in the county — all of them white, and all of them maintaining segregated waiting rooms in their offices — signed a statement denying charges made by Gatch about the hospital. Only the white District Nurse Ann Pitts stuck by Dr. Gatch and fought for him, along with his black midwife assistant Jennie Kitty, and two nurse's aides.

There had been disturbing rumblings from the most primitive elements of the white community. Jenny Kitty received a call from Doctor Gatch reporting that there had been hate calls coming in by telephone, and he had just received one from the Klan threatening his life and announcing a visit. Miss Kitty called her relatives and then Gatch's closest ally in the community, black activist Thomas Barnwell, Jr. Before dusk, more than thirty armed black men arrived and took up positions around Gatch's house, with a few posted in the trees. When Klan members made a preliminary pass to check out the situation they decided to hold off further efforts.

At other levels, it was not possible to protect Don Gatch with a security platoon of black friends. South Carolina's Governor Robert McNair was concerned about the effect that hunger publicity had on the tourist trade and the state's efforts to attract outside industry. According to Senator Ernest Hollings, "You don't catch industry with worms — maybe fish, but not industry." The effort to quiet Gatch, discredit him, or put him out of business was not limited to the local area. Mississippi Congressman Jamie Whitten, who controlled the appropriations for the Department of Agriculture, had Gatch investigated by the FBI.

Touring with Don Gatch on his rounds, I collected an impressively dismal picture of his patients set in some of the most breathtaking and haunting pictures of the imminent situation of the islands of the South Carolina coast — all scheduled to become golf resorts. Wild and remote Daufuskie Island, one of the most beautiful, was only accessible at that time by a small open boat that ferried its few inhabitants back and forth to the mainland. Massive moss-hung ancient oaks shaded impenetrable, darkly mysterious places. Flights of osprey, and white herons, ducks, and seagulls lifted freely in and out of the marshy waterways. It was a Southern Garden of Eden and under the giant extended arms of oak branches there were a few black people living in shacks. As a photographer, I found it a bewitching place to visit. Given a romantic Southern perspective, it was so charged with charm it could have been the source of one of Johnny Mercer's moving ballads.

On an earlier visit, Dr. Gatch had received a telephone call from the family of an old woman on Daufuskie who was lying in a comatose state. Her relatives couldn't tell whether she was dead or alive. After hiring a boat to make the fifteen-mile trip, he found the old black woman in a place that couldn't even be

described as a shack. She was in a condition that he had never experienced and had never even seen in a medical book. She was alive but "her arms, legs, her entire body was covered with maggots." The woman died and the experience left Gatch with a psychic wound that never healed.

Daufuskie Island is now a golf resort, but in those days the giant canopies of oaks shaded the shanties and kept the soil moist in the humid coastal weather. Unfortunately, that soil also housed the larvae that entered the bodies of the barefoot children who defecated on the ground because there were no proper toilets, no running water, and sewage. Ironically, the most beautiful parts of the island were the most dangerous. The oak-shaded beauty was contaminated by a deadly combination of ignorance, poverty, complacency, and the feces of children.

Seeing the terrible conditions of life for many black and poor white families in Dr. Gatch's area, I began to realize that my photography business and my privileged life in Savannah, like the soil under the spectacular oaks of Daufuskie Island had — just under the surface — a lot of problems. I was becoming less and less interested in helping celebrate the "Golden Isles" for high pay as I became more involved with the health and social justice crusade. The piquant notes of Ella Fitzgerald had been replaced by the sad drumbeat of Gullah woes. I missed what I couldn't hear anymore — sweet tones to which I had become deaf.

31 – DR. GATCH'S LEGACY

One of my first experiences of the new journalism I was setting out to practice was to look at poverty in the South in Georgia and South Carolina. One of the places where I worked was near the Savannah River. Don Gatch knew about such pockets of isolation and he took me there. Somehow, his deep sympathy for the underprivileged and broad knowledge of the underprivileged and unusual populations of rural George, and adjacent South Carolina, drew him to such places. Dr. Gatch knew about them. Indeed, he had visited them often and treated them medically, earning their trust and affection.

We set out, until we got to a long-abandoned rambling Gothic structure, with rusted out Royal Crown Cola signs. It stood beside railroad tracks that were overgrown by weeds in a world inhabited only by a few roaming chickens and a stray dog. We started west down a dirt road, through a spit of land cutting through pinewoods. Bounded by creeks and bottomland swamps lined with cypress stumps, oaks, and sweet gums, the road seemed to go on forever.

After a bumpy ride we finally arrived at a cluster of wooden houses, surrounded by old cars in various states of decomposition. As we pulled up, heads popped out of doorways, and a collection of people hobbled and ran toward us. They moved as fast as they could to greet Dr. Gatch. "Don, Don" they yelled, "It's Don," and they surrounded the car to greet their hero.

Dr. Gatch began to socialize and soon Cokes were offered to us. I began taking pictures; no one minded. In fact, I began to spend a lot of time there, photographing in this community of fifty people. A gradual transformation took place in my work as I got to know them. They became people who I related

to, then gradually they became friends, and finally people that I admired because they took care of each other. They also provided me with a moving story that I could hand to Dr. Gatch — documentary evidence of the failure of all the government agencies to help his fight.

As I got more and more photographs, I began to think that holding an exhibition at the Telfair Museum of Art in nearby Savannah would stir the community to the poverty around it. Establishment leaders and fellow members of the Oglethorpe Club would be my audience. I reasoned that poor white people in trouble would be easier for them to accept than poor blacks. That was my strategy. So I got to know them all as individuals. Some people said that their situation came because of isolation. They were so far removed from populous areas, so deep in the backwoods and swampland. Over the past four generations, some had married outside and moved away, but a core of thirty to fifty people had always remained there. Being poor, they had suffered at the hands of their neighbors and from the neglect of local, state, and federal social agencies that might have helped them.

For most of the past hundred years, they had struggled against disease, debts, mortgaged crops, malnutrition, lack of access to education, and minimal income from road and sawmill work. Since the 1930s a few moonshine stills had provided extra cash. Improvements came slowly; electricity in the late 1940s; a single tractor and a few cars in the 1950s. On the school bus their children usually sat together. Most had dropped out before finishing the tenth grade. Sometimes, on Saturday nights, young men from town, would speed through the community lobbing firecrackers and cherry bombs at the houses and shouting insults at the women.

I thought that anyone, even the most conservative Southerner, who saw these pictures would agree that it was unacceptable for any citizen of our rich country to live under such conditions. But I also hoped that the photographs could illustrate the amazing saga of people who had managed to retain the qualities of affection, family loyalty, tolerance, and warmth in the face of such great difficulties and ostracism. They were people who had found within themselves a great source of humanity and warmth, which they shared with each other.

In spite of what I had seen among desperately poor blacks, I had been unprepared to see white people in this condition and I deeply hoped that should I

be able to mount the exhibition I planned, museum-goers in Savannah would have the same reaction.

On July 30th, 1968, Dr. Gatch testified in the United States Senate before Senator George McGovern's Select Committee on Nutrition and Human Needs. There he revealed the fact that 73% of the children of Beaufort County, South Carolina suffered from worms. Totally inadequate sanitation and health care had led to that result. And hunger, he told the committee, was warping the bodies of American children, sapping their vitality and stunting their minds.

As Betsy Fancher put it in *Atlanta* magazine: *"Almost single-handedly, Donald Gatch had made hunger the first order of American business, and he had so stung the American conscience that tons of food were pouring into the low country to be stored in a warehouse, finally penetrating the long, mute despair of Gullahs of the low country."*

Betsy published my pictures with her article. This work was now my weapon of choice to deal with our national disgrace. I also made my photographs available to Don Gatch and they were used effectively with his testimony with Senator McGovern's committee in Washington. Gatch's testimony resulted in the U.S. government making a $550,000 grant to build a clinic in the Beaufort area. I felt very good about this result; it was the way my photography should be used.

There were other results as well. Ernest (Fritz) Hollings, the outspoken sharp-tongued Senator from Charleston, South Carolina took up Dr. Gatch's cause. Senator Hollings was on McGovern's Select Committee. After he was safely elected to the Senate in November 1968, he went to see for himself the conditions in the coastal regions of South Carolina and described what he saw in his book *Making Government Work*, "It still stuns me to think that there I was in 1969, in South Carolina's Low Country, in Beaufort County, standing in another shack that housed 15 black people. It had no heat, no running water, no bath, no toilet; inside or out. Old copies of the *Savannah Morning News* covered the cracks in the wall. The total store of food in the shack consisted of a slab of fatback, a half-filled jar of locally harvested oysters, and a stick of margarine. The only heat came from a wood-burning stove. One of the men was suffering from pellagra, a disease that was supposed to occur only in underdeveloped countries. One of the children had rickets, and another had scurvy. They were dressed in rags.

Others on the islands of Beaufort County suffered from hunger, kwashiorkor, and marasmus. Kwashiorkor is caused by severe protein and multiple nutrient deficiencies. Marasmus develops primarily from lack of food calories. Both are rare except in famine conditions. The then-common belief in the medical community had been that kwashiorkor and marasmus could not be found on the North American continent; yet doctors found both in my little state in the richest country on earth."

Don Gatch continued to agitate step-by-step for the recognition of the problems he had seen, but his medical practice began to fall apart. The decibel level of the news increased; an outraged national press went to work. When *Atlanta Magazine*, *Esquire*, the *New Republic*, and *The New York Times*, however, began to describe Gatch's world, the local reaction turned against him, and enemies began to appear. They had to get him and they did. The drugs habit that he had developed to keep himself sane in an insane world was the wedge they drove into his remaining security.

On May 31st, 1970, a group of middle-class African American women gave a debutante cotillion at the Waldorf-Astoria in New York to raise money for Dr. Gatch's work, at which time they elected him *Man of the Year.*

On the same day that Dr. Gatch was accepting this award, federal and state narcotics agents came to search his office in Bluffton, South Carolina. The Beaufort County Grand Jury indicted him for four violations of state drug laws in November 1970. If convicted, he was to spend up to six-and-a-half years in prison and pay a fine of $6,500.

I contacted a close friend, Aaron Buchsbaum, a lawyer in Savannah, who I had worked with during the Civil Rights days. Gatch denied the charges, saying: "The state of South Carolina has been trying to discredit me for the last two years... and I was told last summer that if I would leave the state there wouldn't be any prosecution." The defense got the state to drop the three most serious charges, and Don pleaded guilty to the minor charge of failure to keep proper records. The judge gave him the maximum fine of $500. But that did not end the case. The transcript of the trial was forwarded to the State Board of Medical Examiners and Dr. Gatch's license to practice medicine was revoked on the charge of keeping inadequate records.

Don Gatch's departure left the situation in Beaufort County with a huge hole in care for the poor. There was now no medical outreach to the scattered, desperate sick patients unable to get to help or pay for it. The federally sponsored clinic resulting from Senator McGovern's committee had not yet been built.

I became involved. My contacts in South Carolina were not strong, but surely members of Savannah society would pitch in. I felt that by appealing to a sense of responsibility that balanced graceful conduct with the clear needs of people who were helpless, a solution could be found. Savannah had, after all, used restraint in handling the problems that had turned other Southern cities bloody in the early 1960s. Confident that some of the same people who had brought the city credit for lifting segregation in public accommodations, school integration, and voting rights would again present themselves, I was optimistic. But I was also cautious, understanding that rural poverty and disease were not on everybody's agenda. Nudging people through the most respectable door I could find, I launched my plan; to have my documentary photography featured at one of Savannah's oldest and most prestigious cultural institutions. I was delighted when the Telfair Museum of Art agreed to do my show on poverty.

I felt that I was working in a great tradition. During the Great Depression in the 1930s, the Farm Security Administration (FSA) of the Federal Government had launched a program that sent photographers all over the United States to record the condition of the country. The photographers brought back images that informed and touched the consciousness of Americans and inspired not only great social changes brought by the Roosevelt administration, but also the next generation of professional photographers, like me. We came to believe that it was not only responsible but also ennobling to uncover conditions that could be resolved when they came to light.

The now famous work of Walker Evans and Dorothea Lange had been inspiring, not only because of the beauty of their images but because of their intentions. The intelligent application of documentary photography toward a social purpose invested my work as a photographer. And my choice of Savannah proved to be the right kind of place because here I could use my social contacts and art to do something I had come to deeply believe in.

Now I set out to call on some of the leaders of Savannah who I knew. Among them were two men with actual connections in Don Gatch's Bluffton, a

charming and influential doctor, and Savannah's most influential banker. And there was the Episcopal Bishop, and the Catholic Monsignor who had responded intelligently to the crisis of the Civil Rights movement. Sadly, my good friend Dr. Waring had died, and would be unavailable to help me coordinate my exhibition at the Telfair with a collective effort to begin a program of medical and financial help for the Bluffton area.

A week before the exhibition was to open at the Telfair, a board member of the museum came to see me. He was a friend, and had been picked to tell me that the Telfair was deeply sorry but the exhibition had to be canceled. It was too controversial.

Deciding to proceed without the exhibition, I contained my fury, kept my mouth shut, and immediately contacted powerful friends who I believed would surely help me: forget the museum show, proceed with practical measures to deal with the medical problems at hand.

I had received a six-page plan from Don Gatch on how to launch a medical solution after his departure from Bluffton. Its purpose was to specifically address the medical needs of this community. Although not all parts of the appeal were attractive to the conservative reflexes of Beaufort County, I felt that in Savannah, a far more sophisticated place, there were those who would rise to the occasion to overcome this obstacle.

SUMMARY Short Term Needs: To serve poor patients from Bluffton and a 40-mile radius a small 2-bed clinic for emergencies with a modest amount of diagnostic equipment... A full-time coordinator for six months: $4,000... Four college students working as aides — receiving college credit would get $1700 for ten weeks room and board... Long Term Needs: Nutrition and Parasite Research and Treatment Center — Laboratory; Treatment Center; Motel-like complex with 8-10 beds for seriously ill... Library and Center would serve research, training for local midwives... including nutrition and parasite specialties... This temporary solution would cost around $14,000.

On the fateful day I met with the men who I hoped would support Dr. Gatch's project, I was told in the most gentlemanly but unmistakable way, face to face; first by the doctor and then by the banker, that because of Dr. Gatch's reputation, it was not possible to become involved in any way. And that was the end of that.

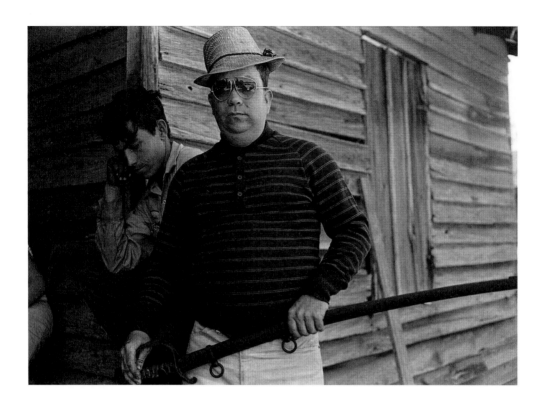

It took me many years to get over the feeling that Savannah, like Daufuskie Island, had living under its grandest oaks, ground that was infected with deadly larvae. Like Daufuskie, not all parts of the island were contaminated. There were open places where the sun dried out the sandy soil and cleansed it with the bright light of day. And, of course, nothing stays the same. Savannah has changed in many ways as well.

Don Gatch left Bluffton, South Carolina and I lost track of him until I received a letter in 1976. It was a long and optimistic letter.

"I have found an almost perfect place in this universe. I am practicing medicine in the beautifully sculpted Navajo Nation. Few other places on earth could have such wonders as the canyon deChelly, Monument Valley, Hopi villages jutting into the southern desert sky, sheepherders, mountain lakes, round hogans, et al.

It is the people themselves who make this a heavenly scene. Proud, noble, immersed in their culture — they have their basic beliefs — to walk in beauty and to live in harmony within themselves and with nature — they are and have been ecologists before there was such a word.

I have also gotten deeply into several disciplines — Zen, scientology, Rastafarianism, Rolfing, acupuncture, yogi Hari Das, some more than others. I stayed one summer at Lama — Ram Dass (Richard Alpert's) commune above Taos, New Mexico. It was like walking among the Gods.

I got off drugs several years ago at Hazelden, Minnesota, an AA rehab center where I stayed six months. Now I only do pot and psychedelics occasionally with friends. Walk in beauty. Don"

Five years or so after Don Gatch had introduced me to the to the conditions of poverty in this region I had a yearning to return there, to go deeper into their lives, to examine the relationships that developed under the extraordinary conditions that I had found.

Later, I heard that Gatch had been working in Thailand with refugees and was killed in a Jeep accident returning from a recreation leave in Bangkok.

In 2009, when I returned to Savannah to open my second exhibition of Civil Rights photography at the Telfair Museum, I was able to visit the Donald E. Gatch Medical Center on Stiney Road in Hardeeville, South Carolina. Unfortunately, the director there could not tell me anything about the man after whom the center was named. But his name was there and at the very least he lived strong in my memory.

32 – NEW YORK

On September 2nd, 1968, in New York City, I began a handwritten diary. Looking back through it, I find that it reveals forgotten details about my early life, school, travels, and more, some of which are in previous chapters of this book. Though much of what's in the diary is boring and repetitive, what I wrote became useful in a new kind of struggle — an attempt to unscramble my brain — to describe a war against myself. I churned out reams of self-analysis, sprinkled with doses of psychic pain and chronicles of idiotic love affairs. Putting things down on paper enabled me to begin to see my life in a deeper way, with more clarity, and this process continued until June 25th, 1970. The resulting hundreds of pages, almost all of which I will spare you, describe my ego-centered mid-life crisis, my efforts to grow up at the age of forty. I have also saved bits and pieces and a couple of raunchy accounts, more comic than pornographic, that also define this period.

By this time, my view of the world had changed. I was no longer interested in trying to balance my life between a charming existence and useful work in Savannah. The cancellation of my Tiger Ridge exhibition, fall-out from Don Gatch's drug bust, and my inability to create temporary solutions for the doctor's desperate patients had been huge disappointments. But these were not greater ordeals than I had previously endured. What was it then? Had these failures affected my desire to settle down, and killed my appetite for conformity? Were the roots of these problems in Savannah?

No, they were in me.

The first thing I did to turn my world upside down was break up my family. I told Monica I wanted a divorce. The building blocks that had formed our mar-

riage had weathered in different ways and they no longer fit. The marriage was a mess. Monica wanted to keep it, but I didn't. Instead of sinking me, Monica saved me. She agreed to an uncontested divorce. She could have taken me to the cleaner's with a tough financial settlement, but she didn't. This would have been the end of my life of exploration. She was generous under what must have been humiliating and painful conditions for her.

Monica decided to remain in Savannah after our divorce. Among the things that kept her there was that she had become involved in the teachings of Mary Baker Eddy and had many devout Christian Scientist friends. She dutifully went to Sweden once a year to see her family, but returned to her life in Savannah, where she was totally absorbed in her new belief system.

At first, the boys were with her as well. Because of the poor academic condition of Savannah's public schools, they had been enrolled in a private Montessori grammar school, but it turned out to be strong on self-expression and low on technical skills. After bringing them to New York to be tested at Columbia's Graduate School of Education, I discovered that they barely knew how to read and write. My education, as well as my brother's, had been guaranteed by a fund that had been set up by our grandfather, Robert Gamble. This made it possible for us to attend private secondary schools. Although both my brother and I were able to go to college on the GI Bill, our earlier education had been funded in this way. The same privilege was extended to Breck and Grattan.

I decided to avoid sending them to "the best" school in Savannah, where things like membership in the yacht club were markers of social status. Boarding school in the northeast was a family tradition. My mother and her mother, her brothers, and all other uncles and my father were shipped off at an early age to schools a thousand miles from home. The same tradition sent, first my brother, then me to St. Mark's School in Massachusetts. There was no effort to match either of us to a particular school with respect to our talents. St. Mark's was a fashionable pick and that was all that was required. I determined to do it differently with my sons, and so, drawing on my disastrous experience with prep schools, the boys and I made the rounds to try to match their needs and talents to a particular school. At best, it was an academic guessing game, but one thing was clear; the schools were all elitist. But I reasoned that if the boys had to cope with elitism, the upgrade might provide more interesting choices.

At Eaglebrook in Deerfield, Massachusetts for example, which Grattan chose, he had a classmate who was the son of the King of Jordan. And Breck went to the Fay School in Southborough, Massachusetts.

I was able to solve my immediate responsibilities to the children in a technical sense, but by 1968 my dream of freedom had become a bad dream. I felt guilty; a dull, debilitating condition settled in my gut, that old familiar feeling — the abandonment thing. But now, I wasn't abandoned, I was doing the abandoning, and it tore my life out by the roots.

In place of Don Gatch's Navajo Reservation, I chose to move into my brother's guest room in his New York apartment, returning intermittently to Savannah to maintain what I could by seeing the boys during their vacations and paying my bills by doing photographic assignments at nearby resorts.

In New York, I searched for myself with a pen and yellow legal pad. I began to drain the *me's* and *my's* of memory, starting with earliest recollections. Don had searched for his redemption through exotic modes of contemplation (with an occasional boost of LSD) but I avoided those experiments. The writing opened some kind of internal valve that released a reservoir of stored experience and energy. It provided intimate insights that would mean nothing to anybody else, but bit by bit exposed hidden fissures in my past.

The 1968 journal actually began as a long letter to young woman I had met soon after moving to New York and was trying to win back after she kicked me out of her life. Christina von Braun was the daughter of Baron Sigismund von Braun, who was German Ambassador to the United Nations from 1968 to 1970, and the older brother of Wernher von Braun, the rocket expert who had been recruited by NASA to work on the space program. She was beautiful, well-educated, and intelligent. Our romance didn't amount to much; she broke it up before it could be described as a romance. But her effect on me was transformative. The letter to Christina that started as an attempt to snare her soon became the first part of two diaries that added up to more than 600 pages. Sometimes the letter/diary sent me into my darkest places, but there were other moments when I zoomed around in dizzy fantasy as I thought up ways to impress Christina. For example, my last-ditch effort to get her to meet me for a reconciliation lunch at the Museum of Modern Art was described in my diary as Plan A:

"A skywriting plane will spell out over Manhattan the following message: 'I'm crazy about Christina. Meet me for lunch at MoMA at Noon' — *all in white smoke."* The diary went on to describe that there were complications: Christina is too long a name to spell out over Central Park and it would be impossible to get "Meet me for lunch at MoMA at Noon" to fit over Manhattan. It could be squeezed in over Hoboken but then she wouldn't find where to meet me.

But I also had Plan B; *"Slip in in a special message in a Chinese Fortune Cookie that said: 'Today is a day of good luck; Go to the MoMA at twelve o'clock, find something nicer than Peking Duck.'"* This message I was actually able to deliver.

At our last meeting at the Museum of Modern Art, the 24-year-old Christina made it clear that our relationship was finished and her response was clear — so much for fortune cookies.

The word that I vividly remember from that meeting was her description of me as *egoistic*. This was particularly bad news because I knew she was right. I returned to my writing, but it changed direction as the letters to Christina became a diary reviewing my life, unsticking memories that came floating to the surface and recording moods of the moment.

In order to make sense of the breakup of my family, I started to examine my old life, to make sense of a new one, searching for clues on how to build something useful out of something that was such a mess. How did it all go wrong? Actually, the *how* was no secret but the real question was *why*?

Sitting next to a priest on an airplane one day gave me the idea of comparing opposites. Immediate circumstances were too mixed up to unscramble, so I began writing about two places, with contradictory characteristics, that had deeply touched me and raised questions about my relationship to these worlds. India had been a land of contradictions, whereas the Arctic provided potent clarity. These differences were marked by an intuitive compass that I hoped would tell me how and where I could dig myself out of my domestic wreckage. This was my starting point but I didn't have any idea where it would lead me.

India was a place that shrank the size of individuals to uncountable specks. The overwhelming reality of a half a billion people, crammed with beauty and horror, made it hard to see the whole of whatever it was. It choked me with its abundance as I observed and tried to record the lives of over-

whelmed Peace Corps Volunteers coping with their jobs. In India we were all ants in the forest, crawling through underbrush of gorgeous confusion — jammed, crowded, invisible, and swallowed by the totality of numbers as well as a myriad of rules that divided and sub-divided humanity into castes and religions through centuries of historical complexity. Conceptually, people here were like dots on a newspaper photo. It wasn't until I got to Lake Pushkar that I was finally able to see India beyond this confusion by looking at its complexity through the unifying relationship of life-giving rivers and monsoons. By making water the unifying concept, I was no longer blinded by the dots. This, of course, was something I wanted to do with my current life — clear the confusion — but I was unable to organize my dots because they felt more like the smears and drips in one of Jackson Pollock's obsessive paintings.

Next, my pen and yellow pad took me for another hundred-page trip to another chapter, the high Arctic and my experience aboard *Titanic*.

The Arctic is clear and unambiguous. When we had chugged into Magdalena Bay, I was at the helm of tiny *Titanic* — Admiral of the Oceans and King of the World — having traversed miles of rock-bound coast thrashed by a raging sea that generously permitted us to pass safely. Of course then, a few days later, it had changed its mind and almost killed us, wave by wave, before our streaming engine finally conked out at Welcome Point on the Hinlopen Straits, six hundred miles south of the North Pole.

That situation polished up my ego. There, it had been possible to stand up clearly revealed — a visible speck — challenging the Arctic nature. Many had died reaching for the spectacular because the Arctic had a powerful attraction for certain kinds of men and I counted myself as one of the survivors.

I had stretched my guts across the Arctic for years. I lived on nerve and willpower. My imagination and a wild attraction to ego-centered risk propelled me in dangerous directions. I thought I was educating myself. I saw my camera as an extension of my curiosity and the Arctic was my chosen teacher. I learned all right. I learned to lie, steal, and stay alive, and at the same time to function as a photographer and deliver what I said I would. I measured myself by doing things that I was proud to describe. I functioned with powerful men who had been brought up to survive where mistakes could be final. These men were strong — really tough but gentle because they knew who they were and what they were.

That taught me something. The Arctic provides final truths, its overpowering nature puts man in his proper place and, that done, there's no need to lie again. I then learned to be attracted to the truth, to recognize it, to face it in the Arctic. I also learned to distrust *certainty* — too many engine breakdowns with *Titanic*, friendships that didn't quite mature as they should have — and I began to be drawn toward what was beyond the obvious. In the Arctic you could see things that were beautiful — humbling — and admit that they were overpowering and you were nothing in the final count, and a better person for that realization. My Texas pal, Stenger, called that phenomenon God; my writing was just another way of looking at it and I didn't know what to call it. But it cleansed me. These moments, like so many in Korea, crystalized something that transformed me.

But what did this have to do with my current state of mind? What had I discovered after Borneo, India, and Afghanistan? What was on my final report card? What really happened after the Arctic? Was I really so brave? No I wasn't. Too often I came in like a whipped dog — back to Monica. It's *that lonely thing* again. But what did loneliness have to do with Monica? Was it related to some deep need that dated back to the memory of my mother allowing me to snuggle up in her bed — once in a while — when I was nine?

The diary began to turn up so many buried clues that had so many shapes. It drew on some things I could remember but its power lay deeper; way, way down there where I couldn't pull things up to the light. It probably started with the dimmest yet the strongest of all my memories. "My father's gone, but who knows why, when I was five?"

What does loneliness sound like? It's like the lone cry of a far-off train whistle at midnight, beyond the stable where the woods began on the edge of our farm in Virginia. Where was it going? Who was on it? I wanted to be crowded aboard. Occasionally a light breeze swished a branch against the tin roof to remind me where I really was — when I was thirteen.

Then, I began to examine my earliest hopes for Savannah. My life there had no direct correlation to either India or the Arctic. It was a watered down middle ground, but it had elements that reminded me of India, its connections to a graceful cultural past, and some ugly realities that sustained it.

As one of America's most beautiful cities, Savannah's thoughtful layout of elegant squares decorated, shaded, and protected by magnolias, azaleas, and

powerful live oaks sent me in the direction of assuming that the graceful archi-
tecture, so appropriately scaled to the environment, had to influence the inhabit-
ants in some positive way. Perhaps a gentler, wiser, and more compassionate at-
titude would cling to them like a special fragrance. But it turned out that this
special fragrance was insufficient to share wildly and it was not the whiff of gen-
tle generosity that I was looking for. This fragrance, should it ever be distilled and
bottled, would require a warning label: *Incorrect use can be too controversial.*
Ironically, the charming doctor and influential banker, friends of my family, oc-
casional wise father figures for me, became naked holy men from India with cow
shit in their hair after they chose to ignore the stench in their own back yard.

The yellow pages of my diary continued to pile up. They were no longer reve-
latory extensions of my letters to Christina but drew from a murky inner swamp
that I was trying to drain. On energetic days, they were sprayed out in a fine fog
of words that quickly became a verbal monsoon, recording my ups and downs.
The downs were spent lying in bed writing, dissecting events that would have
been normally ignored. My pen was like a stick of wood for a shipwrecked man,
it wasn't a life raft but it kept hope alive. At other times it was like an infected
wound that I could lance with my pen to let out the pain with words. There were
long sequences that flowed like poetry but too often it was gibberish.

Sometimes, I got out of my funk through physical exercise. Dashing out of
the apartment, I liked to feel my body moving fast. Bounding along the side-
walks, jaywalking across the streets, walking twice as fast as everybody else:
seeking what? Unforeseen possibilities streaked by — my life was an unedited
film — no plot, no plan. I was the main character followed by my own shadow
— a vague sense of catastrophe nipped at my heels.

*October 4th, 1968. Last night as I was tearing down 57th Street I came upon
a man lying face down in a pool of blood – between 6th and 7th Avenue. There
were six or seven people looking at him, chatting quite casually, as if he were not
real. I cut in and asked whether anyone had called the cops. They didn't know so
I lit out toward the subway on 6th Avenue where I found a cop – thinking that the
man should know that help was on the way. Got back – the people were still
standing around, not too close. He was still face down on the bloody concrete.
"He needs a towel under his face," I thought. We were near a hotel entrance. The
doorman was taking it all in. I asked him if he could get a towel. "See the man-*

ager," he said. No manager, so I found the men's room in the lobby, got a towel, took it and put it under the man's head. He must have been there a while. The blood was sticky. I told him that the cops were on the way and then they arrived. I cut out. I had hardly broken stride. It happened so fast.

Was I really trying to put a comforting towel under my own head to reengage with something real?

These bouts of writing were broken by both work and play. The work part had to do with photo assignments to expand my resort coverage. Gamble's attitude had been very clear and he tried to guide me on a route to economic salvation. He offered to introduce me to a commercial photographer, someone who photographed stockings. He saw better cost accounting procedures as my greatest need.

I still got occasional magazine assignments: an interesting one was a job for *Sports Illustrated* covering the maiden voyage of *HMS Rose*, a 108 foot-long replica of a revolutionary British frigate built in Lunenburg, Nova Scotia for John Millar, an eccentric young millionaire from Newport, RI. The original Royal Navy frigate, launched in 1757, was used to restrict smuggling in the colony of Rhode Island. Her success, which greatly reduced the income of Newport merchants, is credited with bringing Rhode Island into armed rebellion two months before the Revolutionary War began and provoked the creation of a small naval force against vessels like the *Rose* that became the Continental Navy. (Ironically, the original *HMS Rose* was later scuttled in a narrow bend of the Savannah River to prevent the French fleet from supporting the colonial forces that were attacking British-held Savannah in 1779.)

The *Rose* project was a $330,000 endeavor and I joined the ship during the last stages of her rigging in Lunenburg. Although John Millar had hired a small number of professionals to sail her, there were swarms of his young Newport hippie friends who would help to rig her and serve as crew. *HMS Rose* was a full-rigged sailing ship and, like her ancestor, she had no engine or modern nautical hardware. Fortunately, the journey from Nova Scotia south was blessed with good weather, but this couldn't suppress the voice of this brand new antique. While sleeping below deck in a swaying hammock, I found that the wooden ship provided a non-stop symphony of creaks and groans.

As we approached Boston, a strong wind sent us along at a clip that made it difficult for the accompanying tugboats to keep up. As we sailed into the harbor, a powerful gust, briefly deflected by a skyscraper, caught us as we passed, and snapped a topmast that crashed to the deck. A few crew members were trapped in the tangled rigging, and I sprang to their aid. Luckily, nobody was hurt but my instincts were the wrong ones, humanitarian reflexes didn't get the job done. Sadly, I had not only been of no particular help, but most important, I didn't record the dramatic event, a picture that I needed. Did I really have the instincts of a photojournalist? Another question to think about. Maybe I was more inclined to be a documentary photographer, where considered humanitarian reflection was more important than quick journalistic reflexes. I was given a chance to check this out.

On one of my resort assignments at Fripp Island, South Carolina, I bumped into Constantine Manos, a photographer of some note and a member of Magnum Photos. I invited Constantine, known as "Costa," to Savannah as I was anxious to show him a series of new handmade books I had made about the India experience. The black and white photographs, I hoped, visually expressed how I had successfully thought through my feelings about India through the unifying concept of water. In my diary I wrote: *"He asked my permission to be brutally honest. And he proceeded to give me a very sound lecture on the subject of my photography: I didn't get in close enough. I was not catching "the decisive moment," á la Cartier-Bresson; I was not making a definitive statement about the people; I was on the outside looking in. I didn't get to the core of the matter.*

In a final damning evaluation, the India material, he said, didn't contain a single picture that he would want to own, or hang on his wall. When I didn't disagree with any of this he knew he had an attentive pupil on his hands.

To my amazement, the diary indicated that I neither defended myself nor took issue with what Constantine said. This was in spite of the fact that a month earlier, I had taken the India work to show John Szarkowski, Curator of Photography at the Museum of Modern Art. John liked it, said I had a book, and gave me what seemed to be hours of his time. This story illustrates my mindset in 1968. Most photographers would give blood to have heard such kind words from John Szarkowski and I never mentioned this to Constantine Manos or disagreed with any of his pronouncements. This was not Picasso-in-

spired Fred Baldwin. There was no fight in this Fred Baldwin. Good God! I was somebody else.

This conversation must have assassinated my confidence. Nothing was done with the India material. I became even more reluctant to travel to work in my photo lab in Savannah so close to the ruins of my bombed-out marriage, preferring to hide out in New York.

New York wasn't all downbeat. There were stretches in New York that were fun. Gamble was generous in sharing his broad social contacts and he took me to cocktail parties. At one, I met an attractive young woman named Laura Walker. Her date was a young man who looked as though he had been slipped into Brooks Brothers' diapers at birth. He buzzed around while we talked, collecting telephone numbers on the sly. Laura pretended not to notice but retaliated by sitting on my lap. Great piles of soft hair caught my breath. She was warm, kind, responsive, social, and from this circumstantially inappropriate but cozy position, she described her good works for the *unfortunate* that she did via committees and charity balls. She was employed by Lilly Pulitzer Boutique. Lilly was the enterprising socialite from Palm Beach, married to Peter Pulitzer, an ex-roommate of mine from St. Mark's.

Her date returned and neither of us looked at him. Finally he circled back for the third time and stood there, speechless, looking at Laura, who said, "If you've collected enough addresses, we can go." Then she kissed me goodbye and left.

I missed getting her phone number but learned that she lived with her parents. Unfortunately, their number was unlisted. My brother checked his *out of date* Social Register that had belonged to someone else. It worked. I reached her and asked her out and she responded: "Well, what about Tuesday December thirteenth?"

It was November 8th. Laura's schedule was crowded. She was going skiing and on to Bermuda. Then it would be Thanksgiving, and time to gear up for all those balls — the World Series of the New York social season. I jotted her down for December 13th. But I had a terrible feeling that our destiny and her phone number was written on glass. It was going to be too easy to smooth away and that's what happened.

I made frequent trips back to Savannah because of work and because I really missed the kids and felt guilty about running away so I spent every school

vacation with them. They needed attention. Breck said, "Mother doesn't fight me," in front of Monica. She laughed. He meant she didn't challenge his brain. This gave me a sinking feeling. This was my job. The kid was very bright.

On one occasion a few years earlier, Breck bumped his head. I got him some ice and told him that I was going to get him a special hat and fill it with ice and put an advertisement for the ice company on it. He would be able to go out every day and get his hat filled up free of charge. I told him that his brain would be so cold that all he would be able to say was: "brrr, brrr." We made quite a routine out of this. Six-year-old Breck was very amused and so was I.

One year, I took the two boys on a road trip to visit Washington, DC during a school vacation. While driving, when the sun fell and the car lights were turned on, we played a game we made up called "Popeye." The first person to spot a car with only one headlight would yell "POPEYE!" Such distractions kept the kids amused and me awake. When we got to Washington, we visited the usual tourist sites, among them the FBI building. There, in the Visitors Center display area, a young agent described the attributes of a weapon used in suppressing some particularly heinous crime. Fortunately for me, he misidentified the fire-arm and I was able to correct him, explaining that this was actually a .45 caliber Thompson submachine gun and I was further able to identify its weight and rate of fire. The FBI man looked a bit amazed and the boys were delighted.

Looking back, it seemed to me that every vacation, every summer break was filled with the fun of experiencing their development: a range of recreation that included Monopoly games, the beginning of a stamp collection for Breck, a model train for Grattan, and many balsa wood airplanes, some of which actually flew. And, of course, I told them lots of stories. Years after the boys were grown men, I had an exhibition at the Telfair Museum of my Civil Rights work, Breck flew down to Savannah to attend the opening, and he and my friend John Thorsen came together to hear my talk. John was very impressed, and said to Breck, "Your father has a lot of good stories to tell." Breck turned to him with a weary shrug, "Yeah, I've heard 'em all."

Yes, I loved Breck and Grattan, but what I had loved as much was a life that so often took me away from daily contact with them, and thus deprived them to some degree of the interaction that I had missed with my own father after the age of five. My freelance life style was not as wide-ranging as before their

birth, but my principal focus was certainly not fatherhood. I was not available full time, an important condition for the growth of children. There were holes in the program, and *who knows what* dropped through that led to Breck's comment: "Mother doesn't fight me." Like it or not, the young life of boys is so much about learning what to fight, what not to fight, and how to fight.

Back in New York, domestic concerns were replaced in my diary by detailed descriptions of my hurly-burly life-style laced with turgid descriptions of skirt chasing. It was like going to a cocktail party a little bit hungry. So I ate a spicy hors d'oeuvre to kill my appetite. It wasn't very good, I didn't have another, and wished I had waited for a serious dinner. Here's a hot snack described in my diary:

The disastrous evening opened in Camilla's bed with the commensurate fits and starts of imperfect passion. There were frequent ups and downs. I got up at least eight times for liquid refreshment — one bottle of champagne at the beginning of the campaign and two full quarts of soda water during many lulls. Camilla had a tomcat that in all respects was uninteresting except that it had six toes. (I think his name was Damned Cat... at least that's what I called him.) The cat, used to sleeping with Camilla, resented me, so it would playfully jump on my back while I was sleeping — or trying to — or screwing — or trying to, and I would playfully throw it across the room, which wasn't very far because it was a tiny one-room apartment. The size of the apartment isn't important except the cat got the shits from eating some of my romantic provisions — specifically; the Brie cheese that I brought with the champagne and it had numerous movements in its Kitty box, which due to the size of the apartment wasn't very far away. Every time this happened we were notified by the excruciating odor of Brie-flavored cat shit and Camilla would leap out of bed to get the Pine Mist. I would then make another trip to the bathroom to relieve myself of all the liquid I had taken in but it was a hazardous journey as I feared knocking over the bottles or stepping in the Kitty box.

Camilla worked on me between innings and performed some erotica that I had heretofore not experienced. I got more nervous than inflamed... Finally it was bingo and I was totally wiped out, at which time an alarm clock went off. It was officially the moment to get up but I was completely down. Then she said that I was to be her "long-term fucker." I didn't like the sound of it and she added sweetly: "You're going to stay with me Freddy." I tried to change the subject and

finally told her: "I'm an eagle, Camilla. Eagles are very powerful but shy," and described Alfred the Eagle catcher, a butcher, in Arctic Norway, who would make a hole in the top of a mountain, hang out some cow parts, lure eagles into his hole and strangle the big birds for a bounty. I tried to tell her that eagles had to be careful about easy meat; but hope I indicated that I didn't want to be "her long term-fucker" more delicately than that.

Camilla was one of any number of desperate affairs with women I didn't care much about. Then I met Ann Bird. I tripped and fell hard. We met at a cocktail party of an artist friend. My usual stories came bubbling out, ranging from polar bears to Civil Rights; the same material that had landed me a Peace Corps job but hyped and shaped by circumstances and a couple of drinks. When I'm attracted by a woman my delivery is sharpened, the pace adjusted to the target. I felt like a fighter pilot maneuvering tight turns to get in a killing conversational shot. The intensity that Christina had fled from seemed to attract Ann Bird. My target was smart, funny, talented, artistic, impulsive, and unpredictable. That's what I liked best. She didn't fit the norm and I was deeply attracted to the rebel that I guessed was in her. I called her Bird rather than Ann. Bird seemed freer — more avian; Ann was more down to earth. I wasn't stimulated by *down to earth*.

We made love on two occasions and the results were a disaster.

I had only known Bird for a few days when she came over to Gamble's apartment to take a bath. Her hot water heater was broken. We knew that we were to become lovers. It was implicit from the first meeting. We were enormously attracted to each other. When she finished her bath, she came out in my bathrobe and underneath she was naked. Bird's body to me was a thing of rare beauty. I was slightly drunk. We had knocked off a bottle of wine. We started to make love, but it wasn't working as it should have been. There would be another chance; and there was another chance, this time at her place, a run-down apartment way over on East 94th Street. I had already fallen for this girl so the experience was very important.

It was an elaborate evening — transformative — so she was going to give me the full Bird treatment, but at the time I didn't know what that meant. She cooked me dinner, which wasn't very good, then she played Mozart on a huge piano that took up most of the apartment. This was also for me. The Mozart was better than the food, but I stupidly mentioned that I didn't know much about music.

Then she showed me an album of pictures of her family, and I saw her there as a little girl. I was impatient; please, no more Mozart, no more tricycles. I was more interested in the immediate carnal future than high culture. She was determined to continue on trips down memory lane but, finally, she came to bed. It was tiny because her flat had to accommodate that grand piano.

She simply pulled her dress over her head and stepped out of her underpants, which was all she ever wore, and joined me. She aroused me, and I went at her like a hungry dog. But there was a strange, withdrawn quality about her and as she gave, it seemed that she couldn't give. The moment I sensed this, my romantic fantasy shattered and I withered. As I lay on top of her — I still wanted her — but it was the end of lovemaking, and the beginning of an uneasy feeling that I had missed the mark. Making love is not a sex flick; reality smells and tastes quite different. Bird managed what even war had not done. In Korea, I knew who I was, but here I began to doubt myself, not right then, but that was the start. It's odd, it could have been her but I blamed myself. Why?

With problems in the past, there had always been ways to shift, correct, and set sail in a new direction toward things that were possible. But here there were no tools I knew how to use. I had no idea where to look, how to proceed, or who to consult. The compass needle was spinning and there was no north or south, just a weird feeling of being lost. Here the phrase *missing in action* meant missing *the* action. This literally described the problem.

During this time my diary writing continued, chronicling a roller-coaster ride in my relationship with Bird that mapped an emotional course that flew up with hope then plunged to despair, only to start climbing again, and to take another plunge. It was a classic course of intermittent reinforcement. As a student in the psychology lab at Columbia, I had measured the behavior of two rats, both of which were supposed to do some task that I can't remember. One rat was fed every time it performed the task; the other was only fed every other time. Its routine was constantly changed; there was no consistency. The test showed that intermittent feeding influenced the rat's behavior more quickly than consistent rewards. Evidently uncertainty focused its attention more sharply.

Broken lunch appointments, teasing phone calls, I never knew where I stood with Bird and the intermittent feeding had the same effect on me as it had on the rats. I got the idea that I could win her back with creativity. I made a

series of elaborate drawings that were a cartoon version of some of the things we had done together, a montage of movie tickets, snapshots, and drawings. She loved them. She got it, and this was one of the things that drew me to her. But I refused to give her my art. The drawings were, in a way, more real than our relationship. I would have kicked her out of my head but Bird's unpredictability intrigued me. This went on for months. Then there were hints that she might have returned to an old lover or picked up a new one. It was hell, because I found myself dangling on ambiguous interpretations of her tone of voice. Then she told me about her abusive father. Of course, she adored him. I attempted to factor that information into the workings of my crystal ball. She too had abandonment problems. This hooked me even more deeply. I would save her, I thought. After all, I was an expert on abandonment problems.

Prompted by this, I wrote about a dog of mine called Wiltley, that I had owned in Kuching:

For two years in Sarawak, I collected stray animals: dogs, cats, monkeys, fish, and birds. But Wiltley was a big male and I was particularly fond of him. If I had been a dog, I might have been one like Wiltley. A couple of months before we were scheduled to depart from Sarawak at the end of my two-year tour, I found families to take the animals and gave Wiltley to a nurse who liked dogs and would provide a good home. Wiltley had always been a homebody, however, and never so much as strayed out of my yard. The nurse lived near the airport, seven miles out of town. Two weeks later, he showed up back at our house. Wiltley was absolutely berserk with joy at seeing me and finding his way home... The only problem, he got upset every time I went to the office and would go wild when I came back to the house. Wiltley didn't want me out of his sight and would follow me from room to room. When we started packing, it got really bad. The dog knew and he was scared to death. The day before we left, Wiltley disappeared. We never saw him again.

This story hurt so much to tell, it had remained untold, bottled up. It would raise the question, "What about my kids?" But how could any of that relate to a dog in Borneo? He was just a poor abandoned mutt.

The memory still haunted me, and it had brought me back to Monica at moments when I wanted to run to another adventure; I couldn't face dumping her, but I did. My relationship with Bird had also slipped into this mode. Ridicu-

lously, I thought, I could save her — and myself. The diary reflected my condition, and painful moments dribbled out of the end of my pen.

I turned my eyes 180° inward and became involved with practically nothing except myself. This was not a period that left much room for Breck and Grattan. There was love, but its beam must have seemed invisible in Savannah. Monica was a loving mother who believed that peace was the ultimate goal and it mediated her actions. I believed in peace, but my formula to realize it included knowing how to fight to achieve it. I remember that once Grattan told me about a bully, and I told him that I knew about a judo class that he could take. There must have been so many other points in the lives of the boys that I missed.

My diary described a situation in my own youth. This was the kind of story that I didn't tell them.

When I was a kid, I was always on the verge of feeling myself a sissy. When I was about ten years old back in Jacksonville, I went to a party. It was a Halloween outdoor affair and there were a lot of kids, boys from my school there. I don't remember how the thing came up but a couple of friends were telling me how tough a certain kid was. He was the biggest and toughest kid at the party and the next thing I knew, I was screaming "Hi ho, Silver" and away I went after that kid. I hit him with a tackle and down he went with me on top of him. It must have surprised the hell out of that kid. I remember afterwards feeling very proud. Other kids came up to me afterwards and said: "Why don't you do that at school?"

Later I felt badly about my behavior. I liked him. Afterwards I wondered why I had done it but maybe we wouldn't have become friends if I hadn't done it.

Back in New York, there were dozens of flat emotionless affairs. As with Christina, many of the women retreated because of the hurricane of intensity that I provided as my demons elbowed their way out, cribbing my history lessons and delivering me, me, me, irrespective of the needs and moods of others. Heartfelt stories rushed out of my mouth: North Korea at 36 degrees below zero, Picasso and Mexican cowboys, marlin underwater, reindeer herds, and polar bears, it all came pouring out.

By 1970, the Picasso mantra looked like a helmet that had been dented from too many battles. I needed to have a dream, but not a bad dream. My imagination by this time was producing giant hot-air balloons in my diary. My

worst fear was that I had lost contact with the intuitive intelligence that I had accumulated over half a lifetime of experience. My compass was spinning. Signs of this began to show in the pages of my diary. Still, I kept writing, hoping to find something that would come to the surface to help me save myself.

On Jan 25th, 1970, on my forty-first birthday I wrote, *Last night I got a sudden urge to throw the diaries away. They're an excuse to delude myself that I'm working. It's not literature in any sense. It's not building blocks for future reference. It's ego and in many cases it's a painkilling catharsis but what's it worth? It's a detailed catalog of a confused, angry, and pained brain. Is an unedited, undisciplined record of a messed-up mind worth something? It spills out all the garbage but I'll keep it going a little longer — maybe a little bit of something useful will stick to the trash.*

It took a while but I finally got my wish. On May 21st, 1970 on page 408 of the second diary, I wrote:

The time has come to write the final chapter of the Bird Diary. I had heard about her boyfriend so I decided to go over and have a look. I didn't believe he really existed. The front door of the apartment building was locked but by slipping a credit card into the door slot I was able to open it and break in. On the eighth floor, I rang the bell of her apartment. Bird appeared, in a white dress slightly askew with one button undone. There was the smell of cooking. He was there all right — a large nice-looking young man. Bird let me in. We almost had a fight, the boyfriend and I. Supercharged, I said, "You look great in that dress I bought you." And I left.

I didn't accomplish what I had come up to do — throw the boyfriend out and make love to Bird. The battle was lost, but I won the war. He didn't get thrown out but Bird did. I walked out not knowing fear — liberated — feeling like a fully-grown man. It was almost unbelievable: I had won myself back. The pain, the doubts, lifted and I felt cleansed.

It took some time to understand the psychological mechanisms that unlocked the gate that released me, with the help of the felonious use of my credit card, of course. I passed into a new world. Actually it was the old world, where everything was now possible. If I had taken a powerful drug, it couldn't have created a more instant change, but I've come to the conclusion that I had used this prescription before, and — the final commandment of the Picasso mantra

— I had acted. This ended the war against me. Again I felt ready for the next round of battles, as I had on July 28th, 1955, when I walked out the door of Pablo Picasso's Villa Californie.

This closed the four hundred and eight pain-filled pages of what I call the Bird Diary, a continuation after more than 200 pages of the more upbeat Christina Diary. The writing continued, of course, but pain and Bird were gone. In doing research for this book, I noted with amazement that on the last page, number 421, thirty-five days after getting rid of Bird, there was a final notation, *June 25th. Went to Torta's party Thursday night. Met Wendy Watriss.*

Years later, when asked how I met Wendy Watriss by a journalist friend, James Estrin, who edits the photo blog *Lens* for *The New York Times*, I couldn't resist describing our meeting. To my amazement, the following item appeared on March 8th, 2012 in *Lens*:

Before Fred Baldwin *and* Wendy Watriss *became chroniclers of American rural life and inspired generations of photographers and scores of photo festivals around the world, there had to be a beginning.*

So how did their partnership start?

"With a torrid affair," Mr. Baldwin said.

"It was the end of the '60s," Ms. Watriss added, with a smile and a shrug.

That accounts for the miniskirt she was wearing — which Mr. Baldwin still remembers — when they met at a party inside the Manhattan home of an Italian duchess. Though their encounter stirred strong feelings, it took a while for their partnership to gel. (By now, it's so complete that they've gone from sharing by-lines to completing each other's sentences with ease.)

"I split to Vienna," she said.

"Because she left, I immersed myself in yoga," he added.

Ms. Watriss was reporting as a stringer for Newsweek *and freelancing for* The New York Times. *She had no intention of ever returning. But eight months later, she did, for Mr. Baldwin, and shortly after, they loaded up a tiny trailer and set off to write about and photograph rural America. That is where their partnership started.*

Which takes me to the next chapter.

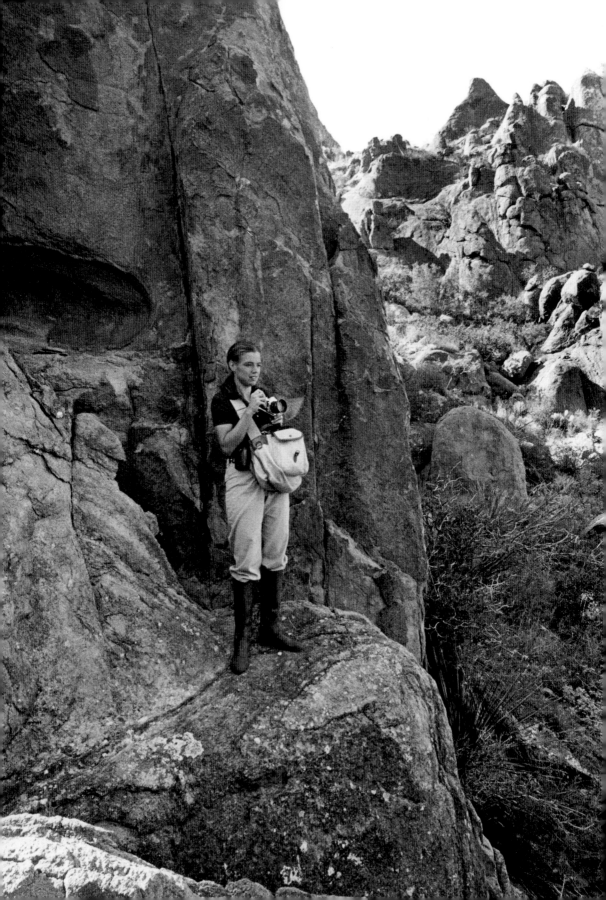

33 – **WENDY WATRISS**
THE FUTURE

The miniskirt that James Estrin referred to was only the first of many "eye-openers" that got my attention. Wendy turned out to not only be sexy but also fiercely intelligent. She had strong opinions, was well read, and had graduated with the Founders Award prize from New York University. Although my recent history revealed a predilection for good-looking, screwed-up women, Wendy wasn't screwed up.

Born in San Francisco, she had lived in Greece and Spain, where her father worked in the U.S. State Department. She had studied in Madrid and in Paris and spoke Spanish and French fluently. By the age of twenty-four she was committed to being a journalist; she had worked as a city hall reporter in Florida at the *St. Petersburg Times*, and been a co-producer and writer at the Public Broadcast Laboratory in New York. Funded by the Ford Foundation, the Public Broadcast Laboratory was the experimental television news channel that became PBS. Recently, she had switched to freelance photojournalism having just finished an assignment in West Africa for *Signature Magazine*.

I seemed to appeal to her. That was a major miracle. She loved my stories and we shared a vision about exploring and doing something socially and politically useful with photography. In the meantime, however, we had to make a living, so we took what assignments we could get. For three months we worked together. Sometimes I found the subjects and sometimes she did. Our first story together was at the Saratoga New York annual Yearling Sales, a kind of debutante party for racehorses. The America Cup was next and we drove to Newport, Rhode Island to cover the race, staying with a friend of Wendy's from

prep-school days. Later, we flew to Montego Bay, Jamaica to do resort work for one of my clients.

In 1971 I met her mother, Lorraine, living in New York. She was sufficiently glamorous to have been on the cover of *LIFE* magazine in 1942 wearing her Volunteer Red Cross uniform. Together with Wendy's father, Jimmy Watriss, a Navy test pilot during World War II, they made an upbeat wartime story. (Wendy's aunt and godmother, Brenda Frazier, a celebrated New York debutante, had preceded her on *LIFE*'s cover in 1938.) Wendy's mother seemed to like me, but had strong doubts about my education, as revealed by my atrocious spelling in thank-you letters. Thank God, the little drawings I included in them amused her.

My introduction to Wendy's father, included a "most embarrassing moment." Wendy and I were invited to meet him for lunch at New York's celebrity-ridden 21 Club. We were ushered to what was evidently an ultra-chic section of the restaurant, to "Jimmy's usual spot." On my best behavior, anxious to make a good impression and curious about the culinary favorite among the "in crowd," I agreed to order a 21 specialty, creamed chipped beef. But when the dish arrived I blurted out in uncontrolled amazement,

"My God, it's 'shit on a shingle!'"

Without knowing it, I had ordered what turned out to be a high-grade version of the low-grade gastronomic disaster that was served on every chow line on every troop ship that I had ever been aboard; a meal that we were convinced was designed to torture Marines. Fortunately, ex-Naval officer Jimmy Watriss knew about such things and my outburst was forgiven.

I met Wendy at the right time. In a war with myself, I had forced the enemy to retreat, captured most of my monsters and locked them up in my diary, a kind of POW camp for bad memories. But there was a huge problem. Wendy was overdue to depart for Vienna to satisfy long-term commitments writing and shooting several stories in Eastern Europe. When Wendy left, I returned to Savannah to clean up my affairs and wait. My strategy was to lure Wendy back with fascinating work possibilities. Letters to Vienna were both declarations from the heart and descriptions of voyages of discovery.

Wendy and I had discussed our mutual desire to re-discover our own country, immersing ourselves in the lives of other people across the country.

My old friend and publishing contact, Jerry Mason at Ridge Press, encouraged me to work out these dreams in a book project to be called *Back Roads of America*. This evidently had the effect I was praying for when I described it to Wendy in a series of letters. In them, I described our prospective discovery of life beyond the superhighways, an examination of our country at low velocity; to stop, look, talk, spend time, and participate, capturing it all on film. She agreed, and after completing assignments in Austria, Czechoslovakia, Hungary, Rumania, and Yugoslavia as a freelance photographer and writer for *Newsweek* and other publications, she returned to the U.S. on March 17th, 1972.

Polishing up my Mercedes convertible, I hooked up a third-hand, $800 thirteen-foot house-trailer and headed north with the top down to meet Wendy, who was debriefing from her European sojourn at her father's farm near Cockeysville, Maryland. The word farm is misleading, but substituting estate would be pretentious. Two handsome stone buildings, a separate one for guests, stood nestled under the broad limbs of several willows. A convenient walk away, there was a pond stocked with fish should you be inclined to catch one. On one edge of the property a stream cut through a wooded area. The driveway from the house extended a half a mile in the other direction, passing through pear and plum trees to Western Run Road. The Mercedes and I were accepted but not our rolling domicile. Wendy's father politely indicated that the trailer should be parked out of sight behind a haystack by a huge stable, another dignified stone structure that supplied the resting place for thoroughbred horses.

We chose Texas as the beginning of our journey because of its size, topography, diverse cultural heritage, and the mythological place it occupied in the American mind. It would provide a "how to" model for the rest of the country. Heading west, we plunged into a life that for Wendy was as exotic as Mongolia. New perceptions are expected in Eastern Europe and Africa, but they abounded as we began our journey from the farm in Maryland, picking a route that followed the path of westward migration. We crossed the Potomac, James, and Roanoke rivers, through the Shenandoah Valley, across the Cumberland Gap, and up into the Appalachians. We crisscrossed in a thousand places the ghost trails of dirt-bound travelers of past centuries. Piercing the great geographic barriers one after another with no great effort, we thought about the contrast of our easy journey with the groaning, sweating labors of those who had come

this way before. We drove on, over the rivers, up and down the tall timbered mountains, stopping occasionally, hoping to see the ghosts of those who had come this way before. We were occasionally teased by the sight of such people: men and women of special angularity. Some of them seemed to have stepped out of the archives of Dorothea Lange, immediately recognizable, adjusted as if by natural forces, nourished from these lands. Their speech and manner had also been tuned by their own special history and our ears were introduced to new voices as we traveled from one deep accent to another.

Country music sounds and gospel tunes poured out of the car radio. Rural AM stations delivered a peppy beat and hours of droning mournful tones of rural reckoning that often snuck in messages from the Lord. The airways were awash with Jesus. It was music that we had rarely listened to. But a few songs stuck with us; *It Wasn't God Who Made Honky Tonk Angels* was one of those. But my favorite, perhaps a hangover from the many hours of radio in the darkroom a few years later, was *Drop-Kick Me Jesus Through The Goalposts Of Life*.

Our lofty goal, set out in a proposal sent to the New York publisher, was "to understand and perhaps better preserve aspects of our national heritage that were being lost to time and technology." How to do it? We had to slow down; it wasn't going to be possible at 55 mph. The ease of speed numbed our perceptions. We missed the cadence of local time. Our velocity, even geared down on the back roads carried us too far away from deeper revelations, which were polished away in a blurred whisk. At first, we parked our rolling bedroom in clean safe havens for overnight stops in state parks, roadside rests and a few meandering side roads that didn't give a damn whether you were there or not, but it didn't connect us.

From the vantage of New York, *Back Roads of America* had seemed an exciting alternative to the familiar international patterns of our lives. But this concept now began to feel amorphous, even naive. We needed to anchor our work to the land and examine how people related to the physical environment and how people were changed by it. The title, *Back Roads of America*, was dropped. If we were to find the roots of our civilization, we would have to limit our attention to a few trees, not the whole forest.

When we reached the Arkansas delta, side roads seemed businesslike, servicing a huge endless sea of crops with only the peaks of storage elevators to

be seen on the horizon. A railroad track bordered U.S. 70, supporting miles of boxcars that collected the vast amounts of rice, soybeans, oats, and alfalfa nourished by the black delta soil. Every inch along the flat alluvial plain that flanks the Mississippi River was either plowed up or wooded, and the little side roads were purposeful routes to agricultural fields; there was neither guaranteed aloneness nor contact with people. There was no place to park. But then things changed.

On the evening of April 18th, my diary noted that we "found a side road cutting a tall stand of trees on one side and a vast field on the other. My headlights bored a long hole through the dusky light, on and on, and then it came to an end at a farmhouse under a stand of oak trees. The lights were on. I couldn't back out with the trailer; so we pulled into the yard to ask permission to turn around on the circle in front of the house. A young boy came out and told us to come on in if we wanted. I asked if there was any place we could park. An older man in overalls joined us and said: "You can stay right here," and we felt safe, covered by the limbs of a giant oak, sanctified by a stranger's welcome.

A few minutes later the same open-faced boy appeared. "Do you need water or anything?" We said we were OK, and then he asked us: "You wanna go frog giggin'?"

"Sure, give us ten minutes and we'll be ready," not completely sure what he was talking about. The boy was back on the dot.

His name was Tom and he was fifteen. Tom soon knew that he had a couple of raw recruits as far as frog gigging was concerned. He was going to make every effort to educate us in its mysteries.

"You want me to bring a huntin' dog?"

"Do you need a dog to hunt frogs?"

"No," he said, "but I thought you might like to have one." The adventure started on this note and it soon became clear that this wasn't just a frog hunt.

Guided by the beam of my flashlight, Wendy and I navigated the harrowed earth with uncertainty until we got the feel and the direction of the land. The stars were bright and gave off a dusty light. Tom's young voice began to add new possibilities.

"Hear that?" he said, "That's a wolf. There's a pack of 'em. I killed one last week by the house."

Sounded like someone's lonesome dog to me. But Tom moved from wolves to panthers, "Killed a black panther in them woods last year." Then he moved to ghosts and four uncles in the Marines. He was going to join the Corps as soon as he could.

Tom was carrying a gig for sticking frogs — an eight-foot bamboo pole with a three-foot trident on the end. Wendy and I slogged through the furrows, the flashlight beam cutting a shadowy path, licking back and forth until we climbed the embankment of an irrigation canal.

"How good you at pipe walking?"

We crossed the twenty-foot canal atop a 15-inch pipe that bridged it. Tom had been talking about wolves, panthers, and frogs, but suddenly, I caught in my flashlight beam a swimming snake. It wasn't very big, about three feet long but its head was unmistakably viper-shaped — a triangular skull. This was a cottonmouth water moccasin – a very poisonous reptile slithering through my flashlight beam, disappearing, then caught again. We stepped over the belly-up corpse of another snake and by now I was willing to believe the place was crawling with them.

Tom took us back to the house via a patch of forest that had an abandoned graveyard — an old black cemetery. Inspired by the fading light, and as we trudged through leaves, ropy vines, and clinging thorny vegetation caught on every footstep, Tom fully expected a ghost to pop out of a grave like a bullfrog. Was the kid taking us on a fantasy party? Snakes and biting bugs and critters began to appear in the undergrowth of my imagination. Tom was getting jittery and anxious not to linger. "Saw a moving light in them graves one night. The light circled all the way around the field."

"What did you do?"

"I ran outta my shoes. Didn't leave nothin' behind but dust."

We got back to the trailer well after dark. Tom bid us a quick goodnight. He had to be up at 5:00 a.m.

We returned with no frog trophies, heated up a can of hash corned beef on the tiny gas stove, and spent a peaceful night in the trailer. The next morning, Tom arrived to invite us for breakfast to meet Bonnie, his mother, a big powerful half-Cherokee woman who drove a tractor-trailer when she wasn't farming. At home, there were two other boys and her much older husband. Bonnie wanted

to know all about us, and was fascinated with Wendy's portfolio showing color magazine pages from work she had had done in West Africa. "They're sure interestin' lookin' niggers. I'd loved ta' seen that." She bubbled with enthusiasm.

Bonnie was full of stories about driving a swaying trailer loaded with cattle along icy roads over the Rocky Mountains, and picking fruit as a farmworker in Oregon, and how at Christmas twenty-five neighbors would gather at her house for dinner.

"You come too," she offered, but we reluctantly bowed out: it was only April. But Bonnie had opened an invisible gate. We were anxious to experience more. Bonnie and her family treated us with an immediate feeling of intimacy. We didn't earn it, yet we were welcome and this was both a surprise and a relief.

We left Arkansas with our curiosity stimulated. Austin, Texas was our next stop. By chance, the back road (State Highway 90) that we used to get to Austin passed through Anderson, Texas (pop. 280), the tiny county seat of Grimes County. It was afternoon, school was letting out and along the side of the road there were nothing but black students filing down the road – a surprise, because I was not aware that Texas had a sizable population of African-Americans. They were simply not part of the literature of Texas at that time. It was a demographic detail that would have a profound effect on our lives.

In Austin, we would find the means to do the research that would change our unfocused quest into a plan. An Austin experience had saved me in 1961, after the *Titanic* adventure, and I had a good feeling about the place. Stenger was supportive and generous, and continued to be when Wendy and I arrived. Although we parked the trailer at his house, and engaged in long debates about the state of the world, we now drew from different wells. Captain Bob Snow and Stenger's rancher friends lived in an action-oriented, ego-driven world that was quite different from what we were finding in other areas of Texas life. Stenger and I, however, remained life-long friends.

In Austin, Ann Richards invited us to a dinner party that turned out to be in our honor. Ann had received a flattering report about Wendy from Bill Josephson, a lawyer friend from New York, who I also knew from Peace Corps days when Bill was Legal Counsel for Sargent Schriver. At this dinner we met a man named Larry Goodwyn and Wendy mentioned that she had been surprised when we discovered a town full of African-Americans in Texas, a state

perceived by so many to be populated solely by the cliché image of Marlboro men. It turned out that Professor Lawrence Goodwyn, soon to be the head of the Department of History at Duke University, was about to publish an article in *the American Historical Review* that reported: "*In Grimes County, 60 miles northwest of Houston, throughout the 1890s an estimated 30 percent of Anglos in the county teamed up with the majority of black voters to win local elections...*"

This amazing encounter was more than a lucky break, Larry Goodwyn changed our lives. We hooked up the trailer with an advance printout of Larry's article and headed for Grimes County.

His writing and political acumen were a huge boost to the project, but when we got back to Grimes County, we found ourselves desperately wondering how to translate the lofty concepts that I had described in my journal into reality. On the simplest level, how were we going to get our trailer parked on somebody's land as we had in Arkansas to get this thing started? We drove around the nondescript rolling farmland, seeing belts of post oaks that broke our vision, with nothing being high enough or flat enough to give the land that enormity that stirred our imagination. There were small farms — fenced; there was barbed wire everywhere, and nothing but the road was public. Every foot seemed regulated by privacy; everywhere were evenly spaced signs to remind us that there was to be "NO TRESPASSING." Then, it started to rain, then it was pouring, and then it stopped. We pulled off the road in a space next to a little white church in a grove of trees to let the storm pass and think things over. We felt slightly desperate.

The play of the rain clouds and their release brought about an immediate transformation to Grimes County. The little weather-scrubbed wooden church became converted for a short time in this light into a steamy, hopeful mirage. Then this passed and the scene returned to the circumstances of poverty, re-transformed in an architectural form to purest simplicity and beauty. The tricks and turns of the setting sun back-lit the late afternoon thunderclaps as they piled up, ponderous, sucking up humid air, and refreshing the world with cool sheets of rain just over in the next field. The elemental feeling of this experience temporarily calmed and distracted us. It was a magical moment and then there was another thunderclap moment — as an old pickup truck came careening down the road, wildly honking and pulled over by the church.

"Maybe, we shouldn't be here," I thought. A big black man got out. He was about forty years old and appeared to be quite drunk. An intense, fast-talking and very suspicious man told us that the property belonged to "his people" but then he unexpectedly offered us a beer. Then he wanted to know: "What are you-all doing?"

We explained that we thought the church was beautiful, were about to take a picture of it, but were also looking for a place to park for the night.

"Oh, just follow me," and as simple as that, he led us out, up over the hill, and into a dirt driveway on the left by a small wooden frame house. The driver got out and introduced us to a towering black man standing there, Willie Buchanan, his father. There wasn't much conversation, but Willie Buchanan unlocked a gate and indicated that we could park the trailer in his back pasture.

In parking our trailer in the back pasture of Willie Buchanan's farm, we were not only provided a rent-free space, but also given a pass into a world that under any other circumstances would have been closed, separated by race and class. Willie's neighbors were his brother, Buddy, and his wife, Alice, and

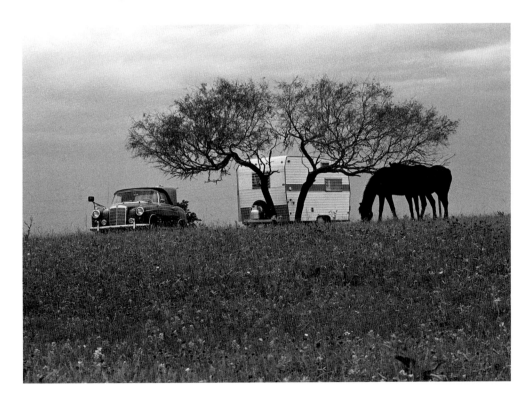

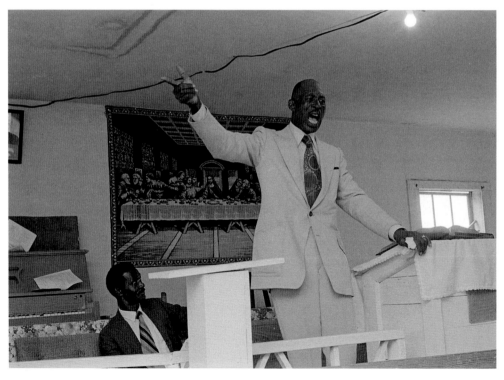

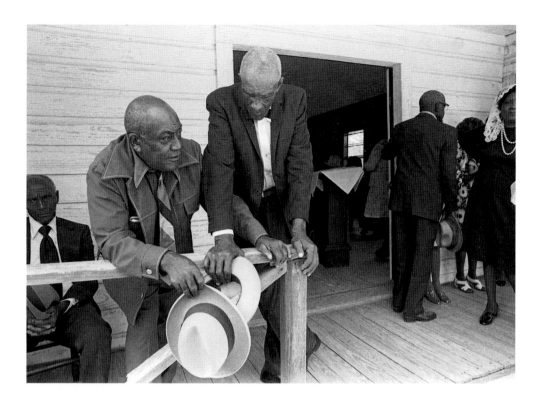

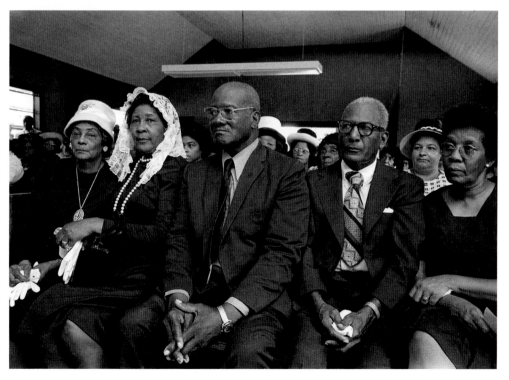

there were nephews and nieces inhabiting small wooden houses dispersed over 200 acres that belonged to the collective Buchanan clan. Alice was the center of activity, a slightly built woman of quick intelligence, though probably illiterate, curious about all things, and funny. Alice opened another gate. She was especially taken with Wendy, and the feeling was mutual. Jokes, gossip, and fun became the backdrop for the beginning of our introduction into the life of the Buchanan family. Photographing the process didn't seem to be an uncomfortable thing to do. Our relationship passed from simple acceptance to warmth. Our friendship was nurtured and then grew more intimate because we all laughed about so many things and Wendy asked so many questions. We were interested in everything that our friends did or said and this, happily, was considered to be a compliment. The actors on the stage of the Buchanan farm seemed inspired by the audience, two white strangers who recorded and responded to everything that was going on. This was something that we considered a welcome miracle.

But we also knew that it would not be understood favorably in all parts of Grimes County and we took precautions. Shortly after settling in to the Buchanan back pasture, we went to visit County Judge H.W. Haynie, County Clerk Tristan Harris, and Sheriff Dick Johnson to introduce ourselves and explain that we were recording life for a documentary on the county. They were all polite and it may have helped that our car had Georgia license plates, but we discovered many months later, after becoming good friends with all three, that they had thoroughly checked us out by the Department of Public Safety and the Texas Rangers, who could not believe that anyone would want to camp on a black man's land unless they were criminal agitators of some kind.

Grimes County provided us with an example of the Southern cotton culture that was established in the 1820s by slave-owning plantation owners who had migrated to Texas after wearing out the agricultural land further east. In the 1830s, German settlers arrived, and later Polish families were brought in after the Civil War because of white landowners' fears of losing black labor after the abolition of slavery.

We became friendly with a young grandson of one of the largest cotton farms along the Brazos River bottomlands — the legendary, even notorious Tom Moore farm, which was the subject of blues musician Mance Lipscomb's

famous *Tom Moore's Farm*. The young Moore took me on a tour of the cotton fields in his pickup and I noticed he had a .45 caliber revolver in the cab.

"Why are you carrying a pistol?" I asked.

"Oh," he explained, "On Saturday nights *they* might get a little rowdy and you can't predict what *they* might do."

It turned out *they* were the black laborers who had been working on this huge farm for years, some for generations. Back at the Buchanan's, we asked about the Moores and got a very detailed description of the family. This was possible because there were Buchanan family members and friends who had worked in many capacities for the Moore family; as cooks, nurses, and field workers on many levels. The *theys* knew a lot about the Moores but the Moores didn't know much about the *theys*, and so goes the myopia of class.

We were lucky enough to see Grimes County from many different perspectives and we began the process by going to church every Sunday, sometimes three times a day. We started with the black churches, and extended our photography to special events like funerals and weddings in the Catholic Church in Anderson, where the Polish congregation was led by an Irish Priest, then the Baptist, Methodist, and Episcopal churches that drew from different economic and social levels in the Anglo- and African-American communities. Each church provided an entrée into the different aspects of culture and history of Grimes County and convinced us to go deep rather than broad in our investigation of the different cultural frontiers of Texas. Before settling in Grimes County for a longer time, however, we needed to see more of Texas. It was time to move on to see if the investigative methods we used in Grimes County would work in other parts of the state where past and present circumstances were so different.

We went to the Rio Grande Valley, Hidalgo County, and through a contact in Austin, Ronnie Dugger, the founder and editor of the *Texas Observer*, we looked up two interesting men who were involved in the political changes that were occurring in the Valley where the Latino political reform movement La Raza had become very active. The first was Manuel Barrera, a barber who was a reform candidate running for mayor of Pharr, Texas, a border town notorious in the 1970s for a Mexican-American protest march that turned into a riot when police shot a bystander. Pharr was known for its economic disparities, inferior

education, and police brutality. When we found Manuel Barrera at his barbershop, I decided to get a badly needed haircut while Wendy interviewed him. I sat in the barber's chair comforted by the photographs of John Kennedy, Robert Kennedy, and Rev. Martin Luther King Jr., knowing that we were in the right place as far as our political sympathies were concerned, and I marveled at Wendy's fluid Spanish as she began to interview Manuel Barrera while he clipped away. There were a lot of questions, and clip, clip, Manuel Barrera became more and more animated in his responses. Clip, clip, clip. Suddenly I began to feel a bit lightheaded, and for good reason. When the interview finally stopped, I was practically bald. Since that day, I have never had a professional haircut. Wendy is my tonsorial artist, but we never discuss politics when she's at work with the scissors.

Other experiences proved to be surprising in other ways. We looked up a young Chicano activist, Narciso Aleman (age 22), described in the local paper as "a sort of resident dean as well as a degree candidate at the school." He was part of a faction that was associated with Jacinto Treviño College. It was founded to teach Chicano history and the college was run by Chicano leaders. Antioch College of Greens Springs, Ohio was supporting this effort with their "Museum Without Walls" program and provided credits from Jacinto Treviño to students, some of whom were local high school dropouts. Wendy and I were very impressed with this bold idea, but much of the Anglo community in Hidalgo County considered the school to be radical and subversive. In fact, it was reported that Rev. Oliver W. Summerlin, pastor of the nearby Mercedes Baptist Church, offered to provide one-way tickets for Jacinto Treviño students to China, Cuba, or the Soviet Union.

It was a shock to Wendy and me to discover that Narciso Aleman was neither impressed nor well disposed toward us in spite of our interest in the Jacinto Treviño program and Wendy's fluency in Spanish. We hoped to get his help to guide us to some of the conditions that were fueling the protest movement in the Rio Grande Valley. By chance, one day while we were photographing farmworkers in the fields, I was wearing a battered fatigue jacket with USMC on the breast pocket and sergeant stripes stenciled on the sleeves. When Narciso discovered I was an ex-Marine and had served in Korea as an enlisted man, his attitude toward us changed completely and he took us to colonies

where the farm workers lived. He made it clear that he would not have helped us had I been an officer.

In Grimes County, we had been accepted. In the Valley, the skepticism of our guide made it clear that we lived in opposite worlds and hadn't had to pay the same price as he had to learn what we were learning. We could join the vegetable pickers to photograph them, but then we could escape — what was a matter of hours for us, was a lifetime for them. That was a feeling that I would always remember.

We photographed a government commodity food program that provided the sizable population of poor Mexican-Americans with powdered milk, cheese, tortillas, and other commodities they needed but had trouble affording. At the end of one day of photographing, the supervisor gave us a large supply of these same groceries. They included an enormous box of Velveeta cheese; she apparently assumed that we were photographing for food. We accepted the donation gratefully because our budget for groceries at this point was three dollars a day.

Economic and social contrasts were very visible in Hidalgo County. Some of the largest landowners in the Rio Grande Valley were transplanted Midwesterners. One of them, Lloyd Bentsen Sr. ("Big Lloyd"), had arrived in the Rio Grande Valley as a first-generation Danish-American from South Dakota in 1917. He became a legendary landowner and businessman, reported to be worth between $50 and $100 million. (He was also the father of Texas Senator Lloyd Bentsen Jr., who served from 1971 to 1993.) We decided to try to meet Lloyd Bentsen Sr. and observe how his lifestyle contrasted with what we were seeing among the workers.

Our trailer was parked in a Chicano barrio where fresh water was drawn from a single hand-cranked pump that served a cluster of little shacks. From there we contacted Lloyd Bentsen Sr., with a call from a pay phone, and asked if we could arrange an interview. To our amazement, he invited us to his ranch, gave us a tour, and treated us to the best steak dinner I have ever had. As we toured his ranch with him, he told us he was not well-to-do and had come to the Valley to make money. This was one of many disparities that we found in the Rio Grande Valley, which was also called the *Magic Valley* by its promoters, but not by Narciso Aleman.

In far west Texas (Presidio County) we found yet another story — a Mexican-American family who had a different kind of tale to tell. Wendy and I and the trailer were welcomed by the Madrid family in the tiny community of Redford (pop. 165), situated near the Rio Grande River on Farm Road 170, sixteen miles southeast of Presidio. There was not much more than a general store and a filling station. A one-room schoolhouse served both Redford kids and children from families that lived across the river in Mexico. The Madrid's son, Enrique, was a graduate of the University of Texas, where he had met his Anglo wife. Enrique and his father ran the filling station and grocery. His mother and wife maintained a remarkable private library with books from around the world. His mother taught in the small school across from their home. A small rowboat was used to ferry the children who came to attend the school from across the Rio Grande, and the boat was dragged into the brush when not in use. This was another version of the American dream.

Further inland, toward Marfa, the land became dryer, wilder, and more dramatic. During the 19th century, British and Scottish banks helped to finance huge cattle ranches to furnish England's need for more meat and leather in its expanding colonial empire. Because of the lack of rain and abundant pastures, it required 340 acres to raise a single cow; the ranches were huge. The German Hill Country was not as much of a mystery to me as Grimes County and South Texas had been. I had spent time in parts of the Hill Country in 1963, holed up in a cabin on the Dan Ault Ranch and when I was attempting to photograph wild boar with A.D. Stenger. But the experience of living in the trailer was very different from that earlier trip that drew from the wild male ego fantasies inspired by my friend Stenger

As we did in Grimes County, we circled Fredericksburg and Gillespie County looking for a place to park. This time our confidence was up and when we spotted a stone house down a rocky road we pulled up, with no particular expectation, and no fear. We met an elderly bachelor couple who spoke with a broad German accent. They were actually brother and sister, Edwin and Paula Rausch. After explaining that we were looking for a place to park our trailer and a brief description of why we had come to Gillespie County, we were directed to go down the continuation of the jagged limestone road until we got to the creek, where we could park. This turned out to be our home for the next

three months and we came to know Paula and Edwin very well. They were plainspoken, friendly, and disarmingly matter-of-fact. Through them we were introduced to a history that was radically different from that of Grimes County or the Rio Grande Valley.

Edwin and Paula were third-generation descendants of emigrants from Germany. Their handsome two-story limestone stone house, hand built by their father, reflected a combination of traditional German architecture and elements of Anglo-Southern homes. Technically, the rooflines were less steep than on classic German farmhouses and the long covered porches with casement windows were an adaptation of Anglo-Southern styles. When we met the Rausches, the trappings of material comfort were either shabby or missing. Light bulbs downstairs dangled from single cords. The kitchen was a hodgepodge of buckets, pots, and pans that were dedicated to the manufacture of traditional *kochkäse* cheese that started with the cow that Paula milked daily. The peeling wallpaper and wood-burning stove were not unusual for American rural farms but they were at odds with the careful and skilled craftsmanship with which their father built the house – a building that was intended to preserve stability and a pride of culture that would last for generations. Should a Houston or Dallas millionaire be lucky enough today to buy the Rausch 200-acre property to create a summer "getaway" residence, everything on the inside would be ripped out and replaced with the latest modern bathroom, bedroom, kitchen, and living room, but not a stone on the outside would need to be replaced. But the outside of the house had been built as the pharaohs built the pyramids – it was built *for forever*.

The Rausch homestead reflected the backbreaking work of German family farmers who came to make a life on the beautiful but hardscrabble land of the Edwards Plateau in the mid-1800s. The Germans survived here when many Anglo-American settlers had failed. German settlers began to arrive here when Texas was an independent republic. A German nobleman, Prince Carl of Solms-Braunfels, envisioned the creation of a Prussian state across the Atlantic in 1844. Prince Braunfels paid for advertisements in German-language newspapers describing rich land for low prices in far-off Texas. For the German farmers this was a Land of Oz. For some, it was a way to avoid the military draft of autocratic war-torn German states; others were escaping the potato blight or

encroaching industrialization. Many were conned by steamship and railroad companies who joined in promoting the scheme with deceptive advertising. Land speculators, who had never set foot in Texas, offered to sell 160 acres for $120 for single men and $240 for 320 acres for families. The arrival of the Germans was encouraged by the Republic of Texas and Anglo planters to the east because the colony would create a buffer between Texas settlements far to the east in an area that was swarming with hostile Comanche Indians, a fact that was unknown to the incoming German settlers. Although transportation from Germany was free, and free farming tools, provisions, and a free log house were promised immediately upon the settlers arrival at the port of Indianola, a combination of greed, inefficiency, lies, and ignorance guaranteed disaster; thousands died of starvation in those early days.

When the early settlers first arrived in what is now Gillespie County, they found lush valleys among the rocky hills. Grass, belly-high, seemed to justify their tortuous trek from the coast, but the black soil was stingy and only an inch deep. Below it, they found plow-smashing limestone rock. At first they struggled, trying to use the traditional farming practices of their homeland, and some starved. Men, women, and children hauled rocks from the fields and built neat stone walls, becoming the first to enclose their land in Texas. Before the era of barbed wire, the stone wall fencing made it possible to experiment in sheep and goat breeding. They learned from Mexican shepherds and eventually developed superior herds. It was the same tenacity and inventiveness that had gone into the construction of limestone houses like the home of Edwin and Paula Rausch. The Germans eschewed slavery, rejected the Confederacy and relied almost exclusively on family labor.

Small two-story "Sunday houses" — tiny dwellings — were built and used by farmers when they came to town on the weekends to rest, attend church, and socialize. In Gillespie County, much of our work was devoted to photographing these community activities, including singing clubs and the *Schuetzenfest*, where young men and old competed in target shooting with strange-looking bolt-action rifles with iron sights and a barrel that extended three feet longer than usual. On Saturday night, we were made welcome at Pat's Dance Hall, where we recorded a spectacle of fun and music where traditional German polkas, schottisches, and waltzes joined country-western songs. Young women

sat along benches along the walls, and between dances, while the young men, beer in hand, stood together eyeing the benches. It cost one dollar and the whole family would go. Children grew up learning how to dance — polkas, schottisches, and waltzes and the two-step.

Another characteristic that marked the inhabitants of Gillespie County was their aversion to displaying class, status, or wealth. The richest man in the county had his larger house well hidden by trees away from view. Even the relatively poor didn't consider themselves marginalized because they were convinced that hard work would change their circumstances. Their German culture, preserved and adjusted, contributed to this attitude. Throughout their struggles, the German settlers built institutions that were designed to survive. The maintenance of collective activities such as bands, parades, beauty contests, and clubs of all kinds, encouraged group interaction. It went back to the early days when impoverished farmers didn't have enough tools to survive but shared their plows with neighbors should they not have one.

Late one afternoon, Wendy and I were returning from photographing in the countryside and we stopped at a gas station at dusk. There had been a sudden shower, the roads glistened, and a pink light slowly settled over the tops of the hills. A man came out of the station, and we all stood silently looking to the north at Enchanted Rock. Then he turned to us and said: "You know where you are? It's God's country."

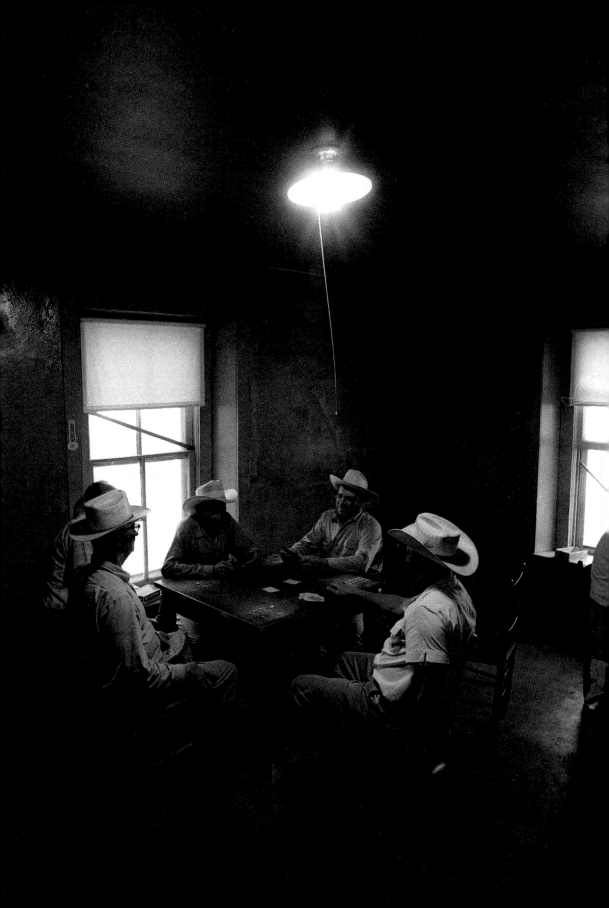

34 – GOING FORWARD

After logging 54,000 miles on my old Mercedes, fixing 34 flat tires, and spending $15,592 of our own money, it was time for a break. Our savings were almost gone. Wendy had to head east but we needed support for the next phase of our project.

I had been visiting a lot of funding "possibilities" in Texas without much success but I proceeded to Dallas for one last try. I had a crippled back from dragging a canvas sack of mounted photographs around what seemed like the entire state of Texas, and then there was the revenge of two old wounds from Korea. When I parked the trailer on the street in Dallas, I was ready to quit but I stuck one more dime into a public telephone and dialed the number of the Leland Fikes Foundation, a private family foundation. I couldn't believe my luck: Leland Fikes himself picked up the phone and agreed to see me immediately.

Lee turned out to be a young man about my age, whose parents had died leaving him in charge of a lot of money that had become the Leland Fikes Foundation. Lee liked our work and he promised $5,000. It was our first grant. I pushed off for Savannah and the east coast.

Back in New York a couple of weeks later, I had to tell Jerry Mason that *Back Roads of America* was no longer an ambling continental exploration. Larry Goodwyn's essay had introduced us to political phenomena hidden under untold histories. Our photography revealed the surface of this history, but to fully relate the rich complexities of the stories that came from the people we encountered, we needed the background of history. We wanted a depth of his-

torical research to inform our documentary photography and oral recordings. We added a reel-to-reel Uher tape recorder to our baggage of tools. We wanted to look *deeply* rather than *broadly.*

After thirteen months of research and fieldwork, Wendy and I returned to the spare room in my mother's basement, next to my darkroom in Savannah, to process 636 rolls of film and hundreds of pages of notes. It took six months to complete the film processing, print contact sheets for each roll, edit them for quality choices, and enlarge 340 selected images.

Before we went back to Texas to what became several years of work in the mid-late 1970s immersed in rural Texas and the 'American' experience, we had a small show of our Texas photographs in New York at Portogallo Gallery and then a larger show at The Phillips Collection in Washington D.C.

On our return to Texas in 1975, we met Dr. William Goetzmann, Pulitzer Prize historian who headed the American Studies Program at the University of Texas at Austin. Innovative and always interested new ideas, Bill Goetzmann was intrigued by our work and together we set up a year-long program in American Studies and Communications departments at the University of Texas. After talking to urban activists in Austin, we sent teams of students, a writer with a photographer, to 'document' the history and social realities of two Austin neighborhoods, one white and one black, which were seeking historic zoning. Goetzmann introduced us to Lonn Taylor, who was in charge of a special project at Winedale, a small town between Austin and Houston that had become a "laboratory for students" at the University of Texas "to explore many fields associated with the history and culture of ethnic groups who migrated to Texas in the early part of the 19th century." We immediately hit it off and Lonn proposed to the Faculty Advisory Committee that they create the Winedale Fellows of American History that would enable us to apply for grants through Winedale to support our work.

After a year of teaching, we returned to Grimes County for two years, then on to Gillespie for another two years funded by the Rockefeller Foundation and the National Endowment for Humanities. In the middle of our Grimes County work, in 1976, through a suggestion of Tom Hess, we went to see Harris Rosenstein, curator of the Rice Institute for the Arts created and managed by Dominique de Menil. Harris became a mentor for Wendy and me in many ways.

Leading up to an exhibition of our Grimes County work, he would send us small jobs while we were still living in our trailer on three dollars a day. He loved what we were doing and would treat us to a steak dinner at Houston's venerable Stables Steak House on Main Street.

Dominique de Menil and her husband Jean were French art patrons who had moved from Paris to Houston before World War II. Jean was president of Schlumberger, founded by Dominique's father and uncle. Much of Jean and Dominique's considerable fortune was dedicated to art, artists, and transforming Houston into a world-renowned art center. When Harris introduced us to Dominique, they had already created the Rothko Chapel, the non-denominational chapel designed by Philip Johnson for meditation and the presentation of a series of huge Mark Rothko paintings. Dominique also founded the Media Center and the Institute for the Arts at Rice University. There we had the good fortune to exhibit 340 of our photographs from Grimes County. (We shared the space with an exhibit of paintings by the surrealist Rene Magritte.) For the opening of the Grimes County exhibit, Dominique sent eight buses to Grimes County to bring many of the people in our photographs to Houston. During the event, the renowned British art critic David Sylvester carefully trailed an elderly woman from the town of Navasota and heard her breathlessly confess to him in front of one of the images, "That's the very spot I got my first kiss."

By 1980, we had finished our research in the German Hill country, and it was time to settle down, leave the trailer, abandon our mobile lifestyle, and write some books. We had to choose between returning to New York and staying in Texas. Dominique offered to rent us one of her cottages in Houston, across from the Rothko Chapel – at the center of what would become the heart of the Menil Collection, the Cy Twombly Museum, the Menil Drawing Institute, the Byzantine Chapel site, and the Dan Flavin installation. We moved there in 1980 and we've been there ever since.

I started my teaching career with Wendy at the University of Texas in Austin and then for six years at the University of Houston. One of the most pleasant events of my academic sojourn at the University of Texas involved a monthly barbecue outing shared by the university's photography faculty from the Journalism and the Art departments. J.B. Colson, my boss, and I represented photojournalism, and Russell Lee (retired), Garry Winogrand, and a few others

came from Art. I remember Garry especially because even back then he was considered one of the great American photographers of the mid-20th century. For a year Garry and I sat next to each other, but during that time Garry and I never exchanged a word that I can remember. He wouldn't communicate. Why? Perhaps I was insufficiently senior or was it my association with photo-journalism as opposed to art? Who knows? But a number of his students kept migrating from his class to mine, saying that he was not an easy man.

In 1983, when I was invited to Malmö, Sweden to participate in a photography festival, Garry Winogrand was there with a large exhibition of his work. Garry was the star, but I knew everybody. My first steps as a photographer were made in Sweden and I had used it as a base from 1957 to 1962. The Swedish photo circle is relatively small and I had worked with many of them, and was godfather to the son of one of their best known photographers, Pål-Nils Nilsson, who was also in Malmö.

I was introduced to Garry Winogrand. He asked me whether we had met somewhere, saying: "You look vaguely familiar."

"I don't think so...," I answered. "But of course I have heard of *you*." I was playing it cool.

Noticing that I knew so many people, he even asked me to do him a favor. "The Swedes don't ask many questions," he explained. "They are very shy. Would you mind helping me break the ice?" Of course, I replied that I would do anything I could to help.

"Ask me: *Why do I tilt my camera?*"

"I would be delighted."

The lecture commenced and when it was time for *questions and answers*, Garry was right, the Swedes didn't say anything. It was time for me to help.

"Mr. Winogrand," I declared in a strong voice, "I want to ask you about something many of us are wondering about. Is it true that the reason so many of your photographs are tilted is because one of your legs is shorter than the other?"

The audience broke up. The Swedes loved it. To his credit, Garry took it all with good humor. He also worked like a fiend and was up at dawn every day shooting endless rolls of film, none of which I ever saw, before he went home. He died not too long after his Swedish exhibition in Malmö, I am sorry to say, because I was getting to like the guy.

In Houston, one assignment that I gave to every class at the university marked my style of teaching. It was more experiential than academic. I would ask each student to go out and photograph something that they were afraid of or uncertain about. One student chose to photograph in a gay bar, another focused on a rather scary-looking disheveled young man who sold newspapers under the viaduct at the entrance to the university.

The slightly homophobic student found that the men in the gay bar were amused by his assignment, bought him a drink, and had no interest in him sexually. He planned to do a book about the bar. As for the man under the viaduct, the scruffy-looking paper peddler turned out to be a university graduate student who was trying to earn enough money to get through school. The discussions we had in class about misconceptions and stereotypes inspired me to continue it every year.

The switch to teaching in Houston gave me time to go back to my earlier photographs and I worked on a selection of my civil rights work for an exhibition at the Telfair Academy of Arts and Sciences in Savannah in 1983. The organizers of the show also published a book with 55 of my photographs and more than 100 oral history interviews of participants in the Civil Rights movement twenty years earlier. The title, *We Ain't What We Used To Be*, had been used to conclude a speech that Martin Luther King Jr. made in 1963. He quoted the words of an old slave preacher: "We ain't what we oughta be. We ain't what we want to be. We ain't what we gonna be. But, thank God, we ain't what we was."

The Savannah exhibition became the 20th reunion of many of the civil rights activists in the photographs, including Hosea Williams, Andrew Young, and Benjamin Van Clark. Ironically, the person who suggested that the Telfair Academy do the show was the wife of the prominent banker who had declined to help Dr. Gatch many years earlier because he was "too controversial." Time had helped the unacceptable come to life.

Wendy continued freelance journalism and photography, and because of the vacation breaks provided by my teaching job, there were regular intervals when my sons Breck and Grattan came to stay in Houston.

Our Branard Street house slowly became a hodgepodge of antiques and we gradually absorbed furniture from Wendy's mother and the sale of my

mother's house in Savannah in the early 1980s. Two elegant little potbellied Biedermeier tables, a style of Viennese furniture (1815-30) described by antique experts as "a backlash against the status quo and propelled by a movement driven by social, domestic pursuits," were a curious echo of our own intentions. Being surrounded by artifacts from our past delighted me. Standing in the front hall was a seven-foot blowgun I had acquired in Borneo. This evoked a fond memory of my time there until I discovered that Grattan was practicing his marksmanship by blowing the accompanying non-poison "poison darts" at an old pillow.

We also had a wonderful hand-painted Swiss armoire dated 1732 with a depiction of the Helvetian national hero, William Tell, shooting an apple off the head of his son with a crossbow. This charming relic from my earliest years and place of birth may well have inspired Grattan to expand his shooting skills.

In 1982, Wendy's story on the effects of the herbicide Agent Orange on U.S. veterans exposed in Vietnam was published in *LIFE* magazine and she won the *World Press Photo* award for editorial photography, Leica's *Oskar Barnack Award*, as well as *Interpress Photo*. Wendy, her mother Lorraine, and I went to Amsterdam to watch Wendy receive the *World Press Photo* award from Prince Bernhard of the Netherlands. While we were in the Netherlands, Lorenzo Merlo, director of the Canon Gallery in Amsterdam, suggested that we visit the Rencontres in Arles in the South of France, an annual event in July that attracted museum curators, photo publishers, and photographers from all over Europe. There, in addition to exhibitions, photographers' portfolios were informally reviewed in the lobby of the Hotel d'Arlatan.

Wendy and I stayed in Arles for two weeks, met many people, and sold prints to museums, and our stories for publication in magazines. Flying back to Houston, we decided that we could provide an amazing opportunity for photographers by creating such an event in Houston. It would be the first in the United States. It would be an international platform for art and artists. It would create new opportunities for artists across the U.S. and throughout the world. It would deal with important social issues.

In Houston, we found that a German friend, Petra Benteler, who ran a photography gallery specializing in European photography, had thought about an international fair for art dealers. We soon discovered that a Le Mois de la Photo

had been started in Paris under the sponsorship of the Mayor of Paris in 1980 to show photography every two years in art spaces and museums that belonged to the city of Paris. With Petra, we decided to combine the festivals in Arles and Paris into a single event in Houston and call it FotoFest. The organization was incorporated as a non-profit in November 1983. It would turn out to be the tallest mountain I could ever imagine climbing, and it required a team.

Ever since childhood, the image of Mt. Everest has towered on the horizon of my imagination. Perhaps it was being born in Switzerland, land of peaks, or was it the presence of a mountain-climbing ice ax that somehow followed me around the world and still lives in my attic on Branard Street? It had belonged to my father, who was an avid climber. For whatever reason, Everest and the alleged words of George Mallory still haunt me: Asked: "Why did you want to climb Mt. Everest?" he replied: "Because it is there." Mallory and his partner, Andrew Irvine, died trying to climb the world's tallest mountain in 1924.

My own "ascent," often referred to as an analogy of mountain climbing in this book, turned out to have different levels of difficulty. My earliest setback, the death of my father, was cushioned by the warmth provided by the women in my life and eased my climb. Teenage years filled with pain and confusion led to steps that took me into adolescent rebellion, and ultimately found me facing the very real challenges of wartime survival. Along the way, I conquered a personal summit by daring to meet the great Pablo Picasso.

Still unsatisfied, however, I set off on a mad ego scramble that somehow took me to another, higher, level that finally ended with a clearer view of purpose, which, thankfully, brought me to the more than worthwhile association with the Civil Rights movement, the Peace Corps, and Dr. Gatch. I still suffered dangerous slips, however, as I left Monica and my sons, Breck and Grattan, and I had to discover a very different route to climb out of this messy landing place. Proceeding further, perhaps I should also include an earlier but less familiar quote from Mallory, "Have we vanquished an enemy? (the mountain.) To which he responded, "None but ourselves."

When I met Wendy I was no longer a solo adventurer. Wendy and I learned from one another as we explored Texas and ourselves and found that we could do more by doing it together. It drew from a common passion. Building on our individual experiences from many different parts of our past, and combining our particular talents, we could find a better way to scrape the sky.

We believed that perhaps through FotoFest we could stimulate a broad field of creative energy through photography. I believe that artists are able to subtly shift human behavior by introducing glimpses of special summits for those who wish to climb a little higher. Wendy has additional beliefs in the power of art, but she doesn't disagree with mine. For over thirty-five years, FotoFest has provided hundreds, maybe thousands, of photographers with a way of fulfilling their dreams on different levels and in multiple ways, and this effort has involved over sixty countries since 1986.

That year, the English-language edition of *European Photography*, a German magazine, advised its readers that, "the first FotoFest was like nothing Americans had ever seen," and that in many ways it reflected the character and personality of its host region, and that it was huge, free-wheeling, star - studded, and utterly sociable. For those Europeans who managed to come, it was a bonanza, a genuinely international gathering characterized overall by one German participant as, "not just America's first Foto Festival, but really the first International Foto Festival anywhere."

From a dream in our heads in 1983 that no one believed was possible, the FotoFest Biennial has taken place every two years consecutively for thirty-five years. It has become one of the world's leading platforms for art and ideas. A full description of this history will join the other missing parts of FotoFest's story in the future.

My addiction to references about climbing mountains and Mt. Everest in particular has not led me into climbing one, but it has led me to admire those who do and read about those who did. It seems that George Mallory had a very unusual style as a climber. One of his climbing partners described Mallory's movements as "almost serpentine in their smoothness... in watching George at work, one was conscious not so much of physical strength as of suppleness and balance."

These observations, from my own experience, have led me to the conclusion that Wendy and I, like George Mallory and his partner Andrew Irvine, had completely different climbing styles. Wendy and I made our ascents in our own ways, and we got to the tops of our own mountains. But our story, and certainly the FotoFest story, is a dual one and must be told by both of us.

Curiously, the life that Wendy and I have led together was forecast by a strange oracular occurrence in 1970. During my tumultuous New York days in

the late 1960s, I had met Michael Looten, an eccentric genius who was renting an apartment from my friend, Muffy Stout, on the Upper East Side of New York. Michael had built a huge computer housed in a clear plastic box a third the size of a shipping container. For a time, his machine was placed in the middle of Grand Central Station and was designed to predict the future for the enlightenment of travelers. Michael described himself as the Chief Astrologer for Grand Central Station. When he learned of my "hot romance" with Wendy, he was anxious to see what the stars, planets, and galaxies had to say about our prospects, and he invited us to come to Grand Central to check us out.

He first asked for the precise time and place of our births. I knew mine — January 25th, 1929 and, courtesy of my Baby Book, the exact hour, but Wendy could provide only her birth date, February 15th, 1943. But Michael felt he had enough information to give us an accurate forecast for a future Aquarian life together.

The machine was switched on, accepted the data, and started whizzing and whining as it revealed what Mars was doing to Venus on January 25th and February 15th. Memory brings back a vague picture of little red and green lights flashing on and off as wheels and reels spun around. It may be my imagination but it seemed to me there were more red lights blinking than green, but what did I know about astrology or computers? Finally, after a minute or so, the machine shut down, cooled off, and spat out a detailed report that Michael read. It took him longer to give us the news than I would have expected from the usually ebullient Michael, but finally he announced in the gravest tones: "If you two get together you are going to be arguing for the rest of your lives." Luckily, so much of my academic life had been spent discounting disastrous "report cards" that Michael's warning had no cautionary message for me.

Like Wendy, I feel that a careless or foolish remark debases serious conversations, but my response draws from different sources, ranging from combat in Korea to survival in the Arctic, my worldwide peripatetic upbringing, and an elitist orientation. Making sense of all this gives me the sense that my real education — life experience — arrived by another route and was imbedded in the "marrow of my bones" rather than collected in my brain.

Although we have shared more adventures together than most people, there are not as many collisions as there might be, considering that we sleep in

the same bed, very often work on the same projects, print photographs in the same darkroom, and travel together for business and pleasure. We each bring a high intensity to our personal relationships. Our long life with one another has been stitched together by a deeply felt respect for one another and a passionate commitment to find even better ways to convert our feelings into action through collaboration — our Texas work and over thirty-five years of FotoFest. In recent years, we have been asked to talk about our life and personal work at a number of museums and festivals. If I may say so, these public dialogues are successful because they are totally unpredictable, amuse us, and are slightly irreverent. These are also the qualities that keep our relationship fresh and fun.

My partnership with Wendy provides a happy ending to this long tale. Quite often, at home in Houston, we get off the racetrack of our busy lives, take a break, and go out for dinner alone to a small Italian restaurant — a secret rendezvous. At least two brimming glasses of Barolo along with pasta or eggplant parmigiana launch the evening. We often rush back almost half a century to the beginning of our relationship. It's amazing to be able to peel away time and sweep off the daily burdens of life that pile up like dead leaves. It's such a miracle to meet each other anew and realize that just under the shielding exterior, daily distractions, and disagreements, there is something that is still so sweet.

A few weeks before this writing, on a Christmas Eve, we were in New York, and again were able to slip away, just the two of us, to an Italian restaurant; once more, good food and wine erased life's intrusions, and again the occasion provided a moment of discovery. This time it went beyond *us* and back to an extraordinary breakthrough for *me*.

This book opens with a disastrous meeting that I had with my mother in Florence, when I explained that I had undertaken dangerous missions in the name of photojournalism to prove myself to her. She had burst into tears and made the devastating proclamation, "You're blaming me for almost killing yourself."

My long record of successes and failures has taught me enough about life to accept myself as I am, variously good or bad, and that's what made it possible to be sitting with Wendy sharing my secrets and stories with her on Christmas Eve. In my lifetime, Christmas Eve has been a special time. We are trained from earliest memory to feel that it is a time of happy expectation. In recent years

Wendy and I have spent the evening of December 24th with my sister-in-law Judith, who was married to my brother Gamble. (My brother died in 2003.) But this year, we were in New York as usual but Judith was down with the flu, so Wendy and I had ventured out a couple of blocks from where we were staying to a restaurant called Giovanni Vente Cinque on 83rd Street between Madison and 5th Avenue. It was Italian, small, and quiet, just what we were looking for. Hopefully, the food and wine would help us cut through a cold, rainy winter night to something warm and intimate.

When we stepped into the place, we entered another world. A waiter in his sixties welcomed us; he looked more like the proprietor than a waiter. We were met with professional assurance. He was one of those Italian waiters who come from generations of dedicated servers who deliver something special that they care about.

The restaurant advertised Tuscan cuisine and was decorated with dark scenic paintings that were hard to make out in the dim light but I presumed were of Tuscany. Hoping to make a connection with my own past, I made a jab at identifying one. "That must be Sienna," I declared as the menu arrived. "No, signore, that's Venice." That, I have to admit, threw me off, killing my chance to regale him with a quick story about my trip to the Palio festival of Sienna as the guest of Count Guido Chigi Saracini in 1955. I immediately changed course: Instead of two glasses of wine, I ordered a full bottle of Il Bruciato 2014 for the two of us. I knew this rich and pleasurable red wine from a visit to the medieval hamlet of Bolgheri about six miles from the Etruscan Coast. The wine didn't disappoint, and as Wendy and I talked on, other things came to the surface.

She was sitting with me under circumstances that I couldn't hope to improve. There was no TV staring from the wall, our fellow diners spoke softly, and a dressy holiday ambiance in the restaurant combined to set a high tone for the moment. I dared to ask her how she thought we had achieved our level of intimacy. She said I made her laugh, was a bit unpredictable, and had not been afraid to take risks to learn and to live a full life. Yes, I had learned to write funny letters to my classmates' sisters at St. Mark's, and I made cartoonish drawings that softened my letters home from Korea, and this facility eventually produced a key that opened Picasso's door, but the habit of making

those little drawings came from my mother; she had illustrated all her letters to me since I could remember. But did the special spark that lit up my drawings come from my father? Had I inherited some of this from him? I remembered the stories about his wit and charm, but they were friendly ghosts from the past created by my mother and a product of the ongoing love affair that marked their marriage. My actual memory of him, as a five-year-old, was like a few dim and out-of-context scenes cut from a movie.

Why was this precious perspective about my father slipping in now? A bit had surfaced through my writing; apparently there was much more. A second glass of wine softened something else. A seismic shift deep inside of me suddenly occurred and a flash of insight flew out as if it had been waiting to escape my whole life. I then told Wendy something that I had never told anybody. I had never even thought of its significance until that very moment.

I told Wendy that ever since I could remember, at countless times in the day or night when I'm home, I look at the top of my bureau drawers at a photograph of my father, aged 49, in a bathing suit, standing on the beach in Barbados.

He is superbly fit, with the body of an athlete who works hard to stay in such condition. Again more wine illuminated another clue about my father — his Alpine ice ax in our attic in Houston. Is that why I so often refer to climbing mountains in this book — and the references to George Mallory?

My mind was drifting away, wandering, thinking. Then suddenly, Wendy asked me to tell her the story of my encounter with my mother in Florence. As I recounted my long-ago meeting with my mother in Florence, I paused. And Wendy said softly: "Have you ever thought that...?"

And then I suddenly realized that I had really been talking to my father.

In all these years of writing this book, what I hadn't fully understood until that moment, was that all the adventures that I have described here were not tales generated to tell my mother, or my imaginary father Picasso, or my friends. They were tales for my father, my real father, Frederick William Baldwin. This revelation came to the surface Christmas Eve, when the trust, comfort, and intimacy of my relationship with Wendy drew it out of some very deep place in my psyche.

Finding my father in a deeper, more intuitive sense was a discovery that I didn't realize could happen. I had pulled him from the darkness as I talked

about his photograph and then about my mother, and then what his photo-graph truly revealed to me.

This book describes many wild rides I have taken, travels, adventures, risks. But why had I done those things? I discovered that night that I had done them all to have stories to tell my father. He was the genesis of the *Picasso mantra,* and Wendy was the key that unlocked these secrets.

And I must not forget to credit the bottle of Il Bruciato — it, too, had been drawn from Tuscan roots.

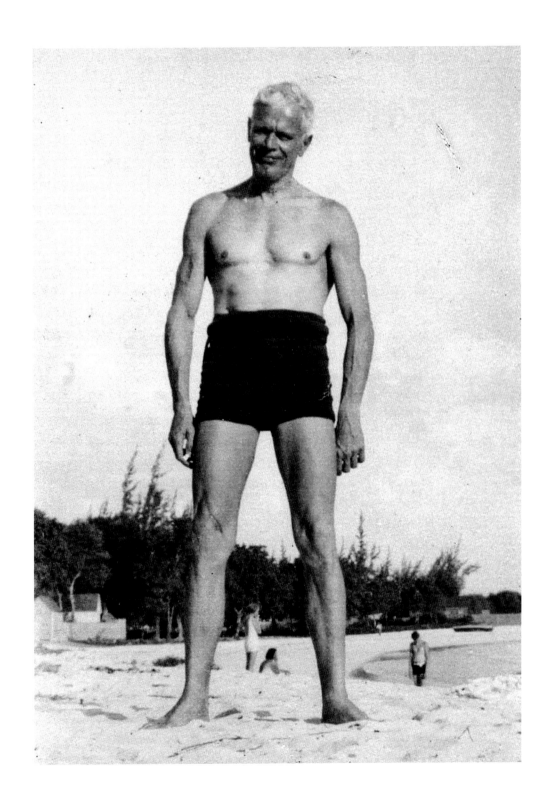

ACKNOWLEDGEMENTS

The list of people who have made it possible to tell these tales begins with Wendy Watriss, my work partner and wife, who is not only a wonderful photographer and writer but also an excellent editor. She is also quite clear about her opinions, so she wisely never read a word of this book until completion and thereby saved the project. Had she indicated that I was not a literary genius, I would have given up in despair. She knew that by carrying the load of managing FotoFest International for the last ten years, an organization that we created in 1983 with Petra Benteler, she made it possible for this book project to move forward.

In the summer of 1955, my classmate Dick Mumma lent me his Rolleiflex camera to take to Europe and I used it to photograph Picasso. In 2006, good luck prevailed again in Mexico City when my friend Pedro Meyer saw some of my color photos of Picasso and published the Picasso images along with my story on his amazing website Zone Zero. That was the beginning of this book. But even before that, Picasso had shifted my destiny. Muriel Fuller, my creative writing instructor at Columbia, read my account about visiting Picasso and sent the story to Beulah Harris, editor at E.P. Dutton, who wrote to encourage me to keep working on my writing: "If you can control your adolescent fantasies; patience and discipline will help organize the freshness of your approach." Later, the Picasso story was nudged closer to possible publication when Ashbel Green, Managing Editor at Alfred A. Knopf, who liked the piece, sent it to Vanity Fair. But it didn't work out so I went back to concentrating on my photography.

In more recent years, Frank Rodick, a cosmopolitan Canadian friend, who is a clinical psychologist, writer, teacher, photographer, and an avid reader, has helped me over and over again with this book. Another reader, Eve France, smart and uncompromising, never got discouraged even as the book became longer and longer. Then there were the professional editors, starting with Ann McCutchen, then Grace Sanders, who kept me on track, and finally Robert Morton, who kept me going until I finished the book. In the early days there were photography colleagues in Sweden, like Pål-Nils Nilsson and Birgitta Forsell, and the railroad worker Lennart Johanssen, who kept me alive in northern climes. The book mentions many more who provided me comfort and psychic survival: Bob Potter, my St. Mark's prep school English teacher; the friendship and expertise of Bob Schwalberg, writer and technical consultant at Leica Camera; in Korea, my riflemen comrades in the Marine Corps and my special friend Bob Glen provided a level of support that made the difference between life and death, hope and despair as we were introduced to Hell during the Korean War. Marine veteran and Washington Post writer Henry Allen encouraged me to be bold with these chapters.

The magazine editors like Adolph Suehsdorf and Albert Squillace at American Sportsman, as well as National Geographic's Andrew Brown, were others who kept hope, film, and fees coming my way. Commercial shoots organized by Charles Frazier of Sea Pines Plantation and David Pearson of Hilton Head made my photography respectable to my family, especially my brother Gamble and his wife Judith. Gamble and Judith's generosity was broad and multi-faceted but their approval of my life style, risky on all levels, was constantly challenged.

Later down the trail, there were numerous individuals who stimulated me and expanded my horizons. In my early days in Texas, John Henry Faulk, Lon Taylor, Larry Goodwyn, and Bob Calvert opened my mind and many doors. In Houston, Harris and Sheila Rosenstein, Dominique de Menil, Miles and Slavka Glaser, Jane Owen, Louisa Sarofim, Abdel Fustok, Daphne Murray, and Roy and Mary Cullen have been enormously important in making it possible for Wendy and me to realize our dreams. Among others who helped are Tono and Henrietta Waring in Savannah; Tom Hess and Betty Wolf in New York. They, like A.D. Stenger in Austin and so many others, have enriched the narrative of this book. And there are others from the past as well as the immediate present

who need to be thanked like Mary Sanger, Mike and Muffy McLanahan, Erica Cheung and Paul Hester.

The volume of detail accumulated in notes, letters, and diaries is staggering and the conversion of this material into workable information required organization and typing, typing, typing. My first wife, Monica, pounded some of the earlier material into recognizable form even after an exhausting day in her office. Many years later George 'Gogo' Neykov traveled from Bulgaria to Houston to scan and archive thousands of Wendy's and my negatives. Help also came from Marianne Stavenhagen and Vinod Hopson at FotoFest, often in the form of administrative first aid to the project. Annick Dekiouk formatted my photographic presentations and made sure my stabs at writing French were tolerable. Brock Kobayashi is my intrepid guide through the internet jungle, where every gizmo is a poisonous snake and current technology is the foliage that often crowds out the light.

The ultimate miracle came when Maarten Schilt of Schilt Publishing in Amsterdam said yes to publishing the book. Equally amazing is the work of bookdesigner Victor Levie, who somehow was able to navigate through a congestion of possible photographs and found the nuggets that were gold and even a few diamonds among the messy mass.

Encouragement for this book has come from individuals from over twenty countries. Some have published parts of my work, others have written about it or promoted my creative efforts as well as Wendy's. There is not enough space to mention them all or detail how they have helped, so I am going to list a few names of those who kept me writing: Shahidul Alam, Bangladesh; Georges Vercheval and Xavier Canonne, Belgium; Finn Trane and Jens Friis; Denmark; Pentti Sammallahti, Finland; Jean-Luc Monterosso (Mois de la Photo, France; Andreas Müller-Pohle (European Photography) Germany; John and Bernadette Demos, Greece; Lorenzo Merlo and Mario Marangoni, Italy; Tatsuo Fukushima and Eikoh Hosoe, Japan; Patricia Mendoza, Mexico; Peter Applebom (USIA), Norway; Evgeny Berezner and Irina Chmyreva, Russia; David Balsells, Barcelona, Spain; Rhonda Breedlove (Rhubarb Rhubarb), Brett Rogers and Mark Haworth Booth; UK; Betty Moody, Surpik Angelini, John Hansen, Alan Rudy, Alan Buckwalter, Vicki Goldberg (New York Times), Jim Estrin (New York Times), Harold Coolidge (National Academy of Sciences), Lawrence Coolidge, Bill Hunt, Rich Levie of Imprint, Nelse Greenway and Chris Olsen, USA.

CAPTIONS AND CREDITS

Credits

Photos pages 1 and 50-654:
Fred Baldwin

Photos pages 663-681:
Fred Baldwin and Wendy Watriss

ISBN 978 90 5330 918 6

© 2019 (text) Fred Baldwin, Houston (TX)
© 2019 (photos pages 1 and 50-654
 Fred Baldwin, Houston (TX)
© 2019 (photos pages 663-681) Fred Baldwin
 and Wendy Watriss, Houston (TX)
© 2019 Schilt Publishing, Amsterdam
 www.schiltpublishing.com

Photo edit
Fred Baldwin and Victor Levie

Design
Victor Levie, Amsterdam
www.levievandermeer.nl

Text correction
Kumar Jamdagni, Zwolle

Print & Logistics Management
Komeso GmbH, Stuttgart
www.komeso.com

Printing
Bechtel Druck GmbH & Co.KG,
Ebersbach (D)
www.bechtel-druck.de

Distribution in North America
Ingram Publisher Services
One Ingram Blvd.
LaVergne, TN 37086
IPS: 866-400-5351
E-mail: ips@ingramcontent.com

Distribution in the Netherlands and Flanders
Centraal Boekhuis, Culemborg

Distribution in all other countries
Thames & Hudson Ltd
181a High Holborn
London WC1 V 7QX
Phone: +44 (0)20 7845 5000
Fax: +44 (0)20 7845 5055
E-mail: sales@thameshudson.co.uk

Schilt Publishing & Gallery books, special
editions and prints are available also online
via www.schiltpublishing.com
Inquiries via sales@schiltpublishing.com

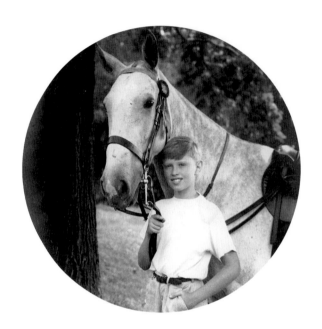